REALIZATIONS

Realizations

NARRATIVE, PICTORIAL, AND
THEATRICAL ARTS IN
NINETEENTH-CENTURY
ENGLAND

MARTIN MEISEL

PRINCETON UNIVERSITY PRESS
PRINCETON, NEW JERSEY

Copyright © 1983 by Princeton University Press
Published by Princeton University Press, 41 William Street, Princeton, New Jersey
In the United Kingdom: Princeton University Press, Guildford, Surrey

This book has been composed in Linotron Monticello
Designed by Barbara Werden
Clothbound editions of Princeton University Press books
are printed on acid-free paper, and binding materials are
chosen for strength and durability

Printed in the United States of America by
Princeton University Press, Princeton, New Jersey

FOR MARTHA, MAUDE, ANDREW, AND JOE

CONTENTS

ILLUSTRATIONS

[x]

A NOTE AND SOME
ACKNOWLEDGMENTS

❖·❖

THE PICTURES in this book form part of the argument, and they are drawn from both popular sources and the fine arts—from book illustration, theatrical reportage, and painting. I often use nineteenth-century engravings after paintings as a matter of choice, on grounds that the version of the image that was most widely known is the version most pertinent to my concerns. But I suspect I may have caught something from the spirit of an age when Charles Dickens could reflect on his encounters with famous paintings:

> Where the drawing is poor and meagre, or alloyed by time,— . . . though no doubt it is a heresy to hint at such a thing,—the engraving presents the forms and the idea to you, in a simple majesty which such defects impair. Where this is not the case, and all is stately and harmonious, still it is somehow in the very grain and nature of a delicate engraving to suggest to you (I think) the utmost delicacy, finish, and refinement, as belonging to the original. Therefore, though the picture in this latter case will greatly charm and interest you, it does not take you by surprise. You are quite prepared beforehand for the fullest excellence of which it is capable.[1]

It was Dickens' business to put into words what many others vaguely felt but would not always admit.

SOME of the standard play series that I have found useful are abbreviated in the notes:

Lacy = Lacy's Acting Edition
French = French's Acting Edition [Lacy's continuation]
French Minor = The Minor Drama
Dicks = Dicks' Standard Plays
Dicks BD = Dick's British Drama
Duncombe = Duncombe's British Theatre
Cumberland Minor = Cumberland's Minor Theatre

The annotation "L.C. MSS" refers to the Lord Chamberlain's files of plays submitted for censorship, now in the British Library. The term

[1] Letter to John Forster (9 March 1845), *The Letters of Charles Dickens*, Pilgrim Edition, Vol. 4 (1844-1846), ed. Kathleen Tillotson with Nina Burgis (Oxford, 1977), pp. 276-77.

"Enthoven" refers to the famous collection in the Victoria & Albert Museum, now integrated into the Theatre Museum, London.

Versions of Chapter 3, "Speaking Pictures," and Chapter 9, "The Material Sublime," have appeared previously, the first in the *New York Literary Forum* 7 (1980), guest-edited by Daniel Gerould, the second in *Images of Romanticism, Verbal and Visual Affinities*, edited by Karl Kroeber and William Walling and published by Yale University Press.

Three professional colleagues generously read the whole of this book in manuscript: Robert G. Hunter, Stephen Orgel, and Hugh Witemeyer. The book would be much poorer without their encouraging severity, and they have my special gratitude. Richard Brilliant, Lindsay Errington, Steven Marcus, John Rosenberg, and Alex Zwerdling brought their tact and intelligence to bear on particular chapters. The sustained interest and shared knowledge of three Columbia colleagues, William Appleton, Karl Kroeber, and Carl Woodring, have added immeasurably to the pleasures of finding and thinking things out. Others who have been especially helpful include William Beattie, Jean Patricia Campbell, Kenneth J. Fielding, Danny Friedman, Margaret Jardine, Martha Mahard, David Mayer III, George Nash, Arthur H. Saxon, Allen Staley, Diana Wilson, and and the late Marian Hannah Winter. A decade ago Michael R. Booth found much to interest him and to encourage in what I had to say about the nineteenth-century theater and the visual arts. His own exploration of the subject may be found in *Victorian Spectacular Theatre 1850-1910* (Boston, London, and Henley, 1981).

I have a notable debt to students in my seminars on nineteenth-century fiction, drama, and the visual arts, and to others who gave me particular help in getting things right: Brenna Clarke, Karen Hornick, Deborah Luskin, Susan Manning, Richard Moye, Terence Paré, Joseph Viscomi, and Tony Whiting. Catherine Palmieri proved a heroic typist, and Joy Hayton, Joyce Gee, and Elnora Johnson helped with the endless concerns that beset a book with pictures.

The first glimmerings of the work before you came in the course of a Guggenheim Fellowship for a quite different project in 1964. I am indebted to the foundation, and to Dr. Gordon Ray for his lively interest in all that developed from that year, most of it in areas of his own vast expertise. The first extended period of research, after the sketch of a compendious article turned into the design for a book, had the support of an ACLS Fellowship in 1970-71. Every part of this book depends on the research, writing, and self-education of that year. A subsequent appointment as a Fellow of the Institute for Advanced Study in the Humanities, Edinburgh, an award from the American Philosophical Society, and two summer grants from the Huntington Library and Art Gallery, helped bring the work to completion. All these institutions and the people who create and administer them have my profoundest gratitude, on personal and on public grounds, for their faith in humanistic scholarship.

Years ago Miriam Brokaw of the Princeton University Press extracted from me the plan of this book and eventually made it welcome. So did Jerry Sherwood, Literature Editor, who first saw the manuscript and whose book it became. It is also Marilyn Campbell's book

for the copyediting and Barbara Werden's and Janet Tingey's for the design. Without them there would be no realization.

The following repositories and organizations have kindly allowed reproduction of pictorial material in their custody. Those with an asterisk have generously waived reproduction fees; the numbers refer to the illustrations. *Baltimore Museum of Art, the George A. Lucas Collection, on indefinite loan from the Maryland Institute College of Art: 91, 92; Bayerischen Staatsgemäldesammlungen, Munich: 1; Bibliothèque Nationale: 24, 69, 79, 80, 82, 83, 86, 87, 96; *Birmingham Museums and Art Gallery: 163, 167, 207, 213; *British Library: 123; British Museum, Department of Prints and Drawings: 2, 15, 17-23, 25-29, 47, 51, 55, 90, 101, 139, 140, 144, 148, 156-59, 161, 169, 172; A. C. Cooper, Ltd.: 174-76; *Fitzwilliam Museum, Cambridge: 164; *Huntington Library, San Marino, California: 124, 136, 143; *Lady Lever Art Gallery, Port Sunlight: 195; Louvre (clichés des Musées Nationaux): 12-14, 67, 76, 93, 153; *Bill Mauldin and Wil-Jo Associates, Inc., by permission: 81; *Metropolitan Museum of Art, all rights reserved: 220; Musée de Versailles (clichés des Musées Nationaux): 77, 78; *Musée des Beaux-Arts de Lyon: 84; *National Gallery, London, by courtesy of the Trustees: 3; *National Gallery of Art, Washington: 63; *National Gallery of Scotland: 11; *New York Public Library, Print Collection, Art, Prints and Photographs Division, Astor, Lenox and Tilden Foundations, 30-45; *Royal Holloway College, Egham, Surrey: 141; Tate Gallery, London: 4-6, 10, 65, 138, 165, 166, 214; *Theatre Museum, London: 114, 125, 171, 191; University of London Library: 52, 57; Victoria & Albert Museum, London: 54, 64, 97, 133; *Wallace Collection, London, by permission of the Trustees: 89, 94; Whitworth Art Gallery, University of Manchester: 59, 196-206, 208-212; *Witt Library, Courtauld Institute of Art: 149; *Yale Center for British Art, Paul Mellon Collection: 132; *Yale University Art Gallery: 193.

MARTHA, Maude, Andrew, and Joe, who must share a single dedication, have all contributed to the substance of this volume. I am not entirely easy that, as children, one or two of them learned to rush past Titian and Velázquez and their like, to head straight for the nineteenth-century narrative painting. And I find it sobering that one declared and others agreed, as they saw this reliable constant in their lives readying for the press, that it seemed as if one's whole youth were over. Still, I like to think that the damage to the next generation has been slight, and the benefits not all on one side. I at least have profited from Maude's feeling for story, situation, and character, from Andrew's quick eye and vivid response to color and form, from Joe's exceptional visual memory and lively sense of analogy, and I hope they do not read this as my attempt at an exhaustive enumeration. Martha, I regret to say, put off some of her own work, which promises to be of more interest to the world, to make a large space for mine. Many of her acute perceptions are incorporated in what follows without further acknowledgment. I do not apologize, since the fact is we are much in each other's debt.

REALIZATIONS

A MATTER OF STYLE

✢ ┊ ✢

*T*HIS BOOK explores some relations between fiction, painting, and drama in the nineteenth century. It keeps mainly to Britain but occasionally looks abroad, especially to France and Germany. It is concerned with formal similarities and with expressive and narrative conventions that fiction, painting, and drama shared, and less abstractly with the intricate web of local connections that show the arts to be one living tissue. I attend to such connections for the period between David Wilkie's coming to London to make his fortune as a painter in 1805, and Henry Irving's departure from the Lyceum Theatre, having lost his fortune as an actor-manager, in 1902; not just because these events span the century, but because they seem to bracket a distinctive set of relations between narrative and picture that constitute the foundations of a style. Earlier figures, notably Hogarth and Diderot, prepared the foundations, and they intrude insistently.

Novels, pictures (including some book illustrations), and plays as staged get nearly all my attention here because these three forms constitute a convenient dialectical field. To common sense, the novel is the most thoroughly narrative and serially progressive of forms; painting is the most pictorial and static; and plays, with a story unfolding through a visible enactment, appear to combine something of both. And indeed, the play in the nineteenth century is the evident meeting place of story and picture, and so it earns a central position in what follows, despite the disjointedness of so much dramatic narrative and the evanescence of nearly all the theatrical images. Common sense, however, as often happens, is not allowed the last word. In the nineteenth century all three forms are narrative *and* pictorial; pictures are given to storytelling and novels unfold through and with pictures. Each form and each work becomes the site of a complex interplay of narrative and picture, rather than one member in a three-legged race to a synthesis.

Poetry also enters these discussions, but less frequently, though it would be idle to pretend that the long narrative poem, for example, and prose fiction have nothing to do with each other. Architecture, music, and much else scarcely appear at all. These omissions probably compromise one ambition of the book, which is to suggest ways of organizing and perceiving representational art that cut across medium and genre and constitute a common style. In some of these slighted

arts, however (nondramatic music, architecture), the representational character is indirect and problematical, while in other instances the applications take care of themselves. Jerome Buckley could be talking about nineteenth-century drama, for example, or a dominant strain of prose fiction, when he describes Tennyson's *Idylls of the King* as implying, in its title, "not a single unified narrative but a group of chivalric tableaux . . . each of the Idylls moves through a series of sharply visualized vignettes toward its pictured climax, its moment of revelation."[1] Naturally I do not mean to suggest that music and architecture are irrelevant; only that they complicate and enlarge the argument. I think one could demonstrate, for example, the affinity between the affective, descriptive, and "effective" character of the new music, freed from many of the constraints of abstract and perspicuous form, and the character of the new dramaturgy. Though I neglect music without an immediate theatrical function, there was in fact no great gulf between the theater and the concert hall.

The shared structures in the representational arts helped constitute, not just a common style, but a popular style. After a period from the Restoration forward of comparative cultural stratification, there was a considerable mingling and enlarging of audiences in the earlier nineteenth century, accompanied by an explosion, technologically induced, of print and picture. The popular audience of print and picture consumers, reaching from the palace to the city streets, came into its own in the nineteenth century, and found entrepreneurs anxious to provide for it, by the penny and by the pound. Consequently, the prohibitive cost and limited sale of a deliberately expensive three-decker novel through much of the century give no clue to its currency in the culture; for that, one needs to know about circulating libraries, serialization, extracts, imitations, penny plagiarisms, and dramatizations. Similarly the uniqueness of an oil painting liable to disappear into somebody's private collection gives no clue to its popular familiarity; for that, one needs to know about exhibitions, versions in steel-engraving, wood-engraving, and lithography, renderings in glass, paint, dioramic projection, graphic parody, "living pictures," and theatrical "realization."

Such diffusion encourages the normal disposition of cultural critics and historians to find that everything connects to everything else. The problem is compounded where the arts are concerned, since there analogy is a legitimate mode of action; it is how invention and imagination work. In the arts, both patrician and popular, the obscure transforming leap of the imagination sometimes eludes chains of cause and effect, networks of demonstrable influence, chartings of source and stream. But where such sensible canons of proof cannot provide a limiting corrective for the intuitions of a rationalizing interpreter, the critical ground turns to quicksand. The discovery of analogies and pointed differences linking the work of hacks and geniuses, painters and musicians, linking social, political, scientific, and artistic innovation, is itself the work of the imagination, and risks degradation from the imaginative to the imaginary. Even Polonius, a man by habit analytical and classificatory, can see whales in the sky when urged by the rage for similitude. On the other hand, even Hamlet can fail to take analogy seriously enough, when, in considering Laertes, Hamlet sees

[1] Jerome Hamilton Buckley, *Tennyson, the Growth of a Poet* (Boston, 1960), pp. 172-73.

but does not see "by the image of my cause . . . The portraiture of his." Unregulated analogy has been the plague of those who would generalize about period style. Not knowing how to take analogy seriously enough has been the defect of traditional historians of the several arts.

To cope with infinite connection and unchecked analogy, I have resorted to a divided approach. In the first section of this book I reconstruct some of the issues that both beset the several arts in the nineteenth century and gave them their opportunities. I also attempt to elicit some of the notions in the technical and critical vocabulary of the day that transcend the divisions of the arts. In the second section I turn to cases, namely to a series of crossings where a literal connection gives the clue to wider cultural and stylistic relationships. I believe these crossings form a rough outline of change, from the beginning to the end of the century, but also display from various angles the constants in a complex situation. The specificity of the connections and the historicity of the language and issues work as a ballast, I would hope, rather than as an anchor. In the end the critic-cum-historian has to remember, for reassurance, that seeking connections, making analogies, and constructing dialogues are not his own bizarre peculiarities, but are much more characteristic of the inventive minds and dispositions that called forth the pictures, plays, and stories here discussed.

The Language of Art

Formal similarities suggesting ways of organizing and perceiving reality, and shared expressive and narrative conventions, the two most pervasive of my announced concerns, are by no means independent of each other; but the latter are much easier to point to and talk about. That there were conventions for the representation of character and emotion or the embodiment of a situation in the nineteenth century we know from old movies and the crude relics that survive even today as mock melodrama. The iconography of character and emotion was less limited than these relics suggest, and it was available for serious uses, while its clichés—like those of any conventional system or language—were even then vulnerable to burlesque. In the iconography of character, external marks—such as a man's fur collar and cigar or a woman's full bosom—came to signal not merely moral qualities, but predictable functions in plot and situation. In the iconography of emotion, interior experience was conveyed through a conventionalized language of facial expression, pose, and gesture, sometimes remote from the gestures of contemporary life, but not narrowly bound to tradition either. It is true that the acting handbooks at the turn of the century and after still used illustration and description descending from seventeenth-century formulas; but in practice the language of representation had evolved. Practical problems of scale and subject matter undoubtedly had more influence in painting and the theater than the "old receipt-books for the passions," in Hazlitt's disparaging phrase.[2]

In the theater, despite its relative conservatism, enlarged auditoriums and a broader audience in the first third of the century made gesture and attitude a more important register of emotion than facial expression

[2] *Complete Works of Hazlitt*, ed. P. P. Howe (London, 1933), 18:10. The most influential work in this tradition was Charles Le Brun's, published as the *Conférence de M. Le Brun . . . sur l'expression générale et particulière* (1698). Its influence persists in Aaron Hill's *An Essay on the Art of Acting (Works* [London, 1753]); in Henry Siddons' version of J. J. Engel's *Ideen zu einer Mimik* (1785), *Practical Illustrations of Rhetorical Gesture and Action* (London, 1807); and elsewhere. See Brewster Rogerson, "The Art of Painting the Passions," *JHI* 14 (1953): 68-94; Rensselaer W. Lee, "*Ut Pictura Poesis*: the Humanistic Theory of Painting," *Art Bull.* 22 (1940): 197-269; Alan S. Downer, "Nature to Advantage Dressed," *PMLA* 58 (1943): 1002-37. Though pedagogic versions of Le Brun continued to appear in England well past the mid-century (*Lebrun's Passions Delineated . . . Admirably Adapted for Students, and All Who Wish to Read the Various Expressions of the Human Face*, 1863), more influential on painters (such as David Wilkie and Holman Hunt) and writers (such as Dickens) was Charles Bell's *Essays on the Anatomy of Expression in Painting* (London, 1806). Darwin, for whom Le Brun's was "the best known ancient work, and contains some good remarks," has genuine praise for Bell in his own fascinating *Expression of the Emotions in Man and Animals* (London, 1872). Hazlitt's exasperation with "the school of Le Brun's heads—theoretical diagrams of the passions" and their deadening effect in the "epic style of art" vented itself regularly. Cf. *Works*, 18:13 and 30.

(the chief concern of the academic tradition stemming from Charles Le Brun) and even language. Some of the available formulas are reported (with reservations) in the most influential of the inexpensive handbooks aimed at an audience of aspirants. A sample will suffice:

> *Joy*, when sudden and violent, is expressed by clapping of hands and exulting looks; the eyes are opened wide, and on some occasions raised to heaven . . .
>
> *Mirth* or *laughter* . . . occasions holding the sides.
>
> *Grief*, sudden and violent, expresses itself by beating the head or forehead, tearing the hair, and catching the breath, as if choking; also by screaming, weeping, stamping, lifting the eyes from time to time to heaven, and hurrying backwards and forwards. This is a passion which admits, like many others, of a great deal of Stage trick . . .
>
> *Melancholy* or *fixed grief*, is gloomy, sedentary, motionless; the lower jaw falls, the lips become pale, the eyes are cast down, half-shut and weeping, accompanied with a total inattention to everything that passes. The words are dragged out rather than spoken; the accent weak and interrupted, sighs breaking into the middle of sentences and words.
>
> *Fear*, violent and sudden . . . draws back the elbows parallel with the sides, lifts up the open hand (the fingers together) to the height of the breast, so that the palms face the dreadful object, as shields opposed against it; one foot is drawn back behind the other, so that the body seems shrinking from danger, and putting itself in a posture for flight. . . . Fear is also displayed, frequently, by a sudden start, and in ladies, by a violent shriek, which produces fainting; the voice is weak and trembling.
>
> *Love*, when successful . . . [has] sometimes both hands pressed eagerly to the bosom.
>
> *Courage* . . . [is shown by] the arms sometimes akimbo.
>
> *Pity* . . . looks down upon the object of compassion with lifted hands . . . the hand sometimes employed in wiping the eyes.[3]

Some of these gestures and attitudes had had a long theatrical and pictorial life before entering Leman Rede's compendium. But such language does not stand still, and there is nothing, for example, in the description of melancholy that reminds one of the braided arms of Ariel's description of Ferdinand in *The Tempest* (I, 2, 222-24) "cooling of the air with sighs . . . and sitting, His arms in this sad knot." That particular visual expression had lost its conventional significance since Jacobean times, but not before Dryden and Congreve.[4] There was also always a practical, executive side to gesture, and in Rede and other practical men of the theater there was an acute sense of the perspective and expectation of the audience. In his accompanying advice, Rede notes that in extreme *Jealousy*, as the actor "must frequently fall upon the ground, he should previously raise both hands clasped together, in order to denote anguish, and which will at the same time prevent him from hurting himself." He also observes that "kneeling is often necessary in all suppliant passions; but it is only necessary to bend one knee in cases of love, desire & c., which must never be the one that is

[3] Leman Thomas Rede, *The Road to the Stage; or, The Performer's Preceptor* (London, 1827), pp. 77-93; and *The Guide to the Stage* (New York, 1868), pp. 31-40, the version followed here. Rede lifts the cited section almost unchanged from Chapter 2 of the anonymous *Thespian Preceptor* (London, 1810).

[4] Cf. Dryden, *The Conquest of Granada, Part Two* (1670), III, 2, 3; and Congreve, *The Double-Dealer* (1694), IV,2, where Brisk, cheerfully inviting his heart to break, "*Stands musing with his arms across.*"

next the audience." In 1882, ripe with experience, the veteran melo-dramatist Dion Boucicault summed up, in explaining why it is the arm farthest from the audience that must, as a general rule, ascend: "gesture must be subordinate to the spectator himself. All things in this art must be subordinate to that. It is a sort of picture."[5]

Rede's formulas undoubtedly continued in use through the century in parts of a vast and dispersed theatrical culture. But through excessive familiarity many of them lost potency and acceptability among the more sophisticated, becoming what Dickens frequently ridiculed and Baudelaire labeled *le poncif*. Associated with a process of mechanical reproduction in art and with bad drawing—it was originally the word for a drawing that served as a stencil—*le poncif* perfectly expressed the blatancy and automatism of the theatrical cliché. Baudelaire writes: "When a singer places his hand upon his heart, this commonly means 'I shall love her always.' If he clenches his fists and scowls at the boards or at the prompter, it means 'Death to him, the traitor! ' That is the 'poncif' for you."[6] As always, "picturesque" or rebus gesture was more vulnerable to ridicule than something more purely "expressive."

What unites all such demonstrations, however, is their externality, especially marked in Rede's catalogue. The actor's challenge always has been to externalize feeling and thought, including that within which passeth show. Only recently in the Western tradition have we accepted the convention that true feeling is always inarticulate and ultimately inexpressible. The earlier convention took for granted a full expressibility in language and behavior; that is, the convention ad-mitted and demanded a direct externalization, with all the analytic simplification that entailed. Barren playwrights would resort to lines like "Astonishment!" and "Rapture!" Great actors and great play-wrights might manage to represent compound feelings and concealed feelings; but it took a Shakespeare to render profound feeling as pro-foundly inarticulate, as in the fourth act of *King Lear*.

Externality is the keynote in Barbara Hardy's admirable account of the expression and notation of the passions in Dickens' characters. She writes, "He never throws off the simplicities, extremities, and physical demonstrations, but along with them go subtle insights and subtle renderings. From *Pickwick* to *Edwin Drood* the Collins method [of which more below] is conspicuous. It is the theatrical and behavioristic rendering." Complexity is achieved, she suggests, by sidelight and indirection, external symbolism, and sometimes a refusal to name (and simplify) a state of feeling. By *Little Dorrit* and *Great Expectations*, character is capable of a reserve expressive of complex emotional states.[7] Dickens was not simply a sport, however, an exceptionally theatrical-ized novelist; he represents a dominant school, international in its character and vigorously popular. He was exceptional in breaking through its limitations.

Hardy's phrase "the Collins method" looks back to that poet's cel-ebrated and much-quoted "Ode for Music," *The Passions* (1750), whose personifying theatricality found its fulfilment on the nineteenth-century stage. (Rede tells the aspiring student that, to express the passions correctly, the best practice is to commit Collins' ode to memory, "and recite the same before a looking glass," to see the effect produced.) On

[5] Dion Boucicault, *The Art of Acting* (New York, 1926), p. 39.

[6] Charles Baudelaire, "The Salon of 1846," in *Art in Paris 1845-1862*, trans. and ed. Jonathan Mayne (New York, 1965), p. 93.

[7] Barbara Hardy, "Dickens and the Passions," *Nineteenth Century Fiction* 24 (1970): 452-57.

the nineteenth-century stage, passion and affect—rationalized, schematized, and abstracted in the century and a half since Descartes[8] set them forth in number and order—were realized finally in character, passing from quasi-allegorical embodiments to the stereotypes of melodrama. There Benevolence appeared as a virtuous, naive, white-haired old peasant or clergyman (in whose image Dickens creates the fraudulent Casby with his long white hair and broad-brimmed hat); Pity—put in the passive mood—materialized in the suffering innocent heroine; Revenge appeared as the villainous "heavy."[9] In such thoroughly reliable characters the gestures and expressions associated with the passions as temporary states became fixed, as mask and attitude. "Latterly," complains a reviewer in 1832, taking his imagery from the revolution in graphic technology, "the drama has become less original and less instructive. It *was* painting, it *is* engraving—it *was* writing, it *is* printing—copies of character are struck off by the thousand; every impression growing less distinct as the work proceeds. The *proofs* are very few; are marked and valued accordingly."[10]

According to Hazlitt in the passage already cited, the old receipt books for the passions could be used to express, not simply emotion, but "characters and story." In fact, the narrative function of conventional expressive gesture became more rather than less important in the course of the nineteenth century. But gesture performed that service for narration by expressing the simultaneous relationship of several figures, rather than one man's passions in serial order; by taking part in a static configuration to symbolize a dramatic situation. A shift in dramaturgy, from a rhetorical to a situational and pictorial mode, coincided here with the shift in problems of narration for the painter who found himself telling a story of private life rather than a history of saints and heroes. Daumier's brilliant painting *The Drama* (1860) puts such a speaking configuration on the stage. Framed as the view from the back of the house, the group on stage is an abstract configuration, a diagram of forces expressing a relationship-in-being between the curved white-muslin figure (whose cascading "back hair" conventionally signals the onset of madness), the dark fallen figure, and the clock-handed figure between. It is a configuration involving madness, death, ambivalence, and extremity, expressing both dissolution and impasse; a story contained in a situation. The figures are faceless and ideal, for it is not their individual passion that counts, but the ensemble. Their facelessness and ideality are appropriate because we are given just the form of the situation, not the specifics of the play. It is the situation of Ophelia, Hamlet, and Polonius; of Marguerite, Faust, and Valentine; of Chimène, Rodrigue, and Don Gomès released from hexameters; and if no such symbolic pictorial moment occurs in these originals, it would in the nineteenth-century pictorial, situational *drame* that here has its audience in thrall. It is the audience, one notes, that is marked with individual passions, set into physiognomic masks and—where the reflected light of the stage reveals it—vivid in diversity and character. The aesthetic problem for the age was to incorporate such individuation, for which it had an enormous appetite and which it perceived as the *real*, with the glamor and readable moral and intellectual coherence of the faceless *ideal*.

Few attempts to resolve the tension that Daumier dramatizes were

[8] *Les Passions de l'âme*, 1649.
[9] Cf. Gilbert Abbott à Beckett, *The Quizziology of the British Drama* (London, 1846), including Leech's frontispiece, "The Stage Passions"; T. W. Robertson's "Theatrical Types," Nos. III-X, *Illustrated Times*, n.s. 4 (Feb.-June 1864), pp. 74, 107, 155, 187, 219, 267, 363, 411.
[10] *The Atlas* 7 (29 Jan. 1832), p. 74.

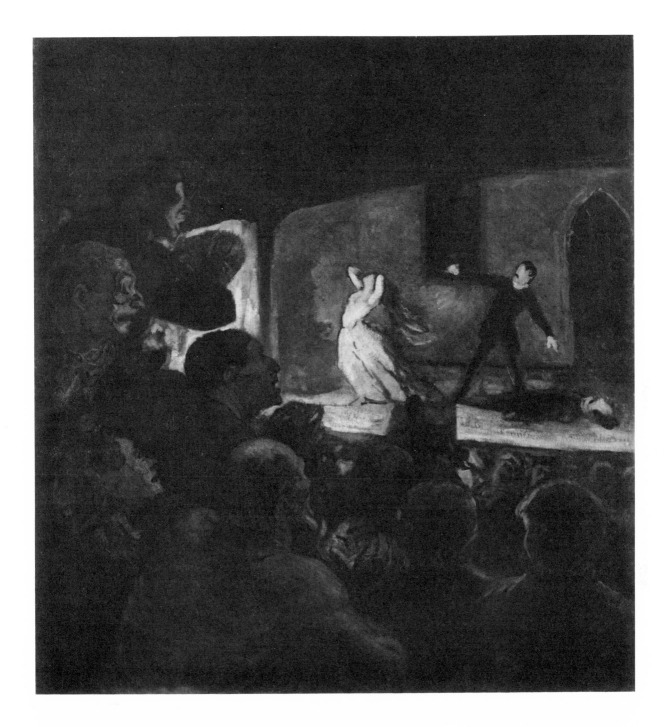

as successful or convincing as *The Drama*. Consequently Charles East-lake, soon to be president of the Royal Academy and director of the National Gallery, thought (in 1847) that "In ideal subjects," meaning in invented or literary subjects, in contrast to portraits,

1. *Honoré Daumier*, Le Drame *(1856-1860), Munich, Neue Pi-nakothek.*

> it is obviously safest to let the character and expression agree with the age and sex of the person. A lovely woman for instance will be more attractive (because more generally natural) with an expression of deep tenderness, melancholy, innocence, hope, devo-

tion, or benevolence, than with a look of profound meditation or grief; which latter supposes a remote cause of which we are left in ignorance, and also destroys beauty. But of all expressions in the head of a beautiful woman that of innocent, confiding, and devoted love is what will best *tell* in a picture.[11]

Arguments about expressive distortion and "accidental" character in painting, and whether such things can be allowed to compromise "beauty," had a long critical history. But it is hard to separate Eastlake's stereotyping—involving as it does the identification of a sentiment or a passion with character, age, and sex—from the stereotyping of the theater. Despite the subject painter's shrinking stage in this era, and the intimate view that the flowering of domestic narrative painting on a "cabinet-picture" scale entailed, the narrative language of painting and that of the drama had much in common. In both, emotion became typified character, and was subordinated to situation. The fact that "situation"—a word with static overtones—played so large a part in storytelling in the theater, on canvas, and between boards, is one of the considerations that point to what might be called a common structure or style.

The foregoing history shows a system for the representation of the passions passing into conventionalized attitude and gesture, into stereotyped character, and finally into "legible" narrative configuration. The mechanical and formulaic aspects are immediately clear; but to stop there would be to miss what was most interesting and vital in the conjunction of narrative and picture in nineteenth-century art and in its strategies of representation. A livelier view suggests itself when one attends to the significance for the least verbal of the three forms under discussion of the very notion of a "language" of art.

It was probably Lessing who divided the literal from the metaphoric in the venerable traditions that equated verbal and nonverbal art. But the notion of the work of art as a kind of linguistic utterance, of art as language, or embodied in a language with a vocabulary and syntax of its own, curiously took on new life in nineteenth-century thought, and eventually found its way into the writings of such post-Romantics as Croce and Collingwood. The assumption of convertibility between verbal and nonverbal representation, like the premise of their formal equivalence, is vulnerable, both from the point of view of modern linguistics and from that of modern art criticism.[12] But all that is hardly relevant; for nineteenth-century notions of "the language of painting" initially developed, not in response to an internal logic, but in response to a felt need.

In the hierarchies of the arts that structured neo-classical theory and remained influential well into the nineteenth century, the most prestigious form of painting was that in the grand style called "history painting." But as the epic, religious, and symbolic-of-the-race events of history painting, events with a clear and usually well-known external reference, gave way to stories of private life (in costume or no), the painter required a more eloquent and more concrete narrative convention than he had inherited. He required a convention, or set of conventions, that could be read for situation and that yet left some space

[11] Sir Charles Eastlake, *Materials for a History of Oil Painting* (London, 1869), 2:394-95.

[12] For a lucid and entertaining summary of the nonequivalence of verbal and pictorial means, see E. H. Gombrich, "The Visual Image," *Scientific American* 227 (Sept. 1972), pp. 82-96.

for freshness, for new combinations and applications, indeed for new coinages that would nevertheless be understood; in short he required something more truly like a language than like a standard iconography. It is not surprising, then, that the nineteenth-century British painter who had most to do with setting domestic genre painting on its course, David Wilkie, seems to have thought quite shrewdly about painting as language.[13] Anticipating a conflict between his impressions of the Holy Land and its people and the conventions of scriptural painting, for example, he reminds himself in his journal, "all works of art, as of poetry, however universal the language may be in which they are embodied, are yet only understood by people of previously-conceived notions making use of that language; a disregard, therefore, of this might render the whole matter to be represented quite unintelligible."[14]

Wilkie also offers the best illustration of a painter struggling to tell a story associated with ordinary life in the absence of a standard iconography or a recognizable tale. He succeeds by expanding the painter's language according to certain rules, rules that are part of the language, so that he can look forward to comprehension by an audience to whom the freshly-coined phrase would be new. Carlyle in later years recalled a conversation with Thomas Chalmers on the subject:

> "Painter's *language*," [Chalmers] said, "was stinted and difficult." Wilkie had told him how, in painting his *Rent-Day*, he thought long and to no purpose, by what means he should signify that the sorrowful Woman, with the children there, had left no Husband at home, but was a Widow under tragical *self*-management—till one morning, pushing along the Strand, he met a small artisan family going evidently on excursion, and in one of their hands or pockets somewhere was visible the *House-key*. "That will do!" thought Wilkie; and prettily introduced the House-key as *coral* in the poor Baby's mouth, just drawn from poor Mammy's pocket, to keep her unconscious little orphan peaceable.[15]

To a modern picture-viewer such symbolism is liable to seem recondite, overingenious, requiring rather than offering interpretation. To an audience familiar with the language, Wilkie's invention is a clever turn of phrase within the rules, actualizing an intrinsic possibility, and fresh rather than obscure. Criticism now takes it for granted that picture-making and picture-reading—even of photographs, and even of the "purest" abstractions with no narrative implications at all—entail a great many shared conventions and assumptions. The point is that in the end Wilkie's art and nineteenth-century narrative in general engage not a fixed set of signs or a closed system of iconic representation, but an expanding universe of discourse, rule-governed but open, using a recognizable vocabulary of gesture, expression, configuration, object, and ambiance. Wilkie's key is eloquent, not as the automatic signifier of St. Peter or the missing phallic male, but through reciprocation in a particular context. It actualizes "potential" meaning in the midst of a fresh statement whose aim is to unite the commonplace and the individual, character and situation, in a single representation.

[13] Compare Charles Bell, who is still thinking in terms of history painting: "Anatomy stands related to the arts of design, as the grammar of that language in which they address us. The expressions, attitudes, and movements of the human figure, are the characters of this language; which is adapted to convey the effect of historical narration, as well as to show the working of human passion, and give the most striking and lively indications of intellectual power and energy." *Essays on the Anatomy of Expression in Painting*, pp. vi-vii.

[14] Allan Cunningham, *The Life of Sir David Wilkie* (London, 1843), 3:375-76.

[15] Thomas Carlyle, *Reminiscences*, ed. C. E. Norton (London and New York, 1932), p. 215.

The nineteenth-century artist, especially the Victorian artist, working for a comprehensive audience, had a double injunction laid upon him. He found himself between an appetite for reality and a requirement for signification. Specification, individuation, autonomy of detail, and the look and feel of the thing itself pulled one way; while placement in a larger meaningful pattern, appealing to the moral sense and the understanding, pulled another. A story rightly told satisfied both requirements. Bulwer-Lytton—always alert to the appetites and interests of his audience, and indeed, the most versatile novelist of his time— wrote that the spirit of the age tended to the development of "a purpose in fiction," symbolical but not obtrusively so; "an inward signification" running through the fable. The writer's job, a "duality of purpose," was to unite this "interior symbolical signification with an obvious popular interest in character and incident." That such signification had to do with narrative as well as other matters, mythos as well as logos and ethos, appears in a comment on drama. Bulwer cites Goethe as saying "to be theatrical a piece must be symbolical; that is to say, every action must have an importance of its own, and it must tend to one more important still." He then adds, on the other side, "It is still more important, for dramatic effect, that the *dramatis personae* should embody attributes of passion, humour, sentiment, character, with which large miscellaneous audiences can establish sympathy."[16]

Readable configurations visually conceived, designed to encapsulate a stage of the narrative (or even a story in toto) and to make an effect, tended to abstraction and conventionality. The broadly conceived, schematically arranged ideal types, in whom character, passion, and narrative function were one, necessarily behaved according to their ethical natures, rather than naturalistic canons of biological and social conditioning. How this could affect the appetite for the real appears (thirty years earlier than Bulwer's remarks) in a review of a very successful topical murder melodrama at one of the better minor theaters. After commending the Surrey's acting and management and its willingness to venture on plays of "ordinary life," the reviewer qualifies his praise:

> The situations are striking and the acting is clever. We would, however, suggest . . . that there is an appropriateness in attitudes, and that rat-catchers and denizens of Seven Dials do not throw themselves into postures of amazement and affright, such as are assumed by the heroes in *tableaux*, or the Hamlets and Richards of tragedy. The effect of a situation, or the close of a scene, is not, we submit, improved by borrowing a gesture unsuited to the character, and belonging more to the beings of poetic creation than to the men of this world. The expression of the passions varies with the habits of those affected, and no emotion will throw a clown into the attitude which fancy assigns to the ideal grace of a Mercury.[17]

The comment is not without class bias. The word "clown" suggests the inherited association of humble life and dialect with comedy, antedating that between low life and "real" life. The writer seems pre-

[16] Edward Bulwer-Lytton, "On Certain Principles of Art in Works of Imagination," *Caxtoniana* (Edinburgh and London, 1863), 2:152-53, 147.
[17] *Examiner* (22 Sept. 1833), p. 599.

pared to tolerate the "ideal" in higher circles than Seven Dials. Essentially, however, he asks for more truth to the familiar and recognizable textures of life, and less convention for the sake of making the situation crystal-clear and giving it "effect."

Another critic of the contemporary scene takes the opposite tack. He refers to what he sees as an obsession with the literal, the authentic, and the concrete as "this Dutch-picture tendency to realizing everything, and thus rendering the details in most cases as prominent as the main design, and destroying the unity of the Ideal by the disruption of the continuity of illusion."[18] Bulwer, of course, asks for both; and G. H. Lewes suggests the qualified terms on which both might be had, in an admirable account of the relations of the working artist to reality on the one hand and to his audience on the other. His formulation locates "inward signification" in affective response, and envisages an art that is neither rigidly conventionalized nor indiscriminately "realized":

> Taking Art as a Representative rather than as an Imitative process (including imitation only as one of its *means* of representation), I say that the test of an actor's genius is not "fidelity to Nature," but simply and purely his power of exciting emotions in you respondent to the situation—ideal when that is ideal, passionate when that is passionate, familiar when that is familiar, prosaic when that is prosaic.[19]

The art and entertainment that furnish the matter for most of what follows is unfailingly Representative, and geared to "exciting emotions in you respondent to the situation." It aspires also to a union of inward signification, moral and teleological as well as affective, with a weighty, vivid, detailed and documented rendering of reality. In its own terms it is an art seeking the technical means and structural matrices for what was surely the most paradoxical of aesthetic enterprises, the Realization of the Ideal.

[18] Richard Henry (Hengist) Horne, Introduction to *Course of Lectures on Dramatic Art and Literature*, by A. W. Schlegel, trans. John Black, 2nd ed. (London, 1840), p. xxvi.

[19] George Henry Lewes, "Was Macready a Great Actor?" (8 Feb. 1851), in *Dramatic Essays, John Forster, George Henry Lewes*, ed. W. Archer and R. W. Lowe (London, 1896), p. 128. Cf. Lewes' "Realism in Art: Recent German Fiction," *Westminster Review* 70, n.s. 14 (1858): 493-94, especially on the false antithesis of Realism and Idealism.

PART I

COORDINATES

1

✦┼✦

THE MOMENT'S STORY: PAINTING

*T*HE UNION of inward signification with a particularized material reality, the goal of so much nineteenth-century art, is best achieved and understood in a narrative of human affairs. The painters who entered the nineteenth century doubted this no more than did the novelists who flourished at its height; but the narrative aspect implicit in any depiction of public or private events raised theoretical and practical problems that were special to picture-making. To tell a story requires time, and time itself is what a story represents, as a change of state in material or psychological reality. The temporality of narrative was the theoretical aspect most worrisome to reasoners on the capacities of painting in the age, though temporal considerations slipped very quickly into the question of the degree of representational realism incumbent upon the artist. How faithful should he be to the phenomenal aspect of things conceived as "instantaneous"—given the presentness of all the canvas contains?

In practice, however, telling a story so that it could be read from the paint brought many other considerations into play, such as configuration, setting, visual emphasis, analogy, pathos, irony, the relation between generated and depicted response, between unity and variety in both event and response. These modified the perceived theoretical issues, and they generated structures and found analogues in other arts according to the demands of the immediate task. In what follows I begin with a glance at how the temporal aspect of painting appeared in theory, and go on to note some of the adaptive strategies wrought in practice for the telling of stories in pictures.

Theory

In 1885—with narrative painting in decline, the avant-garde exhibiting elsewhere, and critics and gallery-goers ready to misuse the term "impressionism"—the Royal Academy calmly chose as the epigraph to its exhibition catalogue some traditionalist lines from Matthew Arnold's "Epilogue to Lessing's Laocoön." The lines describe "the painter's sphere" and its limits:

In outward semblance he must give
A moment's life of things that live;
Then let him choose his moment well,
With power divine its story tell.[1]

There was a becoming modesty in this choice of a motto from a poem whose point was the superiority of poetry to all the other arts. In isolation, however, the lines could be read in a number of other ways: as a quiet rebuke to frivolity and triviality; as a hopeful gesture toward reconciling the phenomenalism of the new and the humanism of the old; and as a pat formulation of the longstanding problem of uniting picture and narrative, the moment and its significance, in one representation or design. Actually, Arnold offers no encouragement to those artists who, rather than use their power divine to tell the story of a moment, tried to use the moment to tell a story. Like Lessing, Arnold reserves to the poet the rendering of temporal extension, what the poem calls "life's movement."

As E. H. Gombrich observes, Lessing's discussion of the dichotomy between the arts of time and space, succession and simultaneity, had important predecessors in England, notably Shaftesbury's *Characteristicks* (1714).[2] But nineteenth-century academic theory in England seems to have taken seriously only two books in its library: Lessing's *Laocoön* (1766) and Sir Joshua Reynolds' *Discourses* (1769-1791). These provided the intellectual framework for most formal pronouncements on the art of painting by Royal Academicians, whose real concern was with practice.

The painter's moment in Lessing's argument is unitary and without duration. Its subject in the phenomenal world, however, will naturally be of long or short duration, and what Lessing calls the "most fruitful moment" for painting, the most suggestive of past and future, will never be the most transitory. Lessing does allow the painter some latitude in extending the limits of his moment by ingenuity for a compensating gain. He cites Raphael's use of drapery to indicate where a limb had been a moment before, and allows Raphael credit "for having had the sense and the courage to commit a trifling fault like this" to gain a greater perfection of expression. Lessing hedges his tolerance, however, by requiring that in such exceptions "the two separate moments border so closely and so immediately on each other, that they may without any difficulty be considered as belonging to one and the same point of time."[3] The argument is uneasy, but it had a precedent in what Shaftesbury called *Anticipation* and *Repeal* in the representation of an action.[4] Lessing's and Shaftesbury's notion of the actual moment of the painting as instantaneous was generally taken as axiomatic in the nineteenth century; but Lessing's notion of the activity and duration of the proper *subject* for painting seems to have met with some resistance.

The most interesting of the academic attempts to restate and modify Lessing in nineteenth-century England was the first. In his third lecture to the Royal Academy, on "Invention" (March 1801), the Swiss-born Henry Fuseli restated the antithesis between painting and poetry to allow for the distinctive qualities of one kind of Romantic painting. In his formulation, "*Successive action* communicated by sounds, and

[1] *Catalogue to the 117th Exhibition of the Royal Academy of Arts* (London, 1885), title page. Lessing put comparable emphasis on the painter's choice of "the moment."

[2] "Moment and Movement in Art," *Jour. Warburg & Courtauld* 27 (1964): 293-94. Other modern analyses that take issue with Lessing's famous distinction (and so testify to its continuing energy) include Etienne Souriau's "Time in the Plastic Arts," *Jour. Aesthetics and Art Criticism* 7 (1949): 294-307; and Rudolf Arnheim's "Space as an Image of Time," in *Images of Romanticism: Verbal and Visual Affinities*, ed. Karl Kroeber and William Walling (New Haven, 1978), pp. 1-12.

[3] Gotthold Ephraim Lessing, *Laocoön; or the Limits of Poetry and Painting*, trans. William Ross (London, 1834), pp. 177-82.

[4] In "A Notion of the Historical Draught or Tablature of the Judgment of Hercules" (1713), in *Characteristicks* (London, 1732), 3:354-56, Shaftesbury asks, "How is it therefore possible, says one, to express a Change of Passion in any Subject, since this Change is made by Succession; and that in this case the Passion which is understood as present, will require a Disposition of Body and Features wholly different from the Passion which is over, and past? To this we answer, That notwithstanding the Ascendency or Reign of the principal and immediate Passion, the Artist has power to leave still in his Subject the Tracts or Footsteps of its Predecessor." Shaftesbury instances the traces of tears in a person newly transported with joy. On the other hand, since the mind easily outstrips the body, the body's "more sprightly parts" may give warning of the future. These different operations "may be distinguish'd by the names of *Anticipation* and *Repeal*." On the problem of painting psychological change, or "the Mind on a sudden turning itself some new way" (Shaftesbury, p. 356), see the discussion of Holman Hunt's ambitions below, pp. 359-68.

time, are the medium of poetry; *form* displayed in *space*, and momentaneous energy, are the element of painting." "Momentaneous energy" is a fine paradoxical phrase, as it must be, since Fuseli accepts the fiction of a moment without extension as the condition of the painter's image. But he rejects Lessing's corollary, that the painter should therefore choose subjects in comparative stasis or repose as most appropriate, and that he should avoid depicting the highest intensity of feeling and expression—Laocoön's scream—because in nature such a climax must be ephemeral. Fuseli argues specifically against an exhibition of inert, unemployed form on the grounds that bodies exist in time as agents of an internal power, and both "character" and harmony of parts are revealed only in action, in motion. He summarizes: "Those important moments, then, which exhibit the united exertion of form and character in a single object, or in participation with collateral beings, *at once*, and which, with equal rapidity and pregnancy, give us a glimpse of the past, and lead our eye to what follows, furnish the true materials of those technic powers, that select, direct, and fix the objects of imitation."[5]

Fuseli describes a moment of apparent kinesis that somehow extends beyond itself, a moment with a readable past and future, expressed in the energy of its agents, alone or in configuration. He implies that while "momentaneousness" can be reinforced by an impression of energy, so can the sense of succession, participation in a narrative temporal order with consequence and cause. Further, his emphasis on character as revealed in action implies ethical causation in the action to be represented.[6]

Fuseli's successors in instruction continue to worry about the relation between a temporal subject and an atemporal medium. Two tendencies appear in the rationalizations, reflecting the antithesis between realism and idealism which was the nineteenth century's favorite way of understanding itself and its art. The first tendency, urging a faithfulness to the phenomenal, appears surprisingly in the *Hand-Book for Young Painters* of that judicious middle-of-the-roader Charles Leslie (1855), in a passage that seems to unite his own art of narrative illustration, marked by telling glimpses of "character," to that of his friend Constable. Leslie differs from Lessing, he says, in that he believes Nature has assigned to "the mission of Art . . . prolonging motion and expression, and suggesting sound," perpetuating and calling attention to fleeting beauties and effects, graces, movements, combinations of color and light, that are otherwise "instant seen and instant gone."[7] The other tendency appears when Charles Eastlake contrasts the painter's art of "*simultaneous*" effect" with the art of words restricted to "*mere succession*," but then resorts to an idealist formula to transcend the merely momentary and phenomenal in the subject. The formula harks back directly to Reynolds' *Discourses*, with their insistence on the generalizing aspect of worthwhile art. Painting, says Eastlake, competes with Nature itself through "power of selection, the attempt to give the large impression in which the idea of beauty resides, and which corresponds with the image which the memory retains, the emphasis laid on the permanent rather than on the accidental qualities of the visible world."[8] Eastlake's stress on the retained image might have found some unexpected support on the phenomenal side in the

[5] *Lectures on Painting by the Royal Academicians; Barry, Opie, and Fuseli*, ed. Ralph N. Wornum (London, 1848), pp. 407-408.

[6] Fuseli's own characteristic compositions show mannerist contradictions of energy and languor, extending that older academic formula for achieving a dynamic stability. Diderot, writing just before Lessing's treatise appeared, objected to energy and repose in the same image as a manifest artifice. Where that formula is employed, "Le tableau n'est plus une rue, une place publique, un temple; c'est un théâtre." *Essai sur la peinture*, in *Oeuvres complètes de Diderot*, ed. J. Asséezat (Paris, 1876), 10:498.

[7] C. R. Leslie, *A Hand-Book for Young Painters* (London, 1855), pp. 6-9. Gombrich quotes Constable's memorable remark on giving "One brief moment caught from fleeting time a lasting and sober existence" ("Moment and Movement in Art," p. 295). In criticizing the "tasteless" detailing of minutiae in Gerard Dow and (by implication) the Pre-Raphaelites, Leslie places his other foot firmly in the idealist camp: ". . . all sterling Art, is ideal. Nature not altered, but 'to advantage dressed' " (p. 11).

[8] Charles Lock Eastlake, Preface to *A Hand-Book of the History of Painting*, by Franz Kugler (London, 1842), pp. xii-xiv.

investigations of Roget and Faraday in the 1820s into the "persistence of vision" which made possible the thaumatrope, the phenakistoscope, and eventually the moving picture. However, the "image which the memory retains" in Eastlake's less experimental formulation had little to do with direct perceptual experience, even as a distillation of earlier impressions of similar phenomena whose collective residue tells us how to interpret what we see. Rather, the "large impression in which the idea of beauty resides" would in all likelihood correspond to the image retained in a tradition of interpretation and representation. There painting could find both a representational language and a matrix for interpretation by its viewers. The "large impression" implies a socially-shared perception; nevertheless, it is only a step from the representation of the image in the memory to the representation of subjective truth, which is where the idealist strain in painting found itself before the end of the century.

Practice

Leslie and Eastlake discuss duration as an attribute of the subject and of the finished representation, but only in its two limiting phases, the instantaneous and the permanent, zero and infinity. Neither artist challenges the idea that the frame of the painting embraces only coexistent objects and simultaneous events. The problem for the narrative painter, however, is to represent a subject of *finite* duration, whose phases are necessarily not all present at once. His subject, then, is not representable in a single frame except with the help of such modifying agents as a convention that permits the "simultaneity" of stimulus and response; as symbolism that does the work of literary foreshadowing and retrospection; as a shared knowledge of specific stories and story formulas which permits the spectator to supply the broken pattern with sequential meaning.

The problem for each painting was preeminently practical in that, whatever theory had to say, it was only the *illusion* of a dimensionless simultaneity that the painter was bound to provide, and this illusion tolerated the modifying conventions. Beginning with an assumed or indeed retrospectively "perceived" coexistence of action and reaction, stimulus and response, the painter would represent contiguous events as "phrases" of action,[9] or moments with duration. In addition, readable expressive and symbolic gesture, grouping (as distinct from composition), and locale could be used to point beyond the moment represented; and freely invented metaphoric commentary, which Hogarth had deeply implanted in English painting, might give a further range to the means at hand (e.g., in the first panel of *A Harlot's Progress*, the dead goose whose foolish, country-bred character; tagged, basketed, deliverable condition; and phallic dangle comment on the character and upbringing of the country girl and predict her fate. On another level, backward-looking, is the contrast between the bird's unsounded and unheeded alarm and the conduct of its distinguished Roman ancestors).[10] Some paintings, compendia of such devices, managed to push out the boundaries of the putative moment to an astonishing extent.

[9] "Just as music unfolds in phrases, so action unfolds in phrases, and it is these units which are somehow the experience's moments in time, while the instants of which the theoreticians speak, the moment when time stands still, is an illicit extrapolation." Gombrich, "Moment and Movement in Art," p. 303.

[10] Ronald Paulson maps out transformations in pictorial language in *Emblem and Expression: Meaning in English Art of the Eighteenth Century* (Cambridge, Mass., 1975). His exemplary discussion there of the first plate of *The Harlot's Progress* supplements the account in *Hogarth: His Life, Art and Times* (New Haven and London, 1971), 1:238ff.

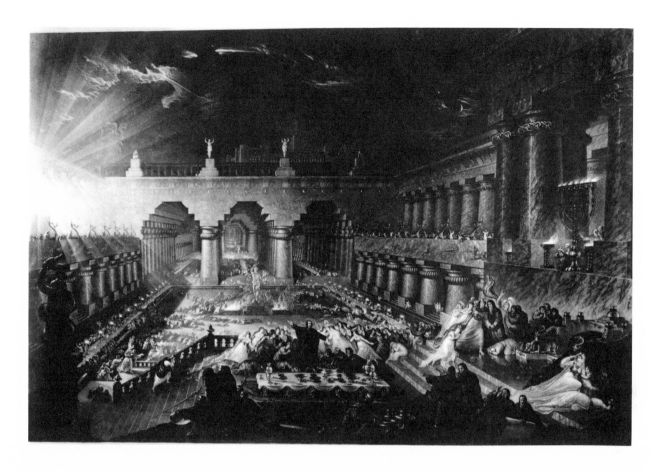

But just as Euclid ceases to represent physical reality where there is an extreme departure from human scale, so do the conventions of pictorial simultaneity. A case in point was the immensely successful *Belshazzar's Feast* of John Martin, a painter as much engaged with modern technology, both social and scientific, as with the pictorial representation of events of the utmost magnitude in the history of creation. After it had caused a considerable sensation at the British Institution in 1820, *Belshazzar's Feast* was independently exhibited in the Strand and a descriptive pamphlet provided, which, if perhaps not entirely written by Martin, certainly conveyed his analytical view of the "intellectual mechanism" of the picture he had painted. The pamphlet declares the painting "an astonishing drama," having its "protasis (beginning), its epitasis (unfolding), and catastrophe, which the artist has the boldness and felicity of concentrating under the same point of view." The three acts, drawn from the Biblical account, are the appearance of the writing on the wall, the consternation that follows, and (after a distinct interval, as the pamphlet reminds us), the prophetic interpretation. That each act of the drama as painted is itself a concentration passes without comment—it stretches no convention—but the author presents the integration through perspective ("under the same point of view") of all three acts in a single canvas as a technical achievement and as a paradox made possible by scale.[11]

Unity is certainly promoted through one-point architectural per-

2. *John Martin*, Belshazzar's Feast *(1821), engraving by John Martin (1826), London, British Museum.*

[11] "A Description of the Picture *Belshazzar's Feast*," reprinted as an appendix to Thomas Balston's *John Martin* (London, 1947), pp. 260-65. There was a further "act" to the drama, not represented directly in *Belshazzar's Feast*, but present prophetically. Martin had painted it as *The Fall of Babylon* in 1819, and later engraved it. In a one-sheet prospectus for works published or in progress in February 1831 (British Museum), Martin observes, "This Engraving will be the Companion subject to 'Belshazzar's Feast'; as, according to the Sacred History, both events happened in the same night."

spective, through the mediating centrality of the figure of Daniel in the composition, and the spectator's knowledge of the story as a whole; but the achievement of a *temporal* unity is presented as above all the result of the sheer immensity of the scene. The pamphlet only once suggests a temporally ambiguous reading, noting that the effect of Daniel's interpretation and the effect of the appearance of the fiery letters may *both* be seen in the consternation of the people. For Martin or his spokesman is chiefly concerned to rationalize the temporal extension, and feels he can do so—thanks to the gargantuan scale—by using perspective to organize a good deal more than space. In his description of the "Second Act of the Drama," he invents a new kind of perspective singularly appropriate to a drama of human events. "Wonder and dread, eagerness and curiosity appear upon every face, control all motions, and decrease by slow degrees in proportion with the distance from the cause of the general consternation. So that to the aerial and lineal perspective, which are executed according to the most rigorous accuracy of common rules, we find here, also, a perspective of light, and (if the expression may be allowed) a perspective of feeling."[12] In the immensity of the space represented, time asserts itself as a dimension of the immediate scene, as a function of space; and succession (the wave of response) appears in a pictorial simultaneity. But the immensities of space exist as much in the psychological as in the physical realm. Distance diminishes geometrically the intensity of a stimulus like light, and legitimates a proportionate diminution of response. The interpretive habit of mind that associates proximity with involvement, distance with detachment, asserts itself in these spaces as well. The result is a "perspective of feeling." This *literal* argument for the incorporation of the three acts of the drama in a single scene, this rationalization that returns to the instantaneous, separates Martin from his many Renaissance predecessors who also painted the successive phases of a story under a single point of view.

It is surely no accident that Charles Lamb's celebrated assault on Martin and his works early invokes another instance of complex temporal representation. Lamb offers, as a distinguished example of the imagination's achieving a unifying inevitability of subject and treatment through all the parts, "that wonderful bringing together of two times" in Titian's *Bacchus and Ariadne*. Lamb describes the abandoned Ariadne and the impetuous Bacchus and his train, falling upon her, as "the *present* Bacchus, with the *past* Ariadne; two stories, with double Time; separate, and harmonizing."[13] Lamb's point, of course, is that Martin has failed to achieve such imaginative integration, and Lamb ignores the literally-construed temporal anomalies in Titian's scene (e.g., the constellation. See below, p. 360n.).

Without too much distortion, Lamb's example may be seen as a concentrated version of Martin's "perspective of feeling," but with a psychological rationale, rather like Shaftesbury's, that Lamb finds more convincing (the persistence in attitude and expression of the mood of the previous moment in the midst of a new sensation). Martin's manipulation of space, his creation of immense distances, permits the tight integration of contiguous moments to loosen visibly. The scale of the scene in Martin's painting is as much an illusion as the temporal unity

[12] Balston, *John Martin*, p. 264. "Perspective of light" involves the effect of the blazing letters on other light sources, and interferes with conventional schemes of contrast for the representation of light. For a related defense of Martin's "unnatural" lighting, see below, p. 168.

[13] "The Barrenness of the Imaginative Faculty in the Productions of Modern Art," *The Works of Charles and Mary Lamb*, ed. E. V. Lucas (London, 1903), 2:226-27. For Holman Hunt's related interest in Titian's painting (in England from about 1806 and in the National Gallery from 1826), see below, p. 360.

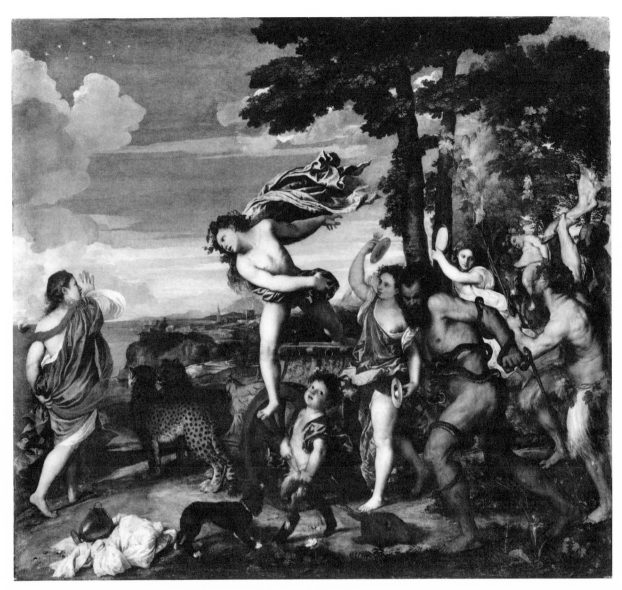

he feels obliged to justify. Martin addresses the problem of narrative expansion and temporal integration by pressing the limits of what the mind takes in at a glance, the perceptual limits associated with a subjective human scale. In this the painter, with his technological interests and alert social vision, brings the inherited structures of the sublime and the apocalyptic into touch with the life of his own century. For as the public was simultaneously discovering in other departments such as transportation and communication, great success in the organization of space necessarily entailed adjustments in the organization and experience of time.

For an artist with a story whose interest lay in the succession of marked stages, there was a perfectly acceptable and entirely obvious solution: serial pictures. Hogarth had legitimatized the mode in England in his four great narrative (or in his view "dramatic") series, and he had numerous successors. Morland, for example, painted a *Laetitia*

3. *Titian*, Bacchus and Ariadne *(1523), London, National Gallery.*

series in six parts, a genteel *Harlot's Progress* with a forgiving ending.[14] Northcote painted a *Diligence and Dissipation* in ten parts—a synthesis of *Industry and Idleness*, *A Harlot's Progress*, and Richardson's *Pamela*—tracing the careers of "The Modest Girl and the Wanton, Fellow Servants in a Gentleman's House."[15]

In the nineteenth century, when numerous editions and cheap copies of Hogarth's prints encouraged new levels of critical appreciation, the direct succession included Cruikshank (see below) and Frith, not to mention the serial novelists, notably Dickens in *Oliver Twist; or, the Parish Boy's Progress*, Ainsworth in *Jack Sheppard*, Thackeray in *Vanity Fair*.[16] Frith's *Road to Ruin* series (1877-1878) originated, he declares in his autobiography, in an idea for "a kind of gambler's progress, avoiding the satirical vein of Hogarth, for which I knew myself to be unfitted." His later series, *The Race for Wealth* (1880), also illustrates a progress and fall, of a fraudulent financier and his dupes (Figs. 177-87). In discussing his two series, Frith uses such terms as "interval" and "acts," very appropriate language given the fact that contemporary drama was also a serial pictorial form. Both his series are in five pictures, the number of acts in "legitimate" tragedy.[17]

Like Hogarth, Frith composed original dramas with a familiar moral and narrative pattern, using broad types in a contemporary setting. But there were other sorts of stories and narrative series. Etty and Burne-Jones favored well-known stories remote from present scenes: Judith and Holofernes, Perseus and Andromeda, Pygmalion. In the Redgraves' account of Etty's three-part Judith series, they observe: "To show that he was prepared to meet difficulties, he chose a continuous action—a drama as it were, in three acts, and requiring three separate canvases to give its beginning, middle, and end."[18] The ambitious American picture series of Thomas Cole on the other hand, *The Voyage of Life* and *The Course of Empire*, embodied narrative at its most generalized, with affinities to an older tradition of temporal representation in painting, non-narrative but sequential and multiply expressed (e.g., the Four Seasons, the Four Times of the Day, and the Ages of Man). The five-part *Course of Empire* also has the structure of legitimate tragedy, varying somewhat the vision in Bishop Berkeley's famous poem, where Cole's dramatic and diurnal imagery are both anticipated:

> Westward the course of empire takes its way;
> The four first Acts already past,
> A fifth shall close the Drama with the day;
> Time's noblest offspring is the last.[19]

Cole put the noonday height of civilization at the center of his drama, and it is worth noting that this canvas, larger than the others that flank it symmetrically, contains the *whole* story, with the decadence of the civilization implicit, and the catastrophic war and cruelty of the next stage anticipated in the games of the children.

The influence of the Pre-Raphaelites helped the triptych stage a comeback (as in Arthur Hughes' *Eve of Saint Agnes*, 1856), stimulating other experiments in multiple framing, and influencing friendly outsiders like Augustus Egg in the three-part domestic drama that

[14] Engraved by J. R. Smith and published in 1789. A new edition in 1811 adds verses and updates the costumes (British Museum).

[15] Title of the first plate in the series, the whole engraved by T. Gaugain & Hellyer (1797); in the British Museum. Joseph Highmore's twelve illustrations to *Pamela*, painted in 1744 and engraved the following year, also exerted a considerable influence on later narrative series.

[16] Fuseli in 1801, following later eighteenth-century academic attitudes, patronizes Hogarth as a painter of local manners subject to degeneration into caricature or unintelligibility (*Lectures on Painting*, p. 419). Lamb's essay, "On the Genius and Character of Hogarth," appeared in 1811; but Charles Leslie dates the full public awareness of Hogarth's "entire excellence" from the exhibition of his works at the British Institution in 1814 (*Hand-Book*, p. 136), when Hazlitt's appreciations also appeared. Austin Dobson in the *DNB* thought that "some careful copies of Hogarth by F. W. Fairholt in Knight's Penny Mag. did much to popularise the artist's works," but the evidence suggests a remarkably wide familiarity with the major series from early in the century.

[17] *My Autobiography* (London, 1887), 2:121-22 and 141. The first series ends in suicide, the second in prison. See below, pp. 388-95.

[18] Richard and Samuel Redgrave, *A Century of Painters of the English School* (London, 1866), 2:204. In 1847, Etty also exhibited a three-part Joan of Arc series. The Judith paintings (1827-1831), now held by the National Gallery of Scotland, are much decayed. One is set just before, one perhaps during, and one just after the slaying. Originally only one painting that told all (Judith in the tent) was intended.

[19] "Verses On the Prospect of Planting Arts and Learning in America," *The Works of George Berkeley* (Oxford, 1901), 4:365-66.

4

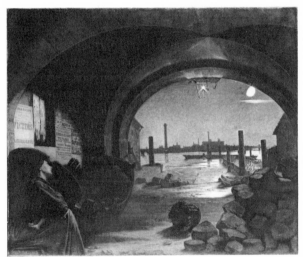

5

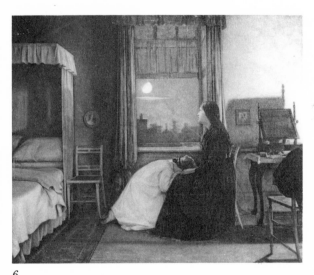

6

came to be known as *Past and Present* (1858). Egg's series has received a good deal of attention in recent years as a compendium of attitudes and images characteristically "Victorian."[20] It is also a compendium of devices for rendering narrative in picture, for expanding the "moment's life of things that live" to include past and future, for making manifest the succession of cause and consequence which constitutes a plot and furnishes the color of necessity to events in time. Nevertheless, Egg's series was anything but "typical." There was originality in its conception and organization, and it would be hard to find its serial counterpart. Like Hogarth he paints, not an "illustration," but an original story of contemporary life embodying a familiar moral and narrative pattern. The three pictures, however, are not consecutive. The first in time presents the discovery of an adultery, and the other two its consequences for the children of the marriage and the offended and offending parents. The moments depicted in the latter two paintings are supposed to occur simultaneously, not two moments but one, and these paintings

4-6. Augustus Egg, Past and Present (1858), London, Tate Gallery.

[20] See Helene E. Roberts, "Marriage, Redundancy or Sin: The Painter's View of Women in the First Twenty-Five Years of Victoria's Reign," in *Suffer and Be Still: Women in the Victorian Age*, ed. Martha Vicinus, pp. 45-76 (Bloomington, Ind., 1972).

were originally displayed on either side of the discovery scene. Their simultaneity suggests some contemporary experiments in the drama in the representation of simultaneous events (e.g., *The Corsican Brothers* in the version Charles Kean played from 1852); and the original display of all three parts in the crowded Royal Academy exhibition echoed the structure of a triptych, with its centerpiece and subordinate pendants.

The structure and the viewer's experience of the painting were further enriched through the accompaniment of the whole, not by a title (which few narrative paintings could do without), but by what one can only call a narrative voice, a diarist speaking confidentially from the perspective of the present, commenting on the affective and moral content of a story whose events are implied. The voice is peripheral to the story but distinctly part of the protagonists' world, like the characteristic narrative voice in Thackeray. The exhibition catalogue reads:

> August the 4th. Have just heard that B _____ has been dead more than a fortnight, so his poor children have now lost both parents. I hear *she* was seen on Friday last near the Strand, evidently without a place to lay her head. What a fall hers has been![21]

The pictures supply the images the voice implies, as if realizing the mute images that might flicker in the mind of an auditor. The viewer reads by passing back and forth between the commentary and the pictures, and is so taken into the intimacy of knowledge.[22]

Despite the simultaneity of the "present" compartments, the woman under the arches is generally treated (and reproduced) as the last image, because it functions as an effective climax to a dramatic series. Yet if these pendants were hung as apparently designed, to frame the discovery compartment, the woman under the arches should be to the left as viewed, her daughters at the window to the right. If one reads in normal Western order, such an arrangement leads from the woman to her daughters, reversing the "effective" serial order.[23] What this arrangement makes clear is that Egg's painting is not really a serial painting, and that the reading required is an intricate passing back and forth, a cross-reference. In such a display order, both mother and daughter are turned toward the same focus, the moon, which lies between them, and (especially if the discovery scene is placed higher or lower as one viewer would have preferred),[24] the two represented moons verge on coincidence. The attitudes and profiles of mother and elder daughter are similar, a similarity reinforced by their divided attention: each, while giving bodily maternal comfort, has turned to contemplative reverie and the moon. The reverie leads back to the first picture, which lies between the two contemplatives, in the moon; to the moment in the past that has torn apart the present, so that what once occupied one space must now occupy two. The younger sister, hiding her face in the elder's lap (perhaps, as reviewers read the pose, in prayer), is reminiscent, moreover, of the shamed, face-hidden, suppliant figure of her mother in the discovery scene. Meanwhile, the infant under the mother's shawl is a reminder of her other children, so that (as in melodrama) the mechanism of coincidence—here thought

[21] *The Exhibition of the Royal Academy of Arts* (London, 1858), #372.

[22] Baudelaire comments, "The ape of sentiment relies above all on the catalogue. It should be noted, however, that the picture's title never tells its subject. . . . In this way, by extending the method, it will be possible to achieve the *sentimental rebus*." The title Egg's series later acquired was more convenient than his original rubric, but scarcely more direct. (In the same Academy exhibition was Miss A. Blunden's *Past and Present* [#428], noticed by Ruskin in his *Academy Notes* immediately after Egg's untitled work.) The "puzzle picture" that became fashionable later in the century fulfilled Baudelaire's dire prediction from "The Salon of 1846," *Art in Paris 1845-1862*, trans. and ed. Jonathan Mayne (London, 1965), pp. 99-100.

[23] This arrangement is implied in the notice of the *Saturday Review* (15 May 1858), p. 501.

[24] *Athenaeum* (1 May 1858), p. 566.

turned in the same direction at the same moment—is given moral force as well as exposition in the divided scene. The effect on the narrative as a whole is to set the crisis in a temporal perspective, and to make the most immediate action recollection, as in so much significant Romantic art. The revolutionary events, adultery and discovery, are distanced, to be united with their aftermath in a moral perspective. The effect of the breathless narrative voice, however, as in so much significant Victorian art, is to turn recollection into reportage. And the vivid scene of discovery thrusts *that* moment forward despite everything into centrality and immediacy.

The whole story can in fact be read from the "situation" offered in the first picture, so that narrowly speaking the last two paintings as well as the narrative voice are superfluous, though as with much fiction of the period, to eliminate the superfluous in the name of functional elegance would impoverish the work of art. However, the concentration of an action into a readable situation, the concentration of narrative into a single picture, was the typical form of narrative painting; and Egg's central picture taken in isolation may serve here as representative of the whole class of nineteenth-century narrative paintings in one frame, where the art of expanding the pictorial moment reached its peak.

Egg succeeds admirably in telling the whole story in his central picture through attitude and expression, the relation of the figures to each other, the genteel domestic setting, and a cluster of symbolic props and emblems: the letter of revelation, the split and worm-eaten apple, one half stabbed through and the knife pointing at the husband's heart, the collapsing house of cards, the reflected door opening into a blank, the dead hearth, and the paintings on the wall—an "Expulsion" over the wife's portrait and *The Abandoned*, Clarkson Stanfield's symbolic painting of a derelict hulk, over the husband's. The future lies in these, and more powerfully in the contradiction and implied sequence of the husband's clenched hands, his vulnerably open body, and his far-focused despair. The future lies also in the diverging configuration of the seated husband and the prostrate wife, whose pleading gesture of clasped hands is thus made pointless and equally despairing. The coming separation from her daughters is also present in the configuration. The centrifugal force at work is fiercest in the wife's tangential relation to the round table which divides her (with vertical reinforcement) from her daughters; she is being hurled out of the picture. The future relation and condition of the daughters is prefigured in their isolation and in the startled awareness of the older and obliviousness of the younger. "In the hands of a great dramatic artist like Mr. Egg," one reviewer wrote, "these omens gather round like the portents which surround a Prometheus or an Orestes."[25]

STUDIES in perception and analogies with television tell us what experience has whispered all along: that a painting is not instantaneously present to the mind at first glance; that, as Gombrich puts it, "It takes more time to sort a painting out. We do it, it seems, more or less as we read a page, by scanning it with our eyes."[26] This is a statement about perception, but perception and comprehension are not to be

[25] *Literary Gazette* (15 May 1858), p. 475.

[26] "Moment and Movement," p. 301.

compartmentalized in the experience of a painting. "Scanning" a painting is also "reading" it in the sense of Lamb's exclusive compliment to Hogarth: "Other pictures we look at,—his prints we read."[27] Reading for meaning includes reading narrative content and "a scanning backward and forward in time and in space, the assignment of what might be called the appropriate serial orders which alone give coherence to the image."[28] From the opposite standpoint, the painter's incorporation of narrative content and a temporal dimension is thoroughly in keeping with the process of looking at paintings, and the elements that function as symbol to establish the appropriate serial orders are not in a class by themselves. The house of cards, the apple, *The Abandoned* are data to be read; as are the moon and cloud that declare the flanking paintings to be simultaneous; as are the more directly expressive clenched fist holding the letter, the brimming stare, the divergent bodies, the respectable furnishings; as are the yet more fundamental shapes and objects that emerge from arrangements of color and outline, light and shade. All these are equally to be read in the course of re-creating the picture out of the blots and blobs on a flat surface.

The central picture of Egg's series tells a comprehensible story because it can be assimilated to available narrative and representational patterns without many indigestible anomalies or excessive ambiguity. It uses a comprehensible vocabulary and syntax, packed with redundancies, to communicate what is half-expected and therefore can be half-supplied by the beholder, a vocabulary and syntax that nevertheless have an approximate and variable symbolic relation to the limitless variety of the phenomenal world. Meaningful pose, gesture, and arrangement as well as more overt symbolism partly correspond with "the image which memory retains," as Eastlake put it; an image conditioned by previous representations and by their effectiveness for communication. Eloquence and effectiveness in all genres were at a premium in this time of expanding audiences; but eloquence and effectiveness sometimes found themselves at odds with attempts to develop new languages that put an emphasis elsewhere: on the merely phenomenal perhaps, the "instant seen and instant gone," or on the understated and ordinary. The considerable interest in the textures of ordinary life, in seeming truth to the object whatever its moral or narrative significance, made all artists that gave precedence to the eloquence and effectiveness of the image liable to a charge of unreality. The preferred stigmatic term for such an art of eloquence and effect was "theatrical."

[27] "On the Genius and Character of Hogarth," *Works*, 1:71.
[28] Gombrich, "Moment and Movement," p. 302.

2

ILLUSTRATION AND REALIZATION

*A*N EXCHANGE between poet and painter over an illustration in Moxon's landmark edition of Tennyson's *Poems* (1857) shows the strains of the manifold collaboration of narrative and picture in the middle of the nineteenth century. Tennyson objected to Holman Hunt's illustration of "The Beggar Maid" on grounds that the picture contained elements not given in the poem. Hunt thought Tennyson had missed the essential point, and said so with his usual vigorous conviction: "I feel that you do not enough allow for the difference of requirements in our two arts," Hunt told Tennyson. "In mine it is needful to trace the end from the beginning in one representation."[1]

Hunt's reply is interesting because it assumes the necessity of telling a whole story, of representing a complete action in an Aristotelian sense. It also states the problem for the pictorial artist who wants to incorporate time in a representation of space unified through rational perspective. But important as these matters are, they are not the immediate issue raised in Tennyson's objection. That rather should be understood as the difference between "illustration" and "realization."

Both terms had importance in the working critical vocabulary of the time, and between them they epitomize strong impulses in the culture. "Realization" and its verb "to realize" are often found in dramatic contexts, where they carry the sense of materialization, even reification. Interestingly, the first listed use for "realize" in the sense of "To make realistic or apparently real" in the *Oxford English Dictionary* comes from Sheridan's *The Critic* (1779), when Dangle comments on the firing of a cannon, "Well, that will have a fine effect," and Puff replies, "I think so, and helps to realize the scene." Mid-nineteenth-century dictionaries—for example, Richardson's *New Dictionary of the English Language* (1844)—begin the definition of "real" and its transformations by relating it to "things" and "facts" as opposed to "persons" and "fiction." Accordingly, a writer in 1856, identifying the chief characteristic of Charles Kean's management as a "strong tendency to REALISM," finds it "not merely in his mode of placing a drama upon the

[1] William Holman Hunt, *Pre-Raphaelitism and the Pre-Raphaelite Brotherhood* (London, 1905), 2:125.

stage, but in his own style of acting. Look at Louis XI.—look at Cardinal Wolsey, remarkable for the specification of little traits and details that serve to realise the character as much as possible in that style which has been called pre-Raphaelite."[2]

"Realization," which had a precise technical sense when applied to certain theatrical tableaux based on well-known pictures, was in itself the most fascinating of "effects" on the nineteenth-century stage, where it meant both literal re-creation and translation into a more real, that is more vivid, visual, physically present medium. To move from mind's eye to body's eye was realization, and to add a third dimension to two was realization, as when words became picture, or when picture became dramatic tableau. Always in the theater the effect depended on the apparent literalness and faithfulness of the translation, as well as the material increment.

Lamb's famous objection to the performance of Shakespeare's tragedies was addressed to the inherent shortcomings of such translation, the impossibility of embodying that within which passeth show. Even he, however, had to acknowledge the seductions of the material increment, virtually identifying the pleasures of realization with our original fall. Harking back to his satisfaction in first seeing a tragedy of Shakespeare performed, with Kemble and Siddons in the leading parts, he writes:

> It seemed to embody and realize conceptions which had hitherto assumed no distinct shape. But dearly do we pay all our life after for this juvenile pleasure, this sense of distinctness. When the novelty is past, we find to our cost that instead of realizing an idea, we have only materialized and brought down a fine vision to the standard of flesh and blood. We have let go a dream, in quest of an unattainable substance.[3]

"Illustration" was something else again. It carried a sense of enrichment and embellishment beyond mere specification; it implied the extension of one medium or mode of discourse by another, rather than materialization with a minimum of imaginative intervention. Exemplification and enhancement by *any* means were inherited meanings that persisted in the word; but the pictorial illustration that we have in mind nowadays when we speak of a book with illustrations was not taken for granted before the 1820s, that is to say before the rapid effect of a series of technological innovations on the production of illustrated books. Before that time, the use of "illustration" to mean a picture that illustrates a text was almost sure to be supported in book titles by other information, such as a well-known artist's name, or a specifying term like "engraved." Conversely, the title of Hobhouse's *Historical Illustrations of the Fourth Canto of Childe Harold* (1818) did not imply a collection of historical pictures, but rather an amplifying body of annotations.

Usage changed, however, and the pictorial sense of "illustration" came to speak for itself. A reviewer of "Illustrated Books" in 1844, complaining that the word as used by booksellers and printsellers now meant anything pictorial or ornamental, proposes a further clarification. He assumes that pictorial illustration still implies "something which

[2] [E. S. Dallas], "The Drama," *Blackwood's* 79 (Feb. 1856), p. 218.

[3] "On the Tragedies of Shakespeare, Considered with Reference to Their Fitness for Stage Representation" (1811), *Works of Charles and Mary Lamb*, ed. E. V. Lucas (London, 1903-1905), 1:98.

tends to explain or throw light upon the text," but he distinguishes between "real" and "ideal" illustration. He claims that the first alone is appropriate in books of Scripture or history. On the other hand, "In illustrating poetry or works of fiction, the artist may be as imaginative and his fancy as unbridled as the poet's own: he has only to avoid the commission of solecisms or palpable incongruities." Some imaginative writers, however—Scott and Byron, for example—give ample scope for both kinds of illustration: for "ideal" imaginings on the one hand, and "real" transcriptions of locale and artifact on the other.[4] The Bridge of Sighs, Lochleven in its present appearance, an ancient bonnet and claymore, monumental sculpture, a view of the writer's home, could thus serve to enhance a poetic text. Curiously—as many nineteenth-century illustrated editions and play productions show—such "real" illustration might pay less heed to the letter and spirit of the fiction than did the illustration licensed as fancy-free.

To judge by painting, we are in a new age of illustration in the nineteenth century, launched with much fanfare just before the French Revolution by Alderman Boydell's grandly conceived Shakespeare Gallery and Thomas Macklin's rival Poet's Gallery. The latter offered a display of works by such artists as Fuseli, Wheatley, Opie, and Gainsborough, tied to a subscription proposal for 100 prints "illustrative of the Poets of *Great Britain*."[5] Boydell's original plan for commissioning paintings of national importance, to be paid for by the vast sale of prints, was not unlike a joint stock scheme, aimed at shifting the burden of finance (or patronage) from the few to the less few, from the aristocracy and its institutions to the moderately propertied classes, in Britain and abroad. Partly because his gallery specialized in Shakespeare, it is a landmark in the painting that illustrates literature, not the least because it was officially touted as advancing a notion of historical painting. Some of the scenes recall the well-established mode of representing actors in a role, and the play as a play being acted; but there are no such explicit depictions, and most of the paintings illustrate the plays with independent pictorial inventions.[6] Fuseli, whose illustrations are among the most inventive in the Shakespeare Gallery, gave a hyperbolic turn to the culturally ambitious side of Boydell's scheme by creating his own Milton Gallery (1791-1800) for a poet requiring illustration on the sublime scale.

Much of the painting of literary subjects so characteristic of the first half of the nineteenth century was, however, on a cosier scale, illustrating less-than-heroic scenes from familiar classics: Cervantes, Goldsmith, and soon Walter Scott. Through much of the century the annual catalogues of the Royal Academy exhibitions were crammed with verse and prose from the works of these and other writers, quotations from memoir and history as well as from literature. Even the literate spectator would not have been familiar with all these texts, which suggests that some of the appeal was as instruction. It should be noted, moreover, that the extension of one medium by another was not all in the same direction. Turner regularly supplied the catalogues with fragments of a poem he called "The Fallacies of Hope," illustrating his paintings; and Rossetti, though not an exhibitor, wrote poems inspired by works of art that sometimes happened to be his own.

[4] "Illustrated Books," *Quarterly Review* 74 (June 1844): 194-96.

[5] *Gallery of Poets . . . April 2, 1790. Catalogue of the Third Exhibition of Pictures, Painted for Mr. Macklin by the Artists of Brittain, Illustrative of the British Poets, and the Bible.*

[6] Lamb nevertheless treats them as attempted realizations doomed to failure, rather than as feeble or uninspired illustrations, which they often are. "What injury (short of the theatres) did not Boydell's 'Shakespeare Gallery' do me with Shakespeare. . . . To be tied down to an authentic face of Juliet. To have Imogen's portrait! To confine the illimitable!" *Letters*, ed. E. V. Lucas (New Haven, 1935) 3:374.

It would be foolish to try to decide which impulse was uppermost in all these paintings: that of giving concrete perceptual form to a literary text (realization), or that of interpretive re-creation (illustration). There were shifts in fashion through the century, however, and the overall result was an extraordinary dialogue of literary and pictorial forms, in the exhibition galleries, in the print shops, and in the parlor. Some statistics here provide a rough guide. There were virtually no quotations from literary texts in the 1780 catalogue of the Royal Academy exhibition, and half of the dozen or so literary subjects were single figures, including portraits in character. In 1800 there were about fifty literary illustrations among the paintings, many evidently related to print and publishing projects, and more than thirty quoted passages from literary texts excluding the Bible. In 1845 there were more than eighty such quoted passages in the catalogue, and perhaps double the number of illustrative paintings. By 1885, however, there is a change of direction. Many of the verses attached to landscape and genre scenes are themselves no more than embellishment (or illustration), comparable to an epigraph, rather than identification of a literary subject. There seem to be only about twenty-five true identifications, including passages from recent military memoirs, and nearly as many scraps of quotation that are chiefly illustrative embellishment. The number of paintings in each exhibition, not a constant, grew over this long period; but the figures nevertheless reflect marked trends, not only in the exploitation of illustrative relationships in painting, but in viewer attention to what would be considered "important" in pictures. There was also perhaps a national bias in these trends. In an article of 1862, Delacroix (who had illustrated Byron, Scott, and Shakespeare) refers to "ce qu'on a récemment appelé, dans un jargon emprunté aux Anglais, des *illustrations*, où le peintre s'empare de l'idée du poète pour la commenter à sa façon."[7] In the 1890s, when someone told Burne-Jones that French painting was not based on literature, he replied, "What do they mean by that? Landscape and whores?"[8]

The great flourishing phenomenon of illustrated serial fiction deserves separate discussion, though it is worth remembering here that Dickens was originally supposed to be Seymour's illustrator in *Pickwick* (1836); that Pierce Egan's text defers to the Cruikshank pictures in *Life in London* (1821); and that Cruikshank was probably justified in feeling that he was the principal author and Ainsworth the illustrator in *The Tower of London* (1840).[9] In the pattern for such collaborations with a popular artist, *The Tour of Dr. Syntax in Search of the Picturesque* (1812; originally a monthly feature in Ackermann's *Poetical Magazine*, 1809), William Combe improvised the verse narrative that illustrated Rowlandson's free-ranging designs.[10]

In the theater, the illustrative bent shows itself pervasively, especially in the classics, in acting as well as in the hypertrophic elaboration of decor. The actor's quest for new "points" in Shakespeare—fresh readings that would stretch the text and startle a jaded audience—unites the styles of all the greats from Edmund Kean to Henry Irving, and indeed provides a precedent for the modern "creative" director. Meanwhile a developing interest in the archaeological illustration of Shakespeare's plays in the theater ("real" as opposed to "ideal" illustration)

[7] Eugène Delacroix, "Charlet," *Revue des Deux Mondes* 37 (1862): 236.

[8] Quoted in Richard Dorment, "Burne-Jones and the Decoration of St. Paul's American Church, Rome" (Ph.D. diss., Columbia, 1976), p. 167.

[9] See John Harvey's judicious discussion of Cruikshank's claims in *Victorian Novelists and Their Illustrators* (London, 1970), pp. 38-42.

[10] Preface, 2nd ed., and *DNB*, s.v. William Combe. Cf. *The English Dance of Death from the Designs of Thomas Rowlandson with Metrical Illustrations by the Author of "Dr. Syntax"* (1815).

took wing with Charles Kemble's *King John* (1823), guided by J. R. Planché, playwright, antiquarian, and eventually Somerset Herald.

Outside the legitimate drama, an instructive and spectacular "moving diorama" became an expected pictorial embellishment of the major pantomimes in the 1820s, usually in the form of "real" illustration, presenting, for example, Venice from the Grand Canal; the sights along the carriage road over the newly-open Simplon Pass; a balloon trip from London to Paris, or from Persia across Europe to Dover.[11] Painting and painters were deeply involved with such spectacular topographic illustration in the theater, in the tradition of De Loutherbourg's *Wonders of Derbyshire* (1779). Though already exhibiting at the Royal Academy, Clarkson Stanfield and David Roberts were the leading diorama artists for the major theaters in the 1820s, and from 1828 to 1830 created an independent annual "British Diorama," exhibiting views of Lago Maggiore, Tintern Abbey, the city of York, the ruins of the Temple of Apollinopolis.[12] The diorama as used in drama was directly inspired by the series of illusionistic contrivances for spectacular illustration that began with De Loutherbourg's Eidophusicon in 1781, and included Robert Barker's Panorama, first exhibited in 1789; Daguerre and Bouton's Diorama, brought to England in 1823; and a host of subsequent "Padoramas," "Udoramas," "Cosmoramas," "Physioramas" and "Dissolving Views," all exceedingly popular in the 1820s to 1840s.[13]

In most of these, the appetite for truth and fact shared the stage with the appetite for wonder. De Loutherbourg's illusionistic marvels had been angled toward the picturesque and the sublime, though they did not exclude verifiable topographic description, and Daguerre's exhibition continued to reflect a primary interest in light and its changes;[14] but starting with Barker's Panorama, the emphasis shifted to fact and truth, and scenic illustration took on an often didactic and literally reproductive character. The illusionistic aspect—the representation of reality by *less* substantial means—was never lost sight of, however, for therein lay the wonder. "Child's Celebrated Dissolving Views" were a vivid case in point. A form of magic lantern show that made part of a varied bill at the Adelphi Theatre in 1837, they shortly thereafter found a permanent home at the Royal Polytechnic Institution, where exhibition and education, science and wonder, were most improvingly combined. The Dissolving Views could be recommended, to parents and others, as "real" illustration (of Constantinople and the Scenery of the Bosphorus, for example), and be enjoyed for the wonder of the machinery and the enchantment of the transformations.[15] In the name of improvement and truth many pleasures could be relished, while facts had a relish all their own.

Not just the illustration of places, but the illustration of events could provide these complex satisfactions. I suppose the creation of *The Illustrated London News* in 1842, its mighty success and its brilliant development of technical and organizational possibilities, ranks among the most important cultural events of the century. But both before and after, the theater provided a form of topical news show that served the appetite for ocular truth and mastery over time, space, and materials, and anticipated not only the illustrated news magazine, but the news-

[11] See David Mayer III, *Harlequin in His Element* (Cambridge, Mass., 1969), esp. pp. 69-73, 129-34.

[12] See British Library catalogue entries for the Royal Bazaar, London. The descriptive pamphlets themselves have been destroyed.

[13] The fullest account of this host of entertainments may be found in Richard Altick's *The Shows of London* (Cambridge, Mass., 1978).

[14] Louis Jacques Daguerre, "Description des procédés de peinture et d'éclairage inventés par Daguerre, et appliqués par lui aux tableaux du diorama," *Historique et description des procédés du daguerréotype et du diorama* (Paris, 1839). In De Loutherbourg's first season of the Eidophusicon, the program began with "Aurora, or the Effects of the Dawn, with a View of London from Greenwich Park," and ended with "Storm at Sea, and Shipwreck."

[15] *Examiner* (25 Dec. 1841), p. 823. On the mechanism, see W. J. Chadwick, *The Magic Lantern Manual* (London, [1878]), pp. 61-66.

[16] *Examiner* (26 Oct. 1834), p. 679: "Victoria [Theatre]. A cleverly executed transparency of the Burning of the Parliament Houses is at present exhibiting here." The fire occurred on the night of the 16th.

[17] *A Vision from St. Helena*, Adelphi Theatre, December 1840. "The lying in state of the Emperor, and the interior of the Hotel of the Invalides, is faithfully represented, according to the French sketches and programme. . . . The interment of the Emperor will, we have no doubt, be made the subject of many stage exhibitions, as well as of Panoramas and paintings by our first artists" (unidentified clipping, Enthoven).

[18] George Raymond, *The Life and Enterprises of Robert William Elliston, Comedian* (London, 1857), pp. 301-306.

[19] James Robinson Planché, *Recollections and Reflections* (London, 1872), 1:64-73.

[20] Quoted, from the original prospectus (1850), in *The Route of the Overland Mail to India, from Southampton to Calcutta* (London, 1852), an illustrated description of the diorama painted by Thomas Grieve, William Telbin, John Absolon, with animals by J. F. Herring and H. Weir; based on sketches supplied by David Roberts and others; costumes supplied by the Oriental and Peninsular Co. and others; accompanied by music and "The DESCRIPTIVE DETAILS by Competent Lecturers." For the later career of the Gallery of Illustration, under Mr. and Mrs. German Reed, see Jane W. Stedman's introduction to *Gilbert before Sullivan* (Chicago, 1967).

[21] Dallas, "The Drama," p. 217. The earlier criticism Dallas probably had in mind was that of G. H. Lewes in the *Leader* (18 and 25 June 1853), repr. in *Dramatic Essays*, ed. W. Archer and R. W. Lowe (London, 1896). Lewes asks, "Is the drama nothing more than a Magic Lantern on a large scale? Was Byron only a pretext for a panorama? . . . Why not give up the drama altogether, and make the Princess's Theatre a Gallery of Illustration?"

[22] Kean's apologia for *Sardanapalus* is reprinted in Lacy, Vol. 11; the version used here, however, is that which accompanied the playbill.

reel itself. Any public event, from the burning of the Houses of Parliament[16] to the disinterment and second funeral of Napoleon[17] was matter for scenic illustration, subject only to the censor's notions of propriety. Ceremonial events translated into theatrical spectacle especially well, as when only two weeks after the coronation of George IV in Westminster Abbey (1821), Elliston restaged the event at Drury Lane.[18] For a *Pageant of the Coronation of Charles X* (1825), J. R. Planché was dispatched to Rheims to sketch the full particulars of costume and decoration. The result at Covent Garden eclipsed a rival production at Drury Lane, though perhaps not the ceremony at Rheims, which had been staged by the master scene designer of the Paris Opera, P.L.C. Ciceri.[19]

It is not surprising that half a century and more after the Shakespeare Gallery, the Poet's Gallery, and the Milton Gallery, one of London's prominent places of entertainment should be known simply as "The Gallery of Illustration," and be dedicated by its artist lessees "to illustrate any passing events interesting to the public mind, that were capable of instruction or pictorial effect."[20] Nor is it surprising that the anatomist of Charles Kean's Pre-Raphaelite "realism," reflecting on the archaeological elaboration of his dramatic spectacles, should recall that, "On the production of *Sardanapalus* [1853], it was said that he had turned his theatre into a Gallery of Illustration, and that, properly read, his playbills invited the public to witness, not the Drama of Sardanapalus, but the Diorama of Nineveh." The writer goes on to treat with some irony Kean's confusion of dramatic function with elaborative and didactic function in the remarkable program for *Sardanapalus*, where Kean claimed, "It is a note-worthy fact that, until the present moment, it has been impossible to render Byron's tragedy of 'Sardanapalus' with proper dramatic effect, because, until now, we have known nothing of Assyrian architecture and costume."[21] Kean, however, knew what he was about. In his production apologia, he refers to himself as "one who has learnt that scenic illustration, if it have the weight of authority, may adorn and add dignity to the noble works of genius." But he also remarks that "interesting as the rescued bas-reliefs which have furnished such information are, they could not find dramatic illustration but for the existence of the only Tragedy which has reference to the period of which they treat," thus reversing the relationship between the play and the artifacts Layard had recently unearthed. From several perspectives, then, the theater had indeed become a gallery of illustration; but through material elaboration, Kean believed, it also became the place where noble works of genius, works of the imagination like Byron's, could be realized concretely. In the theater of Charles Kean, illustration and realization become one.[22]

WHAT TENNYSON wanted from Hunt was a literal realization of his poem, neither more nor less. What Hunt set out to furnish was an "ideal" illustration, a comprehensive image that both embodied the imaginative work of the poet and embellished it through the resources of another medium. Hunt's conception of his task was close to that expressed in an earlier critic's praise for a scene from *Hamlet*: "[the painter] knows how to assist, and by *his* art to bring out the whole

conception of the poet; a conception not to be discovered as embodied, or capable of being embodied, in distinct words and in parts, but gathered from the feeling of the whole, and which to embody by another art, is no small test of genius."[23] But Hunt stops short of the ideal advanced by a modern critic of literary illustration: "What we ask . . . is something like a new poem upon an old, and in what may be called answerable style. We ask a fresh creative act in which the painter either captures the essence of his subject as we conceive it or so transmutes his subject that we are required to see it anew."[24] Hunt did not go so far in his own justification. He claims only the right of taking liberties in order to incorporate the narrative that Tennyson's poem also represents, the story to which his own work must be answerable.

The odd thing is that Tennyson's poem itself is not a full narrative account, but rather—beginning in the midst of things, with a pronoun—a concentration of the whole story in the turning point:[25]

7. Holman Hunt, Illustration for "The Beggar Maid," in Alfred Tennyson, Poems (London, 1857).

> Her arms across her breast she laid;
> She was more fair than words can say:
> Bare-footed came the beggar maid
> Before the king Cophetua.
> In robe and crown the king stept down,
> To meet and greet her on her way;
> "It is no wonder," said the lords,
> "She is more beautiful than day."[26]

So much appeared on the same page with the illustration. The second and last stanza began on the overleaf:

> As shines the moon in clouded skies,
> She in her poor attire was seen:
> One praised her ancles, one her eyes,
> One her dark hair and lovesome mien.
> So sweet a face, such angel grace,
> In all that land had never been:
> Cophetua sware a royal oath:
> "This beggar maid shall be my queen!"

In so concentrating the story, Tennyson's technique is rather like that of a narrative painter to begin with: the story becomes a "situation," a moment of poise, as in some of Millais' story paintings; a moment of epiphany as in some of Hunt's (see below, Chapter 17). Dramatically, the poem approximates the organization of a mid-scene tableau where, after the opening brings the actors into position, gesture is frozen, and the end provides the release. As in a narrative painting, there is a discreet temporal ambiguity in the assemblage of the several telling gestures put before us. Being and becoming are blended. The maid crosses her arms and is identified as fair in the first two lines, and comes before the king in the second two, in no temporal order, but at once, just as the king's stepping down and his rapt admiration happen at once.

Hunt in his illustration tries to tell as much of the story as Tennyson does, and to use as much as he can of Tennyson's detail; so he faithfully includes the lords' coarser admiration, in the shape of one spectator

[23] John Eagles, on The Play Scene in Hamlet of Maclise, Blackwood's 52 (July 1842), p. 24.

[24] Kester Svendsen, "John Martin and the Expulsion Scene of Paradise Lost," Studies in English Lit. 1 (1961): 72.

[25] Tennyson surely and Hunt and Burne-Jones probably found the story in Percy's Reliques, in the 120-line ballad of "King Cophetua and the Beggar-Maid," which begins with a king immune to love, and ends with the death many years later of the good old royal couple.

[26] Tennyson, Poems (London, 1857), p. 359.

and what seems to be an armed guard keeping him at bay. In the poem, the effect of Tennyson's shift of reader attention to the comments of the lords is to leave the king entranced, suspended in admiration. The shift gives the king's admiration words and simultaneously shows it to be beyond words, commensurate with the fairness of the maid. It is this shift in attention, a resource of the verbal medium, that creates the moment of poise, the tableau. In Hunt's picture the foreground figures are an enriching distraction. They are illustrative, compositionally vigorous and useful, but otherwise an impertinent intrusion between the viewer and the narrative configuration.

Moreover, Hunt adds to Tennyson's composition the awkward joining of hands whereby the king draws the maid upward (Hunt's king is stepping up, not down) and the king's symbolic gesture with his crown. The gesture is the artist's visual equivalent of the king's oath, pointing to the end of the story. It is overtly symbolic, unlike the oath, which belongs fully to the moment of its utterance. The result is not a realization, such as Tennyson would have liked, of the poem or one of its conflated moments, but an insufficiently independent attempt to illustrate the poem through a parallel imaginative creation. It fails as compared to Millais' conservative "Mariana" illustration, or Hunt's "Lady of Shalott" (which Tennyson also found too independent), or Rossetti's inventive, peripheral, and even misleading St. Cecilia for "The Palace of Art," all in the same volume. For all these embellish the page, enrich the reader's experience of the whole, and furnish the illuminating extension of one medium by another that the specific delight in illustration demands.

In a consideration of those common features that unite the several arts in the nineteenth century, and of the outright collaborations between the arts, illustration is certainly the more complex and problematical notion. But realization is the more neglected; and realization is central to the persistent pressure toward uniting a concrete particularity with inward signification, the materiality of things with moral and emotional force, historical fact with figural truth, the mimetic with the ideal. This is how contemporaries saw realization; for example, the reviewer of Holman Hunt's *The Scapegoat*, commenting on Hunt's taking the trouble to paint this Old Testament religious symbol on the spot, the shores of the Dead Sea. The reviewer writes that he cannot find fault with "the desire for realization, which, at the present day, either from a wish for novelty, or from a tendency to idealized materialism, is grown almost a passion with our young artists and poets."[27] One may speculate that the apparently naive pleasure in realization lay in its seeming ability, in an age of "idealized materialism," to solve Plato's problem of representation, whereby distance from an original necessarily entails diminished truth and diminished substance. Realization therefore will be more prominent in the series of conjunctions that constitute the second part of this book, though often it will be an illustration that is realized. For illustration makes itself felt in these conjunctions, even in what seem to be the most literal-minded translations from one medium to another for the sake of the material increment. The illustrative impulse—contrary to the usual later view— tries the sobriety and literalness of the materializing impulse, sometimes

[27] "Fine Arts, Royal Academy," *Athenaeum* (10 May 1856), p. 589.

taking on its manner in the lavish provision of detail, but irrepressibly asserting an ultimate independence, as a manifestation of the transforming imagination. And in the end it is illustration that bears witness to what is irreducibly distinctive and particular in the several arts.

3

<center>→·←</center>

SPEAKING PICTURES: THE DRAMA

*T*HE REVOLUTION in the drama that took hold in the age of
revolutions entailed a change in the relation of the subor-
dinate parts to the design of the whole, and indeed a change
in the fundamental building block of the play. The perception
of what was essentially "dramatic" changed accordingly, and with it,
relations between image and action, in the theater and out of it. The
nature of these changes in the making and staging of plays is the special
concern of this chapter.

Dramaturgy

In the inherited drama, the building block of the play was transitive
and rhetorical. It was a unit of action, involving one or more persons,
in which something had to be said and done, or a unit of passion in
which something had to be suffered and expressed. In either case,
such a piece of the dramatic whole typically came from somewhere, or
led somewhere, or both. Meaning and the sensation of drama inhered
in an articulated succession. It is true that in performance every scene,
speech, and action of note may be conceived and experienced as a
"turn," in the music hall sense of the word rather than in the Aristo-
telian sense. A turn contains its own reason for being, and is too full
of itself to spare a thought for the whole. Nevertheless (except perhaps
in opera), the prevailing model asked that doing and suffering have a
justification beyond their intrinsic interest. In this dramaturgy, how-
ever peripatetic the course of the play, however contrastive its juxta-
posed units, however divided its plots or contrived for the accommo-
dation of turns, the standard remains an unfolding continuum.

In the new dramaturgy, the unit is intransitive; it is in fact an achieved
moment of stasis, a picture. The play creates a series of such pictures,
some of them offering a culminating symbolic summary of represented
events, while others substitute an arrested situation for action and
reaction. Each picture, dissolving, leads not into consequent activity,
but to a new infusion and distribution of elements from which a new
picture will be assembled or resolved. The form is serial discontinuity,
like that of the magic lantern, or the so-called "Dissolving Views."

European theaters before the nineteenth century have been highly

pictorial, in the sense of being perspectively organized and acutely aware of the visual ensemble, including scenery and spectacle. A primary interest in spectacle is characteristic of renewals of theatrical life, and one thinks of the Florentine theater under the Medici and Davenant's Restoration extravaganzas. But what is striking and characteristic in the nineteenth-century theater is that its *dramaturgy* was pictorial, not just its *mise en scène*, and that such pictorialism was strongest in what were regarded as its most "dramatic" genres. Its pictorialism could flourish, if necessary, in the absence of much that is normally associated with theatrical spectacle. Though the nineteenth-century theater *was* eminently spectacular, the most powerful expression of its pictorial dramaturgy was not the lavish court spectacle, nor the scenery show, nor its own magical song-and-dance extravaganza, but melodrama.[1]

The best contemporary account of the new dramaturgy is to be found in Edward Mayhew's brief treatise and guide, *Stage Effect: or, The Principles which Command Dramatic Success in the Theatre* (1840). Mayhew discusses the "modern theory . . . that *dramatic success is dependent on situations*"—"situations" which turn out to be not a single intriguing configuration that governs the play, as in a still later drama, but something more plural:

> To theatrical minds the word "situation" suggests some strong point in a play likely to command applause; where the action is wrought to a climax, where the actors strike attitudes, and form what they call "a picture," during the exhibition of which a pause takes place; after which the action is renewed, not continued; and advantage of which is frequently taken to turn the natural current of the interest. In its purposes it bears a strong resemblance to the conclusion of a chapter in a novel.

Mayhew's illustrations, however, come not from melodrama, as one might expect, but from *The School for Scandal* (1777) and the established staging of *Othello*. When the screen is thrown down in Sheridan's play, Charles, Sir Peter, and—according to Mayhew—Joseph cry out, one after the other, varying the epithet, "Lady Teazle, by all that's wonderful . . . horrible . . . damnable." Then "there is a pause; each of the performers remaining statue-like in the attitudes they assumed when the above expressions were uttered; after sufficient space has been allowed for admiration of 'the picture,' Charles turns the interest . . . by bursting into laughter."[2]

Mayhew's illustration from *Othello* shows how the scene of the quarrel on Cyprus (II, 3) has been cut to transform an action that is "stirring and continued" into a prepared pictorial effect. In Shakespeare's original scene (as Mayhew gives it), Othello, disturbed by the rumpus, enters with attendants:

Oth. "What is the matter here? "
Mon. "I bleed still; I am hurt, but not to th' death."
Oth. Hold for your lives.
Iago. Hold, ho! Lieutenant, Sir, Montano, Gentlemen:
 "Have you forgot all place of sense and duty?
 "Hold. The General speaks to you; hold for shame."
Oth. Why, how now, ho? Whence ariseth this?

[1] The best argument for a more evolutionary view of what I have called the new dramaturgy is in Joseph Donohue's invaluable book, *Dramatic Character in the English Romantic Age* (Princeton, 1970). Donohue writes, "A homogeneous dramatic tradition extends from the plays of Beaumont and Fletcher to those of Romantic writers like Joanna Baillie, 'Monk' Lewis, Charles Maturin, Richard Sheil, and many others. This tradition may be aptly termed 'the affective drama of situation.' Plays of this sort have a structure based on a series of circumstances and events unconnected by a strict logic of causality (or Aristotelian 'action'); their situations are deliberately brought out of the blue for the purpose of displaying human reactions to extreme and unexpected occurrences. In these plays the intelligible unit is not the thematic part, placed within a coherent series of other parts, but, as in Fletcherian drama, the scene, which exists in effect for its own sake" (p. 28). My own view of Fletcherian drama differs somewhat, but "the affective drama of situation" is exactly what I am talking about. How it was embodied in dramatic textures in the nineteenth century is the issue; and that is where the pictorialism of the nineteenth-century form is most pertinent.

[2] Edward Mayhew, *Stage Effect* (London, 1840), pp. 44-46. The text of Sheridan's play is an editorial mare's nest; but according to Cecil Price the best evidence ends Charles' line in "wonderful," Sir Peter's in "horrible," and gives Joseph (who has just entered) nothing to say at all. Many early versions supply "damnable" however, in Sir Peter's line; and Mayhew's report of *three* exclamations, using the three terms, probably represents a stage tradition.

"On stage," Mayhew writes, "the passages marked by inverted commas are dispensed with." The scene represents a courtyard with an archway at the center back through which Othello has previously retired. The noise of the brawl increases,

> till Othello appears, and, standing with his sword drawn immediately under the archway, brings all to a climax by shouting at the top of his voice, "Hold for your lives! " at which instant Montano receives his hurt and staggers into one corner. Cassio, conscience stricken by the sound of his General's voice, occupies the other. The rest of the performers put themselves into attitudes—the stage is grouped—and a picture formed, of which the Moor is the centre figure. After this there is a pause; when Othello, having looked around him, walks forward, and the half exclamation of *Why, how now, ho! whence ariseth this?* becomes an inquiry.[3]

Mayhew complains that not only is Nature, as truly expressed in a drunken quarrel, affronted here, but the action is injured, and the "conduct of the fable" (narrative development and continuity) "materially deteriorated." Moreover, Iago's artful and officious remonstrance, soon to be echoed by Othello, is lost. But the vivid plunge from sound to silence, from violent activity and disorder to a frozen pictorial order, has made a splendid "effect."

Mayhew's reported staging of *Othello* seems to have developed in the latter part of the eighteenth century, alongside the dramaturgy of *The School for Scandal*.[4] Sheridan himself had something to say about the trend whose onset he illustrated. At one point in *The Critic* (1779), Puff, author of *The Spanish Armada*, puts Mayhew's "Principles which Command Dramatic Success" in a nutshell as he tells his rehearsal audience, "Now, gentlemen, this scene goes entirely for what we call SITUATION and STAGE EFFECT, by which the greatest applause may be obtained, without the assistance of language, sentiment or character: pray mark!" The premise of Puff's scene is that the two nieces of Sir Christopher Hatton and Sir Walter Raleigh consider their tender feelings for Don Ferolo Whiskerandos to have been slighted. According to the stage directions, they draw their daggers against the offending beloved, whereupon the two uncles catch the arms of their respective nieces and simultaneously direct their swords at Don Ferolo, who promptly holds his own daggers to the two nieces' bosoms.

> *Puff.* There's situation for you!—there's an heroic group!—You see the ladies can't stab Whiskerandos—he durst not strike them for fear of their uncles—the uncles durst not kill him, because of their nieces—I have them all at a dead lock!

Sneer concludes they must stand so forever, but Puff manages to turn the interest with "a very fine contrivance," an invocation of the Queen's name.[5]

Historically regarded, the impasse situation of heroic drama, already full-blown in Corneille's *Cid*, has here been materialized as a frozen image, a tableau, whose only function is "effect." Puff's conjunction of the terms "situation" and "stage effect" does not represent a self-evident tautology for us; our own habits of language would not lead us to explain the one by the other, as—sixty years apart—Mayhew and Sher-

[3] Mayhew, *Stage Effect*, pp. 50-52.

[4] The evidence of the *Othello* promptbooks is also not simple, but the first printed version I have seen to give the *full* cut is H. Garland's edition (ca. 1765). At least two earlier acting versions show partial cuts of the passage, and the full cut becomes standard after 1777. See J. P. Kemble's version of 1804 in *John Philip Kemble Promptbooks*, ed. Charles H. Shattuck, Vol. VII (Charlottesville, Va., 1974).

[5] *The Dramatic Works of Richard Brinsley Sheridan*, ed. Cecil Price (Oxford, 1973), 2:544-45.

idan do. The mediating term in the equation of the two is "picture." From about 1770 to 1870, "situation" implied a pictorial effect in drama, and "effect" was likely to mean a "strong" situation realized pictorially. "Effect" had a wider reference and a more essential part to play in shaping and describing aspects of a style (Chapter 5). The more inclusive character of "effect" apppears in Mayhew's apparently paradoxical but quite sound account of melodrama, the form that was best able to exploit the new dramaturgy. "A melo-drama," he writes, "is defective in action, possessing too little rather than too much; for it is brought only to a certain point called a situation, and there interrupted. In this view, the fourth act of '*The School for Scandal*' is melo-dramatic. To cover their deficiency of action, melo-dramatists give an undue and irregular importance to the scenes and properties of the theatre; and their productions abound in 'effects,' without the aid of which the interest evaporates."[6] A pictorial dramaturgy, then, organizing a play as a series of achieved situations, or effects, created the need for even more effects. These in Mayhew's account are chiefly visual and apparently static; but in fact sound and movement—"real" waves, ships sailing off the stage or sinking through it, forts blowing up and tenements burning down—these too were part of the dramatist's arsenal. Here as elsewhere in drama, sensation in its primitive sense, but sensation charged with wonder over the imitation of a difficult reality or the creation of a marvelous impossibility, was the underlying principle of dramatic effect.

The Critic is a work of practical criticism, rather than a program; and while Puff's ideal of the drama is wonderfully clear, he is less than systematic in presenting it, so that even the pictorial character of his "heroic group," his scene of situation and effect secured "without the assistance of language, sentiment or character," must be inferred from the demonstration. The true prophet of nineteenth-century pictorial drama, antedating Puff and urging it as a program, was Denis Diderot. The boldness of Diderot's argument lay in his advancement of spectacle in connection with theatrical forms that were neither ceremonial and celebratory nor musical and balletic, but directed toward private life *and* claiming serious literary attention. He also attempted to translate his theory into practice, his program for the theater as a whole into a dramaturgy. Accordingly, his play *Le Fils naturel* as published (1757) came equipped with elaborate directions for pantomime and pose, not only as accompaniments to discourse, but sometimes taking its place (for example: "*Constance, un coude appuyé sur la table, & la tête penchée sur une de ses mains, demeure dans cette situation pensive*").[7] In the dialogues on dramatic poetry that accompanied the play, Diderot's spokesman develops a theory of pictorial staging, and attacks those contemporary conventions of performance that run counter to it— actors not looking other actors in the face, always fronting the spectator, holding themselves "en rond, séparés," each at a certain distance from the other and part of a symmetrical formation. At present, he complains, one almost never sees on the stage a "situation" that could be made into a tolerable composition in painting. His alternative idea is statable in a striking, if deceptively simple formula: a dramatic work that is well made and well presented should offer the spectator as many "ta-

[6] Mayhew, *Stage Effect*, pp. 74-75. Cf. William Archer's later definition, in an essay on Victor Hugo: "Melodrama is illogical and sometimes irrational tragedy. It subordinates character to situation, consistency to impressiveness. It aims at startling, not at convincing, and is little concerned with causes so long as it attains effects." *About the Theatre* (London, 1886), p. 320.
[7] *Oeuvres de théâtre de M. Diderot* (Amsterdam, 1772), 1:21. Puff's Lord Burleigh, who comes on the stage to think, is Sheridan's comment on the art of advancing the drama through "dumb show and expressions of face."

bleaux réels, qu'il y auroit dans l'action de momens favorables au peintre."[8] Diderot further supports such a program in the essay which accompanied *Le Père de famille* (1758), where he defines dramatic pantomime as the *tableau* that existed in the imagination of the poet as he wrote his play, and insists on the necessity for continuously grouping and otherwise manipulating the figures on the stage so as to create "une succession de tableaux tous composés d'une manière grande & vraie."[9] Diderot insists on the essentiality of this spectacular, pictorial dimension in drama, and he envisages pictorial action brought to such perfection as to render words unnecessary.

Diderot's influence is traceable in his own theater and in Germany, and through the French and German theaters to England. It is likely that Diderot's own views on pantomime and picture owed something to England in the first place (e.g. to Hogarth and Garrick), just as his program for a "genre serieux" owed something to Lillo and Shakespeare.[10] Nevertheless, it was Diderot, using his dissatisfaction with current practice in the most powerful of eighteenth-century establishment theaters, who shaped these hints into an alternative program with a critical rationale. As program or as prophecy, Diderot's pictorial theater took root in the more popular theatrical forms (helped by a few esoteric and self-conscious experiments), and flourished as the dominant mode for the creation and presentation of plays in the nineteenth century.

Figure and Ground

No revolution is ever neat or complete, and neither was the rise of a pictorial dramaturgy with its underlying assumptions about how to organize audience experience. Nor is the change in the writing of plays isolable from developments in acting, staging, and scene design, as Diderot's arguments and Mayhew's explanations make abundantly clear.

Roughly speaking, the course of development in acting was from a rhetorical, to an illustrative and expressive, to a fully pictorial style, where composition displaced attitude as the governing visual concern. The second stage, the illustrative and expressive acting which codified itself in the eighteenth century, and then handed itself down in nineteenth-century acting manuals, was manifestly not yet the fully pictorial style of the later nineteenth century. Nevertheless, Talma's turn-of-the-century acting (according to a description which is supposed to have greatly affected Goethe's Weimar methods) was "an unbroken chain of pictures," while Edmund Kean's more violently expressive Richard III (according to Hazlitt) was, like his Shylock, "a perpetual succession of striking pictures."[11] Such picture-making, however, was not what Irving had in mind in admonishing the actor to learn "that he is a figure *in* a picture, and that the least exaggeration destroys the harmony of the composition."[12]

IN THE 1760s Garrick altered the lighting of the stage sufficiently to allow the actor to keep within the picture if he were so minded, and in the 1770s (in Garrick's theater), De Loutherbourg converted pic-

[8] Ibid., 1:168-70.

[9] Ibid., 2:418, 420.

[10] See Kirsten Gram Holmström, *Monodrama, Attitudes, Tableaux Vivants, Studies on Some Trends of Theatrical Fashion 1770-1815* (Stockholm, 1967), pp. 24-25, 37, 39. Miss Holmström makes the intriguing suggestion that the pictures in Diderot's " 'peepshow' theatre" were inspired by the art of Samuel Richardson. She also shows Diderot's program to be an extension of transformations in the style of tragedy-acting largely inspired by Voltaire, and of developments in ballet and its criticism. Voltaire's concurrent view—that only in recent years have actors dared to be what they ought: "des peintures vivantes"—is expressed in his *Appel à toutes les nations de l'Europe des jugements d'un écrivain anglais* (1761).

[11] Holmström, *Monodrama*, pp. 103-104 for Humboldt's letter to Goethe (1799); and William Hazlitt, *Complete Works*, ed. P. P. Howe (London, 1930-1934), 5:184.

[12] Henry Irving, *The Art of Acting* (London, 1893), pp. 63-64; my italics. Holmström gives a fuller account of the shift from a rhetorical to "pantomimic and expressive" style, particularly in France, *Monodrama*, pp. 13-39. See also Alan Downer's survey of the evolution of acting styles in England, "Nature to Advantage Dressed: Eighteenth Century Acting," *PMLA* 58 (1943): 1002-37, and "Players and Painted Stage: Nineteenth Century Acting," *PMLA* 61 (1946): 522-76.

turesque and sublime landscape painting to scene and setting and carried the stage a long way toward an illusionistic theater of effect. Nevertheless, much playing continued to take place before or at the proscenium, and there is ample evidence that well into the nineteenth century scenographic art on the one hand and the spectacle of actor and grouping on the other were independent and even mutually interfering effects. For one thing, actors and stage crowds, in motion and in depth, were sure to destroy the scale and perspective of paint. Some such mutual interference lost Alfred Bunn, the patent-theater impresario, the services of Clarkson Stanfield, who had the best claim to be the heir of De Loutherbourg. For a grand-slam production at Drury Lane of Isaac Pocock's *King Arthur and the Knights of the Round Table* (1834, based on Scott's *Bridal of Triermain*), Stanfield prepared a splendid scene representing the "Entry into the City of Carlisle." At the last rehearsal (according to Bunn), Andrew Ducrow, master of equestrian spectacle hired specially for the occasion, "thronged every part of it with *knights*, *squires*, *pages*, *attendants* and all sorts of characters, to give life and animation to the scene. Mr. Stanfield being of opinion that his scene had quite 'life and animation' enough in it, without any of Mr. Ducrow's assistance," demanded that the scene be first discovered "for the audience to gaze on and admire, and the multitude sent on afterwards." Bunn sided with Ducrow, and Stanfield departed.[13] Bunn can be trusted to color his stories; but even reduced to a chaste outline, this one shows how far from complete was the synthesis of the actor and the scene, even in outright spectacle drama, at a time when a pictorial dramaturgy was already full-blown.

Charles Kean was certainly not the first to achieve an unqualified union between figure and ground on the picture stage, but he offers a significant landmark. Priorities in the field are vexed, and both Macready and Madame Vestris in management instituted production practices aimed at such integration. But Charles Kean's production of Byron's *Sardanapalus* (1853) illustrates not only an idea of pictorial integration then normative only in some parts of Pantomime and Extravaganza, but also a more abstractly visual and decorative idea of acting than any contemporary formula would envisage. To complement his elaborate scenic resurrection of Nineveh according to the recent archaeological evidence, Kean strove to accommodate "his own attitudes and those of others to the action of the disinterred frescoes." The startled reviewer (who means reliefs rather than frescoes) wonders "whether this literal copying of the angularities arising from the limitations of Assyrian Art, rather than from their probable truth to the living actions of the time represented be desirable"; but he allows that this "adherence to pictorial authorities . . . adds strangely to the remote oriental character of the scene."[14] Probably Kean, in adopting this style of acting, began with a shrewd preference for an exotic archaeological fact over a commonplace probability, and thought himself the greater realist in consequence. But he used his exotic fact to create a visual synthesis that was not only compositional, but atmospheric. Such a synthesis, unifying a rich and varied whole through visual style and atmosphere, would find its fullest flowering in the 1880s and '90s in Irving's pictorial and atmospheric theater.

[13] Alfred Bunn, *The Stage: Both Before and Behind the Curtain* (London, 1840), 1:224-25.

[14] *Athenaeum* (18 June 1853), p. 745. Other reviewers remark on the "ingenious adaptation of those quaint attitudes," notably G. H. Lewes in the *Leader* (18 and 25 June 1853), reprinted in *Dramatic Essays, John Forster, George Henry Lewes*, ed. W. Archer and R. W. Lowe (London, 1896), p. 25; and the reviewer in the *Illustrated London News* 22 (18 June 1853), p. 493.

It was surprisingly not until 1880 that anyone thought to put a picture frame entirely around the stage, and then it had an unexpected atmospheric effect that suggests what the painters called "keeping." In refurbishing the Haymarket, the Bancrofts did away with the fore-stage entirely, and provided "a rich and elaborate gold border, about two feet broad, after the pattern of a picture frame, [which] is continued all round the proscenium, and carried even below the actors' feet." Percy Fitzgerald reports, as the strangest of some singularly agreeable effects, that "the whole has the air of a picture projected on a surface. There is a dreamy softened air about the whole that is very pleasing."[15]

The late achievement of a fully pictorial theater, in which actor and crowds were fused with the setting in a sustained atmospheric and compositional unity, may seem out of step with the earlier establishment of a dominant pictorial dramaturgy. (A reviewer, certainly exaggerating, could declare *The Lights o' London* [1885] "the first melodrama in the representation of which the effective disposition of supernumeraries was studied.")[16] The fact is that the dramaturgy of effective situation did not depend upon such keeping, but was tied essentially to figural groupings, symbolizing relationships and states of feeling, incorporating bodily attitudes that were themselves expressive and symbolic, and these groupings made the picture. "Tableau" in drama meant primarily an arrangement of figures, not a scene and its staffage; and despite the notable successes of a Macready or a Madame Vestris in disciplining and unifying the scene, before Irving and the Bancrofts the actor was not yet so bounded and contained by the picture, so much *within* it, that his "least exaggeration destroys the harmony of the composition." It is rather to the point that the conventions of academic portraiture at least through Lawrence encouraged a similar disjunction between figure and ground, the latter, even as landscape, often suggesting theatrical scenery. The best painters could use the space thereby opened between art and life to say something about both. Even the Pre-Raphaelites of the 1850s, with their great concern for truthful and effective surroundings on the one hand, and symbolically expressive groups on the other, often show a discontinuity between figure and setting, the narrative picture and the natural one.

It should be said that a significant integration of player and scene did not wait for a full unification of solid figure and painted ground in an illusionistic continuum.[17] Where the theater could reconstruct the playing space to conform with real space, built to scale and solidly furnished, problems of perspective and even of composition nearly evaporate. Such integration was approached in plays set in domestic interiors, and the evidence for it lies not only in reports of productions, but in dramatic texts and in the character of the dramatic activity. The space between acting and setting dwindles in those melodramas where the interaction of men and things, the players and the "practicable" and active elements of the scene, was the essential drama. The space disappears entirely in drawing-room plays like Robertson's *Caste* (1867) and Sardou's *Pattes de mouche* (1860). In the second act of Sardou's play, the crowded and eccentric "*cabinet de Prosper*," the drama lies in what Diderot called the pantomime; and the approaches and separations, groupings and maneuvers of the actors are wholly integrated with the furniture and its placement, the fireplace, the clutter of bizarre

[15] Percy Fitzgerald, *The World Behind the Scenes* (London, 1881), p. 20. See also Richard Southern, "The Picture Frame Proscenium of 1880," *Theatre Notebook* 5 (1951): 59-61. Picture frames behind the curtain were used for "living pictures" earlier in the century. See David Wilkie's report from Dresden, below; and the account of Ducrow's statue-in-a-landscape attitudes in the *Spectator* 3 (18 Sept. 1830), p. 371.

[16] *Athenaeum* (30 May 1885), p. 705.

[17] Fitzgerald reports (*The World Behind the Scenes*, p. 79), "A new system of scenery has lately been introduced in pieces like 'Michael Strogoff' [1871] which consists of grouping living persons and bits of still life with pictorial background into a picture. This is borrowed from the panoramas, and if it be developed and carried farther, will open up a terrible prospect for stage managers. Whole museums will have to be kept of enormous properties" etc.

and useful objects, the walls, doors, window, lamp, and the scrap of blue paper that is the prize of the agon. Together and only together actors and decor constitute the dramatic action, and organize the spectator's interest and response. The "pictorialism" of such a theater, growing up even as the illusionistic theater moved toward a final integration, was not that of the painting, but rather that of the stereoscopic photograph.

Tableau and Tableau Vivant

The fullest expression of a pictorial dramaturgy is the tableau, where the actors strike an expressive stance in a legible symbolic configuration that crystallizes a stage of the narrative as a situation, or summarizes and punctuates it. For example, in the drama C. H. Hazlewood distilled from Mary Elizabeth Braddon's *Aurora Floyd* (1863), the first act ends with Aurora between her present husband, John, and her blackmailing first husband, the resurrected James, with her virtue under suspicion and her bigamous secret imperiled. The stage direction has her

> *forcing a gay laugh, which suddenly turns into an hysterical one, wild and piercing, so as to express great mental agony—this requires to be done with great force so as to achieve a climax as she falls into the arms of* JOHN—*at this moment* MRS. POWELL *from without, pulls back the window curtain, and looks in exultingly—*STEVE *points exultingly to the certificate he holds in his hand, regarding* AURORA *with looks of hate as he stands by door,* R.—JAMES *with his hands in his pockets, and one leg coolly crossed over the other, looks on with indifference as the Act drop falls—Music.*
> END OF ACT THE FIRST.

As Aurora's situation defines itself and achieves an emphatic climax, all the interests and antipathies of the various other members of her world lock into place.[18]

The dramatic tableau has so strong an association with the act endings in melodrama and the use of the act drop that it invites entire identification with this function and technology. Moreover, the curtain tableau is so useful a solution to the eternal problem of getting "off" that one might assume it created a supportive dramaturgy all on its own. As late as 1888, a handbook for would-be playwrights advised, "Pay great attention to your curtain. In melodrama it should certainly be upon a situation of some sort—the comic man denouncing the villain being the most popular. In comedy this is not necessary, but, even there, it should be at some moment of dramatic significance." To the audience "it is the concentrated summing-up of the whole act."[19] However, the tableau of situation and effect appeared independently of what came to be called the "tableau curtain," if Puff's evidence can be trusted at all. We know from the text that Puff has a drop curtain at his disposal, as well as the ordinary closing-in of flats for a change of scene, and we know that he is a master of "situation," or tableau-marked stage effect. But Puff uses quite another convention for terminal punctuation and managing an exit. After the English warriors in quintet kneel seriatim and chorus their immortal pre-Armada prayer in the first scene (mak-

[18] C. H. Hazlewood, *Aurora Floyd; or, The Dark Deed in the Woods*, French's Acting Edition, 58:17. The corresponding scene in the novel, an interview between Aurora and James Conyers in the North Lodge (Chap. 18), provides no such climactic confrontation or inclusive configuration.

[19] "A Dramatist," *Playwriting: A Handbook for Would-Be Dramatic Authors* (London, 1888), p. 18.

ing an admirable picture), the author suggests that the actors go off kneeling—"It would have a good effect . . . and would vary the established mode of springing off with a glance at the pit." But the tradition-bound actors refuse, and Puff therefore has them repeat the last line standing up "and go off the old way." Later Tilburina has a similar exit at the very end of a scene. Parting from Whiskerandos, she goes out "without the parting look," to Puff's intense annoyance. As corrected, she speaks her exit line "Aye for ever. . . . *Turning back and exeunt. Scene closes*"—leaving her confidante to get off as she can.[20] Puff, especially in the prayer, created excellent tableau situations before there was a closing tableau convention. As a hack of genius, Puff is both the first to take up the new and the last to lay down the old. His practice, like Sheridan's, suggests the priority of more general cultural and stylistic currents over limited material causes and utilitarian inspiration in the development of a pictorial dramaturgy. That is, the urge to make and enjoy effective pictures was more important than the availability of a curtain in the creation of a pictorial dramaturgy.

THE TABLEAU in drama had a history of its own, separable from the ferment that surrounded its incorporation in the new dramaturgy. There is, for example, a striking instance in Racine's *Athalie* (1691). The climactic revelation of Joas enthroned (followed by an opening of the back of the theater to reveal the interior of the Temple and the Levites in arms) is staged as the disclosure of a sacred picture, a divine vision given material, iconic form by the artist, the inspired human instrument. Joad, High Priest, inspired prophet, and here sacred artist, is the manager of the scene and of the curtain that opens to reveal the glorified boy:

> *Le rideau se tire. On voit Joas sur son trône; sa nourrice est à genoux à sa droite; Azarias, l'épée à la main, est debout à sa gauche; et près de lui Zacharie et Salomith sont à genoux sur les degrés du trône; plusiers lévites, l'épée à la main, sont rangés sur les côtés.*[21]

The disclosure has a special function and rationale in this play, whose principal *topos* is pentacostal epiphany. For the audience, the scene is theophanic through its allusion to a familiar genre of sacred picture. Racine, however, goes out of his way to remind us of the immense distance between this sacred child, Joas, and the one Joas foreshadows; and the playwright implies a similar gap between his own new art of the sacred image—still staged, imitated, and built of mortal materials— and the sacred reality. The gap is inherent in the deliberate archaism of Racine's resort to a dramatically obsolete iconic mode.

The masque and the *auto* had made large use of the emblematic tableau, as had medieval theater and Renaissance pageantry before them. But there was no continuity and little similarity in iconic method between these theaters and the pictorial theater of the nineteenth century. Intervening uses of the climactic tableau (as in *Athalie*) tend to have a special character and function. In England, the most important use of the climactic tableau apart from the masque was in the "discovery" scene of the post-Restoration theaters. As the Elizabethans used it, the discovery took the form of an internal show—Duke Fer-

[20] Sheridan, *Dramatic Works*, 2:528, 535-36.
[21] Racine's laconic direction for this part of the scene is "*Le rideau se tire.*" The amplification here quoted, from the edition of 1736, assembles elements for the most part explicit in Joad's verbal directions. See *Oeuvres complètes de J. Racine*, ed. Louis Moland (Paris, 1877), 5:244. The frontispiece of the original edition of 1691 combines the two phases of the revelation.

dinand's waxworks in *The Duchess of Malfi*, Prospero's Ferdinand and Miranda at chess in *The Tempest*. The post-Restoration discovery scene was a hopeful compromise between neo-classical decorum and genuine classical sensationalism, a compromise in which the scene opens to show as done what could not be shown a-doing, chiefly slaughter and mutilation. Aaron Hill's *Merope* (1749-1750) offers an example. After the audience has been treated to a vigorous verbal description of the butchery and its setting, the scene opens to show the bloody result, with "Eumenes discover'd on the Altar with the Axe of Sacrifice in his Hand. Merope kneeling, Priest, Attendants and Guards." These form a tableau of the living, set among a tableau of the dead.[22] So special a use may have entered, though indirectly, into the creation of the later pictorial dramaturgy, where the tableau is, among other things, typically resolved out of its elements before the spectator's eyes. Also pertinent to the development of that dramaturgy, though it too was a form of discovery or initial tableau, was a practice Davenant instituted to take advantage of the front curtain in the new proscenium theater, a curtain that was drawn once and for all after the prologue, and might be used to reveal a striking "scene."[23] In either form, the tableau-discovery had predictive affinities with still another related phenomenon that reached its characteristic peak in the nineteenth century, the so-called *tableau vivant*.

THE RISE of a new pictorial dramaturgy coincided with the pervasive European fashion of the *tableau vivant*. It was not the product of the *tableau vivant*, however, nor should the latter form of picture-making be confounded with the dramatic tableau of effect and situation. What they have in common bespeaks a common appetite. Both present a readable, picturesque, frozen arrangement of living figures; but the dramatic tableau arrested motion, while the *tableau vivant* brought stillness to life.

The *tableau vivant* apparently took hold as a widespread genteel social entertainment on the order of charades after Goethe published *Die Wahlwerwandtschaften* (1809), but it had predecessors in Lady Hamilton's "attitudes," and the related art of Ida Brun.[24] Earlier still, Baron Grimm, swelling Diderot's *Salon* of 1765 with his own remarks, reported:

> I have sometimes seen select companies, assembled in the country, amuse themselves during the autumn evenings with a most inter-esting and agreeable game: imitating the compositions of well-known paintings with living figures. First, one establishes the background of the painting by means of a similar decor. Then each person chooses a role from among the characters in the painting, and after having adopted its dress, seeks to imitate its attitude and expression. When the whole scene and all the actors are arranged according to the dispositions of the painter and the place is suitably lit, one calls in the spectators who give their opinion on how the tableau is executed.[25]

The theater is generally quick to notice what society finds "most interesting and agreeable." Consequently the *tableau vivant* had its

[22] Cited in Kalman Burnim's *David Garrick, Director* (Pittsburgh, 1961), pp. 95-96). Burnim quotes a letter showing that the crowd was partly painted, partly personated. The "discovery" and its uses is discussed in Lily B. Campbell's *Scenes and Machines on the English Stage during the Renaissance* (Cambridge, 1923). Hill's play is based on the *Merope* of Voltaire, who uses a less striking, less comprehensive and epitomizing form of the "discovery."

[23] Emmet L. Avery, A. H. Scouten et al., *The London Stage, 1660-1800*, Part 1:1660-1700, ed. William van Lennep (Carbondale, Ill. 1968), pp. lxxxv-vi. The authors cite Pepys on a production of *Heraclius* in 1663-1664: "At the drawing up of the curtaine, there was the finest scene of the Emperor and his people about him, standing in their fixed and different postures in their Roman habits, above all that ever I yet see at any of the theatres."

[24] See Holmström, *Monodrama*, for a thorough account of these arts of the concert and salon to about 1815. Richard Altick continues the chronicle, noting theatrical and nontheatrical variants, in *The Shows of London* (Cambridge, Mass., 1978), chap. 24: "The Waxen and the Fleshly."

[25] J'ai vu quelquefois des sociétés choisies, rassemblées à la campagne, s'amuser pendant les soirées d'automne à un jeu tout-à-fait intéressant et agré-able. C'est d'imiter les compositions de tableaux connus avec des figures vi-vantes. On établit d'abord le fond du tableau par une décoration pareille. Ensuite chacun choisit un rôle parmi les personnages du tableau, et après en avoir pris les habits il cherche à en imi-ter l'attitude et l'expression. Lorsque toute la scène et tous les acteurs sont arrangés suivant l'ordonnance du peintre, et le lieu convenablement éclairé, on appelle les spectateurs qui disent leur avis sur la manière dont le tableau est exécuté.

Diderot, *Salons*, ed. Jean Seznec and Jean Adhémar (Oxford, 1957-1963), 2:155.

own distinct life in the theater, so that, for example, a fascinated David Wilkie could write home from Dresden of the *tableau vivant* as an entr'acte entertainment:

> I have been much interested by an exhibition at one of their little Theatres, of what they call a Tableau. The curtain is drawn up between the acts, the stage darkened, and at the back is a scene resembling a picture frame, in the interior of which most brilliantly lighted from behind, men and women are arranged in appropriate dresses, to make up the composition of some known picture. One I saw the other night was an interior after D. Teniers. It was the most beautiful reality I ever saw. . . . We were quite delighted with it; but so evanescent is the group, that the curtain drops in twenty seconds, the people being unable to remain for any longer period in one precise position.[26]

Later Wilkie directed the getting up of such "beautiful realities" in Anglo-Roman society and at Hatfield.[27] It is surely relevant that Wilkie is one of what must be a goodly company of painters—J.-L. David and Holman Hunt, Tintoretto, Poussin, and El Greco among them—who are reported to have made models of figures and interiors for their paintings, like a miniature waxwork tableau or a stage with a missing fourth wall.

At Hatfield, Wilkie made his own drawings of scenes and characters for the tableaux from Walter Scott's novels.[28] The turn to literary illustration had found countenance in even higher circles. For example, in Berlin, on the occasion of the reception of the Grand Duke (later Czar) Nicholas (1821), the two courts joined to present a pictorial version of Moore's *Lalla Rookh*. "The different scenes and events of the Poem were represented in tableaux vivants and the effect of all was heightened by appropriate and touching music."[29] Public entertainments which were similarly illustrative albums of living pictures drew patrons to theaters in Britain and on the Continent for the next fifty years. Mrs. Yates, for example, varied the fare at the Adelphi Theatre (1837) by a program delineating the Passions, each set in its appropriate scene: Despair in the Dungeon; Hope at the Sea Shore; Revenge and Pity—the Sacked and Burning City; Jealousy—the Garden; Melancholy—the Convent Garden; ending with the "Grand Allegorical Groupe. St. Cecilia Surrounded by the Passions."[30] Many of these associations of locale and emotion correspond to subtypes of narrative painting, some of them noted below. A generation later, hard on the Franco-Prussian War, the Theatre Royal, Dublin, advertised *The Dove and the Olive Branch*, a "Series of Illustrative Tableaux":

First Tableau—Summoned to The War		
2nd	"	Adieu
3rd	"	Prayer for Peace
4th	"	Conscript Farewell
5th	"	Another Sortie
6th	"	Cared For

—and so on, in an obvious temporal progression, to the fourteenth "Allegorical Tableau" (the title emblem), all with "Appropriate Vocal and Instrumental Accompaniments."[31]

The *tableau vivant* in polite society gave the respectable an oppor-

[26] Letter to Thomas Wilkie, 4 July 1826, in Allan Cunningham, *The Life of Sir David Wilkie* (London, 1843), 2:333.

[27] Ibid., 2:408, 415; 3:67.

[28] Published in *Master Drawings* 10 (1972), with Francis Russell's "An Album of Tableaux-Vivants Sketches by Wilkie," pp. 35-40. See also my comment in *Master Drawings* 11 (1973):55-58.

[29] *The Letters of Thomas Moore*, ed. Wilfred S. Dowden (Oxford, 1964), 2:885-86. Colored engravings of the costumes appeared in an elaborate published account, *Lalla Rûkh. Ein Festspiel mit Gesang und Tanz. Aufgeführt . . . an 27sten Januar 1821* (Berlin, 1822).

[30] Playbill, Adelphi Theatre, 22 Feb. 1837. Enthoven.

[31] *Dublin Evening Mail*, 27 Feb. 1871ff.

tunity to taste the pleasures of impersonation and display (George Eliot's treatment of Gwendolyn's performance in *Daniel Deronda* catches the feeling admirably). When the subjects, as often happened, were supplied by well-known paintings and sculpture, the *tableau vivant* also afforded the pleasures of "realization." Such realization, however, was not confined to the independent *tableau vivant*. Realization is in itself an "effect"; and consequently the representation of well-known pictorial images in a *dramatic* context, the union of *tableau vivant* and dramatic tableau of effect and situation, was not at all unusual, and is the focus of much discussion to come. Taxonomically rather than historically, the curious phenomenon of the *tableau vivant* mediates between the picture, painted or engraved, and the nineteenth century's pictorial dramaturgy.

Dramaturgy Evolving

The close identification of "effect" and "situation" noticed in Mayhew's treatise of the 1840s lasted a generation. The accumulating influence of writers like Thackeray, and changes in audience, production, and models of current dramatic excellence then helped alter the language of criticism. A distinction between "situation" and "effect" is a basic assumption in the 1870 equivalent to Mayhew's handbook, Percy Fitzgerald's *Principles of Comedy and Dramatic Effect*. For Fitzgerald, "situation" is the proper vehicle for character and its vagaries, and he reproves T. W. Robertson for his neglect of vigorous, comprehensive situation in spinning out his conversations and manipulating his eccentric personages. On the other hand, Fitzgerald deplores "a too common vice of the stage—the getting broad, coarse effect, at the expense of the situation."[32] He condemns especially the sensational Boucicaultian melodrama of the day and the literal-minded realism that he feels has in general displaced illusion. "All is material, scenes, construction, furniture, and, above all, the play, and the acting. We go not so much to hear as to look. It is like a giant peep-show, and we pay the showman, and put our eyes to the glass and stare." The fundamental confusion in this spectacular theater "arises from the idea, that the closer reality is imitated, the more nearly *effect* is produced. If actual *reality*—the thing itself—can be introduced, the *acme* is reached."[33] In Fitzgerald's critical language, the terms "effect" and "situation" have diverged. While he has no doubt that "effect"—at its best, an *illusion* of nature—is still an essential requirement of theatrical production (witness his title), he sees "situation" as the primary embodiment of the logic of the play.

The primacy of situation and its identification with an inner logic went hand in hand with the contemporary development of the ideal of the "well-made play." The well-made play was the rationalization of effective situation, situation with its causality made manifest. At its heart was a striking conjunction or a seeming impasse, charged with affect or redolent of paradox, and into that situation the whole play was absorbed, as preparation or disengagement. At the fulfilling, necessary moment (the so-called *scène à faire*) a skillfully disassembled picture came together with seeming inevitability, a sublimation of the ethos of the tableau.

When situation ideally had become singular and absorbed the whole

[32] Percy Fitzgerald, *Principles of Comedy and Dramatic Effect* (London, 1870), p. 95.
[33] Ibid., pp. 15, 28.

of the play, and the playwright found himself burdened with not a providential or even probablistic causality, but a mechanistic one, a new critical shibboleth crossed the channel to England. As previously "effect" had to give place to its servant "situation," so now "situation" gives place to *its* servant, and the essential art of the well-made play is identified as "construction."

The new shibboleth gets its due in Frank Archer's handbook of 1892, *How to Write a Good Play*, the successor to Mayhew's and Fitzgerald's. Archer was an actor and a practical man of the theater, and his treatise is a guide to what he himself calls the theater's "conventionalism." As such the book was a target of opportunity for Shaw, the statement of a thesis to which his *Quintessence of Ibsenism* had already offered the antithesis.[34] Citing to different purpose from Fitzgerald T. W. Robertson's comedies and James Albery's refinement upon them, Archer writes critically of "sympathetic plays, in which character and dialogue are the sole elements of attraction." Although undoubtedly successful, "their construction is faulty in spite of considerable ingenuity in what are called 'situations.'" Later he describes the "Crummles system, writing up to certain 'situations,' scenes, and 'effects,'" in which "whether it be in connection with a house on fire, a sinking ship, an explosion in a mine, or a race-course, it is the exception, rather than the rule, to find good construction or delicacy and truth in characterization."[35] In Archer's mind, if not his heart, "construction" is the essential contribution of the playwright, and he gives it primacy over "situation" and "effect," which (in the raw) he associates with defective causality. That "construction" might be no more than the apotheosis of the Crummles system escapes him.

ONE CANNOT help but be aware of a severe tension in the theater of the nineteenth century between picture and motion; between the achievement of a static image, halting (and compressing) time so that the full implications of events and relations can be savored, and the achievement of a total dynamism, in which everything moves and works for its own sake, as wonder and "effect." At one extreme is A. W. Schlegel's early comparison of classical drama to sculpture and Romantic drama to painting. Classical drama he likens to a "free-standing group" brought "all at once" before the eyes. He sees this drama as separated from natural reality by its placement on a base (the stage) "as on an ideal featureless ground"; and as united by one action which, linked to "repose," is more an emblem of action than action itself. Romantic drama is different in that both figure and *ground* are richly portrayed, using light and shade and perspective; and the picture "is like a fragment cut out of the optic scene of the world."[36]

At the other extreme is a writer in the *Magazine of the Fine Arts*, who advances an idea of the stage where nothing is static, not even the scenery:

Theatrical Scenery has made still more rapid and decided advances towards perfection; but there is yet much left for industry and genius to accomplish. Whenever it can be relieved from the charm which holds it fixed and motionless—like the pantomimic corps, struck by the wand of Harlequin—all that can be desired will be

[34] *Music in London 1890-94* (London, 1932), 2:90, 93. "The other day an actor published a book of directions for making a good play. His plan was a simple one. Take all the devices which bring down the house in existing plays; make a new one by stringing them all together; and there you are."

[35] Frank Archer, *How to Write a Good Play* (London, 1892), pp. 51, 96-97. What follows the latter passage, nevertheless, is a handy catalogue of proven effects and situations.

[36] August Wilhelm von Schlegel, *Ueber Dramatische Kunst und Literatur*. 2nd ed. (Heidelberg, 1817), 1:127-28. Schlegel's lectures were delivered in 1808 and translated into English in 1815 by John Black. The last-quoted phrase is from Black's translation, revised by A.J.W. Morrison, *Lectures on Dramatic Art and Literature*, 2nd ed. (London, 1904), p. 343. Schlegel's second lecture, concerned with theatrical effect (*Wirkung*) according to the rubric, likens the dramatic poet to the orator whose art is to create an audience-involving "rhythmus," which the poet makes visible in the progress of the play. Such a model, oratorical and progressive, belongs to an older conception of the art of the theater seemingly at odds with Schlegel's own analogy from *plastik*, and informs his disagreement with Diderot. Schlegel's own effort, however, is to reconcile the two models.

achieved. Let the trees bend gracefully to the kissing breeze,—the animals perambulate the meadows, or browse upon the mountains,—and the illusion will be so far complete.[37]

An attempt to reconcile these conflicting aspirations would and did produce in the theater something like the serial picture in painting.

Given the available models and terminology, any well-intentioned attempt to describe this theatrical compromise was liable to conclude in an oxymoron. For example, the *Times* reviewer of W. B. Bernard's *Robespierre* (1840) declares, "Some admirable tableaux are formed in the course of the drama, which is throughout a moving picture."[38] The reviewer has motion in mind, not affect; and the moving picture, or "picture play" as it also was called, is where hindsight suggests these aspirations are heading. But to put it that way is to do an injustice to prescience and intention. There is more than a little of both, for example, in the formulation of Dion Boucicault, the most cinematic of English melodramatists, when he declares, "The stage is a picture frame, in which is exhibited that kind of panorama where the picture being unrolled is made to move, passing before the spectator with scenic continuity."[39] He invokes an available model; he unwittingly suggests more exotic forms, like the Japanese picture scroll; but it is the moving picture that has taken shape in his imagination.

Only the human habit of mind that finds a pattern in dispersed events made both Hogarth's series and the drama of effective situation into progresses, and serial illustrated fiction published in monthly segments into novels. Early in the century that habit of mind found an analogue in the perceptual paradox on which the moving picture depends: the paradox that turns a succession of briefly arrested images into motion. Nevertheless, one cannot claim that the nineteenth-century theater, whatever its virtues, succeeded in resolving the tension between picture and motion, or in actualizing such a resolution in a fully adequate transforming synthesis. The uneasiness that many witnesses then felt and that some modern critics still feel about the achievement of the nineteenth-century theater—despite its great actors, its splendid scenery and spectacle, its cultural and social importance, and despite Schiller, Büchner, Pushkin, Dumas, Ostrovsky, Ibsen, Verdi, and Wagner—stems at least in part from its failure to do so. Such a transforming synthesis had to wait for the organization of the available technical resources into a new drama, "at once eloquence and an animated picture,"[40] in the studios, laboratories, and movie houses of the next century.

[37] "Theatrical Costume and Scenery." *Magazine of the Fine Arts* 1 (May 1821), p. 30.
[38] *Times*, 6 Oct. 1840, p. 7.
[39] Boucicault, "My Pupils," *North American Rev.* 147 (1888): 438.
[40] Schlegel, *Lectures on Dramatic Art and Literature*, p. 41.

4

✦ ι ✦

TELLING SCENES: THE NOVEL

*T*HE NOVEL, like the play and the picture, is a mimetic art in that most novels imitate other novels. But thanks to its relatively late appearance and low esteem, the novel long lacked the critical "rules" and academic canons that stiffened the spine of drama and painting. It has therefore been particularly open in form and substance to local conditions and the incursive influence of its neighbors, especially in the nineteenth century when its appetite for materials, acceptable formal alternatives, and inspiration grew gargantuan.

Seeking a vocabulary to describe their work (and seeking perhaps the support of more firmly established models), writers turned to picture and drama often enough before the nineteenth century. Smollett, for example, dedicating *The Adventures of Ferdinand Count Fathom* to himself, announces: "A Novel is a large diffused picture, comprehending the characters of life, disposed in different groupes, and exhibited in various attitudes, for the purposes of an uniform plan, and general occurrence, to which every individual figure is subservient." He goes on, however, to insist on a principal personage "to attract the attention, unite the incidents, unwind the clue of the labyrinth, and at last close the scene."[1] In the slippage of the metaphor to more epic and theatrical intimations, one sees that it is only a metaphor. In the nineteenth century, however, as in the eighteenth, picture and drama come into the novel in ways that go beyond a general analogy, and affect both style and structure, meaning the way in which the novel is organized and experienced. Some of these intrusions or conjunctions were peculiar to their time, or went through a development that offers insight into the wider collaboration of narrative and picture in the age. They command attention in any attempt to discern the foundations, under so much diversity, of an evolving common style. Within the genre of the novel, however, the material influence of picture and drama is no simple matter. If it were, neither *Little Dorrit* nor *Vanity Fair* would display (as they do) such a revulsion against qualities identified with the pictorial and the dramatic, a revulsion, in effect, against a part of their own substance and against familiar aspects of the very medium in which they are worked (see below, Chapters 15 and 16).

[1] Tobias Smollett, *The Adventures of Ferdinand Count Fathom* (1753), ed. Damian Grant (London, 1971), p. 2. On Fielding's invocations of Hogarth, see Robert E. Moore, *Hogarth's Literary Relationships* (Minneapolis, 1948).

Picture and Story

The reading experience assumed in most of the serial fiction produced in the middle decades of the century was discontinuous. The narrative was not an endless ribbon to pull with greater or less avidity and persistence, a long spaghetti of type, but a series of packets to be opened individually, generally at a fixed interval. Part of their attractiveness was the variety of what lay within. The writer's mastery of form, to the extent he achieved it, meant taking account of the reader's experience, and often of the range of experiences the various methods of publication for essentially the same book would offer: weekly installment, three-decker library edition, monthly part. Form thus served best when it was adaptable, marked with various lines of cleavage, though initial success (and so initial form) was most important.[2]

But all things considered, publication in parts or in any of the considerable range of serial shapes was no more important than the alliance of picture and text, standard in the monthly part, common in the fiction-carrying journal from *Bentley's Miscellany* (1837) to the *Cornhill* (1860) and after, and common in the bound volume that succeeded the serial version. To read was to experience both picture and text; and that residual shape or impression left behind by a novel, which Percy Lubbock found so inadequte a representation of the novel as experienced, also was a product of both.[3]

The function of the pictures in Dickens, Thackeray, Ainsworth, and others, as some recent studies have shown, was not just decorative embellishment, but narrative enrichment, to tell the story in collaboration with the text.[4] It is perfectly true that illustrations are rarely organic to the story in the sense that the story would appear incomplete without them. Volumes of the "Cheap Edition" of Dickens' works, with only a frontispiece, gave entire satisfaction, and now furnish some of the authoritative texts. But notions of organicism entailing economy of means have little place in discussions of Victorian fiction, which was essentially a generous form, given to exuberant variation and semantic redundancy, a bountiful expansiveness that was part of its greatness and provides much of its delight. To fulfil their calculated role in the narrative, however, the pictures in these novels could not tell so much of the story as to supplant or forestall the text, nor so little that they could not become significantly memorable. Undoubtedly they helped immensely to bridge the intervals in serials with longer periods, and found a use, during the accumulation of monthly parts over as much as two years, as a handy *aide-mémoire*. It is to the point that dramatic versions of *Nicholas Nickleby* and *Jack Sheppard* and other serially-published illustrated novels were essentially dramatizations of the pictures, themselves a sort of epitome of the story (Chapter 13). Just such a play, whose announcements ignored his name, stirred up Cruikshank to claim a joint authorship of novels credited entirely to Dickens and Ainsworth.[5]

Beginnings are only beginnings, but they can be instructive; and there is some truth in the observation that the wave of original fiction published in illustrated monthly parts so important in the development of the Victorian novel began with a text that illustrated the pictures. In the forerunner of the mode, Pierce Egan's *Life in London* (1821), the text (as John Harvey points out) often refers the reader to the

[2] For a sense of the respectable novel-publishing world, and the various shapes that one and the same novel might be expected to take, see J. A. Sutherland, *Victorian Novelists and Publishers* (Chicago, 1976).

[3] Lubbock, *The Craft of Fiction* (London, 1921), p. 11.

[4] See, for example, John Harvey, *Victorian Novelists and Their Illustrators* (London, 1970), Joan Stevens' numerous studies of Thackeray's illustrations, and Michael Steig and Anthony Burton's work on Dickens' illustrators, cited below, Chaps. 15 and 16.

[5] Andrew Halliday's *Hilda; or, The Miser's Daughter* (1872).

plates, and comments on them admiringly, so "illustrating" the pictures.[6] The whole seems inclusively panoramic in intention, but episodically bound to local scene and place in keeping with the model of a picture series. Yet even that collaborative arrangement and final effect evolved more fumblingly than is realized. In the original parts (twelve numbers, with three plates by George and I. R. Cruikshank bound in at the beginning of each), the plates and the text proper often have absolutely nothing to do with each other. Rather, Egan's story proceeds at a garrulous Shandean gait through the earlier numbers, while the inside covers bear an independent "EXPLANATION OF THE PLATES." The explanations make no attempt to suggest a narrative line; rather they cover their narrative deficiencies with an italicized display of cant terms, stimulated by the pictures and complementing them as a guide to "Life in London." The parts break mid-chapter, and the character who becomes Jerry, featured in the first plate of Part I, only appears in the narrative in Part IV. The *scene* of the first plate does not appear until Part V, when, to give an idea of the splendor of Tom's room, the text refers the reader back to the picture "without any farther comments on the subject." When explaining the plate of the appearance of Tom and Jerry in Magistrate's Court on the inside covers of Part III, Egan digresses into a tale of female distress (with no foundation in the picture) that wrings the hearts of all, judge and spectators. (Here Sterne is invoked explicitly.) The whole story is then repeated, incorporated verbatim, in the text of Part VI. By Part IX, however, the text is catching up to the plates, and by Part X they are running neck and neck. Consequently the cover explanations in IX are cursory, and headed by the note:

TO SUBSCRIBERS.

———/———

As the Twelve Numbers are drawing towards a
conclusion, it becomes necessary to observe that, in
future, the only opportunity of giving the
EXPLANATION OF THE PLATES
will be in the body of the Work.[7]

Only at this point has serial illustrated fiction more or less found a form. (In the book issue, where the plates and the appropriate narrative are bound in proximity, all the additional "explanations" are dispensed with.) Nevertheless, it was only Dickens' disruption of the idea of a gallery of comic sporting scenes in *Pickwick* fifteen years later that firmly established the relation between narrative and picture and the dominance of the text in serial illustrated fiction.

As John Harvey also points out, both Dickens and Thackeray experimented with the direct integration of picture and text—Dickens in the *Master Humphrey's Clock* novels especially, where the illustrations occur almost as paragraphs in the text—and then both chose to develop parallel rather than linear integration of narrative and pictorial means. Parallelism meant simultaneity rather than duplication, if "simultaneity" can be stretched to describe the joint presence of static and progressive aspects of a single event. In the case of the much-admired "Fagin in the Condemned Cell," for example, in *Oliver Twist*, Harvey notes that "The drawing complements the novel by giving a

[6] Harvey, *Victorian Novelists*, pp. 9-10. The Combe-Rowlandson "Doctor Syntax" collaborations represent an even earlier stage. See above, p. 32.

[7] *Life in London; or, The Day and Night Scenes of Jerry Hawthorne, Esq. and his Elegant Friend, Corinthian Tom* (London, 1821).

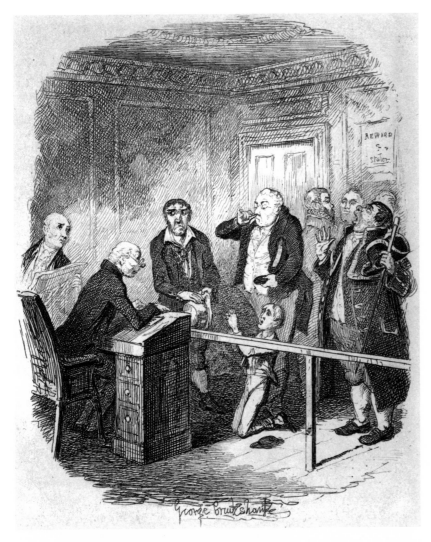

8. *George Cruikshank*, Oliver Escapes Being Bound Apprentice to the Sweep *(1837)*, *Charles Dickens*, Oliver Twist *(London, 1838)*.

visible, lasting emphasis to Fagin's end, while the story moves itself forward."[8] The story at that point has not far to go; but the remark applies equally well to earlier illustrations, such as those for the first two installments in *Bentley's Miscellany*, "Oliver Asking for More," and "Oliver Escapes Being Bound Apprentice to the Sweep" (where Oliver is shown *pleading* rather than escaping). Each embodies a "situation" memorably typifying Oliver's plight, one emphasizing his innocence, caught between staring need and indignant self-righteousness, the other his peril. The resolution in both cases is less memorable and less significant than the situation, which, as an image, is made lasting.

"Fagin in the Condemned Cell" is not an obvious tableau in a theatrical sense. It is one of the few single-figure images among the original full-page plates for Dickens' novels, and in its inwardness and remove from the possibility of action it suggests portraiture. Nevertheless, like the Oliver illustrations, it does the work of a tableau, and is redeemed from the limitations of mere effect by its complementary parallelism with the text and its cumulative narrative and thematic justification. The parallelism means that there is no need here, as in a play, to halt

[8] Harvey, *Victorian Novelists*, p. 210.

the story while the image is achieved and absorbed, and then to start the story up again on a new tack. The text continues its mode of progression, linear and temporal, while the emblematic image the text has generated persists in ocular reality, giving to the whole a vivid extra dimension.

But if narrative is the element that runs, the continuing and developing element, and picture the element that sits, asking to be explored, then the text itself is hardly ever all narrative. Moreover the reader functions, analogously, not simply as a fixed center of attention to what moves, but in motion relative to the scene; not simply as open ear but as mobile eye. Despite the dominance of the text, then, as established by Dickens, the material collaboration of picture and words in the form of the novel complements a distinctive collaboration of narrative and picture in the words themselves. In serialized fiction, this includes a predisposition to an expansive elaboration of a pictorially conceived central event in the textual unit, somewhat analogous to the pictorial dramaturgy which substituted situation for action as the constituting unit of the play. The whole, presenting bursts of lateral development in a progressive movement, a continuity of discontinuities in packets, requires a description as rarefied as that of light: neither wave nor corpuscle, but something of both.

The collaboration of picture and text in the art of the novel is thus ultimately an attribute of style, operating as a presence and influence in the language as well as in the narrative organization.[9] The habit of picturing as one reads apparently varies greatly from person to person, and perhaps from era to era, as does vividness of response to the visual element in ordinary language. But such considerations aside, visuality can make itself felt in a style in a variety of ways; for example, by a frequent recourse to the "word-picture" while the narrative halts, a hoary poetic and rhetorical device. The collaboration of narrative and picture could be much more subtle of course; but the "word-picture" was the concept most available to novelists as the century began, and it affected their practice.

A remark that is indirectly Scott's gives some insight into the assumptions about fictional style at the beginning of the century. Writing to Maria Edgeworth on behalf of the anonymous author of *Waverley*, James Ballantyne refers to Scott's apprehensions of any comparison "betwixt his picture and story and yours." For Scott speaking through Ballantyne, "picture" and "story," alternative and even discrete, constitute the chief elements in the texture of the novel.[10] Ballantyne also reports Scott felt "that the success of his book was to depend upon the characters, much more than upon the story," but "character" is subsumed in the term "picture." "Character" means the "habits, manners, and feelings" of those portrayed, as Scott makes clear in his Postscript to *Waverley*, where he also speaks of his intention "to emulate the admirable Irish portraits drawn by Miss Edgeworth."[11]

"Picture" therefore adds to portraiture something of genre painting. In *Waverley* it also includes—as it rarely does in Edgeworth—conscientious picturesque description, as of the manor house of Tully Veolan, presented (while the story goes into abeyance) as "a chapter of still-life." "Picture" does not mean literal pictorial illustration, to which

[9] For an attempt to treat and define style as integral with narrative function and the developing form of the novel, see Karl Kroeber, *Styles in Fictional Structure* (Princeton, 1971).

[10] *The Letters of Sir Walter Scott*, ed. H.J.C. Grierson (London, 1932), 3:517. Grierson calls the letter "obviously Scott's composition—in the main."

[11] *Waverley*, Chap. 72, "A Postscript, Which Should Have Been a Preface." See also his remarks in the General Preface to the Waverley Novels (1829).

Scott was quite indifferent; nor does it yet mean picture as tableau, that is, picture and story in one, situational and symbolic. Miss Edgeworth had complimented the characters of *Waverley* as "not only finely drawn as separate figures, but . . . grouped with great skill, and contrasted so artfully, and yet so naturally as to produce the happiest dramatic effect." But she does not here mean literal pictorial grouping. There is one obvious tableau in *Waverley*, Waverley's discovery of Flora posed in the moonlit glen beside the waterfall, but Miss Edgeworth sharply criticized it: "the description of the place is beautiful, but *too long*, and we did not like the preparation for *a scene*—the appearance of Flora and her harp was too like a common heroine, she should be far above all stage effect or novelist's trick."[12] Scott, who had Flora arrange it all in the first place, was embarrassed, and apologized in a subsequent note.[13]

Scott's theory and practice would change, however, with experience and under the continuing influence of painting and drama. In *The Antiquary* (1816), for example, the scene of grief in Mucklebackit's cottage (Chapter 21) is presented as a tableau (with due attention to character and configuration) "which our Wilkie alone could have painted," though it still functions more as genre scene than as the striking embodiment of a dramatic situation.[14] The reunion of Jeanie and Effie Deans under the eyes of the jailor in *Heart of Mid-Lothian* (1818) does furnish tableaux that are "picture and story in one" (see below, pp. 290-92); and with Alice Lee's interruption of the duel between Markham Everard and the future Charles II in *Woodstock* (1824)—"There was a dead pause of astonishment—the combattants rested on their swords"—the narrative progression itself has become situational and pictorial, as in the theater (Chapter 28). The interruption creates an impasse where Alice must either discredit herself with her lover or allow the life of the disguised royal fugitive to be jeopardized. While the interest in that situation is sustained, so is the basic configuration. When the interest is released, when Alice makes her choice (only to create a new situation for Charles), the configuration dissolves.

THE PUNCTUATING, emblematic function of a picture in a narrative that might cover many years gained much from the kind of narrative painting that the era had to offer, and the encouragement of course was reciprocal. A minor but respectable and much-read novel of the mid-century exemplifies such a collaborative style. The story of a private life, its crises, achievements, ironies, disappointments, and dispensations, *John Halifax, Gentleman* (1856) by Dinah Maria Mulock (Mrs. Craik) lent itself to the emblematic scenes and the eloquent configurations that typified the painting of domestic sentiment. In these pictures, characters could be highly individualized while remaining types of private life; and the scenes, though crowded with specifying detail, nevertheless aimed at representative moments in the life of man.

Starting sixty-odd years back like so much historical fiction with a genre aspect, the novel chronicles not just the rise of one John Halifax into prosperity and a happy marriage, but his whole life, his becoming and being a true nineteenth-century paterfamilias. On his transcend-

[12] *The Life and Letters of Maria Edgeworth*, ed. Augustus J. C. Hare (London, 1894), 1:227, 230. It is this letter, "To the Author of 'Waverley'" (23 Oct. 1814), that evoked Ballantyne's reply.

[13] *Waverley*, Chap. 22. "The appearance of Flora with the harp, as described, has been justly censured as too theatrical and affected for the lady-like simplicity of her character. But something may be allowed to her French education, in which point and striking effect always make a considerable object."

[14] For the impact of Wilkie's *Distraining for Rent* on this scene, see Lindsay Errington's perceptive remarks in *Sir David Wilkie's* Distraining for Rent: *Sources and Interpretations*, The National Gallery of Scotland, Bulletin Number 2 (1976).

ence of artisan status, the chronicle becomes heavily domestic, linked to the natural cycle as interpreted by the habits of the middle ranks in a provincial, commercial setting: the cycle of love, marriage, birth of children; parental trials with disease and death, parental anxiety as children grow, quarrel, seek and find their matches, and the family seems to be disintegrating; all this accompanied by continuing economic struggle, success, crisis, the taking on of greater social responsibility; followed by the narrowing of horizons and conserving of energies, and finally death in the midst of those whose turn has come. These steps and stages are crystallized periodically in pictures (often identified as such), typical and emblematic, marking the quantum progressions: the family clustered about the bed of a dying child (their beloved blind daughter who has the newborn youngest child in her arms);[15] the desperately gay and beautiful woman (with an unscrupulous tempter in the background) visiting the homely domestic paradise before eloping into adultery and oblivion. One such picture is likened to a real painting, Millais' *Huguenot* (1852) (Fig. 160). The text even suggests that the painting, its visual configuration, was a model for the novel's central domestic relationship (ideal to Mrs. Craik) and for the admirable domestic character of John Halifax himself. The pictorial image is invoked when John Halifax raises the question of moving from a happy home to a larger one in order to assume new social responsibilities (to "widen our circle of usefulness"). The narrator reports:

> He spoke gently, laying his hand on his wife's shoulder, and looking down on her with that peculiar look which he always had when telling her things that he knew were sore to hear. I never saw that look on any living face save John's; but I have seen it once in a picture—of two Huguenot lovers. The woman is trying to fasten round the man's neck [*sic*] the white badge that will save him from the massacre (of St. Bartholomew)—he clasping her the while, gently puts it aside—not stern, but smiling. That quiet, tender smile, firmer than any frown, will, you feel sure, soon control the woman's anguish, so that she will sob out—any faithful woman would—"Go, die! Dearer to me than even thyself are thy honour and thy duty!"[16]

The narrator who vicariously utters this hypothetical cry himself appears in the first picture of the novel, and remains a curious presence through most of what follows. That first picture perhaps best illustrates the emblematic uses of a pictorially rendered moment in the narrative. The scene is an alley where, with his prosperous father, a sickly rich boy in a hand carriage takes shelter from the rain. He there finds a tall, stalwart, handsome street boy of about his own age, his face serious and haggard, who leans against the wall, eyes on pavement, "ragged, muddy, and miserable." The picture creates a poignant contrast between the boy who has all but health and vigor and the boy who has nothing but health and vigor, the unidentified John Halifax.

Thus he stood, principal figure in a picture which is even yet as clear to me as yesterday—the narrow, dirty alley leading out of the High Street, yet shewing a glimmer of green field at the far-

[15] For the stricken child motif in visual art, see Luke Fildes' famous painting, *The Doctor* (1891), Frank Holl's *The Convalescent* (1867), and illustrations for many of the works mentioned in John R. Reed's *Victorian Conventions* (Athens, Ohio, 1975), pp. 165-68.

[16] *John Halifax, Gentleman* (London, 1856), 3:17-18.

ther end; the open house-doors on either side, through which came the drowsy burr of many a stocking-loom, the prattle of children paddling in the gutter, and sailing thereon a fleet of potato parings. In front—the High Street, with the mayor's house opposite, porticoed and grand; and beyond, just where the rainclouds were breaking, rose up out of a nest of trees, the square tower of our ancient abbey—Norton Bury's boast and pride. On it there came a sudden stream of light—I saw the stranger-lad lift up his head and look at it. [1:3]

Much of the effect is in our sense of the sickly boy's eager regard of the street boy. That leads to the bond between them, narrator and subject, as intense as the domestic bond and as lasting. The detail all lends itself to interpretation as narrative symbolism, and the scene also leads, as the expanded view suggests, to the first opportunity and test of character in the history of John Halifax in that corner of the world which would become his lifelong field of action.

ONE OF THE distinctive strains of pictorialism in the nineteenth-century novel appeared in the novel of rural manners, whose predecessors in prose were Goldsmith, Scott, Galt, and Mitford. The genre scene, as practiced by David Wilkie and the Dutch models he followed early in his career, entered the progressive organization of some of these novels, while other fiction sought more dramatic and "effective" images. George Eliot was the most notable worker in this rural vineyard until Hardy, whose *Under the Greenwood Tree, A Rural Painting in the Dutch School* (1872) was partly written to appeal to her audience.[17]

In *Adam Bede* (1859), the work that established her reputation, George Eliot resorts to Dutch painting to explain the scope and truthfulness of her intentions.[18] The references are to genre painting in its apparently simpler form, representing the characteristic life of its subjects in communal settings, rather than the drama of individuals in a critical situation. The novel itself, however, illustrates the developmental bias of nineteenth-century genre painting, a movement from genre scene to narrative picture, from the characteristic to the particular.

Adam Bede opens with a series of rural sketches, manifest genre scenes, which are drawn into a narrative continuity. Most of the titles of these early chapters announce a characteristic scene—"The Workshop," "The Preaching,"[19] "Home and its Sorrows," "the Hall Farm," "The Dairy"—which the text treats pictorially. In "The Rector" (Chapter 5), the first heading to name a person even by occupation, we are placed as spectators looking through a doorframe at the picture of a man and a woman playing chess. In that Dutch interior the furnishings, dress, and jewels are as eloquent as the expression of the stately lady; and the grouping, in a scene pictorially and dramatically associated with lovers, reveals something of the relationship between this mother and son. In "The Hall Farm" (Chapter 6), we are presented with a series of characteristic scenes culminating in a picture of Squire and Milkmaid in "The Dairy" (Chapter 7), a scene with evident narrative implications. It will lead to the later picture, "In the Wood" (Chapter 12), a title with the heavy implications appropriate to a full-fledged

[17] See Sutherland, *Victorian Novelists*, pp. 216, 222. The best recent work on Hardy's "Composite Muse," including what belongs to painting and the theater, is Joan Grundy's *Hardy and the Sister Arts* (London and New York, 1979).

[18] See, however, Darrell Mansell, "Ruskin and George Eliot's 'Realism,'" *Criticism* 7 (1965): 203-216, and more recently Hugh Witemeyer, *George Eliot and the Visual Arts* (New Haven, 1979), pp. 105-125, for a much needed corrective to the simplistic view of George Eliot's "genre painting" given currency by Mario Praz in *The Hero in Eclipse in Victorian Fiction*, trans. Angus Davidson (London and New York, 1956), pp. 343ff. Witemeyer's excellent study puts Eliot's taste for genre painting in the perspective of her other pictorial interests. "These four kinds—portraiture, history painting, genre, and landscape—figure in her fiction in roughly that order of importance" (p. 22).

[19] This scene, where the villagers gather to hear a Methodist field-preaching, has the subject if not the feeling of De Loutherbourg's painting, *A Midsummer Afternoon with a Methodist Preacher* (1777, National Gallery of Canada). Wilkie also had considered such a subject, as the *DNB* notes.

narrative painting. In that "labyrinthine" setting of oaks and beeches fitfully lit with afternoon light, the pleasant young squire and the pretty farm girl find themselves in a half-embrace, he stooping toward her "with a look of coaxing entreaty," she lifting her eyes "with a sweet, timid, beseeching look. What a space of time those three moments were, while their eyes met and his arms touched her! " The configuration is broken only when Hetty's work basket falls to the ground and scatters, a tactful allusion to many another pictorial image of the nubile and accident-prone (and the emblem that helps differentiate this configuration from Millais' in *A Huguenot*). In George Eliot's scene, a developing relationship is crystallized in a situation, an eloquent tableau, isolated from the flow of time, or rather concentrating that flow into a charged stasis.

Near the center of the novel is a genre scene that earns its pivotal place by its assimilation of the involvements, aspirations, and jealousies of separate lives to the life of the community at one of its climacterics. The whole of Book III is devoted to the young squire's coming-of-age festival, one of those characteristic communal events that Breughel, Hogarth, Wilkie, and Frith made into inclusive panoramas. The five chapters present phases of that single event, which, though depicted at large and the subject of a substantial portion of the narrative, nevertheless occupies very little time in the temporal scheme. The five chapters—"Going to the Birthday Feast" (half of which might have been called "Woman before a Mirror"), "Dinner-Time," "The Health-Drinking," "The Games," "The Dance"—present a series of images that belong to one unfolding panorama. They belong also, like "The Harvest Supper" in Book VI, to that intimate interplay between the abiding seasonal rhythms and the communal and personal life which provides so much of the complex temporality of the novel.[20]

DICKENS, planning his work, habitually used the term "picture" for one element in his narration, suggesting a working conception of the novel not far from Scott's (p. 56 above). Dickens' number plans for *Little Dorrit* include such remarks as, "The Factory—Picture," "Park Lane Picture. Evening," "Open with old Pauper out for the day—Picture." His working plans for *Hard Times*, amid terms that evoke the theater ("separation scene," "The great effect"), call for numerous "Mill Pictures," "Wet night picture," "moving picture of Stephen going away from Coketown."[21] Nevertheless, the pictorialism in Dickens' narrative style, even apart from its complement of illustrations, is more difficult to characterize than my previous examples. Recent discussions of its visual qualities have taken their chief clue from Eisenstein's famous essay on Dickens and Griffith.[22] The influence argued so successfully in that essay runs forward in normal historical order, from Dickens to Griffith to Eisenstein and beyond. But critics have found it useful to run that sequence backwards. Taylor Stoehr, for example, argues that in a characteristic Dickens scene, "The reader is presented with a cinematic rendering of continuous space in continuous time, the narrator functioning as a camera-eye." Details seem to be ordered by contiguity, though marshalled by the rhetoric, especially the anaphora which points to their cumulative significance. The further effect of the

[20] George Eliot's contemporary readers did not require such justifications. In his review of *Middlemarch*, for example, Monckton Milnes wrote of the Mary Garth-Fred Vincy strand, where a good deal of *Adam Bede* is reversed, "Their adventures of themselves compose a pleasant story, and have little bearing on the tragic features of the book. They afford, however, the author the opportunity of introducing some of those masterly pictures made up of Wilkie and wit, which rest on the imagination like actual scenes on the eye. There are three connected with the last illness of a miserly farmer which will not fail to be repeated in dramatic and pictorial form—the Waiting for Death, the last struggle, and the reading of the will." *Edinburgh Rev.* 137 (Jan. 1873), p. 251.

[21] *Little Dorrit*, ed. Harvey Peter Sucksmith, The Clarendon Dickens (Oxford, 1979), pp. 813ff.; and *Hard Times*, ed. George Ford and Sylvère Monod (New York, 1966), pp. 234ff.

[22] Sergei Eisenstein, "Dickens, Griffith, and the Film Today," in *Film Form; Essays in Film Theory*, ed. and trans. Jay Leyda (New York, 1949).

anaphora is that of discontinuity within the continuity, the effect of montage, where "it almost seems as if one thing does not lead to another; everything exists at once, juxtaposed, superimposed, articulated in the consciousness by the anaphoric pattern."[23] Montage also provides the model for a description of how the multiple narrative lines are organized. It could be further argued that montage is the principle behind that web of fantastic variation upon iterated verbal motifs which constitutes a poetic dimension in Dickens' narrative style, and—violating Lessing's prohibition on a poetry of enumeration to balance that on a painting of sequence—seems to suggest spatial form.

Such stylistic resources are exemplified in the notable chapter of *Bleak House* (Chapter 47) where Jo's death is represented in a montage of elements, verbal, visual, and auditory: the cart, which occurs first as a punning simile for his hard-to-draw, rattling breath, and recurs as progressively heavier, breaking down, dragging, nearly giving up, and shaken to pieces; "moving on," a police phrase that the novel had earlier improvised from a casual remark into a distillation of social injustice, here given its final, mortal significance; prayer and knowing "nothink" in repeated conjunction, these also rich with the accretions of previous contexts; and (the final elements to enter the montage), the dark, and the light that is coming. In the end the cart, the dark, prayer, the light, rising to a rhythmic climax, produce a violent annunciation of death. The organization of improvised verbal-thematic elements to achieve this effect is rhetorical and perhaps more musical than pictorial. But the result is an analytic, metonymic exfoliation of an event so as to command a time of presentation commensurate with its significance. This, the inner principle of montage, supports the cinematic analogy and Dickens' part in creating its language. To find similar analogues for Dickens' narrative style, however, one need not anticipate so recklessly.

The roots of a style that everyone including Dickens tagged "Inimitable" are not to be found in external conditions alone, in the nature of the medium and the audience, nor in timely historical developments. Nevertheless the happy conjunction of the style and the conditions remains central to an understanding of Dickens' art. An inclusive, heterogeneous audience and a mode of serial illustrated publication are exactly suited by an explicit, iterative, hyperbolic, and expansive style, redeemed by a transformational logic and a gift for linkages beyond the dreams of grammar. Similarly, Dickens' montage of constituent detail and figurative emblematic elements suggests the available English tradition of narrative painting from Hogarth to Augustus Egg, while his organization and rendering of experience, "the narrator functioning as camera-eye," fit admirably with other modes of visual representation indigenous to the age, notably the Panorama and Diorama and all their numerous progeny.

The Panorama, Robert Barker's invention and coinage (1787-1789), placed the spectator in the center of a circular painting in a building of the same form, requiring him to turn through 360 degrees to take in the whole.[24] Since the scene often represented great public events, like the *Procession of the Coronation of George IV* (1822) and the *Battle of Waterloo* (1816), a temporal element might come into play through

[23] Taylor Stoehr, *Dickens: The Dreamer's Stance* (Ithaca, N.Y., 1965), pp. 15-19, 229.

[24] In F. W. Fairholt's description, the lighting came from "a skylight of umbrella form, which is concealed from the spectator by an inner roof, covering a gallery, from which the picture is viewed. The top and bottom of the picture are concealed by the framework of the gallery; thus the spectator, having no object with which to compare those represented in the picture, they appear in their natural dimensions, and, with the aid of aerial perspective, an almost infinite space and distance can be represented with a degree of illusion quite wonderful." *A Dictionary of Terms in Art* [London, 1854]. The best, most comprehensive modern account of the Panorama and related spectacles is in chaps. 10-15 of Richard Altick's *Shows of London* (Cambridge, Mass., 1978). Altick also calls attention to the effect on literature (e.g. Wordsworth) and the interplay with the theater. On the Diorama, see also Helmut and Alison Gernsheim, *L.J.M. Daguerre: The History of the Diorama and the Daguerreotype* (1956; reprint ed. New York, 1968).

the discreet incorporation of successive phases in the scene, in spite of the presumption of synchrony. In its impact, the Panorama was a comprehensive form, the representation not of the segment of a world, but of a world entire seen from a focal height. It profoundly affected the sense of available form in other quarters.[25]

The Diorama, an invention of Daguerre and Bouton (Paris, 1822; London, 1823) brought movement to the spectators and change to the picture, but paradoxically. The audience now was moved, in the passive mood, from one picture to another. The chamber holding the spectators in their seats revolved through an arc of some seventy-three degrees, between segments whose partitions formed "a kind of avenue" to the scene.[26] The fixity and framed limitation of the pictures gave scope to change; and the painter Leslie (objecting to the *trompe l'oeil* illusionism of all such forms) contrasts the strange stillness and silence of the Panorama with the effect of the Diorama, "where the light and shade is varied by movement and the water is made to ripple."[27] By the use of transparencies (canvas painted on both sides, alternately transmitting or reflecting light), the Diorama parlayed (as Daguerre himself boasted) two effects, day and night, into an infinity of effects as in nature.[28] Each picture changed in what seemed a temporally continuous if accelerated fashion, and the audience changed from one discontinuous picture to another as the showman (or one man turning a winch) directed.

The Panorama and the Diorama required special buildings and were limited by that fixity. The solution for those who wished to exploit comparable attractions over a wider field, in the provinces and in already available showplaces, was to create a moving picture: either a "moving panorama" that unrolled before a stationary seated audience, while often a lecturer explained; or a "diorama" framed by a proscenium arch and moving horizontally (or sometimes vertically), and adapted to incorporation in a play before a theater audience. Such scenographic dioramas became the leading spectacular events in the annual Christmas pantomimes at Drury Lane and Covent Garden when Clarkson Stanfield and David Roberts worked there in the 1820s and '30s. According to their most knowledgeable historian, such dioramas might represent 360 degrees of a landscape or cityscape, or present a continuous topographic account (concentrated) of a linear journey: "the sights along the carriage road of the newly opened Simplon Pass" (Stanfield's diorama for Drury Lane in 1829), or journeys by ship from port to port, or even by balloon during the ballooning craze.[29] The progressive character of the moving diorama encouraged a temporalization, however, that went beyond the evident duration of a journey; as in the life and death of a ship, for example, from its launching, through hurricane, to its entry in tow into a foreign harbor.[30] Moving themselves, reinforced by music and sound effects and independent cut-outs, typically linked to a formulaic chase sequence, these theatrical dioramas achieved (in Stoehr's phrase) a "cinematic rendering of continuous space in continuous time." They achieved also an illusion of relative motion in which the spectator, though not shifted bodily as in Daguerre's Diorama, functioned as a moving eye. Such relative and diachronic movement is doubtless what Lionel Tollemache had in mind when writing

[25] See Eric Adams, *Francis Danby: Varieties of Poetic Landscape* (New Haven, 1973), pp. 65, 74; and "The Panoramic Style" in Wolfgang Born's *American Landscape Painting: An Interpretation* (New Haven, 1948), cited in Altick, *Shows of London.*

[26] Fairholt reports the "views" were eighty-six feet long, forty-five feet high. However, Morgan and Pugin's 1823 plan for the Regents Street building shows a back wall in the "Picture Rooms" of seventy-two feet three inches; and these measurements were presumably compatible with the pictures shown in the Paris Diorama.

[27] C. R. Leslie, *A Hand-Book for Young Painters* (London, 1855), p. 4.

[28] Louis-Jacques Daguerre, *Historique et description des procédés du daguerréotype et du diorama* (Paris, 1839), p. 78. "Tous ces tableaux ont été représentés avec des effets de jour et de nuit. A ces effets étaient jointes des décompositions de formes, au moyen desquelles, dans la *Messe de minuit* par exemple, des figures apparaissaient où l'on venait de voir des chaises, ou bien, dans la Vallée de Goldau, des rochers éboulés remplaçaient l'aspect de la riante vallée" (p. 75).

[29] David Mayer III, *Harlequin in His Element: The English Pantomime, 1806-1836* (Cambridge, Mass., 1969), pp. 70, 131-36, 219-20.

[30] Stanfield and Roberts' "Naumetabolia" (1825), Mayer, *Harlequin*, pp. 131-32.

that "Literature is able . . . to give a diorama of what it depicts, while art can give only a panorama."[31]

Stanfield, the greatest of the English diorama artists, was one of the close circle of Dickens' intimates who, as "Stanny," put aside Royal Academic dignities to paint sets for his friend's amateur productions.[32] But Dickens' interest in shows combining picture and motion, art and technology, was not confined to this friendship. One manifestation was a paper in *Household Words* on "Banvard's Geographical Panorama of the Mississippi and Missouri Rivers," an exhibition that the Royal family also found much to its taste. Dickens writes of the panorama that "it is not remarkable for accuracy of drawing, or for brilliancy of color, or for subtle effects of light and shade, or for any approach to any of the qualities of those delicate and beautiful pictures by Mr. Stanfield which used, once upon a time, to pass before our eyes in like manner."

> But it is a picture three miles long, which occupies two hours in its passage before the audience. It is a picture of one of the greatest streams in the known world, whose course it follows for upwards of three thousand miles. It is a picture irresistibly impressing the spectator with a conviction of its plain and simple truthfulness, even though that were not guaranteed by the best testimonials. It is an easy means of travelling, night and day, without any inconvenience from climate, steamboat company, or fatigue, from New Orleans to the Yellow Stone Bluffs (or from the Yellow Stone Bluffs to New Orleans, as the case may be), and seeing every town and settlement upon the river's banks, and all the strange wild ways of life that are afloat upon its waters. . . .
>
> It would be well to have a panorama, three miles long, of England. There might be places in it worth looking at, a little closer than we see them now; and worth the thinking of, a little more profoundly. It would be hopeful, too, to see some things in England, part and parcel of a *moving* panorama; and not of one that stood still, or had a disposition to go backward.[33]

Dickens here recognizes qualities in the form pertinent to his own art. He recognizes that in the moving panorama—where assemblages of particulars, contiguous but discrete, unite in a moving continuity—sweep and scope are not incompatible with a close attention to local detail, where much of the immediate interest lies. He recognizes that, as in the novel, the representation combines simultaneity and succession, and all motion is relative to the spectator. But beyond such matters, when Dickens moralizes the technical characteristics of the panorama (as he does in his last remarks), he is also seeking to uncover its further mimetic potential, and provide the technical means with more ambitious ends. His wishful thinking implies a liberation of the intrinsic idea of the moving panorama from its ordinary material form. In the end he dissolves the distinction between a potential panorama of England and England itself. No novel of Dickens can be said to be built on a literal imitation of dioramic effect or panoramic form, but both enter his conception of the reality he wishes to represent, the

[31] Cited by the *OED*, "diorama," from Lionel A. Tollemache, "Courage and Death," *Fortnightly Review* 19 n.s. (Jan. 1876), p. 117.

[32] See Dickens' loving obituary of Stanfield, *All the Year Round* 17 (1 June 1867), p. 537.

[33] "The American Panorama," *The Examiner* (16 Dec. 1848), pp. 805-806. Dickens, who politely discounts the testimonials, accepts the canny billing (e.g.) on the title page of the pamphlet that supplied him with biographical information on Banvard: *Description of Banvard's Panorama of the Mississippi & Missouri Rivers, extensively known as the "Three-Mile Painting"* (London, 1848). Altick, through simple arithmetic, demonstrates the unlikelihood of such a length of canvas, since an exhibition of two hours would require a brisk travelling speed of 132 feet per minute.

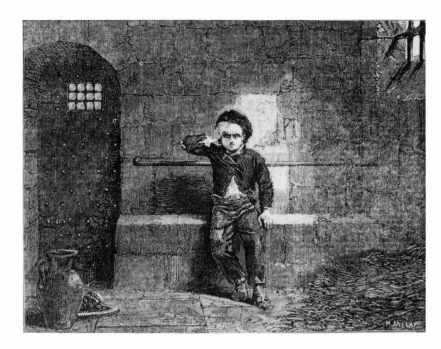

means whereby it can be represented, the experience of the reader before and in the scene, and the social ends to which a work of mimetic representation might be directed. His first novel, *Pickwick Papers*, takes its readers on a coaching tour of the Southern and Eastern counties; and his last completed, *Our Mutual Friend*, seems ambitious to represent the whole of England in a moralized landscape, ranged along the navigable banks of a cloacal and temporalized river. Panoramic and dioramic models affect the style, the form, and the scope of Dickens' fiction. Some instances will appear in later chapters.

Dramatic Effect

All attempts to generalize on the collaboration of narrative and picture in fiction are considerably complicated by the concurrent dominance of a pictorial dramaturgy. In the theater, picture was a prime vehicle of effect, the soul of the art of the stage; but as fiction became not simply a widespread popular art but an industry with lines to suit all pockets, it turned to the drama—that other art of words, deeds, and pictures whose popularity had never depended on literacy—for both matter and manner. Earlier novelists, notably Richardson and Fielding, had had dramatic models very much in mind.[34] But it is not too much to say, in schematizing relations, that the nineteenth century revealed a powerful bent in whole classes of fiction to assimilate themselves with drama, while drama itself was under a compulsion to make itself over as picture.

Narrative fiction shared with drama a structure incorporating serial discontinuity; a texture demanding variety, vividness, and memorability; and a pictorialism associated with the art of effect. The terms of the last were clear by 1801, when Maria Edgeworth, who had criticized the theatricalism of Flora Mac-Ivor, found it convenient to

[34] For Richardson's models in Restoration tragedy for his "History (or rather Dramatic Narrative) of Clarissa" (as he calls it in his Postscript), see especially Margaret Anne Doody, *A Natural Passion* (Oxford, 1974), chap. 5, "Tyrannic Love and Virgin Martyr," and chap. 9, "The Visual Image in *Clarissa*"; also Ira Konigsberg, *Samuel Richardson & the Dramatic Novel* (Lexington, Ky., 1968), and Mark Kinkead-Weekes, *Samuel Richardson, Dramatic Novelist* (Ithaca, N.Y., 1973). For Fielding, see Jean Ducrocq, *Le Théâtre de Fielding 1728-1737, et ses prolongements dans l'oeuvre romanesque* (Paris, 1975), and Andrew Wright, *Henry Fielding, Mask and Feast* (Berkeley, 1965). Wright sees emerging from Fielding's admiration of Hogarth, his experience as a playwright, and his use of a chatty narrator "something new in fiction: novels which are a series of speaking pictures, but always so evidently composed, arranged, fabricated, that they establish and maintain . . . the air of artifice which makes for a festive atmosphere" (p. 122). An important caveat with respect to Fielding and the reciprocities between drama and prose fiction appears in J. Paul Hunter's *Occasional Form: Henry Fielding and the Chains of Circumstance* (Baltimore, 1975), pp. 220-27.

end *Belinda*, a purported anti-novel, with a theatrical tableau. The novel's arch-sophisticate does the stage-managing, and the device is framed in irony and wittily self-subverting:

> "Yes," said her ladyship; "it is so difficult, as the critic says, to get lovers off upon their knees. Now I think of it, let me place you all in proper attitudes for stage effect. What signifies being happy, unless we appear so?—Captain Sunderland—kneeling with Virginia, if you please, sir, at her father's feet—You in the act of giving them your blessing, Mr. Hartley—Mrs. Ormond clasps her hands with joy—Nothing can be better than that, madam—I give you infinite credit for the attitude—Clarence, you have a right to Belinda's hand, and may kiss it too—Nay, miss Portman, it is the rule of the stage—Now, where's my lord Delacour?—He should be embracing me, to show that we are reconciled—Ha! here he comes—Enter lord Delacour, with little Helena in his hand—Very well! a good start of surprise, my lord—Stand still, pray, you cannot be better than you are—Helena, my love, do not let go your father's hand—There! quite pretty and natural!—Now, lady Delacour, to show that she is reformed, comes forward to address the audience with a moral—a moral!—yes
>
> > "Our *tale* contains a *moral*, and, no doubt,
> > "You all have wit enough to find it out."[35]

Such daring self-mockery, so well adapted to the character of Lady Delacour, might do very well in a novel of manners even in the guise of a "Moral Tale"; but in other classes of fiction the means of producing effect had to be treated more soberly, and in these the art of effect was also essentially identified with the art of the picture stage. Louis James writes, "It is not surprising . . . that drama had an important influence on popular fiction. Long series of stories were based on plays, such as Duncombe's *Dramatic Tales* (c. 1836-44), or Lloyd's *Tales of the Drama* (c. 1836-7) drawing on the publicity of the stage versions." James notes that factories for producing popular theatrical woodcuts "existed before the arrival of penny-issue fiction, and the periodical publishers took over their styles and conventions," including curtains and footlights.[36] The fact is that the same woodblock would often do double duty, in the periodical and on the theatrical poster, as in the case of Anelay's striking cut for *The Six Stages of Punishment*, a serial in *Reynolds's Miscellany* and a play at a Shoreditch theater.[37] Undoubtedly the popular drama and popular fiction that so multiplied and fed each other in the second quarter of the century shared "the same approach to style, plot, moral outlook, and character portrayal—that of melodrama."[38]

In addition to the myriad works of popular fiction wholly uncanonized as literature, the so-called Newgate and Sensation novels of Bulwer, Ainsworth, Collins, and Reade were saturated with the climate of the stage. Ainsworth, introducing *Rookwood* (1834), observes:

> The novelist is precisely in the position of the dramatist. He has, or should have, his stage, his machinery, his actors. His representation should address itself as vividly to the reader's mental

[35] Maria Edgeworth, *Belinda* (London, 1811), 3:350-51.

[36] Louis James, *Fiction for the Working Man, 1830-1850* (London, 1963), pp. 146-47, 150.

[37] *Reynolds's Miscellany*, n.s. 2 (1849): 457; poster, New York Public Libr., for H. Melville's *Punishment in Six Stages* (Standard Theatre 5 Feb. 1849). The recycling of woodblocks, often in declining circumstances, is yet to be studied. *Reynolds's* evidently was a great user, and some of its contents written to suit the pickings.

[38] James, *Fiction for the Working Man*, p. 147.

retina, as the theatrical exhibition to the spectator. The writer who is ignorant of dramatic situation and its effects, is unacquainted with the principles of his art, which require all the adjuncts and essentials of the scenic prosopopoeia. . . . The Romance constructed according to the rigid rules of art will, beyond doubt, eventually, if not immediately, find its way to the stage.— It is a drama, with descriptions to supply the place of scenery.[39]

Collins, who became a successful dramatist in his own right in the sixties and seventies, perfected a fictional form based in situation, and wrote as if with the models of sustained effect consistently before him. His dedication of *Basil* (1852) early in his career is concerned mostly with the issues of realism; but when justifying his use of "those extraordinary accidents and events which happen to few men" in order to fix interest and generate response, he fully declares his faith: "Believing that the Novel and the Play are twin-sisters in the family of Fiction; that the one is a drama narrated, as the other is a drama acted; and that all the strong and deep emotions which the Play-writer is privileged to excite, the Novel-writer is privileged to excite also, I have not thought it either politic or necessary, while adhering to realities, to adhere to common-place, everyday realities only."[40] By the time he wrote *No Name* (1862-1863)—a novel concerned with impersonation and, like so many of Collins' works, with the precarious externality of identity—he chose to organize his fiction into eight localized "Scenes" (with epistolary links "Between the Scenes") each developing or achieving a seemingly fixed configuration as a situation.

In Charles Reade, play-making and novel-making are scarcely less involved with each other. He turned his unacted plays into novels, his successful novels into plays, and in one case turned a play (*Gold*) into a novel (*It's Never Too Late to Mend*) and then back into a play. His fiction often breaks into typographical drama, with speech tags and parenthetical directions. As a novelist he builds to striking effects and erects a structure of situations, though he will pack around those situations didactic and descriptive matter that exceeds them in novelty, power, and interest. In *Christie Johnstone* (1853) for example, adapted from an unproduced play, his graphic technical account of a great herring catch is better than anything else in the novel. But fundamental to Reade's fictional method, and evidently compatible with his notions of realism, is his use of theatrical convention for turning events in the narrative into moments of "effect." An example occurs when Gatty, an artist, and his snobbish mother quarrel over the ruby ring he has given to Christie, a fishwife. They are about to say unforgivable things— a mother's curse included—when:

> . . . in a moment, as if she had started from the earth, Christie Johnstone stood between them! . . .
> They were confused, abashed, and the hot blood began to leave their faces.
> She stood erect like a statue, her cheek pale as ashes, her eyes glittering like basilisks, she looked at neither of them.
> She slowly raised her left hand, she withdrew a ruby ring from it, and dropped the ring on the sand between the two.

[39] *Rookwood: A Romance*, 4th ed. (London, 1836), pp. xii-xiii.
[40] *Basil: A Story of Modern Life* (London, 1852), p. xiii. In the preface to his first novel, *Antonina* (London, 1850), Collins uses the language of painting to describe his work (p. xii).

She turned on her heel, and was gone as she had come, without a word spoken.[41]

In this early novel, however, despite Reade's evident relish or need for such tableau effects and superb gestures, the narrative often brings with it an amusing, mannered, ironical tone that undercuts the dramatic situations. The scene that resolves one of the two romances, for example, is arranged as a situation of the hoariest sort, fraught with suspended effect: the aristocratic idler listening to his would-be lady's praise of an unknown hero turns out to be the very man, and the lady's fortune, presumed lost, turns up in the ship he has rescued. But the scene is rendered with a lightness of touch and a mitigation of the familiar melodrama that probably owes something to Thackeray, and anticipates precisely the formula of a much-celebrated dramatic revolution led by T. W. Robertson in the sixties (Chapters 16 and 17, below).

Usually Reade's hand is heavier, and his effects are unmitigated. The influence of the stage in Reade's fictional style has been comprehensively mapped by Emerson Grant Sutcliffe, who makes it clear that Reade's affinities were with the *contemporary* drama rather than with drama as an abstract mode, and in consequence they were as much pictorial as dramatic.[42] The debris from the scaffolding that produced the novels confirms this impression.

Reade necessarily took a serious commercial view of his productivity, and sometimes had to work hard to galvanize the muse. In one of his surviving notebooks is a "Memoranda Agenda" for doing so, where he reverses the usual practice of artists in two successive items:

3. Make Pictures disgorge for the benefit of Tales and plays.
 Capital idea.
4. Study Pictures largely for stage effects.[43]

Such procedures are seemingly at odds with the headline on the verso of the page, "Found Fiction on Statistics," unless one separates the typicality and authenticity of the social situation from the presentation of the individual case. Many of the notebooks are filled with topical items from newspapers and other sources, and a number of classified scrapbooks of scenes from illustrated newspapers and even penny fiction are labelled "Pictura Novella" and "Pictura Theatri." The earliest and most interesting of the picture books, the "Theatre Notebook—Laura Seymour," has sections on "Costume" and "Fashions," but also "Groupes," "Gestures and Attitudes," and "Situations." Out of such material Reade pumped inspiration, and generated some of the fictions that also embodied his genuine impulses toward a scientific realism. In the theater and in picture-making too in the sixties and seventies, realism and sensationalism, echoes of social statistics and the art of effect, went hand in hand.

THE NOVELIST whose relations to the theater critics have most extensively canvassed is Dickens, and my own concern with the theatrical side of his art is already implicit in the brief approach in this chapter to his pictorialism. An argument on the actual character of what has

[41] *Christie Johnstone* (London, 1853), p. 254.
[42] "The Stage in Reade's Novels," *SP* 27 (1930): 669.
[43] London Library, Reade Notebook no. 15 (new classification), p. 1. Cf. no. 39, p. 34.

so often been called "theatrical" in Dickens' fiction, however, may wait for broader consideration of theatricality and the art of effect, in the next chapter. Meanwhile, I hope I have established the disposition of novelists in the nineteenth century to accept contemporary pictorial and dramatic models for their narrative art, and the capacity of the novel itself to absorb pictorial and dramatic elements. Such openness in novelists and the novel formed a climate for other matters that will enter our concerns. These include the treatment of fiction in the theater; the eventual revulsion against pictorialism in Dickens and theatricality in Thackeray; and—to return to the wider prospect—the pervasive collaboration of narrative and picture in the culture, as the matrix of a style and as a way of structuring reality.

5

<center>✦ I ✦</center>

THE ART OF EFFECT

HE SENSATION of the Royal Academy exhibition of 1842 was Daniel Maclise's painting, *The Play Scene in Hamlet.* An admiring reviewer had these words to say:

He dares to tell the whole of a story, some will say, do say, theatrically—that we consider no dispraise. It is the business of the dramatist to make good pictures, and whether it be done by the players or the painter, what matter, so they be effective, and the story worth telling; and how shall they be better told than as the author intended they should be represented? The boards of the theatre and the canvass are the same thing—the eye is to behold, and the mind is to be moved.

The reviewer, John Eagles, is not merely making a traditional analogy here between painter and poet. He is identifying the painter with the players, as artists equally capable of realizing the narrative import and the dramatic potential of the poet's imagined picture. That dramatic potential is what lies in the phrase, "so they be effective."[1]

The pictorial aspect of the new dramaturgy was the burden of a previous chapter (Chapter 3), where the pictorialism found its rationale in drama in the identification of "situation" with the art of effect. The threatrical associations of "effect," however, though they tended to take over, by no means exhausted the whole content of the term, nor did they limit its applications. For one thing there was its history as a technical term in painting; for another there was its utility as a stylistic discriminator in poetry. Hazlitt, for example, distinguishing between "the classical and the romantic style," between ancient and modern poetry, writes: "The one is the poetry of form, the other of effect."[2]

In an ordinary sense all art, like most discourse, aims at being effective. But as I hope some portion of the remarks on the novel and the drama in previous chapters has already suggested, there is an extraordinary nineteenth-century sense of the term whereby "effect" becomes a category like "illustration" and "realization," a category that cuts across the verbal and visual arts and informs the collaboration of

[1] *Blackwood's Edinburgh Magazine* 52 (July 1842): 24. The reviewer is aware of the threat to the painter's originality here, and therefore points out the illustrative (and imaginative) aspect of Maclise's painting. It is not only a concrete realization of the scene, he suggests, but a comprehensive extension of one medium by another. Maclise "knows how to assist, and by *his* art to bring out the whole conception of the poet; a conception not to be discovered as embodied, or capable of being embodied, in distinct words and in parts, but gathered from the feeling of the whole, and which to embody by another art, is no small test of genius."

[2] "Schlegel on the Drama," *Edinburgh Rev.* 26 (Feb. 1816); in *The Complete Works of William Hazlitt,* ed. P. P. Howe (London, 1933), 16:63. In this notable essay, Hazlitt poises the principle of imitation against the power of metaphoric "illustration," things as they are interesting in themselves against their imaginative associations.

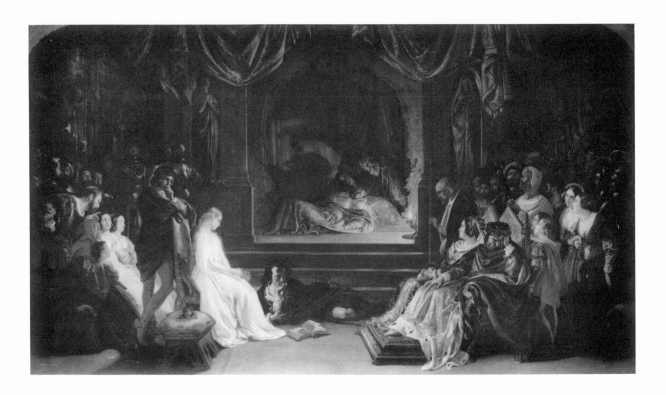

10. *Daniel Maclise*, The Play Scene in Hamlet *(1842), London, Tate Gallery*.

narrative and picture. The art of effect, for good or ill, was a Romantic art, finding sanction in the rebellion against the priority of harmonious proportion, extrinsic form, and a rational correspondence between subjective response and external cause. But already the name of a quality in art, "effect" became the name of a *kind* of art when it acquired its close identification with the theater. I want now, in the present chapter, to consider some broader aspects of the art of effect, particularly as they appear in the thought and practice of extra-theatrical artists and critics, in painting first, and then in literature. But then, before leaving the topic and going on, in the next section of this book, to a series of "conjunctions" largely between theater and other forms, I want to return to this identification of the new art with the theater, and give some thought to what is relative in the idea and attribution of theatricality, and consequently in the art of effect.

Before taking up these various matters, it is well to recognize that not all the most illuminating comment on effect took for its subject the verbal and visual arts, and not all belonged to the nineteenth century. Walpole, for example, in his *Anecdotes of Painting* (1762-1771) applies the term to architecture, attributing to the Gothic "a thousand graces and effects," which he links with a power to convey "impressions to the mind" and to infuse "sensations of romantic devotion."[3] The theatricalization of the concept and its metaphoric broadening took place in the later eighteenth century, so that Kotzebue, a prime architect of the new dramaturgy after 1789, has reason to be defensive even as he proclaims "effect" the sine qua non of drama ("Ein Schauspiel das keinen Effect macht, ist ein schlechtes Schauspiel").[4] His defensiveness is explained by early critical applications of the the-

[3] Quoted in Kenneth Clark, *The Gothic Revival*, rev. ed. (London, 1950), p. 55. See also Nicolas Le Camus de Mézières, *Le Génie de l'architecture* (Paris, 1780), on "les effets et les sensations," p. 7. The *OED* cites a reference from 1736 to "what they call the effect in architecture," meaning an impression of the whole, but I have been unable to confirm it. Walpole goes on to declare, "One must have taste to be sensible to the beauties of Grecian architecture; one only wants passions to feel Gothic," a manifesto in brief of a Romantic architecture, and a link to the other arts (see above, pp. 5-10).

[4] "Betrachtungen über mich Selbst," *Aus August von Kotzebues hinterlassenen Papieren* (Leipzig, 1821), pp. 58-59. The foreign spelling of "Effect" is Kotzebue's. He insists that Effect is a product of the Imagination and therefore a credit ("ein *Verdienst*") to the dramatic poet.

atricalized term, even in politics, to stigmatize any inappropriate appeal through the imagination that disregarded proportion and causality. While Kotzebue's plays were beginning to make their way through Europe, Paine found their qualities in Burke's *Revolution in France*:

> I cannot consider Mr. Burke's book in any other light than a dramatic performance; and he must, I think, have considered it in the same light himself, by the poetical liberties he has taken of omitting some facts, distorting others, and making the whole machinery bend to produce a stage effect. . . . It suits his purpose to exhibit the consequences without their causes. It is one of the arts of the drama to do so. If the crimes of men were exhibited with their sufferings, the stage effect would sometimes be lost, and the audience would be inclined to approve where it was intended they should commiserate.[5]

Insofar as the art of effect implied a direct appeal to emotion through unmediated sensation, music could claim to be its very essence. Certainly the use of music in melodrama supported such a notion, as did the inherited body of theory known as *Affektenlehre*.[6] And yet, with one notable exception, the concept was less important in theoretical discussions of music than one might expect. Wagner, however, was one of several artist-thinkers to comment on the profounder reaches of the aesthetics of effect, and he did so chiefly in his war against Meyerbeer, that is, chiefly in connection with music drama. "To exhibit the consequences without their causes," a means of achieving "stage effect" in Paine's definition, becomes Wagner's definition of effect in the abstract. He exploits chauvinist feelings in distinguishing latinate *Effekt* (which he condemns) from the truly German *Wirkung*, a word bound up with antecedent cause; and he defines *Effekt* as *Wirkung ohne Ursache*—effect without cause. He describes the art that results— a show art, meretricious and perverse if one heeds the imagery—as "the whole of Art . . . resolved into its mechanical integers: the externals of Art are turned into its essence; and this essence we find to be— *Effect*, the absolute Effect, i.e. the stimulus of an artificial love-titillation, without the potence of an actual taste of Love."[7] What Wagner deplores in *Effekt*, however (as his account of a scene in *Le Prophète* makes clear), is the divorce of symbol and evoked response from inner significance. His notion of a validating "cause" is more in tune with a logic of the inner world, the world of imagination and feeling, than with the rational mechanics of prior agency and proportional results, those neo-classical canons against which the art of effect rebelled.

Wagner's definition equates the art of effect with what our own terminology labels "sensational," and relates it to that other great branch of imperfect art, the sentimental, not *Wirkung ohne Ursache*, but emotion without responsibility. The relation to the sentimental is already apparent in Paine's critique. But just as an anatomy of the sentimental in art has to allow for its self-transcendence, in a Richardson, a Dickens, and Wagner himself, so does an account of the sensational. In a composer like Berlioz, effect ceases to be mere effect; it becomes meaningful, its own sufficient cause, through scale and intensity.[8]

[5] Tom Paine, *Rights of Man; Being an Answer to Mr. Burke's Attack on the French Revolution* (1791), Everyman Edition (London and New York, 1915), p. 34.

[6] For the latter, see *Die Musik in Geschichte und Gegenwart* (Kassel, 1949-51), Vol. 1; and *The New Grove Dictionary of Music and Musicians* (London, 1980), s.v. "Affections, Doctrine of," and "Rhetoric and Music," §4. Thomas Holcroft's *Tale of Mystery* (1802), the English version of Pixérécourt's milestone melodrama, *Coelina* (1800), tells all in its musical stage directions: "*soft music, but expressing first pain and alarm; then the successive feelings of the scene.*" "*Music loud and discordant at the moment the eye* of Montano *catches the figure of* Romaldi; *at which* Montano *starts with terror and indignation*," etc. 2nd ed. (London, 1802), pp. 15-16, 19.

[7] Richard Wagner, *Opera and Drama* (1851), trans. William Ashton Ellis (London, 1893), pp. 95-99.

[8] Cf. Wagner, *Opera and Drama*, p. 76. Wagner's fascinated ambivalence toward Berlioz comes out in his irony: "If we mean to recognize the inventors of our present industrial machinery as the benefactors of modern State-humanity, then we must worship Berlioz as the veritable saviour of our world of Absolute-music; for he has made it possible to musicians to produce the most wonderful effect, from the emptiest and most un-artistic Content of their music-making, by an unheard[-of] marshalling of mere mechanical means."

Painting: "Forcible Effects"

"Effect" had its own concrete meaning in the technical language of painting (where it probably originated), operating alongside a wider reference to qualities shared with the other arts. A popular mid-century dictionary of the technical language of art begins its definition of "effect" as, "The impression produced upon the mind by the sight of a picture, or other work of Art, at first glance, before the details are examined," and goes on to associate it with broad treatment, bold outlines, massed light and shade, and what is striking and brilliant in the whole.[9] Ruskin, starting with nature and its laws rather than the painting and its beholder, defines effect while announcing, "I shall first take into consideration those general truths, common to all the objects of nature, which are productive of what is usually called 'effect,' that is to say, truths of tone, general colour, space, and light," and he distinguishes these from "the truths of specific form and colour . . ."[10] Thackeray uses the term in writing of English taste in the 1830s: "With us, the general demand is for neatness, prettiness, and what is called *effect* in pictures, and these can be rendered completely, nay, improved, by the engraver's conventional manner of copying the artist's performances."[11] Neatness and prettiness on the one hand and effect on the other are contradictory qualities. That both were in demand speaks for a heterogeneity of taste in the mid-century.

Earlier, David Cox sought to translate his practice into *A Treatise on Landscape Painting and Effect in Water Colours* (1813), where he divides his art into three branches: Outline, Effect, and Colouring. But despite the tripartite division, he makes clear that in his view the art of landscape painting is essentially an art of Effect; and that Effect is a unifying feeling-tone appropriate to the subject, identified with the management of light and shade, and brought to the subject by the artist rather than found ready-made in nature. He begins, "The principal art of Landscape Painting consists in conveying to the mind the most forcible effect which can be produced from the various classes of scenery . . ."[12] What that most forcible effect might be is a matter of judgment, not of snapshot observation or catching the moment on the wing. Cox gives a survey of "the various effects of Nature, and the class of scenery suitable to each effect; as the great merit of a picture depends on the most appropriate Effect given to each scene." Not all subjects comport equally well with a "grand or stormy Effect" or a "Morning Effect." "Thus, a Cottage or a Village scene requires a soft and simple admixture of tones, calculated to produce pleasure without astonishment; awakening all the delightful sensations of the bosom, without trenching on the nobler provinces of feeling. On the contrary, the structures of greatness and antiquity should be marked by a character of awful sublimity, suited to the dignity of the subject." Effect and affect are here united, in the primacy given to the beholder's response to the picture over the artist's response or responsibility to the living scene. And effects, moreover, though produced in nature by nature's own means, are the results of technique in the painter. A "soft and simple admixture of tones" will produce the appropriate effect in a cottage scene; whereas "Abrupt and irregular lines are productive of a grand or stormy Effect." On the whole it is "the shades, or masses

[9] Frederick William Fairholt, *A Dictionary of Terms in Art* [London, 1854]. In his Eighth Discourse (1778), Sir Joshua Reynolds speaks of "the general harmony and effect" of a painting; but he also contrasts "relief" (or the clear distinction of figure and ground) with "fulness of effect" as two qualities that "can hardly exist together" in one painting. The latter quality he finds produced in Correggio and Rembrandt "by melting and losing the shadows in a ground still darker than those shadows." Blake's annotation here reads, "All This is Destructive of Art." Reynolds, *Discourses on Art*, ed. Robert Wark (New Haven, 1975), pp. 159-60.

[10] *Modern Painters* (London, 1843), [Vol. I.], concluding Part II, sec. 1, p. 98.

[11] "Caricatures and Lithography in Paris," *Paris Sketch Book* (London, 1869), p. 152; as "Parisian Caricatures" *London & Westminster Review* 32 (Apr. 1839).

[12] David Cox, *Treatise on Landscape Painting* (London, 1813), reprinted in *The Studio*, spec. no. Autumn 1922): 11.

of shadow, which usually form the general effect of the composition," and these, Cox recommends, should be "studied" in sepia or India ink.[13] In the rather more rigorous French Academic tradition, effect was identifiable with the calculated organization of light and shade, though by 1870 the term had shifted from "an emphasis on artificial contrivance to one upon natural perception."[14]

Effect in painting, then, was chiefly understood as bearing upon the beholder's response to the picture as managed by the artist's performance, until the beholder's response to the picture lost the greater part of its authority to the natural phenomenon itself and its impact upon the artist. The response implied by the term was sensation *before* interpretation, a response that was "causeless" in Wagner's sense since moral elements and signification had not yet entered, though in a system like Cox's they hovered near. The response implied was also to what is still called, metaphorically, the dramatic or theatrical qualities of a picture, meaning not plot and character, but emphasis, contrasts, emotional coloration, the manipulation of light and shade—artistic melodrama in other words, the "most forcible" side of Cox's criteria, rather than the "most appropriate."

WHILE EFFECT as a term in painting continued to evolve parochially, within the bounds of a technical reference to the painter's means, another dimension tied to the narrative aspect of the image came to the fore with the new dramaturgy and developments in styles of fiction. For a painter whose success depended in good part on his success as a storyteller, "effect" as the ability to create a sense of the whole by suggestion, and to arouse visual interest and emotion by direct manipulation of pictorial elements, was subsumed in a broader concept, one that included narrative performance and dramatic configuration, character and situation.

In France, the association between "effect" in painting and "effect" in drama appears as early as Claude-Henri Watelet's important article on "EFFET, *terme de Peinture*" (1755) in Diderot's *Encyclopédie*. There Watelet associates the term with both sentiment and "une sensation intéressante." Citing the need for leading traits and marked oppositions of character in plays, he comments that "Les détails trop approfondis . . . sont un obstacle à l'*effet* théâtral, qui a des rapports infinis avec les *effets* dont j'ai parlé." Though Watelet only draws an analogy between effect in painting and theatrical effect, the basis for a more unified conception would soon be laid by Diderot himself (see above, p. 41). In England, the broadening of effect was rooted in practice, as John Burnet makes clear in his account of the differences between the English and Dutch schools of domestic genre painting. The Dutch pictures, he argues, "seldom embrace the varieties of action or expression," but are confined to characteristic and representative scenes: brawls, merry meetings, smoking, gambling; where such matters as color or handling are "never disturbed, by endeavouring to give a more intricate or correct definition of the passions."

> Neither do their figures require to occupy that situation which a dramatic story or a complicated composition demands, but merely serve the purpose of an effect of light and shade, or a beauteous

[13] Cox, *Treatise*, pp. 11-18.
[14] Albert Boime, *The Academy and French Painting in the Nineteenth Century* (London, 1971), pp. 27, 169. Boime examines the use of the term in the academic pedagogy of nineteenth-century France in connection with the aesthetics of the sketch. (Cf. Cox's recommendation; and Fairholt's suggestion that the artist can best estimate "the ultimate EFFECT" of a finished work through sketches "made in a broad and vigorous style.") Boime notes that in the evolution of the term, "effect" came to be linked with "impression," the former external and phenomenal, the latter subjective, as in Monet's painting of 1872 titled *Effet de brouillard: Impression* (p. 170). Closer to Cox was Henry Peach Robinson's influential treatise, *Pictorial Effect in Photography: Being Hints on Composition and Chiaroscuro for Photographers, to Which Is Added a Chapter on Combination Printing* (London, 1869).

combination of colour. The inimitable works of Hogarth have taught the English taste to be much more fastidious . . . and the invention is not only to be kept on the stretch, for variety of character, but every incident that can illustrate and render the story effective.[15]

To render the *story* not simply perspicuous, but effective was the problem that beset every narrative painter, including those engaged in the uphill task of accommodating traditional history painting to the new age. How the requirement worked in the consciousness of the painter, how its purposes assimilated "the purposes of an effect of light and shade," and how the result was a narrative strategy that employed the categories of contemporary drama and the manipulation of pictorial means, may be seen in the discussions and explanations that accompanied William Etty's Judith series.

ETTY exhibited the first of his three large Judith canvases (11′10″ x 15′) at the Royal Academy in 1827. It represents the climactic episode in the story of Judith and Holofernes, and in fact succeeds well enough in representing the whole story to reduce the two later paintings to ancillary pendants. The Redgraves describe the moment:

> Judith is preparing to execute her terrible vengeance upon the destroyer of her kindred. She is alone with Holofernes in his tent. There he lies stretched naked in drunken impotence on his couch; the vessels of his carouse lie empty around. Judith, in the front, stands appealing for help to her God. . . . The moment for the attempt is come: the sword of the victim is in her raised right hand, the left gradually gathers his long black hair in her grasp, that she may strike more steadily and more surely; the slightest cry—a groan even—the writhing of her victim in the death-struggle, may bring the watching soldiery upon her . . .[16]

The painting was very well received, the *Times* declaring it "a grand composition, brilliant in colour, generally excellent with respect to drawing, and most striking in effect."[17] Etty explained the dramatic foundation of that effect in justifying his choice of the moment. In contrast to the Old Masters, "I have preferred choosing the point of time immediately preceding the decollation, to that immediately *after*." He so avoids "the offensive and revolting butchery," and gains something he considers much more interesting: a moment when Judith is full of "high and holy resolve"—

> yet she *did* feel her own womanly and tender nature unequal to the deed, without her arm was nerved, and her spirit steeled, by Him who will sooner or later succour the oppressed and destroy the destroyer. At this moment then, of peril, of immense peril, to her country and herself, when she implored that Aid, I have thought it best to paint it. Its very danger begets an interest in the success of an Act which might end in the sacrifice of her own life, if she failed in her purpose of delivering her country.[18]

The Redgraves also read the peril in the moment, to Judith's life and maiden honor; and peril, sustained and renewed, is the very ethos

[15] John Burnet, *Practical Essays on Various Branches of the Fine Arts* (London, 1848), 101-102.

[16] Richard Redgrave and Samuel Redgrave, *A Century of Painters of the English School* (London, 1866), 2:204-205.

[17] *Times* (5 May 1827), Supplement, p. 2.

[18] Quoted in Alexander Gilchrist, *Life of William Etty, R.A.* (London, 1855), 1:236-37.

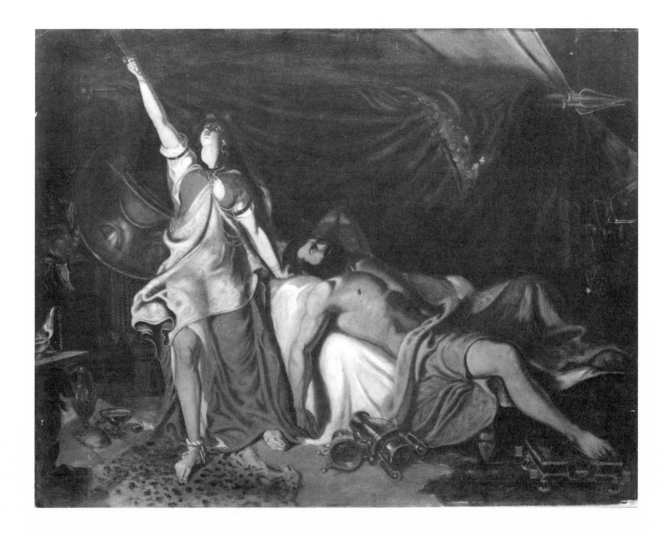

of melodrama. The peril here is achieved through the conversion of an action—Judith killing Holofernes—into a situation, unresolved, with progression momentarily suspended. It is chiefly Judith's situation, for hers is the divided state; a spiritual impasse that will ultimately end (her heroic presence and attitude assure us) in a return to action with the blessings of Providence. The shift from action to situation—to Judith's division and suspense, face and body turned away from Holofernes, one hand in the hair of her victim and one arm stretching to God—carries the peril of this "moment before" away from the unconscious victim, who after all is about to be murdered, and places it with the intended heroine. It is to the point that in the Exhibition catalogue the title of the painting was simply *Judith*. Etty could count on his beholders knowing the story; but to encourage the right reading of the situation (to an uninstructed eye the painting does suggest a confident Judith dedicating her sacrificial ram to God), the accompanying rubric included the prayer from the Book of Judith, "Strengthen me, O Lord God of Israel, this day! "[19]

The *Examiner*, which praised the coloring, praised also the light on Judith and the couch for its "degree of abruptness, in bringing out

11. *William Etty*, Judith [and Holofernes] *(1827), copy (20 × 26½ in.) of the original in the National Gallery of Scotland, private collection.*

[19] *The Exhibition of the Royal Academy, MDCCCXXVII* (London, 1827), #12.

more cogently the noble power of her action," and for preventing the richness and harmony of the coloring "from being too blending and mellow for so spirited a subject."[20] This lighting for effect and as effect (which nevertheless, the review points out, supports the more abstract canons of graduated relations with "lesser lights") is also much praised by the Redgraves:

> Lighted by a lamp, the gloom of the tent looks obscure and terrible. Rich arms are grouped around, steel and gold inlaid; the hangings, the fruits and golden vessels of the banquet, the spread skins of the tiger and the bear, the dim blue sky of the East, seen out of an opening of the tent, with one lone star shining—these all tend to aid the richness of the colouring and the effectiveness of the grouping.

Their account further specifies the daring "abruptness" noted in the *Examiner* review:

> The painter has finely brought his largest and brightest light into contrast with his deepest shade, by the shadow from the falling arm of Holofernes thrown on the sheet on which he lies; while the contrast of the strongest colour in the picture is also made with the brightest light, by the same drapery in contact with the red skirt of Judith. . . . The general hue is lurid and well suited to the subject.[21]

This is the lighting (and use of color) that is often called theatrical, or, less pejoratively, dramatic in the case of a Caravaggio. It here serves, not simply mood or an interest in the rendering of light, but the situation as a concentrated embodiment of the story. It is the lighting that, carried a step further, casts lurid and revealing shadows behind the players in Maclise's *Hamlet*, and strikes Ophelia, fair and luminous, and all in white between the dark Hamlet and Horatio, with such effect that Maclise contrives to make her seem the source of light, not simply the prime reflector, for the circle around her.

THE SECOND painting in the series was the last painted (R.A. 1831), and Etty in the Exhibition catalogue called it "The maid of Judith waiting outside the tent of Holofernes till her mistress had consummated the deed that delivered her country from its invaders—(see the book of Judith)—forming the second and last pendant picture to the principal one." From the point of view of narrative progression it simply sustains the suspense, by a technique that has become familiar through film. It had a further function, one that responds to the heavy stress Etty put on Judith's—and Israel's—peril. The *Examiner* review of the first Judith painting, for example, missed that element, though the reviewer grasped other aspects of Etty's intention. "Her appeal to heaven," he wrote, "as she seizes the hair of her victim, and raises her face and weapon aloft, is to the mind a trumpet-tongued expressiveness of patriotic zeal. It is high-wrought principle brought into daring and efficient action by personal and mental courage." A painting requires the visible presence, token or otherwise, of a danger, for the danger to make itself felt (like the light coming through the door and the

[20] *Examiner* (20 May 1827), p. 311.

[21] Redgrave and Redgrave, *A Century of Painters*, 2:205, 207. The Redgraves' description, including the use of the lamp from within the tent in what they call the two "side pictures," supports what I take to be a direct influence of Pierre-Narcisse Guérin's *Clytemnestra* (see below, pp. 334-36). Writing after an 1822 visit to Paris, Etty announced, "In the Luxembourg . . . I think Guérin, Regnault, etc. the best," and he later named the same painters to Lawrence as "two of their best men." He was in Paris (and spent a week in Regnault's atelier) in 1817, the year of the *Clytemnestra*. See Dennis Farr, *William Etty* (London, 1958), pp. 24, 35, 116, 121.

small dog's alarm in Delaroche's *Children of Edward IV* [1831], Fig. 94 below); and Etty used both his extensions of the series, painted to be deployed like the wings of a giant triptych, to supply the defect. "I imagine it to be about the same point of time," he wrote of *The Maid of Judith*. "The Maid, ordered to wait without, is sitting by the dying embers of one of the watch-fires: the guards overcome by sleep;—the time, past midnight. The darkness and silence are broken only by some strange suppressed noise within. The Maid, unconscious of the intentions of her Mistress, hearing the noise, *Listens*."[22]

The beholder, however, is free to imagine what is going on within, as in a neo-classical tragedy; that is, to move the scene to the moment of invisible action.[23] The visible result and the denouement are in the third painting of the series (the second painted, R.A. 1830), *Judith*, illustrating the text, "And anon after she went forth; and she gave Holofernes' head to her maid, and she put it in her bag of meat."[24] This painting and its successor were not nearly so well received as the first. The *Athenaeum*, for example, complained that Judith going forth was void of dignity and beauty, "in form no less than in attitude, skulking from the tent like a common murderess, and only occupied with the risk of detection." The reviewer implied that Etty had funked the challenge of rendering Judith's post-mortem expression, and had "recourse to his ingenuity to find a reason for averting the face of his principal figure, thus throwing the chief expression of his picture on the head of the female attendant." This reviewer found the light and shadow on the slumbering sentinel "most effective," and the sky and background, "although liable to the charge of being somewhat meretricious, have a character of mystery, which produces an effect almost imposing." But he complained of the failure of the painting, especially in the treatment of Judith, to achieve the ideality of "the historical, the epic idea":

> The argument of the picture, instead of being the noble act of a heroine, raised by her enthusiasm far above the weakness of her sex and the feelings of humanity, is the natural horror of a menial at a common deed of murder. That in the expression of this sensation there is sufficient display of power, will be readily conceded; but it will be as certainly granted that it possesses neither grandeur nor beauty.[25]

Words like "sensation" suggest that for this reviewer "a performance which aspires to rank with epic poetry" has succeeded only as melodrama.

Etty defended and explained this Judith in his autobiographical memoir:

> In the second picture . . . that of her escaping, or endeavouring to elude the vigilance of the guards, and get out of the Camp with the Head to her own city,—I have thought it right to make Judith looking towards these guards themselves: conceiving she would, as a matter of course, do so. I understand I have been censured for so doing; because it turns the face of the Heroine away from the spectator. It is a principle with me, as far as lies in my power, to endeavour to make my heroes or heroines act as they

[22] Gilchrist, *Etty*, 1:324.

[23] The painting, thanks to the mummy's curse of bitumen, is so deteriorated that it is liable to encourage more imagination than perception. The tent opening, which lets out the light, shows part of an erect figure, probably Judith. Etty's "strange suppressed noise"—which in paint depends upon reading the crouching maid's expression as listening—could be anything. Like the maid, we don't really know what is going on; the moment of action becomes *her* situation.

[24] *Exhibition of the Royal Academy, MDCCCXXX* (London, 1830), #124.

[25] *Athenaeum* (15 May 1830), p. 299.

would do if placed in similar circumstances in reality; without thinking or caring which way they turn their faces: endeavouring to forget all consciousness of Art. I am not anxious to imitate those second-rate Actors who, when they are performing, are more desirous to play to *boxes*, *pit*, *and galleries*, than absorb themselves in the passions and natural interests of the scene.[26]

Moreover, Etty goes on to point out, he knows how much may sometimes be gained by leaving something to the imagination of the spectator; and finally, "It seemed to me the natural and spontaneous mode of feeling and telling the story."

The natural is a most unreliable standard, especially where it defines itself against the theatrical. Be that as it may, it is illuminating to find Etty defending himself by insisting on the importance of eliminating self-consciousness in the players of his scene, to avoid the taint of the theatrical; and proclaiming the alternative virtue of "absorption" in the passions and natural interests of the scene. As we shall see, similar arguments have an important place in the views of Dickens and Diderot. Between these two, the great Victorian performer of stories and the brilliant Enlightenment philosopher and critic, Etty provides an unexpected bridge.

Writers and Critics

In a passage commending the seventeenth-century painters of familiar life for the absence of "all that stage trickery of the spectator by which he is made to believe himself touched at heart," the painter Charles Leslie cites an engraving after Teniers called the "Miseries of War" in which there is no maiden, hair dishevelled, on the body of her murdered lover, "in an attitude as carefully arranged to display the charms of her person as her grief." Instead, there are incidents "all the more touching for an entire absence of theatrical, or modern pictorial effect."[27] Not all mid-century critics used the equation of theatrical and "modern" pictorial effect to dispraise. A case in point was John Eagles' defense of Maclise's *Play Scene in Hamlet*. Eagles was responding defensively to voices like that of the *Times* (3 May 1842), whose jaundiced view of the Maclise "lion of the gallery" is set off by praise for Leslie's *Scene from Twelfth Night*: "An admirable picture. It is a pure transcript of Shakespeare on canvass, without the theatrical exaggerations by which the illustrations of the great bard are deformed and distorted in the hands of artists, whose only conception of his character is taken from the absurdities of the buffoons [the actors] by whom they are caricatured." To such criticism Eagles replied that actor and painter were equally obliged to realize "effectively" the conception of the poet, and to engage the eye and move the mind.

In the criticism of fiction, more than in the practice, the role of "effect" is also unsettled, and the critical attitudes are ambivalent. The rise into fashion of a school or style of effect in fiction (of "sensation," to use the later label) did much to encourage the invidious use of the term, for example in the *Examiner*'s formidable attack on Ainsworth's *Jack Sheppard* (1839) and the craze it engendered especially in the theater (see below, p. 265). To stigmatize a particularly gruesome

[26] Gilchrist, *Etty*, 1:286-87.
[27] *A Hand-Book for Young Painters* (London, 1855), pp. 246-47.

detail in that novel, the reviewer observes, "This is effect with a vengeance!" He continues, "So, in a passage at the close of the book descriptive of the burning of Wild's house by an enraged mob, another 'effect' is achieved, which is more peculiar than pleasant, but much too characteristic of the entire style of the narrative to be omitted."[28] The reviewer (Dickens' friend, John Forster) then quotes the offending passage with indignant relish.

A more open ambivalence toward the art of effect, and an anticipation of its importance for the major fictional styles that were to evolve in the course of the century, may be found two decades earlier in a review, mostly written by Scott himself, of the first three Waverley novels. Scott turns severe when observing that "Probability and perspicuity of narrative are sacrificed with the utmost indifference to the desire of producing effect; and provided the author can but contrive to 'surprize and elevate,' he appears to think that he has done his duty to the public." Effect is thus linked to a regrettable devolution of the high style, and of the sublime itself, into melodrama. But then Scott turns modernist by speculating that there may be "something of system in it"—in the author's having "avoided the common language of narrative, and thrown his story, as much as possible, into a dramatic shape. In many cases this has added greatly to the effect, by keeping both the actors and action continually before the reader, and placing him, in some measure, in the situation of the audience at a theatre, who are compelled to gather the meaning of the scene from what the dramatis personae say to each other, and not from any explanation addressed immediately to themselves."[29] Scott's association of the art of effect with the dramatic mode takes him beyond the usual considerations to a conception of how its presentational immediacy can work as a narrative style. It is peculiarly like him to frame his ambivalence with a look backward and a step forward. The art of effect itself became the subject of a conscious dialectic in some of the novels and novelists that succeeded Scott, notably Thackeray, and this internal argument will be pursued in a later chapter.

THE LITERARY artist with the firmest commitment to the art of effect was Edgar Allan Poe. His critical and practical contribution to its definition had repercussions in later European poetry, which he helped transform; but his notion of an art of effect still has to be read in the light of his own milieu and experience, linguistic, literary, pictorial, and theatrical. Poe confesses a commitment to the art of effect in his remarkable essay-lecture, "The Philosophy of Composition" (1846), where he offers the example of his own practice:

> I prefer commencing with the consideration of an *effect*. Keeping originality *always* in view . . . I say to myself, in the first place, "Of the innumerable effects, or impressions, of which the heart, the intellect, or (more generally) the soul is susceptible, what one shall I, on the present occasion, select?" Having chosen a novel, first, and secondly a vivid effect, I consider whether it can be best wrought by incident or tone . . . afterward looking about me (or rather within) for such combinations of event, or tone, as shall best aid me in the construction of the effect.[30]

[28] *Examiner* (3 Nov. 1839), p. 692.
[29] John O. Hayden, ed., *Scott: the Critical Heritage* (London, 1970), p. 114; from the *Quarterly Review* 16 (Jan. 1817): 430-80, on *Waverley*, *Guy Mannering*, and *The Antiquary*.
[30] *Literary Criticism of Edgar Allan Poe*, ed. Robert L. Hough (Lincoln, Neb., 1965), p. 21.

In Poe's psychologically oriented, reader-conscious formulation, "effect" is not merely the starting point, but the end toward which all else is directed. He is aware that the calculated "construction" of effect out of incident and tone reverses the expectations cultivated in readers by the watchword of sincerity and the tradition of an art that conceals art. In keeping with the proprieties of such art, effect should be innocently inherent in content. There is consequently a shocking quality in Poe's revelations, as well as an appeal to backstage prurience; and these he reinforces by metaphorically equating his poet with the contemporary actor-manager, the artist whose effects most clearly depended on novelty and vividness. Poe speaks in theatrical terms of the reluctance of writers to give a true account of composition: they would "shudder at letting the public take a peep behind the scenes . . . in a word, at the wheels and pinions—the tackle for scene-shifting—the step-ladders and demon-traps—the cock's feathers, the red paint and the black patches, which, in ninety-nine cases out of the hundred, constitute the properties of the literary *histrio*."

Poe's conception of effect, however, also goes hand in hand with "unity of impression," and lies behind his resounding challenge (here and in "The Poetic Principle") to the existence of the long poem. ("What we term a long poem is, in fact, merely a succession of brief ones—that is to say, of brief poetical effects.")[31] Though Poe makes no case for an art of effect embodied in longer forms, narrative or dramatic, such an art, he implies, would necessarily entail serial discontinuity, the form taken by much of the characteristic art of the century. The tendency in an art of effect toward the pictorial he adumbrates in an aside on the unitary work: "But it has always appeared to me that a close *circumscription of space* is absolutely necessary to the effect of insulated incident:—it has the force of a frame to a picture. It has an indisputable moral power in keeping concentrated the attention, and, of course, must not be confounded with mere unity of place."[32]

Dickens was not as formidable an aesthetician as Poe, and his best thinking on the art of effect must be deduced from his fiction. The many critics who have identified the essential nature of Dickens' art as theatrical or dramatic, from Ruskin to Garis and Axton, have had the art of effect in mind. The critical tradition until recently found Dickens' theatricalism his limitation, and in this respect many subtle critics belong to the same camp as the purblind *Family Herald*, which asked apropos of Dickens' portrait of Salem House in *David Copperfield*, "Does he calculate upon the utter ignorance of the rich and the educated classes, who never visit a school from one year's end to another? Or does he merely study the art of the stage or dramatic effect, and take his ideas of Nature from Burlesque and Farce . . . ?"[33] Dickens himself confirmed the association of his art with the art of the stage in assorted formal statements, and the variety and complexity of his external relations with the living theater of his day would form a staggering catalogue.[34]

Dickens' own thinking on these matters, however, was by no means merely intuitive and practical. His critical sophistication appears, for example, in the distinction he proposed in a defense of some French paintings at the Paris Exposition Universelle of 1855, paintings whose

[31] Ibid., p. 22.
[32] Ibid., p. 29. In the end Poe allows for, indeed requires, "some amount of suggestiveness—some under-current, however indefinite, of meaning" distinct from overt theme (p. 31). This subtler version of Wagner's "cause" furnishes the bridge between early and late Romantic (Symbolist) art.
[33] Quoted by Philip Collins in *Dickens and Education* (London, 1963), p. 113.
[34] On Dickens' involvements with the actual stage, as playwright, performer, reporter and novelist, and on the adaptation of his novels for the stage, see J. B. van Amerongen, *The Actor in Dickens* (London, 1926); F. Dubrez Fawcett, *Dickens the Dramatist* (London, 1952); S. J. Adair Fitz-Gerald, *Dickens and the Drama* (London, 1910); and T. Edgar Pemberton, *Charles Dickens and the Stage* (London, 1888). Charles Dickens, *The Public Readings*, have been admirably edited by Philip Collins (Oxford, 1975). A convenient assemblage of Dickens' own writings about theater is *The Dickens Theatrical Reader*, ed. Edgar and Eleanor Johnson (Boston, 1964). Pertinent discussion of the impact of the theater on Dickens' style and imagination may be found in William F. Axton, *Circle of Fire* (Lexington, Ky., 1956); Earle Davis, *The Flint and the Flame* (Columbia, Mo., 1963); the Garis book cited in n. 36 below; and among briefer studies, R. C. Churchill, "Dickens, Drama and Tradition," *Scrutiny* 10 (1942): 358-75, and Martin Meisel, "Miss Havisham Brought to Book," *PMLA* 81 (June 1966): 278-85.

merits included "a vigorous and bold Idea," but which English viewers, even "the more educated and reflective," had dismissed as "theatrical." Dickens distinguishes between a dramatic picture and a theatrical picture, "Conceiving the difference . . . to be, that in the former case a story is strikingly told, without apparent consciousness of a spectator, and that in the latter case the groups are obtrusively conscious of a spectator, and are obviously dressed up, and doing (or not doing) certain things with an eye to the spectator, and not for the sake of the story." In both cases, as Dickens' language makes plain, the artist aims at creating a striking effect.[35] Dickens' distinction readily lends itself to a discussion of his own fictions, and in fact it is the distinction Robert Garis develops and applies independently in his fastidious Jamesian critique.[36]

Dickens discovered (in the same essay) that what critics of certain French paintings probably meant by "theatrical" was that the actions and gestures of the figures were not *English*, not conventionally understated. Practicing a fictional style of the fullest statement, Dickens might have defended himself on similar grounds. But the fact is, Dickens does make extensive use of a *theatrical* pictorialism and theatrical effect, according to his own definition. His characteristic performer is a conscious performer, to be perceived and enjoyed as such. In *David Copperfield*, the theatrical picture wherein Agnes announces Dora's death (Chapter 53) fails, not because of its theatricality, but because of its unmitigated, out-of-character conventionality. Dora's dog Jip (with a plaintive cry) falls dead; David (in unconscious parody of Lear) cries:

> "Oh Agnes! Look, look here!"
> —That face, so full of pity and of grief, that rain of tears, that awful mute appeal to me, that solemn hand upraised towards Heaven!
> "Agnes?"

Well might he ask. The grouping and the gestures here are for an external spectator, and a consciousness of that fact on the part of the author shows through, while the characters, if unconscious performers, are certainly not themselves.

Such is not the case, however, with the most theatrical scene of the novel, Micawber's denunciation of the grotesque villain Heep (Chapter 52). There Micawber glories in his "performance" (so labelled), and his theatricalism is in character even when, in passion, he departs from his script, pointing his ruler "like a ghostly truncheon" (the conventional business of Hamlet's ghost) or wielding it like a broadsword while denouncing Heep as the "most consummate villain that ever lived." This is burlesque of melodrama, but yet still in the vein of melodrama, where villains were regularly exposed by comic types (like the "honest little grocer" who resolves the nautical drama described in *Great Expectations*). Heep's behavior, with his final pause at the door for an exit speech ("Copperfield, I have always hated you . . . Micawber, you old bully, I'll pay *you*!") is quite in keeping with character and mode. Meanwhile the rest of the theatrical assemblage— part spectator, part participant—complete the tableau of Heep and

[35] "Insularities," *Household Words* 13 (19 Jan. 1856): 2.

[36] Robert Garis, *The Dickens Theatre: A Reassessment of the Novels* (Oxford, 1965), esp. chap. 1, "Style as Theatre." The self-conscious, or audience-conscious performer is Dickens of course.

Micawber, "Mr. Micawber, supremely defiant of [Heep] and his extended finger, and making a great deal of his chest until he had slunk out at the door."

Theatricalism, conscious performance, has been built into these characters and they quite properly dress and act the part, allowing Dickens scope to expand and exploit this exceedingly situational moment in his story. Elsewhere, just the presence of internal spectators is enough to justify the theatrical effect of a scene. When David and Steerforth break in on the Peggotty household, they catch a scene that is "instantaneously dissolved" but takes a paragraph to describe, a scene straight out of Greuze (*l'Accordée de village*) by way of nautical and domestic drama:

> Mr. Peggotty, his face lighted up with uncommon satisfaction, and laughing with all his might, held his rough arms wide open, as if for little Em'ly to run into them; Ham, with a mixed expression in his face of admiration, exultation, and a lumbering sort of bashfulness that sat upon him very well, held little Em'ly by the hand, as if he were presenting her to Mr. Peggotty; little Em'ly herself, blushing and shy, but delighted with Mr. Peggotty's delight, as her joyous eyes expressed, was stopped by our entrance (for she saw us first) in the very act of springing from Ham to nestle in Mr. Peggoty's embrace. In the first glimpse we had of them all, and at the moment of our passing from the dark cold night into the warm light room, this was the way in which they were all employed: Mrs. Gummidge in the background, clapping her hands like a madwoman. [Chapter 21]

The theatricalism of this "little picture" is made a matter of comment: when he brings the story of Ham and little Em'ly up to date for his visitors, Mr. Peggotty concludes, "Then Missis Gummidge, she claps her hands like a play, and you come in. There! the murder's out!" The scene exists as a tableau to the beholders, however, and makes an effect, only by virtue of the interruption; and of course Copperfield and Steerforth, Em'ly's future seducer, interrupt the scene in more ways than one. The real drama lies, not in the tableau as such, but in the certainty of its imminent dissolution—"so instantaneously . . . that one might have doubted whether it had ever been"—when the spectators enter the picture. (In Phiz's etching, David is shown as both presenting the scene to Steerforth and Steerforth to the scene.) The interruption is thus charged with a function in the larger progression as well as in the effect of the moment. Through the means of its creation, the tableau acquires a significance beyond itself.

The positive side of Dickens' definition of a dramatic picture, one where "a story is strikingly told," also implies effect, but by no means "mere effect." Dickens' achievement in narrative, at least by the time of *Dombey and Son*, was to unite effect, extracausally but imaginatively and symbolically, with the currents of deeper meaning. The scene of the death of Carker in that novel (Chapter 55) anticipates the railroad sensation scenes of Boucicault and Daly. The accident that kills Carker, fortuitous but well-deserved like the hanging of Bill Sikes, is in keeping with the wonder-working Providence of melodrama, but the divine

lightning takes the form it does for Carker on a more profoundly imaginative principle, still rooted in melodrama's poetic justice. Throughout the novel a natural cycle of growth and change is cut across by a newer time, linear, bustling, mechanical, and inexorable. The two are no friends to each other, but with an irony more than a little prophetic, those who attempt to deny or coerce the first are destroyed by the second. The waves and the sea, where time joins eternity, are among the cluster of images that convey the first; the railroad is the principal image for the second.

The railroad appears memorably at various points in the novel (in the disappearance of Stagg's Gardens with its rot and stagnation, to be replaced by the great throbbing vitality around the new St. Pancras station; in the virtuoso evocation of Dombey's subjective experience of his railroad journey to Leamington). And its linearity is evoked in Carker's mindless flight across Europe, toward the climactic moment of his death. Carker has no sense of the permanent rhythms, and with his own inexorable purposes undone his straight run to earth, by carriage, ship, and train, becomes a chaotic phantasmagoria. It is marked by the refrain, "A vision of change upon change, and still the same monotony of bells and wheels, and horses' feet, and no rest." When he stops the whole is "constantly before him all at once," past and present, life and journey; and it is then (in the night of his lugubrious declaration, "My watch is unwound") that he is struck into horrified fascination by the railroad and its potent, superhuman linear inexorability. The sensational death itself is rendered in the imagery of Carker's moral and psychological perception: as the triumph of the juggernaut, red-eyed living monster and jagged mill, "that spun him round and round, and struck him limb from limb, and licked his stream of life up with its fiery heat, and cast his mutilated fragments in the air."

Neither probability nor the logic of necessity justifies the dramatic sensation. But it is grounded thematically and poetically in what has gone before, and grounded psychologically in the subjective state of an experiencing character. The sensation also climaxes a pervasive, ambivalent, profoundly grasped imaginative perception having to do with a historically changed experience of time and life and how that bears upon human values. With this central perception, this inner life of the fiction, Dickens unites his dramatic effect. Because he could do so, Dickens' own art, in which picture and dramatic effect are assimilated, is never threatened in its character as novel, though Dickens of all Victorian novelists made the most of the theatrical art of his day— made more of it than any of the playwrights.

The Attribution of Theatricality

In using the presence within the work of an obtrusive awareness of the spectator to distinguish between the dramatic and the theatrical, Dickens (like Etty earlier) recalls a primary concern of the seminal thinker about many of these matters, Denis Diderot. Diderot campaigned both in the theater and in painting for an art that would seem self-absorbed, an art whose supreme pretense, as Michael Fried has argued, was the absence of the beholder.[37] The demand is apparently

[37] See especially Fried's essay, "Towards a Supreme Fiction: Genre and Beholder in the Art Criticism of Diderot and His Contemporaries," *New Literary History* 6 (1975): 543-85; incorporated in his learned and distinguished book, *Absorption and Theatricality: Painting and Beholder in the Age of Diderot* (Berkeley and Los Angeles, 1980).

simple: actors should act at and with each other, and characters in paint or flesh should seem wholly caught up in the emotion of the moment. But in practice the demand was not so simple, since the art Diderot valued had nevertheless to command the emotional participation of the spectator. A comment on Greuze's *Fermier incendié* (1761) illustrates some of the complexity. Diderot finds that in this scene, where the father of the family addresses himself to the commiseration of the passers-by, all is pathetic and true. "In a painting, I rather like a character who speaks to the spectator without coming out of the scene. Here there is no passer-by but the viewer."[38]

Similarly there are paradoxical consequences when Diderot, through one of his voices in the dialogues that accompanied *Le Fils naturel*, declares that he much prefers tableaux on the stage to *coups de théâtre*. The *coup de théâtre* he defines as an unforseen incident that occurs as action and that suddenly changes the state of the characters. The tableau he defines in part by illustrations from *Le Fils naturel*. What he offers, however, are not simply static, pleasing compositions for visual contemplation on the stage, but situations charged with emotion and emotional appeal that encapsulate the narrative position, intensifications of the ordinary made striking and "effective."[39] His intensely situational examples are: an unhappy lover seeking comfort in the bosom of the friend who is, unknown to him, the equally unhappy cause of his grief; the same friend presenting with a gesture the spectacle of the unhappy lover, stretched out on a sofa "in the attitude of a man in despair," to the young woman who now instead loves him and whom he also secretly loves. For Diderot such scenes were dramatic, both arresting and poignant, but not—given the current conventions that he deplored—theatrical. For later generations such scenes—whether overtly acknowledging an audience or not—were likely to seem theatrical because they seek to compress narrative into situation, and from situation to generate an effect.

The association of effect with theatricality in critical discussions of nontheatrical forms was often used to imply manipulative artifice and crude exaggeration; but the art of effect could not easily be reduced to the label of an inferior species in an age that continued to elevate sensibility, immediacy, and imagination, and had acquired, in Hussey's phrase, "the habit of feeling through the eyes."[40] Therefore, for much of its career, the term included the fact or hope of an intense relationship between the work and an audience, and for much of the century the art of effect was a prevailing mode. Leslie writes, after all, as if "theatrical, or modern pictorial effect" were the characterizing phrase for modern practice, and as if his views and seventeenth-century Dutch painting were both superior anachronisms. Critical fastidiousness and the general appetite did not go hand in hand.

The identification of certain pictorial and poetic or narrative strategies with dramatic effect is in the end a historical matter rather than a matter of logic, while "theatricality" in painting and literature is as relative a notion as naturalism in acting. Greuze is a case in point. The standard reservation about Greuze among nineteenth-century English critics was that he was too theatrical. Tom Taylor, middle-brow art critic and leading playwright in about equal proportions, makes the point in writing about the familiar genre-painting he favors; and Leslie

[38] "J'aime assez dans un tableau un personnage qui parle au spectateur sans sortir du sujet. Ici il n'y a pas d'autre passant que celui qui regarde." Diderot, *Salons* (1761), ed. Jean Seznec and Jean Adhémar (Oxford, 1957), 1:135.

[39] See the "Premier Entretien," esp. pp. 28-34 in the convenient collection, *Diderot's Writings on the Theatre*, ed. F. C. Green (Cambridge, 1936). In the treatise that accompanied *Le Père de famille* called "De la Poésie dramatique," Diderot writes, "Dans une action réelle, à laquelle plusieurs personnes concourent, toutes se disposeront d'elles-mêmes de la manière la plus vraie; mais cette manière n'est pas toujours la plus avantageuse pour celui qui peint, ni la plus frappante pour celui qui regarde. De là, la nécessité pour le peintre d'altérer l'état naturel et de le réduire à un état artificiel: et n'en sera-t-il pas de même sur la scène? " (p. 201).

[40] Christopher Hussey, *The Picturesque: Studies in a Point of View* (1927; reprint ed. London, 1967), p. 4.

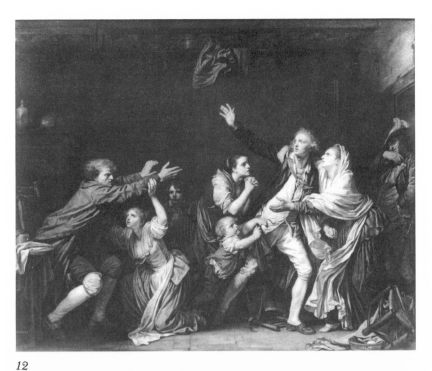

12

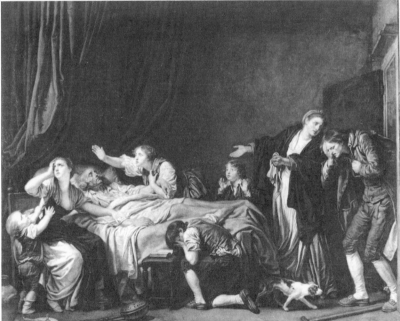

13

12. Jean-Baptiste Greuze, La Malé-
diction paternelle *(1777), Paris,
Louvre (cliché des Musées Na-
tionaux).*
13. *Jean-Baptiste Greuze,* Le Fils
puni *(1778), Paris, Louvre
(cliché des Musées Nationaux).*

cites Greuze as a prime example of those painters of cottage incident
who "carry the mind more into the theatre than into rustic life."[41] What
struck Leslie and Taylor in paintings like *La Malédiction paternelle*
(1777) and *Le Fils puni* (1778) was the tableau effect. They saw a
contained configuration, linear and interlocking, against a simple, flat-
like back wall (with, in the death scene, the suggestion of a stage

[41] Tom Taylor, *The Railway Station,
Painted by W. P. Frith, Esq., R.A.* 2nd
ed. (London, 1865), pp. 28-29; and Les-
lie, *Hand-Book*, p. 246.

THE ART OF EFFECT [85]

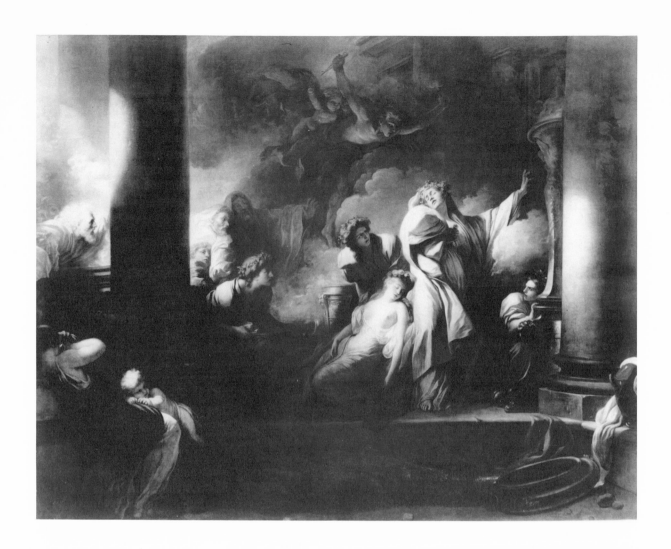

14. *Jean Honoré Fragonard*, Le
Grand-Prêtre Corésus s'immole
pour sauver Callirhoé *(1765),
Paris, Louvre (cliché des Musées
Nationaux)*.

[42] Denis Diderot, *Salons* (Oxford,
1960), 2:156-59. The drawings show a
more Hogarthian crew than the later
paintings, and since less "finished," less
neo-classical, undoubtedly seemed less
"composed." See the reproductions of the
studies for *La Malédiction paternelle* and
Le Fils puni (Lille, Musée Wicar) in Ani-
ta Brookner, *Greuze, the Rise and Fall of
an Eighteenth-Century Phenomenon*
(Greenwich, Conn., 1972), pls. 38, 39.

[43] Diderot, *Salons*, 2:188-98 and pl.
71. Fried also finds it useful to discuss
Diderot's response to this great painting
in *Absorption and Theatricality*.

curtain). They saw heightened emotion externally indicated through
a range of gestures and attitudes illustrating a central situation (gesture
more static than dynamic, more conventional than individual). They
saw narrative concentrated in crisis and demanding an affective re-
sponse, but narrative rendered in a symbolic summary that arrests its
climactic energies.

A century earlier Diderot found Greuze remarkable because so ex-
ceedingly true to life. In an enthusiastic account of Greuze's pilot
drawings (1765) for the two paintings, Diderot finds nothing—with
the possible exception of the mother's presentational gesture in *Le Fils
puni*—that compromises their simplicity and naturalness.[42] He cer-
tainly finds nothing at all of the theater. In contrast, he writes of
Fragonard's big return-from-Rome piece in the same Salon entirely in
theatrical and dramatic metaphor.[43] The account is first of all in a
fictive dialogue with his fellow *philosophe* Grimm, in which Diderot
relates his dream of a Platonic cave wherein the story of the painting
(expanded into a series) is acted out on a canvas screen by projected
shadows. The painting, *Le Grand-Prêtre Corésus s'immole pour sauver*

Callirhoé, shows the priest plunging a knife into his own heart beside the intended victim, a swooning semi-nude, and various supernumeraries, on a red-carpeted platform between framing columns and before the billowing smoke of an altar. Over the whole presides an allegorical Despair with Love riding its back; and the concentrated lighting, beaming in from the upper left, makes for strong contrasts and complex refractions.

Diderot points to the lighting, the climactic chosen moment, the "effect" (though not up to the pathos of the subject in Grimm's view), and the temple setting: "Voilà le théâtre d'une des plus terribles et des plus touchantes représentations qui se soient exécutées sur la toile de la caverne, pendant ma vision." Diderot's interlocutor notes that there are judges of severe taste who have sensed "je ne sais quoi de théâtral" in the whole composition and been displeased by it. Diderot, on the other hand, has been stimulated to the evocation of a dream magic-lantern theater in a quasi-dramatic dialogue.

Diderot's response is to a theatricality that he perceives in the beautiful ideality of the painting and in its irresistible communication of emotion; a theatricality that lies also in the unexpected *coup de théâtre* in the moment represented; in the dynamism of the composition and the lighting; perhaps in the union of that dynamism with the effeminacy of all the central figures (which Diderot admits as a fault), summed up in the mannerist twist of the suicidal priest dying in orgasm. Such "fantômes intéréssans et sublimes," such "simulacres des êtres," belong to an ideal theater apparently antithetical both to Diderot's elsewhere-projected bourgeois theater and to Greuze.[44] That Greuze, in his paintings of domestic narratives as intensified and encapsulated situations, should not appear theatrical to Diderot while appearing extravagantly so to Tom Taylor and Leslie, is not so much a matter of more rigorous standards of naturalism as of a change in the condition of the theater, thanks in part to Diderot: from an ideal platform for an expressive and heroic drama conceived as the representation of action and passion, to a frame for a serial domestic drama conceived as a series of effective situations.

[44] I do not mean to imply that these qualities struck only the contemporaries of Fragonard as "theatrical." In *L'Art du XVIII siècle*, 3rd ser. (Paris, 1895), for example, the brothers Goncourt refer to the painting as "cette scène de drame antique qui semble avoir sous les pieds un rideau du théâtre" and "ce coup de théâtre dont il a dû prendre l'idée et peut-être l'effet même à une des reprises de la *Callirrhoé* du poète Roy; vrai peinture d'opéra demandant à l'opéra son âme et sa lumière" (pp. 258, 260).

PART II

CONJUNCTIONS

6

✦·✦

PREAMBLE TO THE PICTURE PLAY

*W*HEN Luis Buñuel recreates Leonardo's *Last Supper* in *Viridiana* (1961) as a grotesque feast of beggars, and when Robert Altman parodies both in *M*A*S*H* (1970)—and the actors freeze in their da Vincian attitudes to call attention to the joke—these directors reinvent a device sporadic in earlier films and characteristic of their predecessor and progenitor, the nineteenth-century picture stage. For example, *The Last Supper* was reproduced in David Belasco's theatrical production of Salmi Moses' *Passion Play* (1879), which was in effect a gallery of paintings on the stage. It appeared again in a silent-era equivalent, *Christus* (1917), an Italian film whose chief virtue, Kenneth Macgowan thought, "is the marvellous reconstruction—proudly heralded on the programme—of half a dozen famous paintings during the action. . . . Fra Angelico's Annunciation, Correggio's Nativity, Leonardo's Last Supper bring a real power to those moments in the film."[1]

The nineteenth-century theater's use of pictorial allusion was on the whole rather more innocent than that of Buñuel or Altman. There is a scene, for example, having to do with the crosses of love, in H. T. Craven's pleasant comedy, *Meg's Diversion* (1866). The scene is prefaced in the "acting edition" with a note, "☞ The scene and lights are arranged with a view to introduce Calderon's picture of 'Broken Vows.' "[2] The object of these preparations, Philip Calderon's once popular painting (1856), now in the Tate Gallery, is the sort that does a tale unfold through the arrested expressions, symbolic gestures, and emblematic local detail of a moment of high emotion. The painting shows a girl with dark hair and in half-mourning on our side of a fence, clutching her heart, while on the other side her oblivious betrayer flirts with a fair rival. The fused carved initials on the fence, the ring, the dead butterfly in the spider web, and the fallen charm bracelet with cross and anchor askew comment on the story that the figures chiefly tell.

Some time along in the second act of *Meg's Diversion*, "ROLAND *and* CORNELIA *appear behind the palings*, L.C., *a portion of the top of which being broken, admits of their faces being seen.*" Meg hears Roland address Cornelia as his own, and "*staggers against [the] wall piece.*" Roland

[1] " 'Christus': an Italian Photoplay," *Seven Arts* 2 (July 1917): 394. Belasco's production of Moses' *Passion Play* is cited in A. N. Vardac's *Stage to Screen, Theatrical Method from Garrick to Griffith* (Cambridge, Mass., 1949), a pioneering exposition of the continuity between the movies and the nineteenth-century pictorial stage. Macgowan names, among American directors of the time liable to make use of painting, William Christy Cabanne, Herbert Brenon, Thomas H. Ince, Allan Dwan. For D. W. Griffith's embodiment of popular pictorial imagery, see Karl Brown, *Adventures with D. W. Griffith* (New York, 1973), who notes, for example, that in the making of *Birth of a Nation*, "The grouping of the scene of Lee's surrender was an exact replica of an engraving Griffith was holding in his hand" (p. 75); and Bernard Hanson, "D. W. Griffith: Some Sources," *Art Bulletin* 54 (1972): 493-515, a substantial investigation of the sources of Griffith's imagery, particularly in *Intolerance*.

[2] H. T. Craven, pseud. [Henry Thornton], *Meg's Diversion*, French's Acting Edition, Vol. 73, Act II.

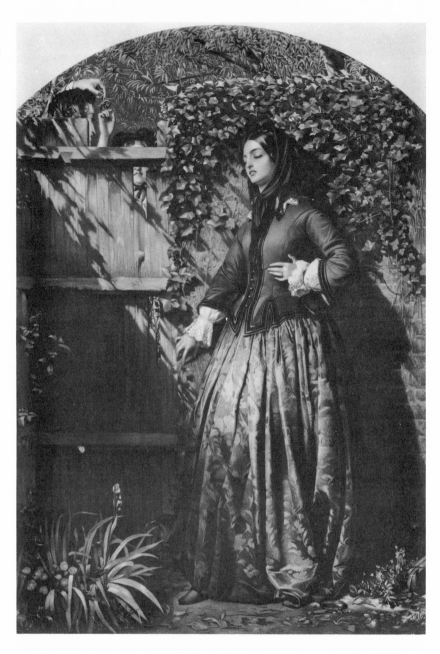

"*holds up a flower, and as* [Cornelia] *attempts to take it, he kisses her—*
Meg *places her hand to her heart—Music—this realizes the picture of
'Broken Vows.'* " There is no evidence in the text that the audience was
alerted to watch for the picture, though obviously at least a portion of
the audience was expected to recognize it. Nor is the play itself an
attempt to dramatize the story in the picture. The heroine of *Meg's
Diversion* is not a tragic heroine, but a practical joker who rather
deserves her heart-pang, and she ends her comedy of the heart with
the lover whose affections she had originally abused. On the other
hand, if the picture is not dramatized in the play, neither is it bur-

lesqued. There is no ironic contrast between the allusion and the scene. The allusion to the painting was above all a vivid pictorial realization, to be enjoyed for its own sake.

The realization of a painting in *Meg's Diversion* was of course no isolated instance, and the frequency of such events in the nineteenth-century theater tells us a great deal about that theater's fundamental habits of staging, acting, and dramaturgy. Moreover, pictorial allusion and the picture realized provide, not only a series of specific conjunctions between the arts (fiction included), but also concrete illustration of their changing relations in the period, to each other and to their audiences.

Pictorial allusion in the nineteenth century differs from earlier kinds of visual allusion in the theater in not being directly iconographical. It attempts to embody a *particular* painting or engraving, rather than an ideal image in the public domain such as we find in the Elizabethan drama (Shylock with knife and scales striking the pose of Justice), and in the medieval tableaux of scriptural events. Nor does the modern practice draw much on classic work to create values by parallels and contrasts or to use allusion for thematic enrichment. With a few significant exceptions, the nineteenth-century form uses contemporary work that has achieved enough current success to have been engraved, displayed in print-shop windows, discussed and illustrated in periodicals, and sometimes pirated. And the allusion is not a hovering presence as it often is in the Augustan literary mode, or a delicate reminder, but an attempt at the fullest possible realization. The realization of a particular painting on the stage, especially one of current interest, creates its own kind of audience response. It constitutes a moment of achieved effect first of all, like any other successful dramatic tableau. But unlike the simple tableau, it also occasions the pleasures of recognition and "truth." The audience marvels at how "real" a painting can be made to seem in another, actually living medium; more real than it could have been in the first place. A sophisticated viewer may be aware of triumphs, not only of pose, dress, and makeup, but of lighting and perspective as a means of achieving effect. But even for the most sophisticated, the seeming truth of the imitation will be primary.[3]

The picture is realized primarily for spectacular, not thematic enrichment, though occasionally, as in *Meg's Diversion*, it may add an intriguing harmonic. Such realizations differ from the pictures on the walls in Hogarth's *Marriage-à-la-Mode*, or in Augustus Egg's triptych on adultery, or in H. K. Browne's illustrations of Dickens, pictorial allusions whose regular function is thematic comment. Moreover, there is a difference in "effect" between Browne's hanging Charles Leslie's *Uncle Toby and the Widow Wadman* (1831) over the dinner table at which Bagstock is inveigling Dombey into marriage, and Craven and his collaborators' turning the entire stage—all that is immediately present to the spectator—into a recognizable picture. Rather more like Browne and Hogarth is Shaw's use, within the scene, of a print of Titian's *Assumption of the Virgin*, along with various other emblematic items in the setting such as a flowered coal scuttle, in *Candida*; and Wilde's use of a tapestry *Triumph of Love* in the first act of *An Ideal*

[3] Théophile Gautier compliments a realized *Radeau de la Méduse* at the Th. Ambigu-Comique: "Les groupes, disposés comme ceux de Géricault et modelés par une lumière livide, sont du plus grand effet et font une illusion complète." And of a similar tableau in an operatic competitor at the Renaissance, he declares, "Géricault lui-même, s'il pouvait rouvrir sa paupière à tout jamais fermée, serait content de cette reproduction de son chef-d'oeuvre." *Histoire de l'art dramatique en France depuis vingt-cinq ans* (Paris, 1858-1859), 1:258, 262 (6 May and 3 June 1839). See below, pp. 192-95.

Husband. These are visual emblems, but have nothing to do with realization. Most reviewers of *Meg's Diversion* make a point of mentioning the embodiment of Calderon's picture and its effect; none of them takes up the matter of its thematic appropriateness.[4]

IN SOME plays the realization of the painter's image came as a surprise; in others, however, subject or title created a pictorial expectation, so that the play and its dramaturgy became a machine for realization. Film again supplies a parallel and illustration.

The memorable images that came out of World War II were produced by the still camera. One of the most successful, in that it had a nearly universal recognition value in America, was Joe Rosenthal's prize photograph of the Marines raising the flag on Mount Suribachi (Iwo Jima) in February 1945. The photograph was apparently the record of a posed tableau, made shortly after the fact; the symbolic image of an action rather than a literal snapshot, it was readily translatable into sculpture.[5] The image succeeded as the emblem of a difficult victory, at once democratic and heroic. It was an old-fashioned picture compared to the best of the war pictures, and our equivalent of the heroic paintings of contemporary history, especially of the Napoleonic epic, in nineteenth-century France. In fact Allan Dwan's exceedingly successful film, *Sands of Iwo Jima* (1949), stands in the same relation to the Iwo Jima photograph as the Napoleonic plays of the 1830s do to the paintings of Horace Vernet (see below, Chapter 11).

Allan Dwan's film sets a fictional drama of the individuals belonging to a schematized "typical" squad (led by John Wayne) in the heart of a quasi-documentary, quasi-historical account of the Marine Corps in the war. Threading these levels of style and subject is a long preparation for the tableau realization near the very end. The invasions and the battles point to this culmination; and on the individual level, the promised display of the flag is a sustained motif throughout. (One squad member carries a flag on his person at all times, though eventually, historically, it is another flag and an anonymous group that fulfil our expectation.) The photograph is realized as a tableau. Near the end, we see six marines on Mount Suribachi push the flag up to its slanting tableau position, where it is held; the picture cuts to the watching faces of the squad's survivors; it returns to the tableau group, still in the same position, and the raising continues to the vertical. There the image is again sustained, and intercut with the watchers, while the Marine Hymn swells. The frame, it is important to note, has not been frozen (the flag flares in the breeze). The actors have realized and held a climactic tableau which, originating in a photograph, is an appropriate culmination to the pictorial montage out of which this stirring and apparently "action-filled" picture is chiefly composed.[6]

The use of such a prepared, indeed featured, and perhaps obligatory instance of pictorial realization in *Sands of Iwo Jima* testifies to its appeal and effectiveness even in a medium whose characteristic expression is not the summarizing symbolic tableau, but the representative image.[7] The effect doubtless would have been compromised or at least different if the image in *Iwo Jima* were not known to originate in a "true" photograph. And just as the photographic origin of the image suits its embodiment in the film medium, so the distinctive origins of

[4] The best account of the scene is in the *Illustrated Sporting and Theatrical News* (27 Oct. 1866), p. 662: "Mr. Cuthbert has supplied a very beautiful scene, 'The Garden of Crow's Farm,' for which he deservedly receives a call nightly. In this scene, by-the-way, is realised most effectually Calderon's picture 'Broken Vows.' Meg on one side of the garden railings (a magnificent bit of scene painting these same railings, with the overhanging trees &c.) overhears the love-talk of Rowland and Cornelia. The scene as a stage effect—and we do not speak now simply of the scene painter's work, admirable as that is, but of the scene as presented by the combined skill of the dramatist, the actor, and the painter—is, in its simple beauty, worth a hundred of the ruck of sensation scenes, let them each be ever so elaborate and costly."

[5] In the Marine Corps War Memorial, Arlington National Cemetery. Edward Kienholz, who makes three-dimensional pictorial agglomerates, used the tableau as the centerpiece of his *Portable War Memorial* (1968) (illustr. in *Museen in Köln Bulletin 9* [Sept. 1971], cover).

[6] Another film using Rosenthal's image was Delbert Mann's *The Outsider* (1961), the painful story of what happened to Ira Hayes, a Pima Indian and one of the flag-raisers, before and after he became famous. To make its social and human point about glory and exploitation, the film re-creates but understates the moment of the photograph, and then shows it blown out of proportion and turned into an arrested and arresting tableau on the front pages of the newspapers. Along with newsreel war footage (also used in *Sands*), the film includes "authentic clips of President Eisenhower's dedication of the Mount Suribachi monument in Washington" (*New York Times*, 8 Feb. 1962, p. 25).

[7] The difference is well illustrated in Hitchcock's *Murder* (1930), his early medium-exploring film equipped with two juxtaposed endings, the first eminently cinematic, the second pointedly theatrical. The first, in a railway train compartment, shows the hero and heroine close up, his arm around her, going off to a future together. The man—a distinguished actor-manager—tells the young woman to save her tears for the part in his next play. The second, in a drawing room, shows the elaborately gowned heroine admitted by a maid and sweeping into the embrace of the hero, where the action halts in a tableau. The proscenium framing then is revealed as the camera slowly pulls back, "naturalizing" the scene while the applause begins.

the earlier tableau realizations, in popular prints and engravings after paintings, suit the special pictorial nature of the nineteenth-century stage. The intimacy of the relation between picture and stage, painting and dramaturgy, was expressed in a review of Douglas Jerrold's *Rent Day* (1832), a play embodying two related paintings by David Wilkie (see below, Figs. 48-49). The critic remarks, "We have seldom felt more interested in any performance. The pictures are excellent; and this praise extends not only to those which have been borrowed from the painter, but to several—Martin surrounded by his children; the robber scene; Rachel fainting across her husband's knee; the broken chair; and the *finale*, where the painter in turn may be indebted to the compositions of the stage manager."[8] The reviewer is suggesting here that each of the second set of images, narrative and situational and together an epitome of the playwright's contribution, was fit to inspire the painter; that, both in composition and in subject matter, they were appropriate material for a pictorial art that was itself narrative and situational; and that on the stage, lit, frozen, and partially framed, they were at least as good as a painting. The reviewer assumes that just as painting is a narrative art, so theater is a pictorial art, and that they share a common language.

THE USE of pictorial realization in the popular theater, in a social range extending from the "legitimate" (but inclusive) Covent Garden and Drury Lane, through the Adelphi, the Queen's, the Surrey, the Coburg, the City of London, the Standard, the Britannia Saloon, says something about the nature and availability of the images employed. The theaters far down the social scale favored Cruikshank, Hogarth, and the illustrations from current serial fiction; but Wilkie also appears, as do popular exhibition pieces by such painters as Henry Dawe and Abraham Solomon. Technical advances in printing and paper manufacture that came into play after the Napoleonic wars; the rediscovered craft of wood-engraving; stereotyping, lithography, and the substitution of steel for copper in mezzotint engraving (as late as 1823) had an enormous cumulative effect, quantitative and qualitative, on the currency of images. In England especially, where, as Thackeray observed in the 1830s, "money is plenty, enterprise so great, and everything a matter of commercial speculation," wood- and steel-engraving flourished and, "by the aid of great original capital and spread of sale,"[9] broadcast the artist's images, much affecting their character. As far as painting was concerned, A. Paul Oppé wrote truly that, "It is impossible to over-estimate the effect on the artist, both in choice of subject and treatment, of catering for a large, uninstructed public through a speculative publisher," so that "many pictures, as for example Martin's and Landseer's, can almost be regarded as a mere stage in the production or publication of a popular artist."[10] Novelists, essayists, and artists have made plain the part played by the print-shop window in giving the image popular currency; even more important were the journals, from the illustrated weeklies with their Academy and Exhibition samplers, holiday numbers, commissioned paintings, and vigorous entrance into the market for reproduction rights, to the working-class penny magazines.[11]

But despite the roles of technology and a changing economic order

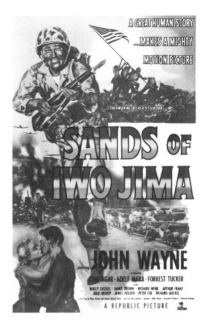

16. *Poster for* Sands of Iwo Jima *(1949), Republic Pictures.*

[8] Quoted in the "Editorial Introduction" to *The Rent-Day*, in *The Modern Standard Drama*, ed. Epes Sargent, Vol. IV (New York, 1846).

[9] "Caricatures and Lithography in Paris," *The Paris Sketch Book* (London, 1869), p. 152.

[10] "Art," in *Early Victorian England*, ed. G. M. Young (London, 1934), 2:122-23.

[11] For example, *Reynolds's Miscellany*, price one penny, a mixture of entertainment and improvement with working-class politics and a working-class audience, offered its readers cheap reproductions of Wilkie's *Rent Day* and *Blind Man's Buff*, Vol. 3 (19 Feb., 18 Mar. 1848); but it also reproduced so unlikely a picture as Windus' *Burd Helen* (a wood-engraving, 5″ x 7″, by Henry Linton), n.s. 20 (3 July 1858), p. 412. The *Rent Day*, offered to *Miscellany* purchasers "at the Extra Charge of only Three Half-Pence," was advertised as a wood-engraving seven months in the preparation, and as "the *finest* as well as the *largest* ever presented to the Public. It is of the exact size of the Original, printed on fine paper, and altogether got up in a style hitherto unequalled and impossible to be surpassed. It is larger than the sheet of REYNOLDS'S MISCELLANY when spread open!" (about 28″ x 20″).

in promoting a machine-based common culture graded from shoddy to fine, the relation between artist and audience in nineteenth-century England owed much to the eighteenth century and to the enterprising genius of Hogarth. Similarly, despite all the changes in dramaturgy, reading habits, and audiences, the conjunctions of narrative and picture on the nineteenth-century stage owed much to the eighteenth century, and are best approached through the stagings of Hogarth. Therefore the discussion that follows (Chapter 7) begins with eighteenth-century anticipations of the picture dramatized, in a less popular, less pictorial theater, and goes on to some revealing nineteenth-century transformations. The subsequent discussions present a variety of meetings and collaborations between narrative and picture; at the same time, they seek to suggest some currents of development through the century. The last discussion (Chapter 19), approaching the end of the century, takes up an achieved and transformed pictorialism in the theater of Henry Irving. Irving exhausts a tradition and initiates a change. His successors turn from the theater of material illusion to the theater of subjective realities.

7

✦ ┃ ✦

FROM HOGARTH TO CRUIKSHANK

T O BEGIN with the incipient pictorialism of the eighteenth-century theater is not simply a matter of historical justice. Hogarth dramatized, in the eighteenth century and then in the nineteenth, offers a contrast in possibilities, a contrast that speaks to the nature of dramatic genre and its effect on the materials upon which drama works. To judge by results, genre was not much more than a bundle of expectations for the audience, and an array of opportunities for the playwright and performer. It was not a fixed form—the practical artist is as much concerned with novelty as with repeating earlier success—but it nevertheless sought its own in new material, while trying to accommodate or ignore what was awkward or foreign. The dramatic genre that could best accommodate Hogarth's picture progresses in the eighteenth century, however, differed from that which could do so in the nineteenth as slapstick pantomime differs from harrowing melodrama. The change reflects not only the rise of new genres, but differences in the conception of that which underlies all genres: the medium itself (theater), and the mode (drama).[1]

The contrast in opportunities appears in altered terms in France, where the revolution in audiences and expectations was considerably more sudden and pronounced. The contrast in the uses of pictorialism before and after the Revolution is all the more revealing for the participation of a self-conscious, atypical innovator of genius, capable of embracing contradictions. Beaumarchais' *Marriage of Figaro* is both aberrant and transitional. It ushers in a pictorial dramaturgy based in situation, but framed in terms of the rococo mock-simplicities and sophisticated indirections for which Revolutionary classicism would find no use. Stylistically, the play reaches backwards and forwards; but the elaborate harmonics of its form of pictorial allusion belong to a different world from the pictorial realizations that succeed it, notably of the paintings of Jacques-Louis David. In the theater of the Revolution, David's paintings are realized, not as indirection and overtone, a way of creating an intriguing ambivalence and an allusive masquerade, but rather as illustration, the direct extension of an existing text and an authenticating and clarifying reinforcement.

[1] Much as I admire Northrop Frye's attempt to clarify and fix the use of these terms, his definitions are not the most serviceable in dealing with the nineteenth-century jungle, and for this chapter I will use medium, mode, and genre as in the foregoing paragraph. To accommodate the wild efflorescence of hybrids, mutations, and variants in the nineteenth century, "species," "subspecies," and the language of natural history would do better service, I imagine, than "genre" and the language of literary classification; but a systematic commitment to the biological metaphor has its own doubtful side.

Hogarth's progresses enjoyed more than one form of translation in the nineteenth century. They became plays, novels, and even other picture series, with a change in the lesson. Cruikshank invented two progresses that follow Hogarth's model closely, and these were also brought upon the nineteenth-century stage as melodrama. But when placed between their graphic models and their subsequent melodramatic embodiments, Cruikshank's progresses illustrate something besides the effect of genre on media translations. In such company, much of the difference in tone and conception between Cruikshank's *The Bottle* and its Hogarthian models appears as the reflex of melodrama, that popular and pervasive serial pictorial form. Characteristic styles and even structures are not confined to a single medium in a given age, and there is no reason why the genre of melodrama should not have influenced Cruikshank directly, given Cruikshank's special interest in capturing its audience. There is plenty of evidence that it did so influence him. But with so much to unite the graphic and the theatrical versions of Cruikshank's serial images, there nevertheless remains an irreducible tension between them, and this marks the limits of convertibility. This tension suggests that genre form and style in the end are *not* fully transferable; that (however transitory) they exist integrally with medium and mode, and can influence but not become one with a sister art.

Hogarth Animated

In October 1759, an afterpiece at Drury Lane attempted to animate a picture by Teniers. Billed as a "*Comic Dance* call'd the Flemish Feast," the afterpiece was one of a rash of costume dances, narrative dances, dances with rustic and domestic subjects popular in the Garrick period, and probably not the only one to attempt to bring a painting to life.[2] The dance, moreover, was not the earliest form to experiment with bringing a well-known picture upon the stage in eighteenth-century England, and it shared some essentials with its predecessors and contemporaries. These tended to be musical and pantomimic. They were sometimes graced with the descendants of the commedia masks, and in England often showed the influence of ballad opera. The first and greatest of the ballad operas furnished Hogarth with the text for a commentary on the art of looking (*Scene from the Beggar's Opera*, 1729-31); and the brilliant duplicity of Gay's "Newgate pastoral" in matching old tunes with new words, ideal pretensions with low life, may also have helped inspire the theatrical device of informing familiar pictures with living actors and action.

A quarter of a century before the *Flemish Feast*, there appeared the first of a long series of theatrical entertainments based on the works of Hogarth. Hogarth's appeal for the theatrical entrepreneur was probably more a matter of ready-made audience than of the dramatic and theatrical character of his images. By mechanical multiplication, advertisement, and display, Hogarth had found a medium and a method relieving him of the necessity of aristocratic patronage, and had created an audience for his images that any theater would be happy to share. But also, in his well-known jottings on his enterprise of "painting and

[2] George Winchester Stone, Jr., *The London Stage, 1660-1800, Part 4: 1747-1776* (Carbondale, Illinois, 1962), 16 Oct. 1759 and 3 Nov. 1761, and p. cxxxvi.

engraving modern moral subjects," he repeatedly urged that his pictures and their subjects be judged as if they were stage compositions; for "my Picture was my Stage, and men and women my actors who were by Means of certain Actions and expressions to Exhibit a dumb shew."[3] Assuming that Hogarth knew what he was about, it is surprising that his great narrative series had to wait until the nineteenth century for full-scale attempts to realize their drama, and until the twentieth century of Auden and Stravinsky for a version approaching the originals in dramatic power. Hogarth reached the stage as a moral dramatist (rather than simply a comic one) and as a picture-maker *and* story-maker, only when drama had caught up with his pictorial method of epitomizing the stages of a progressive action and particularizing a general story.

The Harlot's Progress; or, the Ridotto al' Fresco: a Grotesque Pantomime Entertainment . . . Compos'd by Mr. Theophilus Cibber, Comedian. The Songs made (to old Ballad Tunes) by a Friend was first performed at Drury Lane on 31 March 1733, eleven months after the publication of Hogarth's engravings. In the published scenario, Cibber dedicates the play "to the ingenious Mr. Hogarth, (On Whose Celebrated Designs it is Plan'd)." It had a considerable success, appeared in the bills for the next three seasons, and found hasty imitators.[4]

In Cibber's version, which is all mimed action liberally punctuated by song, Hogarth's "modern moral subject" is pruned of the fifth and sixth plates, the Harlot's death and funeral. Moreover Miss Kitty (as Cibber politely calls Hogarth's M[oll] Hackabout) shares her leading position with Harlequin, who appears in every scene and is harmonized with Hogarth as the clandestine lover of the second plate. But despite such radical departures, the stage enactment of the first four plates recognizably imitates Hogarth, and that of the first and fourth adumbrates the techniques of the age of tableau.

The scene corresponding to the first plate begins with an opening tableau, the revelation of a familiar picture whose implications are then elaborated. The directions read:

> AFTER the Overture, the Curtain rises;—the Scene represents an Inn; The Bawd, the Country Girl, the *Debauchee* and the Pimp, all rang'd as they are in *the first Print.*—The Parson on the Right Hand, reading the Letter, soon goes off [he is apparently horseless]—while the Bawd is persuading the Girl to go along with her, Harlequin appears at the Window, and seeing the Country Girl, jumps down, and gets into a Trunk which belongs to her, while the Bawd sings.[5]

The scene based on the fourth plate (the Bridewell scene) approximates the chief alternative method of the nineteenth century: a picture whose elements are present on the stage is in the course of action "realized." But the realization here is as action, rather than as picture; there is no moment of culminating arrest, but rather a climactic transformation. Transformation, and especially the animation of the inanimate, were essential to the pantomime genre and as such would influence profoundly some of Hogarth's literary and graphic successors, notably Dickens and Cruikshank. In Cibber it appears, not because it is derived

17-22. (following pages) *William Hogarth, A Harlot's Progress, engravings 1732, London, British Museum.*

[3] From Hogarth's autobiographical notes, in *The Analysis of Beauty*, ed. Joseph Burke (Oxford, 1955), pp. 209, 216. Frederick Antal demonstrated Hogarth's debt to dramatic illustration in *Hogarth and His Place in European Art* (London, 1962), p. 105. The most interesting observations on the relation of the dramatic mode to the narrative progress within Hogarth's work are in Ronald Paulson, "Life as Journey and as Theater: Two Eighteenth-Century Narrative Structures," *New Literary History* 8 (1978): 43-58.

[4] These include *The Harlot's Progress: with the Diverting Humours of the Yorkshire Waggoner*, which played at the fairs in 1733 billed as "A new Ballad Opera"; and a *Harlot's Progress* that opened Sadler's Wells as a pantomime house (12 Mar. 1733), apparently anticipating Cibber's entertainment, which, however, had been in preparation for many months. See Arthur H. Scouten, *The London Stage, 1729-1747*, pp. xxxix, 312, 314, and *A Letter from Theophilus Cibber, Comedian, to John Highmore, Esq.* (London, 1733), p. 3. Henry Potter's opera *The Decoy: or, The Harlot's Progress* (1733) shows no evidence of Hogarth in the libretto, despite its parasitic subtitle in the bills. Another ballad-opera which did draw on Hogarth, *The Jew Decoy'd; or, The Progress of a Harlot* (London, 1735), was unperformed.

[5] Theophilus Cibber, *The Harlot's Progress* (London, 1733), p. 5.

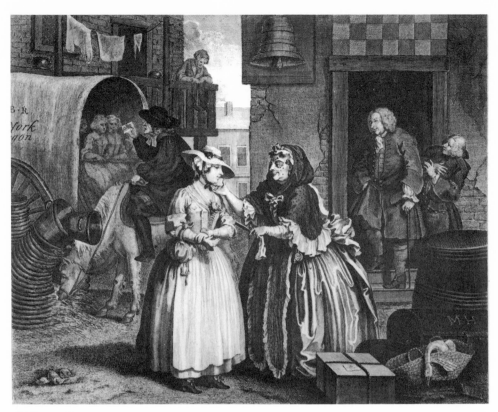

17 Plate I

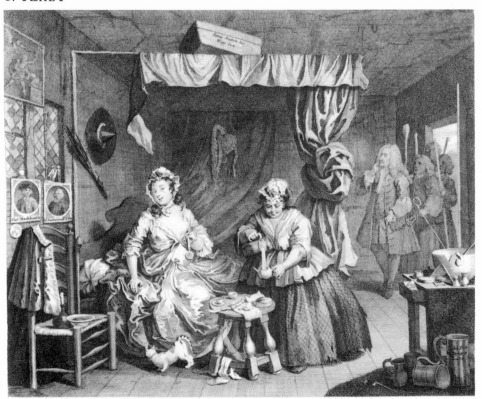

19 Plate III

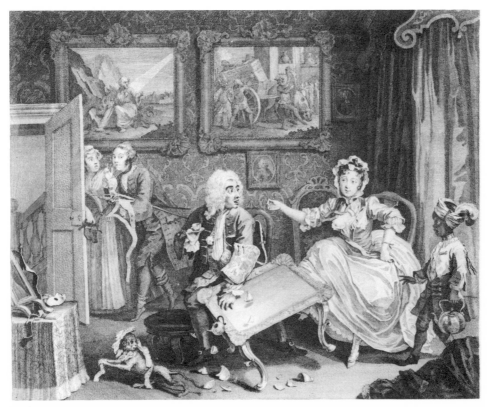

18 Plate II

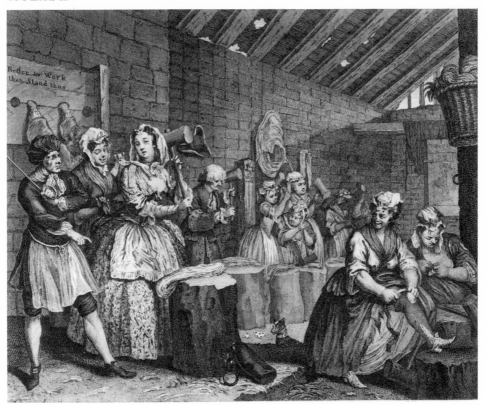

20 Plate IV

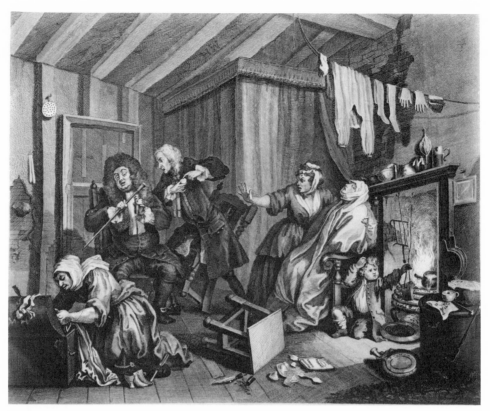

21 Plate V

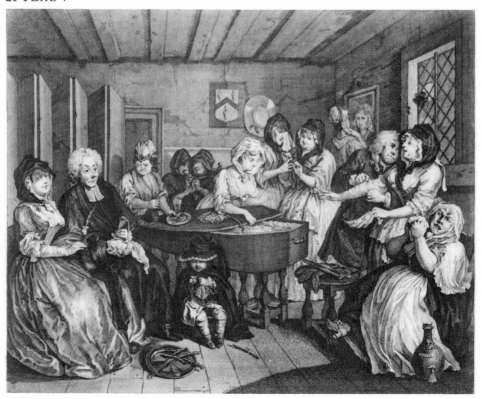

22 Plate VI

from the action or spirit of Hogarth's images, but because transformation was the genre-linked concomitant of the actions that normally constituted the pantomime dumb show. In Cibber's Bridewell,

> The Women are discover'd all leaning in an indolent manner upon their Blocks.—The Keeper enters, and seeing them so idle, threatens to beat 'em—as they take up their Hammers and Beetles, and are going to beat, the Blocks all vanish, and in their stead appear Harlequin, Scaramouch, *Pierrot*, and *Mezetin*, each takes out his Lady to dance, and signify they'll go to the *Ridotto al' Fresco*; the Keeper runs away frighted, they all dance off. [p. 12]

The intervening two plates—the Harlot in high keeping and in low lodgings, about to be taken by the Magistrate—are cited in the libretto and enacted, but are not brought even close to realization as tableaux. Their action is approximated piecemeal, at the expense of any meaning that depends on simultaneity, in the interests of a generically more appropriate action. In Hogarth's second plate, for example, the Harlot, looking sly, upsets the tea table to cover her lover's retreat. In the pantomime, "*Kitty* appears in Confusion, and makes Signs to the Maid to let Harlequin out; but while he is attempting to steal away, he accidentally drops his Sword and Cane, which surprises the *Jew*, who turning about perceives Harlequin, upon which Miss *Kitty* in a Passion over-sets the Tea-Table" (p. 10). The characters imitate the attitudes and the actions in the plate, but consecutively, giving the action as a whole a different meaning. The change allows "Beau Mordecai" to secure both the door and Harlequin as preliminary to singing a duet of abusive recrimination with Kitty and to pursuing Harlequin about the stage. The picture as such and its narrative content are imperfectly imitated in order to occasion the actions—leaps and transformations—appropriate to the genre of the play:

> A Picture falls down, Harlequin jumps thro' the Hangings, and the picture returns to its place and conceals him.—The Subject of the Picture, which was before an Historical Story, is now chang'd to a Representation of the *Jew* with Horns upon his Head.—While he stands in astonishment the other Picture changes likewise, and represents Harlequin and *Kitty* embracing—upon which the *Jew* runs out in the greatest surprize. [p. 11]

In Hogarth's plate, the Old Testament scenes on the wall supply a metaphoric comment on the relations of the Harlot and her keeper. Elsewhere Hogarth occasionally uses the accidents of perspective to effect a "transformation," as in the horned husband in *Evening (The Four Times of the Day)*. But even if the notion of suggesting an equivalent for such devices struck Cibber, his first requirement was to imitate the medium of enactment, a compound of pantomime and ballad opera. Musical situations and pictorial situations may be easily reconciled; but the primary effect of the slapstick chase and literal transformations of Pantomime—the obligatory active expression in that medium of the comic evasion of consequences—was to subvert Hogarth's picture and story as well as his moral drama.

Pantomime, however, is essentially spectacular, and there is abundant evidence in the scenario remains of Cibber's harlequinade of a determination to exploit spectacle as fully as possible, as an avenue of imitation. The Hogarthian sets were evidently elaborate, for between any two of the scenes taken from the plates is a scene in "the Street," obviously there for the carpenters. The first interscene also serves to make a narrative transition between Plate One, the Country Girl about to be served up to Colonel Charteris (Cibber's "Debauchee"), and Plate Two, Kitty as the kept mistress of "Beau Mordecai." Like the Hogarthian scenes, the grand masquerade and dance that conclude the whole provide the pleasure of spectacular recognition: "The Scene changes to the *Ridotto al Fresco*, illuminated with several Glass Lustres, (the Scene taken from the place at *Vaux-Hall*)."[6]

Other dramatic works with obligations to Hogarth appeared in the course of the century.[7] The most interesting of these is a brief "Musical Entertainment" by George Colman, with overture, air, and recitative, called *Ut Pictura Poesis! or, the Enraged Musician* (1789). Its prologue[8] refers the audience to Colman and Garrick's *Clandestine Marriage* (1766) as an earlier trespass on Hogarth. Garrick's prologue to the earlier and better-known collaboration declares:

> To-night, your matchless Hogarth gives the Thought,
> Which from his Canvas to the Stage is brought.
> And who so fit to warm the Poet's Mind,
> As he who pictur'd Morals and Mankind?

It is only the thought, however, that the play shares with Hogarth, and not very much of that:

> But not the same their Characters and Scenes;
> Both labour for one End, by different Means:
> Each, as it suits him, takes a separate Road,
> Their one great Object, MARRIAGE-A-LA-MODE![9]

The loveless alliance of blood and money with which Hogarth's satirical homily on marriage and society begins never even takes place in the play. Though sentimental comedy could accommodate a modern moral subject, the root fable, perspective, and affective form of the genre left little room for Hogarth.

Ut Pictura Poesis! was a different matter. Hogarth's broadly comic single plate, *The Enraged Musician* (engraving 1741) is the foundation and culmination of the entertainment, and whatever the print has to say about the trials of "higher" art in a *Beggar's Opera* world (prominently advertised) is joyously incorporated in the musical farce. Colman's slight additional plot of the elopement of "Castruccio's" daughter with Young Quaver is only mildly sentimentalized, and in any case is subordinate to the scenic and musical requirements.

After an interior scene (in which Castruccio's Celebration Ode is interrupted by cannon) and various preliminaries which draw on the elaborate detail of the print, Quaver enlists all the pedlars and noise-makers of the street to assist the elopement. As they congregate, Ca-

[6] Jonathan Tyers reopened the Spring Gardens at Vauxhall on 7 June 1732, with a famous "Ridotto al Fresco." Hogarth was early involved with the decorations. See Lawrence Gowing, "Hogarth, Hayman, and the Vauxhall Decorations," *Burlington Magazine* 95 (1953): 4-19.

[7] See Robert E. Moore, *Hogarth's Literary Relationships* (Minneapolis, 1948), pp. 60-61, and Antal, *Hogarth*, p. 105.

[8] Handwritten in the British Library copy, 8th ed. (London, 1789), as are the additional prompter's directions quoted below.

[9] George Colman and David Garrick, *The Clandestine Marriage, a Comedy* (London, 1766), p. [vii].

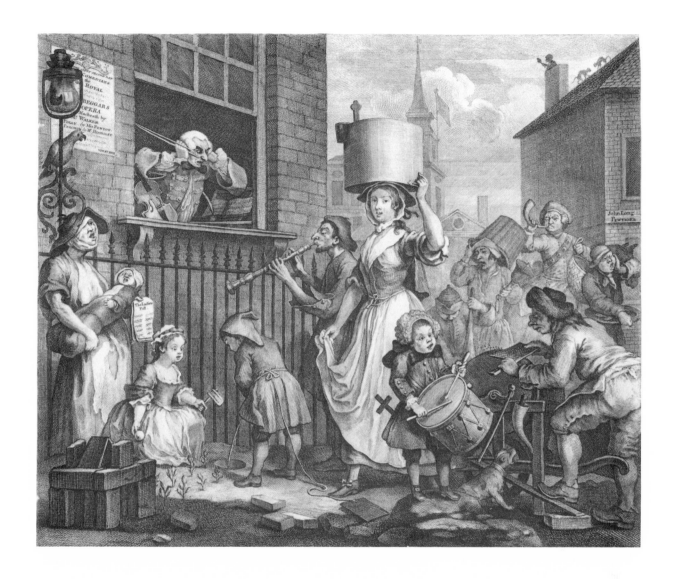

struccio throws up the window and curses *recitativo*, while, screened
by the distraction, the couple make off. Then comes a "Glee," a rhym-
ing counterpoint of Castruccio's curses and the street cries. The final
printed stage directions read, "*At the end of the Glee, or before,* Quaver
and Castruccina *return with the drums and marrow-bones and cleavers,
and kneel before the window, which enrages* Castruccio *still more: And
the rest of the piece concludes amidst the confusion of drums playing,* &c.
a girl, with a rattle, little boy with a penny trumpet, old bagpiper, &c. *as
near as possible to* Hogarth's *Print of* THE ENRAGED MUSICIAN" (p.
17).

This of course is not quite Hogarth's print, which includes such
unstaged detail as a little boy urinating, and is innocent of the kneeling
couple. Their return, like that of the fugitive couple in *She Stoops to
Conquer*, is a gesture toward the sentimental, marking the limits of
Laughing Comedy, and is generically and pictorially an intrusion in
Hogarth's scene. Nor does the embodiment of the scene quite resolve

23. William Hogarth, The Enraged
Musician, *engraving 1741. Lon-
don, British Museum.*

[10] A figurative silence, since the later tableau-realization was conventionally signaled and accompanied by music (cf. *Meg's Diversion*, above). This, however, was subjective sound—music expressive of the dominant passions embodied in the picture and of the audience's proper response to an "effect"—rather than objective sound generated by action or surroundings.

One further pictorial allusion on the eighteenth-century English stage is worth remarking for its mimetic circularity. In a re-creation of Garrick's festival entertainment *The Jubilee*, at Drury Lane, 18 Nov. 1785, Mrs. Siddons appeared in the concluding pageant as the Tragic Muse, after Reynolds' splendid portrait of her in that character (exhibited 1784). Accounts vary, but that in the *Morning Post* suggests that the first-night audience refused to recognize the self-impersonation, let alone the pictorial allusion (19 Nov. 1785).

[11] Thomas-Simon Gueulette, *Notes et souvenirs sur le Théâtre-Italien au XVIIIᵉ siècle*, ed. J.-E. Gueulette, Bibliothèque de la Société des Historiens du Théâtre, no. 13 (Paris, 1938), p. 177.

[12] Letter of 8 Nov. 1761, *Mémoires et correspondance littéraires, dramatiques et anecdotiques, de C. S. Favart* (Paris, 1808), 1:200. Favart makes clear that the "scène française" at the end was responsible for the success of the piece and general rapture. Since a response had to be based on having seen this attraction at the recent salon, it says something about the social character, as well as the tastes, of this audience.

[13] Diderot, *Salons* (1761), ed. Jean Seznec and Jean Adhémar (Oxford, 1957), 1:141-44.

[14] Greuze, at least in retrospect, conceived *L'Accordée* as part of a series of "petits drames familiaux" whose principal recurrent figure would be "le père de famille" (see Émile Dacier, *La Gravure de genre et de moeurs*, in *La Gravure en France au XVIIIᵉ siècle* [Paris and Brussels, 1925], p. 78). He left a novelistic scenario for a twenty-six part picture series called "Bazile et Thibault, ou les deux éducations," with an evident debt to Hogarth's *Industry and Idleness* (repr. in Anita Brookner, *Greuze* [Greenwich, Conn. 1972], pp. 156-64; also 47-48, 136). Diderot's debt to Hogarth is demonstrated by Jean Seznec, *Essais sur Diderot et l'antiquité* (Oxford, 1957), pp. 27-29, and R. Loyalty Cru, *Diderot as a Disciple of English Thought* (New York, 1913), pp. 425-26.

in the tableau immobility of the nineteenth-century "realization"; for the final handwritten prompter's stage direction reads, "Drop Curtain in the Midst of the Confusion, and the Noise continues some little time after." Animating the picture in Colman's theater means giving life to the noise, noise that depends on motion, and the forms of a pictorial dramaturgy are not yet so overriding and unreasonable, not yet so attuned to the graphic visual image, as to ignore this necessity. Only the nineteenth-century theater would be paradoxical enough, or simple enough, to try to give life and truth to such a picture by returning it to stillness and silence.[10]

Meanwhile in France

On the eighteenth-century French stage, pictorial allusion appears rather later than in England; but then it had the impressive support of a reformist theory which applied the venerable analogy between painting and poetry to the practical art of the theater. The earliest instance in France of the animation of a known painting that I am aware of was in Carlo Bertinazzi's *Les Noces d'Arlequin* (1761), recorded by a contemporary as, "Com. Ital. mêlée de chants. Ils formaient un tableau tout pareil à celui que Mʳ de Greuze avait exposé au salon en 1761, représentant la signature d'un contrat de mariage de paysans."[11] Favart reported—in language that emphasizes animation—that Greuze's recent painting, *L'Accordée de village*, "est mis en action avec tant de vérité, que l'on croit voir le tableau même dont on a animé les personnages."[12]

Four years earlier Diderot's revolutionary commentary on the dramaturgy of *Le Fils naturel* had appeared (above, p. 41); and in the year of *Les Noces d'Arlequin* his enthusiastic *Salon* account of *L'Accordée* elucidated its ordonnance as a scene of character and mingled emotion focused by the familiar situation.[13] Greuze must have been aware of Hogarth, and presumably thought to refine upon him; and as much can be said for Diderot, as a theorist of the drama.[14] Hogarth's prints offered a lesson in visually composed, serially ordered dramatic narrative. But Diderot also knew and used, to the point of trespass, Hogarth's *Analysis of Beauty* (1753), which concludes with some striking observations on stage action. On the stage, Hogarth declares, "The actions of every scene ought to be as much as possible a compleat composition of well varied movements, considered as such abstractly, and apart from what may be merely relative to the sense of the words." Hogarth explains what he means by "supposing a foreigner, who is a thorough master of all the effects of action, at one of our theatres, but quite ignorant of the language of the play; it is evident that his sentiments under such limitations, would chiefly arise from what he might distinguish by the lines of the movements belonging to each character." The translation of movement into visible lines and affectively charged pattern, of a temporal into a dynamic spatial notation, is implicit here. Also implicit are Diderot's eloquent pantomime and his embracing pictorial model for the stage, though not yet the structure of arrest and progression that they led to. Hogarth, however, continues with a prescient analogy which unites the theatergoer and the picture-viewer,

time and space, narrative and scene. He observes "that as the whole
of beauty depends upon *continually varying*[,] the same must be ob-
served with regard to genteel and elegant acting: and as plain space
makes a considerable part of beauty in form, so cessation of movement
in acting is absolutely necessary; and in my opinion much wanted on
most stages."[15]

THE ACTUAL tableau configuration of Greuze's painting would reap-
pear in countless tableau diagrams in nineteenth-century prompt books
and acting editions. The family is disposed in a tight semicircle, closed
in by the notary on the right, the basket and broom on the left, and
the picture plane, with the father's open-handed gesture bridging the
unavoidable gap in the tangled chain of arms and hands introduced
by the new son-in-law, now possessed of the bride and the dowry. The
stage, basically a narrow, walled-in space, is here confined and do-
mesticated. The tableau is not in contemporary terms "theatrical," but
it is a particularized version of a general story concentrated and dram-
atized. Transferred to the theater, such a scene foretold a redefinition
of the stage and the stage picture.

24. *Jean-Baptiste Greuze*, L'Accor-
dée de village *(1761), lithograph
by J.-F.-G. Llanta. Paris, Biblio-
thèque Nationale.*

[15] *The Analysis of Beauty*, pp. 161-62.

25. (facing page) *Carle Vanloo*, La Conversation espagnole *(1754), engraving by J.-F. Beauvarlet (1769), London, British Museum.*

16 Friedrich Melchior Grimm, *Correspondance littéraire, philosophique et critique par Grimm, Diderot, Reynal, Meister, etc.*, ed. Maurice Tourneaux (Paris, 1877-1882), 13:323 (June 1783) and 519 (April 1784).

17 COUNTESS
Take my guitar. (*The Countess, seated, holds the paper to follow the song. Suzanne is behind her armchair and plays an introduction while looking at the music over her mistress's shoulder. The little page stands before the Countess, eyes lowered. This tableau is precisely the beautiful print after Vanloo called "*THE SPANISH CONVERSATION.*"*)
Pierre Augustin Caron de Beaumarchais, *Théâtre complet*, ed. G. D'Heylli and F. de Marescot (Paris, 1869-1871), 3:99 (Act II, sc. 4). The engraving, by Jacques-Firmin Beauvarlet, was completed in 1769. Beauvarlet exhibited preparatory drawings of the *Conversation* and a companion piece by Vanloo in the salon of 1765. The painting had been completed in 1754 when, according to Baron Grimm, it won the suffrages of all connoisseurs, and remained famous in the next two decades. Grimm identifies the lady as "une comtesse flamande, veuve, qui tient un papier de musique et qui chante. Derrière son fauteuil on voit la soubrette qui l'accompagne de la guitare." *Correspondance*, 2:410 (1 Oct. 1754), and 10:118 (15 Dec. 1772).

Infinitely more complex was the relation between picture and stage in what was taken for other reasons to be the most revolutionary play of its time. In *The Marriage of Figaro* (1778-1784) Beaumarchais attempted to pursue the dramaturgical implications of Diderot's dramatic pictorialism, by creating for them, as for more subversive matters, a historical and stylistic reverberator. Beaumarchais provides a labyrinthine comic intrigue, a large dose of progressive plot which, as Grimm found, furnishes the integument for a series of brilliant situations.[16] Each situation exists discretely, but varies and repeats. Each is bound up with a form of substitution and demystifying exposure, both in the end metaphoric and thematic. The situations form a serially incremental assertion of an equality in fundamental humanity (all cats in the dark are grey), and contrariwise of an irreducible individuality. Each act is built with such a situation as its fulcrum or climax, and (if one allows the spectacular fourth-act ceremony which is supposed to substitute for the *jus primae noctis* as a variation), the emphatic result is a picture. The mechanism is simple in the first act, when Cherubin is revealed (after multiple displacements) under the cloak on the armchair, and the actors freeze with surprise or dismay. It is complex in the last, where Beaumarchais contrives the piecemeal assembly of a picture before our eyes to climax a final crescendo of substitutions and exposures, helped imaginatively by night and a garden setting that breathes rococo eroticism.

By placing his satirical anatomy of privilege, custom, and institutions in the perspective of a supposed Spain, supposed feudal practice, and comedy of intrigue, Beaumarchais established something like an optical ambivalence, a shifting double image which, however perspicuous in the end, permitted evasions. "Substitution" and "equivalence" are not confined, then, to the levels of theme and situation; they belong to the primary encoding. The rules for reading and response required seeing double. It was this which made the difference between the one intriguing instance of pictorial allusion in *The Marriage of Figaro* and most such events in the drama of effect and situation still to come.

In the midst of the second act, Cherubin gets to sing his new song to an old tune to the Countess in her bedroom. Suzanne volunteers to accompany him, and takes up the Countess' guitar, whereupon—in Beaumarchais' directions—a picture is formed:

LA COMTESSE
 Prens ma guitare. (*La Comtesse, assise, tient le papier pour suivre. Suzanne est derriere son fauteuil, et prélude en regardant la musique pardessus sa maîtresse. Le petit Page est devant elle, les yeux baissés. Ce tableau est juste la belle estampe d'après Vanloo, appellée "*LA CONVERSATION ESPAGNOLE.*"*)[17]

Actually the *belle estampe* contains, in addition to an interested bachelor spaniel, another human figure, a young girl seated beside the lady, staring straight at the viewer with an expression rather like a knowing Eros; and in place of the young page is a mature, curled, beribboned, and bearded cavalier, whom the lady receives with a melting look. Moreover the scene is not the lady's boudoir, but the figures are grouped before an architectural screen (with a backdrop of landscape and ar-

chitecture in the arcade openings) like that which defined the playing space in a Palladian version of the classical theater.[18] In painting, such a background came to function as a symbolic *theatrum* or an abstractly ideal setting. In Vanloo's picture it helps define a fictive world that is both theatrical and erotic, stylized and intimate. Beaumarchais' evocation of Vanloo's scene would thus bring the newer dramaturgy, and the style of representation it called for, into comparison with a sophisticated, older conjunction of theater and picture, not on the stage but in painting.

For the fully aware spectator in Beaumarchais' theater, the image glimpsed through the configuration of the Lady, the Page, and Suzanne would provide an additional piquant insight into the ambiguous relationship between the Countess and Cherubin. It would also add to the romantic (as well as prudent) *espagnolisme* of the play.[19] It would invoke, moreover, the recollection of another courtier, adult and passionate, and another musical "conversation," in the play that occasioned this sequel. In *The Barber of Seville*, "Lindor" (Almaviva) declares his love to Rosine, the future Countess, also by putting new words to an old song. ("Prenez ma guitare," says Figaro, as the Countess will say to Suzanne. Later, in the memorable scene of the music lesson, Rosine takes in hand the music of "La Précaution inutile," and sings Lindor an "ariette, dans le goût espagnol.") In Beaumarchais' sequel, the superimposition of images, with Almaviva present by proxy in the evocation of Vanloo's picture, brings into a single harmonic concurrence the play's antithetical sexuality: Cherubin and Almaviva, youth and full-fed maturity, one overflowing and generous, the other acquisitive and monopolistic. It is Phèdre's superimposed image of Hippolyte and the young Thesée again, brought to a comic and forgiving conclusion. At the center of the picture is the Countess, and the knowledge of time that darkens and deepens the play.

BEAUMARCHAIS' sophisticated indirections hardly suggest the pictorialism of a popular theater. Such a theater, however, self-consciously of and for the people, was only a few seasons away, and makes an instructive comparison. The differences lie, not only in the uses of pictorial allusion, but in the pictures themselves and their place in popular consciousness. This is not to say that Jacques-Louis David's classical paintings did not operate as political statements by a species of indirection, but they came equipped with a prior interpretive consensus. What is striking in the theater, then, is the blatancy of the image, the universality of its apprehension, and its use as a symbol to crystallize the message in concentrated form. So, for example, a controversial production of Voltaire's *Brutus* in November 1790 had the play's newly imputed revolutionary nationalism reinforced definitively by the culminating spectacle of David's *Brutus* (1789). Voltaire's play ends decorously, with the announcement by messenger of the execution of the protagonist's insufficiently patriotic son. But on the second night of the new production, the painting that (according to observers) every Parisian knew and the whole audience recognized was "set in action." At the moment of the announcement, "this unfortunate father places himself on an antique chair like the Brutus of the painter, and one sees

[18] See David Rosand, "Theater and Structure in the Art of Paolo Veronese," *Art Bulletin* 55 (1973): esp. 222-24.

[19] Dacier puts the engraving in a context of eighteenth-century exoticism, with an "espagnolisme" like the "turquerie" and "chinoiserie" of fashion.

the passage of the funeral cortege that brings his two children back to his house."[20] Ten years later a refurbished version of N. F. Guillard's and Salieri's opera, *Les Horaces*, brought life to David's painting of the *Oath of the Horatii*. The painting had been enacted en masse in the Robespierre-David "Festival of the Supreme Being" (1794), and any subsequent production of the opera might have been hard put to avoid that famous work of the painter who on such occasions transformed much of Paris into his canvas and stage.[21] David's great mass spectacles of the Revolutionary period had much to do with the future course of the pictorial impulse in the French theater, which turned in the next few years to the panoramic celebration of the Empire.[22]

The Brigand

Forty years gape between Colman's last adventure with Hogarth and the sudden burst of picture plays in England and France in the theater of the 1830s. The interval had been a time of extraordinary transformations, and in the theater, long before 1830, "situation," "effect," spectacle, and the tableau that was their dramaturgical product had been thoroughly installed, along with serious pantomime, *melodrame* accompaniment, and other devices that competed with "legitimately" spoken dialogue. Appropriately, the first notable instance of pictorial realization in England in the age of the tableau was the work of James Robinson Planché, who had already constituted himself a pioneer of spectacular archaeological illustration (above, pp. 32-33).

In 1829 Planché hastily adapted a recent *vaudeville* called *Le Bandit*, by Théaulon de Lambert and others, first performed at the Nouveautés on 12 September. Two months after the French production, *The Brigand* appeared at Drury Lane with attractive features not found in the original. Planché's "Romantic Drama," as the acting edition called it, shifts the lighter musical vaudeville toward melodrama, a play of high passions and striking situations. The compound is laced with songs and choruses, characteristic of both forms and here quasi-operatic; but *The Brigand* is also self-consciously full of painting. Massaroni, the title character, comes to grief through capturing a pair of young artists, who sketch his picturesque attitudes even as their fate hangs in the balance. His own particular Sheriff of Nottingham is the remorseful Italian nobleman who once seduced his mother and fathered him, and in the end unwittingly kills him. The belated recognitions come about through a worshipfully enshrined painting of the wronged mother. All this serves to enhance the most striking of Planché's innovations, noted in the bills and described in the stage directions:

> *Scene 1st Summit of the Mountain of Guadagnola with the Mediterranean in the distance. On the right of the Spectator large Masses of Rock intermingled with shrubs and trees in the front of which upon a detached fragment Massaroni is discover'd reclining; his wife Maria seated at his head watching him. At the angle of the Rock and on the brink of the precipice stands an oak or Ilex its branches stretching over the abyss—beside it a Brigand is seen on guard. The distance is shrouded in mist at the rising of the curtain and becomes clear during the execution of the following Round the Symphony to*

[20] Grimm, *Correspondance*, 16:117 (Nov. 1790). See also David Lloyd Dowd, *Pageant-Master of the Republic: Jacques-Louis David and the French Revolution* (Lincoln, Neb., 1948), pp. 35-36.

[21] *Courrier des Spectacles*, 19 Vend. IX (11 Oct. 1800), p. 2. See Edgar Wind, "The Sources of David's *Horaces*," *Jour. Warburg* 4 (1940-41): 133-35; and Dowd, *Pageant-Master*, p. 123.

[22] David's Directory painting, *The Sabine Women* (1799), gave rise to a vaudeville, *Le Tableau des Sabines* (1800), whose action unfolds before the entrance to the exhibition where the citizens flock to see David's painting. At the high point of a quarrel, between rival suitors and their partisans for the hand of Laure, the participants accidentally fall into place in an elaborately detailed contemporary version of the painting, recognized by the stage crowd itself. Though the image is by definition a parody, the details "are all so much homage to the first painter of France" (*Courrier des Spectacles*, 9 Germ. VIII, or 29 Mar. 1800). The setting, the crowd, and the play speak eloquently of a conjunction of painting and theater as popular dramatic spectacle. (For a fuller description, see Kirsten Gram Holmström, *Monodrama, Attitudes, Tableaux Vivants* [Stockholm, 1967], pp. 218-21.)

26. (below) *Charles Eastlake*, Sonnino Woman and Brigand Asleep *(1822), engraving by William Say, London, British Museum.*

27. (facing page) *Charles Eastlake, A Brigand's Wife (1823), engraving by Charles Turner (1824), London, British Museum.*

[23] From the autograph MS, "The Brigand Chief. A Drama in Two Acts with Music," Lord Chamberlain's Plays, British Library, Add. MSS 42898. Subsequent directions are quoted from the published version, *The Brigand, a Romantic Drama in Two Acts*, Lacy, Vol. 2. The playbill—using the shorter title—credits the scenery to Marinari, Andrews, and Clarkson Stanfield (Enthoven).

which must be sufficiently long to allow the contemplation of the picture formed from the 1ˢᵗ of the popular series of Mezzotinto Engravings after Eastlake—"an Italian brigand chief reposing & c."[23]

Just before the end of the scene, Maria "*springs upon a jutting rock, under the oak-tree, c., grasping with her left hand a branch that overhangs the precipice, and looking anxiously down the mountain.—Forming the second picture from Eastlake's Series, 'The Wife of a Brigand Chief watching the result of a Battle,' &c.*" The play ends with the last picture of the series, *The Dying Brigand.*

The enveloping medium of melodrama, here romantic and picturesque, and Planché's emphasis on the contemplation of the picture so that it may make its full effect, are characteristic of the new age. Planché is interested in realizing, not merely the speaking configuration, but the persons in their authentic habit and as much of the scene itself as possible. It is worth noting that the setting in the opening scene is a clever but simple and practicable conflation of the landscape in the first two Eastlake pictures, making use of some repetition of elements. As the mist that initially shrouds the distance clears behind the immobile

26

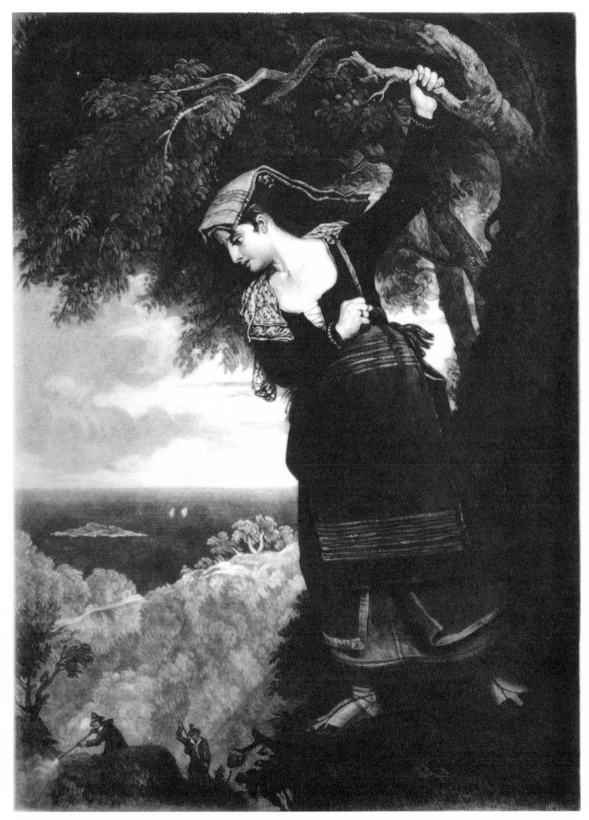

27

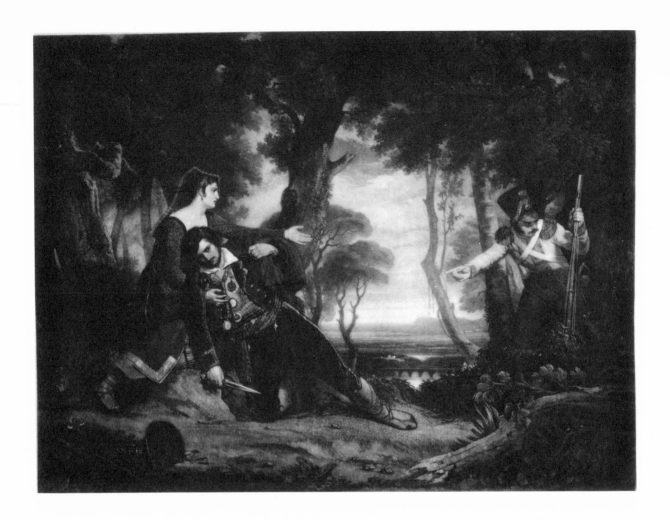

28. *Charles Eastlake*, A Brigand
Wounded and Other Figures
*(1823), engraving by S. W.
Reynolds as* The Dying Brigand
(1826), London, British Museum.

figures, the setting of the opening tableau is transformed to that of the second realization, which supplies the final effect of the scene. For his opening tableau, Planché ignores the small figures of approaching soldiers in the upper right of Eastlake's first picture, figures that add a note of imminent peril and premature disruption. Planché requires initially a more stable situation for contemplation, since his skeletal Brigand's Progress proceeds by swift changes in state, marked by the tableau realizations.

In his memoirs, Planché (never bashful) claims credit for initiating the fashion of pictorial realization in the theater, and throws some light on the matter of recognition and response: "In this melodrama I introduced three tableaux from Eastlake's well-known pictures . . . engravings of which had been just published by Messrs. Moon, Boys, & Graves, and were in all the printshop windows. They were very effective, and led to the adoption of this attractive feature in several subsequent dramas, Douglas Jerrold's 'Rent Day,' founded on Wilkie's celebrated picture, in particular."[24] Planché may indeed have given impetus to the subsequent proliferation of this attractive feature in the age, but he says nothing of his own inspiration, apart from Eastlake.

[24] *The Recollections and Reflections of
J. R. Planché* (London, 1872), 1:152-53.

Planché was an extensive borrower from the French stage, scouting it professionally in his frequent visits to Paris; and in 1826 and 1827 he traveled through Germany, where the *tableau vivant* had invaded the theater (see Wilkie's letter of 1826, above, p. 48). Yet so much inspiration and more he might have found at home. Planché was an antiquarian by temperament, and as a considerable pioneer of scenic development in his own right, very much attuned to the visual. Moreover, between 1811 and 1827 more than one minor theater that Planché sometimes visited mounted a production that claimed to be founded on Hogarth's *Industry and Idleness* (noted below). It is probably no accident that in the first unequivocal instance of pictorial realization in the new era, Planché incorporates his play with a picture *series*, one that already seems to tell a dramatic story.

Any narrative continuity in Eastlake's brigand series is suggested rather than fully elaborated; but his engraved subjects arrange themselves in a serial order that can be read as either long or short in period, as the stages of a progress or as a nearly continuous action. His intentions, however, probably lay more in the realm of picturesque genre, wherein danger and domestic interest enhance the exotic dress and surroundings. Both Scott and Salvator hover in the background. Lady Eastlake reports that these "Banditti subjects" served Eastlake "as a further occasion for indulging his love of landscape, and at the same time gave a romance of a quasi-historical character to his scenes, which appealed to a larger public."[25]

Scott, especially his *Rob Roy*, certainly influenced Planché's *Brigand*. Like Rob Roy *and* Eastlake's protagonist (but unlike the brigand in Planché's French source), Massaroni has a domestic side, a helpmeet who can lead and fight as well as watch and mourn. Planché's brigand is proud, generous, heroic, but he is also a melodramatic *burlador*, much of whose audience appeal lies in a daring prankishness, and whose depredations and outlawry are anarchic social criticism. The principal plot, however, is the outcome of a fatal alienation in the family (fatal only in the English version), a distant echo perhaps of Schiller's *Die Räuber*. Eastlake's pictures at beginning and end frame this elemental plot of ironic retribution and revelation, marking the beginning and end of a downward linear progression that complements the retributive circularity. The result is not, in any obvious way, Hogarthian; but it points to a link with the picture progresses of Hogarth's deviants from the path of wholesome domestic order. It is worth remarking that the picture series and the domestic storytelling picture remain characteristic of the native English theater, while in nineteenth-century France pictorial realization is chiefly devoted to the grand, panoramic, historical, sensational canvas.[26]

Hogarth Amplified

The Brigand in 1829 was the first instance of pictorial realization in the nineteenth century to make its mark in England; but a number of minor-theater versions of Hogarth's most popularly oriented and executed series, *Industry and Idleness*, survive as titles from the previous two decades. An advertisement for the Surrey Theatre in the *Times*

[25] "Memoir of Sir Charles Lock Eastlake," in his *Contributions to the Literature of the Fine Arts*, 2nd ser. (London, 1870), p. 101. Several of the paintings were exhibited at the British Institution in 1823 and 1824. In the print-shop windows, in addition to those engravings Planché identifies as *An Italian Brigand Chief Reposing* (engraving by W. Say), *The Wife of a Brigand Chief Watching the Result of a Battle* (engraving by Charles Turner, 1824), and *The Dying Brigand* (engraving by S. W. Reynolds, 1826), Planché probably also saw *The Wounded Brigand Chief Successfully Protected* (by his wife and a stream from pursuing soldiers, engraving by W. Say, 1824), and the single-figure *Bandit of the Apennines* (engraving by Charles Turner, 1824). A later larger engraving called *The Brigand* (engraving by W. Humphreys), dedicated by the publisher to James Wallack, star of Planché's play, shows the title character looking down on the approaching soldiers, his wife with her hand on his shoulder, and two other brigands in the shrubbery. The titles attached to the paintings vary, and are not always the same as those appearing on the engravings. The variants are sorted out in David Robertson's *Sir Charles Eastlake and the Victorian Art World* (Princeton, 1978), where the prints Planché realized appear under items 68, 77, and 78 of "Appendix A: Paintings by Eastlake." Robertson discusses and illustrates the bandit subjects and some theatrical prints after the play, pp. 17-18, 23-24, 36-38. See also George Speaight, "The Brigand in the Toy Theatre," in *The Saturday Book* 29, ed. John Hadfield (London, 1969), pp. 204-215.

[26] Planché himself had a taste for the rococo, reflected in his subsequent use of pictures on the stage. The most successful was a musical entertainment called *The Court Beauties* (1835), set in the reign of Charles II, where "LELY's portraits . . . are realized in *tableaux vivans*, by the ladies personating the fair originals," and come to life in their frames as part of a prank on Buckingham (*Spectator* 8 [4 April 1835], p. 325). *The Golden Branch* (1847), a Christmas extravaganza, incorporated tableaux from Watteau and Lancret in its ballet; and *Love and Fortune, a Dramatic Tableau (in Watteau Colours)* (1859) discovers (after a prologue) "The Gardens of Cassandre's Country House, Group from Watteau—'Noces de Village' " (Lacy, Vol. 42).

of 26 and 27 April 1811, declares: "THIS and every EVENING will be presented, a new grand Melo-Dramatic and moral ilustration [*sic*] founded on Hogarth's Apprentices, called INDUSTRY and IDLENESS, written by Mr. [Dennis] Lawler." And in the Christmas season of 1827, the Royal Coburg presented "a New Interesting, Local and Moral Drama, replete with Splendid Pageantry, founded partly on Hogarth's celebrated series of Engravings, and partly on a Drama which has recently acquired great popularity in Paris, called, THE LONDON APPRENTICES; OR, INDUSTRY AND IDLENESS." In the latter instance, the principal spectacular feature was not Hogarth, but a moving panorama of London in 1610, from the Tower to Westminster, accompanying the "Procession of the Lord Mayor's Show by Water." Hogarth was more directly present in the succeeding "Procession to Tyburn," the "Procession of the Lord Mayor's Show by Land," and the concluding "Grand Civic Festival in Guildhall" (cf. Hogarth's *Industry and Idleness*, pls. VIII, XI, XII).[27]

In the burst of pictorial realization in the early 1830s, the first instance of Hogarth appeared at the Adelphi, a theater which made a feature of such pictorialism. Again, the source was *Industry and Idleness*. On the same bill as *The Forgery* (incorporating two of David Wilkie's paintings), appeared *The Printer's Devil; or, A Type of the Old One*, a "Caricaturish Burlesque Burletta" with "Idle Bob, a devilish bad Boy (Mr. John Reeve), Jerry Button, a Devilish good Boy (Mr. Buckstone), Nicholas, a Printer's Devil with a seductive tale (Mr. O. Smith)," numerous ghosts, Whittington and his cat, and "Hogarth's Tableau Vivant of the Idle Apprentice!" (26 Mar. 1832). The burlesque sends up many of the emblems of prentice morality, and perhaps signals a disposition in the audience to take its Tom Idles and Frank Goodchildren with a good deal of salt. At any rate, for the next two decades, the popular theater turned to the pictorial drama of Hogarth's more sophisticated series.

The first *Rake's Progress*, by William Leman Rede, appeared in 1833, and seems to have played widely in London.[28] Some of Hogarth's scenes are clearly approximated; but the acting edition makes certain only one tableau realization, of the first plate (I, 3). Rede's Tom Rakewell halts at many of the same stations as Hogarth's—a gambling den, marriage to a rich old woman, prison, the madhouse—but in Rede's play Tom's story is much sentimentalized. The melodramatic vehicle easily embraces Hogarth's moral drama and the pictorial progression, but it suits his social and moral satire less well. Even comedy is segregated in scene and character, much reducing the human complexity. In Rede's play, the pregnant girl whom Tom wants to buy off in Hogarth's first plate is transformed into a chaste attachment, niece of Tom's future rich wife; and Tom is made an innocent, led on by parasitic sophisticates. The irony of Rake succeeding to Miser disappears. In the end, after a *scena* in the madhouse, the Rake dies between keeper and true love most pathetically, but without the rich commentary of lunatics and sightseers that Hogarth provides. The play was revived in 1839 at Davidge's Royal Surrey Theatre, just before the appearance there of two much more interesting Hogarth plays: T. H. Reynoldson's *Curse of Mammon* (1 Apr. 1839), and J. T. Haines' *The Life of a Woman* (20 Apr. 1840).

[27] Playbill, 31 Dec. 1827, Enthoven. Nicoll also lists a *Hogarth's Apprentices; or, Industry and Idleness* at the Royal Amphitheatre, 23 Apr. 1821.

[28] *The Rake's Progress: A Melo Drama, in Three Acts . . . The Only Edition Correctly Marked, By Permission, From the Prompter's Book*, Duncombe, n.d.

From a dramaturgical point of view, the title of Reynoldson's play in the printed edition is lucidity itself: *The Curse of Mammon; being a Fac-simile Embodiment of Hogarth's Marriage à-la-Mode. A Pictorial Drama, in Five Acts.*[29] The first four acts begin with what are called the first four pictures of Hogarth's series (actually the third, the visit to the quack, is discreetly omitted); and after a front scene to begin the last act, *"The Curtain rises and discovers the Fifth Picture of Hogarth's Marriage, à la mode—the Suicide."* The *Examiner*, after complimenting the novelty and effectiveness of the play, observes of the conjunction of modes:

> The author has evinced some skill and ingenuity in uniting the situations of these well-known pictures with an interesting and effective drama. To a certain extent, of course, he has enlarged upon the subject Hogarth has chosen, but he has been happy in not departing from the details, and in being able, without injuring the fidelity of the *tableaux*, to link them with matter which adds to the interest of the piece.[30]

The "enlargement" incorporates a complex drama, rather well plotted, of an exchange of infants in the cradle, and the attempted seduction of a virtuous young woman, the young lawyer's supposed sister. Lawyer Talbot (Hogarth's Counsellor Silvertongue) is in fact the deprived rightful heir of Lord Normanfield (Hogarth's Squanderfield); and the steward of the second plate knows something about it. An elevated attachment between the citizen's daughter and the lawyer is made antecedent to the arranged marriage, and she is therefore neither vapid nor sullen as in Hogarth's first plate, nor is he buttery. There is an added low-comic element in the plot, to compensate for the romantic elevation of the principals and to provide the serio-comic range, variety, and contrast looked for in both drama and fiction. Toupee, the hairdresser in the fourth plate, is comically in love with the Countess, and also serves as the agent of catastrophe. He carries on a running joke about the height of one's "spear" (at one point he tells old Mammon, of his daughter: "You didn't choose the proper spear for her. A lord's spear is too high for a citizen's daughter—you should have married her to Mr. Talbot"). One would like to think this spear was the verbal form of the prominent motif in the engravings represented in the first scene by the Jesse tree springing from the founder's loins in Lord Squanderfield's pedigree, the cannon firing from between the legs of his portrait, not to mention his crutch and the guttering candle; and by the broken sword in the second scene, and the erect narwhal tusk and elevated cane in the third.

The production was painstaking and elaborate, and its pictorial nature was further emphasized in a prologue spoken by Davidge, the manager, who also played the steward. According to the stage direction, he appeared with mastiff "in the character of HOGARTH . . . (Vide the celebrated Portrait of 'Hogarth and his Dog.')" The production owed something to the fact that Yates' pictorially accomplished Adelphi company joined with Davidge's on this occasion, with Yates and his wife playing the mismated couple. According to D.—G., the ubiquitous editor of Cumberland's editions, "The living tableaux were exact counterparts of their well-known originals; they were correctly grouped,

[29] Cumberland Minor, Vol. 15. Nicoll lists the play (under Unknown Authors) as *The Curse of Mammon; or, The Earl's Son and the Citizen's Daughter*. G. A. Sala, who once shared quarters with Reynoldson, identifies him as "the 'stock' or hack-author at the Princess's" in the 1840s, paid not more than three pounds a week; and as "a gentleman of considerable talent, who in his youth had known Samuel Taylor Coleridge. He was for some time on the stage, and was noted as the original Mr. Pickwick in the version of Dickens' novel brought out at the Strand Theatre" (i.e. W. T. Moncrieff's *Sam Weller; or The Pickwickians*, 1837; see below, p. 252n.). Sala, *Life and Adventures* (London, 1895), 1:191-92.

[30] *Examiner*, 7 Apr. 1839, p. 216.

and bore the true expression of the master"; and the *Examiner* reviewer confirms that they were "rendered with great spirit and fidelity." Visual fidelity is suggested as well in the stage directions, as for the opening of Act III, "The Toilette and Levee," corresponding to Hogarth's fourth scene:

> Signor Farinelli *is seated* R., *holding a music-book and singing—* Herr Weidmann *stands behind him, playing on the flute—the* Earl of Normanfield, *with his hair in paper, is seated next, drinking chocolate—*Sir Felix Foxglove *and* Lord Leatherhead, R.C., *the latter asleep—*Lady Foxglove, *in raptures with the duet,* C.—Jupiter *behind her, handing chocolate—the* Countess *is seated near her toilette,* L.C., *attending only to* Talbot, *who is reclining on a sofa,* L., *presenting her a masquerade ticket—*Toupee, *with curling-irons, is dressing her hair—*Asdrubal, *the black boy, is in the left corner behind a basket of curiosities, and pointing with a significant leer to the horns of a little Actaeon.—After a few bars, Lady Foxglove raises her arm suddenly, knocks over the cup of chocolate which is being handed to her by Jupiter, and the Singer stops.*

The whole was a considerable success, encouraging the *Examiner* to declare, "the way in which this piece is received by the numerous audiences which nightly attend its representation, speaks much for the improvement of the taste of those who attend the theatre."

Improvement was also ostensibly to the fore when eight years later G.W.M. Reynolds advertised in his *Miscellany* the commencement of "an entirely New and Original Tale, by the Editor, entitled THE DAYS OF HOGARTH; OR, THE Mysteries of Old London."

> Hogarth's immortal pictures are truly national works; and many mighty morals—much strange variety of character—and an everchanging succession of social phases are delineated on the surface of the canvass which his pencil touched. It is therefore contemplated to found a TALE upon the most popular and the best known of HOGARTH'S PICTURES, and to illustrate it with faithful representations of those pictures, engraved on wood in the very first style of the art. The Millions will thus be placed in possession of what may be termed the "HOGARTH GALLERY OF PICTURES."[31]

The "gallery" brings in pictures from the two Progresses, *Industry and Idleness*, *The Four Stages of Cruelty*, *The Four Times of the Day*, as well as *Gin Lane*, *A Midnight Modern Conversation*, *Strolling Actresses Dressing in a Barn*, and *The Lady's Last Stake*. Engravings after *Marriage-à-la-Mode* illustrate a major strand of the very complex tale, a strand apparently influenced by Reynoldson's *Curse of Mammon*.[32] Ten years after the novel, the Britannia Saloon, Hoxton, presented *The Days of Hogarth; or, Marriage Ala Mode and the Mysteries of Old London. A Drama in Two Acts Founded on the Celebrated Pictures of the Marriage a la Mode*. The drama is stolen, in fact, from Reynoldson, with adjustments from Reynolds. Many of the names (like the title)

[31] *Reynolds's Miscellany of Romance, General Literature, Science and Art* 2 (22 May 1847), p. 32. The story ran until 29 Apr. 1848 (Vol. 3), and was later republished separately.

[32] Nicoll lists a *Hogarth's Mirror*, acted also as *Hogarth's Marriage à la Mode*, which played at the Strand 26 April 1847, only a month before the serial began its run. The play is not among the Lord Chamberlain's MSS, and the chances are it was a resurrected *Curse of Mammon*.

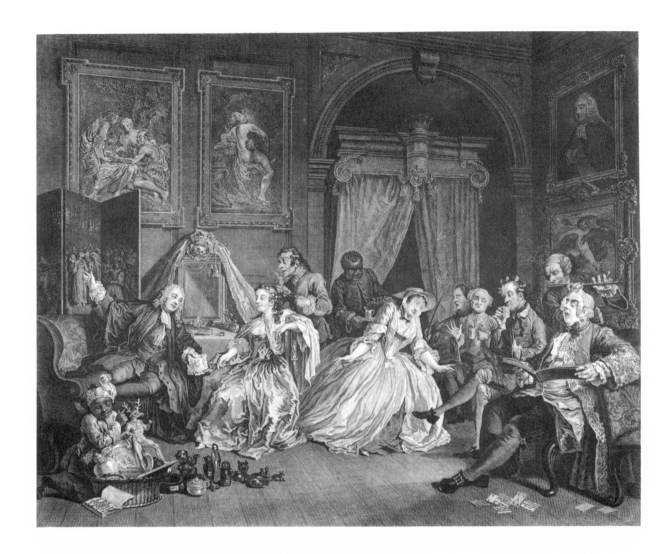

belong to the novel, but the plot has been confined to the Reynoldson segment, much less skillfully managed. The substituted heir and the ancillary attempted seduction reappear, and the same five out of Hogarth's six plates are "realized," supported by those additional pictures that a pictorial dramaturgy and the special character of melodrama require.[33]

In the autumn season of 1839, both the Surrey and the Adelphi Theatres capped the pictorial success of *The Curse of Mammon* with their versions of Ainsworth's *Jack Sheppard* (below, pp. 271-78). The Surrey followed in the spring with "an entirely New Original Pictorial Drama of Interest, forming a VILLAGE TRAGEDY! called the LIFE OF A WOMAN *or, the* CURATE'S DAUGHTER. Presenting a living embodiment & moving amplification of the conception of the immortal HOGARTH'S Celebrated Series of Pictures, denominated The HARLOT'S PROGRESS." The author, J. T. Haines, had also written the Surrey's *Jack Sheppard*, whose visual aspects had been looked after by Cruikshank himself.[34] A distressed reviewer fumed,

29. *William Hogarth*, Marriage-à-la-Mode *(1745)*, *Plate 4:* The Countess's Levee, *engraving by S. Ravenet (1745), London, British Museum.*

[33] L.C. MSS Add. 52965, licensed 11 Apr. 1857.

[34] Playbills, Enthoven, 27 Apr. 1840, 28 Oct. 1839.

"Scarcely three months have elapsed since the whole metropolis were rabid through the Jack Sheppard mania; and now, we are sorry to see, a new attempt has been made by the manager of the Surrey Theatre to pander to the beastly appetite that in such filth as 'Nix my dolly, pals,' could find agreeable food."[35]

Haines' play further illuminates the effects of genre expectations and opportunities on realization, and the strategies whereby the authentic visible image may be accommodated to technical and generic requirements. *The Life of a Woman* gives "living embodyment" to all six of the plates in *A Harlot's Progress*; but much of Haines' "moving amplification" is an evasion of their evident signification, and some ingenuity is required to realize the authentic pictures in an altered context. The compulsion to achieve a visually exact realization which distinguishes this dramatization from its eighteenth-century predecessors does not then extend to the whole spirit of the original work. In fact, as the *Examiner's* response to the *Curse of Mammon* made plain (p. 117 above), the ingenuity of the reconciliation of Hogarth's pictures to other matter, such as a traditional lost-heir plot, was itself appreciated. On another level, the playbill for *The Life of a Woman* stresses the morality and didactic efficacy of Hogarth's series, and implies a similar virtue for itself. But the morality of melodrama as a genre, or rather its affective form, imposed its *own* new requirements, which also had to be reconciled with the "authentic" physical detail and arrangement of the pictures. For the "effect" of a realization depended, not on the new wine, but on the old bottles. Accordingly, a notice on costume in the acting edition admonishes would-be producers of Haines' play that "The correct character of the dresses can only be understood by a reference to Hogarth's Work. The elaborate costumes are of the style of 1733, and the pictures alone afford the opportunity of attiring this drama with accuracy as well as furnishing embodyment of Tableau and Scenery."[36]

The first three scenes prepare an interpretive context for the detailed realization of Hogarth's first picture by showing Gourlay, servant to the rake Chartres, beating the bush in Yorkshire where the Curate lives with his two daughters, and Chartres concerting plans with Mother Needham. In the fourth scene, the picture so prepared, the Country Girl's arrival in London, is realized as an opening tableau; but the Curate on horseback, for example, though visually the same, has to be read very differently. Hogarth's plate is then further interpreted by a second, climactic tableau in the scene, where one "Lilly Jem" Dalton (whose wig box appears in Hogarth's third picture), having gallantly tried to interfere with the ensnaring of the Curate's daughter, is pinioned by Chartres' crew.

In the second act, the foolish-clever harlot of Hogarth's second scene is shown as very much the tearful, shame-struck, wan, and fallen magdalen: "*her dress is profusely extravagant, but her countenance is pale, and her eyes downcast and filled with tears.*" The unofficial second lover of the engraving is converted into Jem Dalton, whom Fanny allows on the premises not for clandestine frolic, but by virtue of a fraudulent message from her father. Realizing the picture as tableau poses a difficulty in that Fanny is in violent action; and a prompter's direction has crept into the printed text:

[35] Unidentified clipping, Enthoven. "Nix my dolly pals, fake away" was Jack's hit canting song, originally from *Rookwood*.
[36] Dicks, #468.

(*Wait till Picture formed.*)
SCENE III.—*The Bedchamber.*
[*The* PICTURE NO. 2—*Realized*]

The "Village Tragedy" of Haines' Fanny Rosemay lies between father and daughter, though a disappointed village lover also hovers in the background. In this emphasis, the play recalls *The Vicar of Wakefield*, anticipates *David Copperfield*, and yearns toward an epitomizing image that Hogarth doesn't supply, something along the lines of Rossetti's *Found* (below, Fig. 167), or Henry O'Neil's *Return of the Wanderer*.[37] After the scenes that realize Plates III and IV, her "Apprehension by a Magistrate" and the scene in Bridewell, Fanny encounters her questing father in the dark, and horrifies him into a solemn curse with her anonymous tale. She sickens then and dies, not of venereal afflictions, that inevitable concomitant of the harlot's life in Hogarth's moral world, but of a broken heart. The realization of Plate V, the death scene, is pictorially very close to Hogarth, with the English and French quacks quarreling and the landlady rummaging; only the harlot's neglected child and the venereal implications are omitted.[38] But the scene develops into a further interpretive tableau, much the same as its predecessor as far as the central group and event go, but purified of the ironic commentary provided by the minor figures. After Fanny's apparent last words—"A chord [*sic*] seems loosened round my heart, its broken and I die"—Dorcas says she will fetch Fanny's father. "*She is going.—Fanny rises—with supernatural energy stands for a moment unable to speak—her hand extended*, 'No, no! do not fetch him— he will curse me!'—*Falls.—Dorcas, with a shriek, flies to her, raises her as the scene is closed in.*" However crudely, this second tableau shifts the theater of moral action from the social and physical worlds to the inner world, the world of intentions, affections, memories, and passions, by which characters are judged apart from their deeds. This is the world of moral reality in melodrama, the form so committed, paradoxically, to the authentic mimesis of material reality.

The reunion of father and daughter is effected in the last scene, "The Funeral" (after a scene in Westminster Abbey by moonlight where Chartres, exposed by a reformed Gourlay, is captured by the forces of virtue). Hogarth's Plate VI is realized as an initial tableau; but then, after the folding screen visible in the engraving is placed before the coffin, Chartres is brought in, in custody. He is followed by the virtuous characters, including Fanny's maddened father, who throws down the screen and dies like King Lear. The final picture is a compound Pietà, with "*Dorcas . . . lying over the coffin—Adam* [the village lover] *with head of Abel* [Fanny's father] *on his knee—Grace* [the unfallen sister] *kneeling near—Sir John* [the Magistrate] *points to the group—Chartres horror struck. Tableau.*"

In the play as a whole, there is more life in the slang and manners of the underworld than in the elevated diction of the "serious" characters, and the attack on the play that linked it with *Jack Sheppard* (also indebted to Hogarth) was right insofar as Haines probably intended to create a pathetic female equivalent to that villainously conspired-against good fellow gone wrong. The gallant Jem Dalton—who is reported hanged before the end—is Jack in a more direct form. Even

[37] O'Neil's painting (Royal Academy, 1855) became the centerpiece of C. H. Hazlewood's *Jessy Vere; or, The Return of the Wanderer* (Britannia Saloon, 1856), French, Vol. 25. In the painting, engraved by W. H. Simmons, the Wanderer appears prostrate upon her mother's grave, her infant set down beside her, while her stricken father, supported by another daughter, is seen entering the graveyard gate. Fathers and daughters pervade the imagery of sexual transgression in this century, and O'Neil's picture may be seen as a pendant to Richard Redgrave's 1851 Diploma painting, *The Outcast* (illustrated in Robertson's *Eastlake*, p. 349).

[38] Haines separates the Harlot's nose-fallen servant and companion of the last four plates into two figures: Hockley Peg (played by a man) who serves the tea and fixes her garter in the scenes realizing Plates III and IV; and faithful Dorcas from Yorkshire who comforts and bewails her former mistress in the scene realizing Plate V, the death scene. The compound of debasement and kindliness in Hogarth is thus separated into its elements, which is the tendency in melodrama.

the charms of vice, however, regularly give way to the play's leading attraction, the authentic realization of Hogarth's picture series. The playbill is careful to point out the morality of Hogarth, with verse tags and quotations credited to John Ireland. But the play is melodrama, with its own moral and affective structure; and therefore the pictures make an effect as starting points rather than as narrative culminations. They require interpretation and even capping by morally and affectively functional final tableaux.

Hogarth's prentices returned, perhaps stimulated by Cruikshank's two temperance progresses, *The Bottle* and *The Drunkard's Children*, which occupied the minor theaters in 1847 and 1848, and by Reynolds' contemporaneous serial novel, *Days of Hogarth*. A *Hogarth's Apprentices; or, Industry and Idleness* cropped up at the Britannia Saloon, a theater well down the social scale.[39] In the play, the main lines of Hogarth's counterpoint are observed, but the two prentice progresses are more directly bound up with each other through the "amplification." There is a good deal of added comedy, some wholly irrelevant, between Mincing, a servant maid who writes bluestocking plays, and Nob, a beadle and would-be poet. The churchyard scene (where Hogarth's beadle appears) is given further point by Tom Idle's discovery that he is gambling on his father's grave. Tom's relationship with his mother is developed early in the play, and the harlot who betrays him in Hogarth's series becomes his faithful girl Sarah, whom he neglects for bad companions, ruins, and then scorns, provoking her revenge. Tom himself is victimized by a villainous aristocrat. In the judicial scene (Plate X), Goodchild commits Tom partly on Sarah's testimony, whereupon she dies, having taken poison, and Tom stabs himself, and so avoids the scene at Tyburn. The last scene, as in Hogarth, is a "Tableau, of Lord Mayor's Show." As in the dramatizations of Hogarth's other series, the progression in counterpoint of the two prentices is assimilated to a plot of external manipulation and intrigue, and above all to the moral and affective character of the host form.

Hogarth dramatized began with Cibber's pantomime, and in the nineteenth century it returned to pantomime, now developed into an improbable musical-spectacular form which dominated the theaters annually from Christmas well on to Easter. The Drury Lane Christmas pantomime for 1851 was *Harlequin Hogarth; or, The Two London 'Prentices*, billed in the scenario as a dish "*partly served up on Hogarth's 'PLATES,' with EXTRA SEASONING to suit the TIMES.*"[40] Both topical seasoning and the choice of subject owed something to the Great Exhibition, which provides a running gag and a grand tableau at the end, "The Interior of the Crystal Palace." The opening, in the form of a prologue with allegorical figures, is set in "*The Haunts of Idleness & Ignorance—the whole scene having the appearance of desolation.*" Idleness and Ignorance, "in a passion / To see the March of Intellect, become so much the fashion," set up a Manufactory of "Fetters for the Human Intellect! / Clogs on the Understanding / Stumbling blocks in the way / Of Useful Knowledge," and other such goods; whereupon out of two illuminated, expanding beehives come Industry and Knowledge, who change the factory into a "Cheap Printing Es-

[39] L.C. MSS Add. 43009.
[40] Lacy, Vol. 5. A fuller script is L.C. MSS Add. 43038A (the text quoted below). The authors were John Maddison Morton and Nelson Lee.

tablishment" producing innumerable Tracts for the People, a Library of Useful Knowledge, and so on. The whole scene is similarly transformed: the wastelands appear richly cultivated, a broken bridge becomes a suspension bridge, the Railroad comes on, and the School of Idleness becomes a School of Industry.

So far Hogarth has not appeared; only the updated spirit of Hogarth. But now the allegorical antagonists decide to join battle through a Drury Lane pantomime, whereupon *"outside of Printing Office, appears a circular frame."*[41]

The inner play begins in Whittington's vein, on the outskirts of London in 1761, with the two prentices making their way to the city. Hogarth's pictures appear, not in the course of an unfolding story, but as a dream "Vision of the future," parodying the tent scene in *Richard III*: *"Six of Hogarth's plates to be illustrated—two to be seen at a time, so as to contrast, the future career of the two apprentices . . . during the Vision,—Toby, as quiet as a lamb,—David, tossing about, then rushes wildly forward, a la Richard,—falls kicking—gets up Signifies, it's only a dream—takes a swig at Brandy . . ."* It is not clear how the visions were managed—whether they were paint, projection, or ghostly tableau—but, on a stage sometimes verging on the picture gallery, they were pictures within pictures.

Idleness and Ignorance eventually give up, and the harlequinade follows, full of topical jokes on the Peace Congress, vegetarianism, Bloomerism (a sign after a mixed battle reads "A Bloomer Row, More honor'd in the breach than the observance"); and of transformations, traps, flaps, acrobatics, visual puns and animism (Clown explodes four people—a black footman, a soldier, a Quaker, and a cobbler—and he and Pantaloon reassemble them with arms, legs, and heads all mixed up. Harlequin strikes a box marked "Patent Drilling Machine" and "discovers a Company of little soldiers"). These visual jokes, characteristic of the most surreal and spectacular of nineteenth-century theatrical forms, link the powerful graphic tradition that passed into nineteenth-century visual art in its "low" forms (Gillray, Heath, Cruikshank) with the curious imagination of Dickens and the madness of the early cinema.

[41] As in the L.C. MSS and Lacy's edition. Presumably the name of Hogarth's dog, Trump, has been confused with the name of Hogarth's victim, Charles Churchill, in *The Bruiser*, a satirical print based on Hogarth's self-portrait. Trump appears in both pictures.

"The essence of Cruikshank's grotesque," wrote Baudelaire, "is an extravagant violence of gesture and movement, and a kind of explosion, so to speak, within the expression. Each one of his little creatures mimes his part in a frenzy and ferment, like a pantomime-actor."[42] Cruikshank's relationships with the theater of his day, both direct and indirect, formal and stylistic, are exceedingly rich and illuminating and form the heart of a later chapter; but his greatest success in the theater may be understood as an extension of the Hogarthian dramatic mode, not the least because his pantomime extravagance was here subjected to the stylistic restraints of a "modern moral subject." The fact that emulating Hogarth's serious moral drama entailed a suppression of comic energy and satirical fancy in the treatment of the principals reflected not on Hogarth, however, but on the currently available notion of moral drama. In adopting Hogarth's narrative design and various identifiable motifs, Cruikshank brought his own series into a significant relation with contemporary drama. But he also found himself obliged to modify the style that Baudelaire admired by substituting one current form of dramatic expression for another, temperance melodrama for pantomime.[43]

The Bottle (1847) and *The Drunkard's Children* (1848), though cheaply reproduced and aimed specifically at those drinking classes that could not afford the vice, commanded a response in classes and subcultures that normally felt themselves superior to temperance melodrama. Dickens also reached from penny gaff to club and university; but even Dickens never provoked Matthew Arnold to verse, verse that focused precisely on the shattering effect of this eruption from lower life among "Valleys and men to middle fortune born."[44] As Cruikshank must have expected, the manifest relation to Hogarth—most obviously to *Gin Lane*, to some of Tom Idle's scenes in *Industry and Idleness*, to the two *Progresses*, and to the last of the *Four Stages of Cruelty*—was a source of strength, rather than a derivative enfeeblement, especially in predisposing response. It was generally recognized that parts of Hogarth were out of tune with modern sensibilities, and what Hogarth was to the eighteenth century, Cruikshank could be to the nineteenth. "This is as much a social history as *The Rake's Progress*," one *Bottle* reviewer declared; "And like it, as Lamb said, it is to be read, rather than looked at." But what this reviewer read was not only a nineteenth-century content, but nineteenth-century structures, including condensation of pictorial and dramatic forms:

> There is, so to speak, excellent dramatic conduct in this tragedy of *The Bottle*.—(By the way, it will, no doubt, be speedily placed upon the stage. We already see the "acknowledged domestic heroine" coyly refusing the glass, with Mr. Osbaldiston, in his airiest manner recommending the juniper poison.) The story is well prepared; and event follows event in natural order, leading as surely to the tragic end, as the fable of a Greek tragedy. All the details, too, are rendered with a nicety of observation, delicacy of touch, and a profound knowledge of all the requirements of the subject. In a word, *The Bottle* is a perfect domestic drama, in eight acts.

[42] "Some Foreign Caricaturists," *The Painter of Modern Life and Other Essays*, ed. Jonathan Mayne (London and New York, 1965), p. 189.

[43] Cruikshank had predecessors in the graphic serial mode of temperance melodrama and in adapting Hogarth to that end, notably Robert Seymour in his posthumous *Drunkard's Progress*, a series of ten lithographs, and E. V. Rippingille in his *Progress of Intemperance*, "a Series of Six Engravings from Original Paintings" (rev. *Art-Union* 1 [1839]: 141, 187). In neither is the domestic focus as intense as in Cruikshank. Temperance drama should be understood as an established form of domestic melodrama; if Douglas Jerrold invented the latter as he claimed, it was with *Fifteen Years of a Drunkard's Life!* (1828; see below, p. 147). Pertinent to Cruikshank's modified style and its generic character are four drawings of 1842 for John O'Neill's *The Drunkard. A Poem.* These are powerfully emblematic, but neither narrative, nor progressive, nor in a formal sense dramatic. E.D.H. Johnson characterizes them as "almost surrealist," and as such "far more terrifying than the would-be naturalism of the two famous series." See Johnson, "The George Cruikshank Collection at Princeton," *Princeton U. Libr. Chron.* 35 (1973-74): 28.

[44] "To George Cruikshank. On Seeing, in the Country, his Picture of 'The Bottle.'" Dickens wrote an admirable critique of the sociological shortcomings of the two series, with an appreciation of their graphic power, "Cruikshank's The Drunkard's Children," *Examiner* (8 July 1848).

The comfort and even coziness of the home—the husband has returned to dinner, and all about him bears evidence of careful, happy huswifery—render the last scene more appalling by the contrast. The wife is induced "just to take a drop:" she consents—the fiend Drink is welcomed to the hearth, and the tragedy is begun.[45]

In the event, however, Cruikshank's serial dramas required almost as much adaptation as Hogarth's, not because domestic melodrama was insufficiently pictorial or insufficiently moral, but because other canons and habits of the genre asserted themselves—for example, variety—and other notions of grace and reprobation. Also the medium asserted itself. The art of the serial picture-maker was an art of vivid compression, of putting the stages of an action into readable visual situations; the art of the dramatist added to that requirement the art of time-filling elaboration.

If there was an official dramatic version of *The Bottle* among the many that appeared in the minor theaters that October, it must have been T. P. Taylor's at the City of London (18 Oct. 1847); for the playbills announced, in type only less prominent than the title, "The whole of the Tableaux under the Personal Superintendance of MR. GEORGE CRUIKSHANK."[46] The play opens with "*A neatly-furnished Room in Thornley's House.* TABLEAU THE FIRST.—'*The Happy Home; the Bottle is brought out for the first time.*'" All eight of Cruikshank's plates are realized, all by discovery at the beginning of a scene, with intervening scenes to allow proper preparation and effect. The amplification includes a group of superfluous comic characters who complete melodrama's expected full range. In the moral drama proper, the principal characters are idealized types rather than strongly-marked individuals, a genre-characteristic apparent also in Cruikshank's protagonists and established in the model "Happy Home" of his first scene. In the following plates facial expression does not usually convey character, but rather—notably in the Husband, who has the best part—it expresses the passions (or, in II and III, alcoholic stupor). Such treatment of character and expression belongs to the tradition of serious acting, the acting of the passions; and both the expressive formulae of Le Brun and their acting-handbook equivalents are evident in the Husband of the last four plates. Comic character on the other hand, in the theater as in the popular print, was strongly marked, individual, and external, a matter of mask. But only one or two of the minor characters in *The Bottle* have physiognomic character—e.g. the sour Pickwickian bailiff in Plate III—though the son has acquired a marvellous little wise-guy look by Plate VIII. This close confinement to the central drama and its mood of high pathos relaxes in *The Drunkard's Children*, especially in the public scenes, where physiognomic character individuates members of the crowd—e.g. the bloated proprietor and the crazy-looking cross-eyed cripple in the Gin Shop (*DC* I). The world still tends to be divided, however, into idealized figures (namely the daughter) and character parts, comic and grotesque.

The primal fall in *The Bottle* is self-induced. The father introduces the poisoned apple to the happy home as a spontaneous, careless act, and the rest follows. For the playwright, however, a moral drama of

30-37. (following pages) George Cruikshank, The Bottle, (1847), glyphography, New York Public Library.

[45] *Douglas Jerrold's Weekly Paper*, 11 Sept. 1847, p. 1141.
[46] Playbill, N.Y. Public Libr. The text of Taylor's *The Bottle* cited here is that in French Minor, no. 20. Other dramatic versions of Cruikshank's first series include *The Bottle* (Royal Pavilion, 10 Oct.); *Our Bottle; or, A Drunkard's Progress* (Standard, 18 Oct.); *The Bottle Bane; or, A Drunkard's Life and Fate*, by G. D. Pitt (Britannia Saloon, 20 Oct.); and *The Bottle and the Glass; or, The Drunkard's Progress, A Drama of Every Day Life*, by C. Z. Barnett (Albert Saloon, 25 Oct.). All are in the L.C. MSS. Other spinoffs included a swiftly produced serial novel, advertised in *Reynolds's Misc.* 2 (23 Oct. 1847), p. 384, called *The Bottle; or, The Drunkard's Career*, in weekly penny numbers and monthly sixpenny parts, "Illustrated in the style of George Cruikshank."

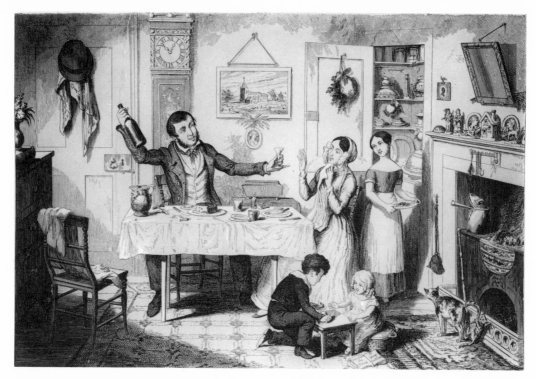

PLATE I. The bottle is brought out for the first time: the husband induces his wife "just to take a drop."

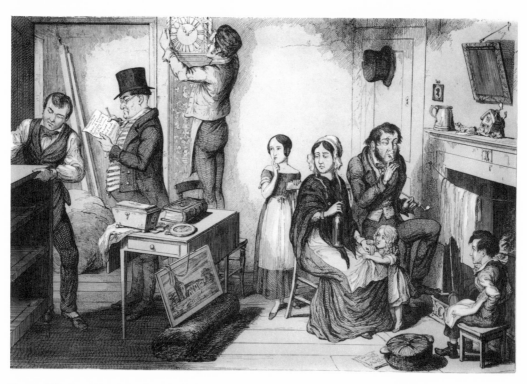

PLATE III. An execution sweeps off the greater part of their furniture: they comfort themselves with the bottle.

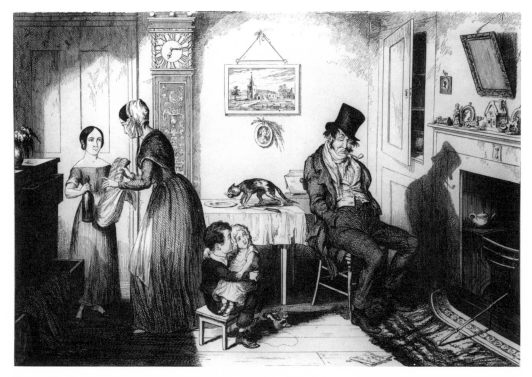

PLATE II. He is discharged from his employment for drunkenness: they pawn their clothes to supply the bottle.

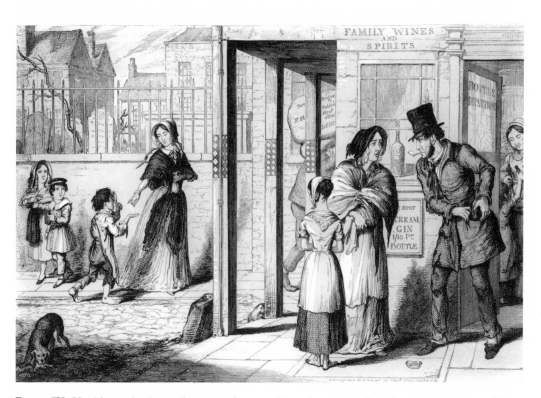

PLATE IV. Unable to obtain employment, they are driven by poverty into the streets to beg, and by this means they still supply the bottle.

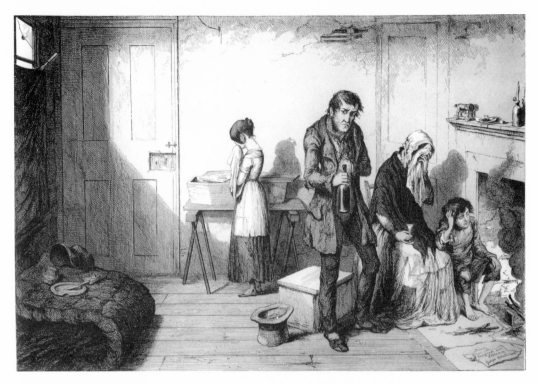

PLATE V. Cold, misery, and want, destroy their youngest child: they console themselves with the bottle.

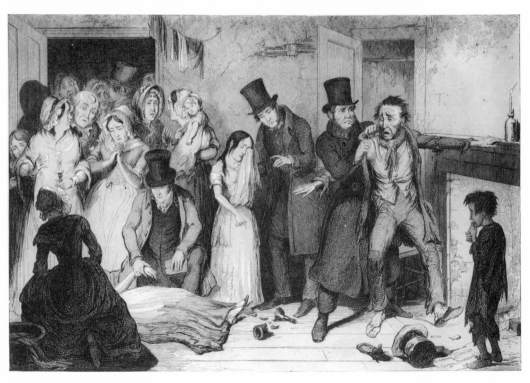

PLATE VII. The husband, in a state of furious drunkenness, kills his wife with the instrument of all their misery.

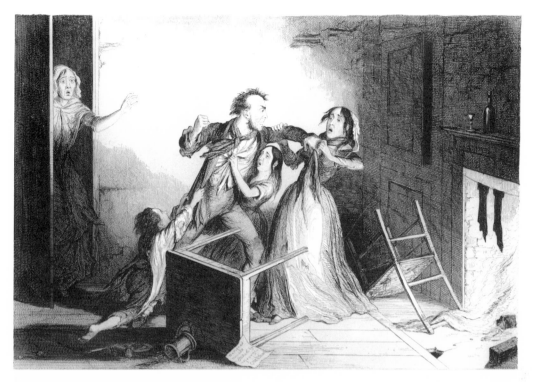

PLATE VI. Fearful quarrels, and brutal violence, are the natural consequences of the frequent use of the bottle.

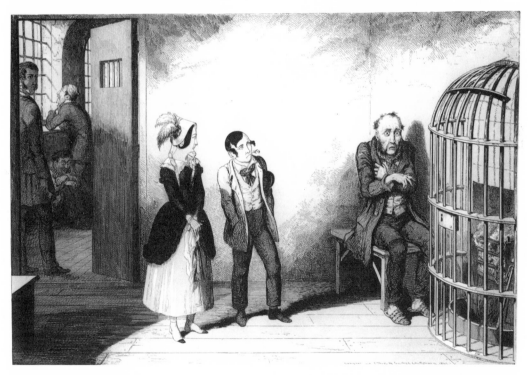

PLATE VIII. The bottle has done its work—it has destroyed the infant and the mother, it has brought the son and the daughter to vice and to the streets, and has left the father a hopeless maniac.

the Fall required a somewhat altered mechanism. In melodrama, evil is not accidental, but essential or retributive. It is not spontaneous, but a conspiracy against the good. If there is a malevolent villain-seducer in *The Bottle*, it is the Bottle itself; but the animism this implies, despite the support of the captions, is absent from the prosaic image. In Taylor's amplification of *The Bottle*, the conspiracy of evil is personified. Thornley, the Husband, is furnished with a good and bad angel: a virtuous friend, George, who tries to persuade him against the vice; and a scoundrel companion, "Dognose," who leads him astray. George is removed when a gentleman villain with designs on his betrothed tricks him into enlisting in the army, whereupon Dognose draws Thornley into public-house gambling as well as drink. The consequences appear in the next two realizations, stages in the decay and dismantling of the home (I, 5 and 8).

The first of the two acts ends, however, with a temporary reprieve. After the scene of the execution on their household goods (*Bottle* III, a repeated, highly charged scene in contemporary literature and art), a benefactor pays off the debt. Melodrama has a structural requirement for a strong act cadence, and nothing is more effective than a climactic reversal. In the resulting pattern, the achievement of maximum intensity in each of the dramatic units leads to release and renewal, a transformed situation. Such a pattern interferes with the pattern of incremental catastrophe in the picture series, and modifies its inexorable linear progression.

That progression, successive stages in the destruction of a house, would be extended into the sequel, *The Drunkard's Children*. The most powerful of classical subjects, the fall of a noble house, is democratized and rendered in nineteenth-century domestic images, whose center in *The Bottle* is the hearth. The image of the hearth itself culminates, after the catastrophe, in the barred-off fire of the last plate. For having murdered his wife, the Drunkard's punishment is exclusion from the secular heaven, not incarceration; and he appears like a ghost beside the madhouse hearth, haunted himself and haunting. His isolation is anticipated, however, in the composition of Plate V, marked by the first of the irreversible losses. The child's coffin in the bare ruined scene is itself, in this century, a poignant and familiar domestic image; but the essential nature of this summarizing moment in the progressive destruction of the house is expressed in the centrifugal disposition of the figures, each in his solipsistic sorrow or guilt, unsupported and self-enclosed.

Prominent among the emblematic domestic detail in the early plates of *The Bottle* is the picture of a church, explained in the play as the village church where the Thornleys were married. It reappears in the drama's second act, appropriately in the room of the beleaguered sweetheart of Thornley's shanghaied friend. This couple survive separation and hardship through virtue and sobriety, to offer a hopeful positive example. In addition to this function, however, the image of Esther holding body and soul together with needlework in her miserable room (echoing Hood's "Song of the Shirt," 1843, and Richard Redgrave's *Sempstress*, 1844) projects a sense of the pains and constraints of poverty surrounding the temptations and consequences of drink. Social

and economic arrangements are thus given weight in the causality, and are added to the private moral drama. In the play, workers are paid off in taverns, factories close suddenly, distraints for a trifling indebtedness are a constant threat to the home, discharge from employment may happen at any time, and upper-class predators make the most of their opportunities. Esther, sewing, soliloquizes on work:

> Weeks and weeks I have scarcely had any, and now it comes all at once—more than I can get through, and am now compelled to send for assistance. Work, work, work, and yet of no avail; it will not clear away the poverty by which I am surrounded. The dreadful threat of the few things I have got together being taken from me, the fear of being thrust forth homeless, checks every zealous intention, defies all industrial efforts. Well, well, I must try—still struggle on, still struggle on. [pp. 42-43]

Fortunately, Esther's George returns from the wars just in time to save her from a distraint, a providential intervention probably not the audience's experience outside the City of London Theatre.

The events of Cruikshank's last four plates, the death of the youngest child, the quarrel, the murder, and the madhouse, are linked into a nearly continuous action, a single epoch that occupies the second act. The "perfect domestic drama, in eight acts" is thus adjusted to a conventional two-act structure, with the help of a lapse of three years in the interval. Moral progresses in such drama tended to make such leaps, shifting a linear moral structure to a circular one, from inevitable succession to retributive consequences. The famous French melodrama *Trente ans; ou, la Vie d'un joueur* (1827), which so stirred Dickens, and Jerrold's *Fifteen Years of a Drunkard's Life* (1828) had set the temporal pattern.

By the second act, Dognose is attempting to lead Thornley's boy astray, giving him counterfeit coins to pass, and this provides the transition between the quarrel and the murder. The scene that begins with the realization of the sixth plate ("Fearful Quarrels and Brutal Violence are the Natural Consequences of the Frequent Use of the Bottle") ends with Ruth Thornley trying to hold Dognose for the police she has summoned, while Thornley tries to pull her off. "*As he is frantically dragging her from him, Dognose rushes out. Thornly [sic] seizes the bottle from the mantelpiece.*" The scene is then "*Closed in.*" In an intervening scene, Dognose is apprehended in a garret room, and then the main sequence resumes:

> SCENE VIII.—*The Room, as before.*
> TABLEAU.—"*The Bottle has done its Work.*"
> RICHARD *is seized.*

Or, as Cruikshank puts it, "The husband, in a state of furious drunkenness, kills his wife with the instrument of all their misery." The realizations are thus linked by action and even intermediate tableaux, but emphasized as realizations by the crosscut scenic interruption. Again, the scene that begins with the tableau of the murder and arrest ends with Thornley's strange laugh, evidence of coming distraction; then, after an intervening scene of moralizing, the last scene begins

with the picture of Thornley in the madhouse visited by his thoroughly corrupt children. Time is very elastic here. The interrupting scene, whatever its length, can stand for seconds or months in the main progression, and accommodates Cruikshank's authentic images and serial form to an altered temporal structure.

Taylor's play found it necessary to soften the inferno of Cruikshank's last scene. Faced with the wreck of their father, the Drunkard's children decide to abandon their fine feathers and resume honest poverty, whereupon George, Thornley's ineffectual virtuous counselor, promises to take care of them. Lucid again, but full of remorse and horror, Thornley dies embracing his children, who pray for him, while George, standing in for the audience at the final tableau, watches much affected.

A kindlier Providence also marks the end of a cruder, more powerful and economical translation of *The Bottle* into dramatic form, the only other version requiring some attention, C. Z. Barnett's *The Bottle and the Glass*.[47] The technical superiority of Barnett's play as translation lies in the greater effect inherent in an end-scene or even mid-scene realization. The experience of seeing the pieces drop into place, the shock that comes with the fulfillment of an expectation from which we have been half-distracted, reinforces the sense of a fatal progression so important in the plates. Such is the effect of the first realization, when an initial public-house scene (where Gilbert Graceless brings a reluctant George Thornton), followed by a scene of miserable repentance, leads to a family reunion; and there, as a final gesture of reconciliation, George brings out the bottle and says, "Let me induce you for the first time just to take a drop—(Plate 1 realized)."

Such effect is combined with a pleasing economy in "The Wreck of Home," where the second plate, in which the daughter is sent out to pawn clothes and supply the bottle, opens a scene that concludes with the tableau of the distraint. For transition, Grasp, the broker, appears demanding the rent, and then begins his inventory. George passionately defends the clock (his mother's) until his daughter reappears, her errand performed:

ROSE The Bottle Father.
GEO Ah the Bottle [,] take the clock—everything[—]
 to you[,] leave me the Bottle.
 Realization of Plate 3
 End of Act 1

Similarly, the scene of the murder begins with the tableau of the dead child (*Bottle* V). George drinks to console himself, becomes jealous, and accuses his wife of taking consolation from "a baser source" than the bottle. As she tries to leave, he attacks her, realizing Cruikshank's quarrel scene (*Bottle* VI). Cruikshank's plate provides for an interruption, by the landlady; and thereafter George continues drinking and raging. The actual murder takes place, not as in Cruikshank's series and in Taylor's play, between or behind the scenes, but before us, when the wife tries to take away the bottle. The prudently abbreviated direction for this horrific scene reads "(*drinks*) BUS[iness] (*enter Jerningham* [a gentleman] *Policeman and Neighbors*)." On the policeman's query, "What did he strike the woman with," Rose answers, "With—with the bottle (*points to fragments realizing Plate 7*)."

[47] L.C. MSS Add. 43006. All eight plates are realized.

The madhouse scene, however, abandons the preference for a climactic realization. Cruikshank's last plate is realized as a discovery, and then amplifies into considerable violence, for the other two inmates visible in the plate are George's former drinking companions. One, the graceless villain, is slain, and George then stabs himself; but the play is not over. A final scene brings back "*The Club room of the Dolphin as in Act 1st. George Dis[covered] sleeping with the bottle in his hand.*" He starts up, realizes with relief that he has only dreamed his drunkard's progress, and resolves, presumably with the audience's approval, to take the experience as a sobering "prophetic warning."

THE OFFICIAL version of *The Drunkard's Children* was that at the Royal Surrey Theatre (3 July 1848), "Dramatized exclusively for Mr GEORGE CRUIKSHANK, from his Original Designs, under his immediate Superintendence, and the entire Arrangements directed by himself."[48] The playwright's name is omitted from the playbill; but it was T. H. Reynoldson, who nine years earlier had furnished the Surrey with an accomplished version of Hogarth. Unlike T. P. Taylor in his approved version of *The Bottle*, Reynoldson presents the eight plates of the second progress in one unbroken series—one act "in eight tableaux"—and so preserves the sense of an inexorable rhythm in the march to destruction. Each scene except the last begins with a Cruikshank plate discovered, and all but one scene ends with a second, supplementary "picture" that reinforces the initial point and underlines the stage of decline. The two tableaux in each unit frame a development section, however, where linkages have their place. The play begins, for example, with the tableau-realization of a genre scene, The Gin Shop (*DC* I); then animates the various typifying incidents, still in the spirit of genre, starting with the Irish group feeding the baby gin; then focuses on the groups around Emma and Edward, the Drunkard's children. These, deprived and neglected as Cruikshank's caption has it, have fallen "into the hands of wretches who live upon the vices of others." Neither child is wholly lost, however, and Emma has influenced her brother not to deal with his cracksman friends. But in the end the friends persuade him back, and the scene stabilizes in a tableau reinforcing the point of the whole:

Jack ... (aside to Mat) That tale about the Sister did the
 business!—
Mat ... AND THE GIN!!!—
 Picture[.] Edward C tossing off the last glass—The two cracksmen a little behind, Mat with quartern measure in his hand—Holding it up significantly. END OF TABLEAU 1ST.

The two following scenes, the Beer-Shop and the Dancing-Rooms, also begin as genre scenes, and then develop as drama, leading to a final restatement as picture.

The fifth scene, the Old Bailey, is merely "exhibited as a Tableau Vivant with Music from Beggars Opera"; but the sixth, the prison visit and parting, uses its development section for a significant enrichment, an extended retrospection that is in effect all pictorial allusion. After the realization, Emma, working on Edward's better nature, paints an elaborate word picture of the fatal day when Drink was first introduced into their parents' home—a picture, including gesture and

[48] Playbill, Enthoven. The title page in L.C. MSS Add. 43013 also declares, "Arranged by and Dramatized under the Exclusive Direction of GEORGE CRUIKSHANK embodying the *Eight Tableaux* of his new work." Other quickly mounted versions included J. B. Johnstone's *The Drunkard's Children* (Royal Pavilion, 13 July), French, Vol. 99; G. D. Pitt's *Basil and Barbara, the Children of the Bottle; or, The Curse Entailed* (Britannia Saloon, after 10 July), L.C. MSS 43013; and J. Courtney's *Life: Founded on the Drunkard's Children* (Victoria, after 10 July), L.C. MSS 43013.

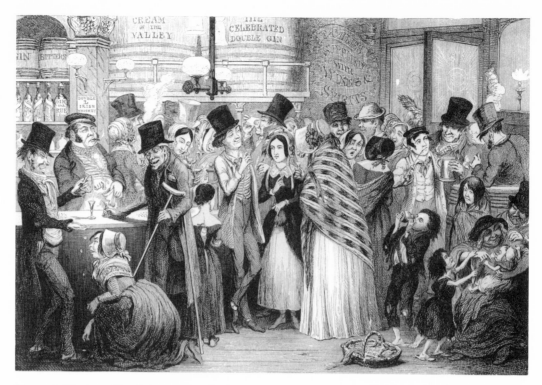

PLATE I. Neglected by their parents, educated only in the streets, and falling into the hands of
wretches who live upon the vice of others, they are led to the gin-shop, to drink at that fountain
which nourishes every species of crime.

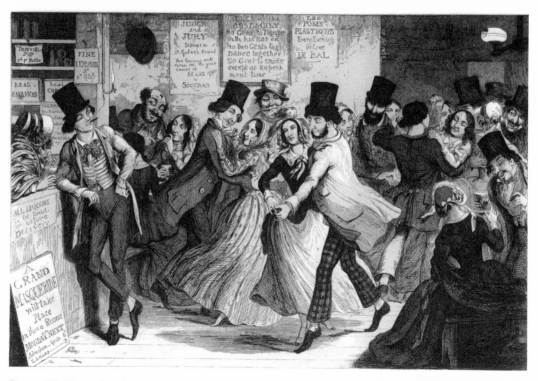

PLATE III. From the gin-shop to the dancing-rooms, from the dancing-rooms to the gin-shop, the poor
girl is driven on in that course which ends in misery.

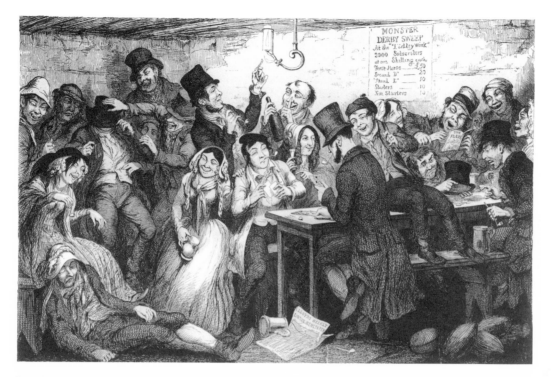

PLATE II. Between the fine flaring gin-palace and the low dirty beer-shop, the boy-thief squanders and gambles away his ill-gotten gains.

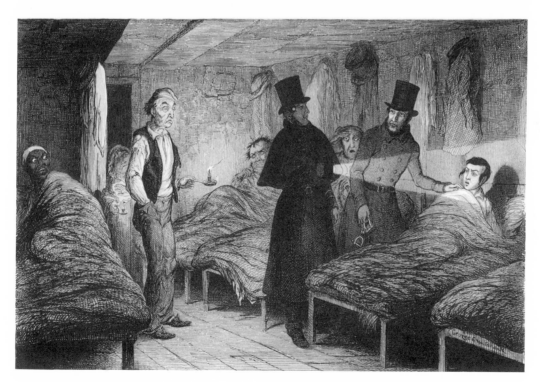

PLATE IV. Urged on by his ruffian companions, and excited by drink, he commits a desperate robbery.————He is taken by the police at a three-penny lodging house.

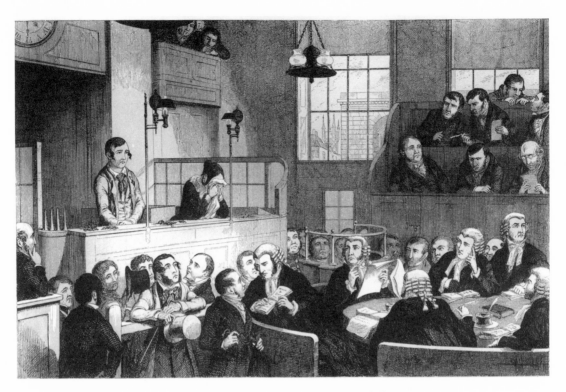

PLATE V. From the bar of the gin-shop to the bar of the Old Bailey it is but one step.

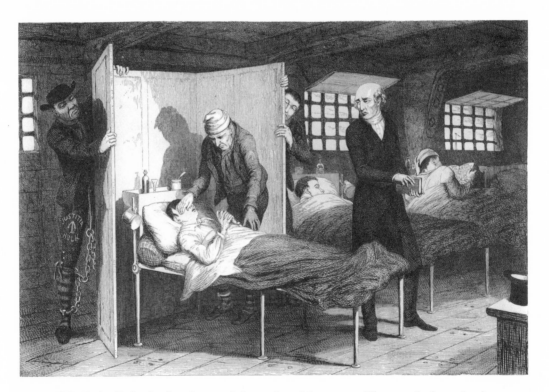

PLATE VII. Early dissipation has destroyed the neglected boy.————The wretched convict droops, and dies.

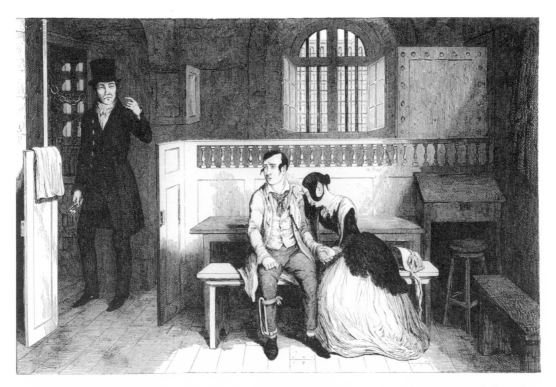

PLATE VI. The drunkard's son is sentenced to transportation for life; the daughter, suspected of participation in the robbery is acquitted. The brother and sister part for ever in this world.

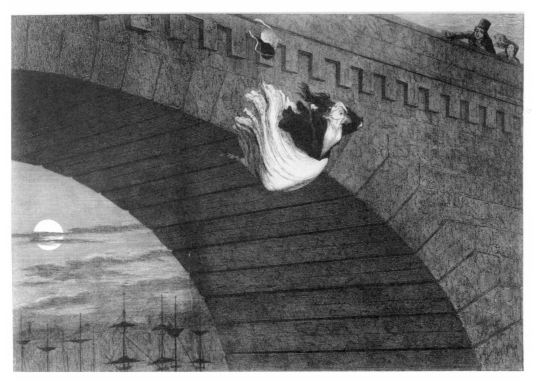

PLATE VIII. The maniac father and the convict brother are gone.———The poor girl, homeless, friendless, deserted, destitute, and gin-mad, commits self-murder.

[49] The caption of *DC* VI declares that "The brother and sister part forever in this world." In the play, however, Emma enters after Edward's death aboard the convict ship (*DC* VII), and throws herself on the bed for the closing picture of the scene.

[50] Later commentators have ignored this journalistic analogue, and found the Old Bailey scene weak. Dickens, however, mentions particularly the power of the night suicide, the deathbed scene on board the hulks, and the trial scene at the Old Bailey, where "The very light and atmosphere of the reality are reproduced with astonishing truth." Both the hulks, atmospherically distanced, and that "very light" of the Old Bailey courtroom would reappear in *Great Expectations*. The river suicide (a common motif) and a number of other elements are anticipated in the last of Dickens' *Sketches by Boz*, "The Drunkard's Death."

[51] For example, "Cold, misery, and want, destroy their youngest child: they console themselves with the bottle" becomes "he still consoles himself with the Bottle."

[52] The *locus classicus* in England, Tom Hood's *Bridge of Sighs* (1844), inspired G. F. Watts' *Found Drowned* and perhaps *Under a Dry Arch* (1848; Watts Gallery, Compton), and received admirable illustration by Millais and Fitzgerald of the Junior Etching Club (1858) and Gustave Doré (1870). Cf. Augustus Egg's *Past and Present* (1858) and Luke Fildes' *Found Dead on the Embankment* (*The World*, 25 Dec. 1878). Among plays, Edward Stirling's *The Bohemians; or, The Rogues of Paris* (1843), W. T. Moncrieff's *Scamps of London* (1843)— both derived from Dennery and Grangé's *Les Bohémiens de Paris* (1843)—and Charles Selby's *London by Night* (1845) unite the same visual components in a despairing heroine's attempted suicide. Stirling's version at the Adelphi of Louise's attempted suicide in *The Bohemians* is close enough to Cruikshank's in some of its components to claim attention as a plausible source. The acting edition (Dicks BD, Vol. X) calls for a night scene and "*The underneath of a first arch of a bridge of which the top must be practicable. An embankment, at the bottom of which is the river Seine.*" At the climax, Louise, who has been seduced and abandoned, appears on the bridge "*wretchedly attired.*" She is seen and overheard by her former virtuous admirer, who rushes up the steps onto the bridge, only in time to peer over after her as "*Louise, with a scream, throws herself from bridge.*" Some adaptations of the French play had the heroine come down the steps and make the leap from the landing; but C. Z. Bar-

position, of Plate I of *The Bottle*. She follows with an account of the succeeding fall, all as represented in the succeeding plates of *The Bottle*. It is for Edward's own good, Emma says, that she has "recurred to these harrowing scenes."[49]

Emma is emphatically the better half of the doomed couple throughout this drama; better than the plates suggest, though it is noteworthy that in Cruikshank's Old Bailey (*DC* V), where all the faces are as vacant as those in the mass portrait of a trial scene in the *Illustrated London News*, the daughter is the only figure to register a proper emotion.[50] The dramatized versions of both series consistently aim at lessening the woman's guilty participation, and strain toward that extraordinary symbolic image of the sexual and domestic relation characteristic of the time, an angelic nature tied to the fate and crimes of a coarse and anarchic one by mortal love. Recasting drink as the original male sin (contrast the intoxication in *Gin Lane* and *Paradise Lost*) had some basis in experience (that of wife-battering, for example). But the demonology of drink and of the temperance movement was much affected by the Victorian apotheosis of the granddaughters of Eve. Cruikshank himself apportions the guilt very unevenly, but not as unevenly as the playwrights. In *The Bottle*, the wife is induced to take the deadly glass with an amiable passivity; but the dramatic versions do their best to make her a sorrowing abstainer, wishing to draw her husband back to virtue and faithful to him under all circumstances. Even in T. P. Taylor's approved version of *The Bottle*, the slightly altered captions of the tableau realizations in the playbill take care to make the vice of drink only "his."[51]

In Reynoldson's *Drunkard's Children*, Emma is the prime agent of good, though the hereditary curse is too much for her. That legacy is more than a thoughtless pattern of debauchery and vice (as in the first three plates) or the fruit or parental neglect. It is a blight on positive goodness and its chances. The unsavory young rake leaning against the bar in Cruikshank's Gin Shop and Dance Hall (*DC* I, III) is turned into a virtuous suitor, who knows the character of Emma's present life, but is willing to take her anyway. (Emma's sexual status is clear in the prints, but ambiguous in the play, where she behaves chastely, though she has obvious brothel associates including a pimp. If there is no direct indication that she has prostituted herself, the emphasis on her suitor's nobleness in wanting to take her off to another land as his wife and the emigration solution itself point that way.) It is only when she reveals to him that her father is a murderer and still alive, a hopeless maniac, that "Every earthly bond is broken—every tie that could make life worth living for dissevered."

The image of the woman visiting in prison the less innocent creature to whom she is tied by blood or affection (*DC* VI) was recurrent in the iconography of the age (see Chapter 14, below); and so was the concatenation of the stone arch, the river, the night, and the fallen woman contemplating or committing suicide (*DC* VIII).[52] Cruikshank's caption—"The maniac father and the convict brother are gone.— The poor girl, homeless, friendless, deserted, destitute, and gin-mad, commits self-murder"—does not take away from the pity and terror of his extraordinary last picture. In the play, it is the first print to be

realized at the end, rather than at the beginning of a scene, suggesting that Reynoldson had deliberately reserved a culminating range of effect. But the play subtly shifts away from Cruikshank's sternness into something less terrible and more pathetic, consistent with the relationship of the protagonists. Emma's suicide in the play takes place on the same night as her brother's death. Emma hates drink—in the prison visit she persuades her brother to swear off, and dying he says he has kept his promise—but she also drinks to forget. Now she kills herself, not gin-mad, or in the final despair of a prostitute's degradation, but to avoid ultimate degradation as a victim of the demon drunkenness. The scene opens with "The Bridge—Moonlight;—wharf or landing place below.—The river at back—Music.—a boat comes on behind the landing place—Watermen seen standing up as if bringing her to land." Emma explains herself in soliloquy and then rushes off. There is confusion at the top of the bridge;

Voice outside (very loudly) She's on the top of the parapet!
A Scream (very loud) Emma throws herself from the parapet of the bridge and disappears in the water below—persons seen looking over with horror depicted on their countenances as
CURTAIN FALLS
END OF THE DRAMA

Reynoldson's play is more powerful and persuasive than the other extant dramatic versions; and where it chiefly fails is in that area where the pictures do so much of the work of telling the story that there is nothing more to be said. It makes explicit some of the social bearings of the subject—the first scene exposes the publican's vested interest in the ruin and corruption produced by the trade in gin, and the second dramatizes the exposure of a beer-hall landlord's fraudulent lottery—but its chief concern is the moral drama, where it constantly sets the curse of drink against hope for the future and the possibility of change. It is the curse that prevails; an Old Testament curse that the parents have entailed on their posterity. As in Cruikshank, the message is not reform, but taboo. The rhetorical purpose is to create conviction of the certain misery, evil, and death that is carried in the taste of a drop of gin.[53]

The moral was too simple and strong even for the strong and simple morality of melodrama, which believes in radical innocence, the possibility of redemption, and a benevolent, rather than inscrutable and inexorable Providence. Consequently the disposition to redeem essentially innocent victims observable even in the plays Cruikshank supervised is developed a little further in the rival versions. To judge by the stage directions, the final picture of *The Drunkard's Children* may have been even more authentically realized in J. B. Johnstone's version at the Royal Pavilion:

SCENE SEVENTH—*London Bridge. A section of it only seen, the scene so constructed that the upper part of it may admit of persons being both seen and heard (the painting of it as Plate 8); lights down. Enter* MARY *on bridge from* R.

nett's at the Surrey Theatre, like Stirling's, Moncrieff's, and the French original, also used the long leap, with memorable effect: "On Monday night, during the first performance of the *Bohemians of Paris* at the Surrey Theatre, Mrs. R. Honner met with a most unfortunate accident. In the first act she has to jump from a bridge to the stage, a height of nearly fifteen feet, and in so doing she missed the mattress that should have broken her fall. Mrs. Honner was so seriously injured, as to render it uncertain when she may be able to appear again." *Pictorial Times* 2 (2 Dec. 1843), p. 237. Selby's slightly later *London by Night* exists in drastically different versions. In that of 1845 (L.C. MSS Add. 42985), his heroine, Ellen, tries to drown herself by rushing down the steps from Blackfriars Bridge. In that of 1868 (L.C. MSS Add. 53066), a revision by other hands, only the villain leaps, when pushed from a window into the river. In a third version printed in 1886 (Dicks, #721), possibly someone else's early adaptation of *Les Bohémiens* under Selby's title, Louisa (*sic*) "*throws herself into the water,*" and the drunkard, Dognose, leaps from the bridge to save her. This is the version whose illustration so strikingly recalls Cruikshank's last plate.

[53] In Charles Kingsley's *Alton Locke* (1850), when MacKaye the bookseller shows Locke the London that ought to be his proper subject, his description of the Gin Shop, clearly affected by Cruikshank's series, forces him to a similar theology: "Look at that Irishwoman pouring the gin down the babbie's throat! . . . Drunkards frae the breast!—harlots frae the cradle! damned before they're born! John Calvin had an inkling o' the truth there, I'm a'most driven to think, wi' his reprobation deevil's doctrines!" *Alton Locke, Tailor and Poet. An Autobiography* (London, 1902), 1:201.

46. *Cover illustration for* London by Night, *Dicks' Standard Plays #791 [1886].*

LONDON BY NIGHT.

A DRAMA, IN TWO ACTS.

BY CHARLES SELBY.

First Produced at the Strand Theatre, January, 11th, 1844.

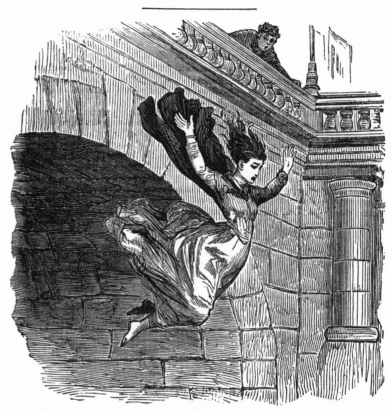

When she leaves momentarily a barge floats on containing Martin Merit (her lover), and Prince (the black man who appears in *DC* IV).

Music—at this moment, MARY *appears, and with a scream, jumps from the bridge.*

She jumps, however, not in despair over any crime or degradation that has tainted her own intrinsic innocence, but because of her benefactor's "unconscious suspicion," in view of the family history. Martin Merit saves her, and they live happily ever after.[54]

It is hard to believe that any stage really managed an adequate realization of Cruikshank's last plate, with its arch thrusting out of the picture, no bottom in sight, and the girl flying out at the spectator in frozen velocity. Accomplished as the Victorian stage was in death-defying leaps, and moonlight, bridge, and river effects, it was equipped with neither strobe nor zoom. The difficulty points out an essential quality in the pictorial conception of Cruikshank's two series. All are pictures in which the situation is emblematic of a condition, of stages in the progression, and so all are stable images—except the last, which

[54] Other names in this barebones melodrama (French, Vol. 99) are Sam Swiller, Mr. Meanwell, Mrs. Crumb-comfort, and Robert and Mary Reckless. Louise's leap in the numerous versions of *The Bohemians of Paris* ends in a similar rescue, sometimes by boat.

puts the whole in the lap of the spectator. Moreover it is noticeable, particularly in *The Bottle*, that the more violent and impassioned the action, the more obviously tableaulike is the image, in direct proportion. The most violent image in *The Bottle*, the quarrel scene, is not only a picture that can be held, but a stable composition, academic and classical, of pyramids and parallelograms. The potentially more violent picture of the murder we are not shown, but only its reactive denouement, an anecdotal panorama of response where occurs the only genuine suggestion of instability in the whole series, in the husband's legs. Yet even he is braced to take part in a holdable picture, whose real subject is not the act of murder, nor even the depicted arrest, but his state of horror and remorse before the irretrievable thing that has come upon him.

The Drunkard's Children is on the whole more passive; it is a chronicle of consequences rather than of actions. Concomitantly there is more activity than in the first series, especially in the drinking-place and dancing-room genre scenes, in place of action symbolically rendered as tableau. Picture, however, is still used as emblematic of a condition; we are shown the *life* of the two victims of their parents' sin, but not the deeds. The last five plates—arrest, trial, prison, death—are what happen to the passive protagonists, and almost require to be rendered in inert images, including the very last. But here, just where the conventions of pictorial dramaturgy, of serial illustration, and of narrative itself, teach us to expect the stability of a concluding configuration, Cruikshank draws on the accumulated pressure of his double progress, for effect, and breaks out of the forms of pictorial narration by serial tableau, into life.

TRADITIONALLY, genre categories serve as a means of classifying within a comprehensive mode. Here, they serve rather as an index to translations between modes (pictorial and dramatic), and to transformations of the modes themselves. Since these and their audiences, like genre, exist culturally and historically, they also are liable to depart from an eternally fixed character. The crowning blow to the notion of genre as fixed, immutable, and finite fell in the nineteenth century, whose practice reveals a faith in the infinite variability and particularity of genre (witness the descriptive subtitles of the drama). Hogarth, who erected his system of beauty on the firm foundation of "Variety," according to the title-page emblem and motto of his *Analysis of Beauty*, would seem in this to be the prophet of the nineteenth century. Similarly, by including within the notion of "continually varying" its opposite, "cessation of movement," he seems to project the nineteenth century's characteristic union of narrative and picture as a structural principle in fiction and drama. Only when attempting to translate Hogarth's integral comic seriousness into current language, visual and dramatic, did the nineteenth century show how the variety of the rococo era diverged from the abrupt transitions, packed detail, comic-pathetic range, and subordination of "keeping" to "effect" that constituted its own popular aesthetic.

8

✦⊣✦

THE POLITICS OF DOMESTIC
DRAMA: DAVID WILKIE

T WO SEASONS after the success of Planché's *Brigand* at Drury Lane, that much-violated temple of legitimacy produced Douglas Jerrold's pictorial and domestic melodrama, *The Rent Day* (25 Jan. 1832). Jerrold was then a struggling anti-establishment journalist, still nearly a decade away from *Punch*, but already a well-established writer for the minor theaters, author of some three dozen plays including *Fifteen Years of a Drunkard's Life* (1828), *Black-Ey'd Susan* (1829), and *Martha Willis, the Servant Maid* (1831). The last is a play that owes a substantial debt to Hogarth (*A Harlot's Progress*), and "abounds in strong and highly-wrought pictures of real life."[1] Alert to popular taste and feeling, Jerrold now turned to two of David Wilkie's best-known paintings for the title and leading feature of his new melodrama of rural life. The *Spectator* observed:

> *Tableaux vivants*, or animated pictures, are the order of the day; and the painter now shares the glory of success which before was divided between the actors and the dramatist. WILKIE's famous picture of "The Rent Day," has given rise to a drama at Drury Lane, which is likely to vie with it in popularity, and which embodies the spirit of that admirable performance in a story of very great interest. Mr. JERROLD, the author, reads "a great moral lesson" to the absentee landlords, which we wish they could all peruse and profit by. The rising of the curtain discloses an animated realization of the picture of "The Rent Day;" and at the end of the first act, it falls upon another of "The Distraining for Rent."[2]

Since *The Brigand*, a number of plays had made use of pictorial realization; but *The Rent Day* was so very successful with the feature that it managed to displace attention from its recent predecessors.[3] There was in this conjunction of village melodrama with Wilkie's genre painting a felt appropriateness that in itself constitutes an aesthetic sensation. A reviewer, who characterized one of *The Rent Day*'s predecessors as "got up at immense expense, as if to teach us how a fine

[1] From the "Address to Martha Willis" that prefaces the acting edition (Dicks) and presumably appeared on the playbill (Royal Pavilion Theatre).

[2] *Spectator* 5 (28 Jan. 1832), p. 87.

[3] These included two spectacular Napoleon plays (below, pp. 219-21) and Thomas Haynes Bayly's "Operetta," *The Picturesque* (25 Aug. 1831). In the wake of *The Picturesque*, a correspondence developed in Leigh Hunt's *Tatler* over the originality of the "Stage Personation of Pictures": *Tatler* 3 (1831): 195-96, 205, 207.

picture could be spoiled by making its frame a proscenium," found, on the contrary, that in Jerrold's play "a great master is honoured and his work illustrated. . . . Mind has whispered to mind. The pencil becomes a pen, and this drama is the illustrative letter-press which ought for the future to accompany the picture."[4]

Naturally, not all reviewers were equally pleased. The production of such a play at Drury Lane provoked the new satirical journal, *Figaro in London*, to declare, "When hackneyed engravings are taken for the ground-work of pieces at our national theatres, it is high time for some kind of reform in the drama."[5] *Figaro in London* was distinctly reform-minded at this tumultuous moment in the politics, economy, and society of England, and its satire often took a severe, high-minded tone toward privileged institutions such as Drury Lane. But its standards for the Temple of Shakespeare were those of aesthetic decorum rather than politics.

To a modern critical eye, neither the "hackneyed engravings" of *The Rent Day* and *Distraining for Rent* nor Douglas Jerrold's play seems to have much to do with the political tumult of the moment, or with the important transformations then taking place in the life of England. Each work can be assigned a place according to its kind in the history of styles, in painting or in drama, without recourse to "extrinsic" considerations. There is no obvious political message, no hint even of an industrial or agricultural revolution in these rural dramas. The only insistent extrinsic consideration is the oddity of their connection with each other. And yet that connection is the key to their involvement in a climate of social and political events, with feelings of the moment seeking expressive form. The details of that involvement, the character and quality of the emergent pictorial and dramatic forms, and the strategies for assuring their acceptability, are the burden of the discussion that follows. What resulted was an expressive vehicle with enough vitality to persist through an era of carefully qualified realism, and reemerge with revolutionary impact in the theater of naturalism.

Distance and Immediacy

The compatibility between Wilkie's paintings and Jerrold's play was certainly stylistic. Both belong to a strong current in the arts that can be called, for convenience, domestic realism. Both, moreover, were thought stylistically innovative in their respective times and arts, though the play was not treated as solemnly as the paintings. Innovation, however, is not only an aesthetic issue; it is also, in several senses of the word, political, and leads one to consider whether—in a society of consumers who in certain areas pay only for what they like, or feel they ought to like—politics in art and the politics of art are not ultimately inseparable. As an innovating domestic realist shaking off the constraints of the cottage picturesque, Wilkie's politic way was to invoke Dutch analogues and strike a note of what may be called "mitigated immediacy." At a time when geographical distance from the metropolis could translate into temporal distance and a temporal perspective, he took his characteristic scenes from rural and provincial life. Such distancing, however, like Jerrold's idealization of certain

[4] *Atlas* 7 (29 Jan. 1832), p. 74.
[5] *Figaro in London* 1 (28 Jan. 1832), p. 32.

dramatic figures, was not enough to secure the style and the work from social and political pertinence.

Looking back from the 1860s on a century of painting, Richard and Samuel Redgrave observed that after Hogarth's death large-scale historical and religious subjects dominated figure painting, portraiture excepted. But "soon after the beginning of the present century, several painters almost simultaneously rose into notice, whose works had at least a common likeness, in that they were of cabinet size and bore somewhat the same relation to historic art that the tale or the novel does to history."[6] Genre painting—what the Redgraves have in mind—they understand as centrally concerned with "domestic and familiar incidents from home life and the affections." The definition is of its time, and it is a good part of what I mean by domestic realism.

The new school of genre painting in England aimed at producing a convincing version of the real, rather than yet another version of the cottage picturesque, that poor relation of the beautiful. It dates from Wilkie's coming to London from Scotland in 1805 to make his fortune. Wilkie admired his English predecessor, Morland, and he drew on native Scottish sources, notably Fergusson and Burns among poets and David Allan among artists. But he looked elsewhere for his manifest models, notably to Northern painters of the seventeenth century, especially Teniers and Ostade. Every critic and connoisseur saw the Dutch analogy, and it undoubtedly helped Wilkie's paintings make their way with the cautious. But the analogy was effective because, in tandem with the young Wilkie's success and influence, the standard of reality was just then taking a turn for the literal, while the sentiment of reality attached itself to scenes from humble life. In Wilkie's paintings scenes from humble life ceased to be "picturesque." Prose—or a prose style—replaced the poetry of the picturesque, and the sentiment of reality displaced the sentiment of beauty in the viewer's response and expectation.[7] In the language of a critic reviewing the major engraved version of Wilkie's *Chelsea Pensioners*, "His has been termed a 'pauper style.' Its virtue is truth—exact truth to Nature; but then he treats her no better than he would a brown jug or a pan. WILKIE has been said to be of the Dutch school: he is rather the founder of another—the Scotch. He is the CRABBE of painters."[8]

Reality in representations is never an absolute, however, and the new school departed from its Dutch analogues in ways that increased its contemporary acceptability. The Dutch school, as then appreciated, represented the jollities and pleasures of peasant and town life from the midst of that life, as if merely by looking around. Moreover, the Dutch emphasis on things, on domestic and communal festive occasions, and on what was characteristic and immediate, struck nineteenth-century English writers as a neglect of anecdote. In contrast, the new style of English genre painting included a distancing strategy; and it quickly adopted a characteristic anecdotal, and even narrative content.

History painting provides a parallel to the distancing strategy. Edgar Wind makes the observation, interesting for what it suggests about the temporal resources of painting, that the American Indian in Benjamin West's *Death of General Wolfe* acts as a kind of "repoussoir," tactfully compensating for the modernity and dramatic actuality of the

[6] *A Century of Painters of the English School* (London, 1866), 2:216.

[7] The Redgraves contrast Morland's "loutish clowns grouped with the most vulgar of domestic animals" with Gainsborough's graceful rustics. But Morland's pigs, though less Arcadian than Gainsborough's (e.g. in Gainsborough's famous *Cottage Girl with Pigs*, 1782), continue under the influence of the picturesque point of view on rural life. Wilkie's impact is best understood in relation to his *immediate* predecessors in England, especially painters of the rural scene such as Morland, Opie (influenced by Gainsborough), and Wheatley. Qualities we associate with realism actually diminish in the 1780s, so that painters influenced by the narrative tableaux of Greuze, such as Wheatley, prettify figure and scene and soften sentiment and drama. Even Hogarth is much dulcified, as in Morland's *Laetitia* series. Other forms, such as the "conversation piece," belonged (in the categories of the day) more to portraiture than to subject picture, and therefore would not be seen as holding the place in the realm of art subsequently occupied by Wilkie's genre painting.

[8] *Spectator* 4 (22 Oct. 1831), pp. 1028-29. Northcote is the source of the mot on Wilkie's style.

represented event. He mentions Racine's dictum in the preface to *Bajazet:* "Distance of country compensates in some sort for nearness of time."[9] Wilkie's reception, and that of the school of painters of ordinary life that followed him, depended on such distancing, as one might almost deduce from the fact that as late as 1850 W. P. Frith, who was later to paint *Derby Day* and *The Railway Station*, and whose whole bent was toward "modern life subjects," was unmanned at the thought of using contemporary urban dress in an oil painting.[10] The history painters, in Wind's view, succeeded in adjusting truth and expectation through "a style of mitigated realism." The genre painters did much the same through a strategy of mitigated immediacy.

The essential problem for the early nineteenth-century genre painter was to create a vivid, instantly recognizable reality, whose "familiarity" would avoid the perils of raw immediacy on the one hand, and of enervating artifice on the other. Charles Leslie—a considerable painter in his own right—found the formula in Wilkie's *Penny Wedding*. The painting, he wrote, is "as far above all commonplace or vulgarity as it is free from anything of over-refinement. Wilkie in such subjects seems as if he were guided by the precept of Polonius—'Be thou familiar, but by no means vulgar.'" Leslie invokes this profound wisdom in a *Hand-Book for Young Painters*, and his advice may be taken as prescriptive.[11]

Wilkie's mitigated immediacy, not the cause but a condition of patronage and popularity, was chiefly a matter of subject, affective tone (often humorous), and geography, and not of color, manner, or "beauty." It is to be found in a number of his near contemporaries, among writers as well as painters of scenes from humble life. It was no accident for Wilkie's metropolitan success that he was a Scot, or that the painting which first roused a general enthusiasm in London, *Village Politicians* (1806), has an almost topical political point (noted below), but a rural Scottish setting and characters. As compared to the Dutch and Hogarth, Wilkie struck a vein of genre that was fundamentally provincial and regional. He so fed an appetite in his metropolitan and cosmopolitan audience for something between immediacy and exoticism; for something scrupulously and shrewdly true, but not vulgar and unsettling; for genre in perspective, or the familiar at one remove. Maria Edgeworth, Galt, Scott, and Wilkie could thus deal in provincial subjects but be more than provincial artists. And Wordsworth, whose declared poetic program included an evocation of the familiar at one remove, set his commonplace matters in the borderlands as well as in the perspective of memory.

Memory plays a part in the creation of a temporal perspective; but so does physical distance. For the contemporaries of Wordsworth and Wilkie, a displacement in space could incorporate literally—not just psychologically—a displacement in time. Since Goldsmith at least, renderings of English rural and village life were sure to be fused with a mood of nostalgia, with the evocation of a healthier past against a present (often picturesque) decadence. The evidence no longer supports this picture of a real decline in the economy and populousness of the countryside. There was indeed change: periods of intense enclosure activity that altered old local arrangements, and something labeled today as "The Agricultural Revolution" in the century and

[9] Edgar Wind, "The Revolution of History Painting," *Jour. Warburg* 2 (1938-39): 116-17. Charles Mitchell points out that Joseph Warton invokes Racine's dictum in his influential *Essay on the Genius and Writings of Pope* (1756) to support a caution on the otherwise laudable use of "domestic" (i.e. British) subjects for historical drama ("Benjamin West's 'Death of General Wolfe' and the Popular History Piece," *Jour. Warburg* 7 [1944]: 28).
[10] *My Autobiography and Reminiscences* (London, 1887-1888), 1:101, 185, 243-44; 2:195.
[11] Charles R. Leslie, *Hand-Book for Young Painters* (London, 1855), p. 148.

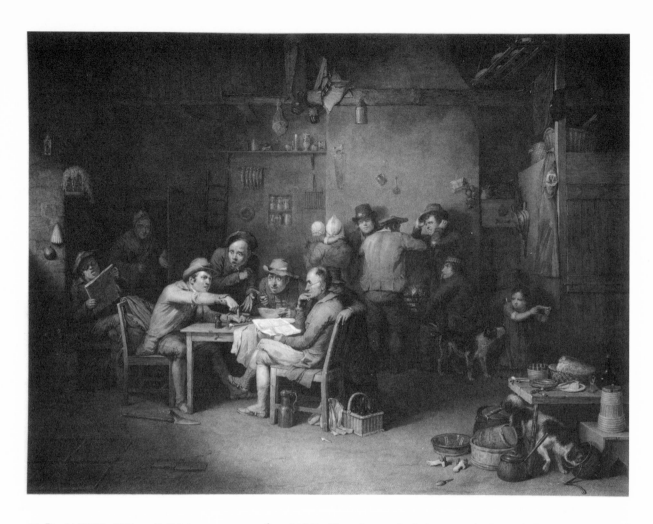

47. *David Wilkie,* Village Politicians
 *(1806), engraving by Abraham
 Raimbach (1814), London, Brit-
 ish Museum.*

[12] A convenient survey and synthesis of
the economic, demographic, and agricul-
tural history of the countryside in this
period is J. D. Chambers and G. E.
Mingay, *The Agricultural Revolution
1750-1880* (London, 1966). See also
Chambers' posthumous *Population,
Economy, and Society in Pre-Industrial
England* (London, 1972). In *The Agri-
cultural Revolution*, the authors note that
while the number of families engaged in
agriculture during the period may even
have risen as productivity also rose, the
proportion in relation to the total popula-
tion fell, so that "the contribution of the
Agricultural Revolution was not to re-
lease labour for industry, but to make
possible a greater output without making
a correspondingly larger demand upon
the available labour supply" (p. 3). The
net result was rural underemployment, a
lagging wage in the districts remote from

more after 1750. But the underlying revolution of the period was a
demographic explosion which contributed to the sense of increasing
poverty and relative stagnation in the countryside, where there was
less mobility and not enough work to go round, in contrast to the
relative dynamism of the urban centers, new and old.[12] The dramatic
growth of the urban centers, the improvements in transportation and
communication for which they provided the hub, the acceleration of
events—the revolutions, the wars, the new industries, and a new cen-
tury—all contributed to a sense of change as something radiating from
the center. They eclipsed the changes localized in the periphery and
even gave them a retrograde cast. Mere distance from the center thus
became the measure of a temporal, even historical perspective.[13]

What emerges—and it may be found in Scott, Samuel Howitt, even
Cobbett—is a temporal continuum embracing rural England, and
reaching into the border regions and beyond, in which the past is most
persistently present at the mountainous circumference and dwindles
nearer home, vanishing entirely in the modern metropolis. Signifi-
cantly, Wilkie as a painter of "familiar life" generally avoids the urban
scene, so that when Hazlitt wished to dispute the claim that Wilkie
was an extension of Hogarth, he argued that "we know no one who
had a less pastoral imagination" than Hogarth, whereas "Mr. Wilkie

paints interiors: but still you always connect them with the country."
On the other hand, Wilkie neither confined himself to Scottish subjects,
nor painted the exotic and picturesque clans and glens and Highlands,
so that Hazlitt finds no difficulty in arguing that Wilkie's pictures are
meritorious through "*reality*, or the truth of the representation."[14]

A physical distance with a temporal implication to help mitigate a
too vulgar, too radical immediacy was one pleasing peculiarity of the
new school of genre painting; the elaboration and dominance of nar-
rative content was another. Indeed the general habit, borrowed from
history painting, of painting recognizable scenes from fiction or drama
can also be understood as a way of hedging the direct representation
of life. But the tendency toward story included and went beyond mere
literary illustration. Eventually what the painters called "subject" would
be hard to distinguish from what the playwrights called "situation,"
and the invention of "effective" picturable situations, pictures that were
narrative epitomes, would be equally incumbent on both. Only later
in the century did it become clear that situation and narrative them-
selves might be a mitigating distraction from the rawest and most
rigorous kind of truth in representation.

The Rent Day

Domestic melodrama had not yet emerged as a distinct type in 1807,
when Wilkie painted *The Rent Day*, or as a dominant strain in 1815,
when he exhibited *Distraining for Rent*. According to the most knowl-
edgeable recent historian of English melodrama, "The drama dealing
with the household and family relationship . . . did not grow up in-
dependently, but evolved as part of a melodrama which by 1825 had
developed three closely related but distinctive branches: the Romantic,
encompassing Gothic and Eastern melodrama; the nautical (partly
Romantic and partly domestic), and the domestic itself, roughly in that
chronological order."[15] The popular drama lagged behind painting,
then, in differentiating a distinct genre that was consciously native and
homely rather than exotic and picturesque, as it would run ahead in
dealing with modern poverty, crime, and the contemporary urban
scene. When the new domestic drama emerged, it was as an unam-
biguously popular form, "vulgar" in its patronage as well as in its
subject matter; and at the beginning of a new phase of social and
political ferment. Perhaps in consequence it became a prime vehicle
for social feeling, despite an official dramatic censorship, which, how-
ever, concentrated on a rather narrow range of taboos. When, during
the real and threatened upheavals of the early 1830s, Jerrold launched
his landmark village melodrama, he invoked the respectable pictorial
predecessor of the form partly as legitimation.

With *The Rent Day*, Jerrold set his mark on English domestic drama
firmly enough to convince himself that he had fathered it. According
to his son, he was wont to say that this "new and original class of
dramatic entertainment" was "a poor thing—but mine own"; and un-
doubtedly he gave considerable impetus to the drama placed (like
Shakespeare's Audrey) in very humble circumstances.[16] Thereafter—
through most of the Victorian theater—domestic melodrama domi-
nated, and a "domestic interest" was mandatory in melodrama of any

industry, and the chronic problems that
Speenhamland and the New Poor Laws
variously tried to cope with. However
flourishing this period was for English
agriculture in general, there is no gain-
saying "the increasing poverty which
characterized much of the countryside in
the later eighteenth century and after"
(p. 97).

[13] For this equation of geography and
history in current thought, see M. Mei-
sel, "Waverley, Freud, and Topographi-
cal Metaphor," *U. Toronto Q.* 48
(1979): 226-44.

[14] William Hazlitt, "On Mr. Wilkie's
Pictures," *Champion* (5 Mar. 1815), in
Complete Works, ed. P. P. Howe (Lon-
don, 1930-1934), 18:96-100. It was only
when preparing to paint *The Penny Wed-
ding* that Wilkie in 1817 made a tour of
the Scottish islands and Highlands, his
first as far as one can tell. His corre-
spondence shows that he was then stirred
to what Scott calls a more "romantic"
view of his country and its peasantry.
Nevertheless, in *The Penny Wedding*
where, according to Wilkie's biographer,
"the manners and customs and character
of old Scotland reign and triumph," the
manners, dress, character and setting still
belong to the Lowlands. See Allan Cun-
ningham, *The Life of Sir David Wilkie*
(London, 1843), 1:459ff.; 2:9.

[15] Michael Booth, *English Plays of the
Nineteenth Century* (Oxford, 1969), 1:23,
203. Booth identifies village melodrama
as one large group in the domestic type.
See also Gilbert B. Cross, *Next Week—
East Lynne: Domestic Drama in Perform-
ance, 1820-1874* (Lewisburg, Pa.,
1977). Cross declares that W. T. Mon-
crieff's *The Lear of Private Life* (1820;
based on Amelia Opie's *Father and
Daughter*, 1801) "may justly be called *the
first domestic drama*" (p. 17). Moncrieff,
however, plagiarizes sections of Marie-
Thérèse Kemble's earlier adaptation,
Smiles and Tears (1815), including the
restorative happy ending.

[16] Blanchard Jerrold, *The Life and Re-
mains of Douglas Jerrold* (Boston, 1859),
p. 84.

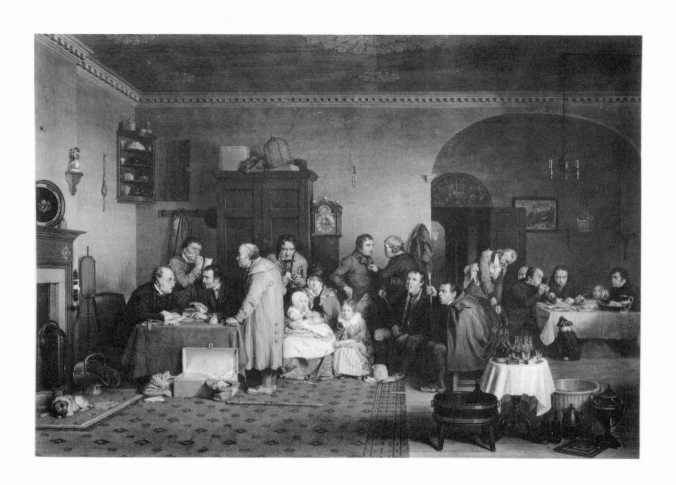

48. *David Wilkie*, The Rent Day *(1807), engraving by Abraham Raimbach (1817), London, British Museum.*

sort. Through most of it, the presentation of humble life and character as imperiled by the law, sophistication, and aggressive cupidity, sexual and material, carried an implicit political animus. Scott, and before him Coleridge, had objected to such a "confusion" of the right relation between the moral and social orders in one parent of domestic melodrama, the "domestic tragedy" of Kotzebue and his like. The "affectation of attributing noble and virtuous sentiments, to the persons least qualified by habit or education to entertain them; and of describing the higher and better educated classes, as uniformly deficient in those feelings of liberality, generosity, and honour, which may be considered as proper to their situation in life," Scott condemns as "the groundwork of a sort of intellectual jacobinism."[17] Fortunately, in Scott's own fictive histories (less dangerous than the drama, but rapidly translated to the stage), human pathos, deep feeling, and noble and virtuous sentiment are allowed to appear in humble life and cottage circumstances with powerful effect. There is persuasive evidence that Wilkie's *Distraining for Rent* helped Scott to uncover this vein, starting with the tableau of grief in Mucklebackit's cottage in *The Antiquary* (1816), and including the trials of Jeanie Deans.[18]

IN THE ORIGINAL production of Jerrold's *Rent Day*, the title picture appeared at the rise of the curtain as an opening tableau, while Wilkie's *Distraining for Rent* appeared at the end of the first act as a final

[17] "Drama," *Supplement to . . . the Encyclopedia Britannica* (Edinburgh, 1824), 3:669. Cf. Coleridge's *Biographia Literaria*, chaps. 22 (Letter 2) and 23.

[18] See Lindsay Errington's remarks in *National Galleries of Scotland, Bulletin Number 2* (1976).

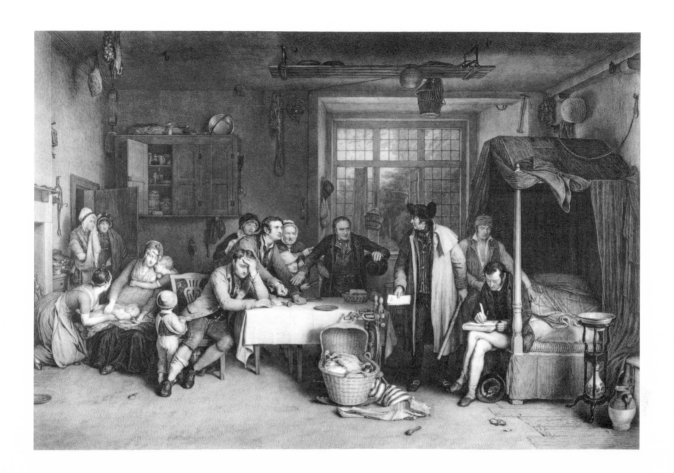

realization. The latter scene takes place in what is described as "*The Interior of Heywood's Farm. The Scene, Furniture, &c., as in Wilkie's Picture of 'Distraining for Rent.'* " As it ends, Martin Heywood cries out "God Help us! God help us! (*buries his face in his hands. The other Characters so arrange themselves as to represent* WILKIE'S *Picture of* 'DISTRAINING FOR RENT.' " "The arrangement of the various persons, as the drop fell, was so striking," wrote a reviewer, "that the audience testified their approbation by three rounds of applause."[19] Wilkie was among them, if not on the first, then on the second night, and testified to his own delight in a letter to Clarkson Stanfield:

Kensington, Jan 27th, 1832.

DEAR MR. STANFIELD,

I went last night to the Theatre, Drury Lane, and cannot express how much I was gratified by the compliment paid to my humble performances in the dramatic representation of the "Rent-Day." Would you, therefore, if occasion offers, give assurance of how much I feel obligated to those who, with yourself, have contributed to render this scenic representation perfect; and particularly to Mr. Jerrold, whose inventive fancy has created out of the dumb shew of a picture, all the living characters and progressive events of real life; and, while paying an unprecedented honour from the dramatic to the painter's art, has, with the help of life, movement, space, and time, shown us in comparison how station-

49. *David Wilkie*, Distraining for Rent *(1815), engraving by Abraham Raimbach (1828), London, British Museum.*

[19] Lacy, Vol. 15; and unidentified rev., Enthoven.

ary and how confined is that *one instant*, to which our elaborate art is limited. Without being a judge at all of the merits of dramatic composition, I cannot help expressing how much I was struck with the preparation and completion of the Tableau of the "Distraint," which, in acting, had much of the effect of the denouement of the play acted before the King in Hamlet—the surprise of an expected event.[20]

Despite his disclaimer, Wilkie shows himself both a judge and anatomist of dramatic effect. Though not a painter one would describe as "dramatic" in the usual metaphorical sense (at least while he kept to his "humble style"), Wilkie's art had shown from the beginning fundamental affinities with the theater, and specifically the nineteenth-century popular theater. Leslie observes, for example, that:

> Hogarth seems to have considered it always proper that the spectator should suppose himself to be in the apartment represented. But there is no absolute necessity for this. The side of the room not represented may be imagined open, as in many of Wilkie's compositions, and as in scenes on the stage . . ."[21]

The back wall parallel to the picture plane is also common to both; and critics observed the smallness of Wilkie's figures in relation to the size of the rooms, an effect of the contemporary stage. More important, his sense of the fundamental relation of onlooker to picture was rooted in the theater, as both his language and practice suggest. John Burnet reports "a method which he availed himself of till the last,—that of having a small box made in the shape of the interior he intended to paint, into which was placed the entire group, modelled in clay, dried, and painted in a rough manner." This enabled him to arrange and study the effects of light and shade; and, "The perspective of the whole was also more correct, as the point of distance was chosen sufficiently removed, so as to embrace the entire composition at once."[22] Just as Wilkie assumes a theatrical "point of distance," so he invokes almost thoughtlessly theatrical analogies in order to describe the relation of both the painter and the painting to an audience. His reference, in the letter to Stanfield, to the "performance" and "dumb shew" of the painter was not merely the influence of the occasion. In a series of "Remarks on Art," for example, Wilkie argues that the unsophisticated but responsive man "is probably a far better judge of what art should perform than the professor [the painter] who, like the actor on the stage, must be content to receive the fiat of success or failure from an audience who, to form judgment of the illusion, must necessarily be excluded from behind the scenes."[23]

In the medium in which Wilkie was most eloquent, in his admirable painting of *The Blind Fiddler* (1806) for example, the child imitating the fiddler embodies mimetic activity in histrionic form, linking painting and acting. Meanwhile, Wilkie (a fiddler himself) sets off and defines his own vein of sympathetic comedy by the burlesque. Again, in *The Wardrobe Ransacked* (1810), Wilkie's subject is dressing up and playing the fool. Like Bottom, he had an appetite to play more than one part, and his engraver notes that "his own plastic features, studied

[20] Introduction to *The Rent Day*, in *The Modern Standard Drama*, ed. Epes Sargent, 4 (New York, 1846). A MS transcription of Wilkie's letter pasted to the back of *Distraining for Rent* (now in the National Gallery of Scotland) shows some variations from this text, whose source was James Wallack. In another letter (also affixed) Wilkie urges the owner of the picture, William Wells, to go see it "acted to the life in Tableau" in the new piece. A later letter from Stanfield to Wells explains the tattered state of Wilkie's note of thanks by supposing "I carried it about in my pocket (in pride of heart) to show to the admiring actors concerned in getting up the drama." It is worth noting that Stanfield had also painted the scenery for *The Brigand*, and that James Wallack played the lead in both plays. William Mulready told Frith that he and Wilkie went together to the first night of *The Rent Day*, after Wilkie himself had put the actors in position at rehearsal. Not only "did they get the groups right, but they managed to select people really like those in the picture. I was delighted," and Wilkie shed tears of pleasure. (Frith, *My Autobiography*, 3:416).

[21] Leslie, *Hand-Book for Young Painters*, p. 161.

[22] John Burnet, *Practical Essays on Various Branches of the Fine Arts* (London, 1848), pp. 115-16. Cf. Leslie, *Hand-Book*, who notes the addition of "proper doors and windows" and general forms of the furniture (p. 191), and the Redgraves on the painting of Wilkie's *Preaching of Knox* (A Century of Painters, 2:288).

[23] Cunningham, *Wilkie*, 3:148. Elsewhere Wilkie observes that "the back view of a figure in a picture, as of an actor on the stage, must be shown sparingly, however much this may appear to deviate from the accidental grouping of people in life" (p. 166). Leslie, in contrast, urges the necessity of such back views "to avoid a theatrical or artificial look" (*Hand-Book*, p. 43).

in the mirror, assisted his unrivalled power of expression on the canvass."[24]

Wilkie's analogy between the man looking at a painting and the spectator before the scenes demonstrates his abiding concern with the idea of a popular art, a *vernacular* art. He argues that to "create a taste and understanding of her powers . . . to become useful and popular, [Art] must not shape her taste to suit a party or a class, but adapt it to the tastes and capacities of a whole people."[25] In Scotland he had found some inspiration in a play, Allan Ramsay's vernacular "pastoral comedy," *The Gentle Shepherd*; and in London he found a model for the inclusive audience he sought in the box, pit, and gallery of the theater. His success preceded his formulated theory; but the affinity between his art and some of the strongest "vernacular" currents in the earlier nineteenth-century theater is real enough to stand by itself. This affinity goes considerably beyond physical settings and frontal arrangements and new attitudes to rural and domestic subject matter. It includes an emphasis on strongly marked characters, individuated by externals to the point of oddity; a clustering variety of local incident, sometimes at the expense of unity and focus; the peculiar mingling of comic and pathetic interest evident especially in *The Rent Day*; and the shift from genre scene to narrative tableau evident in *Distraining for Rent*. These, having to do with the conception and representation of human life as well as with the relation of an audience to the representation, are the grounds of a stylistic affinity between Wilkie's paintings and the early nineteenth-century theater which found its expression in Jerrold's play.

Stanfield seems to have carried out his commission faithfully, and Jerrold replied with much effusion to Wilkie's relayed compliments, modesty belittling the importance of his own contribution:

> The drama of *The Rent Day* has succeeded beyond all that the author could have ~~wished~~ hoped for [*sic*]. But he cannot forget how great a portion of that success is attributable to the Painter, who has made the pictures—of which that drama is the shadow—the familiar "household gods" of the English public; and who has thus created associations, which, being seized upon by the dramatist—have cast a value and a beauty around a work, and whilst they have rendered it prosperous are wholly extrinsic of it. Never had drama so powerful—so significant a prologue (if I may use the word) as had the *Rent Day*. The picture, on the rising of the Curtain, in its mute eloquence, told the story, and thus saved the dramatist his greatest labour.[26]

The play, however, was originally in two acts, and by the end of the first the paintings were all used up. Moreover, the drama of rackrent and foreclosure which can be generated from Wilkie's related but more contrastive than sequential paintings lacks a resolution, in which justice is seen to be done and Eden restored. The paintings therefore are not dramatized as such, but rather are united with a drama of an unjust steward found out by his unrecognized and heretofore absent young master (as in Maria Edgeworth's novel *The Absentee*).[27] This drama is amplified in the second act by a plot of domestic anguish and traduced

[24] Abraham Raimbach, *Memoirs and Recollections . . . Including a Memoir of Sir David Wilkie, R.A.* (London, 1843), p. 156.

[25] Cunningham, *Wilkie*, 3:180-81.

[26] Jerrold to Wilkie, 16 Feb. 1832, National Libr. of Scotland MS 9836.

[27] Edgeworth's novel, pub. 1812, includes a Rent-Day scene set in the neglected manorial apartments. The main incident places a widow and her irate son before the agent and his brother, who refuse to renew a lease despite the lord's former promises. The absent lord's son is present incognito, and eventually reveals himself with fine effect. Christina Colvin points out the affinities with Wilkie's earlier *Rent Day* in her edition of Edgeworth's *Letters from England, 1813-1844* (Oxford, 1971), p. xviii. Jerrold in turn found a use for Edgeworth's situational version of the scene of the painting.

and vindicated innocence, where Martin Heywood, the distrained-against young Job of Jerrold's play, finds his wife Rachel locked up with the young squire, as her only means of saving that gentleman's life from some enterprising villains. The squire emerges with pistols, and "A good picture is here produced, by *Martin Heywood* levelling a pistol at the 'squire because he believes him to be the seducer of his wife, and the squire himself taking him to be one of the villains who have conspired against him, and, consequently worthy of being shot."[28] Rachel intervenes, and the picture formed is one of those "where the painter in turn may be indebted to the compositions of the stage manager." The situation has something about it of David's *Sabine Women*; but it can remind one even more forcibly of Puff's splendid pictorial impasse in *The Critic*.

Contemporaries found nothing unusual in the plot of *The Rent Day*; only in the skill with which it was managed for "effect." As for the implicit political and social bearings, these are not strikingly apparent to the modern observer, who notes that the rent problem is solved at last when Martin, struggling with the broker's men over his grandfather's chair, tears it apart to discover a nest egg of golden guineas. Moreover, we learn from the very review that treats the play as a great moral lesson to absentee landlords that the actor who played the squire took the precaution of dressing "in the costume of the last century," and "looked as though he had walked out of the frontispiece to one of the old novels."[29] Nevertheless, the presence at Drury Lane of so democratic a form as domestic melodrama did cause some uneasiness; and the inability of a painfully virtuous and industrious tenant farmer to meet his agricultural rents was more than just a melodramatic *donnée* in January 1832. The preceding year and a half had seen hardship and violence in the southern counties, and something approaching a general revolt of the laborers in the winter of 1830-31, when Captain Swing appeared, workhouses were pulled down, and threshing machines destroyed.[30] The years from 1828 to 1832 "were characterized by poor crops, high prices and enormous importations," putting a considerable strain on the capital of farmers, nearly half of whom were too small to employ any labor outside the family.[31] The number of bankruptcies among tenant farmers, burdened by high rents and tithes, was a frequent political theme.[32] The revolt of the laborers, abetted by some farmers, proved frightening and was harshly (or "firmly") put down; but like all other agitating issues, those of rural misery and inequity were absorbed in 1831 into the battles and expectations of Reform.

RADICAL measures or seditious sentiments on rural exploitation are not directly promoted in Jerrold's play, though Bullfrog the auctioneer is ironically urged to sell people; but the relation of the situation to the times, in conjunction with the class bias in domestic drama as a genre, gives the play political bearings. The landowning aristocrat is not the villain in this melodrama, but his agent is; and the rest of the general commodity of nastiness is shared between the swashbuckling drones of society and its petty officialdom. Even the grasping steward, engaged in swindling the absentee landlord as well as in squeezing the tenant, is powered by a thirst for revenge on the son of the gentleman-seducer

[28] Unidentified rev., Enthoven.

[29] *Spectator* 5 (28 Jan. 1832), p. 87.

[30] Machine-breaking began in June 1830, and the last trial concluded in September 1832, eight months after Jerrold's play. See E. J. Hobsbawm and George Rudé, *Captain Swing* (New York, 1968), and "The Last Labourers' Revolt" in Barbara Hammond and J. L. Hammond's classic, *The Village Labourer 1760-1832* (London, 1911 etc.). "Captain Swing," whose name the laborers sometimes signed to warnings and demands, seized the popular imagination and temporarily entered the language. Three fictitious biographies appeared in 1830 and 1831, and he is invoked allusively in *Pickwick* (1836) and *Tom Brown at Oxford* (1861).

[31] D. G. Barnes, *A History of the English Corn Laws from 1660-1846* (New York, 1930), p. 235; and Chambers and Mingay, *The Agricultural Revolution 1750-1880*, pp. 93, 133.

[32] E.g. in the debate on the King's Speech of 1830, *Annual Register, 1830*, pp. 20-21.

who stole his wife and drove him to ruin. Virtue, however, in the shape of charity, integrity, and industry, is shared by those whom agent and officials oppress. The oppressed are not rioting have-nots, or large, prosperous farmers fallen on hard times, but the modest representatives of an ideal and imperilled domesticity, threatened with deprivation of their homely possessions and of the tenancy that is theirs by right of several generations. The play makes provocation to violence the ultimate peril to Martin Heywood, though it also generates a certain sympathy for the manly impulse. For an audience receptive to a propaganda for the dignity and respectability of the common man, the economic threat is typically incorporated with and symbolized by the domestic threat in all its forms. Brutal foreclosure, slander, and seduction are here equivalent; and responsive violence, while thoroughly deplored and cast in the role of a perilous temptation, is offered as the consequence of such abuse of common humanity, of such a threat to domestic integrity.

If significant political bearings are no longer immediately apparent in Jerrold's *Rent Day*, they are probably even less so in the paintings that inspired it. Wilkie's *Rent Day*, mixing broad comedy with mild domestic pathos (the seated widow and her children), and making much of the consoling meat and drink that were a regular part of this quarterly concurrence of the manor and the cottage, would hardly seem more than a shrewdly observant celebration of the farmer's calendar and of the old paternal relations. Stretching a point, one might take the painting as a cautious criticism of their decay (both the room and its occupants testify to an absentee landlord). But surprisingly, even *The Rent Day* is summed up by Wilkie's conservative-minded contemporary biographer, Allan Cunningham, as if it were a radical social tract in which Wilkie "holds out a lesson on the insolence of office, and shows how age, and want, and widowhood suffer from the hard of heart." Cunningham cites as a parallel Burns' lines on the "Laird's court-day," and his whole description assumes a rackrent relationship. The chief group he describes as the steward and "a young husbandman, who is pleading the cause of a very old man, who stands a figure of silence and of patience, and endeavours to reclaim some of his rent, as due to him both in justice and mercy. . . . The whole picture awakens feelings of a painful nature."[33]

Cunningham's account of the painting links it to an indignant satirical passage in Burns' poem, "The Twa Dogs. A Tale" (1785), a dialogue between Caesar, who lives with the gentry, and Luath, a ploughman's collie:

> I've notic'd, on our Laird's *court-day*,
> An' mony a time my heart's been wae,
> Poor *tenant-bodies*, scant o' cash,
> How they maun thole [endure] a *factor's* snash [abuse];
> He'll stamp an' threaten, curse, an' swear,
> He'll *apprehend* them, *poind* their gear,
> While they maun stand, wi' aspect humble,
> An' hear it a', an' fear an' tremble![34]

There are indeed affinities between the poem and the painting. The two dogs are distinctly represented in Wilkie's scene, and the patient

[33] Cunningham, *Wilkie*, 1:153, 163-64.
[34] *The Poems and Songs of Robert Burns*, ed. James Kinsley (Oxford, 1968), 1:140.

old man fits the image of Burns' tenant-body. Moreover the irate arguing younger man fits the sentiments of Burns himself, standing alongside his text. Burns saw his father, "worn out by early hardship" and advanced in years, persecuted by "a Factor who sat for the picture I have drawn of one in my Tale of two dogs. . . . my indignation yet boils at the recollection . . ."[35] The point of the poem as a whole, however, is that poor folk have their jollities and powerful domestic contents, and the rich their malaise, follies, and discontents.

Wilkie was steeped in Burns, found other subjects in his poems, and undoubtedly knew the autobiographical epistle to Dr. Moore published in James Currie's then-standard edition of the poems and letters. But if, as seems likely, Burns made a contribution to the imagery of the painting, Wilkie mitigates the more intense emotions and subsumes the individual drama in the characteristic occasion. There is no ranting tyranny in his steward; the old man is less a trembling victim than a patient bystander in the debate over his dues; and to the beholder the vigorous intervention of the young man in his behalf is more reassuring than desperate. Though the estate, as represented by the room, shows evidence of neglect through absenteeism (an element in Burns' poem), social criticism is distinctly subordinate to the lively interest in character and the loving interest in things.

CUNNINGHAM was anxious to establish a serious ambition in Wilkie's *Rent Day* in the form of a moral intention. He is not subtle, and is led into implying not just social criticism, but social protest, and thereby surely distorts the essential character of the painting. There is evidence, however, that a similar wish not to be known as merely a comic painter was part of Wilkie's own motivation in his *Distraining for Rent*.[36] For contemporary viewers, the chief available frame of reference for the nonpicturesque representation of humble life was comedy; for artists, the handiest instrument for mitigating the possible radical character of such representation was comedy. Wilkie apparently saw the need to free himself from these supports in 1815.

Nothing in Wilkie's correspondence or in the various memoirs of his life points to any great concern with politics. His chief response to the revolution of July 1830 (apart from sympathy for the "aged King") was to consider whether, "If the system of [17]93 is to be again revived there might be another harvest in the importation of pictures . . . for my own part I see no advantage in all these commotions, because I see no advantage to art."[37] His patrons were of both parties, and he himself was prudent, moral, conventional, and unpretending. Nevertheless, he was exceptionally aware of the politics of the Royal Academy, and (as I have argued) of the politics of art where it concerned innovation and expectation. But such awareness complemented rather than undermined an independence that could seem no more than a vein of placid stubbornness. Easy to patronize, Wilkie was always ready to receive and incorporate in his paintings innumerable suggestions (in contrast to W. P. Frith, for example, who advertised for suggestions but never took them), but he consistently resisted being limited and classified. He aimed to please his patrons, but also went his own way when it would have been easier and safer to continue in established courses. Thus, in the course of his career, he resists the classification

[35] *Letters of Robert Burns*, ed. J. De Lancey Ferguson (Oxford, 1931), 1:107-108. Cf. *The Works of Robert Burns: with an Account of his Life*, ed. James Currie, 5th ed. (London, 1806), 1:40-41.

[36] See Raimbach, *Memoirs*, p. 164.

[37] Wilkie to Andrew Wilson, 9 Sept. 1830, National Libr. of Scotland MS 3812.

of Scottish painter by taking up English subjects, of genre painter by taking up history, of comic painter in the present instance; and relatively late, after visiting Ireland and Spain, he throws over everything with which he has been identified, style, substance and techniques, to the sorrowing consternation of his friends.

Whatever Wilkie's intentions, certainly the reception of his second *Rent* picture leaves no doubt that it was felt to be charged with dangerous political implications. By 1815, when the painting was exhibited, the closing down of the war economy was producing a severe commercial distress; and as the *Annual Register* for that year put it:

> This source of private calamity was unfortunately coincident with an extraordinary decline in agricultural prosperity, immediately proceeding from the greatly reduced price of corn and other products, which bore no adequate proportion to the exorbitant rents and other heavy burdens pressing upon the farmer.[38]

Abraham Raimbach, the engraver of both *Rent* paintings, recorded that the second failed to find an immediate purchaser though the price was "moderate" and the painting generally acknowledged to be one of Wilkie's most admirable works. "The objection was to the subject; as too sadly real, in one point of consideration, and as being liable to a political interpretation in others. Some persons, it is said, spoke of it as a '*factious* subject.' "[39]

The painting was bought by the British Institution at a good price; but in suggesting this was a saving intervention, Raimbach is probably doing that organization a kindness. Leslie recalls the episode in a passage on the popular patronage of British painting through engravings and their sale. During Wilkie's meticulous two-a-year period, the sale of the engraving supported his method. But having bought *Distraining for Rent* (and exhibited it the following year), the British Institution put the painting in its cellars and refused to allow an engraving until Raimbach himself took it entirely off their hands, by purchase. "The great excellence of this picture had, at first, induced the Directors of the Institution to buy it as soon as it was seen at Somerset House. But they were afterwards frightened at what they had done, on it being suggested that the subject was a satire on landlords."[40]

The explanation, I suspect, is that events surprised them. The motion to purchase, after all, was seconded by one of the greatest landlords in the United Kingdom, the Marquis of Stafford, later the first Duke of Sutherland.[41] The motion was put in May or early June 1815, shortly before Waterloo. There had been urban riots earlier in the year, notably during three or four March days and nights in London and Westminster. But these were directed against the Corn Importation Bill, a bill that favored the "agricultural interest" in general and was supposed to relieve the very distress represented in the painting. The act, however, passed in March, had no positive effect, since the crop of 1815 turned out plentiful despite some drought and the price of wheat fell lower than in the two previous years. The squeeze was a sharp shock to the farmer, generally a tenant who had prospered during the war, but whose rents had typically risen by some 90 percent during the era of high prices.[42] Rents had not been reduced, owing in part to

[38] Quoted in Hammond and Hammond, *The Village Labourer*, 3rd ed. (London, 1920), p. 152. The agricultural decline began with the harvest of 1813.

[39] Raimbach, *Memoirs*, p. 163.

[40] Charles Robert Leslie, *Autobiographical Recollections*, ed. Tom Taylor (London, 1860), 1:215.

[41] According to Joseph Farington, Sir George Beaumont said that he had proposed the purchase and Stafford had seconded him. (*The Farington Diary*, ed. James Greig [London, 1922-1928], 8:8; 9 June 1815). At the time, an anonymous *Catalogue Raisonee* [sic] *of the Pictures Now Exhibiting at the British Institution* (1815) brought the B.I. under satirical attack for not doing enough to foster British art. This may have precipitated the purchase, which had only been "spoken of" previously. See the transcription of the Windsor MS of Farington's diary, p. 6687 (22 June 1815), Huntington Library and Art Gallery.

[42] Chambers and Mingay, *Agricultural Revolution*, pp. 118, 129.

the expectations created by the Act of 1815, and "the loss of the capital of the farmers as a result of three successive losing crops made their condition almost unendurable. Petitions once more covered the tables of both Houses of Parliament, not protesting against additional protection as in 1814 and 1815, but begging for some relief for the harassed farmers."[43] The *Annual Register* for 1815 observed,

> that seldom has there been a more general depression of spirits in any class of people, than was apparent about the close of the year among that most useful part of the community; and that the number of farms thrown up in consequence of the insolvency and despair of the occupiers was truly lamentable. [p. 144]

In this crisis the "land interest"—landlords, farmers, and their dependent laborers—was no longer perceived as monolithic.

Wilkie's painting was still being exhibited at the British Institution in February 1816, when the *Examiner* reported, "it has become a valuable ornament to the rooms,—an exemplar and stimulant to the Students."[44] But as the economic climate continued to worsen, the fragmentation of the "land interest" affected how the painting was perceived. With shortages, demobilization, and a disastrous year in the making in 1816 ("The Year Without a Summer"), the rural laborer, whose work and wages "fell fast and far immediately after the war," now found himself caught between unemployment and scarcity. From May 1816, there were widespread laborers' outbreaks, riots, and burnings through the eastern counties, in Suffolk under the flag of "Bread or Blood."[45] By then, when even more of the farmers of the kingdom than in 1830 were still family farmers, the painting had become the eloquent summation of their despair; and before long it also seemed to represent the selfishness and unfeeling cruelty—exercised through petty tyrants—of the landlords, who emerged as popular villains.[46]

Byron reflects on all this, in "The Age of Bronze" (1823), where he points a contrast between a rent-day scene (like Wilkie's), with its "goodly audit ale" and prosperous tenants during the war, and what followed; and crucifies what he calls "the land self-interest":

> Safe in their barns, these Sabine dwellers sent
> Their brethren out to battle—why? for rent!
> Year after year they voted cent. per cent.,
> Blood, sweat, and tear-wrung millions—why? for rent!
> They roar'd, they dined, they drank, they swore they meant
> To die for England—why then live?—for rent!
> The peace has made one general malcontent
> Of these high-market patriots; war was rent!
> Their love of country, millions all misspent,
> How reconcile? by reconciling rent!
> And will they not repay the treasures lent?
> No: down with everything, and up with rent!
> Their good, ill, health, wealth, joy, or discontent,
> Being, end, aim, religion—rent, rent, rent![47]

Both the painting and the play, then, appeared in similar circumstances of agricultural distress and rural revolt, though nearly seventeen

[43] Barnes, *History of English Corn Laws*, p. 158.

[44] *Examiner* (25 Feb. 1816), p. 97.

[45] Chambers and Mingay, *Agricultural Revolution*, p. 129. See A. J. Peacock's monograph on this rebellion, *Bread or Blood: A Study of the Agrarian Riots in East Anglia in 1816* (London, 1965).

[46] Barnes, *History of English Corn Laws*, p. 148, and Chambers and Mingay, *Agricultural Revolution*, pp. 92, 124. The latter endorse Barnes' analysis, that since the new Corn Laws of 1815 "left the landlords posing as the protectors of the tenants and agricultural labourers, and facing the hostility of the city labourers, annuitants and manufacturers . . . they succeeded, almost as a matter of course, to the position of hatred and opprobrium which the corn dealers and millers had occupied for so many centuries in the eyes of the common people." Taken sequentially, this Janus image of the landlord matches the shifting perception of Wilkie's painting by his patrons.

[47] *Lord Byron, The Complete Poetical Works*, ed. Paul Elmer More (Boston, 1933), p. 306. The verses are also cited in Barnes, *History of English Corn Laws*.

years lay between them; and whatever Wilkie's intentions, *Distraining for Rent* had distinct associations which made its realization at the time of Jerrold's play particularly appropriate. In one sense, the political character of the painting was quite independent of Wilkie's intentions, as the history of its reception shows. Its politics were determined by events. But in another sense, its politics were a product not so much of circumstances as of kind; and that kind was chosen, and indeed partly shaped, by the painter. The true appropriateness in Jerrold's use of Wilkie's painting lay in the inherent politics and assumptions of domestic drama, with its serious treatment of suffering and joy in humble circumstances, and its habitual location of the sources of undeserved suffering in the local agents and unworthy possessors of property and power.

Village Politicians

Jerrold's play was rapidly plagiarized and imitated. Sadler's Wells put on A. L. Campbell's *The Rent Day, and Distraining for Rent; A Domestic Drama* (20 Feb. 1832), clearly derived from Jerrold's play.[48] And the Adelphi Theatre shortly thereafter put on J. B. Buckstone's "Domestic Burletta" *The Forgery; or, The Reading of the Will* (5 Mar. 1832), in which:

> Two scenes were greatly admired: the first was a realization of WILKIE's "Village Politicians," the other of his "Reading of the Will;" both were very good—the later, indeed, was most excellent; it could not have been so well done on any larger stage; the characters exactly filled the scene in most perfect grouping . . . the artist has reason to be satisfied with the arrangement of the manager, he has done ample justice to his original.[49]

The artist, moreover, was simply repaying his debts. An entry in Wilkie's journal dated 6 December 1808 reads "Called on Liston and Bannister [leading actors of the day, one gifted in low and the other in genteel comedy], who proposed to me for a subject 'The Opening of a Will;' which I consider an excellent idea, and I am much obliged to them for suggesting it."[50] Wilkie kept the idea by him until 1819, when the King of Bavaria commissioned a painting. In exhibition, Wilkie embellished the painting with a quotation from a similar scene in Scott's *Guy Mannering* (1815); a scene, Scott says, which "might have made a study for Hogarth" though Wilkie, having supplied the picture, omits the phrase.[51] The subject of course is perfect situational drama. Bulwer-Lytton uses it in his play *Money* (1840); George Eliot makes hay with it in *Middlemarch*, and Shaw exploits it in his most blatant farrago of conventional melodrama redeemed, *The Devil's Disciple*. (Wilkie's preliminary drawings show he considered painting a tense domestic drama halfway between Greuze and Dickens—a drama Shaw would stand on its head—between the reprobate son of a previous union and the young son of the widow.)

Something of the completeness of the theatrical realization appears in the stage directions of the acting edition of Buckstone's play, which should be compared with Wilkie's finished scene:

[48] Duncombe, Vol. IX.

[49] *Examiner* (11 Mar. 1832), pp. 165-66.

[50] Cunningham, *Wilkie*, 1:212.

[51] Except for the omission, the exhibition catalogue rubric varies only negligibly from the following passage in *Guy Mannering* (Chap. 38): "Mr. Protocol accordingly, having required silence, began to read the settlement aloud in a slow, steady, business-like tone. The group around, in whose eyes hope alternately awakened and faded, and who were straining their apprehensions to get at the drift of the testator's meaning through the mist of technical language in which the conveyance had involved it, might have made a study for Hogarth." *The Waverley Novels* (Edinburgh, 1865-1868), 4:117-18. The elderly spinster who cuts a figure in Wilkie's scene corresponds, in Scott's novel, to the deceased, but also distinctly recalls the churchgoing old maid and her page in Hogarth's *Morning*. Smollett anticipates Scott in Chapter IV of *Roderick Random* (1748) where he notes, "the will was produced in the midst of the expectants, whose looks and gestures formed a group that would have been very entertaining to an unconcerned spectator."

SCENE V.—*An Apartment at Mrs. Neyland's.* LAWYER MUTE, *discovered reading the will. The* LIEUTENANT [Lizzard, a designing heavy villain] *leaning over the Widow's shoulder—*ELLEN [the Widow's cousin] *in the corner—*WILLIAM [the young heir] *at the fireplace—*JOHN NEYLAND [the chief villain] *seated behind the lawyer—the* NURSE *with the child near* MRS. NEYLAND [the Widow]—GRUB [church warden] *at the table with the tube in his ear—a Livery Servant standing over him.* MISS VERJUICE [an old-maid relation], *attended by* JACK SPRAT, *is entering the door. Relations and Friends complete the group, which realizes Wilkie's picture of "The Reading of the Will." It is seen for a few seconds, accompanied by a piano strain of music, and the drop falls.*[52]

The picture, however, is rendered so faithfully at the cost of a plot awkwardness. We learn in the next act that the will has been set aside in favor of another that satisfies the vultures and impoverishes the widow. This second will is the forgery of the title, and the heart of the intrigue. It provides the opportunity for a splendid sensation in the first act: the villains guide the hand of the corpse—only partly visible—in signing the substitute will, so as to be able to swear safely to the forgery.

It is, however, the elements focused in the realization of Wilkie's other painting, *Village Politicians*, that make the play more noteworthy than an ordinary drama of the attempt to defraud virtue and innocence of property. Jack Sprat, temporarily in service to Miss Verjuice in the will scene, was the comedy part Buckstone wrote for himself. He appears in the first scene—a country public house with the locals smoking, drinking, and arguing—as the village radical, in hot dispute with the pointedly deaf Churchwarden Grub, otherwise a tallow chandler with a vested interest in candles. Grub is all for Subordination, and turns his place in the vestry to profit by promoting parish illuminations and forcing the paupers to live on eighteen pence a week. Jack decries the "radical defects" of society, and his stereotyped rhetoric is both comic and convincing. This side of the play is reinforced at the beginning of the second act, where a hot debate on the power of the Churchwardens and the parish Overseers opens with a formal realization of Wilkie's picture, *Village Politicians*.

Buckstone's play appeared as the Reform Bill was entering its final crisis, though at a moment of optimism and relative quiet. Four months earlier, however, the situation had appeared to be revolutionary. The riots in Bristol, according to the *Annual Register*, were the worst the nation had seen since Lord George Gordon's in 1780. The mob had besieged and stormed a Mansion House dinner for the Recorder of Bristol—an opponent of reform—who escaped with the city magistrates through the rear of the building. All the jails were broken open, and the Mansion House itself, along with the Bishop's Palace, the Custom-House, and some private houses burned down. Twelve people were killed, and ninety-four wounded, mostly rioters. The special commissions created to sit upon these and similar events elsewhere generated trials and executions throughout the first quarter of 1832, when Buckstone's *Forgery* appeared.

[52] Dicks #835, Act II, scene 5.

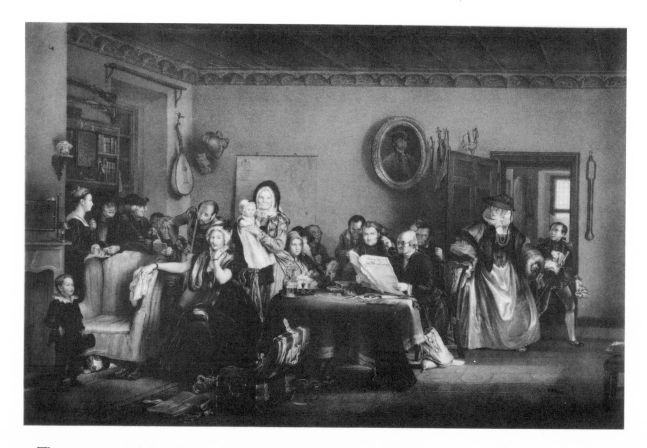

The arguments of the village politicians of the second act bear fruit in the third. After a report that Jack is rallying the paupers, we are presented a proper Dutch picture of the official Vestry dinner: "*A Room at an Inn. A table spread out with wine and fruit, & c*" and lined with the parish dignitaries. Following Grub's speech, comically evil in its gross complacency over the profits wrung from misery, the windows smash in and the mob, under Jack Sprat, drive off Grub, Overseer Nibble, and the whole of the Select Vestry. Jack and the mob are left in triumphant command of the stage, so that the play, visually speaking, presents the staging of a successful revolution. All is made safe, however, with a mere report in the next scene that the mob has been defeated. In the end, Jack appears in custody, undaunted, and the villains of the will plot are discomfited in routine fashion. The report of the defeat and the appearance of Jack in custody fall far short of the victory as a dramatic effect; and similarly the gesture toward even-handed satire of anarchic radicalism falls short of the satire of the parish authorities in their venality and callousness toward those who are subject to their power.

Wilkie's picture, *Village Politicians*, was certainly not without an intrinsic political character. The title is satirical, and might be read as merely derisive of helotic presumption, if the painting (and Raimbach's "celebrated Engraving," which commands its own line on the Adelphi playbill) were not so good-humored. That the issue before the would-be politicians in the picture is ultimately one of property, the child and

50. *David Wilkie*, The Reading of a Will *(1820), lithograph, London, British Museum.*

the dogs make plain; but more immediately it is one of liberty, justice, and the rights of man.

Village Politicians began, not as a scene which might be observed in all ages and places, a scene typical of the life of man, but as a picture tied to a particular time and atmosphere. Wilkie conceived it in 1803 (when hostilities between Britain and Consular France reopened) with an eye to Hector MacNeill's anti-Jacobin satire, *Scotland's Scaith* (1795).[53] In MacNeill's dialect poem, Will and Jean are a happy couple until, suddenly and simultaneously, "*News* and *Whisky* / Sprang nae up at ilk road-side." Will and others form a club, for drink and discussion; and seeking greater light "*Now whan a' are Politicians*," jointly subscribe to the *Edinburgh Gazetteer* (an antigovernment newspaper of 1792-93). They sit "in grave CONVENTION / To make a' things *square and even*," but the upshot is the ruin of the domestic happiness of Will and Jean.[54] Wilkie, according to his biographer, "meditated on the subject for some time, filled his mind with the memory of the political ferment of his youth, when every smithy had its evening group of agitators, and every change-house its club of orators, who discussed the merits of the ale, and descanted on the rights of man." Cunningham has as little sympathy as possible with such politics and politicians, and observes that between Wilkie's first sketch of the subject and his painting of it, the accessory figures, "which in the first sketch represent vulgar souls in whom contradiction and deceit have called up the savage, and made them fit for treason, stratagem, and spoil, are sobered prodigiously down."[55]

In 1806, Wilkie, only twenty, and a year away from Scotland, made a resounding first splash in London with *Village Politicians*. Anxious to establish his career, and at this stage exceedingly aware of his dependence on patronage, he managed to produce a painting that was a striking combination of innovation and familiarity, and that—in addition to other virtues—managed to incorporate a political interest without being "factious." In 1806, with Fox in the "Ministry of All the Talents," the threat of a domestic radicalism had receded, and the former changehouse politicians were defending the coasts or still toasting Trafalgar. Their portrayal could afford to be friendly and humane. The fact of village politics of a radical cast is not deplored or even greatly disparaged in Wilkie's painting; it is humorously observed. As a consequence, in 1832, when radical agitation and revolutionary ferment were once more topical, and when the popular theater had an interest in capitalizing on their topicality without running the risk of appearing to foment sedition, Buckstone found that the political but not factious character of *Village Politicians*, its humorous neutralization of village (not urban) politics, nicely suited the ambiguous duplicity of his village domestic drama.[56]

THE FORMULA was too successful not to be repeated, and a number of plays in the 1830s touch on rural unrest, uniting domestic trials with imperfect social conditions in a realistic genre atmosphere; plays with titles like *Wealth and Want; or, The Village Politicians* (1835), which also may have realized Wilkie's picture.[57] The mode was even burlesqued—sure sign of success—in Gilbert à Beckett's *The Parish Rev-*

[53] Cunningham, *Wilkie*, 1:48.

[54] Hector MacNeill, *Scotland's Scaith; or, the History o' Will and Jean: owre true a tale! A new edition embellished with engravings* (Edinburgh, 1800). The plates were from designs by David Allan, Wilkie's progenitor as a painter of Scottish genre scenes. Wilkie's painting, *The Village Holiday* (1811), also grew out of MacNeill's poem.

[55] Cunningham, *Wilkie*, 1:48, 49.

[56] There was a further topical pertinence in Buckstone's use of *Village Politicians*. The association of poor men's drinking places with revolutionary agitation, so important in Hector MacNeill's poem, was once more much in mind in the early 1830s. By an act of 10 October 1830, new back-lane beershops opened in an atmosphere affected by the July Revolution in France, and these were much blamed by the gentry for the Swing risings and other disorders, and investigated as centers of conspiracy. Hobsbawm and Rudé report "the widespread accusation that the new beerhouses and the Radical newspapers which were read there lay behind the riots" (*Captain Swing*, p. 88 and note).

[57] L.C. MSS Add. 42939. In the copy submitted for licensing, W. L. Rede's *Wealth or Want* was subtitled *The Barnburners*.

olution (1836), a surprising play in its way, with a historically interesting and partly serious sketch of the schoolmaster as radical. The parish rises under the leadership of the schoolmaster against the older local authorities—the Mayor, the Churchwardens, and the Beadle. The occasion is the Mayor's preventive attempt to "crush rebellion to the ground" by forbidding Guy Fawkses and firecrackers. The rebels win by disguising themselves as turnips and scaring the Mayor; as turnips, because:

> *You've* heard, & it has caused you many sighs
> That every eatable is on the rise.[58]

Parish revolutions and radical agitation were welcome targets of burlesque at the St. James's Theatre for at least a portion of the same audience whose sympathies had been enlisted at Drury Lane for Martin Heywood, and against baliff, beadle, churchwarden and estate agent. Does that not suggest the political impotence of such carefully hedged works as Jerrold's, Wilkie's, and the style of domestic realism to which they belong? Only if one takes a narrow view of the logic of political behavior, or limits the political efficacy of art to a rigorous class analysis incorporated in narrative and situation, or to a positive call to action. One modern art historian contrasts the static character of Wilkie's genre paintings with the energy and incitement to action of paintings (like Wilkie's *Maid of Saragossa*) that can awaken an analogous kinetic response in the viewer.[59] But the politics of Wilkie's genre painting lie in the solidities and circumstantial modesties of a circumscribed realism, not in Romantic kinesis. As for the kinesis of emotion, it is true that Wilkie's genre scenes, with the exception of *Distraining for Rent*, did not strike most contemporaries as charged with strong feeling, particularly of the kind we might call sentimental today. Nature and truth he treats "no better than he would a brown jug or a pan." What his genre scenes did do was find acceptable means to invite sympathetic and aesthetically serious attention to the unprettified humble and to the diversity and individuality of the ordinary. They so contributed to several revolutions of the nineteenth century, including the revolution in social sympathy.

Distraining for Rent was an exception, and it came about when Wilkie attempted to release his subject from the mitigations of the humorous, a referential category for the representations of humble life long antedating the cottage picturesque, which Wilkie had also left behind. The result was to release more than anyone apparently expected, including a dangerously direct and immediate relation to current political topics. Even *Distraining for Rent*, however, has an action concerned with things, and emotion displaced on to the useful and familiar objects of domestic life. Lindsay Errington writes, "no one who has seen the rural melodramas of [Greuze] can fail to be struck by the proportion of poignancy borne in Wilkie's picture, not by human ranting and raving but by the appeal of mere things lying strewn about the floor. The baby's cradle and the spinning wheel are more important compositionally than the stupefied farmer clutching his brow."[60] Significantly, Wilkie saw fit to compliment Jerrold especially (in the letter already quoted) for his "great skill in the contrivance of incidents

[58] L.C. MSS Add. 42939.
[59] Helene Roberts, in an unpublished commentary.
[60] *National Galleries of Scotland, Bull.* No. 2.

dependent upon the articles of furniture already upon the stage." It was the poignancy and felt truth of the circumstantial reality, together with the more general symbolic value of its represented situation, which gave the painting a lasting social and political character.

The theatrical form of domestic realism had no less interest in the prosaically real than Wilkie's pictorial form;[61] but the theatrical form differed because the direct generation of strong feelings of sympathy and antipathy was essential in melodrama. To dismiss the result as "sentimental," or to assume (with Brecht) that a largely affective response is politically self-sterilizing, is to ignore, for example, what the sentimentalizing of children and animal life by Victorian painters and storytellers helped produce in law and society. Though the plots of Jerrold's nautical and domestic dramas swathe class tensions in classless sensations, in private passions, and in a general humanitarianism, these same dramas served to enlarge the classes and categories perceived as fully human and deserving of justice and respect. They also express social resentments, pose the threat of retributive anarchy, and embody popular feeling in the conventions of a popular art.

Genre Scene and History

One other play of the 1830s realizes a Wilkie painting in a domestic drama: George Soane's *The Chelsea Pensioner* (1835), a slight play about an old relic of the wars and his lovely daughter. Through a misunderstanding, her sailor lover is enlisted as a soldier in time for Waterloo, while she is beset by Vice in the persons of a German baron and a French bawd. The play, with its popular patriotism and xenophobia, exists chiefly for the realization of Wilkie's *Chelsea Pensioners Receiving the London Gazette Extraordinary of Thursday, June 22d, 1815, Announcing the Battle of Waterloo*, that milestone painting where the tradition of heroic commemoration, aristocratic in its premises, gives way to a busy genre scene full of domestic interest, a celebration of patriotism at home, of peace and plenty and private joys, and of the always threatened Eden of domestic drama.[62]

There is more, of course, to this commemorative painting commissioned by Wellington. The Londoners who crowded to see it at the Royal Academy in 1822 were able to recognize the pensioners from the neighborhood of the Duke of York public house in Chelsea, Royal Hospital Row. There was pleasure in the recognition, and in the appeal to the sentiment of reality. The immediacy, for once, was not distanced or mitigated—at least as far as the genre aspect goes. The immediacy of the battle, of the great historical event, is of course distanced and mitigated, by the extraordinary indirection in the choice of subject. We are given, not an apotheosis, but a human celebration; not the battle and the victory, but the news and the peace; not the heroes of the day—the generals sitting a-horseback on a hill, while the regiments engage ant-size between their horses' legs—but the private soldiers of another day.

For this is a historical picture. That is, Wilkie has gone out of his way to incorporate his genre scene with a temporal dimension, to set

[61] *Figaro in London* 1 (10 Mar. 1832), p. 56, complains of Buckstone's *Forgery*, "There is an attempt at nature in part of the dialogue, but it is such nature as one may see any day without paying for. Who for instance would give a couple of shillings to see two women sitting at work, and hear one ask the other for the thread, or watch one of them get up *naturally* to snuff the candles. This kind of domestic twaddle may be very true to life; stockings are darned, thread is passed from hand to hand, and candles are snuffed we dare say, but to sit in a crowded theatre and see it done is a most unprofitable way of spending one's money in these days of scarcity."

[62] See Soane's "Domestic Drama in Three Acts," Duncombe, Vol. 15, Act II, sc. 3, where the persons are "*grouped exactly after the manner of Wilkie's celebrated Picture.*"

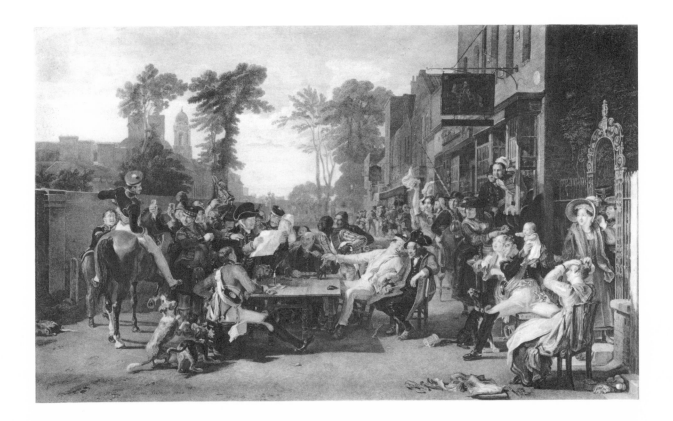

it in a graduated historical perspective. In the rubric that accompanied the painting, the pensioners are identified by the wars they served in; and in the painting itself, their uniforms identify them by regiment or branch and period. The oldest pensioner, reading from the *Gazette*, was with General Wolfe at the taking of Quebec in 1759. The most recent, swinging the baby, was at the Battle of Vittoria in 1813. Others served with the Marquis of Granby in Germany in the 1760s; at the siege of Gibraltar beginning in 1779; in France in 1789; in the Revolutionary wars in the 1790s and after. All the wars involved the French (the American part of the American Revolution is sidestepped) and every decade since Quebec is represented. In that long perspective of nearly sixty years, Waterloo and the peace in prospect are a culmination.[63]

The union of genre and history that Wilkie here achieves was typically the concern of the novelists: of the "provincials," Maria Edgeworth, Galt, and above all Scott, and later of George Eliot and Tolstoy. These depart from the example of Goldsmith's earlier novel of genre by giving private dramas not only the reality of a distinctive milieu, but also a significant location in history. Like the lesser artists of their age, they adopt conflations of narrative and picture to represent both temporal progression and synchronous configuration, innovation and interconnection. They try to relate the private life and the communal life to the processes of change; and the greatest of them are interested in exploring the interplay of the common experience and the historical experience, the petty and particular events which are the prime matter

51. David Wilkie, Chelsea Pensioners *. . . (1822), engraving by John Burnet as* Chelsea Pensioners Reading the Gazette of the Battle of Waterloo *(1831), London, British Museum.*

[63] *The Exhibition of the Royal Academy MDCCCXXII. The Fifty-Fourth*, #126. The rubric may also be found in Algernon Graves' *Royal Academy of Arts* (London, 1905-1906), s.v. "Wilkie."

of "domestic realism" and the grand events, the eternal rhythms, and the progressive and apocalyptic transformations.

Afterword

The metamorphosis of domestic realism in the art of the nineteenth century into realism unqualified is a subject too formidably intricate to deal with here. The drama, however, presents an instance that is indicative of the lines of filiation. To a backward-looking eye, that landmark drama of avant-garde naturalism, Hauptmann's *The Weavers* (1892), is also the crowning dramatic expression of pictorial forms gathered from domestic realism, and the last word in the fusion of genre and history for which Scott was the chief inspiration. Specifically, considered apart from the propaganda of naturalism, *The Weavers* stands forth as a final penetrating realization of Wilkie's paintings stripped of their mitigations, and as the bold successor to the politically prudent, pictorially organized domestic dramas that, in the 1830s, first embodied these paintings. It helps substantiate the sense of a formal and generic continuity, however, to know that Hauptmann, responding to the Silesian distresses of 1891, turned to the grimmer distresses of 1844 partly as a distancing strategy, and that he made the provincial and dialect character of his subject (modified but not eliminated) an essential part of his claim to representational truth. It also helps to know that Wilkie, patronized by the king of Bavaria, seminally influenced the school of anecdotal domestic realists that blossomed in Germany in the 1840s and flourished for decades thereafter; and that Hauptmann himself had attended the art academy at Breslau and later studied art history. The famine and rebellion of the Silesian weavers in the 1840s provoked a considerable contemporary literary response (e.g. Heine, Freiligrath, Geibel); and one of the painters Wilkie influenced, Carl Hübner, made a noteworthy debut in 1845 by painting their miseries.

But *The Weavers* itself best testifies to its kinships. The play is organized as a sequence of genre pictures, of representative tableaux, rather than as a continuous plotted action. Act I is a scene like Wilkie's *Rent Day*, the weighing and paying room in a cloth factor's house, with the weavers waiting, delivering goods, getting paid, pleading their individual needs with managing agent. Act II, like the *Distraining* picture, is the domestic scene itself, a weaver's cottage exposed in its misery and necessity and threatened with dissolution (though at a moment of kindling desperation rather than at the moment of fullest dramatic pathos, the moment of breaking up). Both I and II are true genre scenes in that much of "action" is illustration and specification of a condition, and the condition is the true subject of the representation. Act III enacts the *Village Politicians* again, with consequences. It presents a village tavern with its ordinary complement of travellers and locals arguing issues from standpoints rooted in class and vocation. Weavers in numbers, present for a factory delivery day, gather with other angry spirits, and the scene finally dissolves as the weavers empty out in a concerted force singing their song, "Bloody Justice." Act IV begins with another sort of genre scene: a social occasion in the taste-

lessly luxurious living room of the cloth factor's house. The climax is local revolution (as in *The Forgery* and the like), with the perspective of the previous act reversed: as the factor, the clergyman, and their wives flee the scene, the mob breaks in, shattering the windows and taking possession of the stage. The last act presents another weaver's-cottage genre scene, one that draws on the pictorial tradition of cottage realism as developed by Wilkie and his successors down to Leibl and Van Gogh. It begins with a tableau of a weaver family seated around a table, amid the implements of their daily life and work, at morning prayers (as in Wilkie's *Grace Before Meat*, etc.). It ends, however, with the random senseless death of the old father at his loom as the revolt outside is met by force, and with an exemplary demonstration (through the choice of the young weaver) of the superiority of Captain Swing over peasant quietism, of direct action against social injustice over faith in an ultimate justice inherent in the unchanging nature of things.

9

<center>✤⊹✤</center>

THE MATERIAL SUBLIME:
JOHN MARTIN, BYRON, AND
TURNER

F NOTHING ELSE, domestic realism in its homeliest dress was a welcome antidote to the varieties of sublimity that passed from theory into practice in the late eighteenth century, and then evolved and differentiated through Romantic fiction, exclamatory poesy, the acting of tragedy and melodrama, and the more grandiose forms of painting and music. There was no monolithic uniformity about the sublime as practiced, nor was it fixed and unchanging as a category of response in audiences, viewers, and readers. Something of its fate in the nineteenth century can be learned from considering the translation of the work of two of its notable practitioners among painters into theater. Both John Martin and J.M.W. Turner are thought of as Romantic artists, both share stylistic and thematic features with contemporary writing, and both reflect developments in the eighteenth-century notion of the sublime, one of the chief begetters of Romantic art. Their radically different versions of the sublime as well as the qualities they share with contemporary writing turn out to be implicated in the translation of their work into theater, magnified by the apparent vulgarization. The complex of these relations is reciprocally illuminating, and suggests a less fragmented, more entangled and interconnected model for the culture at large than one would gather from more single-minded and fastidious approaches.

I will not try to deal here with all the ways Martin and Turner relate to the theater nor with many of the ramifications of those connections I mention. For convenience I will start with Martin and the sublime, and then pursue the theatrical realization—by way of Byron—of Martin's images, before taking up the transformations of Turner. Ultimately I will address the question raised by the difference in their histrionic fates. Turner and Martin were awarded antithetical assign-

ments in the theater, with correspondingly different functions for an audience. Why this was so has little to do with the comparative excellence of the two painters; but it does bear upon the deepest psychological structures of their work and on the fundamental matrices of the viewer's response.

Substance and Scale

A good place to start is the ringing phrase with which Charles Lamb characterized the achievement of his contemporary, John Martin. Martin's structures, Lamb declared, were "of the highest order of the material sublime"—a gift phrase for anyone in charge of publicity, but not intended as a compliment. It appeared early in 1833 in an essay Lamb eventually called "The Barrenness of the Imaginative Faculty in the Productions of Modern Art," wherein he also compares *Belshazzar's Feast*, then Martin's most famous painting, to a "pantomime hoax" (see above, pp. 21-23).

The phrase pointed to some other condition of sublimity than "material"; but it also pointed to what Lamb conceived of as Martin's theatricality. Coleridge—who may have made the phrase current before Lamb—certainly uses it to characterize a theater of spectacular effect. "Schiller," he observes, "has the material Sublime; to produce an effect, he sets you a whole town on fire, and throws infants with their mothers into the flames, or locks up a father in an old tower. But Shakespeare drops a handerchief, and the same or greater effects follow."[1] That Martin was, figuratively speaking, a "theatrical" artist was often asserted during and after his lifetime, usually disparagingly. Sometimes, in an odd terminological leakage, critics argued whether his art was "legitimate" or "illegitimate" theater. Nevertheless, Lamb's phrase had a special appropriateness to the nineteenth-century stage and particularly to its insistent attempt to translate the sublime into the spectacular.[2]

The nature of the stage and its means simply ran counter to a fundamental Romantic endeavor: to free the sublime from material causes and correlatives and to claim it as a subjective terrain. The shift this endeavor entailed may be summed up neatly by juxtaposing Burke, who constructed his argument to establish a correspondence between external events and internal events and associations, and Schiller (as philosopher rather than playwright), for whom the sublime occurs when we are reminded of our absolute transcendence of external nature and what relates to it.[3] The theater meanwhile strove mightily toward a material illusionism. Inevitably, inadequacy of means, failures in "realization," and the inescapable awareness of machinery—dramatic and theatrical—for the successful production of "effect" emphasized the materiality of the theater and its distance from a more transcendent sublimity. Between matter and spirit, however, in popular imagery and philosophical speculation, there was a bridging substance: light. One can argue that even in the theater this century of technical progress in the creation of a materially illusionistic stage concluded antithetically, in the work of such scene-philosophers as Edward Gordon Craig and, especially, Adolphe Appia. The stage was dematerialized when

[1] Lamb's essay appeared originally in the *Athenaeum* (12 Jan.-2 Feb. 1833); *Works of Charles and Mary Lamb*, ed. E. V. Lucas (London, 1903), 2:226-34. Coleridge's remark appears in his table talk under 29 Dec. 1822, but was published in 1835, *Specimens of the Table Talk of the Late Samuel Taylor Coleridge*, ed. Henry Nelson Coleridge (New York, 1835), pp. 33-34. Keats also uses the phrase "material sublime" in his verse epistle "To J. H. Reynolds, Esq." (25 Mar. 1818, printed 1848), in *The Letters of John Keats*, ed. Hyder Rollins (Cambridge, Mass., 1958), 1:261.

[2] The issue of Martin's "legitimacy" is indignantly dismissed by the *Examiner* 25 (15 Apr. 1832), p. 244, reviewing his engraving *The Fall of Babylon*. Martin's obituary in *Gentleman's Magazine* 195 (1854): 433-36 concludes: "No doubt his art was theatrical. He addresses the eye rather than the mind. He produced his grand effects by illusion—perhaps by imposition; but it is not to be gainsaid that he did produce effects. Possibly it was scene-painting—sleight of hand; but it was also new. . . . legitimate or illegitimate, there was a spell in Martin's art. It had power over the eye, and often led captive the judgment."

[3] See Burke's *Philosophical Enquiry into the Origin of Our Ideas of the Sublime and Beautiful* (London, 1759), Part 5, secs. 1 and 2, and Schiller's "On the Sublime," *Essays Aesthetical and Philosophical* (London, 1875). Burke's treatment of language in Part 5 already moves toward a subjective uncoupling.

Appia advanced beyond light as effect and even light as movement to the direct creation of dramatic space by light.

Meanwhile lurid light, incoherent light, the light that never was on sea or land, when it appeared in the other arts was declared "theatrical," and so was Martin. An enthusiastic reviewer of his *Destruction of Pompeii and Herculaneum* (1822) defends its rendering of light in the following terms: "The light, from its central energy on Vesuvius, is gradually carried off with exquisite judgment to the darkened extremities of the picture. . . . The whole scene has a red and yellow reflex of fiery light, that, terrible in its glory, makes the spreading ocean, the winding shore, the stately edifices, the vegetative plains, the gradually rising hills and mountains, with the astounded population, look like the Tartarean regions of punishment, anguish, and horror." To those who would object, the reviewer cites assurances that the "fiery effect" of the actual eruption "*cannot* be exaggerated." Nature herself is sometimes theatrical.[4] Objections, however, to the quality and control of Martin's light tended to disappear when the paintings were translated into engravings. Like Hogarth, Martin was his own chief engraver, in direct control of the medium through which he was chiefly known. His extraordinary contemporary reputation as, among other things, a master of effect through the control of light and dark rested on the black and white of his engravings. His gift here, however, was to create not light, but material darkness; Milton's "darkness visible."

The materiality of Martin's sublime chiefly lay in the features that excited most wonder: his rendering of space, multitudes, and perhaps above all architecture; his manipulation of perspective and scale; what Uvedale Price, summarizing the principal features of sublimity, had called "infinity; [and] the artificial infinite, as arising from uniformity and succession."[5] The immensity was not merely in these physical things, however, nor in the actual size of the canvases, but in events, which also have their scale. The characteristic event was nothing less than Apocalypse, and Martin early established himself as the chief painter of the Apocalyptic Sublime. But the apocalyptic strain is rampant in the first half of the nineteenth century; and among painters it is nowhere more important than in Turner, most obviously in his plagues, in his deluge paintings, in his *Angel Standing in the Sun*, but also in avalanche, shipwreck, storm, and fire, and the reiterated consummations of things. In historical criticism it is Turner who, unfortunately for Martin, must furnish his chief foil; for in Turner of the apocalyptic imagination one sees the fullest transformation in painting of the sublime into a subjective terrain, the sublime as the affective dissolution of material forms in light.

It should be said that the charge against Martin that he was trapped in the material made no sense to most of his huge nineteenth-century audience, for whom he was an "ideal" painter whose greatest work served precisely to demonstrate the vanity of the material and of all earthly pomp and pride. His vast physical spectacles were thus redeemed by their catastrophic character, as well as by their embodiment of specifically Biblical history (or prophecy); and so redeemed, made instruments of edification, they found their way into that unwitting nursery of the Romantic imagination, Haworth Parsonage, and pious

[4] *Examiner* 15 (7 Apr. 1822), p. 219.
[5] *A Dialogue on the Distinct Characters of the Picturesque and the Beautiful* (Hereford, 1801), p. 11. Price, theorist and advocate of the picturesque, takes his summary straight from Burke. He lists "obscurity, power, all general privations, as vacuity, darkness, solitude, silence," as well as greatness of dimension, and the two infinities, natural and artificial—a range of qualities with an evident appropriateness to many of Martin's best-known works. Burke had observed that "magnitude in building" often involves "a generous deceit on the spectators," vastness by effect rather than dimensions. "No work of art can be great, but as it deceives; to be otherwise is the prerogative of nature only." He so theatricalizes art and provides for its assimilation to the illusionistic stage (*Enquiry*, Part 2, sec. 10).

and respectable households by the thousand. What one critic calls "the School of Catastrophe" took much of its character and imagery from Martin, as well as its continuing association with Christian melodrama.[6] Between 1816 and 1828 Martin painted seven major visions of catastrophe, five of them direct embodiments of Biblical history: *Joshua Commanding the Sun to Stand Still upon Gibeon* (exhibited 1816), *The Fall of Babylon* (1819), *Belshazzar's Feast* (1821), *The Destruction of Pompeii and Herculaneum* (1822), *The Seventh Plague of Egypt* (1824), *The Deluge* (1826), and *The Fall of Nineveh* (1828).

Apocalyptic Enactments

The dematerialization of the sublime, its translation into subjective terms, doubtless found its most congenial medium in the poetry of the first third of the century. Shelley (for whom light had meanings and uses analogous to Turner's) carried the impulse furthest as the inventor of an imagery "drawn from the operations of the human mind"[7] and as the poet most concerned to evoke the unimaginable. But it was Byron, externalizing that within which passeth show, who swept Europe as the poet of the subjective sublime, of an inner drama set among scenes of glaring material sublimity and intermingled sordidness. The relation between these flawed and shadowed inner and outer sublimities is often heavily ironic in Byron. But interestingly this poet of unaccommodating inner states and outer substances was found to be better partnered by John Martin than by anyone else when the time came to attempt to realize Byron's conceptions in the theater.

When Shelley turned to psychodrama, an action played out in the theater of the mind, the reenactment also had to take place in the theater of the mind. The difference from Byron lies in the imagery, as appears when comparing passages in *Prometheus Unbound* (1820), Shelley's supreme drama of mental kinesis, where a change of mind transforms the universe, with passages of like design in Byron's closet psychodrama, *Manfred* (1817). Manfred visits Arimanes, the prince of the dark powers, in a scene that was eminently realizable pictorially, as we shall see. In *Pometheus Unbound*, Asia and Panthea similarly visit the mysterious Demogorgon, to question him:

SCENE IV.—*The Cave of* DEMOGORGON. ASIA *and* PANTHEA.
Panthea. What veilèd form sits on that ebon throne?
Asia. The veil has fallen.
Panthea. I see a mighty darkness
 Filling the seat of power, and rays of gloom
 Dart round, as light from the meridian sun.
 —Ungazed upon and shapeless; neither limb,
 Nor form, nor outline; yet we feel it is
 A living Spirit.

 [II, 4, 1-7][8]

The negatives, *this* darkness visible, evoke and define the unimaginable (without form, and void), evoke not being, but its predecessor in our mental life, a procreative power of becoming, experienced kinesthetically: "we feel it is." There is no materializing this scene.

[6] See Curtis Dahl, "Bulwer-Lytton and the School of Catastrophe," *Philological Quarterly* 32 (1953): 428-42, and "Recreators of Pompeii," *Archaeology* 9 (1956): 182-91. Bulwer-Lytton's panegyric on Martin in *England and the English* appeared in 1833, and his *Last Days of Pompeii* in 1834.
[7] From Shelley's Preface to *Prometheus Unbound*, in *The Complete Poetical Works of Percy Bysshe Shelley*, ed. Thomas Hutchinson, Oxford Standard Authors (London, 1960), p. 205.
[8] *Poetical Works*, p. 236.

In *Manfred* (II, 4) the scene discovers *"The Hall of Arimanes—Arimanes on his Throne, A Globe of Fire, surrounded by the Spirits."* The Spirits accompany this fully realizable tableau with a hymn of hyperbolic praise, almost none of it pertinent to the visualization of Arimanes in his setting, but all of it, even the personification of his apocalyptic powers, imaginable. Equally to the point is another scene of spiritual apparition in *Manfred*, that of the Witch of the Alps (II, 2). Manfred conjures her up before the valley cataract that provides the setting of the scene; and *"After a pause* [she] *rises beneath the arch of the sunbow of the torrent."*[9] Here, the spirit is visualized for us through Manfred's description; but the image "in whose form / The charms of earth's least mortal daughters grow / To an unearthly stature, in an essence / Of purer elements," is clearly a sublimation of flesh and blood and nothing else. Her "hair of light" and "eyes of glory" become normal hyperbole in the company of such similitudes for her coloring as the sleeping infant's cheek, and "the rose tints" of twilight "upon the lofty glacier's virgin snow." The imagery that colors and defines the scene shows it to be realizable through material illusion, as a manifestation of the material sublime (Fig. 60).

The sublimation of spectacle in the theater and the materialization of the sublime in painting visibly converge in the Biblical and Byronic stage productions that use the imagery of John Martin and his school. Both dramatic strains also reflect the contemporary interest in the imagining of apocalypse and the turn toward archaeological historicism. But an essential prior link between the two manifestations of sublimity, pictorial and theatrical, was forged by an earlier painter whose influence may be traced both in Turner and in Martin as well as directly on the stage: Philippe Jacques de Loutherbourg, inventor of the Eidophusicon (1781), an illusionistic theater on a reduced scale, a theater of "effect," where moving and changing scenery temporalized by mechanical means and changing light supplanted entirely actor and play. One can argue that de Loutherbourg's influence lay behind most of those persistent attempts of the English nineteenth-century pictorial stage to endow itself with motion and ultimately to define itself by light.[10] His influence is clear, at any rate, in the first dramatic production that seems to reflect the particular creations of John Martin, W. T. Moncrieff's *Zoroaster; or, The Spirit of the Star* (Drury Lane, 19 Apr. 1824). The high point was an "Eidophusicon, or Image of Nature, shewing The Beauties of Nature and Wonders of Art," really a moving diorama supplemented by its namesake's light changes and mechanical effects, painted by Clarkson Stanfield. It featured an eruption of Vesuvius; and its climax was "The City of Babylon in All its Splendour," giving way to "The Destruction of Babylon."[11] Martin's *Fall of Babylon* had been exhibited at the British Institution in 1819, where it drew sizable crowds. It was reexhibited in the Egyptian Hall in 1822, where the other chief attraction in this strictly commercial venture was Martin's new and sensational *Destruction of Pompeii and Herculaneum.*

Yet what redeemed paint and the still more chaste ink of a steel-engraving to a pious and even evangelical eye could not redeem everything. It could not redeem the theater. Therefore, when a tide of

[9] *Lord Byron, the Complete Poetical Works*, ed. Paul Elmer More (Boston, 1933), pp. 488, 485.

[10] The fullest accounts of De Loutherbourg's theatrical art are in Ralph G. Allen's dissertation, "The Stage Spectacles of Philip James de Loutherbourg" (Yale, 1960), and in Rüdiger Joppien's *Die Szenenbilder Philippe Jacques de Loutherbourgs. Eine Untersuchung zu ihrer Stellung zwischen Malerei und Theater* (Cologne, 1972). See also Sybil Rosenfeld, "The Eidophusicon Illustrated," *Theatre Notebook* 18 (Winter 1963-64): 52-54. The memory of the Eidophusicon, and perhaps its remains, had a long life in the realm of spectacle. Kean attempted to duplicate some of its effects in *King Lear* (1820); and Scott invokes its magic for his melodrama, *The Doom of Devorgoil* (1817, pub. 1830), where he notes that an "imperfect, or flitting moonlight," seen through the shafted windows of a waste and ruinous Gothic hall, can be managed "upon the plan of the Eidophusicon" (II, 2).

[11] Playbill for *Zoroaster* (19 Apr. 1824), Enthoven; and published text, 2nd ed. (London, 1824).

pictorial "realization" in the theater rose in the early 1830s, there was some difficulty, apart from the merely technical, about realizing the Biblical catastrophes of Martin and his school on the stage, at least in England. One hopeful attempt is rather reminiscent of the evasions of Davenant in the declining years of the Commonwealth, when all dramatic performances necessarily had to be called something else. In February 1833 Covent Garden presented *The Israelites in Egypt; or, The Passage of the Red Sea: An Oratorio, consisting of Sacred Music, Scenery, and Personation. The Music composed by Handel and Rossini. The Drama written, and the Music Adapted by M. Rophino Lacy.*[12] The performance was sanctioned by the Bishop of London as well as by the Lord Chamberlain; and at least one reviewer poked fun at them both for allowing this drama while suppressing others on the grounds that the theater would profane a religious subject. This reviewer praises everything in the production but the scenery; for "two finer subjects, more completely marred, than the *Temple of Worship*, and *the Passage of the Red Sea*, never were exhibited at a booth."[13]

The second subject, important enough to furnish the alternate title, appears in the book of the play as follows:

Pharoah and the Egyptians enter the path among the Billows taken by the Hebrews. Moses, who, with the Israelites, has already gained the land, stretches out his hand over the Sea, when the waters furiously coming again together, the Egyptian Host is drowned; while the Hebrews, with a bright celestial glory beaming on them, are discerned on the opposite bank, returning thanks to the Lord for their miraculous preservation.

The conception sounds difficult to live up to; but an effective rendering was not beyond the spectacular resources available. The artists concerned, the Grieves, were certainly equal to their part. A pen-and-ink sketch for the scene survives (University of London); it bears a clear relation to Francis Danby's *Delivery of Israel out of Egypt* (1825), published as an engraving in 1829 under the title *The Passage of the Red Sea*. But a later maquette, with palmiferous wings and cutout waves, shows how the realization fell short, so that the audience, the reviewer tells us, condemned it as a "positive burlesque." Francis Danby, who for a time managed to rival Martin on his own ground, here had anticipated Martin, and his picture was well known from all the print-shop windows. Martin's mezzotint, *The Destruction of Pharoah's Host* (1833), with more sea in the foreground than in Danby's painting, also has affinities with the Grieves' scene. It is conceivable that, faced with the theater's attempt to do justice to these apocalyptic images, the Covent Garden audience responded less to any gross inadequacy than to the uneasiness that attended the mounting of a sacred subject on the English stage.[14] For the unembarrassed realization of Biblical catastrophe as stage spectacle in this period, one must go to France.

The unmistakably popular taste in the French theater for what Théophile Gautier always benignly related to the "Biblical enormities sketched [*ebauchées*] by Martynn"[15] had its severe critics in England. Thackeray, for example, who was most English when abroad, seethes with indig-

[12] Published by W. Kenneth: The Dramatic Repository [London, 1833].

[13] Unidentified rev., 24 Feb. 1833, Enthoven.

[14] A conflicting but circumstantial report on the effect of the scene appeared in the *Times*, 23 Feb. 1833, p. 5: "The scenery, which is entirely new, is beautiful and striking, and the last scene most remarkably so. It represents the Israelites pursued by Pharoah and his host, and saved from destruction by their miraculous passage through the Red Sea. The pursuers hang upon their rear, and rush after them into the water. The waves then close up, the clouds descend, and the Egyptian army is ingulfed. After a few moments the clouds clear off, and the Israelites are discovered on the opposite bank, returning thanks to the God whose power has rescued them, while the sea is strewn with the trophies of the discomfited host of their enemies. This is so well managed as to render it one of the most effective scenic representations we ever remember to have seen." Among the many dioramic exhibitions in London during this period (regularly reviewed in the fine arts columns) was a physiorama which, in 1832, included views of Danby's *Passage of the Israelites* [*sic*] and Martin's *Joshua*.

[15] *Histoire de l'art dramatique en France depuis vingt-cinq ans* (Paris, 1858-1859), 2:309. See also 1:180, 333-34, reviewing *David et Goliath, Le Massacre des innocents*, etc.

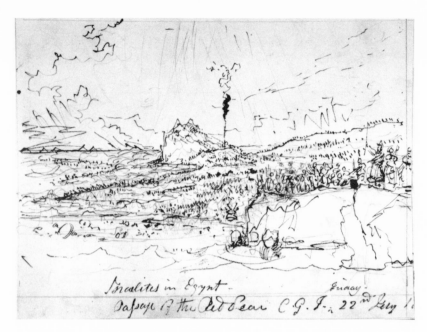

52. Grieve family, Scene design for The Israelites in Egypt *(1833), University of London.*

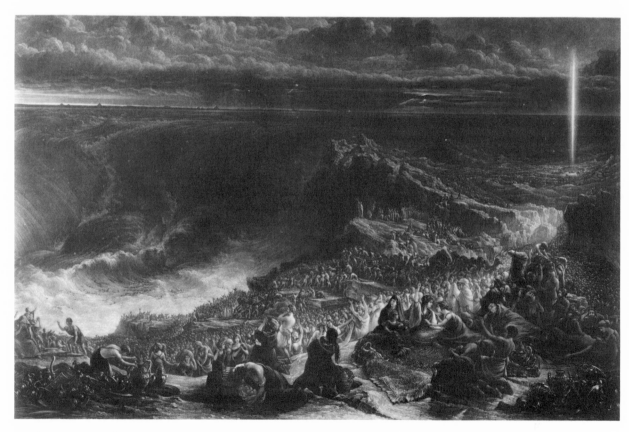

53. Francis Danby, The Delivery of Israel out of Egypt *(1825), engraving by G. H. Phillips as* The Passage of the Red Sea *(1829), private collection.*

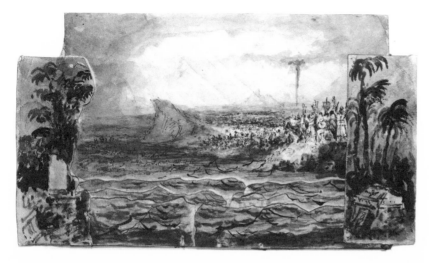

54. *Grieve family, Maquette drawing for* The Israelites in Egypt *(1833), London, Victoria & Albert Museum.*

nation at a *Festin de Balthazar* in June 1833, though he must give credit where credit is due:

> At the *Ambigu Comique* is an edifying representation of "Balshaz-zar's Feast." The second act discovers a number of melancholy Is-raelites sitting round the walls of Babylon, with their harps on the willows! A Babylonian says to the leader of the chorus, "Sing us one of the songs of Zion"; the chorus answers, "How can we sing in a strange land?" and so on; the whole piece is a scandalous par-ody of the Scripture, made up of French sentiment and French decency. A large family of children were behind me, looking with much interest and edification at the Queen rising from her bath! This piece concludes with a superb imitation of Martin's picture of Belshazzar.[16]

The theatrical impresario Alfred Bunn, fresh from the imperial ma-neuvers that would unite Covent Garden and Drury Lane under his leadership in the fall, visited Paris that summer, and like Thackeray felt the urge to display his national colors. He notes in a journal: "Went afterwards to *L'Ambigu Comique*, to see *Le Festin de Belthazzar* [*sic*], and a precious mess of blasphemy and impiety it is!"[17] Nevertheless, he was soon to give proof that he had not escaped unscathed.

Bunn began his reign, like many another Napoleon, with the need to do high-toned things "by way of being extra legitimate," as he himself put it. One promising avenue had been opened up by his predecessor in the management of Covent Garden. "The impression," Bunn writes, which "the dramatic representation of the *Israelites in Egypt* had made upon the town, now led to the preparation of another sacred subject, *Jephtha's Vow*, on precisely the same scale." But pres-sure from what Bunn calls "persons high in authority" led him to withdraw the *Vow* suddenly. Moreover, repetition of the *Israelites in Egypt* itself was interdicted; and the licenser made clear that all ora-torios "to be represented in character and with scenery and decorations" would be excluded in the future.[18] If anything resembling a striking and edifying sacred spectacle were to be realized, it would have to be

[16] "Foreign Correspondence," *National Standard*, 6 July 1833; in *Stray Papers*, ed. Lewis Melville (London, 1901), p. 37. The play, by Robillard d'Avrigny et al., opened 15 May. Augustin Hapdé, who at the height of the Empire invented Napoleonic spectacles that anticipated those of 1830, anticipated also the bibli-cal spectacles that flourished from 1830 on. In 1817 he and his Parisian collabo-rators staged an exceedingly ambitious *Passage de la Mer Rouge; ou, la Déliv-rance des Hébreux*. In 1830 he provided the Cirque Olympique with a *Déluge universel; ou, l'Arche de Noé* wherein, ac-cording to one historian, the astonishing final tableau united the thoughts of Pous-sin, Daguerre (who had displayed a Del-uge at the Diorama), Girodet, and John Martin. Marie-Antoinette Allevy, *La Mise en scène en France dans la première moitié du dix-neuvième siècle*, Biblio-thèque de la Soc. des Historiens du Thé-âtre, vol. 10 (Paris, 1938), p. 72.
[17] Alfred Bunn, *The Stage: Both Before and Behind the Curtain* (London, 1840), 1:128.
[18] Ibid., 1:134, 176-77.

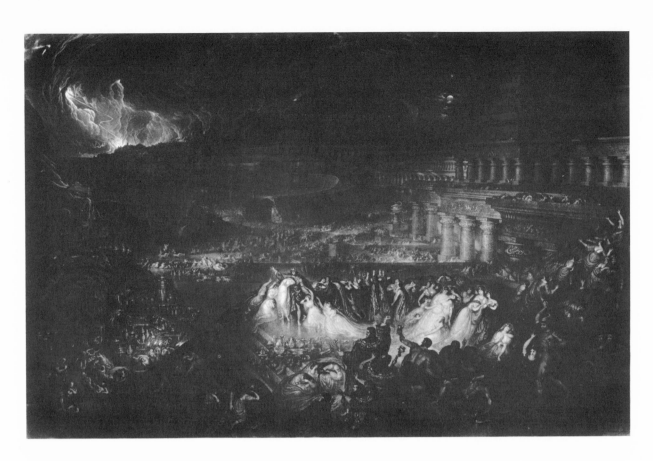

55. *John Martin,* The Fall of Nine-
veh *(1828), engraving by John
Martin (1830), London, British
Museum.*

managed indirectly. Inspired, perhaps, or at least supported by *Le
Festin de Balthazzar*, Bunn turned to the notably profane drama of
Lord Byron.

In April 1834 Bunn mounted a production of *Sardanapalus* at Drury
Lane, with Macready and Ellen Tree. The *Examiner* thought that the
end, with its homage of the soldiery and the raising of the pyre, bor-
dered on the ludicrous as well as the horrible; "and if it had not been
for the concluding scene—a scene worthy of the imagination of MARTIN
and the execution of STANFIELD—they might have proved fatal to the
piece." The *Athenaeum* reported:

> The burning itself, and the disappearance of *Sardanapalus* and
> *Myrrha* were capitally managed, and drew down shouts of ap-
> plause. There was rather too much black smoke in front, which in
> some measure marred the effect of the discovery of the burning
> city; but this may be easily obviated in future. We believe we
> need not inform our readers, that the last scene is a copy by Mr.
> Stanfield, from Mr. Martin's picture of "The Fall of Nineveh."[19]

Success was not likely to give pause; and management therefore was
not yet through with the team of Byron and Martin. In 1827 Martin's
remarkable illustrated *Paradise Lost* began to appear, issued in parts
and in two sizes, engraved by himself. There was an affinity between
Martin and Milton, that greatest practitioner of the material sublime,
creator of the Heavenly Artillery; and Martin's illustrations, if not as
independently intriguing as Blake's, are still probably the best that
Milton ever got. They were certainly Martin's own finest achievement.

[19] *Examiner* (13 Apr. 1834), p. 231;
Athenaeum (12 Apr. 1834), p. 276.

The illustrations had great success, and in April 1829 Burford's Panorama in Leicester Square advertized a "View of PANDEMONIUM, as described by MILTON, in the first book of 'Paradise Lost' . . . the whole forming the most sublime and terrific Panorama ever exhibited." The accounts of the architecture, with its overwhelming scale, its "huge masses and endless repetitions," make clear the influence of Martin.[20]

In England, Dryden had set his Restoration hand to a dramatized version of *Paradise Lost*, and there was at least one oratorio version; but no nineteenth-century licenser would have permitted a staging of *Paradise Lost*, nor—more to the point—would public notions of propriety.[21] Therefore any attempt to realize theatrically illustrations to *Paradise Lost* had to be in a strictly pictorial mode, like Burford's (whose vision of Pandemonium De Loutherbourg had anticipated by half a century); or it had to be in a dramatic context that bore no direct relation to sacred history. In the fall of 1834 Bunn's Covent Garden replied to the success of *Sardanapalus* at Bunn's Drury Lane with an even bolder venture, the production of Byron's *Manfred*.

A mediocre actor named Denvil had the success of his career in this first production of *Manfred*, though the great attraction was necessarily—in the words of a reviewer—"the beauty of the scenery, its music, and its mechanical and scenic effects, which are equal, if not superior, to any thing ever yet seen." The first-night playbill had proclaimed a measure unusual in those days of bright auditoriums: "In order to produce the necessary effects of Light and Shade, the Chandeliers around the Front of the Boxes will not be used on the Evenings of the Performance of *Manfred*." The review continues: "The Messrs. Grieve have exhibited some of the most beautiful specimens of their art; the Jungfrau Mountains, the Cataract of the Lower Alps, and a Terrace of Manfred's Castle are exquisite pictures, & the Hall of Arimanes, a copy of Martin's Pandemonium was terrifically grand." The Grieve drawing for the last-mentioned scene confirms this pleasurable recognition.[22]

Better known as *Satan Presiding at the Infernal Council* (when issued as a separate engraving in 1832, it was called *Satan in Council*), Martin's picture illustrates the opening of Book 2 of *Paradise Lost*:

> High on a throne of Royal State, which far
> Outshone the wealth of *Ormus* and of *Ind*,
> Or where the gorgeous East with richest hand
> Show'rs on her Kings *Barbaric* Pearl and Gold,
> Satan exalted sat, by merit rais'd
> To that bad eminence. . . .

But even more does it illustrate Act II, scene 4 of Byron's genuinely undramatic but eminently pictorial dramatic poem, published ten years before the Milton engravings: "*The Hall of Arimanes—Arimanes on his Throne, a Globe of Fire, surrounded by the Spirits.*"

Though he liked to profess ignorance of Milton, Byron had him somewhere in mind in writing this scene. He also had Beckford's *Vathek* (1786) in mind, on the evidence of Byron's most striking addition to the Miltonic scene, the globe of fire. When Vathek and Nouronihar penetrate to the center of the Hall of Eblis, they enter a "vast tabernacle" where numberless bearded elders and armored demons

[20] *Spectator* 2 (Apr. 1829): 255, 267. Aside from Martin's "Pandemonium" plate, the strongest direct influence on Burford's scene was actually Martin's *Fall of Nineveh*, first exhibited only the previous year. Compare the outline drawing from Burford's program booklet, reproduced in Wolfgang Born's *American Landscape Painting* (New Haven, 1948), fig. 55.

[21] *A Paradis perdu* by d'Ennery and Dugué (1856; in *Le Théâtre Contemporain Illustré*, series 43, Paris, 1856) proved the climax of spectacular scriptural illustration in the French theater. It was eclectic in its images as well as in its text, which (as Dickens pointed out) mixed Milton with Byron's *Cain* (John Forster, *The Life of Charles Dickens* [London, 1872], 3:108). A Deluge scene evokes Martin, Danby, and Girodet, and the play realizes unmistakably Prud'hon's allegorical *La Justice et la Vengeance divine poursuivant le Crime* (1808), now in the Louvre, and Martin's Satan in Council, discussed below. Cf. G. H. Lewes, *On Actors and the Art of Acting* (London, 1875), pp. 204-206.

[22] Playbill for 29 Oct. 1834, and unidentified rev., Enthoven. See also the *Observer* (2 Nov. 1834), and the *Times* and *Morning Chronicle* (30 Oct. 1834). The last, the only severely critical notice, finds Denvil "little more than the showman of a series of splendid scenes painted by the GRIEVES; and as the house was kept in darkness, the effect was quite dioramic." Cf. Henry Crabb Robinson, *The London Theatre, 1811-1866*, ed. Eluned Brown (London, 1966), p. 145: "it should be called a show in which grand pictures are explained by words."

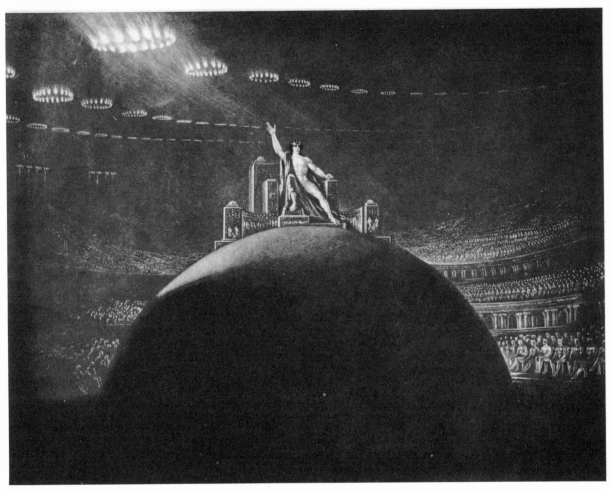

56

56. (above) *John Martin, Book 2,*
 line 1 [Satan Presiding at the
 Infernal Council] (1825),
 The Paradise Lost of Milton
 (London, 1827).
57. (facing page, top) *Grieve family,*
 Maquette drawing for Manfred
 (1834), University of London.
58. (facing page, bottom) *Isaac Tay-*
 lor, Frontispiece [Eblis Enthroned]
 in Vathek, *William Beckford*
 (London, 1815).

[23] William Beckford, *Vathek*, 4th ed.
(London, 1823), p. 209. E. H. Coleridge
notes the "throne of Eblis" parallel in
The Works of Lord Byron, Poetry (Lon-
don, 1898-1904), 4:113n. See also By-
ron's remark in Thomas Medwin, *Con-*
versations of Lord Byron, ed. Ernest J.
Lovell, Jr. (Princeton, 1966), p. 258:
" 'Vathek' was another of the tales I had

"had prostrated themselves before the ascent of a lofty eminence; on
the top of which, upon a globe of fire, sat the formidable Eblis."
Beckford also remembered Milton's Satan, as the description of Eblis
makes clear: "His person was that of a young man, whose noble and
regular features seemed to have been tarnished by malignant vapours.
In his large eyes appeared both pride and despair; his flowing hair
retained some resemblance to that of an angel of light." He bears the
marks of the thunder, and, like Milton's Moloch (and Byron's Ari-
manes), is a scepter'd king.[23]

For his Miltonic Pandaemonium, Martin also may have drawn on
Beckford and his illustrator, Isaac Taylor.[24] Martin's architecture often
seems like an embodiment, in real space and geometry, of the vast
platforms, towers and multitudes, perspectives, courts, columns, and
arcades, of "an architecture unknown in the records of the earth" in
Beckford's Eastern gothic fantasy. But Martin unquestionably drew
directly and frequently on Byron, not only for Byron's sense of the
gorgeous East and her Kings Barbaric, but also for his sense of apoc-
alyptic ironies. Martin's *Fall of Nineveh*, which Stanfield recreated for
the Drury Lane production, drew some of its inspiration (discernible

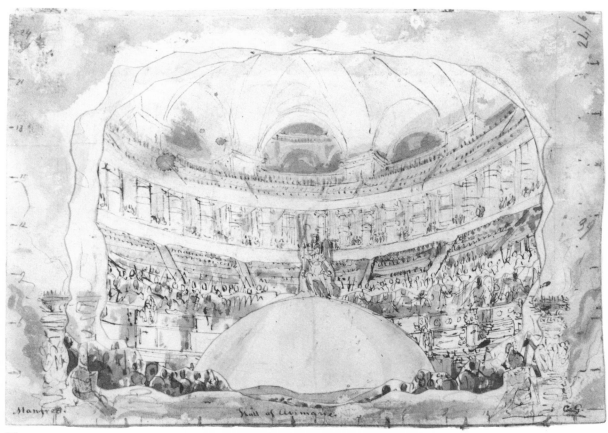

57

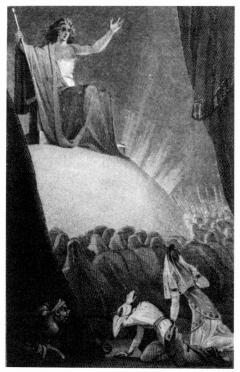

58

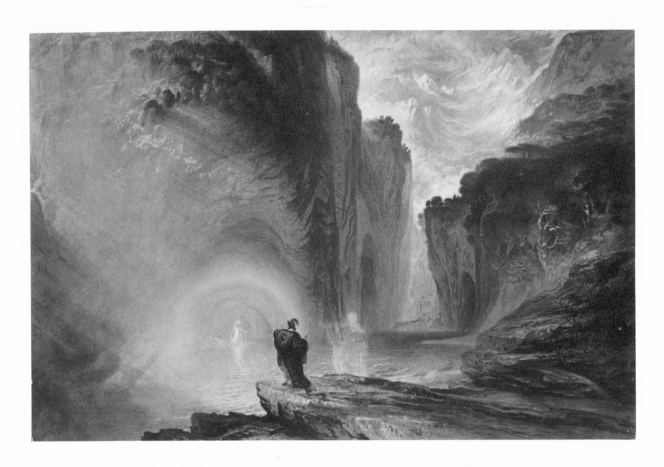

59. *John Martin,* Manfred and the
Witch of the Alps *(1837), Man-
chester, Whitworth Art Gallery.*

a very early admiration of. . . . What do
you think of the Cave of Eblis, and the
picture of Eblis himself? There is poetry."
[24] Jean Seznec, *John Martin en France*
(London, 1964), pp. 19, 20. Seznec
notes that the frontispiece of the 1815
London edition of *Vathek* "annonce le
Satan présidant le Concile Infernal." For
Martin's direct connections with Beck-
ford, see William Feaver, *The Art of John
Martin* (Oxford, 1975), pp. 60-64. De
Loutherbourg also worked for Beckford,
and there is indirect evidence of his effect
on the writing of *Vathek,* notably on the
Hall of Eblis, making the chain com-
plete. See *The Travel-Diaries of William
Beckford,* ed. Guy Chapman (Cambridge,
1928), 1:xxv, and Richard Altick, *The
Shows of London* (Cambridge, Mass.,
1978), pp. 121-22.
[25] Reproduced in Feaver, *John Martin,*
Pl. 114.

in the foreground melodrama) from Byron's *Sardanapalus.* Martin's
Last Man (1833, 1849) owes a great deal to Byron's extraordinary
poem "Darkness" (1816), as well as to works by Mary Shelley and
Thomas Campbell. The self-conscious temporal structure of *Belshaz-
zar's Feast* has affinities with Byron's "Vision of Belshazzar" (1815).
In the description of his own *Deluge,* Martin refers to "that sublime
poem," Byron's *Heaven and Earth* (1821), which ends with the won-
derful stage direction: *"The waters rise: Men fly in every direction; many
are overtaken by the waves; the Chorus of Mortals disperses in search of
safety up the mountains; Japhet remains upon a rock, while the Ark floats
towards him in the distance."* And shortly before producing his Milton
illustrations, Martin painted *Manfred on the Jungfrau* (1826). A later
version in watercolors (1837) shows a diminutive figure, among fan-
tastic peaks and gorges, seized at the moment he is about to spring
into oblivion.[25] A companion painting, *Manfred and the Witch of the
Alps* (1837), possibly took more from the theatrical embodiments of
the scene than it gave to them.

Manfred was twice revived during the century for London audiences,
both times with considerable success as the embodiment of the sublime
as spectacle. Phelps put it on at Drury Lane in 1863, sharing the stage
management with William Telbin, the scene painter and designer. The
music was the same that Henry Bishop had provided for the first
production. The costumes were billed as "from designs by R. W.

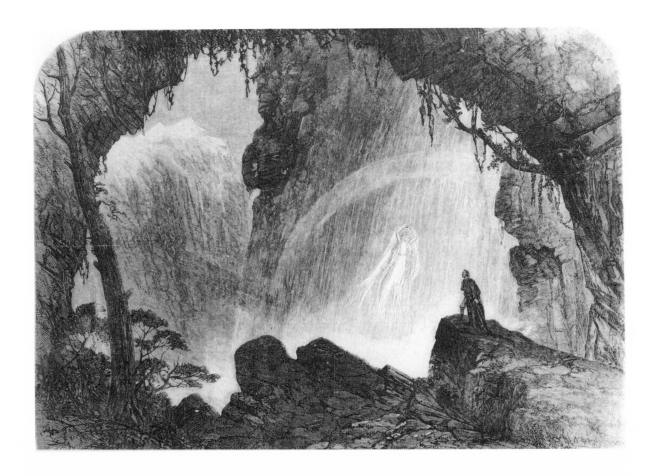

Keene, Esq., and from Flaxman's illustrations of Classical and Myth-ological conceptions." The reviews had much to say about the history of the play, its present classic status, its reflection of the French Rev-olution and the years of reaction.[26] The *Spectator*, however, makes it clear that what has "drawn crowds every night during the week has unquestionably been the scenery." The writer praises especially Tel-bin's Alps; "but the great sensation scene is, of course, that in the second act, 'the dwelling of Arimanes in the nether world,' the idea being taken from Martin's celebrated picture. Arimanes is seated on a globe of fire, in the centre of a vast amphitheatre filled with a lurid glare, and peopled by thousands of indistinctly seen spirits." The sub-limity of it all, however, seems not to have overcome this reviewer. He goes on: "The effect is decidedly appalling; but it is difficult to avoid comparison between the globe of fire and a monster plum-pud-ding, and the fiend at the top, with outstretched wings, resembles at first sight in no small degree the sprig of holly which usually sur-mounts the Christmas dish."[27] It was by no means the first time one of Martin's conceptions collapsed before the tendency of the human eye and spirit to assert a more comfortable and more human scale. Nevertheless, the realization was repeated at the Princess's Theatre in 1873 with the intended awesome effect, in a further revival that met with the now usual "enthusiastic applause of a crowded audience" and "a very complete success."[28]

60. *"Scene from 'Manfred' at Drury-Lane Theatre: The Steinbach Wa-terfall, Haunt of the Witch of the Alps,"* Illustrated London News (17 Oct. 1863), p. 389.

[26] See Lacy, vol. 60, and the newspa-per announcements of the production (10 Oct. 1863) for the costume note. The long notice in the *Illustrated London News* 43 (17 Oct. 1863), p. 384, makes much of "the impulses and influences that were set in motion by the French Revolution." These of course affected Martin no less than Byron.

[27] *Spectator* 36 (17 Oct. 1863), p. 2631. The batlike wings "Amateur" de-scribes do not show in the illustration re-alized, but appear in other engravings in the series. Danson and Sons rather than Telbin were immediately responsible for the scene.

[28] Dutton Cook, *Nights at the Play* (London, 1883), pp. 199-202.

Without question Martin's image of Satan enthroned spoke eloquently to his age, in good part through the relation of figure and setting, and it is appropriate at this point to glance at how his conception fit into a range of iconographic possibilities. The fundamental image of power elevated and enthroned admitted several alternatives for its defining ambient architecture in the early nineteenth century: the palace court, the temple, and Milton's tribune amphitheater. Beckford's "vast tabernacle" was essentially a temple, and Byron's hall of audience is characterized by an elaborate ritual of divine worship. Even the vast and mysterious construction at the end of Canto I of Shelley's *Revolt of Islam*, written in the year of *Manfred*'s publication, is "a Temple such as mortal hand / Has never built" (likened to the "incommunicable sight" of unrealizable cosmic immensities as intuited by Genius: no art "can invest that shape to mortal sense"). Shelley's poem, however, seeking to redeem for the hopes and imagination of mankind the essential meaning of the French Revolution, places within the temple a great aisled and columned hall of thrones under a hemispherical evocation of the heavens, with an initially vacant throne in the midst, "Reared on a pyramid like sculptured flame." The many thrones and their occupants form "a mighty Senate," giving the hall a certain republican character.[29] This conflation of architectural forms, though visionary and "ideal," had a recent historical precedent.

The alternative to the palace hall and temple as the setting for power, the tribune amphitheater, took shape in Milton, but also came to Shelley and Martin and others of the post-Revolutionary age by way of the Church of the Jacobins. In *The French Revolution* (1837), Carlyle quotes a description by a contemporary witness:

"The nave of the Jacobins Church" says he, "is changed into a vast Circus, the seats of which mount up circularly like an amphitheater to the very groin of the domed roof. A high Pyramid of black marble, built against one of the walls, which was formerly a funeral monument, has alone been left standing: it serves now as back to the Office-bearers' Bureau. Here on an elevated Platform sit President and Secretaries, behind and above them the white Busts of Mirabeau, of Franklin, and various others, nay finally of Marat. Facing this is the Tribune, raised till it is midway between floor and groin of the dome, so that the speaker's voice may be in the centre. From that point thunder the voices that shake all Europe: down below, in silence, are forging the thunderbolts and the firebrands. Penetrating into this huge circuit, where all is out of measure, gigantic, the mind cannot repress some movement of terror and wonder; the imagination recalls those dread temples which Poetry, of old, had consecrated to the Avenging Deities."[30]

In the report of Carlyle's witness "who happily has eyes to see," as in Martin's imposing vision, the conflation of the temple and the theater is the foundation of the show of sublimity, and of the "movement of terror and wonder" that is the mind's response to its own engagement in the picture.

What triumphed in Bunn's production of *Manfred*, however, and in every subsequent one to use Martin's *Satan in Council*, was the purely

[29] Shelley, *Poetical Works*, pp. 51-53.
[30] Carlyle, *The French Revolution*, Part 2, bk. 5, chap. 8 ("The Jacobins"); Everyman's Library ed., 2:78.

theatrical aspect of the image of dark power, which Milton first and then Burke used to stigmatize a hemisphere in antithetical convulsion. In Byron's poem it is only Manfred's intrusion and his projected inner drama that turn the Hall of Arimanes from temple and court into a theater, and the spirits and their ruler into spectators; but in production the theater preexists the intrusion and has to capitalize on its own nature, so that the theatrical aspect prevails. Martin's scene is reduced, as Grieve's design shows, from a gigantic circuit all out of measure behind an overwhelming foreground presence, a theater extending unbounded into the stadium darkness, to a theater per se with box, pit, and gallery in a roofed-in vertical order. In Covent Garden, we the audience, in familiar circumstances, collectively supply the other half of the semicircle. In Martin's Pandaemonium, we stand individually in reduced scale and inferior position before the mighty throne.

THE ADVANTAGES of *Sardanapalus* over *Manfred* were not only that *Sardanapalus* was written with half an eye to dramatic requirements and that, dispensing with spirits, it incorporates a pair of villains, a pair of interesting female parts, and a domestic triangle. The advantages were also that *Sardanapalus* borders on sacred history without actually invading it; and that it culminates in an apocalypse physical in nature and staggering in scale.

Manfred also was given a visible apocalyptic ending in the theater. The last scene is described in the 1834 playbill as "THE GLACIERS OF THE UPPER ALPS! / PARTLY / Borne down by a violent THUNDER STORM, / and exhibiting in their Ruins, the Evidences of / *Crime & Punishment, with the Moral of the Drama.*" Sherwyn Carr, in his essay entitled "Bunn, Byron and *Manfred*," tells us, from the musical score, what was exhibited: "Rocks fall, & discover [once more] at the back the Palace of Arimanes." The good and evil spirits then do battle, and the good spirits win. This external combat and apocalypse run quite counter to the end of Byron's *Manfred*, whose spirits are scornfully dismissed, like plebeian interlopers, and whose point is the irrelevance of Manichaean angel and demon to one who "was my own destroyer, and will be / My own hereafter." Moreover, for an audience with a factual, material, historical appetite, a *real* apocalypse like that in *Sardanapalus* was much more satisfying than such an objectified allegory of subjective experience.[31]

When Charles Kean produced his monumental *Sardanapalus* in 1853, extraordinary advantages had accrued in historical and archaeological research. Austen Layard's *Nineveh and its Remains* had appeared in 1848-49, and a popular abridgment was selling in the railway stalls by 1851. His *Discoveries in the Ruins of Nineveh and Babylon*, based on a second series of excavations, appeared in 1853. Paul-Émile Botta had published his alternative account of Nineveh, in France, and H. C. Rawlinson and others had deciphered Persian cuneiform. Winged lions now sat in the British Museum, and the Crystal Palace was acquiring a Nineveh Court. But the material remains of the past had not yet diminished the fascination of apocalypse. If anything, the fascination had been reinforced and authenticated by the work of the archaeological resurrection men, as Kean's treatment of Byron's text

[31] Carr's article appears in *Nineteenth-Century Theatre Research* 1 (1973): 15-27. Henry Bishop's Weber-influenced score for *Manfred* entails a good deal of resectioning of the text, and is quite operatic in character. See BL MSS Add. 27727. The reconstructed ending puzzled most of the reviewers, who were not sure whether Manfred (forgiven by Astarte) was damned or saved.

Among the Grieve drawings at the University of London, cheek by jowl with the full cut-scene design labeled "Manfred. Hall of Arimanes C.G." (#604) is a more traditional-looking scene of battle between the heavenly hosts and the armies of the night (#605), framed by a curtain and displaying at its apex a medallion bearing the name and image of Milton. Though this design appears to share elements with that for the Hall of Arimanes, such as the frieze of figures in arms at the lower border, and the arc behind the leading combatants which suggests the globe of fire itself, transformed, it was almost surely meant for Mme. Vestris' operatic-spectacular production of *Comus* at Covent Garden (2 Mar. 1842). The *Examiner* (5 Mar., p. 150) found especially trying "the irreverent puerility of the closing scene, in which Heaven and Holy Angels are brought down in burlesque literalness of the last verse of the masque" to rout Comus and his rabble (Cf. *Times*, 3 Mar. 1842).

makes plain. Byron's text hastens to an end after Sardanapalus mounts the pyre and Myrrha, at his signal, ignites it:

Myrrha: 'Tis fired! I come.
(As Myrrha springs forward to throw herself into the flames, the Curtain falls.)

The last direction in Kean's version reads:

MYRRHA *springs forward and throws herself into the flames; the smoke and flames surround and seem to devour them—the Palace bursts into a general and tremendous conflagration—the pillars, walls, and ceiling crumble and fall—the pyre sinks—and in the distance appears a vast panoramic view of the Burning and Destruction of Nineveh.*[32]

The record of the scene Kean's artists made for him shows a wall collapsing in flames, and a background of Martin-like structures, but no realization of Martin's painting, which in a sense had been superseded by the discoveries it may have helped to provoke. Nevertheless, Martin's vision can still be felt, here and in the grand scene that precedes it, "The Hall of Nimrod," where the scale, the perspective, the repeating elements, even some of the detail that the archaeologists had not yet managed to supply, show the underlying paradigm of Martin's material sublime.[33]

In his playbill apologia Kean takes every opportunity to invoke the proximity of his subject to sacred history, while making clear that the relation to sacred history is merely ancillary and illustrative. At least one of the reviewers goes further, crediting the historicity of the production to not merely the "pictorial" but also the "scriptural authorities recently brought to light," thus innocently invoking a branch of archaeological and historical thinking that was causing some uneasiness in Christendom.[34] But for Kean—who actually drilled himself and his company in the attitudes found on the Assyrian reliefs—there are no such problems, and he can scarcely contain his joy at the coincidence of truth and beauty, the scientific and the exotic spectacular, the material and the sublime. "In decoration of every kind," he declares, "whether scenic or otherwise, I have rigidly sought for *truth*"; and Layard himself had approved. And the truth (in Kean's illuminating phrase for the ruins of empires past) is "the gorgeous and striking scenery, that has been so unexpectedly dug from the very bowels of the earth."[35]

Turner

Turner had his catastrophic and infernal side, and Martin his paradisal side. Turner had his sea monsters, death ships, plague, avalanche, and typhoon, not to mention his versified "Fallacies of Hope"; Martin, his blooming Edens and his vast *Plains of Heaven* (1853), perhaps the truest embodiment of a Sunday school heaven ever painted. A large proportion of Martin's illustrations for *Paradise Lost* and the paintings he developed out of them necessarily have to do with the earthly or heavenly paradise, and a student of the whole history of

[32] Lacy, Vol. 11. Kean's interest in *Sardanapalus* antedated Layard's discoveries.

[33] Both in the department of prints and drawings, Victoria & Albert Museum. Frederick Lloyd's "Hall of Nimrod" is reproduced in Sybil Rosenfeld's excellent *Short History of Scene Design in Great Britain* (Oxford, 1973), p. 127, and (as a wood-engraving) in the *Illustrated London News* 22 (18 June 1853), p. 493. The *Athenaeum* reported (18 June 1853, p. 745) that the Hall of Nimrod was "so managed in its perspective that it appears endlessly extended in a lateral direction, with an infinite number of square projections guarded with winged lions, and decorated with figured frescoes."

[34] *Illustrated London News* 22 (18 June 1853), p. 493.

[35] Enthoven; the playbill was adapted as an "Introduction" in Lacy's acting edition.

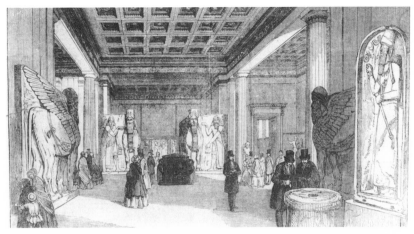

61

61. *"The Nineveh Room, at the British Museum,"* Illustrated London News *(26 Mar. 1853), p. 225.*
62. *"Scene from the Tragedy of 'Sardanapalus,' at the Princess's Theatre.—The Hall of Nimrod,"* Illustrated London News *(18 June 1853), p. 493.*

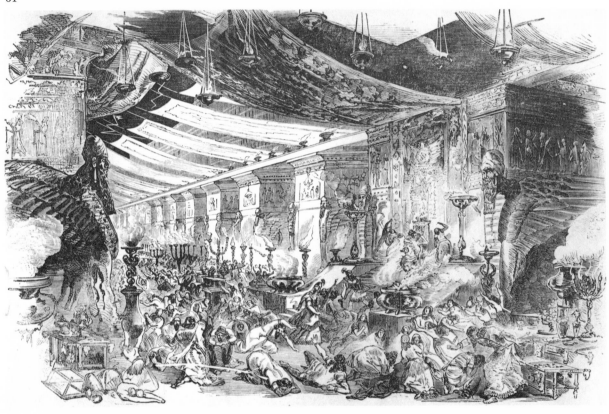

62

Milton illustration finds him the only artist to portray Adam and Eve fully in the setting Milton provides for them.[36] Yet, as seen through the curious prism of the theater—a type of the popular eye—Martin is par excellence the infernal, catastrophic artist, and Turner the paradisal one. The reason, apparently, lies not so much in differences in subject but rather, more interestingly, in differences in the use and rendering of form, color, and light.

A pictorial theater concerned with the translation of brushwork into

[36] Marcia R. Pointon, *Milton and English Art* (Manchester, 1970), p. 179.

JOHN MARTIN, BYRON, AND TURNER [183]

"effect," and aiming in some of its moods at enhancing the magical character of its illusions, had much to learn from Turner. One of the leading scene-painters in the latter part of the century wrote, concerning his art and its requirements:

> The boy crossing the stile in Turner's vignette to Rogers' "Poems," exquisite as it is, would be too delicate and modest in effect, but the same painter's "Dido building Carthage," Ulysses deriding Polyphemus," "Bay of Baiae," are magnificent lessons to the scene-painter in colour, composition, and poetry. How many times have not his compositions of "Tivoli," "Ancient Rome," "Modern Italy," "The Temple of Jupiter," and a host of others, been copied for act drops, for which they are, indeed, the "beau ideal," or been the inspiration for—well, perhaps a little *less* satisfactory "original" compositions?[37]

The world of the stage lay between act drop and backdrop. The backdrop extends that world, dissolves its limits; the act drop conceals it, but also transforms the space that is shut away, seemingly opening it to the eye, and epitomizing the place of magic and beauty that lies behind.

Paradise in the nineteenth-century theater—apart from its ironic reference to the part of the auditorium that held the "gods"—was to be found in pantomime, fairy-play, and extravaganza, that cluster of related forms. When a pantomime began in hell, as it often did—the cave or other grim abode of some malevolent spirit—the visual analogies with Martin's art were often striking. But a grim opening and a dark scene, and the garish malevolence of a horde of imps and demons, served to set off the paradisal character of what everyone knew was to come and had come to see, whose climactic visual achievement became the underlying rationale of the form. What is important through all the shifts and changes of these nineteenth-century forms is, first, the constancy of *transformation*, and second, the progressive identification of pantomime and Easter spectacle as an ideal entertainment for children. As such, it still gave liberal scope to broad mischief; but the formal heart of it was a manifestation of the prelapsarian world, full of beauty and wonder, benign influences, overgrown vegetation, and visionary palaces, like the *Childhood* and *Youth* panels of Thomas Cole's allegorical *Voyage of Life* (1842; first version 1839).

The scene-painter who supposedly had most to do with this spectacular achievement was William Beverley. Joseph Harker, resurrecting Beverley, as he feels, from undeserved oblivion, thought that "Beverley, without a doubt, owed much to the influence of Turner's supreme art, and excelled in depicting scenes of atmospheric and poetic beauty." But beauty was not all:

> It is to the magic brush of Beverley that we owe the invention of what came to be known as Transformation Scenes—marvels of intricate design and development, of subtle changes of light and colour, that were created to decorate the fairy-plays of Planché for Madame Vestris at the Lyceum, and gradually crept into successive pantomimes for many years as their culminating glory.[38]

[37] William Telbin [the Younger], "Art in the Theatre. I—Scenery," *Magazine of Art* 12 (1889): 95-96.

[38] Harker, *Studio and Stage* (London, 1924), p. 166. Harker saw himself as the heir and end of the tradition.

Movement and light, color and change, wonder that was not mimetic and material, but magical and atmospheric—these things form the basis of what Harker sees as Beverley's debt to Turner.

63. *Thomas Cole*, The Voyage of Life: Childhood *(1842), Washington, National Gallery of Art.*

Metamorphosis itself—the spectacle of form in flux—was essential to wonder; not the disruption of form in the mill of cataclysmic energies, as in some of Martin, but a liberation of form in the flow of light and color. Harker describes the transformation scene as belonging "to an era of scenic art in which the audience was content to watch one stage picture gradually grow out of another in mysterious fashion, thanks to the ingenuity and fancy of the artist. Today we sit in the dark, while one scene is hustled into another by violent and noisy human agencies of a different kind," clearly a fall from an angelic to a demonic world, from innocent wonder to cynical knowledge.

Metamorphosis was also much on the mind of the irreverent reviewer in *Blackwood's* who turned to a spectacular entertainment, a variety of "magic lantern," in order to characterize Turner's contributions to the 1842 Academy exhibition:

They are like the "Dissolving Views," which, when one subject is melting into another, and there are but half indications of forms, and a strange blending of blues and yellows and reds, offer something infinitely better, more grand, more imaginative than the distinct purpose of either view presents. We would therefore recom-

mend the aspirant after Turner's style and fame, to a few nightly exhibitions of the "Dissolving Views" at the Polytechnic, and he can scarcely fail to obtain the secret of the whole method. And we should think, that Turner's pictures, to give eclat to the invention, should be called henceforth "Turner's Dissolving Views."[39]

A few months earlier, a reviewer in the Christmas Day *Examiner* finds little to choose between the technical magic of the dissolving views and the wonders of the pantomime as a family entertainment. He is enraptured at the dissolving views by the transformations: how the "opening glory of the Bosphorus went gliding into a valley of Sweet Waters, from which there rose, as by enchantment, the richest scenes of the great city—with all its fantastic mosques and spires, its gorgeous palaces, and glittering bazaars." The educational and topographic features are clearly swallowed up in the marvelous, and Turner's Venice is perhaps not remote.[40]

It was Turner who provided the fundamental image in Charles Kean's most notable attempt to realize the paradisal world, as the magical moonlit wood of *A Midsummer Night's Dream* (1856). That Shakespeare's version of the wood has something of hell and madness in it—as Fuseli knew—was here suppressed, in keeping with the Victorian domestication of fairyland. Three years earlier, however, Kean had been capable of reminding his audience that they were about to witness, in the Nineveh of Sardanapalus, a living picture of an age "long since passed away, but once as famous as our own country for its civilization and power." With a somewhat similar thought for present glory, Kean now set his paradisal wood in the frame of an Athens restored to its Periclean magnificence. Reviewers mostly recognized that in so dealing with the Athens of Theseus, Kean had gone beyond the "illustrative and historical accuracy" identified with his system. They did not always grasp the significance of the contrast, however, between the architecture of an imperial civilization at its height and the beautiful world of innocent imagination, defined by light, atmosphere, music, and metamorphosis, where

> the perpetual change of scene and incident, the shifting diorama, the beams of the rising sun glittering upon the leaves, the gradual dispersion of the mist, with the hosts of fairy beings who are there discovered, light and ethereal as gossamer, grouped around the unconsciously sleeping mortals; these, and an endless succession of skilfully-blended pictorial, mechanical, and musical effects, bewilder the faculties with the influence of an enchanting vision.[41]

The scene that epitomized this protean world (Act II, scene 1) was William Gordon's "A Wood Near Athens," a recreation of Turner's *Golden Bough*, with the evidence of man's cultural presence omitted. Transposed to moonlight, it united classical and Romantic landscape, and substituted, for the claustrophobic maze of the wood near Athens, Turner's central avenue to infinity by way of water and light.[42]

Turner had sent the painting to the Academy exhibition in the spring of 1834, precisely when Byron's *Sardanapalus* and Martin's *Fall of Nineveh* might be seen in their first joint realization at Drury Lane, and *Manfred* at Covent Garden was in the offing for the fall. A

[39] [John Eagles], *Blackwood's* 52 (July 1842): 26. It is worth recalling that a *Blackwood's* review of 1836 first sent Ruskin to the defense of Turner, and that one of the reviews of this same exhibition of 1842 provoked him into beginning *Modern Painters*. The first volume was attacked at length in *Blackwood's* 54 (Oct. 1843): 485-503; and Ruskin replied savagely in the preface to the second edition, citing *Blackwood's* 1842 exhibition review as evidence of incompetence. The pictures exhibited were *Snow Storm—Steam-Boat off a Harbour's Mouth*; *Peace—Burial at Sea*; *War: The Exile and the Rock Limpet*; and two Venetian paintings.

[40] *Examiner* (25 Dec. 1841), p. 823.

[41] *Illustrated London News* 29 (Oct. 1856), p. 393. William Gordon's splendid scene of Athens from Theseus' palace is reproduced in Rosenfeld, *Short History*, p. 123.

[42] The relation of Gordon's scene as recorded for Kean by his artists (V & A) to Turner's painting was observed by Martin Hardie, *St. James's Gazette* (17 Apr. 1902).

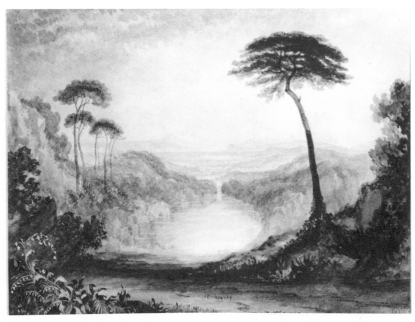

64

64. *William Gordon, Scene from* A Midsummer Night's Dream, *Act II, scene 1. "A Wood Near Athens. Moonlight" (1856), London, Victoria & Albert Museum.*
65. *J.M.W. Turner,* The Golden Bough *(1834), London, Tate Gallery.*

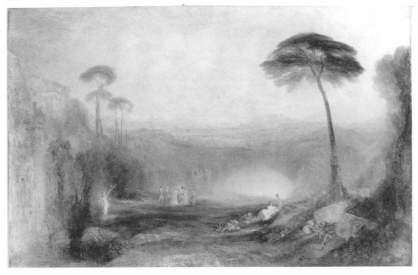

65

reviewer in the *Athenaeum*, impressed with the brilliance of Turner's contributions to the exhibition, especially *The Fountain of Indolence* (after Thomson) and *The Golden Bough*, tried to come to terms with the sense of a difficulty in seeing; that is, a difficulty in standing outside the pictures in the role of conceptualizing observer and being sure of boundaries, surfaces, identities. The problem lay deeper than a rivalry of line and color, and he explains the seeming contradiction as a fault, a slovenly neglect of finish, an absence of the "last touch." But the difficulty in "seeing" remains oddly paradoxical, something associated not with darkness but with light. He suggests as much in his description of *The Fountain of Indolence*: "the scene is magnificent—golden palaces, silver fountains, romantic valleys, and hills which distance

makes celestial, are united into one wondrous landscape, over which a sort of charmed light is shed, that is almost too much for mortal eyes." *The Golden Bough* is even more perplexing: "almost dim through excess of brightness."[43] Thus, the paradox of Martin's "material sublime," which found an appropriate content and analogue in the "darkness visible" of Milton's hell, had its true antithesis in Turner, and in Milton's heaven, where the "Fountain of light, thyself invisible . . . Dark with excessive bright" irradiated creation.

Why was Martin given the infernal and apocalyptic assignments in drama and Turner the paradisal ones? I can only venture a suggestion.

In Martin the perceiver empathizes with the represented experience of scale, with the radical duality of the miniscule human and majuscule inhuman. In Turner the perceiver is implicated in the dissolution of boundaries and objects, in the unity of perception and experience. The attempt to discriminate often has to be abandoned at a given point, and one is drawn into the vortex or the path of light. Discrimination gives way to sensation as a source of affect, a reassertion of the primal order. It is profoundly infantile.

In Martin the structure is one of separation, alienation, diminution of the ego in the face of cosmic or physical reality. It embodies the nightmare of annihilation and humiliation, but with a persistent kernel of bounded identity. It is adolescent or perhaps even menopausal (I am put in mind of the catastrophic *Manhood* panel in Cole's *Voyage of Life*). It represents not state or process, but climacteric.

In Turner the self is already dissolved in cosmos—in light, or in the vortex of the elements, or in the landscape itself. Even in storm, there is an identity of self with the universe of perception, of experience, of imagination, and of process. Experience, in and of the painting, is kinesthetic, and the pictorial image is liberated from the "imaginable"—from the abstraction of bounded forms in a projected and time-fixed Euclidean space. The "structure" may be infantile, but the achievement reconstitutes the paradise we have lost.

[43] *Athenaeum* (10 May 1834), p. 355.

10

✦·✦

PERILS OF THE DEEP

The Scene represents the open Sea in the midst of a Hurricane. A large dismasted Vessel tossed on the tempest is seen rolling heavily among the billows. Four or five only of the crew are left on the wreck, and are clinging to the spars and broken mast. At intervals between the roar of the ocean and the peals of thunder, broken sentences are caught from those on board . . . A terrific peal of Thunder is heard— the lightning runs along the sky, and the vessel goes down bodily, amidst a shriek from those on board. The waves wash over her, and nothing is seen but the open sea. In a few seconds two men are visible buffeting with the waves, and Gaspard *crawls on to a small rock on the foreground.*[1]

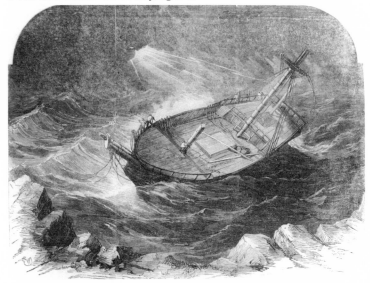

66. "*Scene from the New Drama of 'The Chain of Events.'—The Shipwreck*," Illustrated London News *(24 Apr. 1852), p. 325.*

O F THE three main branches of melodrama that had differentiated successively by 1830, *The Brigand* continued the Romantic strain—and appeared as "A Romantic Drama" on the playbills—while *The Rent Day* gave impetus to the domestic strain. The first, with a lingering Gothic echo here and there, was consciously "picturesque" in conception; the second was consciously "realistic," that is, homely and familiar. The intervening nautical strain, Michael Booth suggests, was partly Romantic, partly do-

[1] G. H. Lewes ("Slingsby Lawrence") and Charles Mathews, *A Chain of Events, a Dramatic Story in Eight Acts* (London, 1852), Act II, "Storm at Sea."

[2] See above, p. 147, and Michael Booth, *English Melodrama* (London, 1965), pp. 99-117.

[3] A still earlier approximation, in a Romantic *ballet d'action* melodrama, of a well-known image involving shipwreck occurs in J. C. Cross' *The False Friend; or, The Assassin of the Rocks* (1806), summarized in the author's *Circusiana, or a Collection of the Most Favourite Ballets, Spectacles, Melo-drames, & c., Performed at the Royal Circus* (London, 1809), Vol. II. The play opens (p. 36) with a "*Distant Sea View after a Tempest, with a Ship nearly a Wreck on the Ocean—Corn Fields, and a Cottage in the Fore Ground.* The Widow Wantley, Alice, and Children are discovered on the stage, grouped similarly to the Characters in Bigg's painting of the Shipwrecked Boy." The boy is telling his story as in the painting, also known as *The Shipwrecked Sailor Boy* by William Redmore Bigg, R.A. (1755-1828), very popular according to the *DNB*, and engraved.

[4] Introduction, *Shipwreck of the Medusa*, in *Richardson's New Minor Drama* (London, 1828-1831), Vol. IV. An English edition of Alexandre Corréard and H. Savigny's *Naufrage de la frégate la Méduse* was available by 1818, as *Narrative of a Voyage to Senegal in 1816* (reprint, London, 1968).

[5] Enthoven. June 19 is usually given, evidently erroneously, as the date of first performance. The playbill makes clear that the revival was limited by the availability of T. P. Cooke for the role of Jack Gallant, Boatswain.

[6] Lee Johnson's authoritative account, "The 'Raft of the *Medusa*' in Great Britain," *Burlington Mag.* 96 (1954), shows how the competition seems to have spoiled the returns outside of London. He cites (p. 251) a travelling panoramic show advertised as a "lately finished, entirely novel Marine Peristrephic Panorama of the Wreck of the Medusa French Frigate and the Fatal Raft. Also the ceremony of crossing the line. Each view Accompanied by a full and appropriate band of music. The picture is painted on nearly 10,000 sq. feet of canvas . . . the figures on the Raft and on the boat being the size of life . . ." The panoramic painting included six scenes from the narrative.

mestic, a doubleness that worked to the advantage of both sensation and sentiment.[2]

Nautical melodrama, drawing on the circus and water-tank spectacles of the Napoleonic wars, but also making much of the hearty, open, jargon-speaking sailor of earlier fiction, song, and drama, ripened in the 1820s. The first of the nautical melodramas manifestly written to realize a picture was C. A. Somerset's "*The Sea!*" (Queen's, 1833), whose embodied paintings encapsulated the union of Romantic sensation and domestic sentiment characteristic of the genre. One of the earliest examples of the genre in full rig, however, did its best to exploit the notoriety of a much greater painting, representing an actual disaster at sea as a drama on the heroic scale. This play was W. T. Moncrieff's *Shipwreck of the Medusa; or, The Fatal Raft* (Coburg, 1820).[3]

Moncrieff's play, written nearly a decade before the fashion for pictorial realization took hold, probably did not try to re-create Géricault's great painting, at least initially. Moncrieff claimed that he had used the Corréard and Savigny narrative of the shipwreck, published in 1817, as his source; and his purpose was clearly to mobilize the sensationalism and familiarity of the event itself through a conventional dramatic fiction centered on villain-crossed lovers and spiced with a heroic British tar.[4] There are a number of scenes on the Fatal Raft after the Act I shipwreck, but no indications in the surviving text itself of a tableau realization of the painting. The moment of the painting, the moment when the survivors sight their potential rescuers, is in fact not treated as a tableau at all, but rather as a scene of hurried and confused activity.

Géricault's painting, however, based on the same narrative and displayed at the Salon of 1819, came to England for speculative exhibition and was shown publicly in London from 12 June 1820. At this point, it would seem, the play took on new life. The playbill for the 19 June reopening of the Royal Coburg declared, "It was intended to Re-Open this Theatre with *Three Entirely New Pieces*, from the Pen of Mr. MONCRIEFF . . . but the great anxiety expressed by many of the Patrons of this Theatre, who have not yet been able to obtain Places to witness the Representation of 'THE SHIPWRECK of the MEDUSA; *or*, THE FATAL RAFT,'—in which the deplorable state of the surviving Crew of that Vessel on the Raft a short time previous to their Discovery & Preservation, as depicted in the *Great Picture now Exhibiting in Pall Mall* . . . is so pathetically and correctly delineated, has determined the Proprietors to continue it, as an Afterpiece, for a few Nights longer."[5] The painting itself was now a sensational event, to be capitalized upon if not competed with; and at this point it may have influenced the staging of the play.[6] A decade later, however, a painting so well known was bound to influence the staging. Accordingly, when the play was revived in 1831, the frontispiece in Richardson's contemporary edition, "from a Drawing taken in the Theatre by Mr. Seymour," shows the influence of the painting on gesture, attitude, and design, and on the choice of the moment depicted.

The engraving shows as well how the heroic character of the painting, and the affective and philosophical content that made men like Leslie and Thackeray uncomfortable, were much tamed in this dramatic counterpart in the vein of nautical melodrama. There is no image

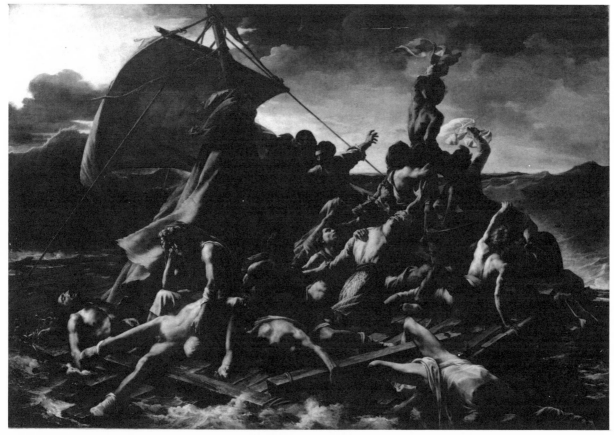

67

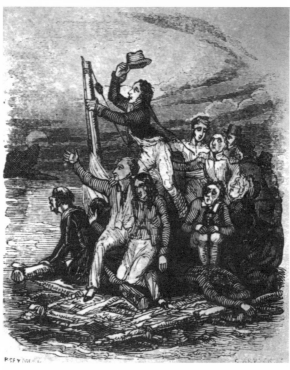

68

67. *Théodore Géricault,* Le Radeau
de la "Méduse" *(1819), Paris,*
Louvre (cliché des Musées
Nationaux).
68. *Robert Seymour, Illustration for*
Shipwreck of the Medusa *by*
W. T. Moncrieff, engraving by
G. Armstrong, Richardson's New
Minor Drama, Vol. IV [1831].

of irremediable despair in the scene; the effeminate-looking sailor in a swoon is the disguised heroine of the drama; and the sighting is the unambiguous herald of rescue, which arrives in the providential nick of time. In the actual event, rescue was too late for nine-tenths (or 135) of those on the raft, a state of affairs that Géricault keeps memorably in the foreground. Moreover, the incident in Géricault's painting, at least as reported in Corréard and Savigny's third French edition (1821), is the distant sighting of a ship which then disappeared. Reversing the dominant reading habit of a century, recent commentators have accepted this identification of the moment with few reservations. It is unlikely, however, that any simple view of the "correct moment" in the narrative will exhaust Géricault's narrative intentions.[7] Given the experience of the common viewer, and the surging projection of will, life, and desire virtually negating the distance from the rescue ship in the painting, it is hard to believe that Géricault failed to calculate, perhaps cruelly, on the hopeful reading of the image to which human nature seems prone. There is certainly ambiguity as well as irony in the isolated sentence, taken from the account of the false vision of hope, that accompanies the lithograph after Géricault's painting in the third edition: "The sight of this ship spread among us a delight difficult to depict. Each of us believed his salvation certain, and we rendered to God a thousand acts of thanksgiving." As a comment on providential agency and expectation, Géricault's vision seems to embrace rather than oppose the comfortless vision of its seeming rebuttal, Caspar David Friedrich's *The Sea of Ice*, miscalled *The Wreck of the Hope* (1821), where ice replaces the aspiring heroic pyramid of hopeful humanity. In effect, Géricault unites Job's cruel universe with a heroic humanism.

Because it became a charged political issue, the shipwreck of the Medusa had no chance in the French theater before 1830. In fact, it had no representation there before 1839, and then the painting rather than the event was the chief object of imitation. The first *Naufrage de la Méduse*, a *drame* by Charles Desnoyer (Ambigu, 27 Apr. 1839) "was only, so to speak, a supplement to the Navalorama," as Gautier thought.[8] The play starts in 1799 aboard a British ship (assaulted and captured by the end of the act) with the complicated perils of a French prisoner and a plot of lost children; and develops, after the end of the wars, into a three-cornered love rivalry over one of these children, grown into young womanhood. The plot is stirred throughout by a violent, sly, appetitive villain, who causes all the private miseries and—as a fictive embodiment of the incompetence and anarchic selfishness portrayed in the Medusa narrative—brings about the public catastrophies, rendered in some historical detail. All parties eventually find themselves aboard the Medusa, which looms over the second act still in shipyard scaffolding, departs in the third, and strikes and sinks by the end of the fourth. In the fifth act, "Le Radeau," "The action takes place on the open sea. On all sides, the horizon. The raft, by the effect of perspective, seems lost in this immensity. It is tossed about by the waves. The winds whistle with violence. The sky is somber. Of those who were shipwrecked, fifteen survive. . . . The features of all these unfortunates are pale and livid, their clothing in rags, and everything about them bespeaks an excess of misery and despair, reaching the point of delirium."[9] In the course of the act a ship is sighted, and the

[7] See Benedict Nicolson, "The Raft from the Point of View of Subject-Matter," *Burlington Mag.* 96 (1954): 241-49, and Lorenz Eitner, *Géricault's Raft of the Medusa* (London and New York, 1972). Eitner, who is profound on some of the moral and psychological implications of the structure, ignores the naive response represented, for example, by the English advertising for the exhibition which he quotes. The presence of the tent in the painting affects the issue, since the Corréard narrative suggests it was set up after the false alarm (Nicolson to the contrary). Regarded only a little less simplistically, the result seems to be a conflation of two moments, one especially picturable, the other less so.

[8] Théophile Gautier, *Histoire de l'art dramatique en France depuis vingt-cinq ans* (Paris, 1858-1859), 1:257-58.

[9] Charles Desnoyer, *Le Naufrage de la Méduse, drame en cinq actes*, in *Le Magasin Théâtral*, Vol. 25, p. 34. The stage direction advises all persons who were unable to see the admirable decor of MM. Philastre and Cambon "to consult, in order to gain some idea of this *lever de rideau* and all the details of this last act, the beautiful engraving of M. Jazet, after Géricault's masterpiece."

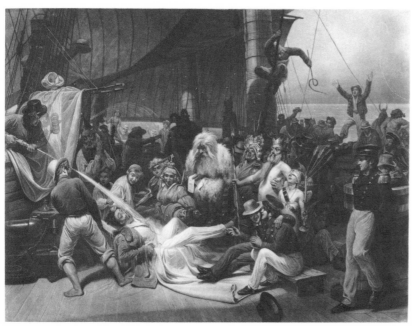

69

70

69. *François-Auguste Biard*, Le Bap-
têne sous la ligne *(1834), en-
graving by J.-P.-M. Jazet as* Un
Baptême des matelots sous l'é-
quateur, *Paris, Bibliothèque Na-
tionale.*
70. *Célestin Nanteuil*, Naufrage de la
Méduse, *Acte V,* Le Monde
Dramatique *[Paris] 8 (1839),
opp. 273.*

characters—five of them the personages of the domestic drama—raise
up the signaling group that distinguishes the moment of the painting.
But the ship disappears, precipitating a suicidal despair. It then reap-
pears, much larger, just as the domestic plot resolves; and the play
ends as the raft is abandoned.

Though the play is in five acts, "there were really only two," Gautier
wrote; "two *tableaux* we meant to say, one imitated from the *Passage
du tropique* of M. Biard, the other from the *Radeau de la Méduse* of
Géricault." Corréard and Savigny had made an effective point out of
the contrast between the ceremonial follies of crossing the line and the
shipwreck, and so does the playwright. "Between these *tableaux* there
is the difference between M. Biard and Géricault; all the difference

between a burlesque of Vadé with its carnival gaiety and a somber Byronian poem."[10] With dramatic variety and contrast so secured, the theatrical realization of Géricault's painting could afford a few modifications, represented in Célestin Nanteuil's lithograph from *Le Monde Dramatique*. These included rather less heroic nudity, and a domestication represented by the near couple, the heroine and one of her quasi-paternal guardians. Moreover, the apocalyptic undertone of the painting seems to have vanished: the raft is more removed from the spectator, and it does not fill the visible world. The corpses, however, on the stage at least, remained vivid; "un peu avancé" according to Gautier, who doubted that imitation could be carried further. *Le Monde Dramatique* admired the rocking raft, the furious sea, the white foam, the lightning flashes that touched the crests of the waves with red, the whole forming "a spectacle surpassing anything the Diorama or the Opera have shown us up till now."[11]

Opera, however, was not to be outdone. An operatic *Naufrage de la Méduse* opened less than a month after the drama, with music by Flotow and Pilati, words by Cogniard *frères*. The plot, Gautier thought, had no more life at the Renaissance than it did at the Ambigu-Comique; but "when it comes to the *tableau* representing the raft of sinister memory, one finds only what is praiseworthy; it is beautiful, terrible, gripping;—Géricault himself, if he could reopen his eyes now forever closed, would be content with this reproduction of his masterpiece. The art of the scene designer and stage manager has never gone further. The waves rise, fall, curl and break with surprising truth; it is no longer painted canvas, but water, spume, which threatens to soak the spectator and extinguish the footlights. This setting without wings, without sky borders, without ground row . . . is composed only of two uniform immensities, the sky and the sea." He admires particularly the pictorial grouping, and finds the pitching of the raft good enough to make one seasick on sight; only the corpses at the Ambigu had a superior putrefaction.[12]

Gautier thought the real protagonist of the earlier play was the vessel, from its shipyard launching to the final dissolution of its last sail and plank. The fascination with shipwreck, particularly in the Romantic century, was surely a far cry from the concerns of domestic life. The fascination of the sea was in its power to annihilate and exalt the human creatures who ventured to make it their convenience, its power to evoke the daring and peril of being. Géricault's painting was in these respects like the sea and like shipwreck. But the spectator who finds a fearful joy in a vicarious glimpse of the abyss, in nature or the self, may also crave the reassurance of a formulaic reenactment showing that the abyss is tamed by a providential ordering to human needs and human scale. At the end of Desnoyer's *drame* of the *Méduse*, the lost child is found through a medal given his father. The medal bears the inscription, "The King of France, to Jacques the pilot. May God protect the savior of the shipwrecked." The father's merit is apparently transferable to his descendants, and Providence, recognizable through its manifold special attentions, asserts itself. All at once the rivalry between the new-found brothers in the play disappears; the axe-wielding villain is killed; rescue arrives, with the heroine (who has once

[10] Gautier, *Histoire*, 1:258. François-Auguste Biard's *Le Baptême sous la ligne; scène de la vie maritime*, exh. Salon of 1834, was among his most popular paintings. Desnoyer's text calls for "la reproduction fidèle du tableau" (p. 33). Jean Joseph Vadé, an eighteenth-century poet, wrote vaudevilles, and is credited with creating "la littérature poissarde."

[11] *Le Monde Dramatique*, 2nd ser. 6 (1839): 281.

[12] Gautier, *Histoire*, 1:262.

more been lost overboard) intact; and domestic felicity is promised in the form of a wedding and a family reunion under the maternal roof. In place of the abyss, or an empty immensity, "a fine, stout copper-lined ship" takes up the spectral survivors for the "hoped-for denoument of this long nightmare, where apotheosis is replaced by chicken broth and the wine of Bordeaux."[13]

THE EARLIEST nautical drama manifestly written to realize a picture was a little less ambitious than these *Medusa* dramas, but not far removed in feeling. C. A. Somerset's *"The Sea!"* embodies two paintings that offered an exemplary fusion of perilous sensation and domestic feeling. Behind them, as behind Géricault's painting, lay a tradition of apocalyptic Deluge painting; but they belong as well to a strain of pictorial narrative dramatizing mother love *in extremis*. The two strains are not distinct, for the mother attempting to lift her infant to safety from the waters is a pathetic feature in Deluge painting from Poussin's *Winter (The Flood)* onwards.[14] The play capitalizes, not only on two recent and well-known paintings using this motif, but also on a number of popular topicalities, including a song called "The Sea!" that had been "ground in our ears by every barrel-organ within the bills of mortality, chaunted by every itinerant chorister, and swelled the horn of every Omnibus." The song furnished Somerset with his title, and with the counterpart of Biard and Desnoyer's tropical carnival, "the idea of christening 'the Ocean Child;' which ceremony is performed by his Majesty King Neptune, assisted by his Queen and Tritons, with no lack of solemnity or grog."[15] The song, like the pictures to come, was quoted bodily, as part of the theatrical ceremony.

The Ocean Child belongs to the sailor, Harry Helm, whose wife the Captain attempts to seduce. The result is mutiny, and Harry is made to walk the plank for his pains. When he attempts to climb back aboard, the Captain has his hand chopped off, a hand that will figure prominently eighteen years later, in the nautical-Gothic second half of the play. Meanwhile, Providence shows its patience exhausted, and thereby provides the occasion for the pictorial realizations:

> SCENE VI—A Storm—part of the Wreck of the Windsor Castle discovered, R., the Bowsprit extending sufficiently to realize the two beautiful Pictures by Dawe—First, a Female struggling with an Infant in her arms, against the raging billows—Second, that of a brave Seaman, letting himself down from the Bowsprit, and thus suspended between air and ocean, snatching both the Mother and her Infant from a watery grave.[16]

Henry Edward Dawe was a painter and mezzotint engraver, a younger brother of George Dawe, who in 1813 had exhibited a striking painting of *A Child Rescued by its Mother from an Eagle's Nest* (based on one of William Hayley's *Ballads Founded on Anecdotes of Animals*, 1805, originally illustrated by William Blake).[17] In 1831 H. E. Dawe exhibited another representation of the trials of motherhood. Titled *My Child! My Child!*, it was accompanied in the catalogue by a purported quotation: "A brig having been wrecked on the coast of Norfolk in the night, a female and her infant, with some others, took refuge on a

[13] Ibid., 1:259.
[14] See, for example, Jean-Baptiste Regnault's *Le Déluge* (1789), where the woman on her back in the waters, breasts exposed, lifts her infant above her in a lurid light, as in the first of the paintings discussed below; reproduced in *French Painting 1774-1830: The Age of Revolution* (Detroit, 1975), no. 149. Similar groups occur in Turner's *Deluge* (1805) and John Martin's *Deluge* (1834).
[15] C. A. Somerset, *"The Sea!"* a Nautical Drama, in Two Acts, Cumberland Minor, Vol. VII, Remarks by D——G.
[16] Ibid., Act I, sc. 6.
[17] See T.S.R. Boase, *English Art, 1800-1870* (Oxford, 1959), pl. 56 and 20. Edward Fitzball's *The Dillosk Gatherer* (1832), also titled *The Eagle's Nest* and *The Eagle's Haunt*, probably made use of George Dawe's picture. "It was the interesting tale of the dillosk gatherer, who rescues her child from the eagle's nest. Every one has seen the popular print on that subject." Edward Fitzball, *Thirty-Five Years of a Dramatic Author's Life* (London, 1859) 1:220. Hayley's heroine, however, is pastoral rather than littoral. Cf. the 1908 Edison film, *Rescued from an Eagle's Nest*.

71. *Henry Edward Dawe*, My Child! My Child! *(1831), engraving by Thomas Illman, in* The Token *(Boston, 1835).*

72. *Henry Edward Dawe*, A Mother and Child Rescued from a Watery Grave *(1832), engraving by Thomas Illman as* They're Saved! They're Saved!, *in* The Token *(Boston, 1835).*

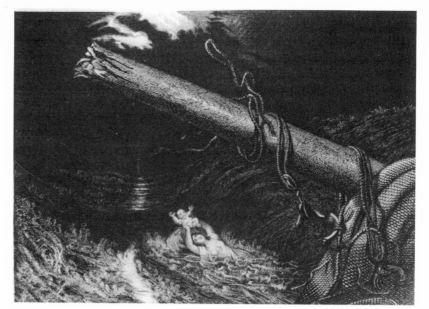

71

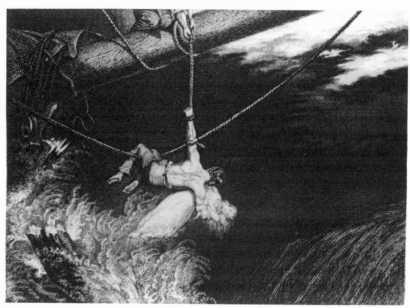

72

part of the vessel, when a heavy sea washed the mother and her infant overboard; she almost immediately rose to the surface and was heard to exclaim 'My Child! My Child!'—in another moment they disappeared for ever."[18] At least one sophisticated reviewer found pleasure in penetrating its popular appeal, and predicting its inevitable fate:

Mr. H. E. Dawe has provided a very different entertainment for us in a large picture, (No. 404) intended to be pathetic, yet which it is hardly possible to contemplate without a smile. The subject is a shipwrecked female, about to be swallowed up by the waves, with her infant; but the whole is such a theatrical, *melodramatic*

[18] *Exhibition of the Society of British Artists, 1831, #404.*

affair, and she is balancing the child with so studied an attention to effect, that we are assured that she is only sinking very cleverly through a trapdoor in the stage, and that the sea and sky, and the nicely painted mast of the ship, are nothing but canvass. We are, too, the more comfortably convinced that such is the case, as the strong glare that falls upon her and her baby evidently proceeds from the footlights, and not from any rent in the pitchy clouds.[19]

Dawe's own engraving of the scene appeared in the exhibition of the following year, where he also sent in a painted sequel suggesting, with serial effect, a providential bias in favor of imperiled innocence, willing even to cancel the finality of an eternal decree ("they disappeared for ever" in the rubric to *My Child! My Child!*). The providentiality of *A Mother and Child Rescued from a Watery Grave by the Intrepidity of a British Seaman* appears in the shift from the self-helping intrepidity of the mother in *The Eagle's Nest* to the intervention of a benevolent external agent. The title language is already that of nautical melodrama, needing only a bit of amplification to serve as Somerset's spirited stage direction. In 1833, the year of the play, the second picture also appeared as an engraving, retitled *They're Saved! They're Saved!* while *My Child! My Child!* was reexhibited at the British Institution. The engravings crossed the Atlantic and appeared in small in *The Token* (an American "keepsake" annual), reengraved by Thomas Illman and illustrated by a lengthy poem, "Changes on the Deep," by Miss H. F. Gould.[20]

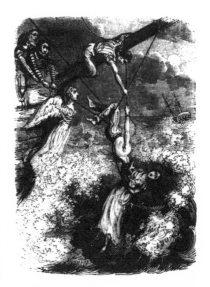

73. *Robert Cruikshank, Illustration for "The Sea!" by C. A. Somerset, engraving by G. W. Bonner, Cumberland's Minor Theatre, Vol. VII [ca. 1834].*

"Mr. Dawe's well known pictures" were easily recognized in Somerset's play, and "night after night it rolled with the full tide of popular favour."[21] When published, the frontispiece, "from a Drawing taken in the Theatre, by Mr. R. Cruikshank," predictably rendered the second of Dawe's pictures, but with a restored ship's figurehead, to make visible the Guardian Angel lurking behind the scenes.

NAUTICAL melodrama and its descendants continued to provide opportunity for scenes of shipwreck, whose effectiveness stemmed from something more than technical accomplishment. In the affective iconography of the age, the image carried an unspecified charge of psychological and metaphysical disaster, appearing in hot, apocalyptic form in Turner, and as the frozen analogue of metaphysical doubt and despair in the arctic imagery of Friedrich, Mary Shelley, and even Landseer. Nautical melodrama reflects the fascination of shipwreck. It enlists the affective power of this image of disaster through spectacle, and concurrently attempts to exorcize or at least allay its terrors by a contextual domestication. Every actual nautical disaster to capture the popular imagination was re-created in the theater, with means that were sometimes as remarkable pictorially as mechanically. Conspicuous among these dramas of imagined real disasters was Edward Stirling's *Grace Darling; or, The Wreck at Sea* (1838), one of the many popular celebrations of that lighthouse heroine. The play is dominated by its sea, ship, and storm pictures, and by a shipwreck emblematic of the double life of the image, in the real world and in the inner worlds of imagination and feeling. The wreck appears to us twice, once as the heroine's anxious and prophetic vision ("*Scene gradually opens, and*

[19] "The Suffolk Street Exhibition," *Fraser's Mag.* 18 (July 1831): 685.

[20] *The Token and Atlantic Souvenir*, ed. S. G. Goodrich (Boston, 1835), pp. 371-75. The mother and child of the first picture and the action of the second also bear a relation to Francis Wheatley's illustration of *The Comedy of Errors* (the rescue of Aemelia) for Boydell's Shakespeare Gallery. See T.S.R. Boase, "Shipwrecks in English Romantic Painting," *Jour. Warburg* 22 (1959): pl. 31f. Both the woman holding an infant above the waters and the derelict ship motif occur in Shelley's fragmentary poem, "A Vision of the Sea."

[21] "The Sea," Remarks by D——G.

discovers the deck of the Forfarshire, as seen in the second act, in a state of wreck. Wild music—blue fire"), and once as the catastrophic reality.[22]

A later, more elaborate shipwreck drama, showing the fullest awareness of a rich tradition that included its own domestication, was T. W. Robertson's *For Love!* (1867), a re-creation of the famous wreck of the troopship Birkenhead (with women and children aboard) near the Cape of Good Hope fifteen years earlier. In the years when Robertson nurtured a new, understated style at the genteel Prince of Wales with plays like *Caste* and *Society*, he continued to write in the alternative tradition for the popular theater. *For Love!* is an anthology of pictorial effects whose climax, situational and spectacular, is the scene of the shipwreck, differing from its dramatic predecessors chiefly in its elaborate attention to light and color among the elements of picture-making.

Such self-consciousness plays a part in the first of the spectacle climaxes in *For Love!*, a realization of *Eastward Ho! August 1857* (1858), Henry Nelson O'Neil's exceedingly popular topical representation of soldiers departing for India at the time of the Mutiny. The painting elaborates one of Robertson's favorite situations, a military parting (see below, pp. 356-58), but here as a crowded genre-scene with numerous stories implicit, rather than as a situation framed and concentrated in a single pair of lovers. In its narrative character, the painting is close to Frith's anecdotal panoramas of modern life in public places, except that it offers a representative fragment only, boldly cutting off the figures and groups and the wall that is the ship's hull, and seeming to accept the arbitrary planes of close-in observation with photographic carelessness. Much of the effect secured by re-creating such a genre scene on the stage had to lie in the pleasure of mimetic realization itself; but the effect became situational and dramatic through the shipwreck in prospect, and the known fate of the contingent of soldiers who sailed on the historical Birkenhead.[23]

The sunset effects, keyed to the shipboard romance of the second act, yield in sensation to the striking of the ship on a reef and all that ensues. The Birkenhead legend comes to life as the regimental draft keeps order, quashes the panic, helps the old and the weak to the boats, and nobly stays behind, still in ranks, "For love! " according to the Lieutenant (for whom the emotion is particularized). After some unflinching British ceremonial following the departure of the boats, "*The ship breaks up and sinks. Fragments of the ship are seen with soldiers clinging to them, the sun sets blood red. The sea is purple, a steamer with a long trail of smoke from her funnels is seen across the disc of the sun as it is sinking.*"[24]

The third act, however—set on an island in the tropics—improves on the action of Providence in the historical disaster, wherein 438 out of 630 persons on board perished. In the play, it turns out that most of those left abroad have survived; and the reunions that follow, domestic and amative, reconcile one to the dangers past and are finely contrived for touching effect.

In shipwreck melodrama the imagined real events were always tied to a fictive threat to domestic happiness, present or prospective, and to a contest, providentially and favorably concluded, between inno-

[22] Edward Stirling, *Grace Darling; or, The Wreck at Sea, A Drama in Two Acts*, The Acting National Drama, ed. B. Webster, Vol. VI.

[23] Unlike a number of other reviewers, the *Times* found the result visually ineffective because of the "petty dimensions" of the ship's hull as shown, and the "insufficient filling up of the picture with figures" (9 Oct. 1867, p. 12). The scene as such was not altogether novel on the stage, and O'Neil's original viewers might easily have brought theatrical images to the spectacle of the painting. A. H. Saxon reports of a *Battle of the Alma* (Astley's, 23 Oct. 1854), performed only one month after the historical event and received with exceptional fervor: "In the opening scene, while the orchestra played 'The Girl I Left Behind Me,' a large body of troops entered through the circle, marched up the inclined plane [to the stage] in order, and embarked in a ship at the rear of the stage" (*Enter Foot and Horse*, New Haven, 1968, p. 144). Telbin and Grieve added to their moving panorama, *The Overland Mail* (1854), a "Route of the British Army to the Seat of the War," beginning with an embarcation of troops at Southampton (Richard Altick, *Shows of London* [Cambridge, Mass., 1978], p. 480).

[24] *For Love!* L.C. MSS 53061.

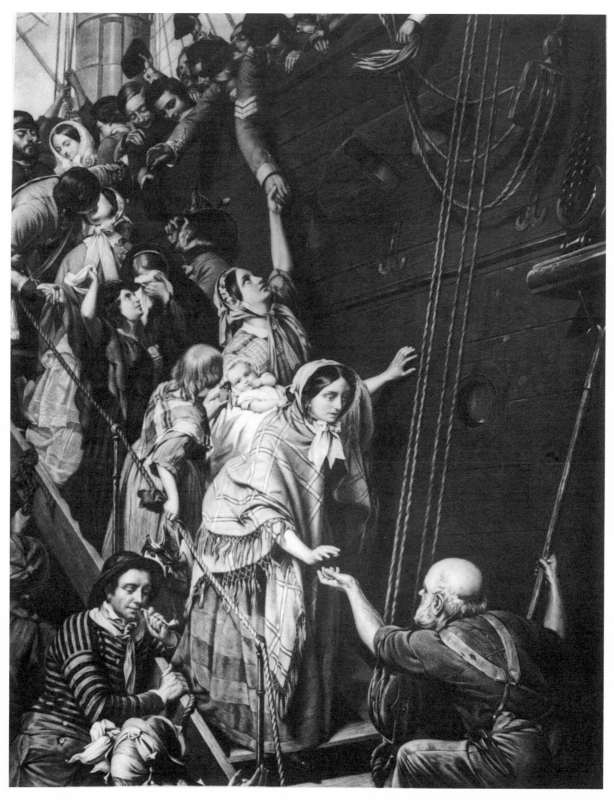

74. *Henry Nelson O'Neil,* Eastward Ho! August 1857 *(1858), engraving by W. T. Davey (1860), private collection.*

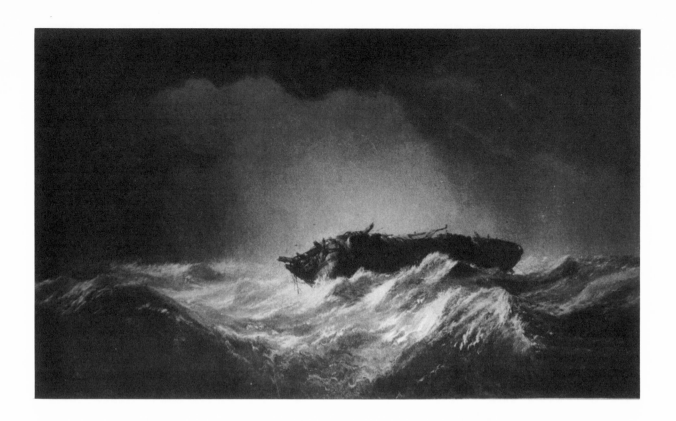

75. *Clarkson Stanfield,* The Abandoned *(1855-56), from a collotype print.*

[25] See, besides Boase, "Shipwrecks," Lorenz Eitner, "The Open Window and the Storm-Tossed Boat: An Essay in the Iconography of Romanticism," *Art Bull.* 37 (1955): 281-90, and George P. Landow, "Shipwrecked and Castaway on the Journey of Life: An Essay towards a Modern Iconography," *Rev. de Littérature Comparée* 46 (1972): 569-96, and " 'Swim or Drown? ': Carlyle's World of Shipwrecks, Castaways, and Stranded Voyagers," *SEL* 25 (1975): 641-55.
[26] John Ruskin, *Notes on Some of the Principal Pictures Exhibited in the Rooms of the Royal Academy, and the Society of Painters in Water Colours, No. 2, 1856* (London, 1856), #94.
[27] "Les Sept Vieillards," from *Les Fleurs du mal* (1857).

cence and vice. Outside the drama, however, the compulsion toward metaphysical reassurance was not as great, and the metaphoric and symbolic uses of shipwreck were more open.[25] Turner's *Slave Ship* and *Fire at Sea*, Byron's *Don Juan*, and Brontë's *Villette* raise various Romantic questions about theodicy which, as in Coleridge's mariner's tale and Melville's epic, are often the companions of an inner voyage. The most interesting wreck picture of the Victorian Age in England was probably Clarkson Stanfield's *The Abandoned*, the grandeur of whose sentiment—Ruskin thought—was generated by no effect of lighting, arrangement, or "elaboration of idea, but by simple fact of deserted ship and desert sea."[26] Without a human presence, a meaningless Godforsaken ark, the image transmitted all the more potently a symbolic charge. The image, nevertheless, was also subject to domestication, along the lines of Tennyson's dreary poem, "The Wreck," a dramatic narrative by an adultress laboring the connection between the "storm within" and the "storm without." Stanfield's evocative image suffers such reduction on the wall of the violated home in Augustus Egg's *Past and Present* (Fig. 4). Baudelaire also assigns a particular meaning to his image of the wreck:

> Et mon âme dansait, dansait, vieille gabarre
> Sans mâts, sur une mer monstrueuse et sans bords![27]

But he does not domesticate; and the symbol of the floating wreck gained in him new life, and took an important place in the poetry of the next dispensation.

11

✦·✦

NAPOLEON; OR, HISTORY AS SPECTACLE

TN JULY 1830, in France, England, and much of Europe, the French Revolution and the Empire of Napoleon became history. The promotion (or relegation) of a given segment of the past to the status of history is a psychological event, not entirely governed by the lapse of time and the succession of generations. Often an external event precipitates the change. World War II made history of World War I; and similarly the July Revolution made history of the first French Revolution and of the grand Empire.

There were, of course, special reasons. In France, Restoration and reaction, under Louis XVIII and Charles X, were not only a repudiation of the immediate past, but a wishful knitting of the present to the antediluvian world, before 1789. For the rising generation, "the present, the spirit of the age," became—in Musset's phrase—a "spectre, half mummy and half foetus."[1] The repression of the Revolutionary and Napoleonic eras particularly under Charles X, as an act of historical denial, actually pushed them into an unrealized future, and unfortunately promoted the confusion of Bonapartism with progressive politics which was to bedevil French affairs for the next half century. The revolution of 1830—the return of the repressed—was also a reassertion of temporal progression, validating both Revolution and Empire as progenitors of the present. Forward motion seemed to have recommenced, a new present to have been established, and those glorious and momentous eras so emphatically denied in the Restoration interval could be promoted into history.

That blinkered interval between Waterloo and 1830, now definitively concluded, became, not history as yet, but food for history, whose inchoate substance would be shaped and assimilated by the living witnesses. Most notably, Stendhal's two great novels and Musset's *Confession* (1835) advanced this work of definition. With good reason Stendhal claimed, in a preface that conditions the reading, that *The Charterhouse of Parma* was written in the winter of 1830, though in fact the novel was written toward the end of 1838. He insists on 1830

[1] Alfred de Musset, *La Confession d'un enfant du siècle*, new ed. (Paris, 1864), p. 8.

[201]

as the temporal locale of the writing to explain its tone and style, and—by implication—its subject. Eighteen thirty is not the locale of the tale, however. Though that hearkens back to the revolutionary transformation of Milan by the young French army in 1796, the world of the novel comes into being where we first join the subjective experience of the hero, at Waterloo. The book thus embodies the interlude between Waterloo and the July Revolution, making a style out of its discords and contradictions: between intrigue and ardor; between belated Bourbon minicourts, the debris of liberalism, and Bonapartist nationalism. It is an age of anachronism, a time of contretemps, wherein one must live.

Musset, who is supposed to have invented the modern notion of a generation, articulated the sense of a life and an age suspended between two worlds, between "a past forever destroyed, still twitching on its ruins, among all the fossils of the centuries of absolutism," and a future still only the first glimmerings of the dawn on an immense horizon. "And between these two worlds—something resembling the Ocean that separates the old continent from the young America, an ineffable something, indistinct and fluctuating, a surging sea full of shipwrecks, crossed from time to time by a distant white sail or a ship venting heavy vapor; the present age, in a word, which separates the past from the future, and is neither the one nor the other . . ."[2] Consciously perhaps, the passage evokes some of the charged imagery of Géricault's masterpiece of the period, *The Raft of the Medusa*.

In England, the July Revolution seemed to many 1789 all over again, especially since it came in a season of serious rural rebellion and constitutional crisis at home. But Charles X's brand of religious politics, and the foolish *coup d'état* of his ministers against constitutional limitations and the press, also disposed England almost from the first to accept his overthrow as France's 1688. Even the *Times*, reassured by the rapid emergence of Louis Philippe, expressed satisfaction with the swift, courageous, and apparently moderate action of the French people to vindicate their liberties. By 7 August it could declare, "the English people at least cannot quarrel with the adoption of a principle which their own revolution has consecrated." It had concluded from the direction of events and "from the deep admiration and close imitation of the English constitutional precedents which the leaders of the Liberal party in France have now for some time manifested, that the precedent of 1688 will be very earnestly appealed to, if not followed."[3] One may read the subtext here as the effect of politic flattery working on a disposition to self-congratulation; but there is plenty of evidence from France, in the arts for example, that "the deep admiration and close imitation" of perfidious Albion, including the precedent of 1688, was not altogether imagined. The theater's immediate response, however, was to find history nearer at hand.

The Hero and the Multitude

During the Restoration, Bonapartism had been systematically exiled from the theater, as usual more vulnerable to a determined political censorship than other forms. Alexandre Dumas records that hardly

[2] Trois éléments partageaient donc la vie qui s'offrait alors aux jeunes gens: derrière eux un passé à jamais détruit, s'agitant encore sur ses ruines, avec tous les fossiles des siècles de l'absolutisme; devant eux l'aurore d'un immense horizon, les premières clartés de l'avenir; et entre ces deux mondes . . . quelque chose de semblable à l'Océan qui sépare le vieux continent de la jeune Amérique, je ne sais quoi de vague et de flottant, un mer houleuse et pleine de naufrages, traversée de temps en temps par quelque blanche voile lointaine ou par quelque navire soufflant une lourde vapeur; le siècle présent, en un mot, qui sépare le passé de l'avenir, qui n'est ni l'un ni l'autre et qui ressemble à tous deux à la fois, et où l'on ne sait, à chaque pas qu'on fait, si l'on marche sur une semence ou sur un debris. [Ibid., pp. 7-8.]

[3] The *Times* goes on to express its trust that "the old jacobin faction will be peremptorily and effectively kept under," while nervously pointing to signs of its stirring. The press generally took notice that, in his speech to the French Chamber, the then Duke of Orleans mentioned England and no other country. Straining a little, the *Morning Herald* interpreted this as a flattering reference to "that part of the civilised world whose principles and whose policy it will be the object of the new government of France to adopt." From the review of press comment in *Spectator* 2 (7 Aug. 1830), p. 582.

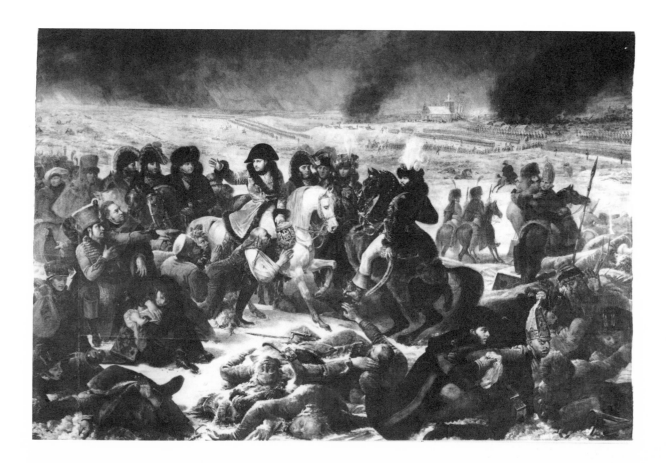

had the new regime settled into place when several directors of theaters approached him for a Napoleon play. His previous obligations to Louis Philippe led him to seek the new king's authorization. By 25 October, when Dumas began writing without it, "Six theaters were putting on their Napoleons, and I, I was still waiting."[4] In October, also, the great battle-paintings of the Empire reemerged in an exhibition at the Luxembourg "for the benefit of the wounded." The major pieces were three of the greatest paintings of Antoine-Jean Gros, *Bonaparte Visiting the Jaffa Plague Victims* (1804), *Murat at the Battle of Aboukir* (1806), and *Napoleon on the Field of the Battle of Eylau* (1808). Musset, reviewing the exhibition, speaks of the paintings as the "contemporaries" of an age already quite distant, and of the painter, "the writer of these three sublime pages of our past history," as in the peculiar position of finding himself a spectator at the judgment of posterity.[5] Nevertheless, the three paintings among them summarize the historical myth seeking expression in the Napoleonic epic as it now burst forth in the theater. The cultist deification is in the first painting; the heroic scale, élan, and mastery of chaotic energies is in the second; and the vision of modern warfare is in the third, where also the war god and thaumaturge gestures his humane compassion. These elements now sought renewed expression, not just in the theater, but in an immense pictorial progeny. In the self-conscious and derivative Napoleonic creations of the later time, however, something of faith is lacking. Historicity becomes a

76. *Antoine-Jean Gros*, Napoleon on the Field of the Battle of Eylau *(1808), Paris, Louvre (cliché des Musées Nationaux).*

[4] *Théâtre complet de Alexandre Dumas* (Paris, 1863-1899), 1:312. Jules Janin comments on the moment, "Déjà Bonaparte était partout, et l'on pouvait se demander qui donc régnait, Bonaparte ou Louis-Philippe?" He describes Dumas' play as "Une gloire sans fin suivie de cette longue agonie, écouté avec autant de larmes et de transports que le récit de la passion de Notre-Seigneur." *Histoire de la littérature dramatique*, 2nd ed. (Paris, 1855), 1:61-2.

[5] Musset's review in *Le Temps* (27 Oct. 1830), reprinted in his *Oeuvres complètes en prose*, ed. M. Allem, Bibl. Pléiade (Paris, 1951), p. 964.

limitation, heroism an attitude. Conviction and passion have to be pumped up, and the synthesis of heroism and modernity that Gros achieves never quite comes off.

The bourgeois monarchy of Louis Philippe soon established an official form of history painting, in the grandiose project of a *Musée historique* at Versailles, dedicated in an inscription over its portico "À toutes les Gloires de la France." It was conceived as a museum of painting and sculpture ordered according to subject and chronology, one suite of rooms illustrating events from Clovis to Louis XVI, another from 1796 to the present. According to a critical English observer, there were "*nineteen* salles 'CONSACREES' to the glory of Napoleon"; but for the period from the beginning of the Revolution to Napoleon's accession, very little except the battles on the frontiers. By the same critic's count, most of the paintings were battle pieces—all but 70 out of 214 in one series—so that "almost every room in the museum is a *petite* gallerie des *battailles*." The chief sensation and major creation of the king, however, was the *grande* Gallery of Battles, wherein was to be enshrined a parade of thirty-three of the greatest of France's *gloires militaires*, painted on a vast scale.[6] The government was able to incorporate a few of the paintings already in the royal collection, including Gérard's *Austerlitz* (1810) and Horace Vernet's *Fontenoy* (1828); but most had to be commissioned. Vernet became the most prolific and characteristic supplier of the Gallery, especially of its Napoleonic phase; and Vernet was the painter most likely to be realized in the theater.

The Revolution and the Empire, however, had sufficiently altered the consciousness of war to affect the imagery of war and battle painting, and to pose problems where a painter had both epic and historical ambitions. The phenomenon of "the mass" had entered deeply into popular consciousness; but the matter of its representation had not been entirely solved. Threatened by the invading and counterrevolutionary armies, the Convention had discussed—in the light of revolutionary theory as well as of practical efficacy—the creation of mass armies, as opposed to drilled regiments, to meet and overwhelm the enemy by sheer numbers. In August 1793, it decreed the "levy en masse," the first mobilization of an entire population in modern history, and it established the basis of the national conscription that was to create the immense Napoleonic armies.[7]

The action of these immense armies in war, deployed over scores and even hundreds of miles as they came to grips with an enemy, was on a scale and of a nature to hamper the "true" representation of a given climactic battle. When three of Vernet's huge battle paintings for Versailles appeared in the Salon of 1836, the wits all remarked that there was scarcely any battle represented; nor could there be, since the emperor had to be present and prominent. Consequently *The Battle of Jena* shows the emperor and his generals reviewing the Imperial Guard, and exploits the anecdote of a young soldier who had the temerity to cry from the ranks, "*En avant!*" *The Battle of Friedland* shows Napoleon in the rising foreground issuing commands to Oudinot. *The Battle of Wagram* shows him again at his command post observing the effects of the artillery. Musset, defending Vernet, cites

[6] [John Wilson Croker], *Quarterly Review* 61 (Jan. 1838): 13, 20 (containing an astute critique of the politics of Versailles). See also André Pérate, *La Galerie des battailles, au Musée de Versailles* (Paris, 1916).

[7] See John Hall Stewart, *A Documentary Survey of the French Revolution* (New York, 1951), items 82, 97, 157.

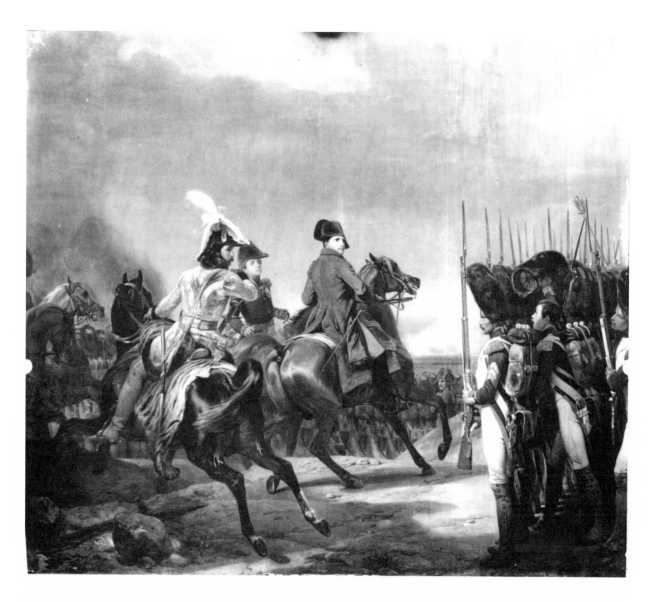

David's complaining parable of the painter who wants to paint two lovers in the Alps. Either he does justice to the Alps and makes his lovers insignificant, or paints full-sized lovers and loses his Alps. Vernet, then, has made his choice between the mass action of the battle itself and the controlling will that, in the Napoleonic myth, animated the vast machine and directed the outcome. "You want to see a plain? the army? something else? why not the enemy? and the Emperor lost in the midst of all that? But if he were so little and so far away, no one would hear what he says. . . . Since the actor is Napoleon, and since the action is accurately depicted, what would you want him to show you between the four legs of his horse?"[8]

Canons of optical verisimilitude and of historicity imposed the alternatives on the painter; and other Vernet battle pictures—for example his *Battle of Jemappes* (1821) and *Battle of Montmirail* (1822), painted in a different climate—chose the Alps over the lovers. Such paintings,

77. Horace Vernet, The Battle of Jena *(1836), Versailles, Musée.*

[8] Voudriez-vous voir une plaine? l'armée? que sais-je? porquoi pas l'ennemi? et l'Empereur perdu au milieu de tout cela? Eh! s'il était si petit et si loin, on n'entendrait pas ce qu'il dit. . . . Puisque l'acteur est Napoléon, et puisque l'action est exacte, que voudriez-vous qu'il vous montrât entre les quatre jambes de son cheval? [Musset, *Oeuvres complètes en prose*, pp. 981-82.]

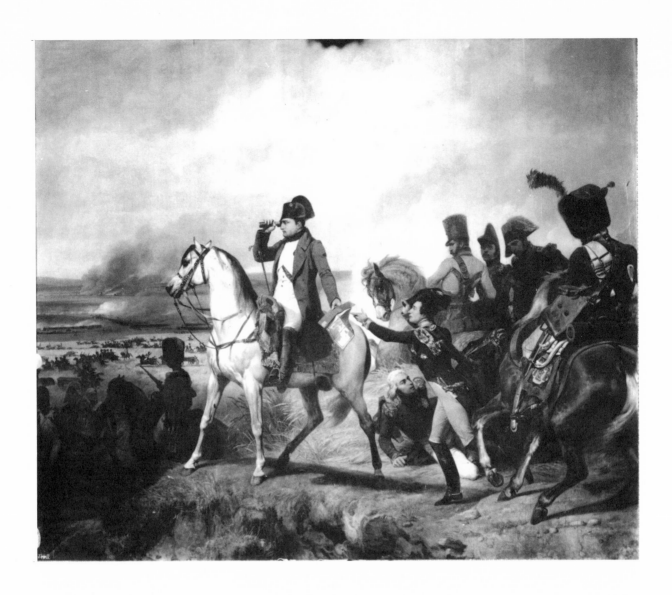

78. *Horace Vernet*, The Battle of
Wagram *(1836), Versailles,
Musée.*

9 Antony-Béraud, "Salon de 1837," *Le
Monde Dramatique* 4 (1837): 205-206.
Cf. Richard Muther, *History of Modern
Painting*, rev. ed. (London, 1907), 2:95.
(Muther's brief account of the evolution
of the nineteenth-century military picture
remains among the most useful.) Vernet's
most articulate and merciless critic was
Baudelaire, who wrote of him, "I hate
this fellow because his pictures are not a
matter of painting, but a dextrous and
frequent masturbation, an irritation of the
French skin . . ." *Salon of 1846*, trans.
and ed. (somewhat more gracefully) by
Jonathan Mayne, *Art in Paris 1845-
1865* (London, 1965), p. 94.

executed on a large scale, show vast battlefields framing local engage-
ments, and the deployment and movement of troops in the critical
action. Probably these would have better pleased the critic of 1837
who, adverting to the battle titles of Vernet's Bonapartist machines of
the previous year as "une bonne plaisanterie," observed that it was
nevertheless in paintings of great size, "where the littleness of the
personages permits the painter to represent the action in nearly its
whole extent, that one may find, according to the talent of the artist,
a more or less faithful image of a battle." This same critic summed up
the whole genre of paintings destined for Versailles as "toujours du
Cirque,—tableau final . . . au rideau!"[9] The circus analogue, as we shall
see, was exceedingly apt, though the circus had the advantage of a
double perspective which could spare it the choice between the em-
peror and the battle.

The alternatives seemed to be, then, the painting that represents a
great battle as a deployment of organized multitudes, and the painting
that represents it as a mounted master spirit "who alone looks the

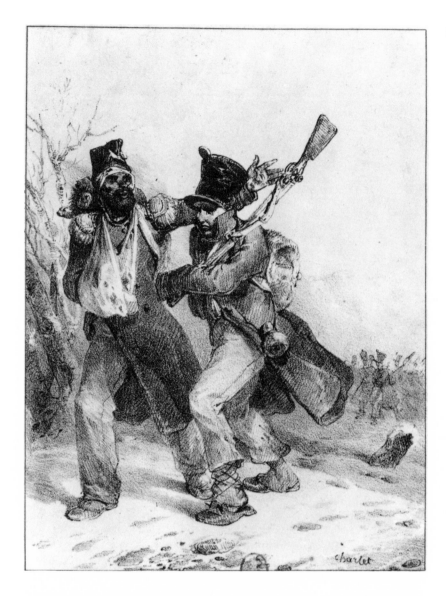

79. *Nicolas-Toussaint Charlet, 'Fla! quel plaisir . . . d'être soldat [Ah! How nice . . . to be a soldier] (1826), Paris, Bibliothèque Nationale.*

public in the face as if to say, 'It is indeed I! here I am! don't deceive yourselves!'—as if a great battle, a victory had to be epitomized in one man."[10] But where the subject or the painter escaped from the peculiar formula of literalism and glorification that Versailles seemed to impose on its Napoleonic painters, a further alternative appeared, already present in the *Aboukir* of Gros, and reaching back to Rubens and before. It was represented in the Salon of 1837 by Delacroix's *Battle of Taillebourg*, in which the passionate energy of battle, its thrust and intensity, is rendered directly and affectively, and indeed heroically.[11] This mode undoubtedly captured the poetry of war, but not the prose. For that, the best alternative to the battlefield *veduta* was the military genre picture.

The masters of the military genre picture of the Napoleonic wars had no need to wait for 1830 to license their work, nor did they depend on the expensive patronage that supported historical painting. Nicolas-Toussaint Charlet and his juniors, Hippolyte Bellangé and Auguste

[10] Antony-Béraud, "Salon de 1837," p. 205.

[11] See the interesting vector analysis of the painting (also destined for the Gallery of Battles) in René Huyghe, *Delacroix* (London, 1963), pp. 330-32.

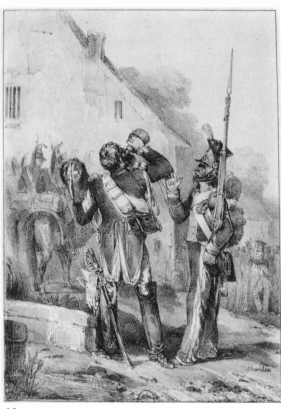

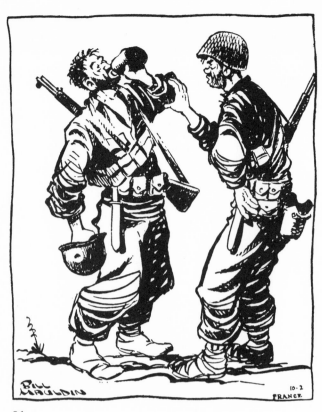

80

81

80. (above left) *Nicolas-Toussaint Charlet*, Tu as le respiration [sic] trop long [Your wind is too good] *(1824), Paris, Bibliothèque Nationale.*

81. (above right) *Bill Mauldin,* "Gimme my canteen back, Willie. I see ya soakin' yer beard full" *(1944), in* Up Front *(New York, 1945).*

82. (facing page, top) *Auguste Raffet*, Retreat of the "Bataillon Sacré" at Waterloo *(1835), Paris, Bibliothèque Nationale.*

83. (facing page, bottom) *Hippolyte Bellangé*, Moscow (7 September 1812). Napoleon Emperor. Taking of the Russian Great Redoubt by General Walthier's Division of Cuirassiers; Death of General Caulaincourt *(1832), Paris, Bibliothèque Nationale.*

Raffet (all at one time pupils of Gros) took advantage of the new and virtually unregulatable medium of lithography and the economics of the popular print to create images of the late lamented quarter-century of campaigns that were more satisfying in their kind than the grandiose images of the official memorialists. In an era of battles whose scale defeated the visual imagination, the military genre scene provided refuge for precious qualities of human experience, character, and memorable incident. At the same time it represented the experience of warfare, almost for the first time, as the experience of the common soldier. Charlet in some moods is the direct ancestor of Bill Mauldin's chronicle of World War II as the vicissitudes of Willy and Joe.

Having given a distinctive character to the common soldier, in a context of characteristic incident, the artists still had before them the challenge of the dissolution of individual character in the phenomenon of the mass, and the absorption of incident by the scale of historical action. Their task was to convey these experiences, not mechanically, but affectively. The adumbration of such an idea may be found in Gros' *Eylau*, in eloquent tension with its theophanic center; and a further development (again in the setting of a vast snowy plain, but no longer as modern history) is in Delacroix's *Battle of Nancy* (1831; Salon 1834). But the feeling is nowhere so strikingly evoked as in the work of the lithographers, where the qualities of the medium applied to the larger scene virtually encourage the dissolution of forms and the absorption of individuality in the phantasmagoria of limitless battle. Raffet, some of whose best work has a distinctly symbolic character,

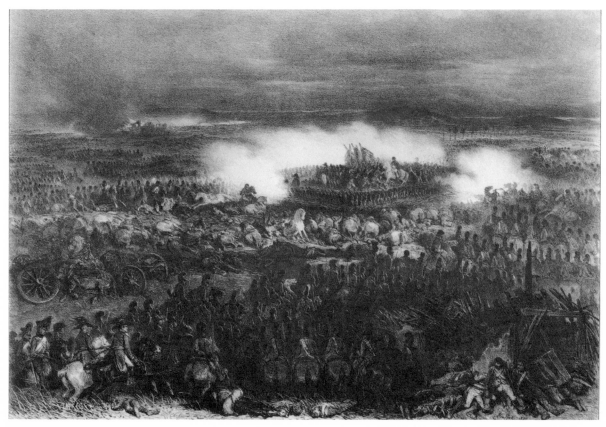

82

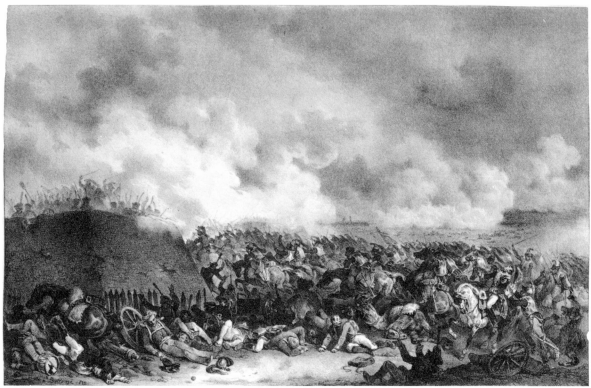

83

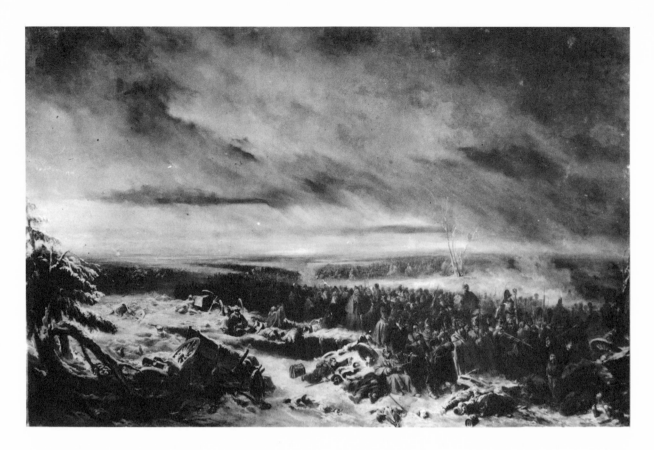

84. *Nicolas-Toussaint Charlet*, Episode in the Russian Campaign *(1836), Lyons, Musée des Beaux-Arts.*

is the master of such effects, for example in his *Retreat of the "Bataillon Sacré" at Waterloo*; but they may be found elsewhere, for example in Bellangé's *Moscow . . . Taking of the Russian Great Redoubt*, and belong to the school and the medium.

The popular print was a potent source of imagery for some of the more notable paintings of the era—witness Delacroix's *Greece on the Ruins of Missolonghi* (1826) and *Liberty Leading the People* (1831).[12] The lithograph provided both the graphic language and formal conception of another painting which, in the eyes of some of its acutest contemporaries, achieved expression of the historical experience of the mass at the moment of profoundest trauma and anagnorisis. In Charlet's *Episode in the Russian Campaign*, exhibited at the Salon of 1836, translated into etching and lithograph by Raffet, and widely known, the romantic illusion of the heroic will and its material triumph has evaporated, action has given way to passion, and a numberless and leaderless humanity is left to suffer in the inhuman endlessness of frozen plain and sky.

Charlet's use of the word "episode" in the title of the painting was an extravagant gesture of modesty, according to Musset in his eloquent recognition and interpretation of its impact. The unpretentious term points to the antiheroic character of the painting, but ignores the qualities that make it for Musset "tout un poème."

In seeing it, one is struck at first by a vague and uneasy horror. What is this painting supposed to represent? Is it Beresina? Is it

[12] For Delacroix's *Liberty*, for example, see Charlet's *L'Allocution* and Decamps' *Arrêt de la Cour Prévotale*, in Armand Dayot's *Journées revolutionnaires 1830-1848* (Paris, n.d.), pp. 48, 60.

Ney's retreat? Where is the General Staff? Where is the point that attracts all eyes that we are used to finding in our museum battle scenes? Where are the horses, the plumes, the captains, the marshals? Nothing of all that here. This is the *grande armée*, the common soldier, or rather, this is man. Here is human misery quite alone, under an overcast sky, on an icy earth, without guide, without leader, without distinctions. Here is despair in the wilderness. Where is the Emperor? He is gone. Far off, there, on the horizon, among those fearful whirlwinds, his carriage is rolling perhaps over heaps of corpses, carrying away his betrayed fortunes; but one sees not even his dust. One hundred thousand of the wretched march at a steady pace, however, head down, and death in the soul. This one stops, tired of suffering, lies down, and falls asleep forever. That one rises up like a spectre and holds out his arms as a suppliant. "Save me," he cries, "Don't abandon me!" But the crowd passes on, and he will soon fall back. The crows hover over the snow full of human forms. The skies stream and, burdened with frost, seem to sink down upon the earth. A few soldiers have found some brigands pillaging the dead; they shoot them. But not one of these fragmentary scenes either attracts or distracts. Everywhere the eye wanders it finds only horror, but horror without ugliness, and without exaggeration.[13]

Charlet has painted the end of rhetoric and glory; his horror is a horror of absence. The familiar rhetorical gestures and focal embodiment of the heroic will are missing from the painting. Without that beglamouring of the eye, realities assert themselves, as in the actual negative epiphany of 1812. Incident and character are absorbed by the common fate, rendered in weather and landscape and the universal loneliness of multitude.

An Epic Without a Hero

In ordinary narrative the dual representation of the hero and the multitude was not a technical problem. In fiction Scott had effectively combined the situations of individuals (private men caught in historical circumstances) with the action of larger groups, heterogeneous and collective. The movement from the wide battlefield to the individual encounter and back again, like that between personified cause and communal effect, was in fact the epic norm. Formal history also could pass easily from the councils and commands of sovereign individuals to the behavior of nations as collective entities. But despite Vico, before the nineteenth century historical narrative had not found it necessary in any notable degree to apply its resources to representing the *agency* of the multitude on the stage of history. Here too 1830 gave the necessary perspective; and the refocusing of history as a mass spectacle and a mass experience, with the representation of the crowd in intrinsic, directional, and irresistible motion, appears with all the force of a revelation in Carlyle's epic narrative of the French Revolution.

Musset opens and closes his account of Charlet's painting by praising it as a poem. "A page of an epic poem, written by Béranger," he calls it, the qualification suggesting a democratic epic, one that rises out of

[13] La *Retraite de Russie*, de M. Charlet, est un ouvrage de la plus haute portée. Il l'a intitulé *Épisode*, et c'est une grande modestie; c'est tout un poeme. En le voyant, on est d'abord frappé d'une horreur vague et inquiète. Que représente donc ce tableau? Est-ce la Bérésina, est-ce la retraite de Ney? Ou est le groupe de l'état-major? Où est le point qui attire les yeux, et qu'on est habitué à trouver dans les battailles de nos musées? Où sont les cheveaux, les panaches, les capitaines, les maréchaux? Rien de tout cela; c'est la grande armée, c'est le soldat, ou plutôt, c'est l'homme; c'est la misère humaine toute seule, sous un ciel brumeux, sur un sol de glace, sans guide, sans chef, sans distinction. C'est le désespoir dans le désert. Ou est l'Empereur? Il est parti; au loin, la bas, a l'horizon, dans ces tourbillons effroyables, sa voiture roule peut-étre sur des monceaux de cadavres, emportant sa fortune trahie; mais on n'en voit pas même la poussière. Cependant cent mille malheureux marchent d'un pas égal, tête baissée, et la mort dans l'âme. Celui-ci s'arrête, las de souffrir; il se couche et s'endort pour toujours. Celui-là se dresse comme un spectre et tend les bras en suppliant: "Sauvez-moi, s'écrie-t-il, ne m'abandonnez pas!" Mais la foule passe, et il va retomber. Les corbeaux voltigent sur la neige, pleine de formes humaines. Les cieux ruissellent et, chargés de frimas, semblent s'affaisser sur la terre. Quelques soldats ont trouvé des brigands qui dépouillent les morts; ils les fusillent. Mais de ces scènes partielles pas une n'attire et ne distrait. Partout où le regard se promène, il ne trouve qu'horreur, mais horreur sans laideur, comme sans exagération. [Musset, "Salon de 1836," *Ouevres complètes en prose*, pp. 976-77.]

An important painting in the preceding Salon was Boissard de Boisdenier's *Épisode de la retaite de Moscou* (Musée de Rouen), an anecdotal picture blown up to disconcerting size (more than 5′ x 7′). Boissard (also a pupil of Gros) shows a soldier, sheltering beside a broken wheel and a dead horse, waking to find his companion also dead, while in the distance is a grim dawn and some soldiers moving across the frozen plain.

Delacroix coolly plagiarized Musset in his essay on Charlet, *Rev. de Deux Mondes* 37 (1862): 234-42. Both go on to consider the painter's technique and its clear links with lithography.

a popular art, and makes its "hero" the people en masse. It is more than coincidence that Mill opened his notable review of Carlyle's *French Revolution*, published the year after the painting, by declaring, "This is not so much a history, as an epic poem; and not withstanding, or even in consequence of this, the truest of histories."[14] It is a poem, Mill suggests, because it is experiential and evocative. Rather than provide "plausible talk *about* a thing," it satisfies the appetite for "an image of the thing itself," and in this it is at one with historical plays and romances. Mill names specifically Schiller's *Wallenstein* and Lodovic Vitet's dramatic trilogy on the period of Henri III. Other reviewers found analogues in painting; and in fact Carlyle wrote to his brother of his intention "to make an artistic picture of it," and records seeking pictures of the Revolution in the British Museum. But he found little that was useful, except Dürer, and two months later he declared, "It shall be *such* a book: quite an epic poem of the Revolution: an apotheosis of Sansculottism!"[15]

Mill's dramatic analogy, more thoughtful than the direct analogy to painting, in fact invokes a pictorial form of historical drama. Vitet published his trilogy between 1827 and 1829 not as drama, but as history written in dramatic form. In the preface to the first part, *Les Barricades*, he argues the superior impact of direct presentation—the view Carlyle embodies and Mill articulates. Vitet describes, however, a visual and panoramic rather than otherwise dramatic texture, embracing *scène pittoresque* and *tableaux de moeurs*, based on the imaginative authorial act of strolling about Paris, in May 1588, as an observer. The actual text is composed of a lengthy introduction which is straight historical narrative, and then a series of objectively rendered dramatic scenes, so that narrative and spectacle remain separated. Carlyle's union of narrative and spectacle, whereby the reader becomes the experiencing subject in the immediacy of a theater of events, is never achieved.

The striking originality of *The French Revolution* as perceived by its contemporaries was its experiential style, and its protagonist. Carlyle's protagonist is the people as such, whose multitudinous activities, however contradictory and anarchic in appearance, furnish the will and the means whereby the idea whose time has come achieves its historical realization. Exceptional individuals and organisms surface in the turbulence of events and (biographically) in the texture of the narrative, and enter into a dialectic with the democratic multitude, as its leaders, voices, and would-be heroes. But these give way one after the other, until the Revolution, whose life coincides with the mass protagonist in historical action, is over.

The experiential style in *The French Revolution* is a matter of tense. After establishing a Past, in the days of Louis XV, it moves in a narrative present from his death through the circumstantial gestation, birth, flowering, and decay of the Revolution; and it is this moving present that focuses the panorama of events and the comment thereon. The shifts, to a panoramic overview, sometimes temporally retrospective and projective, punctuate but do not compromise the flow of the present tense, reinforced by a first-person subject that puts us in the middle of events before their consequences have colored them, and identifies us, the readers, with the actors. In Carlyle's grammar, *we*

[14] *London and Westminster Rev.* 27 (July 1837): 17-53.

[15] James Anthony Froude, *Thomas Carlyle . . . 1795-1835* (London, 1882), 2:438, 456. Cf. Thackeray's review (*Times*) and Herman Merivale's (*Edinburgh Rev.*), in *Thomas Carlyle: The Critical Heritage*, ed. Jules Seigel (London, 1971).

are the Convention, the Jacobins, the Dantonists, and in some profoundly imaginative sense the central experiencing will of the moving moment. It is perhaps only the reflective irony that keeps the style sane; that and the sense of a comprehensive action, whose life—like the life of a play in performance—materializes in the present tense of the actors, but anticipates and pervades the whole.

The end is also a matter of tense, a shift of the verb *to be* from present to past, where "the thing we specifically call *French Revolution* is blown into space . . . and become a thing that was!"[16] It is not only the Revolution, but also the experiential journey that ends here and becomes history. All that remains for the reader is an afterword ("Finis") where, however, conclusion is denied—the historical epic "does not conclude, but merely ceases." What is further denied is the pastness of the French Revolution except in a chronological sense. For Carlyle, as for Scott, the true historian is necessarily concerned with the transformation of the past into the present; and ceasing his account of "a New-Birth of TIME" whose soul still lives and works far and wide (III, 7, 6), Carlyle in his punctuating shift to the past tense chiefly signals his own and his fraternally-conceived reader's emergence into the present. Past and Present in Carlyle's *French Revolution* are ultimately defined as having a common ground in the chaotic Mahlstrom, the Fire-Sea, and innumerable other metaphors for living energy in search of a form, which was Carlyle's subject of subjects; an imagery associated through the rest of the century not with the hero, but with the crowd.

A RENASCENT cult of the hero and a new recognition of the historicity of the mass were both released in the wake of the Revolution of 1830, and each found expression in narrative and picture. From the official viewpoint of the middle and later thirties, however, the age of *gloire* and heroism excluded the chaos of the first Revolution, and ignored the tragic interlude of 1812, though not the heroic consummation of Waterloo. As in art, so in politics, the myth of the hero and the myth of the people tended to part company. But in 1830, it seemed briefly that the two could be as one, and it was to seem so again in 1848 and its unfortunate sequel.[17] Narrative and picture in their received forms did not lend themselves easily to such a synthesis, and it took considerable innovative genius in the case of Carlyle and Michelet, or mastery of a new popular medium in that of Charlet and Raffet, to turn the official forms of history into an expression of the agency and experience of the mass, an expression both epic and "true."[18] The theater, however, had in its grasp the technical means of uniting the cult of the hero and the action of the mass, directly apprehended. The result was both popular and ephemeral; but it was also a comprehensive expression of the climate that produced both the Gallery of Battles and the *Episode in the Russian Campaign*; the Bourgeois Monarchy and *The French Revolution*; and eventually, the Second Republic and the lesser Napoleon.

The Arena of History

That "circus" with which contemporary critics identified the panoramic battle paintings of the 1830s began in the last quarter of the

[16] Part 3, bk. 7, chap. 7, "The Whiff of Grapeshot."

[17] The myth of the people as felt in the July days was admirably expressed in Casimir Delavigne's "Une Semaine à Paris" from *Les Messéniennes*, poems whose popular and national character Musset likened to Vernet. An anthology of the imagery pervading the popular prints of the July days, Delavigne's "Semaine" also invokes the "Grande ombre de Napoléon," while declaring:

> Qu'ils aient l'ordre pour eux, le désordre est pour nous!
> Désordre intelligent, qui seconde l'audace,
> Qui commande, obéit, marque à chacun sa place,
> Comme un seul nous fait agir tous,
> Et qui prouve à la tyrannie,
> En brisant son sceptre abhorré,
> Que par la patrie inspiré,
> Un peuple, comme un homme, a ses jours de génie.

[*Oeuvres complètes de Casimir Delavigne* (Paris, 1855), p. 517]

[18] Jules Michelet began his monumental *Histoire de France* immediately after the historical release of 1830, and published *Le Peuple*, an essay on the character and experience of the multitude, in 1846.

eighteenth century as an indoor ring for equestrian display. The buildings soon acquired a stage at one end of the ring; and early in the nineteenth century this conjunction generated the popular dramatic form known as "hippodrama," wherein—in the words of one of its prophets—"the business of the stage and the ring might be united."[19] The connections between the English circus theaters and their French counterpart were originally close. Philip Astley, whose name was attached to the most famous of the English circus theaters, built and for some years wintered in the first of the Parisian circus buildings, but abandoned it during the Revolution to Antonio Franconi, who later built (and rebuilt) after English models the famous Cirque Olympique (1807).

The simultaneity of stage and ring—slow to be exploited—allowed both the spectacular deployment of masses and a heroic focus, so that the battle did not need to appear between the horse's legs. Astley's stage of 1804-1841 even had a multilevel capability, with "immense [moveable] platforms or floors, rising above each other, and extending the whole width of the stage." These could carry galloping or skirmishing horsemen, and be masked to represent battlements, heights, bridges, and mountains. After the Cirque resumed the Napoleonic epic in 1830, ramps connected the stage to the ring to allow the greatest fluidity and flexibility.[20] The dramatic mode, moreover, allowed for an alternation between individual drama and general action or panoramic scene. The circus melodramas of the 1820s featuring the Napoleonic wars—staged freely in London, but not in Paris—combined a great deal of private domestic drama among soldiers and sweethearts, invaders and native patriots, with anecdotal vignettes of the great historical figures, and leaps, perils, explosions, centaur feats, and climactic mass battles carried out in intelligible maneuvers. Thus, the rather classically ordered "Grand Military Melo-Drama," *The Battle of Waterloo* by J. H. Amherst (1824), ends each act with a battle scene: the Bridge of Marchienne (won by the French), Quatre Bras (the Allies), and Mont St. Jean (match point, the Allies). In the second act Wellington appears before "*Ligny in flames, and panorama in the extreme distance*" to give orders, exhibit coolness, and utter some of his best-known phrases. The duke and his staff ride off under fire, and the battle begins, following a precise scenario and rhythm:

> *Enter a body of* French *infantry and cavalry, with shouts of Vive L'Empereur. The Officer orders a regular fire to be kept upon the* Highlanders *among the corn, who are rapidly thinn'd; at the same time a party of* English *horse charge from the same side as the* French *entered, and endeavour to force the wood by performing a circular movment. The* French *obtain possession of it after a struggle, and from the most advantageous situations defend their positions. The* English *are now much worsted from the advantageous position of the enemy, and are retreating under a heavy fire, when the* Black Brunswickers *advance in most gallant style.*[21]

The Duke of Brunswick is shot from his horse, and becomes the focus of the action for a moment (compare Caulaincourt in Bellangé's *Moscow*). Eventually Blücher and his Prussians arrive with artillery, and

[19] Charles Dibdin the Elder, reflecting on his part in conceiving the new Royal Circus in 1772, quoted in A. H. Saxon, *Enter Foot and Horse* (New Haven, 1968), pp. 11-12. Saxon's book is an excellent history of hippodrama in England and France, with a chapter on the "Gloire Militaire."

[20] Saxon, *Enter Foot and Horse*, p. 13 (quoting Charles Dibdin the Younger, in John Britton and Augustus Pugin's *Illustrations of the Public Buildings of London*, 1825-1828); and pp. 23-24.

[21] J. H. Amherst, *The Battle of Waterloo*, Lacy, Vol. 98.

85. *"Death of the Duke of Brunswick at the Battle of Waterloo,"* in *J. H. Amherst*, The Battle of Waterloo *(1824), Lacy, Vol. 98.*

fight *"with a desperate resolution"* to victory. As always, the scene ends in a triumphant tableau.

Amherst's "Military and Equestrian Spectacle" of the following year, *Napoleon Bonaparte's Invasion of Russia; or, The Conflagration of Moscow*, is more varied and elaborate in its scenic effects.[22] It calls frequently for large bodies of troops in motion, including Cossack evolutions and ceremonial reviews, and each act climaxes in a scene of mass activity. But there is also a development of purely pictorial effects. Act I, scene 2, for example, presents the French army in "a circle of real camps." They are all struck simultaneously at the end, *"forming a sudden picture."* Scene 6 offers a *"Romantic View. Heights.* BUONAPARTE *discovered lying near a watch fire with a map before him . . .* SOLDIERS, *eagles, &c perpetually defiling in the back-ground [sic]."* The scenes of Act III anticipate Charlet's *Episode*: *"Immense Tract of Country. Snow storm; carts overset; horses dead; immense piles of dead bodies heaped on one another; canon, &c. A few wretches huddled here and there, and perishing. A file of* MEN *bivouacking on snow . . ."* (III, 1); and *"Wood of Firs, heavily laden with snow; extensive view of frozen country, with the wreck of the Grand Army; here and there a* WOMAN, *and two or three* SOLDIERS *frozen to death* (III, 4).

The most sensational of the culminating mass spectacles was the burning of Moscow at the end of Act Two. The conflagration, worked with transparencies, appears first in the distance, and then engulfs the scene in a general chaos of French soldiers and Russian inhabitants rushing about and dying. In the end a house front collapses, and Napoleon on horseback *"dashes through everything and brings* [a woman and child] *out in safety."* Napoleon is presented throughout as spartan, ambitious, somewhat cold, but commendably democratic in his belief that "merit is the only nobility." He is also an exemplar of that ideal of melodramatic war, the fraternity and generosity of the brave across the battle lines. Even the third act, given over to the horrors and

[22] Lacy, Vol. 13.

miseries of the retreat, permits such chivalry, though the brutalities of the Cossacks and of some of the starving French, and the one-sidedness, amid the fireworks, of the final battle, leave the pageant of military glory somewhat tarnished. As an ultimate sacrilege in this temple of the hippodrama, a French cuirassier brings in the frozen leg of his dead horse, and the cannibalistic feast is only prevented by the exterminating onslaught of the enemy.[23]

By virtue of its popularity, the hippodrama was not confined to either *gloires militaires* or the circus theaters. The image of the horse apparently spoke to this age with a special eloquence, and the fascination with the drama of horses coincides with their intensely charged appearance in French Romantic painting. Bonaparte, manipulating images, knew what he was about in his instructions to David that he be painted, not sword in hand, but "calme sur un cheval fougueux"—resulting in the best-known of all Napoleon paintings, *Le Passage du Grand-Saint-Bernard*.[24] Both the mastery of embodied passion and energy, and the pure passion and energy itself, ready to shake off or run away with the presumptuous human will, were part of the fascination of the horse and its drama. The runaway side found full expression in the image which always advertised the most widely played of the hippodramas, *Mazeppa*, based on Byron's poem of 1819, where the story is set in a framework that evokes the catastrophe of 1812.[25]

The image of Mazeppa, bound naked and on his back to a wild horse of the steppes, was realized dramatically in England (1823, 1831) and France (1825), and pictorially by Géricault, Delacroix, Boulanger, and several times by Vernet. Whatever the image meant personally and psychologically to its beholders, in its political and historical bearings it negated the mounted figure of the man of destiny, and evoked the helpless, headlong rush to a common destruction, strangely allied with a sensation of freedom and release, that writers on mass phenomena such as Carlyle and Dickens evoked through the imagery of the sea and the conflagration. In Byron's poem, when Mazeppa and the horse reach what seems an untamed world, they encounter briefly "A thousand horse, the wild, the free / Like waves that follow o'er the sea," a great thundering single-minded mob that has its natural leader, but has never known rider, regulation, or restraint.

The Napoleon plays that filled the Paris theaters three months after the July Revolution differed from their English predecessors in that, however elaborate and spectacular the battle, the principal focus was the man—the man as myth, and the myth as history.[26] The title of Dumas' delayed piece for the Odéon tells all: *Napoléon Bonaparte; ou, Trente ans de l'histoire de France* (11 Jan. 1831). The Cirque Olympique offered *L'Empereur; événemens historiques en cinq actes et en dix-huit tableaux* (6 Dec. 1830). Some months before, however, in the immediate glow of the Revolution, the Cirque presented a piece that briefly symbolized the illusory union of the popular and heroic myths: *La Prise de la Bastille* ("gloire populaire"), *et le Passage du Mont-Saint-Bernard* ("gloire militaire"), one entertainment in "deux époques."[27]

Another difference was in the pictorial dimension of the major productions. The Revolution and the Empire had become history, as the titles industriously declare. The plays required, on the visual side, in

[23] Saxon notes this startling event, *Enter Foot and Horse*, p. 143. Two greater works in the panoramic mode, that adopt the double perspective allowed by the stage and ring to structure an ambivalent and ironic vision, are Grabbe's *Napoleon; or, The Hundred Days* (1831) and Hardy's *Dynasts* (1903-1908). Neither drama of the Napoleonic age can be contained by an ordinary theater; but as Joan Grundy writes, "If *The Dynasts* looks forward to *The Birth of a Nation*, it also looks back to the representations of Waterloo and other combats staged at Hardy's beloved Astley's" (*Hardy and the Sister Arts*, London and New York, 1979, p. 175). Grabbe's play, which oscillates between the mass in its various guises and the hero, was written, according to its author, just before the July Revolution, and embodies a Germanic version of the mood of yearning, cynicism, and depression.

[24] J. L. Jules David, *Le Peintre Louis David 1748-1825, souvenirs & documents inédits* (Paris, 1880), p. 383.

[25] Mazeppa in old age tells the story to Charles XII on the retreat from the Battle of Pultawa, a disaster for Charles brought about by an annihilating Russian winter and a scorched earth policy, as in the case of Charles' successor, Napoleon. Byron invokes the "more memorable year" (1812) that

Should give to slaughter and to shame
A mightier host and haughtier name;
A greater wreck, a deeper fall,
A shock to one—a thunderbolt to all.
[ll. 11-14]

For an account of the many other elements in the response to the Mazeppa image, see Hubert F. Babinski, *The Mazeppa Legend in European Romanticism* (New York, 1974).

[26] For some French predecessors, nearly all from before 1815, see Louis-Henry Lecomte's exhaustive *Napoléon et l'Empire racontés par le théâtre, 1797-1899* (Paris, 1900), and Tristan Rémy's "Pantomimes Napoléoniennes," *Europe* (1969): 310-25.

[27] The latter, by Henri Vilmot, Théodore Nézel, and Ferdinand Laloue echoes J.-B.-A. Hapdé's *Passage du Mont-Saint-Bernard*, performed in 1810.

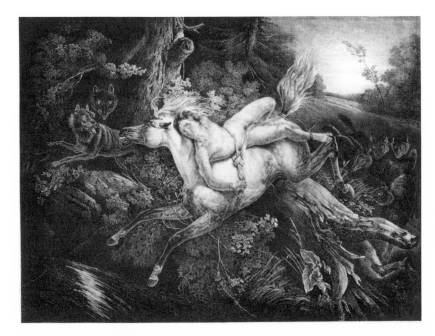

86. *Horace Vernet*, Mazeppa and the Wolves *(1826), lithograph by Charpentier and Mellinet, after an engraving by L.F.M. élèves de M. Laidet, Paris, Bibliothèque Nationale.*

addition to striking spectacle, archaeological authenticity and iconic evocation. By employing widely familiar pictorial images as a form of external authentication, the Napoleonic myth could pass itself off as history. At the same time, recognition of the image, a shared epiphany, would unite the audience into a community of worshippers.

Ferdinand Laloue, the great *metteur en scène* (and collaborative author) at the Cirque, was the most consistent user of such iconic evocation and authentication, and is likely to have set the fashion by recalling David's painting in the *Passage du Mont-Saint-Bernard*. A relation to known graphic images appears in the printed stage directions for the Cirque's succeeding *L'Empereur* (e.g. "*Le passage des troupes s'effectue d'après la gravure*" for the scene of the disastrous crossing of the Beresina; and "*Il pousse un soupir et expire. Tableau d'après la gravure*" for Napoleon's death at Longwood).[28] In the interval, however, the Porte-St.-Martin, temple of melodrama, staged its exceedingly successful *Napoléon; ou, Schoenbrunn et Sainte-Hélène* (20 Oct. 1830), incorporating some of the best-known Napoleonic images. Part I ends with a tableau evocation of Pierre Gautherot's *Napoleon Wounded before Ratisbonne* (1810), historically displaced, but appropriate to this moment in the play, where Napoleon at Schoenbrunn has just triumphantly survived an assassination attempt. Foot in the stirrup, he gives the command, "À cheval, messieurs!" while the drums beat and the troops shout, "Vive l'empereur! " Part II reaches its pathetic nadir in the death scene, which closes with the direction, "Il faut, en ce moment, que la chambre du mourant offre la représentation exacte du tableau de *Steuben*."[29] Carl von Steuben's painting, *The Death of Napoleon* (1830), was in the current exhibition at the Luxembourg for the benefit of the wounded, and reappeared in nearly every subsequent play to carry the epic spectacle as far as Napoleon's death.[30]

It appears, for example, on the other side of the Channel, in the

[28] M. Prosper [A. Lepoitevin de Saint-Alme, F. Laloue, and A. Franconi], *L'Empereur; événemens historiques en cinq actes* (Paris, 1830), pp. 39, 55. Laloue's work at the Cirque Olympique and his "specialty" of pictorial realization is discussed in Marie-Antoinette Allevy, *La Mise en scène en France dans la première moitié du dix-neuvième siècle*, Bibliothèque de la Soc. des Historiens du Théâtre, vol. 10 (Paris, 1938), pp. 110ff. See also Théodore Muret, *L'Histoire par le théâtre, 1789-1851*, 3rd ser.: *Le Gouvernement de 1830, la Seconde République* (Paris, 1865), pp. 95ff.

[29] Charles Dupeuty and H.-F. Régnier-Destourbet, *Napoléon . . . drame historique en neuf tableaux*, in *La France Dramatique*, vol. 12 (Paris, 1835), pp. 260, 273.

[30] See Dickens' delighted report of a performance in Genoa of a play called *St. Helena, or the Death of Napoleon* by the *marionetti* of Milan, in *Pictures from Italy* (London, 1846), p. 71.

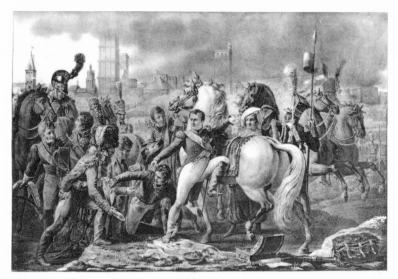

87

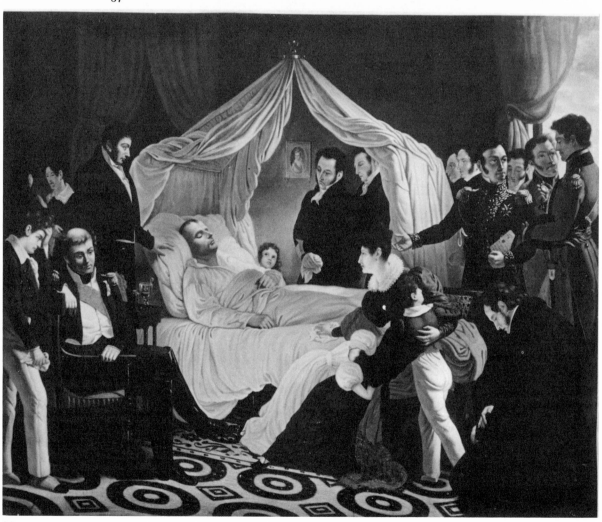

88

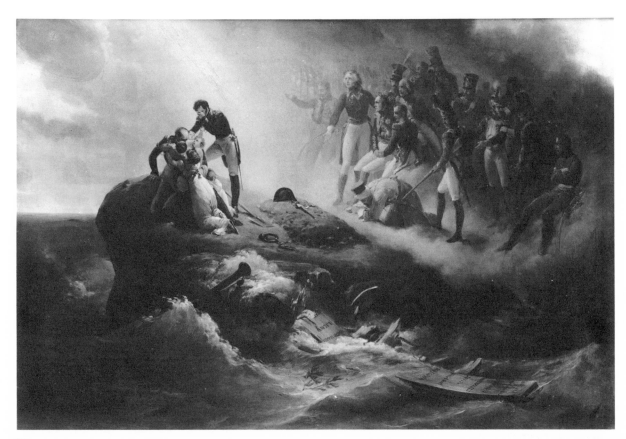

89

Surrey Theatre's *Napoleon; or, The Victim of Ambition*, one of several such plays to reach the London theater in the spring of 1831. As its title indicates, the Surrey *Napoleon* took a prudent English tack. It concentrates on the later stages of Napoleon's career, and its two most ambitious episodes, already well tested in England, were moving-dioramic presentations of the Russian campaign and of the Battle of Waterloo. The whole, as the playbill declares, is "Historical, Allegorical, and Pictorial," spectacle infused with the melodrama and comedy of common life, that is, of life in the ranks, as in Charlet's lithographs. Napoleon's death is borrowed directly from the Porte-St.-Martin: "*The Chamber of the just expired Monarch must offer the exact representation of Steuben's picture—Two black curtains slowly draw together, and close in the picture.*"[31] The succeeding apotheosis, however, draws on other sources.

The French play at the Porte-St.-Martin was one of several to join its apotheosis to the repatriation of Napoleon's ashes, a consummation Louis Philippe would put off for as long as he could, or about ten years. The English play—omitting a vigorous condemnation of Sir Hudson Lowe, Napoleon's custodian—has its two black curtains unclose to show the "*Valley of Geranium*" on St. Helena, and the procession to the open grave for the interment. "*The sky is dark, but as the Characters in front, kneel at the Grave, suddenly the Horizon is seen to clear, and the clouds dividing show the celebrated Apotheosis of Horace*

87. (facing page, top) *Pierre Gautherot*, Napoleon Wounded before Ratisbonne *(1810)*, *lithograph by C. Motte as* Bataille de Ratisbonne, *Paris, Bibliothèque Nationale.*

88. (facing page, bottom) *Carl von Steuben*, The Death of Napoleon *(1830)*, *formerly collection of Peter Claas, London.*

89. (above) *Horace Vernet*, The Apotheosis of Napoleon *(1821)*, *London, The Wallace Collection.*

[31] L.C. MSS Add. 42905, f. 475. Licensed 21 Dec. 1830, produced 21 May 1831, and so (as the playbill reports) "a long time in preparation."

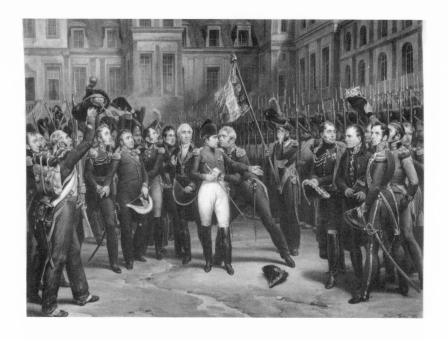

90. *Horace Vernet*, Les Adieux de Fontainbleau *(1825), engraving by J.-P.-M. Jazet (1829), London, British Museum.*

Vernet. Napoleon, his head uncovered—his Air calm and proud—stands out a prominent transparency in the magic picture. THE CURTAIN FALLS."
Vernet's *Apotheosis*, painted in 1821 (the year of Napoleon's death), informs the scene with two appealing contemporary motifs, the shipwreck of human hopes and achievements on the barren promontory of this world, and the ghostly fellowship of heroic patriotism beyond.

The Surrey *Napoleon* was anticipated by a few days at Covent Garden by a comprehensive "Grand Historical and Military Spectacle" in the manner of *L'Empereur*, called *Napoleon Buonaparte, Captain of Artillery, General and First Consul, Emperor and Exile*, by M. Rophino Lacy. It also concluded with what the playbill, and the special program supplying chronological links between the episodes, called "The Apotheosis of Napoleon. From Horace Vernet's Celebrated Picture." In addition it included, "in living representation," Vernet's *Adieux de Fontainbleau*, Napoleon's farewell to his soldiers;[32] and David's *Passage du Grand-Saint-Bernard*. Both the critic in the *Times* (17 May 1831) and Leigh Hunt in the *Tatler* made a special point of the last image; and Hunt, in keeping with his politics, found the production and reception of the piece "a curious sign of the times, and *a great credit to them*." The times, in fact, had just seen the election of the Reform Bill Parliament, and the country stood expectant and militant, at least in its slogans. King William, however, was relatively popular for his action in April to dissolve the previous parliament, where the Bill had been checked. Meanwhile, Europe bloomed with hopeful liberal and national revolutions and new constitutions. Hunt notes the omission of Waterloo in the play, and the radical delight of the audience when Napoleon humbles the Austrian emperor:

The Castlereagh times are evidently clean gone out of favour, to the very last spark. It was plainly enough signified last night, that the audience had no sort of respect for legitimate despots of any

[32] *Programme of the New Grand Historical Military Spectacle (in Seven Parts), Called Napoleon Buonaparte . . .* (London, 1831).

sort, or for any of their footmen, *high* or low. Justice was done to King William, at the end of the piece, by a call for "God Save the King;" and justice was done, *during* the piece, to what was really admirable, or pardonable, or pitiable, in the life and adventures of the wonderful man who was the subject [of] it,—*with this special momento by the way*,—that when somebody in the dialogue said, that *if he had fought for liberty always as he did at first,* he would never have been conquered, *there was an enthusiastic reception of this sentiment*; a circumstance which completed the interest of the performance. . . .[33]

As further evidence of the change, Hunt later reported that as of 2 June "not less than *five* dramatic pieces" with Napoleon as hero were on the English stage.[34]

Not all English critics found the Covent Garden play politically or aesthetically gratifying, despite its popular success and its self-conscious historicism. (The *Programme* asserted, "The Costumes actually worn by Napoleon and the Principals of his Staff, have been brought from France.") The *Examiner* described the play, sourly but shrewdly, as "some dozen detached and well-known anecdotes, and about as many situations closely copied from pictures, which every one has, or may have, seen in the print-shops."[35] And later the *Atlas*, to emphasize the virtues of the Jerrold-Wilkie *Rent Day*, declared that the ordinary prints gave a better notion of what the original Napoleon paintings looked like, and that "Napoleon was got up at immense expense, as if to teach us how a fine picture could be spoiled by making its frame a proscenium."[36]

All in all, the Napoleonic season was a mixed success in England, and though battle spectacle and military drama remained a staple of the popular theater through the century, its heroes were more likely to be named Dick than Napoleon, Marlborough, or Cromwell; and its scene was more likely to be the present-day Crimea or garrison India than either Agincourt or Waterloo. The Great Man as an embodiment of the national *gloire*, the notion of history as an expression of the masterful will, appealed very little to the English audience; and during this great imperialist and expansionist age, even the splendid revivals of *Henry V* (by Macready and Charles Kean) were innocent of such interpretation. Rather, the interest in historical figures was overwhelmingly private and domestic: in Alfred the Great in the neatherd's cottage; Richard the Lionhearted in prison, found by song; Henry II and Fair Rosamond; Charles I as a family man. The same preferences ruled in painting, though some painters of large ambition spent themselves trying to make it otherwise.

In France, the Napoleonic epic continued in full spate for a longer time, though modified by external events and fresh perceptions. In contrast to England's view of its presence overseas, France's modern imperialist venture, especially in North Africa, was not popularly regarded as essentially commercial and missionary, politically liberating for the natives, and only in a residual "protective" sense military.[37] In France, the new imperialism was trumpeted as the successor of the old, and therefore as the expression of the national *gloire militaire*. Vernet moved directly from supplying the "Gallery of Battles" to ful-

[33] *Tatler* 2 (17 May 1831), p. 875.

[34] Drury Lane, competing feebly, put *The Little Corporal; or, The School of Brienne* into the bill (from a French original), with Miss Pool as the budding hero; then (8 June) tried the attraction of a "Tableau Vivans, Suggested by and illustrating A. Scheffer's beautiful print, called the SOLDIER'S WIDOW," followed by a version of *The Battle of Waterloo*. Astley's added a successful *Napoleon Buonaparte* to its program, but had in fact responded earlier to the July Revolution with a revived *Battle of Waterloo*, "curtailed exceedingly of its fair proportions" and apparently in the wrong mood. The *Spectator* was quick to rub it in: "It is proper, no doubt, that the scenic splendour of that glorious carnage should abate in some proportion to the decreased estimation in which the actual victory is held. 'What good came of it at last?' said little Peterkin. The tricolour flag was levelled in the dust—it has risen again in double glory: a military despotism was defeated—a dozen civil tyrannies were substituted: the Bourbons were restored to the thrones of their ancestors—another of the race is an exiled fugitive: the wrongs of the French Revolution were avenged—the French again are pointing the road to liberty. What then have we gained by all the expenditure of blood and treasure, by all the intrigues, by all the policy, of which this victory was hailed the consummation?—About four hundred millions of debt. Mr. DU-CROW is quite right in spending no more money on the *Battle of Waterloo*." *Spectator* 3 (11 Sept. 1830), p. 707.

[35] *Examiner* (22 May 1831), p. 325.

[36] *Atlas* 7 (29 Jan. 1832), p. 74.

[37] Nevertheless, a school of military genre painters prospered in England, along with military and imperialist melodrama of a topical cast. Among the school were Talbot Kelly, Richard Caton Woodville, and Miss Elizabeth Thompson, later Lady Butler, whose *Roll Call* had to be specially guarded at the Royal Academy in 1874, and whose *Twenty-Eighth Regiment at Quatre Bras* Ruskin notices as the chief popular attraction at the Academy in 1875. What the school avoids is epic and historical pretension; its style has affinities with that of the *Illustrated London News*.

91. (facing page, top) *Auguste Raffet*, Vive l'Empereur! ! ! Lutzen 1813 *(1834), Baltimore Museum of Art, George A. Lucas Collection.*

92. (facing page, bottom) *Auguste Raffet*, The Nocturnal Review *(1836), Baltimore Museum of Art, George A. Lucas Collection.*

[38] Théophile Gautier, *Histoire de l'art dramatique en France depuis vingt-cinq ans* (Paris, 1858-1859), 4:317 (17 Aug. 1846). Vernet's painting (now at Versailles) was the dinosaur of the Salon of 1845. The canvas—according to the museum catalogue (1931)—is over twenty-one meters long, or about seventy feet. The maximum opening of the stage at Astley's, "the largest and one of the best equipped stages in England" according to Saxon, *Enter Foot and Horse*, was sixty feet. An earlier biographer reports what he calls a frequent but baseless criticism of the painting: that Vernet erred in not unifying his composition by creating a central point of interest to which the various episodes of the combat could attach themselves. This reproach seems just, he says, when looking at the engraving or a reduced copy of the painting, where the eye can take in the whole scene; but not before the painting itself, where Vernet's intentions become clear. The painting is made to be seen in segments, without such a central focus: "C'est une sorte de panorama qui se déroule devant nous à mesure que nous avançons, et il faudrait prendre une trop grande reculée pour en embrasser tous les détails dans un même coup d'oeil" (Amédée Durande, *Joseph, Carle et Horace Vernet, correspondance et biographies*, Paris, 1863, p. 281). Apparently the heroless panoramic mode could fully assert itself in the Bourgeois Monarchy, in the absence of any convincing representative of the heroic will.

[39] Gautier, *Histoire*, 4:49 (17 Feb. 1845).

[40] Ibid., 2:37-38 (9 Mar. 1840). The latter effect was repeated in *L'Empire* (1845), and had its likely source in Raffet's lithograph.

filling the king's commission for a series of vast machines, also for Versailles, to decorate the "Constantine Hall," wherein the taking of that African town in October 1837 would be immortalized. The theaters, and especially the Cirque Olympique, lost no time in celebrating such events, as in *La Prise de Constantine* (4 Nov. 1837), and *Mazagran, ou 123 contre 12,000* (1840, in four different versions). Later the theaters could celebrate the commemorative paintings. Gautier reported, three years after the historical event, that "for a glorious finish to the season," Franconi and his collaborators were preparing "the taking of the *smala* of Abd-el-Kader, where the principal incidents of Horace Vernet's painting will be reproduced, and two authentic camels featured."[38] The felt continuity between the two phases of the national glory was neatly summed up in Ferdinand Laloue and Fabrice Labrousse's *L'Empire* (1845) at the Cirque Olympique. In the obligatory apotheosis, Napoleon, crowned with laurel, appears "in a sort of pantheon peopled with heroes, in the midst of his brave companions in arms." There, at the sound of canon in the distance, Napoleon announces, "A new victory is in the making for the tricolor flag! Let us go and applaud these conquerors." The backdrop vanishes and reveals "—what?—The battle of Isly [1844] and the parasol of Abd-er-Rahman!"[39]

Not all of France was united behind the African venture (whose first notable success occurred, in fact, just a few days before the July Revolution), and not all of France was pleased at the steady submergence, once more, of the political ideals of the Revolution in those of Empire. By 1840, the expansionist nationalism that Louis Philippe rather nervously exploited was shadowed even at the Cirque, perhaps in response to the formidable rising of Abd-el-Kader. In reviewing *La Ferme de Montmirail* of Laloue and Labrousse, Gautier pointed out that heretofore the Cirque had always represented the French as victors; but now it had ventured to stage the *deroute* from Moscow, "that grand expiation of the pride of the Empire." The play was subtitled *Episode de 1812 à 1814*, and its chief effect came through an embodiment of Charlet's painting (Fig. 84), whose successful translation onto the stage Gautier greatly admired: "It is a sad and solemn spectacle, this interminable white plain where the cadavers of men and horses mark out the route, this limitless horizon where, from time to time, troops of Cossacks pass like swarms of grasshoppers, bent over the necks of their horses. One sees there the seamy side of glory." Something is left, however. Gautier describes how the column of soldiers, collapsed with cold and fatigue, not even roused by the approach of the enemy, becomes aware of the silhouette of a figure on a white horse, with a little hat and grey coat; and the sick, wounded, and freezing, "all that miserable mob in rags which is no longer even the ghost of an army, contracting with a galvanic movement of enthusiasm, stands on its frozen feet, waves its dead hands and cries, 'The Emperor! The Emperor! Vive the Emperor!' and resumes its march."[40]

Charlet's painting was re-created also, with striking effect, in Laloue and Labrousse's *Le Prince Eugène et l'Impératrice Joséphine* (1842), an anthology of brilliantly realized images, to judge by Gautier's report. The terminal "suite of apotheoses" included David's great *Sacre*, made

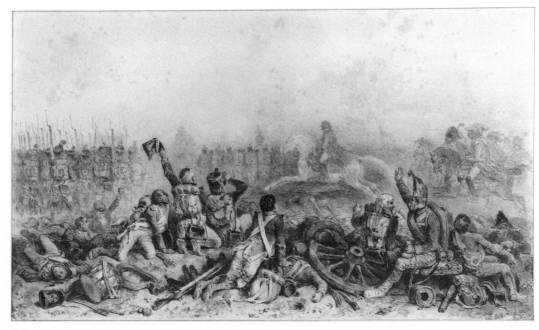

91

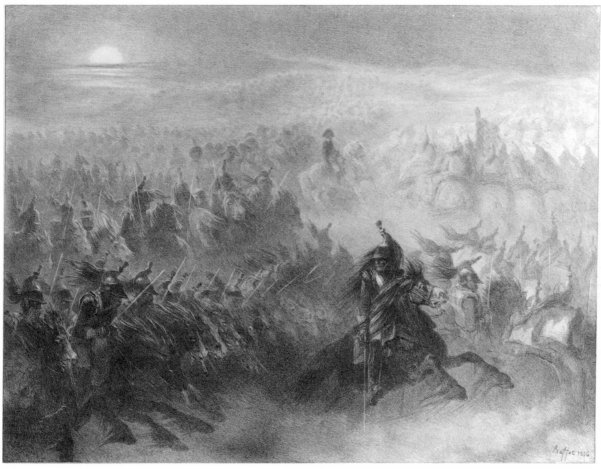

92

vaporous and hallucinatory, and Raffet's extraordinary lithograph of the ghostly form of the Imperial legacy, *La Revue nocturne* (1836).

> After a bloody sunset behind the Arc of Triumph, the planet of the dead rises in the bluish mist, where the shapes of men and horses begin to form. The squadrons stir, helmets glitter, swords flash, eyes gleam under visors, and the Emperor appears on his pale courser, silvered by the moon.[41]

The final tableau, the apotheosis proper, of a splendor "truly magical," shows the emperor, Josephine, and Prince Eugène in a glittering architectural paradise of the elect and heroic.

Every piece at the Cirque Olympique, Gautier pointed out, ends with an apotheosis, where the heroes are promoted to godhead. But in the early forties, in the face of an insinuating skepticism and disillusionment with current enterprises, the apotheoses became more complex and elaborate, as if in wishful compensation. The apotheosis in *Murat* (1841), for example, follows Murat's voyage into darkness, in Charon's boat, with a vision of the death of Napoleon, a "complete reproduction" of Jazet's aquatint after Steuben; which gives way in turn to a scene recalling Girodet's Ossianic *Apotheosis of the French Heroes who Died for the Fatherland during the War of Liberty* (1802), painted for Napoleon's Malmaison. In Gautier's excited description of the final vision—where Napoleon replaces Ossian—the clouds withdraw to reveal:

> . . . a sort of warrior paradise, a universal Valhalla, where are assembled all the *gloires militaires*: Alexander with his golden breastplate, Caesar crowned with laurels, Bayard in his medieval armor, Frederick the Great with his top boots and Prussian pigtail, Attila all hairy and bristling, the complete general staff of scourges of God and illustrious killers, with Napoleon at their head. The whole is piled up in a Babylon of triumphal arches and memorial trophies bathed in dazzling light. Murat, transfigured and cured of his Pizzo wounds, advances toward the emperor, who receives him in his arms through a deluge of Bengal lights, as is the custom in all apotheoses worthy the name.[42]

At the time of these apotheoses, the ashes of Napoleon had at last been conveyed triumphantly to France (1840), but the present Bonapartist claimant was confined for life for attempting his own *retour d'Elbe* (also 1840). At his trial he had appealed to the still disregarded "supremacy of the people," and he would cultivate that slogan through the Revolution of 1848, only changing his tune thereafter. A reverberation of that revolution and its aftermath may be found in the second installment of Dumas *père*'s dramatic contribution to the Napoleonic epic, *La Barrière Clichy* (21 Apr. 1851), produced in the Théâtre National, *ancien* Cirque Olympique. In January 1851, President Louis Napoleon Bonaparte had begun the overt moves that would lead to his coup at the year's end, followed by Dumas' flight. The title of Dumas' play refers to a crowning tableau, realizing Horace Vernet's much reproduced painting of 1820. Vernet had completed the painting before he became the official painter of any regime, and it had populist

[41] Ibid., 2:311-13 (20 Dec. 1842). The lithograph (1836) illustrates verses from a ballad of the same title, reportedly translated from German by its Hungarian author, M. Sedlitz. The poem begins:

> C'est là la grande revue
> Qu'aux Champs-Elysées,
> À l'heure de Minuit,
> Tient César décédé.

The ballad, "une espèce de songe, d'évocation tout-à-fait dans le genre germanique," first appeared in France in the notes to *Le Fils de l'homme; ou, souvenirs de Vienne* (Paris, 1829), pp. 39-42, by Auguste Barthélemy and Joseph Méry, prime promoters of the Napoleonic myth.

[42] Gautier, *Histoire*, 2:178-79 (8 Nov. 1841).

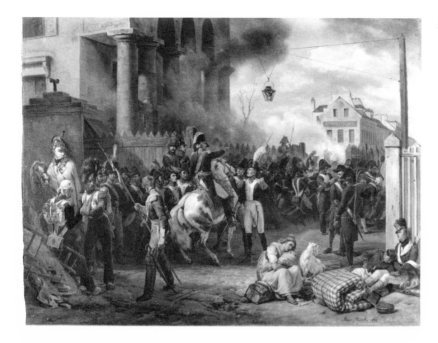

93. *Horace Vernet*, Defense of Paris, 30 March 1814 *(1820), Paris, Louvre (cliché des Musées Nationaux).*

and libertarian as well as nationalist associations. Its subject was the last-ditch defense of Paris and its people against the invading allies of 1814 by a force of National Guardsmen, invalids, and youngsters from the schools, among them the young Charlet. In the play, Dumas puts libertarian sentiments in Napoleon's mouth (on the grounds that the theater is not, after all, a *cours d'histoire*, but "a tribune through which the poet spreads and propagates his own ideas").[43] The visual climax brings both Dumas and Vernet back to a starting point, a perception of another and better relation between the national and the popular than prevailed in the long intervals between intoxicating moments of promise in the cyclical revolutions of modern history.

Stage Crowds (a Postscript)

A stage crowd is not simply a matter of numbers, for stage processions and balletic displays (in Pantomime, for example) might involve large numbers and not be seen as crowds, whereas two or three or half a dozen in Shakespeare might perfectly well represent public opinion, or the fickle multitude. A history of stage crowds would doubtless also be a history of political ideals, and reflect social and institutional structures quite apart from the theater. So it is that a glance at the organization and character of stage crowds in the nineteenth century encounters the dialectic between the mass of men and heroic individuality so important in various other departments of life. Eventually (as I shall suggest) the theater arrives near the end of the century, not at a resolution, but at an illusion that unites, once more, the hero and the crowd, and the individuality of the members of the crowd with a participation in multitude.

There is a distinction to be made between the dramatic character of

[43] *Théâtre complet de Alexandre Dumas,* 18: end note.

a stage crowd—its action or passion and its representative attributes—and the theatrical management of a stage crowd—its organization and its role in the dynamics of performance. Both aspects are pertinent.

Two of the most original characterizations of the stage crowd in the post-Napoleonic era never reached the stage in the authors' lifetimes. Pushkin's *Boris Godunov* (written 1824/25, published 1830) and Büchner's *Danton's Death* (1835) both create crowds in revolutionary circumstances. Pushkin's crowd is remarkable in its unconsciousness; Büchner's bloodthirsty, victimized, self-burlesquing mob is remarkable in its self-consciousness, its awareness of a role and character to sustain, an ideal image of itself drawn from the heroic republican past. Pushkin's play is also remarkable for the dramaturgy that shows the crowd—a collection of individuals, some cynical, some self-absorbed—*becoming* a single sentient expressive entity as it is caught up in the wave of a mass emotion (scene 3). Schiller had dramatized the diversity of an army in *Wallenstein's Camp* (1798), and unified and ennobled a populace in its patriotic revolutionary character in *William Tell* (1804); but he never achieved so striking and subtle a conception of the phenomenon of the mass as that in Pushkin's *Boris*.

Schiller, however, *was* much produced, and his crowd scenes required an innovative staging that affected operatic form and operatic styles of production. French grand opera was a creation of this period, and the crowd had a prominent role and a problematical but strongly marked character in the action of most of Meyerbeer's great machines, climaxing in *Le Prophète* (1841; on John of Leyden and the Anabaptist revolt). Scribe was Meyerbeer's principal librettist, and Scribe had a hand also (with Delavigne) in Auber's earlier landmark opera, *La Muette de Portici* (1828). Auber's opera, based on historical events of 1647, presents a popular nationalist revolution in Naples led by the fisherman Masaniello (Tomaso Aniello). When performed in Brussels in August 1830, a few weeks after the stirring events in France, its sentiments set off the Belgian revolution that resulted in the modern independent state. There were numerous English adaptations, as opera, ballet, burlesque, and "Musical Drama." In the last of these, for the unruly lower-class clientele of the Coburg Theatre (1829), the revolution goes out of control, and Masaniello, shot down by his own followers, abuses the mob from the point of view of a singular and egregious virtue:

> From you, from you Tomaso meets his death; and it is well, for he was mad enough to think that liberty could take into her ranks those whose abject souls stamps them eternally slaves. Your freedom is debauchery, plunder, and murder; your justice, petty and remorseless vengeance; your very vital air is crime; your portion menial drudgery; the curse of your own vices be upon you, for never can fair liberty unfold her banner, but where bright virtue stands to uphold the sacred standard, armed with the radiant blade of justice to defend it.[44]

No doubt the Coburg audience endorsed this view of the multitude, inasmuch as it applied to a ragged horde of foreigners remote from the shores of virtue. The hero's view of himself, betrayed and isolated in

[44] H. M. Milner, *Masaniello; or, The Dumb Girl of Portici* (London: Davidson, n.d.), Act III.

the failure of the common heroic enterprise, belongs to an age of after-math.

THE MANAGEMENT of stage crowds through the century is at least as revealing as their dramatic character and function, though in the end these matters interpenetrate. Stage crowds in the nineteenth century were for the most part casually hired and outfitted, like extras in the movies or operatic spear-carriers. Composed of "supernumeraries," they represented numbers and little else. In opera, choruses were not asked to do more than sing and perhaps form part of a picture. The modern history of the management of stage crowds therefore may be said to begin with the drilled and programmed maneuvers of the nineteenth-century military spectacles, and it was continued by a line of powerful actor-managers concerned almost equally with pictorial values and realistic, as opposed to symbolic, representation. The result of such ambitions was sometimes archaeological, opening a historical distance between the audience and the work; and sometimes topical, fitting a modern perception and experience of historical reality to the work. Macready's *Coriolanus*, as responsive to current myth and current concerns as any circus spectacle, is a case in point.

Macready's *Coriolanus* appeared in the restless year that produced the People's Charter (1838), and one year after Carlyle's *French Revolution*. It was brought to the stage by a man of profoundly bourgeois temperament and ideology, with an extraordinary personal ambivalence about the crowds that gave him his living and necessary applause. The more simply conservative *John Bull* wrote of the mounting of the play, and especially Macready's Roman crowd in the opening scene:

> When the stage becomes animated with a seeming countless mob of barbarians, armed with staves, mattocks, hatchets, pickaxes, and their wrongs, we become sensible that it is not a mere coward crowd before us, but the onward and increasing wave . . . of men who have spied their way to equal franchises, and are determined to fight their way to the goal. There is no mistaking the struggle for power that has begun. It is not noble against serf, but against freeman. . . . But it is not with the acting of one or two parts that we now have to do. A whole people are summoned up, and a drama instinct with their life rolls its changes o'er the scene.[45]

Nineteenth-century England took the analogy of Rome unto itself; and this "tide of human existence poured upon the stage" is in fact a French Revolutionary crowd adapted to English issues (the franchise) and self-conceptions. The crowd is certainly not Shakespeare's; and its transformation gives a nineteenth-century focus and immediacy to the play as a whole, as the dramatized encounter of the politics of heroism with the politics of popular democracy.

The crowd appears again after the war scenes, "on the hero's return, crowned with the oaken garland." The stage "is filled with crowds of all classes, with laurel boughs in their upraised hands; the walls and battlements are lined with spectators." The staging now presents a people ordered for the moment, and fixed pictorially, by its focus on a hero. The two states of the crowd, animated and pictorialized, are

[45] *John Bull* (19 Mar. 1838), quoted in George C. Odell, *Shakespeare from Betterton to Irving* (New York, 1920), 2:212-13. Odell's history of Shakespearean performance contains a scattered history of the stage crowd.

in the strongest contrast, though both are spectacular. Neither is entirely satisfactory; and, in the play, the government of heroes soon proves as unwholesome a prospect as the government of mobs.

In Macready's theater, "the supernumeraries were directed with as painstaking care as the principals," a notable innovation in legitimate drama, where the principals themselves were often known to surprise each other at performance. Macready's managerial practice "directed the attention of his successors in England and his disciples in Germany to the dramatic potential of the theatrical mob"—dramatic rather than merely pictorial, and so capable of interacting with the principals of a scene, and of contributing to the progressive structure of tensions and resolutions. But on the evidence of the promptbooks, Macready's crowds frequently acted and reacted more or less as one, with a stylized uniformity, subject to "general movements" and uniform starts of surprise or joy.[46] When the Duke of Saxe-Meiningen took up the lesson of Macready from Samuel Phelps and Charles Kean, he gave his amazing crowds a diversity in their unity, a variety and individuality that was nevertheless integrated in an encompassing effect and a controlling idea of the whole.[47] The Meininger troupe's crowds of individuals greatly impressed the English on its momentous visit in 1881, and affected the practice of such actor-managers as Henry Irving and, later, Herbert Beerbohm Tree. There was a notable difference, however, between German and English practice. For while the organizing and controlling will (the Duke's) in a Meininger performance effaced itself, leaving an illusion of spontaneous diversity and organic purpose in the crowd, the great actor-manager was by definition both the visible mark for all eyes, and a heroic will extending through a vast and cumbrous organization. In their theaters, the likes of Irving and Tree were both high priest and visible god, the heroes of every occasion; and theaters and productions were designed to magnify their impact. The incorporation of the coherent diversity and purposeful energy of the heroless Meininger crowds into the theaters of the great actor-managers repeated, in the house of illusion, the experience of history.

It did not escape some of the spectators, notably Tolstoy, Shaw, and Napoleon Bonaparte himself, that the heroic will on the stage of history, the historical Man of Destiny, was also an actor-manager, for whom the arts, theatrical and pictorial, were prime instruments for the creation of a satisfactory heroic persona, and its promotion into glory.

[46] See Alan S. Downer, *The Eminent Tragedian, William Charles Macready* (Cambridge, Mass., 1966), pp. 242-46.

[47] Downer, *Macready*, pp. 252, 352, and Muriel St. Clare Byrne, "Charles Kean and the Meininger Myth," *Theatre Research* 3 (1964): 137-53. See also Antoine's shrewd and ample letter to Sarcey on the Meininger crowds (23 July 1888) in André Antoine's *Memories of the Théâtre-Libre*, trans. Marvin A. Carlson, ed. H. D. Albright (Coral Gables, Fla., 1964), pp. 80-86.

12

ROYAL SITUATIONS

ITTLE ARTHUR's history, as Shaw called the genre,[1] anecdotal, familiar, and scaled to domestic requirements, gave more opportunity to the storytellers in paint and words in the nineteenth century than did the dialectic of the hero and the crowd. To forego heroic action and panoramic spectacle, however, did not mean relinquishing the art of effect. Indeed, in the inherited Gothic tradition, which depended upon the trappings of exoticism and in turn colored much historical representation, history was nothing if not effect. But at the same time, in the shifting experience of artists and audiences in the nineteenth century, another impulse was at work. Once a moment in the past could be perceived as history, through lapse of time, change of circumstance, or present events; once difference and distance took on substance, they straightway induced the necessity of refamiliarization. One could be comfortable with the past and with the great, and learn from them, if it appeared, *mutatis mutandis*, they were much like us; and that meant in the nineteenth century if they were largely preoccupied with familiar moral and emotional concerns. The selection and humanization of the great symbolic figures and the lesser attendants on the scene made for a style of historical representation at once personal and situational, elaborately individuated and broadly accessible. Exoticism could be found in the accurately rendered material details, costume, and decor; familiarity in the readable human situation.

The refamiliarization of history had urgency in an atmosphere of increasing analytical historicism and accelerated change. It meant reconnecting the past to the present; it meant also making the unexpected present familiar. Such affective refamiliarization is probably no less respectable than reinterpreting the past in the light of newly acquired intellectual schemata, or rewriting it in the light of present political and social developments. Certainly the most successful historical representations in the nineteenth century were those that did most to bring the past and the present to bear upon each other, even antithetically. In a sense, the refamiliarization of the past in the art of the nineteenth century fits the classic account of the function of dreaming: a process of assimilating the strange to the familiar, of integrating the

[1] After Maria Callcott's *Little Arthur's History of England* (1835).

[229]

old and the new, of eliminating anxiety. It took a peculiar genius like Kleist in his play *Penthesilea* (1808) to embody a world in which historical differences create unbridgeable distances, absolute barriers to mutual translation between equally human groups and individuals; and Kleist found it difficult to live with that knowledge.[2]

The discussion that follows attempts to look at some examples of the more personal and familiar range of historical representation so typical of the nineteenth century, with an eye to the uses of the past by the present. The examples, though few, range from the momentous and moderately durable in the case of Delaroche's *Cromwell and Charles I*, to the patently insipid in the case of Fradelle's *Mary, Queen of Scots*. All exploit the past, but there are qualitative differences in the exploitations, based partly on immediate circumstances, partly on the available tradition. Differences in using anecdotal situations in painting or literature to penetrate historical character and define historical relationships may be judged as intellectual differences. I would argue that differences in framing historical issues for present contemplation are also aesthetic differences.

I begin with two French paintings from English history that provide a contrast between an intimately conceived historical scene used to give form to the present (Delaroche's *Cromwell*), and one used to give form to the private world of nightmare (the same painter's *Children of Edward IV*). Both these paintings entered into a complex interplay with other forms of representation, and with cultural and political concerns both in and out of their original milieu. Therefore, after locating these paintings on English subjects at home, in France, I follow one of them abroad, to England; and in a second phase of the discussion, attempt to show how, in such a complex interplay, situational and domesticated versions of history served to ritualize partisan issues. Finally, the entire enterprise of illustrating history is set in the dim light of Fradelle's example of the vast class of works treating history as costume and sentiment and nothing more. The intent is not to eclipse the previous examples, but to set off their advantages.

English History and French Politics

In the France of Charles X, things English had a prominent place in aesthetic controversy, which was often highly politicized. It was especially the Romantic innovators who were interested in English models and subjects—Delacroix, Hugo, Dumas, Vigny, Berlioz. In 1830, English history became charged—not for the first time—with topical political applications, by virtue of France's liberal revolution. The Salon of 1831 celebrated that revolution in an appropriate manner, which included the manner of Hippolyte Paul Delaroche.

Delaroche (Horace Vernet's son-in-law) was a prudent man in art and politics, but managed a sensation in both areas. The first Salon since the July Revolution exhibited over forty canvases inspired by those events, including Delacroix's *July 28: Liberty Leading the People*.[3] Delaroche contributed four historical canvases, two on French subjects, two on English. All four paid due attention to setting and costume, the material detail, but put their strongest emphasis on psychology

[2] The pioneering serious investigation of the uses of anecdotal historical painting in the nineteenth century is Roy Strong's *And When Did You Last See Your Father? The Victorian Painter and British History* (London, 1978); and Strong's watchword for the recovery of that period's historical iconography is Thomas Buckle's dictum, "There must always be a connexion between the way in which men contemplate the past, and the way in which they contemplate the present; both views being in fact different forms of the same habits of thought" (from *The History of Civilisation in England*; Strong, pp. 45, 75). The present chapter may be read as a supplement to Strong's study since we are often concerned with the same images, though in my case the selection was guided by the fact of theatrical realizations.

[3] Heinrich Heine, "The Salon of 1831," in *Heine in Art and Letters*, trans. Elizabeth Sharp (London, 1895), p. 44. Later counts (by title) give different figures.

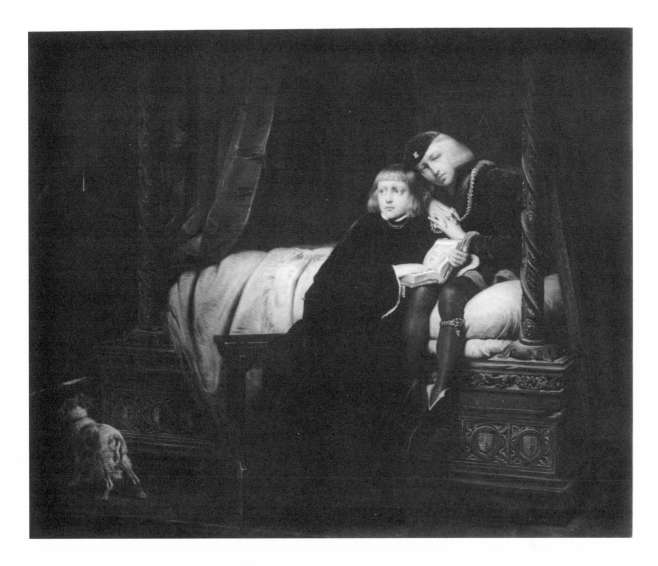

and situation. The result was historical painting as a hybrid form of
narrative and genre painting, rather than what the earlier Revolution
and Empire had made it, the epic vehicle of a national iconography.
The artistic caution of Delaroche, his dispostion to trade off elements,
in a painting and between paintings, appeared in a curious cross-
relation between scale and subject. The two French scenes—showing
Richelieu in his barge towing Cinq-Mars and de Thou to execution
(as in Vigny's historical novel of 1826, *Cinq-Mars*), and Mazarin on
his court-surrounded deathbed—are full of figures and elaborate decor,
and have a relatively dispersed interest, but are quite small; in Heine's
phrase, "almost like what are called cabinet pictures." The two English
scenes reverse this relationship. These, *The Children of Edward IV*,
showing the Yorkist princes in the Tower, and *Cromwell and Charles
I*, showing the Protector contemplating his dead antagonist, are limited
to two figures in a confined setting with an intensely focused interest,
but are painted life-size. Any epic pretension is here neutralized by
the eclectic relation of scale and intimacy. The latter two paintings,

94. *Paul Delaroche*, The Children of
Edward IV *(1831)*, *London, The
Wallace Collection.*

however, because they are so charged with "effect" and their focus is both so personal and situational, accord very well with the contemporary development of an historical *drame*.[4]

From a political point of view, Delaroche's response to the moment was as carefully hedged as his double compromise between genre and history painting. For one thing, he uses the indirection of historical and geographic displacement (in contrast to the directness of Delacroix's barricades). Nevertheless, perhaps to the painter's consternation, his English *Cromwell* impressed contemporaries with its topical daring. Heine expressed a common view in his analysis of the painting's political and philosophical implications: "It cannot be denied that in exhibiting this picture, Delaroche seems to have had the intention to challenge historical parallels. If one begins with a parallel between Louis XVI and Charles I, one naturally proceeds to draw another between Cromwell and Napoleon."[5] The parallel extends further, to the two Restoration periods, English and French, and their revolutionary terminations. But then the parallel redoubles; for Louis Philippe in 1830 put himself in the very position with respect to the elder branch of the Bourbons previously occupied by Napoleon as emperor, and by his own father, Philippe Égalité, who voted for the death of Louis XVI. The whole series appeared to be condensed in the depicted relation of Cromwell to Charles I.

The painter further hedged his daring in providing the occasion for such comparisons by the psychological ambiguity of the pictorial situation: a *scène à faire* where spectators could read both sorrow and triumphant ambition in Cromwell, both martyrdom and quixotic stubbornness in Charles. But while such considerations provided the psychological and intellectual interest in a reading of the painting, they failed to soften the impact, which came as immediate "effect." The effect was in the ragged red wound across the throat of the livid corpse, whose exposure was a second, ocular violation. The painting itself, in the face of taboo, made the viewer a participant in king-killing.

If the effect was greater than Delaroche expected, that may have been because the painting evoked a number of established pictorial configurations, among them the pious tribute of hero and conqueror, not just to a fallen enemy, but to a predecessor and rival in glory. Alexander had visited "la famosa tomba del fero Achille"; Augustus put a hand to the mummy of Alexander; Scott (in a painting attributed to Wilkie) is shown visiting the tomb of Shakespeare; and the Emperor Charles V in *Hernani*, the most notorious representative of the new historical drama, finds his nobility and empire at the tomb of Charlemagne.[6]

The famous battle in the theater over Victor Hugo's *Hernani* commenced in February 1830, five months before the July Revolution. In the doubly monumental fourth act, Don Carlos, who is waiting for word from the Electors of the Holy Roman Empire and for an assassination conspiracy to show its hand, visits the vault enclosing the tomb of Charlemagne at Aix-la-Chapelle. As the first scene ends, "*Don Carlos, left alone, falls into a profound reverie. His arms cross, his head sinks upon his breast; then he comes to himself and turns toward the tomb.*" Alone, he addresses Charlemagne in a soliloquy of 178 lines, a

[4] The version of *The Children of Edward IV* (here reproduced) in the Wallace Collection is a reduction of that in the Louvre. The pillared and curtained bed and the stool are set on a platform more apparent in the original version, where it adds to the theatrical feeling. The original title in the Salon *livret* was *Edouard V. roi mineur d'Angleterre, et Richard, duc de Yorck, son frère puîné.*

[5] Heine, "The Salon of 1831," p. 72.

[6] Alexander and Achilles are cited from Petrarch, *Le Rime*, #187. *Scott at Shakespeare's Tomb* (sold at Sotheby's, 20 Nov. 1968, and catalogued as "Wilkie") shows an older Scott standing reverently before Shakespeare's bust, which he much resembles, as that sculpture looks down at him from the monument in Holy Trinity Church, Stratford. (Reproduced in Samuel Schoenbaum's *Shakespeare's Lives* [Oxford, 1970], where it is credited to Sir William Allan.) Scott kept a cast of the Stratford bust in the library at Abbotsford, in a niche and on a stand prominently marked "W.S." Thus no alteration was required when Shakespeare was displaced by Chantrey's noble bust of Scott after the latter's death.

The visit of Caesar Augustus to Alexander's remains in the city he founded took place, according to Dio Cassius, upon the defeat of Antony and the Egyptians and Caesar's emergence as "Sole sir o' the world." The historian's account throws light on the representation of Napoleon's visit to Frederick, discussed below: "The Egyptians and Alexandrians were all spared, and Caesar did not injure one of them. The truth was that he did not see fit to visit any extreme vengeance upon so great a people, who might prove very useful to the Romans in many ways. . . . The speech in which he proclaimed to them his pardon he spoke in Greek, so that they might understand him. After this he viewed the body of Alexander and also touched it, at which a piece of the nose, it is said, was crushed. But he would not go to see the remains of the Ptolemies, though the Alexandrians were extremely anxious to show them, for he said: 'I wanted to see a king, and not corpses.'" *Dio's Rome*, trans. Herbert Baldwin Forster (New York, 1906), 3:331-32 (Bk. 51, chap. 16).

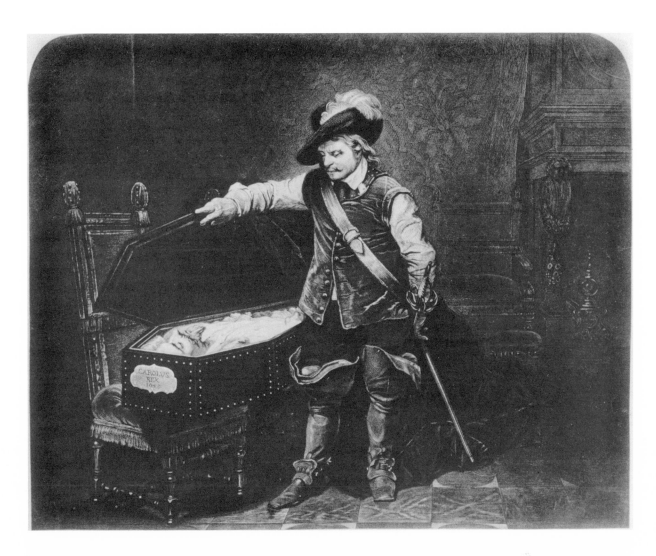

daring tour de force on government, kings, Empire, the restless sea of the people, with evocations of the late Napoleonic world. It is this sustained moment that provides the most memorable image of the play. Then Carlos enters the tomb itself, emerging to surprise and over-master the conspirators on the signal of his election. Finally he is left alone again, for a parting address to Charlemagne confirming what we have seen, the transformation of Carlos from erratic king to magisterial emperor.[7]

Napoleon exploited such monumental meetings, from the pyramids to Prussia, and his visit to the tomb of Frederick the Great was com-memorated in art. In a contemporary print (after a design by Heinrich Dähling), Napoleon stands contemplative and apart, spurred leg ad-vanced and in some versions with hand on Frederick's sarcophagus (by way of brotherhood perhaps), and thinking deep thoughts. Like Cromwell's imagined visit to Charles, Napoleon's visit to the dead hero-ruler had its crueler side, for it was an episode in the humiliation of Prussia. It signaled the mutability of glory and its succession, the ascendancy of the present over the past. In Delaroche's painting, Crom-

95. *After Paul Delaroche*, Cromwell and Charles I *(1831) unidentified engraving, rephotograph*.

[7] Victor Hugo, *Hernani*, ed. John E. Matzke (New York, 1891).

ROYAL SITUATIONS [233]

8 For the related deathbed scene so pervasive in late eighteenth- and early nineteenth-century art (Steuben's *Napoleon* is a late example) see Robert Rosenblum, *Transformations in Late Eighteenth Century Art* (Princeton, 1967), pp. 28-39. The visibility of Charles in the coffin evokes this mode, though it operates ironically. Equally ironic is the relation to the motif of the pious widow—e.g. Andromache mourning over Hector's body or visiting his tomb (Rosenblum, pp. 39-48).

9 See Strong, *And When Did You Last . . .* , fig. 162. Strong finds the Christian parallel already present in the first painting, and the reference may have been intended; but if so, then the perceived historical analogies overwhelmed the religious associations, disturbing the political balance.

10 Richard Altick, *The Shows of London* (Cambridge, Mass., 1978), fig. 65, and p. 222: "The Duke was also a frequent visitor at Madame Tussaud's, where, seeing him contemplating the effigy of Napoleon, the Tussaud brothers commissioned Sir William Hayter [*sic*] to paint the scene. The picture, finished after Wellington's death, hung in the wax museum until it was destroyed in the fire that gutted the building in 1925."

11 François Guizot, *History of the English Revolution of 1640, Commonly Called the Great Rebellion: from the Accession of Charles I to His Death*, trans. William Hazlitt (New York, 1846), 1:455. Guizot cites only the dubious Mark Noble, who, however, had grace enough to hedge his own report: "Some say, that [Cromwell] went to feast his eyes upon the murdered king, put his fingers to the neck, to feel whether it was entirely severed, and viewing the inside of the body, observed how sound it was, and how well made for longevity. There was no excuse for this . . ." *Memoirs of the Protectorate-House of Cromwell* (Birmingham, 1784), 1:144n. The account in Chateaubriand's *Les Quatre Stuart* (1828), which Delaroche cites in the Salon catalogue, paraphrases Guizot, but characterizes Cromwell's emotion as "l'orgueil inexorable: il se délectoit dans la victoire par lui remportée sur un monarque et sur la nature" (*Oeuvres complètes*, ed. C. A. Sainte-Beuve [Paris, 1859-1861], 10:399). Delaroche, who had no reason to doubt the historicity of the event, changes this monstrous gloating to a neutral "contemplation": Cromwell "soulève le couvercle du cercueil pour contempler les restes de ce prince" (*Le Salon de 1831*, #2720). Chateaubriand also remarks on the interest generated by the discovery and opening of Charles's coffin in 1813. He calls it an extraordinary testimony, among other things, to the "enchaînement des événe-

well's disclosure of the freshly-killed, reassembled body of his antagonist and predecessor further compromises the configuration's pious associations.[8]

Six years later, as if to compensate for any misunderstanding, Delaroche exhibited a *Mocking of Charles I*, a conscientious translation of another traditional scene, and an unambiguous assertion of the Christlike condition of the martyr king.[9] The final irony in this system of associations came later still, in a painting derived from Delaroche's *Cromwell* with an indirect assist from Steuben's *Death of Napoleon*: Sir George Hayter's *The Duke of Wellington Visiting the Effigy and Personal Relics of Napoleon at Madame Tussaud's* (1852).[10] The engraving suggests a fine poignancy in the visit of the greying warrior, frock-coated but spurred, to the younger image of his defeated enemy, lying amid the trappings of an imperial blood and state; and it creates a fine contrast between the contemplative vigor of the duke, alive to the ends of his hair, and the preternatural clarity and stillness of the waxen corpse.

The confrontation between Cromwell and the dead Charles—or a death's-head reminder of him—had its own direct literary and dramatic predecessors, however, and indeed was something of an obligatory scene. So fitting was it felt to be, which is all that "obligatory" means in such contexts, that the notion that Cromwell had waked the coffin of the dead Charles entered the stream of orthodox history. Guizot must bear much of the responsibility, through framing the acccount in his *History of the English Revolution* (1826) without the cautious qualification it warranted: "The scaffold being cleared, the body was taken away: it was already enclosed in the coffin when Cromwell desired to see it; he looked at it attentively, and, raising the head, as if to make sure that it was indeed severed from the body; 'this,' he said, 'was a well-constituted frame, and which promised a long life.' "[11] In Walter Scott's novel of the same year, *Woodstock; or, The Cavalier* (1826), wherein Cromwell makes an appearance, the execution of the king is three years past; but Scott manages the confrontation in spite of that difficulty, in a scene where Cromwell unintentionally turns from the wall a portrait of Charles I, which he contemplates "with a strong yet stifled emotion . . . his dark and bold countenance, agitated by inward and indescribable feelings." Then Cromwell, "assuming a firm sternness of eye and manner, as one who compels himself to look on what some strong internal feeling renders painful and disgustful to him," proceeds as in soliloquy to praise the unfading power of Van Dyck's image and to repudiate the reproaches "of that cold, calm face, that proud yet complaining eye." With his feelings "swelling under recollection of the past and anticipation of the future," he declares the "stern necessity" and admits the "awful deed."[12] There is much in this description that might serve to gloss expression and situation in Paul Delaroche's subsequent painting.

Woodstock, translated into French in the year of its publication, simultaneously came upon the stage as melodrama. In England, in the principal version by Isaac Pocock, the scene with the portrait appears as in the novel, but compressed.[13] In Bourbon France, at least in the published form of the drama, Cromwell is kept off the stage entirely, while Prince Charles (though he has beaten the Parliamentarians) withdraws to find "in this lovely country a new homeland: France was

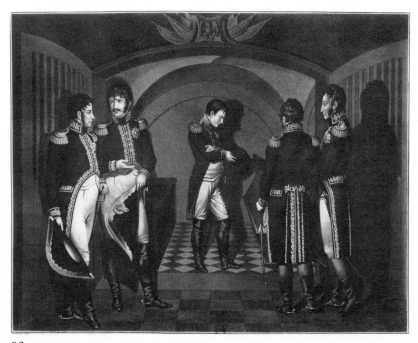

96

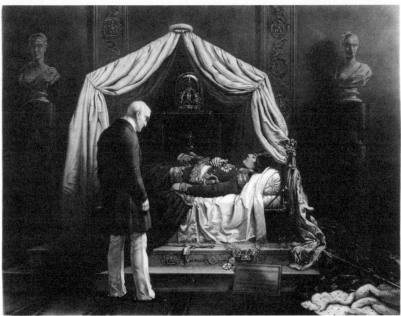

97

96. *Heinrich Dähling*, Napoleon I
Visits the Tomb of Frederick II,
25 October 1806, *engraving by
J. F. Jügel, Paris, Bibliothèque
Nationale.*

97. *George Hayter*, The Duke of
Wellington Visiting the Effigy
and Personal Relics of Napoleon
at Madame Tussaud's *(1852),
engraving by James Scott (1854),
London, Victoria & Albert Museum.*

ments et de la complicité du crime de
1649 avec celui de 1793." Guizot argues
the analogy between the two national
revolutions rather than their dependency,
but declares that only the experience of
the French Revolution has permitted the
English one to be thoroughly understood.

¹² *Woodstock*, chap. 8; in *The Waverley
Novels* (Edinburgh, 1865-68), 39:226-
27.

¹³ *Woodstock. A Play in Five Acts.
Founded on the Popular Novel of that
Name* (London, 1826). Covent Garden,
20 May 1826.

¹⁴ Felix D[e] C[roisy] *et al.*, *Charles
Stuart; ou. Le Château de Woodstock, mé-
lodrame en trois actes, à grand spectacle,
tiré du roman de Sir Walter-Scott* (Paris,
1826). Porte-Saint-Martin, 8 Sept. 1826.

¹⁵ *Cromwel dans le château de Windsor*
(*Salon de 1831*, #514). See Martin
Kemp, "Scott and Delacroix, with Some
Assistance from Hugo and Bonington,"
in *Scott Bicentenary Essays*, ed. Alan Bell
(Edinburgh, 1973), pp. 213-27, pl. 10.
Kemp reports the portrait scene "featured prominently" in the 1826 stage
version, but I cannot find the evidence in
the French text.

always the refuge of unfortunate kings."¹⁴ Nevertheless, the legendary
confrontation by proxy between Cromwell and the prince's father made
an effect in France. Delacroix painted the scene from the novel in the
manner of intimate historical genre he acquired from Bonington, and
exhibited it (along with his *Liberty*) in the same Salon of 1831 in which
Delaroche unveiled his *Cromwell*.¹⁵

A few months after the publication of *Woodstock* (and a few years

in advance of *Hernani*), Hugo, having devoured a historical library, began writing his *Cromwell*. It was his first play since *Amy Robsart* (1822), the latter based on Scott's *Kenilworth* and still in manuscript.[16] *Cromwell* was not produced, but (with its preface) made a sensation as the manifesto of a new school. In Hugo's *Cromwell*, the casement window in Whitehall through which Charles stepped to his execution functions as the death's head and, charged with memory, reminds the Protector of his guilt and ambition (II, 3 and 15).

Hugo's *Cromwell* shows the diffused influence of Scott and Shakespeare; but there is also a Napoleonic analogue at work in Hugo's interpretation of the Protector—in Cromwell's ambition for a crown, rooted in past injuries where talent was compromised by inferior position; in his relations with his family; in the alliance against him of fanatic republicans and unreconstructed royalists. Hugo's Cromwell, however, is that foxy, complex being, a histrionic ironist, who does what Bonaparte failed to do: rejects a crown in the midst of the coronation ceremony. An actor who assumes a virtue he does not have for a people sick of kings, he disarms the poised opposition and wins back the boundless enthusiasm of the crowd and the soldiery. Scott also felt and evoked the Revolutionary and Napoleonic analogue. As early as 1824, he wrote to Robert Southey, "By the way, did you ever observe how easy it would be for a good historian to run a parallel betwixt the great Rebellion and the French Revolution, just substituting the spirit of fanaticism for soi-disant philosophy." Scott carries the parallel into the two restorations, and then—with an eye to the religious politics of the Bourbon monarchy—remarks, with great prescience, "I hope Louis Baboon will not carry the matter so far as to require completing the parallel by a second Revolution."[17] While writing *Woodstock*, he was simultaneously reading and writing for his monumental biography of Napoleon, and as Scott's modern biographer remarks, "it was inevitable that his mind should dwell upon the resemblances and the differences between the towering and overbearing personality who as First Consul and as Emperor had made himself the dictator of all continental Europe and the man who as Lord Protector had made himself the dictator of Britain."[18] Even more inevitable then, with two such works to fix the Cromwell of the imagination, was the parallel that spectators read in Delaroche's version of the confrontation of Cromwell and the dead Charles.

Authenticated Nightmare

The proximity of violent death in a scene involving notable figures from "modern" history established a Delaroche mode. Thackeray, writing on the European reknown of *Les Enfants d'Edouard*, which had appeared "in a hundred different ways in print," observes: "This painter rejoices in such subjects—in what Lord Portsmouth used to call 'black jobs.' He has killed Charles I. and Lady Jane Grey, and the Dukes of Guise [*sic*], and I don't know whom besides."[19] And Holman Hunt, writing of Ford Madox Brown's *Execution of Mary, Queen of Scots* (1841), remarks on a "fashion for such subjects as the executions of monarchs being then the rage even in England,"[20] a fashion whose leader among painters was Delaroche.

[16] André Maurois, *Olympio: The Life of Victor Hugo*, trans. Gerard Hopkins (New York, 1956), pp. 102, 123.
[17] John Gibson Lockhart, *The Life of Sir Walter Scott, Bart.* (London, 1896), p. 525.
[18] Edgar Johnson, *Sir Walter Scott: The Great Unknown* (New York, 1970), 2:1057.
[19] "On the French School of Painting," *Paris Sketch Book* (London, 1869), p. 46.
[20] *Pre-Raphaelitism and the Pre-Raphaelite Brotherhood* (London, 1905), 1:121.

The fashion for "black jobs" in France drew support from Shakespeare's indecorous way with monarchs on the stage, and so was entwined with the interest in things English. Since picture and stage enjoyed fully reciprocal relations in the 1830s, it is not surprising that the reinforcement was mutual. Accordingly, when Thackeray reports on the Paris theater in 1833, he mentions three plays, all of them featuring pictorial realizations English in subject or author. The first, "an edifying representation of 'Belshazzar's Feast,'" concluded with "a superb imitation of John Martin's picture of Belshazzar" (see above, Fig. 2). The second, a Porte-St.-Martin drama called *Bergami*, "vivifies Hayter's picture of the House of Lords at Queen Caroline's trial." The third, "one of the best acted tragedies I had ever the good fortune to see," was Casimir Delavigne's *Les Enfants d'Edouard*, built on the painting by Delaroche.[21]

Bergami et la Reine d'Angleterre was a five-act prose drama of intrigue, with anticipations of Hugo's *Ruy Blas* (1838) and Dumas' *Three Musketeers* (1844). The events of the Caroline affair of 1820 are much fictionalized (Caroline is poisoned in the last act; Bergami, her putative lover, kills the villain, "Lord Ashley," and wins the king's pardon; but Hayter's picture is there to add the conviction of authenticity. George Hayter's *View of the Interior of the House of Peers during the Trial of Queen Caroline* (1823, but recently engraved) was in its own right a piece of posterity-oriented historical reportage, a commemorative gallery of portraits whose sum was the portrait of a historic occasion.[22] Nothing seems further from the interest in high-life domestic drama and the drama of situation that animates the play. Yet at one time royalty on trial was itself a situation; and the painting otherwise serves the play as spectacle, and attempts to remove it from the category of mere melodrama. History, in the form of a visual document, is here used to stamp this drama of situation and private feeling as "historical." Meanwhile the historical Queen Caroline is assimilated to the universal figure of the loving woman traduced and persecuted, from the realm of the private imagination.[23]

Casimir Delavigne dedicated the play that roused Thackeray's enthusiasm, *Les Enfants d'Edouard*, "A mon ami Paul Delaroche," as a polite acknowledgment of the inspiration for Delavigne's three-act verse tragedy. The inspiration relates as much to Delavigne's privatization of history as to his embodiment of the Delaroche painting. The play like the painting shows a prudent formal eclecticism. By an application of the principle of classical concentration, it shapes from suggestions in Shakespeare's *Richard III* a situational drama of maternal love and fraternal sentiment. In his criticism of Delavigne's "tragédie prétendue" as merely a laborious paraphrase of the painting, the astute Gustave Planche observed that "the defect of the painting is also that of the tragedy. M. Paul Delaroche had painted on a ten-foot canvas [actually about 7' x 6'] a subject whose composition and outlines would be much better suited to the dimensions of a watercolor. M. Delavigne has spun out in the three acts of a tragedy the small number of ideas and images that would have comfortably furnished an elegy."[24]

The last act in fact is essentially the stretched-out realization of the painting. The act begins with its formal realization, and ends with the achievement of its narrative implication. The initial image is of the

[21] "Foreign Correspondence," *The National Standard* (6 July 1833), in *Stray Papers*, ed. Lewis Melville (London, 1901), p. 37.

[22] Title as in the mezzotint engraving by John Bromley and J. Porter, published London and Paris, Mar. 1832.

[23] Cf. Fontan, Dupeuty, and Maurice Alhoy, *Bergami et la Reine d'Angleterre, Drame en Cinq Actes* (Paris, 1833). The direction for IV, 2 reads: "*L'intérieure de la chambre des lords à Londres.—Au changement à vue, le théâtre représente la copie exacte de la gravure de Georges Hayter, seulement le fauteuil que doit occuper la reine est encore vide.*" After an address by Brougham, her counsel, and a brief debate, she enters and completes the picture.

[24] Gustave Planche, "Les Enfans d'Edouard," *Rev. de Deux Mondes*, 2nd ser. 2 (1833): 526.

closed and curtained space in the Tower, with "Edward seated on the bed; the Duke of York, on a seat next to him, holding a book."[25] The configuration is that of the painting, but the moment is not. York has been reading, and Edward is absorbed in the contemplation of a disturbing dream; but their murder is not yet upon them.

In the painting, York appears to look up from the shared picture book in the first stirrings of apprehension while Edward remains contemplative. A small dog, tail down, directs us toward the light seeping under the door and beside the jamb. The drama of the painting is in the moment so defined, the moment just before the murderers burst in; and the "effect" is in the contrast between the familiar and familial innocence inside the room and the implied potent horror outside. The invasion by lurid emanation is the messenger of imminent violation, which will turn that bed with its heavy trappings into the instrument of murder. Edward, afflicted with premature knowledge and in the sacrificial trappings of his rank, has nevertheless naively carved his royal name on the furniture. The irregular carving, which in the passing phase of the present moment neutralizes and domesticates the heraldic bedstead, functions in the coming phase as the name on a sarcophagus, like the "Carolus Rex 1649" on Charles's coffin. The situation, the occasion of effect, is thus a tension between two times, one to succeed the other, and two locales, soon to become one. All are present, however, in the scene as depicted, in the momentary equilibrium or suspense that the tension of situation demands.

In the play, the primary "action" of the princes in the tower is waiting—for their uncle of Gloucester to complete the arrangements for Edward's coronation, which will end their confinement; for a glimpse of their mother; and finally, for the external signal that will announce their salvation. The figurative waiting in the painting—for the arrival of what lies behind the door—is thus extended through a whole act, which incidentally develops the paternal emotions of Tyrrel and the hopes and sufferings of Queen Elizabeth. The waiting terminates ironically, at a moment when the princes—one rising on the bed, the other beside it—embrace, believing they are about to be saved, whereupon the door bursts open to admit their murderers. This fulfils the narrative expectation which is so much of the content of the painting. The violent eruption through the door disrupts a visual configuration that partly recapitulates the opening realization of the painting. It also terminates the situation the play has sustained, elaborated, and inevitably diffused.

A cruder melodramatist than Delaroche might have chosen for his tableau the psychologically simpler, but more obviously effective moment *after* the murderers had burst in the door, in which case the tableau character of the scene would have been blatant, by virtue of the arrested kinesis. Holman Hunt, who had a kind word for Delaroche as the one man among the French school during Hunt's own formative period who was capable of soaring above the mechanical, comments especially on the drama of the moment *before*, the indirection that avoids "a scene of carnage" and yet achieves so telling a situation as *Les Enfants d'Edouard*.[26] Though he does not say so, it seems likely that it was precisely the refinement of the historical moment into something ephemerally psychological, the representation of a dawning apprehen-

[25] *Oeuvres complètes de Casimir Dela-vigne* (Paris 1836), p. 375. Prud'homme's engraving after the painting accompanies the play in this edition and some later ones.

[26] Hunt, Pre-Raphaelitism, 1:187.

sion in York (bracketed by the fully-alert dog nearer the door and the oblivious Edward farther away), which enlisted Hunt's interest. The attempt to capture such psychological phenomena in a situation was characteristic of Hunt, alone among the early Pre-Raphaelites (see below, pp. 359-68). Delaroche's interest, however, to judge by the painting, was more in the perpetual imminence of an unspeakable horror from the private world of our nightmare fears. The putative historicity of the scene depicted serves to authenticate the nightmare; and more recent analogues, still charged with political trauma, served to substantiate and inform the historicity. Roy Strong suggests that in this version of a helpless and vulnerable childhood there are resonances of the mysterious fate of the Dauphin in the Temple Prison. There is also, in the plight of the young princes, separated from a loving parent and under the hand of the enemy, a reminder of the King of Rome. A charged but ambiguous reference to active political passions suited Delaroche, as we have seen; but the interplay of past and present, while important in the final effect, serves principally to augment the nightmare threat to our vulnerable private selves, and to the circle of our affections.

Renewed Engagements

Delaroche's *Cromwell and Charles I* appeared as a realization at the Porte-St.-Martin as early as 1835;[27] but its most interesting moment on the stage—most interesting with respect to the politics and aesthetics of historical representation—came in the 1870s and in England, in a minor war of the theaters. A realization appeared in a counterblast to a play whose royalist bent and sanctifying partisanship of Charles I were taken as a challenge, not only to radical republicanism, but to the Whig view of history and the principles of Liberalism itself. The whole episode, however, suggests not a call to battle, a rekindling of the inherited or translated passions of the past, but rather a ritualization allowing these passions to discharge themselves in a symbolic form of combat.

It would be too much to say that the passions of 1650 were still burning furiously 200 years later; but there is no doubt that they were still alive in some religious contexts, putting heat into the interpretation of the past and the resurrection of its heroes for present-day partisan political uses. The past in any event had recognizable symbolic values in the present. About 1825 Mary Russell Mitford had written a *Charles the First; An Historical Tragedy*, and it was refused a license by George Colman, the Licenser, and the Lord Chamberlain, who "saw a danger to the State in permitting the trial of an English Monarch to be represented on the stage, especially a Monarch whose martyrdom was still observed in our churches."[28] In 1834 the play was produced at the Victoria Theatre, then outside the Lord Chamberlain's jurisdiction, and met with a fair success, though the *Spectator* reviewer noted a disruption and "fancied we discerned the feeling of partisanship in the reiterated applauses which particular passages met with that bore in favour of either Charles or Cromwell." The play presents Charles— from his imprisonment at Carisbrook, through "his trial, and his part-

[27] In A. Cordellier-Delanoue's *Cromwell et Charles premier. Le Monde Dramatique* asks, "pourquoi M. Delanoue a-t-il pris à M. Delavigne un tableau de M. Delaroche?" 2nd ser., 5th yr., 1 (1835): 55.
[28] Mary Russell Mitford, *The Dramatic Works* (London, 1854), 1:xxx, 244-45.

ing with his family (in which STOTHARD'S picture is embodied as a *tableau vivant*), to his execution"—in a running contrast with Cromwell, more or less as they are interpreted in Hume's *History of England*. Charles is amiable and virtuous; Cromwell "bold, subtle, and relentless."[29]

Charles's failure as politician, soldier, and statesman put the burden of his nobility on his private virtues, notably his behavior in adversity and his domesticity. Miss Mitford consciously departs from history only for the sake of the domestic interest. She brings Henrietta Maria from France as the devoted wife of an exemplary husband, to be present at the trial and to plead privately with Cromwell for her husband's life. The production gave further vivid emphasis to this conception of Charles by its realization of Stothard's *Charles I Taking Leave of his Children* from Robert Bowyer's "Historic Gallery," commissioned to illustrate his monumental folio edition of Hume's history.[30] The happy domesticity of the royal family, threatened with imminent disruption by cruel, venal, and ambitious men, became the essential situation in the Tory Victorian version of the drama of King Charles.

In September 1872, *Charles the First, an Historical Tragedy* by W. G. Wills, a painter himself, opened at the Lyceum Theatre with Irving in the title role. Written on Irving's suggestion, the play, thought the *Athenaeum*, was "less a regularly constructed drama than a study of the life of Charles, illustrated by a series of pictures," though powerful nevertheless in character-painting, language, and situation.[31] Irving's makeup and several costumes reproduced Van Dyck exactly, in keeping with the well-established partnership of spectacle and archaeology.[32] Of the pictures, however, the most fully realized was Frederick Goodall's *An Episode of the Happier Days of Charles I*.[33] According to Laurence Irving, H. L. Bateman (then managing the Lyceum), particularly anxious to avoid politics, urged Wills and Irving to concentrate on the domestic tragedy.[34] They started accordingly with Goodall's picture of a royal family outing in blissful weather, the proud and benign father upright, holding a book that marks his piety and intellectuality, his lovely wife cradling a young spaniel that marks her affectionate nature. She sits in the midst of her children and tends to her youngest, who is feeding the appreciative swans. On the landing is a numerous guard that hints at other times.

The first of four acts—ruffled only by voices and messages from the distant world of politics—culminates with Goodall's domestic idyll. Clement Scott, a strong partisan of most of Irving's doings, was of two minds about it:

> And this is how Mr. Wills dramatises the life of Charles the First. In a lovely scene, an almost perfect specimen of stage landscape, representing the gardens near Hampton Court, on the banks of the Thames, a lawn of flowers, with a background of green avenues and transparent water, the domestic side of the King's life is illustrated. He is a careless, happy father of a family, dotingly fond of his wife, ridiculously indolent regarding the aspect of the political horizon, only happy as long as he can carry the little ones "pick-a-back," recite to them the ballad of King Lear, throw himself on his back on the lawn, dance his children

[29] *Spectator* 7 (5 July 1834), p. 635. Another view of Charles is taken in Browning's *Strafford* (1837), a failure at Covent Garden, despite Macready in the title role. Delaroche's *Earl of Strafford Going to Execution*, painted for the Duke of Sutherland and several times engraved, was then the most popular handling of Browning's subject. (Strafford, kneeling on a landing, is blessed by Laud through prison bars.)

[30] David Hume, *The History of England, from the Invasion of Julius Caesar to the Revolution in 1688* (London, 1806), Vol. 8 [Vol. 4, pt. 2], opp. p. 470. The prospectus for the gallery and edition (published in parts) appeared in 1792. Bromley's engraving after Stothard is dated 1794.

[31] *Athenaeum* (5 Oct. 1872), pp. 440-41.

[32] Austin Brereton, *The Life of Henry Irving* (London, 1908), 1:139. Irving had a triptych of Van Dyck heads painted by Edwin Long to keep before him while making up. The playbill (28 Sept. 1872) announces that scenery, appointments, and dress "have been prepared with the intention of giving reality to a reproduction of the actual period during which the incidents are supposed to have taken place" (an interesting division of fact and fiction); and even the music was "founded on popular Airs of the 16th Century."

[33] Exhibited R.A. 1853; engraved 1856 by E. Goodall as *The Happy Days of Charles the First* and chiefly known by that name.

[34] Laurence Irving, *Henry Irving: The Actor and His World* (New York, 1952), p. 214.

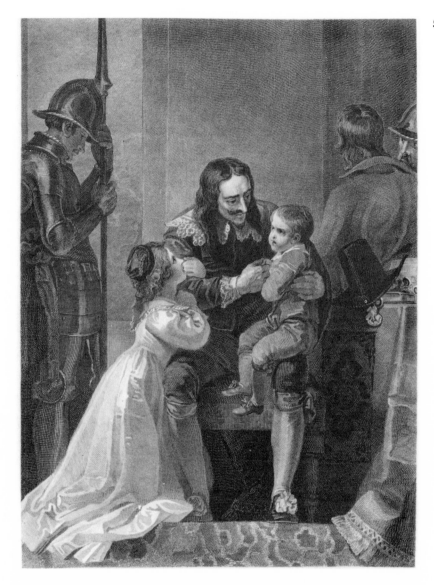

98. *Thomas Stothard*, Charles I,
Taking Leave of His Children,
*engraving by W. Bromley
(1794), in David Hume*, History
of England *(London, 1806)*.

on his knee, and summon a gilded barge to take the happy family
for a sail on the silver Thames, a scenic illustration of Mr. Good-
all's well-known picture. Now all this is extremely pretty, but it is
not dramatic. When the audience has feasted on the delightful pic-
ture of Mr. Hawes Craven [the scene-painter], and applauded the
disappearance of the summer barge to a sigh of melancholy music,
the feeling supervenes that the story has not even commenced.[35]

Other pictures, however, were more "dramatic" in that their effect was
more immediately a product of situation. Most critics, for example,
had nothing but praise for the tableau that ends the second act, where,
by producing a swarm of armed gentlemen she had the foresight to
conceal, the queen foils Cromwell's devious attempt to arrest the king.
"The situation is cleverly brought about, and has genuine dramatic
fire. Its effect upon the audience was very strong."[36] The situation at

[35] Clement Scott, *From "The Bells" to
"King Arthur"* (London, 1896), p. 17.
The final stage direction in the text that
represents the version Irving played in
America reads: *"They enter the barge, and
as it moves slowly off the curtain falls to
soft music"* (New York and London:
S. French, n.d.).
[36] *Athenaeum* (5 Oct. 1872), p. 441.

99. (facing page, top) *Frederick Goodall, An Episode of the Happier Days of Charles I (1853), engraving by Edward Goodall (1856), private collection.*

100. (facing page, bottom) *Hawes Craven, Act Drop, Lyceum Theater (1872), from* The Magazine of Art *18 (1895): 340.*

[37] *Times*, 30 Sept. 1872, p. 8. The farewells were supposed to have been inspired by Jerrold's old nautical melodrama, *Black-Ey'd Susan* (L. Irving, *Henry Irving*, p. 215). Millais' exceptionally situational painting was not universally recognized in altered costume, to the apparent detriment of effect. The *Athenaeum* reviewer complained, "A last embrace previous to eternal separation is prolonged, and husband and wife stand in one attitude of contact so close, that neither significance of movement nor play of feature is visible to the spectator." This reviewer was made uncomfortable by the exceptional quantity of hugging and other domestic caresses before strangers; he finds it "scarce kingly."

[38] *Times*, 30 Sept. 1872.

[39] The drop continued in use at the Lyceum, and W. L. Telbin—who argues for a decorative subject that will serve all genres—cites it for its inappropriateness to other plays in "Art in the Theatre: Act Drops," *Magazine of Art* 18 (1889): 337, 340.

[40] Brereton, *Life*, 1:136ff.

[41] Queen's Theatre, 21 Dec. 1872; originally published as *Cromwell; a Drama* (London, 1847). An 1873 edition contains Col. Richards' animadversions on the production.

[42] Unidentified rev., Enthoven, 28 Dec. 1872.

the end of the last act also resolves in a picture that focuses effect. The *Times* declared, "the last farewell to the Queen, the grouping of which was apparently copied from the 'Huguenots' [*sic*] of Mr. Millais [Fig. 160], could not be excelled in sustained pathos."[37]

This parting tableau was in fact the expanded realization of the implicit narrative suggestion in the picture of Charles's happier days, just as the bursting in of the door and of the murderers realizes the narrative content in Delaroche's image of the children of Edward IV. The *Times* reviewer says as much in discussing Goodall's picture as an aesthetic contrivance for creating and organizing a spectator's affective response. "The sentiment awakened by a contemplation of this picture would lie dormant did not the imagination of the spectator wander beyond the limits of [the] scene presented to his eyes, until it reached the scaffold at Whitehall. It is the knowledge of the unhappiness by which the happy days were followed which gives the subject its interest." That knowledge—which makes the painting "situational" in a sense appropriate to contemporary drama—is rendered explicitly, and (with respect to the painting) analytically, in the pictorial progression of the play. The pathos generated by the awareness of later temporal states in the presentness of the picture pervades the whole, and "links together the several parts of the not very closely constructed play."

That Irving and his artists were in fact thinking analytically with respect to Goodall's painting, and synthetically with respect to what seemed at first "so many insulated pictures" comprising the four acts of a play,[38] appears in the act drop, the "curtain" called for after the disappearance of the barge "to a sigh of melancholy music," and in the act intervals thereafter. The drop shows the barge at a landing, but seems to represent the embarcation of Charles and Henrietta Maria, the beginning of their journey rather than the end. As a visual refrain, the drop represents the joys of the river idyll as an unqualified prospect, a path of light; and recalls the lost happiness in the intervals of a darker future.[39]

The domestic focus of the play did not finally serve to neutralize its presentation of a venal Cromwell; if anything it set Cromwell in a darker light. Unhappy reviewers attacked the historicity of this Cromwell, generally invoking Carlyle's milestone edition of Cromwell's letters and speeches "with Elucidations" (1845), and Wills had to defend himself in the press. The Prince of Wales visited the play in October on what became a noisy occasion, with the audience dividing over the positive Royalist sentiments coming from the stage and what were understood as anti-Gladstonian allusions.[40] A play taking a higher view of Cromwell and the cause of English liberty, published a quarter of a century earlier and dedicated to Carlyle, was thereupon reissued, and produced at the end of December.

Oliver Cromwell: An Historical Tragedy by Col. Alfred Bate Richards[41] was no great success in the theater, but it received some undeserved respect as a Whig-Liberal response to the Tory Royalists, and a corrective to Wills's "misrepresentation of the great Reformer's character."[42] The obvious debater's points in the drama proper included a strong thread of domestic concern, developed as a conflict between the

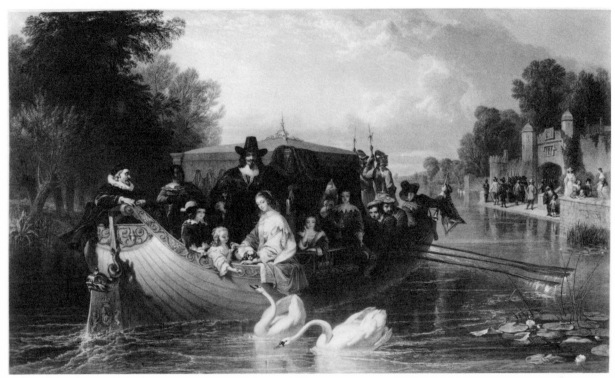

99

100

domestic and political in Cromwell's own situation, from St. Ives to the regicide; and a featured pictorial realization, identified in the program as "Cromwell Beside the Body of Charles (After Paul de Laroche)." The evidence is clear that Charles' body was at no time made visible to the audience in this realization, but that Cromwell's long soliloquy in its coffined presence was pleasurably received. This decorous bowdlerization of Delaroche's image removed the imputation of morbidity or vindictiveness that a literal contemplation of one's executed enemy might have brought upon the colonel's Cromwell. Cromwell in fact lacks a royal antagonist, since Charles has no direct role in the play, and "the space that ought to have been occupied by the story of the Royal family is delivered up to a trifling love tale." Shaw would have been pleased, however, at the reception of this would-be Play for Puritans; for "there can be no doubt that the audience resented the intrusion of a love underplot, and had set their minds on the political action of the play."[43]

Big History and Little History

The interest in royal situations is not of itself political or deeply historical, any more than the interest in the private lives of movie stars. And yet nothing is clearer than that, in the high Victorian years, among the more affluent print-buying classes at least, history had a symbolic value that lay in a perceived relation between the historical subject and current ideals of government, religion, and society. The lives of Charles and of Cromwell as known to popular history were rather less crowded with intriguing situations than those of some other royal figures, such as Mary Stuart. And yet the Printsellers' Association list of engravings registered for publication between 1847 and 1891 includes none with Mary, but (in addition to several portraits) five of Charles and eight of Cromwell at various telling moments.[44] There are more scenes with Cromwell than with any other British ruler before Queen Victoria, and Charles comes after Cromwell. Elizabeth only appears as Princess Elizabeth in the days of her peril, religious and dynastic.

Nevertheless, the romantic figure of Mary, Queen of Scots was also a prime subject for illustration;[45] and with Schiller's play and its derivatives and *The Abbot* of Walter Scott (1820) for stimulus, it surfaced frequently in the drama. Wills, for one, brought her to the stage in *Mary Stuart; or, The Catholic Queen and the Protestant Reformer* (1874), another pictorial album, with one scene perhaps inspired by Henry Joseph Fradelle's insipid favorite, *Mary Queen of Scots and her Secretary Chastelard* (originally *Chatelar Playing the Lute to Mary Queen of Scots*, 1821).[46] Fradelle's painting, a true pictorial equivalent of historical costume drama, was brought upon the English stage with some frequency, the first time even before *The Rent Day*. It appeared, significantly, in a vehicle that had something to do with painting, sentiment, dressing up, and impersonation, but nothing to do with history. In Thomas Haynes Bayly's "operetta," *The Picturesque* (1831), probably adapted from a French *vaudeville*, a painter, "Mr. Dauberry," promises his daughter to the suitor who can make the best painting from Dauberry's sketch of Mary and Chastelard—"the same, by-the-bye, as in

[43] Ibid. See George Bernard Shaw, Preface to *Three Plays for Puritans*, Standard Edition (London, 1931), pp. vii-xx.

[44] These include R. Hannah's *Harvey, Demonstrating to Charles I his Theory of the Circulation of the Blood* (engr. H. Lemon, 1849), Charles Landseer's *Charles I on the Eve of the Battle of Edgehill* (F. Bromley, 1851), S. Blackburn's *Charles I Presenting the Bible to Bishop Juxon on the Morning of his Execution* (C. Knight, 1855), F. Goodall's *Happy Days of King Charles the First* (E. Goodall, 1856), and R. A. Muller's *Charles I, and Vandyck* (P. Cottin, 1877). The Cromwell subjects include Charles Lucy's *Cromwell's Last Interview with his Favourite Daughter, Mrs. Claypole* (C. A. Tomkins, 1853), Lucy's *Cromwell Resolving to Refuse the Crown* (R. Graves, 1858), T. H. Maguire's *Cromwell Refusing the Crown of England* (S. Bellin, 1859), H. Andrews' *Cromwell's Daughter Interceding for the Life of Charles I* (W. Gilles, 1863), Lucy's *Cromwell at Hampton Court Palace, A.D. 1658* (S. Bellin, 1866), P. Wescott's *Cromwell's Protest against the Persecution of the Waldenses* (F. Bromley, 1869), F. Newenham's *Cromwell and Milton: Cromwell Dictating the Letter to the Duke of Savoy Demanding Religious Liberty for the Protestants of Piedmont, A.D. 1655* (W. H. Simmons, 1882), and D. Neal, *Cromwell's First Interview with Milton* (C. O. Murray, 1884). See *An Alphabetical List of Engravings Declared at the Office of the Printsellers' Association, London . . . Since Its Establishment in 1847 to the End of 1891* (London, 1892).

[45] Roy Strong counts 56 paintings on the theme of Mary between 1820 and 1897 at the Royal Academy alone. For roughly the same period, however, he counts about 175 paintings in the Academy exhibitions "connected with Charles I and his family, Oliver Cromwell and the Civil War" (*And When Did You Last . . .* , pp. 133, 141, and Appendix).

[46] Act III shows some influence of the painting, or another like it, but no formal realization (L.C. MSS Add. 53134). Fradelle (1778-1865) settled in London in 1816, and also painted an *Escape of Mary, Queen of Scots, from Lochleven Castle*.

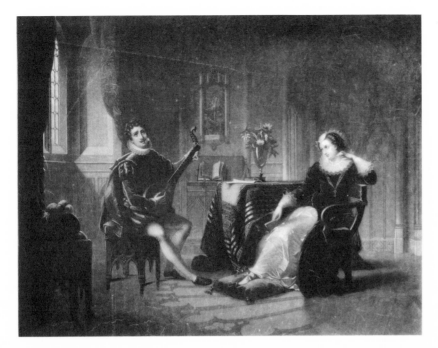

101. *Henry Joseph Fradelle*, Chatelar
Playing the Lute to Mary
Queen of Scots *(1821)*, *engrav-
ing by W. Say as* Mary Queen
of Scots and her Secretary
Chastelard, *London, British
Museum.*

FRADELLE's popular picture." By the advice of a maid, the daughter
and her favored suitor assume the dress and attitudes of the painting
behind a frame, "a curtain is withdrawn, and *Dauberry*, in ecstacies,
avers that if *Lorimer* had a hand in producing the group he shall alone
marry his daughter."[47] The values in Fradelle's art are summarized by
the *Spectator* in terms that speak to some of the common qualities of
the genre:

> Mr. Fradelle's present fame rests upon his successful picture of
> Mary Queen of Scots and Chatelar. . . . This picture had claims
> to merit independently of the ornamental style of art in which it
> was painted, and the tasteful selection, judicious arrangement, and
> brilliant imitation of accessories or furniture of the picture. It rec-
> ommended itself to the approval of the critic, as well as the admi-
> ration of the multitude, by the beauty of the countenance of the
> lovely MARY, and the pleasing character of the sentiment con-
> veyed in the melancholy thoughtfulness and rapt attention of her
> look. This it was that made every one admire a picture which
> otherwise had no claims to distinction on the score of expres-
> sion.[48]

Fradelle gave earnest attention to historical costume and to feature,
and he was particularly prone to subjects made current and familiar
by Scott, but there is no comparison between the two as artist-histo-
rians. Scott, though the father of nineteenth-century costume drama,
also founded the great school of historical literature concerned with
the nature and the experience of historical change and with the situ-
ations of disjunctive and transitional societies, not just the situations
of famous individuals.

Scott also has a Mary and a Cromwell in his fiction. The one em-

[47] *Morning Post*, 26 Aug. 1831, p. 3.
A correspondence developed in Leigh
Hunt's *Tatler* as to the use on the Eng-
lish stage "of a popular German pastime
(the personation of a picture)." *Tatler* 3
(1831): 195-96, 207. For the realization
of Fradelle's painting in a play on Mary
Tudor (1840), see below, p. 280n.
[48] "Mr. Fradelle's Engravings," *Specta-
tor* 3 (31 July 1830), p. 567.

bodies all that is retrospectively attractive in a changing world; the other is riding a transforming force. And in their respective novels, each acts on a perceiving consciousness in the foreground of the fiction, a protagonist endowed with a certain ambivalence. In *Woodstock*, though it is among Scott's most situational novels, that private ambivalence belongs to Colonel Everard, a loyal Parliamentarian who nevertheless sees with regret "the downfall of our ancient monarchy, and the substitution of another form of government in its stead; but ought my regret for the past to prevent my acquiescing and aiding in such measures as are likely to settle the future?"[49] Because of his wider historical view and sympathies, Everard is able to create and maintain his own integrity. Psychology and motivation are thus linked to what is genuinely historical—concerned with process, the rivalries of groups and ideologies, and the making of the present—and are not merely contained in a personal situation in fancy dress. Despite their considerable diversity in period and setting and their pervasive delight in rendering the authentic details of local life, Scott's novels are set by and large in the same place: in the temporal borderland between the past and the present. They serve, not only to make the past familiar, but to make the present understood.

Delaroche's Cromwell cannot speak his thoughts, any more than his waxwork Charles can, and for that we should be grateful. What speaks in the painting are the tide of red (the plush chairs, Cromwell's plume, the lining of his boots, and the wound), an arresting effect; and the emblematic situation, a visual configuration of vertical against horizontal, a parallelogram of forces in equilibrium. The personal equation, because mute and with an unreadable component, allows speculative historical generalization and analogue, and so becomes the matrix of interpretation. Despite the odds, the painting escapes the limitations of "little history"—history as costume and private passion, history as melodrama and mere situation—because it brings the past to bear on the actual life of the present in an act of historical imagination.

[49] *Woodstock*, chap. 9, 39:234-35.

13

✦⋅✦

NOVELS IN EPITOME

*A*N INDUSTRY devoted to the theatrical realization of novels on the stage—the fate of much popular fiction in the nineteenth century—casts a refracted light on the art of conjoining verbal and pictorial narrative, in the book designed for reading no less than in the play designed for viewing. In the following pages, I concentrate on some of the novels of Dickens and Ainsworth and how they were brought upon the stage. Since the order is partly chronological, one can follow the establishment, tentative at first, of what became the standard method for enacting the serial illustrated novel. That these earlier plays, rushed before an audience, sometimes required improvised resolutions helped make the visual—costume, scene, and picture—the locus of perceived authenticity. But though rendering the novel by way of its pictures became the theatrical standard, there were significant differences in how the realizations worked in the dramatic versions of Dickens and his illustrators and the versions of Ainsworth and his. Since the plays emanated from the same playwrights, often used the same actors, and appeared in the same theaters, such differences lead back to the function and coherence of the illustrations in the original novel form, and to the matter of imaginative priority in the original collaboration.

Priorities

Cruikshank's biographer, Blanchard Jerrold, credits Thackeray's admiring remarks on the illustrations to *Jack Sheppard* (1839) with inspiring the artist's claim to have been more author than illustrator of several of Ainsworth's and one of Dickens' novels.[1] Thackeray had written, "it seems to us that Mr Cruikshank really created the tale, and that Mr Ainsworth, as it were, only put words to it." Thackeray asks, what does the reader remember? "George Cruikshank's pictures—always George Cruikshank's pictures." He mentions especially the pictures of the storm and the murder on the Thames, where any man "must acknowledge how much more brilliant the artist's description is than the writer's, and what a real genius for the terrible as well as for the ridiculous the former has."[2]

[1] *The Life of George Cruikshank, in Two Epochs* (London, 1882), 1:242.
[2] "George Cruikshank," *Westminster Rev.* 34 (June 1840): 53-54.

Jerrold points out that *Jack Sheppard* was "the natural sequence to *Rookwood*" (1834), where Ainsworth first tapped the Newgate vein with an account of Dick Turpin's ride to York which "became the talk of all England."[3] Indeed, three years before *Jack Sheppard*, in a new edition of *Rookwood* (also illustrated by Cruikshank), Ainsworth projected a series of novels on "the robber," the series to form a complete portrait:

> In Turpin, the reader will find him upon the road, armed, mounted, laughing, jesting, carousing, pursuing, and pursued. In Du Val—if I should succeed in working out my scheme— . . . He shall find him at the theatres, at the gambling-houses, on the Mall, at court, basking in the sunshine of royalty, and favoured by the smiles of beauty: In Shephard [*sic*], he shall discover him in the dungeon, shall witness his midnight labours, admire his ingenuity and unconquerable perseverance, and marvel at his extraordinary escapes.[4]

Cruikshank did not, however, claim to have originated the idea for *Jack Sheppard*, or even to have laid out the narrative line (though he did claim as much for other novels).

Such priority, moreover, is not the issue Thackeray raises, and should not have displaced the true issue, which has to do with the imaginative energy and proportionate impact of the shares in an artistic collaboration. Doubtless the more successful the collaboration, the more difficult to distinguish the creative contribution of the collaborators. Where the collaboration results, however, not merely from a partnership of minds but from a partnership of means—word and picture—it is easier to frame an argument materially, with an eye to comparative vitality and the direct and indirect testimony of audiences. In the case of fiction, it is tempting to base priority on one kind of coherence: narrative coherence, in answer to the question, "which of the two elements could stand by itself?" But such priority is even less useful than that based on origination. In an opera, the most banal libretto generally has more narrative coherence than the most eloquent music.

Allocative arguments about collaborating individuals degenerate; but arguments about forms have contributed to the understanding of those forms. The most interesting arguments about creative priority have concerned forms where the collaborative means are associated with different modes of apprehension: as in the masque (and *comédie-ballet*), the opera, and the serial illustrated novel. The argument between Jonson and Jones over the masque developed from revolutionary views and revolutionary practices in the organization of perception and response. In epitome, the argument asked whether the fusion of poetry and spectacle was addressed in the first place to "an audience" (hearers) or to "the spectators" (viewers).[5] The issues in the burgeoning collaborative form of serial illustrated fiction could have been framed in similar terms in the nineteenth century. Instead, they tended to reduce to the question, who was illustrating whom?

Jerrold's attempt to lay the embarrassment of Cruikshank's claim to priority at Thackeray's door fails on narrower grounds: Thackeray's response was widely shared and variously expressed. It may be found,

[3] Jerrold, *Cruikshank*, 1:245.

[4] W. Harrison Ainsworth, *Rookwood: A Romance*, 4th ed. (London, 1836), pp. xxi-xxii. That Balzac was in his mind as he conceived this "plan . . . of a more extensive edifice, which, in time, I may be able to construct" is clear from other parts of the introduction. Newgate stories were a staple of English equestrian drama, and the Royal Amphitheatre's *Richard Turpin, the Highwayman* (1819) with scenery by Clarkson Stanfield seems to have been crossbred into later theatrical adaptations of Ainsworth's novel. *Rookwood* itself, which follows Bulwer (*Paul Clifford*, 1830; *Eugene Aram*, 1831) in infusing Newgate materials with Gothic melodrama, shows the influence of the theater's moving diorama in the famous ride: "Away—away! He is wild with joy. Hall, cot, tree, tower, glade, mead, waste, or woodland, are seen, passed, left behind, and vanish as in a dream. Motion is scarce perceptible—it is impetus—volition" etc. (p. 412). Cf. Carker's flight in *Dombey*, and the remarks on panoramic and dioramic audience experience above, pp. 61-62. One should note that similar visual analogues are responsible for some of Cruikshank's most striking illustrations in *Jack Sheppard*.

[5] See Stephen Orgel, "The Poetics of Spectacle," *New Literary History* 2 (1971): 367-89.

along with a creditable analysis of the function and appeal of the *Jack Sheppard* pictures, in a review whose writer is so far from admiring anything about the book that he treats it as the fatal sign of a coming catastrophe, like *The Marriage of Figaro* before the French Revolution. He refers the reader to the illustrations as "the shortest and perhaps the best means" of estimating the whole:

> In these graphic representations are embodied all the inherent coarseness and vulgarity of the subject; and all the horrible and . . . unnatural excitement. . . . The engravings are, in fact, an epitome of the letterpress, and they seem to bear the same proportion to the entire work, that Mr. Stanfield's beautiful scenery does to a picturesque melodrame; leaving it doubtful whether the plates were etched for the book, or the book written to illustrate the plates. Perhaps it were a better comparison to say, that the plates perform the same part in these volumes, that "the real gig" of Thurtell did on the Surrey stage; and that the authors in both cases have trusted to the *oculis fidelibus*, for producing that "elevation and surprise," which their pens could not elicit from such a theme. These faithful images of "what you shall see," beaming from the windows of booksellers' shops, like the baked meats and sausages depicted on the outsides of cookshops in Italy, are appeals *ad hominem*, not to be resisted . . .[6]

The characterization of the plates as "an epitome of the letterpress"—that is, an epitome of the whole—would be borne out by the dramatizations of the novel. The analogy of the plates with Stanfield's settings for picturesque melodrama acknowledges their superior imaginative power and appeal; the analogy with Thurtell's gig points out their superior access to the sentiment of reality. The advantage in both respects is with the visual, which, if it *means* less than expressive discourse, *is* more.

Thurtell's gig was an appropriate ghost to raise against *Jack Sheppard*. G. A. Sala conjectured much later that the vogue of "Old Bailey novels"—in which *Jack Sheppard* was a benchmark—"was due to the amazingly strong grasp which had been taken of the public curiosity by the revelations incidental to the murder of Weare by Thurtell" (1823), and by one or two other sensational crimes.[7] The gig, where the murder actually began, became proverbial (as in Carlyle's "gigmanity") after a witness supposedly declared Weare respectable because he kept a gig. In the play at the Surrey Theatre, "hashed up by Milner if I remember rightly . . . not only was exhibited *the* Gig—purchased for the occasion—but the 'identical sofa' on which Thurtell slept on the night of the murder and the 'identical table' round which the party supped was exhibited on the stage!!!"[8]

What Thurtell's gig illustrates best is that the sensationalism of the authentic material witness, true cross or true gig, feeds an appetite superior to fashion or shifts in taste. But the incorporation of undigested lumps of authenticity for effect in imaginative art, lumps set in brackets by the advertising, is nevertheless not a constant in human nature. Neither is the taste for immediacy and recognizable authenticity in the fictive representation of social disorder and crime. Dickens wrote in

[6] *Athenaeum* (26 Oct. 1839), p. 803.

[7] *The Life and Adventures of G. A. Sala* (London, 1895), 1:96. Cf. Richard D. Altick, "Early Murders for the Million," in *Victorian Studies in Scarlet* (New York, 1970).

[8] A.L.S. from E. L. Blanchard (23 Apr. 1883), bound into the British Library copy of *The Gamblers, A New Melodrama, in Two Acts, of Peculiar Interest, as performed for the 1st and 2d times November 17 & 18, 1823, Suppressed by Order of the Court of King's Bench, Re-Performed for the 3d time, Monday, January 12, 1824, At the New Surrey Theatre* (London, 1823).

1841 of those whose delicacy had been offended by *Oliver Twist*: "A Massaroni in green velvet is quite an enchanting creature; but a Sikes in fustian is insupportable. A Mrs. Massaroni, being a lady in short petticoats and a fancy dress, is a thing to imitate in tableaux and have in lithograph on pretty songs; but a Nancy, being a creature in a cotton gown and cheap shawl, is not to be thought of."[9] Yet Sikes in fustian and Nancy in cotton *were* thought of, partly because of changes in taste and style since the creation of Massaroni in Planché's *Brigand* of 1829; changes reflected in the vogue of Newgate fiction and drama, and implicated with intuitions about reality and authenticity. Emphasis passed from the romantic brigand of Eastlake and Planché, set in an exotic Mediterranean locale (Figs. 26-28), to the "real" outlaw and his underworld milieu, native, urban, and familiar, of Cruikshank, Ainsworth, Bulwer, and Dickens. The line claimed kin with Hogarth, not Salvator, and with the Newgate chronicles, not Scott or Byron. That same shift in emphasis, in favor of the sentiment of reality, enhanced the appeal of the ocular partner in the collaboration of means within novels, and in the translation of their fictions to the stage.

ONE CANNOT use the testimony of the drama as a complete index to imaginative priority in any particular instance of collaborative fiction, because the drama itself was so much a serial pictorial form. The dramatization of novels as a series of pictures reflects in the first place on the character of the drama. But when the series of pictures is chiefly composed of a novel's illustrations "realized," the phenomenon reflects also on the imaginative appeal of those particular pictures, on their particular usefulness as vivid epitomes, and (more remotely) on how the whole genre of serial illustrated fiction was originally experienced. The adequacy of this mode of dramatic translation to the task of representing the novels, or indeed of "realizing" them, need not trouble us beyond a certain point. It was the norm; and why that was so, and what the method can tell us about fiction, drama, and their audiences are proper concerns. Even while the method flourished, however, two opinions of its adequacy were possible, depending on whether or not beholders perceived the illustrations as an "epitome of the letterpress." One reviewer, for example (possibly John Forster), strongly antipathetic in general to dramatizing literary "works of genius," takes special exception to a stage version of *Barnaby Rudge*:

> The attempt seemed to please the audience, but was little to our taste. . . . The one point considered had been to drag in, without the remotest attempt at connexion, a certain number of what the bills call realizations; in other words, tableaux from the somewhat poor woodcuts of the tale: these ranged from the first scene to the last, and some of them were well done: but the general effect was as though a man should undertake to tell a tale of humour, character, and pathos, in a certain number of grins through a horse-collar.[10]

Another, more representative reviewer, however, found the method of this same dramatic version of *Barnaby Rudge* admirably appropriate: "It is scarcely necessary to detail a plot which is so well known and

[9] "Author's Preface to the Third Edition," *Oliver Twist*, ed. Kathleen Tillotson (Oxford, 1966), p. lxiii.

[10] *Examiner* (25 Dec. 1841), p. 823.

generally admired as Dickens's last novel, bearing this title, the tale being fully borne out in the drama here presented, in the most perfect and attractive manner, by a series of *tableaux vivans*, copied from the illustrations of the tale; these *tableaux* were the admiration of the audience, who testified their delight by the most enthusiastic applause."[11]

It should be noted that the second reviewer assumes his readers' familiarity with the story and its illustrations, and it was what the play-makers depended on as well. The effect of a realization depended on recognition; and beyond that, familiarity would allow the series of images to work as evocation of a more compendious whole. The first reviewer gives no indication that he would find such considerations relevant. There is a more fundamental difference, however, between these two reviewers, that goes deeper than the uses of familiarity. The series of realizations that the one reviewer found merely an illustrative excrescence, dragged in "without the remotest attempt at connexion," the other declared the means whereby the tale was "fully borne out . . . in the most perfect and attractive manner." Here are diametrically opposite views of the function and coherence of the illustrations in the original fictional form.

Dickens through a Horse-Collar

Stage versions of Dickens' novels began appearing in March 1837, when his first novel, *Pickwick*, was barely two-thirds through publication. "To trace the after work, in the way of transferring 'Boz's' scenes and characters from the pages of the book to the boards of the theatre, would be a tedious and unfruitful task: it is sufficient to say that every low scribbler of London has essayed the thing, the man most conspicuous amongst the lot being Mr. Stirling."[12] The "after work"—Dickens on the stage—has been thoroughly canvassed by scholars; moreover, a good beginning has been made with the dramatic (or theatrical) character of the fiction itself (see above, p. 80). My concern here is with the pictorial bridge between the plays and the fiction: with the plays as serial pictures.

Stirling became stage manager of the Adelphi Theatre during the management of Frederick Yates, when that theater was strong in talented actors of melodrama and comedy, and had a reputation for novelty and pictorial effect. Yates had supervised the production of Buckstone's *Forgery* at the Adelphi in 1832 (see above, p. 157) in the wake of the success of *The Rent Day*. During the run, he characteristically provided a Lenten program twice a week called "Yates's Views of Himself & Others," interspersed with "Novel Illustrations of Shakespeare! exemplified by Tableaux Vivants, or Living Pictures," and concluding with H. Childe's "Tableau Optique," the predecessor of the Dissolving Views.[13] In 1839 a reviewer observed, "Yates has earned a deserved celebrity for producing what are called 'effects'; and often have we seen things done upon the little stage of the Adelphi that put to blush the effects of other managers."[14]

The Adelphi was the theater most given to the embodiment of illustrated fiction as pictorial drama. It was pressed hard by a popular theater with a rather different tradition of spectacle, panoramic and

[11] Unidentified rev., Enthoven (Dec. 1841).

[12] Unidentified rev., Enthoven (22 Nov. 1840) of Edward Stirling's *The Old Curiosity Shop* (Adelphi, 9 Nov. 1840).

[13] Playbill for 23 Mar. 1832, Enthoven. The final Shakespearean tableau was "Harlowe's celebrated Picture, of the Trial of Queen Catherine."

[14] Unidentified rev. of Buckstone's *Jack Sheppard* (Adelphi, 28 Oct. 1839), Enthoven.

equestrian. The Surrey Theatre under Elliston had mounted a *Napoleon* that united panorama and pictorial realization (see above, p. 219); and under Davidge, in 1839 and 1840, it interspersed versions of Dickens and Ainsworth with serial representations of Hogarth (see above, p. 119). Half a dozen other minor theaters, however, would commonly mount versions of a successful serial novel within days of each other, and sometimes provide the more instructive examples.

THE FIRST of Stirling's adaptations, *The Pickwick Club; or, The Age We Live In!*, was made for one of these other theaters (City of London, 1837), and it shows him feeling his way toward the method of presenting a novel through the tableau realization of the illustrations.[15] His tendency through much of the play is to use the plates for setting and costume, and to render them as action, with at most some passing point of rough realization. For example, "The yard of the White Hart Inn" (II, 1) embodies, more or less midscene, Browne's "First Appearance of Mr. Samuel Weller." "The Hustings" (II, 4) "discovers" Browne's view of "The Election at Eatanswill," though the row in the foreground only breaks out at the end of the scene. The play evokes the illustrations throughout (eleven of the twenty-one plates in the first nine numbers of the novel), but through the first half contrives its own pictorial effects to meet the requirements of the dramaturgy. The language of printed acting editions is not always reliable, however, and the absence of the signal word "tableau," especially midscene, does not mean there was no tableau realization in production. It is significant nevertheless that the verb "group" (as in "Boarders *groupe on the stairs*" in the scene, II, 7, that presents Browne's "Unexpected 'Breaking Up' of the Seminary for Young Ladies") and the noun "tableau" appear increasingly in connection with the illustrations in the second half of the play. The tableau realization of the plates seems to become more important as the episodic, situational, and inconclusive nature of the material asserts itself (Stirling wrote with only half the novel at hand). Toward the end there are direct references to part number, plate, and even page, as in the opening stage directions for the scene (III, 3) at the White Horse in Ipswich, where Pickwick finds himself in the wrong bed (in Stirling's version, the lady in the case is economically turned into Aunt Rachel). The realization occurs midscene, with Pickwick in the bed and the lady brushing her hair:

> *Pick.* Oh lord! [*Starts up and peeps through curtain.*
> *Tableaux* [*sic*]. (See plate, No. 8.) *With astonishment.*]
> It's a female Dick Turpin!

By the end of the play, Stirling seems to have found the most economical and acceptable method of dramatizing such fiction: by concentrating on the pictures, not just for the narrative line, but as the basis of the dramaturgical unit and as the prime vehicle of effect.[16]

Oliver Twist, Dickens' most important collaboration with Cruikshank, began generating dramatic versions in the spring of 1838, when about half the novel had appeared in *Bentley's Miscellany*. The most interesting version to survive, however, is George Almar's for the Surrey Theatre (19 Nov. 1838), produced ten days after book pub-

[15] Duncombe, Vol. XXVI.
[16] Stirling's version was less successful than Moncrieff's *Sam Weller; or, The Pickwickians* (Strand, 1837). Both Moncrieff's play and W. L. Rede's *Peregrinations of Pickwick* (Adelphi, 1837) approximate a number of the most situational plates without systematically realizing them.

102. *Hablot K. Browne, "The Middle-Aged Lady in the Double-Bedded Room" (1836), in Charles Dickens,* Pickwick Papers *(London, 1836-37).*

lication of the whole.[17] Almar's version is highly pictorial; but he also has no formula for a pictorial rendering, and therefore contends afresh with the problems of translating text and picture, action and situation, into the language of the stage. The first half of the play capitalizes thoroughly on the vividness and familiarity of the plates. To the middle of Act II, eight of them are prominently evoked, in scenes that tend to animate the pictures rather than realize them as tableaux. So, for example, the opening of the play presents "*the house of* MRS. CORNEY . . . *according to the etching of the history*" (i.e. "Mr. Bumble and Mrs. Corney Taking Tea"). In the course of the scene, Bumble "*instantaneously turns back his collar, places his hat and stick upon a chair, and draws up another chair to the table; as he slowly seats himself he looks at the lady; she fixes her eyes upon the little teapot.*" She gets another cup, serves him, and he hitches his chair over to hers. The picture is quite fully actuated; but the pictorial medium itself is not imitated by a sudden stasis.

After the out-of-sequence opening, the plates (starting with "Oliver

[17] *Acting National Drama*, ed. B. Webster, Vol. VI.

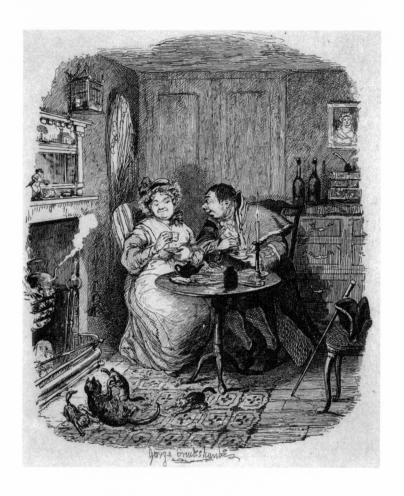

Plucks up Spirit") follow in their narrative order to the middle of the second act. Some vivid scenes not illustrated—such as Oliver in Feng's office—are also dramatized, and some of the best dramatic pictures come directly from the text. So, for example, though Cruikshank's "Oliver Recovering from the Fever" in the house of Mr. Brownlow is fully realized at the opening of Act II as a discovered tableau, the scene ends with the much more effective and situational tableau, not to be found among the plates, of Grimwig and Brownlow, who *"each sink into their chairs, with their eyes fixed attentively on the watch upon the table between them"* as they await Oliver's return from his errand of trust. The effectiveness of the initial tableau depends on the recognition of the plate. The effectiveness of the concluding tableau depends on the situation itself, helped perhaps by the recollection of the text.[18] This concluding tableau recurs, however, four scenes later, at the opening of a scene, making a bridge over the intervening episodes in montage fashion. In this second appearance, the effect *does* depend on a retained visual image, but from the play itself. Dickens similarly recapitulates the image, in his next chapter, after showing what has happened to Oliver; but as a concluding tableau. ("The gas-lamps were lighted; Mrs. Bedwin was waiting anxiously at the open door; the servant had run up the street twenty times to see if there were any traces of Oliver; and still the two old gentlemen sat, perseveringly, in

[18] "With these words, he drew his chair closer to the table; and there the two friends sat, in silent expectation, with the watch between them. . . .

"It grew so dark, that the figures on the dial-plate were scarcely discernible; but there the two old gentlemen continued to sit, in silence: with the watch between them" (Chapter 14).

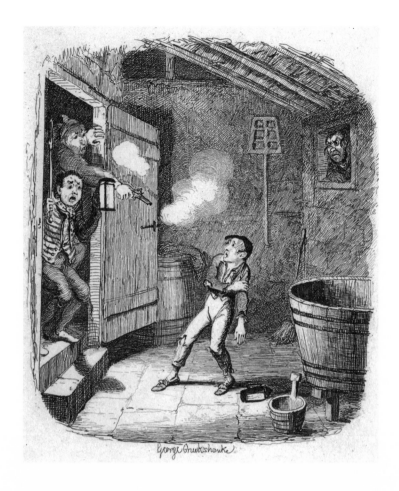

104. George Cruikshank, "The Burglary" (1838), in Charles Dickens, Oliver Twist.

the dark parlour: with the watch between them.") More cadence in the novel than "bridge," the passage closed the seventh installment in *Bentley's Miscellany*. In the translation of the novel into drama, it was the evocative power of the word that asserted itself; but it was the word in its most pictorial mood.

The second half of the play uses fewer plates than the first half. This reversal of what happens in Stirling's *Pickwick* has something to do with the state of completion of the novel dramatized, its design, and the sheer volume of the narrative burden on the dramatist. Almar *must* provide pictures for important narrative completions, such as for Oliver's reunion with the Brownlow household and Rose Maylie. The image of Fagin in the condemned cell, on the other hand, not yet so famous as to be obligatory, he could render economically as Fagin soliloquizing prior to his capture on a fearful dream. Twice Almar finds it useful to reverse the perspective of the plates: once in the climactic scene of the burglary at the end of the second act, and once in the scene of "Oliver Twist at Mrs. Maylie's Door." In the former, the scene in the play is in the garden, *outside* the brewhouse, which has a practicable window. Sikes, Toby, and Oliver come over the wall; Oliver is put into the window, shot at, and pulled out and over, whereupon a crowd with lights, noise, and shooting rushes on for a final tableau. This reverses the perspective of Cruikshank's plate, which

shows Oliver inside clasping a wounded arm, Sikes looking after him through the window, and two armed men standing in an inner doorway, terrified and terrifying. Cruikshank's image is more effective, but Almar chooses to follow the structure of incremental tension in the narrative, which lies, all but the climax, in the long outside approach. For that climax Almar substitutes, in the Surrey style, the crowd-sensation scene and tableau that end the act. The reversal of perspective, of exterior and interior, in the scene of Oliver at Mrs. Maylie's door, also chooses the point of view in Dickens' narrative, rather than that which Cruikshank takes for the climactic discovery in the plate.

The problem of rendering simultaneous action, interior and exterior, in painting, had its equivalent in the problem of rendering continuous action, interior and exterior, in the theater. The conventions were rather less flexible in nineteenth-century painting than in the theater, despite the similarities, for example, between Wilkie's interiors and the theater's developing convention of the missing fourth wall. When Augustus Egg wished to paint simultaneous scenes in different locales in *Past and Present*, he had to make two pictures, though that created a certain amount of bewilderment in his viewers. When Holman Hunt decided he had to show inside and outside to tell the whole story of *A Converted British Family Sheltering a Christian Missionary from the Persecution of the Druids* (1850), he found a disconcerting "real" solution that has been called "at once beautiful, original, and ingenious." He made the shelter a fisherman's hut open to the river—that is, with a naturally missing fourth wall—set in the larger scene.[19] The only ordinary solution for relating inside and outside available in the age was the window, which was thus sufficiently important to be charged with deep iconographic significance. Yet the painter was still obliged to choose a standpoint within or without.

Almar, having reversed perspectives earlier, resolves the problem of uniting inside and outside in the sensation scene near the very end of the play. This is the scene in which Sikes, exposed and pursued by the aroused virtue of Charley Bates, providentially hangs himself, and (in the novel only) is joined by his abused dog in death. The scene begins in "*The interior of an old house situated on Jacob's Island with a view of the Thames by moonlight*," and Toby Crackit playing cribbage with Charlie Bates. It ends both inside and outside, as the music plays and Sikes rushes out, to reappear on the roof, where "*he sets his foot against a stack of chimneys, fastens one end of the rope firmly round it*" (as in Cruikshank's plate), makes a running noose, gets it over his head, and sees Nancy's eyes. "*In turning his head he staggers and is precipitated from roof, the rope tightens and he is left hanging, the mob below shouting 'He has hanged himself'—others overcome* Toby. *Picture*."

Cruikshank more conventionally separates outside from inside in his potent image of Sikes and his dog on the rooftops. But he had more than enough direct involvement with the theater to learn from its capacity for transcending pictorial and temporal rigor. *The Gamblers* (1823), memorable for Thurtell's gig, had had the boldness to remove the entire facade of an inn, and show rooms upstairs and downstairs (like an anticipatory *Death of a Salesman*) through which the action moved. Such a rationalized multiple locale had successors in melodrama

[19] The device is discussed and admired by Alice Meynell and F. W. Farrar in the *Art Annual* volume, *Holman Hunt* (London, 1893), p. 6.

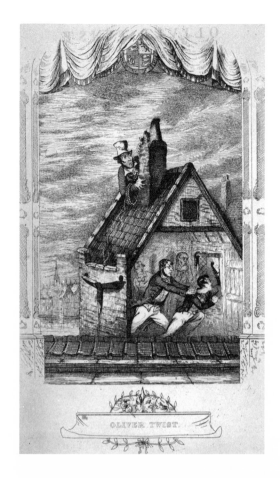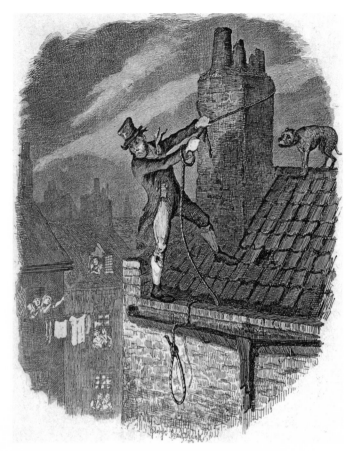

(e.g. Fitzball's *Jonathan Bradford*, 1833 and Boucicault's *Poor of New York*, 1857). But it had a successor also in the multiple diagrammatic illustrations of the escape in *Jack Sheppard* (discussed below). The compensatory tendency in the pictorial theater to expand the picture frame and temporalize the picture found an analogue in Cruikshank the illustrator.

ON THE VERY DAY the Surrey produced Almar's *Oliver Twist*, the Adelphi unveiled Stirling's *Nicholas Nickleby* (19 Nov. 1838).[20] The novel had begun publication in April, and the playwright was able to draw on only seven of the twenty parts. Nevertheless Dickens for the first time found something to applaud in one of these cuckoo fledglings. He wrote to Forster praising, among other things, "the careful making-up of all the people," and finding "the tableaux formed from Browne's Sketches exceedingly good." Mrs. Keeley, as adept at impersonating pathetic waifs as cockney chambermaids, played Smike; and "Mrs. Keeley's first appearance beside the fire (see wollum), and all the rest of Smike, was excellent . . ."[21]

The citation of the as yet nonexistent volume referred to Dickens' text rather than to a Browne illustration. In that text, moreover, Smike's first appearance is in the yard of the school, and his presence at the kitchen fire just previously is only talked about. But in the play the

105. *Pierce Egan, the Younger, Illustration for* Oliver Twist *by George Almar (1838),* The Acting National Drama, *Vol. VI.*

106. *George Cruikshank, "The Last Chance" (1838), in Charles Dickens,* Oliver Twist.

[20] Edward Stirling, *Nicholas Nickleby, A Farce in Two Acts,* in the *Acting National Drama,* Vol. V.

[21] *The Letters of Charles Dickens,* ed. Madeline House and Graham Storey et al. (Oxford, 1965), Pilgrim Edition 1:459-60. Dickens had proposed to furnish Yates with a dramatized *Oliver Twist.* It was Stirling, however, who produced the book for the Adelphi version, in which Yates played Fagin to Mrs. Keeley's Oliver and O. Smith's Sikes. *Letters,* 1:388.

107. *Scenes from Stirling's* Nicholas
Nickleby *(1838),* The Penny
Satirist *(8 Dec. 1838), En-
thoven. Above, "The Orphan—
Mrs. Keeley as Smike." Below,
"Do-the-Boys Hall—Nicholas,
Mr. J. Webster." [See* Nicholas
Nickleby, *Plate 9: "Nicholas
Astonishes Mr. Squeers and
Family."]*

implied picture made an effective opening for the interior scene that
followed, and on the evidence of Dickens' testimony, and a rough
woodcut which appeared in *The Penny Satirist*,[22] the playwright and
the theater here contributed pictorially to the memorable realization
of the novel.

By and large, however, this fairly short play makes a feature of
Browne's illustrations. It realizes plates, all but one as tableaux, from
each of the parts available except the first. The opening scene, realizing
"Nicholas Starts for Yorkshire" from *Nickleby*, Part 2, is unusual in
that it too expands the stage picture to accommodate both exterior and
interior scenes. The plate in the novel is an exterior scene, with Nich-
olas on the Yorkshire coach and Newman Noggs handing up his warn-
ing letter. The scene in the play is "*The coffee room, the window of
which extends across the stage—inn yard of Saracen's Head, Snowhill
seen through it.*" After an episode with Squeers at breakfast, the scene

[22] *The Penny Satirist* 2 (8 Dec. 1838),
p. 1.

108. Hablot K. Browne, "Nicholas Starts for Yorkshire" (1838), in Charles Dickens, Nicholas Nickleby (London, 1838-39).

in the plate is realized. Nicholas having mounted the coach in the yard, Noggs offers the letter. Nicholas asks, "What's this," and Noggs hushes him, and "*Points to* RALPH *who has entered . . . with all the characters for tableau.*" After the realization—"*Tableau. (See work.)*"—the Guard declares, "Now gentleman—coach ready." The horn is blown, Noggs jumps up, and for a final effect the coach moves slowly off while "snow descends heavily as scene closes in."

The last scene (II, 4) achieves a similar concentration of effects. It begins with the tableau realization of the plate in Part 6, "Miss Nickleby Introduced to her Uncle's Friends." The scene develops this "discovery," however, into an improvised denouement, in which Mantalini substitutes for Sir Mulberry Hawk as Kate's persecutor, and Smike is produced with evidence demonstrating Ralph's villainy in a plot to keep Smike out of his just inheritance. The result, of course, is an epitomizing tableau: "*Music. Chord. Picture.* RALPH *appears over-*

whelmed with confusion." As a denouement this was so satisfactory that it served as a model for the plagiarizing novelist whose *Nickelas Nicklebery* dogged the serial issue of the original.[23]

In March 1840, some months after the conclusion of the novel (and after the extraordinary success of Mrs. Keeley in the part of Jack Sheppard), the Adelphi produced Stirling's *The Fortunes of Smike; or, A Sequel to Nicholas Nickleby*.[24] It begins in one sense just after the earlier play leaves off, with the Crummles material from Part 9. It cannot quite claim a serial relation to the earlier play, however, because it has to ignore the improvised denouement which exposed Ralph and left Smike an heir and happy forever after. (The art of undoing the end of a previous episode was only fully developed in the Hollywood serials.) It realizes eight of Browne's plates in its two acts, and culminates in the next to last scene with the death of Smike, to slow music and the tears of Nicholas; one of Mrs. Keeley's pathetic masterpieces, and the forerunner of her Jo.

The following autumn, the Adelphi audiences were favored with Stirling's *The Old Curiosity Shop; or, One Hour from Humphrey's Clock* (9 Nov. 1840).[25] Yates played Quilp and Mrs. Keeley, Nell, which she followed on the same evening with Jack Sheppard, still a staple after more than a year. The playbill as usual proclaims the scenes and situations, but also cites the "Illustrations" that embody them; ten in all, with a page reference and a quotation from the text of the novel for each. One severe reviewer, conscious of paradox, observed that with writers like Dickens, as "dramatic as their compositions are in themselves, so unsuited are they to stage representation." In the case of "an unconnected and badly put together" (and still incomplete) fiction like *The Old Curiosity Shop*, he felt the difficulties to be insuperable. But "The scenery is a perfect copy of the beautiful little sketches that have come from the magic pencils of Brown and Cattermole; the same may be said for the dresses: and here all ground for eulogy ends."[26]

Perhaps with such considerations in mind, Yates waited until December 1841 before his playbills announced "the ADELPHI VERSION of the celebrated Tale lately brought to a conclusion by BOZ, and which has been held back for that purpose, embodying all the Numbers, entitled BARNABY RUDGE!" The playbill lists "*Realization First*, Page 233. – – – *THE MAYPOLE AND ITS CUSTOMERS*" down to "*Realization Fifteenth*, Page 406 . . . *Miggs & her Pattens*," one or two "realizations" to each scene.[27] It was this production, in the mature Adelphi mode, that was likened to "a certain number of grins through a horse-collar."

Mrs. Keeley did not appear as Barnaby in the Adelphi version, though the character in the novel is so suited to her line that it is arguable that Dickens was influenced by her Smike. Nor does Stirling's name occupy its usual place on the playbill, or appear in conjunction with the manuscript submitted to the Lord Chamberlain, though it is possible Stirling was its author. Instead, Mrs. Keeley appeared earlier in the year at another theater in Stirling's two-act version of *Barnaby*, with an anticipation of the climactic riot scenes and an improvised ending (New Strand, 9 Aug. 1841).[28] Of the numerous earlier versions, the best received and most interesting was that of Charles Selby and Charles Melville at the English Opera House (28 June 1841).[29] De-

[23] See Louis James, *Fiction for the Working Man, 1830-1850* (London, 1963), p. 64, for a summary. "Bos" brought his plagiarism to a close after Dickens' tenth number, or two months after Stirling's play.

[24] *Acting National Drama*, Vol. IX.

[25] Duncombe, Vol. XLVIII.

[26] Playbill (9 Nov. 1840), and unidentified rev., Enthoven.

[27] Playbill (10 Jan. 1842), Enthoven. The pagination is that of *Master Humphrey's Clock*, perpetuated in the early separate issues of *The Old Curiosity Shop* and *Barnaby Rudge*. The text of the play survives in L.C. MSS Add. 42960.

[28] L.C. MSS Add. 42959. Another version with prominent realizations was at the Olympic Theatre (licensed 14 Aug. 1841), L.C. MSS Add. 42959.

[29] *Barnaby Rudge. A Domestic Drama in Three Acts*, in Duncombe, Vol. XLIV.

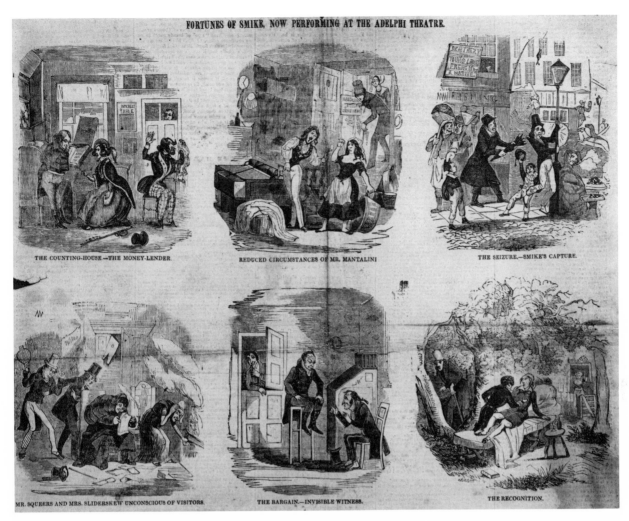

FORTUNES OF SMIKE, NOW PERFORMING AT THE ADELPHI THEATRE.

THE COUNTING-HOUSE—THE MONEY-LENDER.

REDUCED CIRCUMSTANCES OF MR. MANTALINI.

THE SEIZURE.—SMIKE'S CAPTURE.

MR. SQUEERS AND MRS. SLIDERSKEW UNCONSCIOUS OF VISITORS.

THE BARGAIN.—INVISIBLE WITNESS.

THE RECOGNITION.

spite its early date, it lasted nearly three hours and realized fifteen illustrations as tableaux (the last scene, leading to the improvised ending, begins with "The Churchyard from the Old Curiosity Shop"). The improvised ending, however, is full of sensation; the acting edition has three "Tableau" directions in twenty lines, not counting the final tableau. The *Examiner* reviewer, despite his reservations about such translations, calls the play "the best imagined, best executed, and, in some few characters, best acted adaptation, we can remember to have seen. The admirably dramatic marking of character in the original, tended to this effect no doubt; but the detail is worked out, carefully, cleverly, and with complete success."[30]

Formally, in the drama of the age, there were three sorts of tableaux: the discovery at the head of the scene, the midscene tableau, and the final tableau, each with its particular effects. The illustrations in *Barnaby Rudge* and *The Old Curiosity Shop*, integrated with the text rather than accompanying it on "plates," fall into similar functional groups. In the dramatic realization of these illustrations, however, there is no direct transfer of function. The primary effect of the realization is achieved through recognition; and for the rest, the tableau must be made to work as well as possible in the total dramatic economy. Never-

109. *"Fortunes of Smike, Now Performing at the Adelphi Theatre"* (1840), The Penny Satirist *(21 Mar. 1840)*, Enthoven.

[30] *Examiner* (3 July 1841), p. 421.

110. *Hablot K. Browne, Illustration for Charles Dickens,* Barnaby Rudge *(1841), Chapter 3, tailpiece.*
111. *Hablot K. Browne, Illustration for Charles Dickens,* Barnaby Rudge, *Chapter 23, tailpiece.*

great-coat which he took off for the purpose, they proceeded onwards at a brisk pace: Barnaby gaily counting the stars upon his fingers, and Gabriel inwardly congratulating himself upon having an adventure now, which would silence Mrs. Varden on the subject of the Maypole for that night, or there was no faith in woman.

110

arm, to take his seat in the chair and be carried off; humming a fashionable tune.

111

theless—as in any translation worth considering—the adjustments from novel to stage are often reciprocally enlightening. So, for example, the tailpiece in Chapter 3 showing Barnaby and Gabriel Varden over the body of Edward Chester occurs, not at the point in the text where it would reinforce the narrative, but after the reader knows Edward is alive, and he has been wrapped and moved. Concluding a chapter and a number, the epitomizing image has a punctuating function in the novel, but a less important narrative function than if it were midscene.

112. Hablot K. Browne, Illustration for Charles Dickens, Barnaby Rudge, *Chapter 23, headpiece.*

112

In the play, however, it occurs at the opening of a scene (I, 3), and the duration of the picture coincides with an uncertainty and apprehension over the state of Edward's body. The epitomizing image here has an "effective" arresting function; and the scene that follows emerges out of it.

Sometimes functions coincide as well as images. For example, the satirical tailpiece of the Chesterfieldian Mr. Chester entering his sedan chair, which comments upon and punctuates the chapter in the novel in which he interviews Hugh (Chapter 23), does the same work in the play (III, 1). (Taking his hat, Mr. Chester folds it under his arm, and is "*about to step into the chair. Music.* Tableau No. 10 CHESTER *steps in, and the chair is taken off* R. H. *Scene closes.*") The scene in the play also realizes in midcourse the illustration that opens the chapter, in the novel, where it serves as an arresting epitome. (The resemblance between Chester and his uncouth and unacknowledged son, Hugh, is striking.) Both scene and chapter are structured by the two images.

The flexibility of the novel in combining and separating narrative and picture had no ordinary equivalent on the contemporary stage. The result in translation was frequently a coarser but more concentrated effect. The conflation of inside and outside for the last appearance of Sikes was one result. More typical is the conflation of effects in the dramatic version of Dolly Varden's frightening encounter with Hugh of the Maypole on the path through the brush. In the novel the first effect comes at the end of a weekly number (Chapter 20), and depends on the uncertain identity of the apparition. The encounter is therefore not illustrated, though the final lines in other respects have the impact and arrest of a striking curtain tableau:

> But how came the wind to blow only when she walked, and cease when she stood still? She stopped involuntarily as she made the reflection, and the rustling noise stopped likewise. She was really frightened now, and was yet hesitating what to do, when

"Did you come to meet me?" asked Dolly.

Hugh nodded, and muttered something to the effect that he had been waiting for her, and had expected her sooner.

"I thought it likely they would send," said Dolly, greatly re-assured by this.

"Nobody sent me," was his sullen answer. "I came of my own accord."
The rough bearing of this fellow, and his wild, uncouth appearance, had

the bushes crackled and snapped, and a man came plunging through them, close before her.

At the beginning of the next number, Dolly recognizes Hugh with "inexpressible relief." But he remains sullen and uncouth, and soon shows "something of coarse bold admiration in his look"; whereupon Dolly's normal "vague apprehension" of him quickly turns into a terrified and immobilized timidity. At the point of change between relief and apprehension comes Browne's illustration of Hugh and Dolly.

This is the image realized in the play. In Act II, scene 6, "A cut wood," Dolly soliloquizes her apprehensions. "*As she is going* L. H. HUGH *meets her abruptly and* Tableau No. 8 *is formed.*" The effect is in the abruptness of the formation, as well as in the realization itself. The realization assimilates Browne's embodiment of the far subtler and more transitive second situation in the novel to the explosive and more "effective" discontinuity of the first. Occurring early in the scene, the tableau in the play has no terminal function like that of the purely verbal image in the novel, and no transitive function like that of Browne's

illustration, for the scene has to start up again, from rest. The extra gain for the play, however, is in the pleasure of recognition, and the atmosphere of authenticity such realization gives. The beneficiary is that larger enterprise of realization which is the rationale of the novel dramatized.

Jack Sheppard and Company

A scant two years after the first stage versions of *Pickwick*, the pictorial novel dramatized pictorially reached an exemplary climax in the *Jack Sheppard* craze. Ainsworth and Cruikshank complemented each other famously, not only in this novel but in other collaborations. But when realization in another medium was proposed, the solidity and circumstantiality and matter-of-fact brutality that were Ainsworth's special contribution to sensational fiction were no match for the imaginative incandescence, the energy in figure and detail, and the capacity for nightmare that were Cruikshank's. For that reason if no other, the tableau embodiment of the pictures that accompanied Dickens' text was never so obligatory as the tableau embodiment of Cruikshank's share in the collaboration with Ainsworth.[31]

The Jack Sheppard phenomenon was above all a popular enthusiasm, and was roundly attacked in the journals of the "responsible" classes. Starting with the novel, it embraced songs, posters, prints, piracies, and adaptations, "alike rife in the low smoking-rooms, the common barbers' shops, the cheap reading places, the private booksellers', and the minor theatres." Even the *Penny Satirist* found a social threat in the phenomenon, notably in the conjunction of impressionable youth with the intenser reality of the theater. John Forster thought public morality and decency had scarcely been so endangered "since *Tom and Jerry* crowded the theatres with thieves and the streets with brawlers."[32]

Contemporary middle-class critics certainly failed to perceive that the Jack Sheppard craze was "fundamentally gay" (as the chief modern writer on the Newgate novel argues), rather than Chartist, working-class, or even reformist.[33] For contemporaries with some experience of violent mob action, or even an impression from Carlyle or the newspapers, the gaiety itself was both a snare and a threat. For the alarmed, if the Jack Sheppard craze was not directly Chartist or republican, it was a parallel expression, responding to the same social distempers that generated those radical movements. The *Athenaeum* reviewer justified his apocalyptic view of the novel by an account of the intensifying social alienation and economic anxiety of the present time; "an increased artificiality of social life, an estrangement from nature, and a consequent merging of all individualities in one common character." In his view, the novel is a pathological response to "the struggle for existence," urbanization, and "the routine habits of a sordid industry." In a money-centered, utilitarian society, "the prevalence of uneasy sensations, the constant anxieties, the absence of all pleasures, and more especially of domestic pleasures, arising out of difficulties and uncertainties respecting the means of existence, sour the temper, and deprave the heart." Like the cartoonist in the *Penny Satirist*, he points out the failure of the "harvest of intellect" produced under the stimulus of the French

[31] A fine account of the narrative and pictorial rationale of Cruikshank's work with Ainsworth and Dickens is Anthony Burton's "Cruikshank as an Illustrator of Fiction," *Princeton University Library Chronicle* 35 (1973-74): 93-128. Burton is particularly illuminating on how formal continuities between the plates reinforce and create narrative continuities. Also valuable is John Harvey's *Victorian Novelists and Their Illustrators* (London, 1970), and J. Hillis Miller's "The Fiction of Realism: *Sketches by Boz, Oliver Twist*, and Cruikshank's Illustrations," in *Charles Dickens and George Cruikshank* (Los Angeles, 1971), pp. 1-69.

[32] *Examiner* (3 Nov. 1839), pp. 691-93. Cruikshank was also deeply implicated in this earlier public scandal on at least two counts. The playbill for W. T. Moncrieff's version of *Life in London* (Adelphi, 26 Dec. 1821) proclaims itself "Replete with prime Chaunts, rum Glees, and Kiddy Catches; founded on P. EGAN's well-known and highly popular work, of the same Name, THE COSTUME and SCENERY superintended by Mr. J. R. CRUIKSHANK [sic], from the Drawings of himself and his Brother, Mr. G. CRUIKSHANK." Moncrieff later declared (minimizing his debt to Egan), "But to return to TOM and JERRY,—it need scarcely be stated that it is founded on Cruikshank's inimitable plates of LIFE in LONDON." See "Remarks to the Second Edition," *Richardson's New Minor Drama*, Vol. I (London, 1828). About half the scene descriptions in the playbill use phrases from the picture titles in the novel, and fifteen of the nineteen different dramatic locales are illustrated in the thirty-six plates. Nevertheless the evidence of both the Larpent MS (Huntington Libr.), which is close to the original production, and the revised *Richardson* text indicates that the plates were not "realized," but rather that the scenes represented were loosely assembled and approximated, in action, dialogue, and song. "The New Pedestrian Equestrian and Operatic Extravaganza TOM AND JERRY" at Sadler's Wells (1822) went further afield, with country and sporting scenes, including pony races, but it billed itself as "Put into shape, (exclusively for this Theatre) by PIERCE EGAN." Well down, the playbill observes: "The Scenes from Drawings taken on the Spot, by Mr. GREENWOOD . . . The Sporting Subjects, by Mr. G. Cruikshank, from designs by himself and Brother, Mr. I. R. CRUIKSHANK."

[33] Keith Hollingsworth, *The Newgate Novel, 1830-1847* (Detroit, 1963), p. 141.

114. *"The March of Knowledge,"* The
Penny Satirist *(15 Dec. 1839)*,
Enthoven.

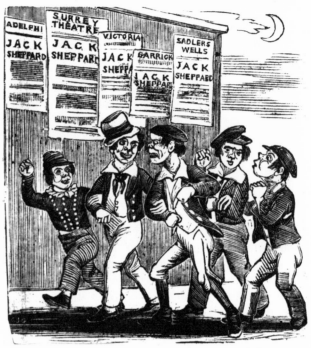

THE MARCH OF KNOWLEDGE:
OR JUST COME FROM SEEING "JACK SHEPPARD."

JACK SHEPPARD.

FIRST JUVENILE.—I say, wasn't it well acted? SECOND JUV.—I believe you. I do likes to see them sort o' robber-pieces. I wouldn't give a tizzy to see wot is call'd a moral play—they ar' so precious dull. This Jack Sheppard is worth the whole on 'em.

THIRD JUV.—How I should like to be among the jolly cocks; plenty to eat, drink, and spend—and every one has his *mott* too.

FOURTH JUV.—Ar; shouldn't I like to be among 'em in real arnest. Wot jovial lives they seem to lead! and wot's the odds, so long as you ar' happy? Only see how such coves are handled down to posterity, I thinks it's call'd, by means of books, and plays, and pictures!

FIFTH JUV.—Blow'd if I shouldn't just like to be another *Jack Sheppard*—it only wants a little pluck to begin with.——ALL FIVE.—That's all.

Revolution, and suggests that classes below those that form the paying public for the novel, classes educated by circumstance, "are brooding over the elementary principles of social existence, and are heaving with all the passions incident to the first crude conceptions of the most stirring truths."[34] E. J. Hobsbawm observes that "Social banditry and millenarianism—the most primitive forms of reform and revolution— go together historically."[35] And they go together culturally as well. Since the middle ages, the social bandit was a cultural confection in England, rather than a raw reality. In 1829 he appears in the shape of the heroic Massaroni, Planché's quintessential romantic brigand based on Eastlake's picturesque Italian scenes, and is broadcast in play, print, song, china, and toyshop (see above, pp. 111-15). In 1839, he appears in urban, native dress and circumstances in the shape of the boyish Jack Sheppard, and sheds his remote, picturesque, "ideal" character. The shift reflects not only a change in style and taste, but a changing social reality and new currents in the cresting tide of secular millenarianism.

Jack Sheppard appeared in *Bentley's Miscellany* between January

[34] *Athenaeum* (26 Oct. 1839), pp. 803-804.
[35] *Bandits* (London, 1969; Pelican ed. 1972), p. 29.

1839 and February 1840, overlapping *Oliver Twist*. However, the complete novel was issued in three volumes in October 1839 before serialization ended, and the chief dramatic versions appeared before the end of that month. Though Ainsworth conceived of the work as "a sort of Hogarthian novel,"[36] the text is by no means without direct dramatic and fictional models apart from his own previous work. The Gothic heritage of melodrama speaks in the language, and appears in the allegorical configurations of character—Jack between his saintly (once fallen) mother and the demonic Jonathan Wild, whose special malice toward Jack is motivated by a secret revenge. ("Mine—mine forever!" says Wild when Jack picks a pocket in church as his mother faints; when she asks Wild, after Jack chooses conclusively "between good and evil;—between him and me," how many years he will give her son, "NINE! answered Jonathan sternly," much in the spirit of Weber.)[37]

The relation to melodrama is apparent also in the seeming deaths which are not deaths, in the overriding concern with "effect," and even in the songs at regular intervals, long the obligatory mark of the illegitimate drama. (In one instance, Ainsworth supplies the music; in others, in the 1840 edition, he refers readers to the settings and arrangements made for the stage.) The brace of villains, one a tormented aristocrat, the other a grim vulgarian; the permanently spotless ingenue; the suffering "heavy" female; and the permanently astonished *père bourgeois* belong to the standard lines of melodrama in a fixed-company theater. They speak a conventional dramatic language, including asides. Sir Rowland declares:

"I will struggle no longer with destiny. Too much blood has been shed already."

"This comes of fine feelings!" muttered Jonathan, contemptuously. "Give me your thorough-paced villain. But I shan't let him off thus. I'll try a strong dose.—Am I to understand that you intend to plead guilty, Sir Rowland?" he added. "If so, I may as well execute my warrant." [p. 144]

The Thames Darrell plot, with its concealed parentage, proud and wicked uncle, and struggle in the dark over an inheritance, is staple melodrama; and the mode is underlined by Ainsworth's pervasive use of a melodramatic Providence. In melodrama, the more patent and blatant the providential coincidence, the better, the more believable. Coincidence in this mode is evidence of truth, as it is of coherence in the nature of things; and coincidence creates "effect," the effect of melodrama.

Of eighteenth-century dramatic ancestors, *The London Merchant* clearly left its mark on the prentice plot, along with Hogarth. *The Beggar's Opera* influenced the style of Jack Sheppard's gallantry and the ambiguous polarity of thief and thief-taker, and would further influence some of the dramatizations. The novel also bears the mark of Scott and the new canons of historical fiction: in the Jacobite background to the intrigue, and the considerable interest in antiquarian detail. There is much topographic information on the streets, on the sanctuary quarter of the Mint and its history, and on London Bridge, including

[36] Quoted in Hollingsworth, *Newgate Novel*, p. 134, from a letter of 29 May 1837 in S. M. Ellis, *William Harrison Ainsworth and His Friends* (London, 1911), 1:328.

[37] Citations here are from Bentley's one-volume edition of 1840. Wild's promise comes at the end of "Epoch the Second," p. 229.

a technical account of the starlings (piers) where—in night and storm—some of the action takes place. Closely related are the detailed descriptions of costume and of interior settings, scrupulously congruent with the plates, but lacking the vivid autonomy characteristic of Cruikshank's detail.

Ainsworth's concern with manners and actions is consistent with his archaeological historicism. The flash language he reports is offered for its intrinsic interest, as is the precise, detailed, and deliberately uninventive narrative of Jack Sheppard's famous escapes. The account of these is chiefly physical—a sequence of carefully described actions in chronological order, with an occasional comment by Jack early on, and an occasional reflection on his sensations. The interest is technical; but the technique—Ainsworth's equivalent of the mimed action so important in the melodrama of the first half of the century—is also a technique for generating incremental suspense. Formally if not qualitatively, the objective accounts of the escapes suggest later phenomenalistic styles of narration, by way of precisely detailed (relatively affectless) objects and actions, analyzed into small units serially arranged. Cruikshank renders the narrative of Jack's chief escape, and of his final procession to Tyburn for execution, in multiple step-by-step plates, ten serial images on three plates for the escape, six on two for the procession and execution. With Cruikshank (as with Hemingway), the externality can be more apparent than real, even when the image is pointedly technical and diagrammatic. Thackeray, enthusiastic over all the pictures, thought "the gems of the book are the little vignettes illustrating the escape from Newgate . . . a series of figures quite remarkable for reality and poetry too." He notes, sensitively, "the extreme *loneliness* of them all."[38]

The weight placed upon precise external description and verifiable external detail in the text promoted the disposition to take their pictorial version as the truer, fuller, more authentic representation. Despite the melodramatic psychomachia, the chief events of the novel are visible and concrete, not internal or abstract. Indicative of the hierarchy that results is the facsimile representation in the midst of the text of the rough letters of Jack's name, carved on the beam in the days of his apprenticeship "(of which, as it has been carefully preserved by the subsequent owners of Mr. Wood's habitation in Wych Street, we are luckily enabled to furnish a facsimile)." The same carving appears in Cruikshank's plate, that "famous drawing of 'Jack carving the name on the beam,' " Thackeray calls it, "which has been transferred to half the play-bills in town."

The pictorialism of the novel of *Jack Sheppard*, then, goes beyond its Hogarthian inspiration. That inspiration is manifest, however, not only in the borrowed scheme of *Industry and Idleness*, and the representation of eighteenth-century urban low-life, but also in the reflexive presence of Hogarth in the novel culling inspiration for his idle prentice from the example of Jack. The allusions to Hogarth are on Cruikshank's part as well as on Ainsworth's; not only in the illustrated scene at Tyburn, which recreates the end of Hogarth's Tom Idle, but more subtly, in "Mrs. Sheppard expostulating with her Son," where she lies in a canopied bed with a hatbox on top like that in the third

[38] "George Cruikshank," p. 57.

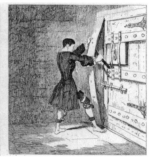

115 *The Escape No. 1* 116 *The Escape No. 2*

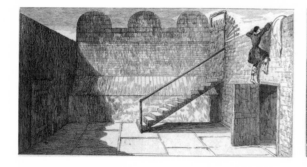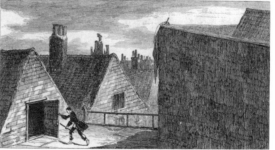

117 *The Escape No. 3*

plate of *A Harlot's Progress* (Fig. 19), while Jonathan Wild, peering around the curtain unobserved, and the open door recall the entry of the magistrate in the same scene. The Hogarthian emblems on the wall—including a print of Mary Magdalene—underline the reversals.

In all this Cruikshank was as concerned as Ainsworth with authenticity. Consequently his plate of "Jack Sheppard escaping from the condemned hold in Newgate," drawn through the bars by his two doxies in the presence of his jailers, is a direct transcription of the frontispiece of Sheppard's *Narrative*, purportedly "written by himself during his Confinement" in the year of his execution.[39] Similarly the scene of "The Portrait" (where Hogarth, Gay, and Thornhill appear)

115-17. George Cruikshank, "The Escape No. 1" "No. 2" and "No. 3," in W. H. Ainsworth, Jack Sheppard *(London, 1839).*

[39] *A Narrative of all the Robberies, Escapes, & c. of John Sheppard,* 8th ed. (London, 1724), sometimes attributed to Defoe. Ainsworth quotes phrases from this document.

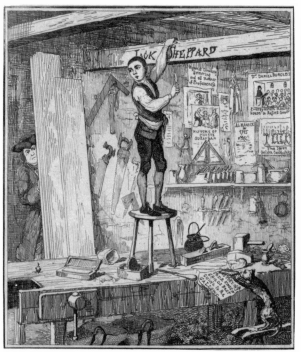

118

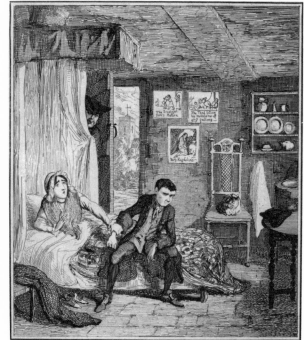

119

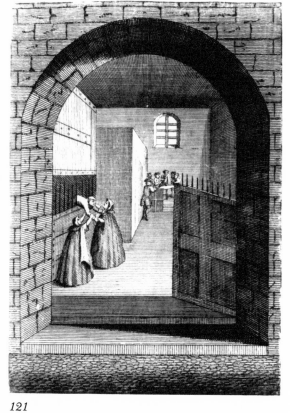

120

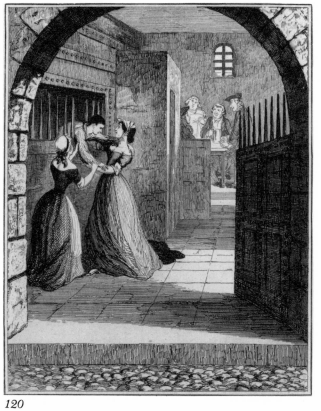

121

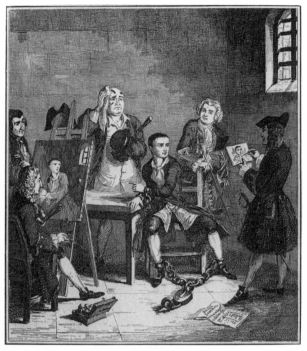

122

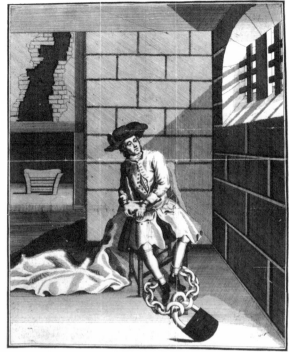

123

and the vignettes of "The Escape" incorporate details from Thornhill's portrait, and from a contemporary engraving, "Jack Sheppard, Drawn from the Life," showing "A. The Hole he made in ye Chimney when he got loose." Even the multiple-image plates had a predecessor, in a seven-compartment Thief's Progress by Nathaniel Parr (fl. 1730-1760), let into the Huntington Library copy of Sheppard's *Narrative*, and a plausible link between Hogarth's Tyburn scene and Cruikshank's. All this is not simply influence, but a witty form of iconic documentation, in the interest of authenticity.

THE DRAMATIC versions of *Jack Sheppard* that survive are faithful to the pictures, and rather free with the text. They rely on the pictures for effect, but even more for authenticity, as a realization of the novel. Other effects could be added thereto as long as the pictures were faithful, including even the lark of having Mrs. Keeley play Jack in the most successful of all versions, at the Adelphi.[40] The advertising, especially for this version (by Buckstone), makes the special importance of the pictures clear. The unusual poster that went out on the hoardings, in place of a mere listing of scene and situation, presents pictorially twelve of the "Illustrations" as an epitome of the whole.[41] The Surrey playbills supported J. T. Haines' "Singularly Graphic, Melo-Dramatic, and Panoramic Adaptation" with a letter from Ainsworth declaring him "*satisfied it will furnish a complete representation of the Principal Scenes of the Romance. . . . The fact of the whole of the Scenery having been superintended by Mr. GEORGE CRUIKSHANK, must be a sufficient guarantee to the Public for its excellence and accuracy.*"[42]

118. (facing page, top left) *George Cruikshank, "The Name on the Beam," in W. H. Ainsworth,* Jack Sheppard.

119. (facing page, top right) *George Cruikshank, "Mrs. Sheppard expostulating with her Son," in W. H. Ainsworth,* Jack Sheppard.

120. (facing page, bottom left) *George Cruikshank, "Jack Sheppard escaping from the condemned hold in Newgate," in W. H. Ainsworth,* Jack Sheppard.

121. (facing page, bottom right) "*The manner of John Shepherd's Escape out of the Condemn'd Hole in Newgate," in* A Narrative of All the Robberies, Escapes, &c. of John Sheppard, *8th ed. (1724).*

122. (above left) *George Cruikshank, "The Portrait," in W. H. Ainsworth,* Jack Sheppard.

123. (above right) *Jack Sheppard, Drawn from the Life, London, British Library.*

[40] Mrs. Honner played Jack at Sadler's Wells; but Mr. E. F. Saville played him in the version Ainsworth and Cruikshank endorsed, at the Surrey.

[41] A similar poster had advertised Al-

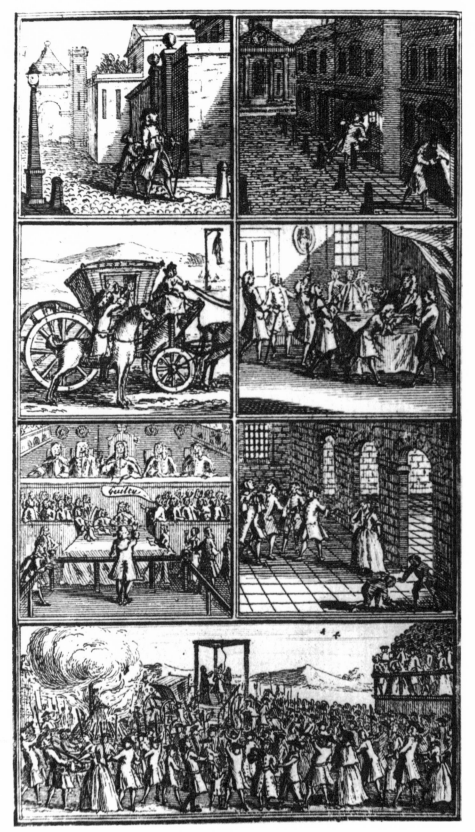

124

124. *Nathaniel Parr [A Thief's Progress]*, San Marino, Cal., Huntington Library.
125. *Poster for J. B. Buckstone's* Jack Sheppard, *Adelphi Theatre (1839)*, Enthoven.

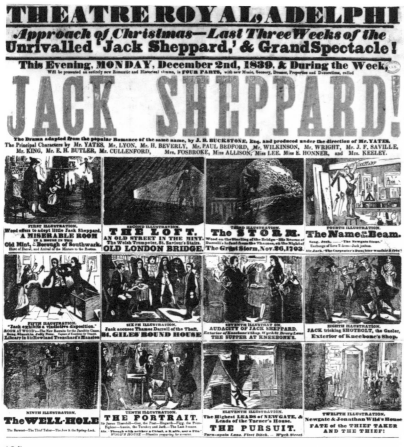

125

None of the plays could in fact furnish a complete representation of all the principal scenes, even as embodied in the illustrations. There were twenty-seven plates, five of them with multiple pictures. Haines' play therefore skips what the book calls "Epoch the First, 1703," the period of Jack's infancy, and begins with the famous image of the idle apprentice carving his name on the beam. Buckstone's play on the other hand skimps some of the later episodes, but realizes (in two instances approximates) eight of the first nine plates, and begins where Cruikshank begins, with a tableau-discovery of the first of the illustrations, "Mr. Wood offers to adopt little Jack Sheppard."

In the novel, "Epoch the First" was illustrated by three of Cruikshank's dark scenes, the two most powerful set on the river. The *Times* (whose enthusiasm for the Adelphi version was reinforced by Buckstone's vigorous use of the shears on Ainsworth's narrative, "for scissors would not have been sufficient" to reduce "the almost endless rubbish, balderdash, twaddle, and vulgarity") reported that for the realization of one of these scenes, "the whole stage of the theatre is sunk about eight or ten feet below its general level. The storm on the Thames is introduced with a very surprising mechanical effect; and the distant view of St. Paul's Cathedral and the houses on the Middlesex side of the river, as seen from one of the starlings and through an arch of Old London-bridge, is excellent."[43] The visual climax (and realization) of the scene is represented by the stage direction, "*The river rises high.—*

mar's *Oliver Twist* at the Surrey Theatre (Harvard Theatre Coll.).
42 Playbill (28 Oct. 1839), Enthoven.
43 *Times*, 29 Oct. 1839.

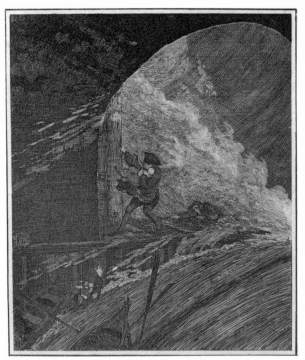

126

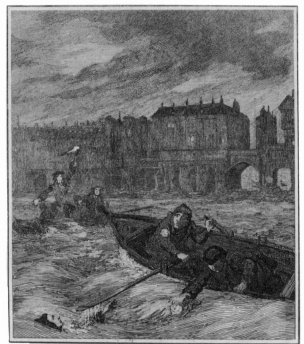

127

126. *George Cruikshank, "The Storm," in W. H. Ainsworth, Jack Sheppard.*

127. *George Cruikshank, "The Murder on the Thames," in W. H. Ainsworth, Jack Sheppard.*

WOOD *clings to the starling, holding the child firmly in his arms—the water almost covers him*"; but prior to this moment, action and detail represented in the other river plate, "The Murder on the Thames," are incorporated in the scene.[44] Thus Buckstone brings into the play, by verbal or visual allusion, the plates not actually reproduced. Conversely, scenes not illustrated tend to disappear no matter how "dramatic" by current standards. So, three of the four plates belonging to "Epoch the First" are reproduced, and the fourth evoked indirectly, but the tableau confrontation (ending a chapter) between Mrs. Sheppard and Jonathan Wild is omitted, though it defines the moral and dramatic contest that follows and in itself reeks with theatrical effect. It is here in the novel that Jonathan reveals his particular malice, and promises to hang Jack "on the same tree as his father."

"Pity!" shrieked the widow.

"I'll be his evil genius!" vociferated Jonathan, who seemed to enjoy her torture.

"Begone wretch!" cried the mother, stung beyond endurance by his taunts; "or I will drive you hence with my curses."

"Curse on, and welcome," jeered Wild.

Mrs. Sheppard raised her hand, and the malediction trembled upon her tongue. But ere the words could find utterance, her maternal tenderness overcame her indignation; and, sinking upon her knees, she extended her arms over her child.

"A mother's prayers—a mother's blessing," she cried, with the fervour almost of inspiration, "will avail against a fiend's malice."

"We shall see," rejoined Jonathan, turning carelessly upon his heel.

[44] J. B. Buckstone, *Jack Sheppard, A Drama in Four Acts*, in *The Acting National Drama*, Vol. VII, Act I, sc. 5. The opening scene direction reads: *"Old London Bridge—The starling of the bridge—The storm (see Illustration)."*

And, as he quitted the room, the poor widow fell with her face upon the floor. [pp. 51-52]

Not illustrated, it is therefore not the obligatory scene one might think in a melodrama; and Buckstone's Jonathan has to declare his malice for the son of Tom Sheppard more economically, in soliloquy. The contrast with Almar's treatment of the tableau of Brownlow and Grimwig is significant.

Buckstone's scene in the "Flash Ken" (III, 1), where Jack and Blueskin sing the wildly successful song (borrowed from Ainsworth's *Rookwood*) "Nix my Dolly Pals, Fake Away," reflects an intention to shift Ainsworth's Newgate drama into a lighter, gayer key, closer to *The Beggar's Opera*. The drink shop itself, and even the positions of the principal persons who come on the scene, are drawn directly from the Cruikshank plate titled "Jack Sheppard gets drunk & orders his Mother off."[45] But this unsympathetic action is dropped (and with the principal situation altered, the scene is not advertised as an "illustration"). The development of lighter tones, however, especially for the character of Jack, did not preclude the embodiment of the most sensational nightmare scenes; as for example, when Sir Rowland, the less confirmed villain, is hurried out through a door in the scene representing Wild's rooms. Blows and cries sound through the scene-change, to (III, 8) "*The Well Hole—A door seen at back, on the top of the stairs—* SIR ROWLAND *darts down them, through the door, streams of blood pouring down his face.*" He is forced over the rail, "*clings to it with both hands, and appears hanging fearfully over the hole.*" Ignoring his cries,

> JONATHAN *savagely strikes his hands with the loaded bludgeon—* SIR ROWLAND *falls into the abyss. (See illustration of "*JONATHAN WILD *throwing* SIR ROWLAND *down the Well Hole")*
>
> *A hollow plunge is heard, as of* SIR ROWLAND'S *descent into the water—A groan.*

At the end of the scene—"horribly effective" in the *Times*'s view—Wild and his torchbearer Mendez find themselves accidentally trapped by a shut door. This turn of events has no great consequence in the novel for Wild; but Buckstone uses it to contrive his sensational ending.

The chief claim to fame of the original Jack Sheppard, and a major concern of the novel (with four such occasions represented in six of the plates) were Jack Sheppard's prison escapes. These are somewhat skimped in Buckstone's Adelphi version, and the chief escape is represented with evasive ingenuity. The latter begins in a "*cell in Newgate, in the castle,*" with a precise frozen realization of the most self-consciously pictorial of Cruikshank's pictures (IV, 3):

> JACK *discovered sitting for his picture by* SIR JAMES THORNHILL HOGARTH *is taking a sketch on the L.—*FIGG, *a prize-fighter;* GAY, *the poet; and* AUSTIN, *a turnkey, standing by.* JACK *is fastened to the ground and handcuffed.* (*Vide Illustration, '*THE PORTRAIT.*'*)

When Jack is left alone, he begins his escape as represented in the first vignette on the first of three multiple-image plates. His action (Mrs. Keeley's) is partly danced and sung—a gay substitution for the tense pantomime of the novel—and it is confined to one cell. Jack's song is

[45] Compare the tavern scene in *The Rake's Progress*, particularly the third state.

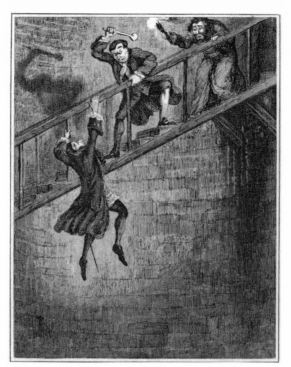

128

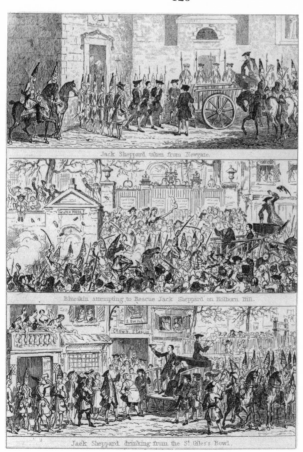

Jack Sheppard taken from Newgate.

Blueskin attempting to Rescue Jack Sheppard on Holborn Hill.

Jack Sheppard drinking from the St. Giles's Bowl.

129

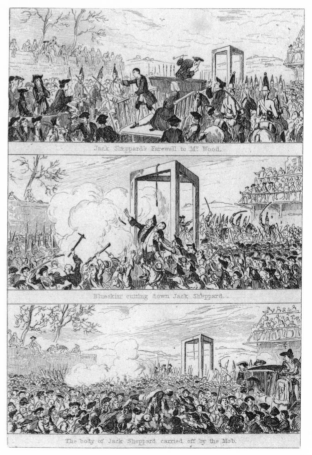

Jack Sheppard's Farewell to Mr. Wood.

Blueskin cutting down Jack Sheppard.

The body of Jack Sheppard carried off by the Mob.

130

a medley, in the style of Macheath's soliloquy in the condemned cell. For the rest of the escape—represented in Cruikshank's ten vignettes as a series of actions progressing through a series of locales, from confinement to freedom—Buckstone resorts to a parallel montage solution. He shifts to a short scene elsewhere, Wood's house in Dollis Hill, where Wood enters singing and dancing; and then shifts back, for a realization in action of the end of the escape, beginning (IV, 5): *"The highest leads of Newgate, and the leads of the Turner's house. A loft-door on* R. *(See Illustration)* . . . JACK *is discovered descending by the wall on the* L.—*his blanket is fastened to a corner of it by a nail* . . ." The montage technique is then extended through a series of quick scenes—Jack in flight, his henchman Blueskin raising a torch-carrying mob—into the spectacular ending.

Buckstone makes considerable use of mobs in the play, as in the first scene, where "*a mob of women and men armed with bludgeons, some carrying saucepans with stones in them, which they rattle, others with bladders on sticks, torches, hatchets, pickaxes. . . . all enter yelling, whistling, leaping, howling . . . the mob entirely filling the stage.*" They answer a summons to fight bailiffs who have entered the old sanctuary of the Mint, but they are easily manipulated and prove dangerous to the well-disposed. In this the play follows Ainsworth, whose mobs—particularly in the virtual revolution near the end of the novel—elicit an apocalyptic imagery that is also found in Dickens and Carlyle.[46] In place of Cruikshank's moving-panorama procession from Newgate to Tyburn, however, followed by the multiply-illustrated events of "The Last Scene," Buckstone concentrates his conclusion into a single mob-sensation scene before Newgate, drawing together the several strands of action in the previous scenes. The mob attacks and sets ablaze the house of Jonathan Wild (events of the previous evening in Ainsworth's novel, where Wild escapes to live again in Fielding). Wild and Mendez, still trapped, appear at a window, and "*A roar of delight escapes from* BLUESKIN *and the Mob.*" Wild tears away the bars and hangs out the window "*in helpless agony,*" to be pelted and laughed at. Jack is brought in, pinioned; Wild wickedly exults—"Ha! I have kept my oath! To Tyburn!"—and the interior instantly collapses, burying him with Mendez "*in the smoking ruins.*" Jack then kisses his old master's hand, the virtuous young couple of the story embrace, the mob cheers, and the curtain falls on what is a final tableau. Buckstone's version, constrained perhaps by the small Adelphi stage, concentrates the ending into a single situation, and combines vigorous sensationalism with the tendency to go easy on Jack which marks the Adelphi adaptation. In the final tableau, with Jack framed by the triumphant mob raised for the purpose of rescue, Jack's fate is left ambiguous despite Wild's triumphant cry. The *Times* reviewer comments on the conflagration: "This scene, which is actually terrific, concludes the piece. There is no execution on the stage, and the spectators are saved the disgust which the catastrophe of the novel represents."

A simple, more faithful, and much less economical solution to the problem of the final scenes was offered in the Surrey version, which, "having been superintended" by Cruikshank, realized nearly every illustration in the novel after "Epoch the First." The burning of Wild's house took place, as in the novel, beforehand; and the succeeding scene

128. (facing page, top) *George Cruikshank, "Jonathan Wild Throwing Sir Rowland Trenchard down the Well-Hole," in W. H. Ainsworth,* Jack Sheppard.

129. (facing page, bottom left) *George Cruikshank, "The procession of Jack Sheppard from Newgate to Tyburn," in W. H. Ainsworth,* Jack Sheppard.

130. (facing page, bottom right) *George Cruikshank, "The Last Scene," in W. H. Ainsworth,* Jack Sheppard.

[46] The crowd-sea imagery that the other two use so brilliantly appears in Ainsworth's account of Jack's execution, e.g. (p. 479), "The body of Jack Sheppard, meanwhile, was borne along by that tremendous host, which rose and fell like the waves of the ocean, until it approached the termination of the Edgeware road." (Cruikshank's visual rendering of the scene combines revolution and sacred deposition.) Though it borrows its weather from Gothic melodrama and John Martin ("The destroying angel hurried by, shrouded in his gloomiest apparel. . . . Ten thousand steeds appeared to be trampling aloft, charged with the work of devastation" [p. 63]), the apocalyptic note is more than obligatory convention in this novel.

in the press room (illustrated), where Jack has his irons knocked off, was—in the language of the playbill—"to be followed by a new, peculiar and extensive"

DIORAMA!
PROCESSION from the OLD BAILEY to TYBURN!
With Authorities, Civil, and Military.
The First Tableau:—
EXTERIOR OF OLD NEWGATE!
With the Removal of Jack to the Cart!
Second Tableau:—
HOLBORN HILL, WITH ST. ANDREW'S CHURCH!
Attempt of the Mob to Rescue the Culprit, led by Blueskin!
Third Tableau:—
ST. GILES'S.
The halt at the Crown, *Saint Giles's Bowl*—Here, according to Ancient Custom, the Criminal Drank his Last Refreshment on Earth.
Fourth Tableau:—
TYBURN:—THE TRIPLE TREE!
The executioner summoned—THE VEIL!—The Rescue—The Death of Jack and Blueskin—The Attack on Wild, with GRAND AND IMPOSING TABLEAU![47]

The "Diorama" here was a moving background, a long continuous scenic strip in a form (see above, p. 62) that was surely the original inspiration for Cruikshank's strip illustration of the procession. In the theater the movement was evidently arrested at each of the stages in Cruikshank's representation, and these were realized as tableaux.[48]

The fourth tableau to punctuate the Surrey diorama represents the plate Cruikshank titled "The Last Scene," actually a threefold scene whose parts were labeled "Jack Sheppard's Farewell to Mr. Wood," "Blueskin cutting down Jack Sheppard," and "The body of Jack Sheppard carried off by the Mob." Here, in the theatrical version, the background is constant but the situation is fluid and complex (whereas during the procession the underlying situation remained constant and the background changed). The action of the the last scene is realized directly in the play, and through a species of visual action in Cruikshank's plate. The gallows forms the most obvious reference point in Cruikshank's three pictures, and the tracking approach from the first to the medium-close second, the swift retreat from the second to the wide-angled third, create motion in the act of perception, and make of three images a continuous scene.

The absorption of the pictorial language of the theater into Cruikshank's narrative inventions, and its passage back into the theater is illustrated also in some of the dramatic versions of the escape from Newgate. Thomas Greenwood's *Jack Sheppard* for Sadler's Wells (and probably Haines's version for the Surrey) used an elaboration of the compartmentalized set, combining the simultaneous interior set of *The Gamblers* (like the four boxes of Cruikshank's "The Escape No. 1" and "No. 2") with the inside and rooftop outside of Almar's *Oliver Twist*. Greenwood's scene (IV, 1) asks for "*Newgate—four Cells, two*

[47] Enthoven.
[48] This dioramic progress is recreated in Peter Brook's film of *The Beggar's Opera*, where the procession to the gallows along Holborn, the stop for the last cup, and the Tyburn scene are closer to Cruikshank than to Cruikshank's model for the Tyburn scene, Hogarth.

*above and two below—grated windows in the back—a lead flat on the
top—doors, leading from one cell to the other—a fire-place at the back of
the condemned cell,* L. *Moonlight.* JACK SHEPPARD *discovered in the
condemned cell,* L., *heavily ironed to the floor."*[49] In the course of the
scene Jack breaks himself free, ties up his chains, digs out stones from
the wall of the chimney with a broken link, wrenches out the bar, and
climbs up the chimney. *"Blows are heard—a hole is made in the wall
of the cell above, he creeps through the aperture with the bar, and goes to
the door at the side of the cell."* With difficulty, he breaks out plank and
lock and makes his way into the second upper cell, and then breaks
out the door on the other side. *"He rushes through, and re-appears on
the lead flat."*

> *Jack.* (*Looking down from the roof, and shuddering.*) " 'Tis a
> fearful height!" (*Considering.*) "Ah! my blanket! I had forgotten
> it."
>
> (*Music.—He hastens down, and re-appears in the upper cell,* R.,
> *and is seen traversing the different rooms, until he gains the lower
> one,* L.—*he snatches the blanket, ties it round his body, and returns
> hurriedly to the upper cell,* R., *falls on his knees, but, looking up,
> shudders and hides his face in his hands—he then tears the blanket
> into strips, ties them together, and disappears at the door,* R.—*on
> reaching the roof, he drops the blanket down behind, fastens it to a
> hook, and is seen through the grated windows descending to the street,
> as the scene closes.*

Greenwood manages to incorporate much of the action Ainsworth
describes, and many of the particular images through which Cruik-
shank represents the stages of the arduous escape (including a reminder
of an earlier illustration of Jack and his doxie escaping by blanket from
Clerkenwell Prison). More important, Greenwood captures both the
suspenseful technical interest and the serial and simultaneous character
of Cruikshank's memorable embodiment of the escape. Ainsworth is
careful to note the time for each stage of the escape—one hour and a
quarter to break out the chimney wall, six hours all told to reach the
roof of the prison, ten minutes to re-escape with blanket. The narrative
of course takes a good deal less time, and the theatrical enactment—
without losing its representational quality, its effect of intolerable du-
ration, or its reality—is also much shorter; lasting perhaps no longer
than the time it takes to really "read" the pictures.

THE PICTORIAL staging of other Ainsworth-Cruikshank collaborations
in the early 1840s followed the patterns developed by Stirling, Yates
and the rest, and do not add appreciably to our understanding of the
interplay of picture and story, of situation, spectacle, and action. But
these stagings did reinforce the practices and attitudes that led Cruik-
shank to think of himself in some of his collaborations as more *auteur*
than illustrator. *The Tower of London*, issued serially, appeared in 1840,
and produced a crop of plays toward the end of that year. For the
version at the Surrey (by J. T. Haines), the playbill made a feature of
every "Realization of Tableau! "; but also of the historicism, including
the facsimile signatures of "Jane the Quene" and "Marye the quene."[50]

[49] *Jack Sheppard; or, The Housebreaker
of the Last Century, A Romantic Drama
in Five Acts*, in Cumberland Minor, Vol.
XV.

[50] Playbill for *The Tower of London; or,
The Days of Queen Jane and Queen Mary*
(1 Feb. 1841), Enthoven.

Ainsworth in this "Historical Romance" let loose his whole delight in archaeological historicism, using the romance discoverable in the lives of Mary Tudor, Jane Grey, and the young Elizabeth as a prime excuse. He declares that he shaped the story for the purpose of "exhibiting the Tower in its triple light of a palace, a prison, and a fortress," and "endeavoured to contrive such a series of incidents as should naturally introduce every relic of the old pile—its towers, chapels, halls, chambers, gateways, arches, and drawbridges . . ."[51] There is much straightforward guidebook writing, and the first complete edition was equipped with an index. There is also a drumfire of melodrama with both Gothic and comic effects. The result was to promote the importance of the pictorial side of the collaboration in two directions. Their superiority for architectural description increased the authority of the pictures; and the archaeological interruptions put the burden of providing the memorable embodiment of atmosphere and situation more heavily than ever on the pictures.

The functions are conveniently divided. The first is served by some fifty-eight wood engravings in the text providing straightforward local description. The second is served by the forty full plates (etchings) epitomizing the narrative situation. It is not surprising that Cruikshank should later claim credit for his ideas as well as for his designs, quite apart from how one interprets his statement that he "used every month to send [Ainsworth] the *tracings* or *outlines* of the *sketches or drawings from which I was making the etchings to illustrate the work, in order that he might write up to them*, and that they should be *accurately described*. And I beg the reader to understand that all these *etchings or plates were printed and ready for publication before the letterpress was printed*, and sometimes even before the AUTHOR *had written his manuscript* . . ."[52]

THE NEXT collaboration between Artist and Author but one was *The Miser's Daughter*, whose fatal adaptation by Andrew Halliday provoked Cruikshank's formal claim to recognition thirty years after the original publication. In the *Times* notice of the play, Cruikshank found his name was "not mentioned in any way in connection with the novel—not even as the illustrator." The artist thereupon claimed that he had "originated" the tale, had suggested the principal character relations and the setting in 1745, "and also wishing to let the public of the present day, have a peep at the places of public amusement of that period, I took considerable pains to give correct views and descriptions of those places which are now copied and produced upon the stage."[53]

Halliday's play[54] does in fact show a great interest in the scenic panorama of the novel, which often pauses in its narrative to give the history of various pleasure grounds and places of public resort. But despite his considerable use of locale as represented in the plates, Halliday places, comparatively, no great emphasis on their tableau realization. Numerous plates are echoed, and doubtless were approximated in scene, costume, and arrangement in production; but only three must have been realized. This change reflects not so much a change in acting and production styles in melodrama as the reduced recognition value of the plates since the original Adelphi version by Edward Stirling

[51] Preface to *The Tower of London. A Historical Romance* (London, 1840). Originally issued in parts, Jan.-Dec. 1840.

[52] George Cruikshank, *The Artist and the Author, a Statement of Facts* (London, 1872), pp. 8-9. The Adelphi mounted a peculiar version of *The Tower of London* (30 Nov. 1840) by T. P. Taylor, who would later dramatize Cruikshank's *The Bottle*. Taylor's version (Dicks #502) compounds material from Ainsworth's novel with an alien text, Hugo's play *Marie Tudor* (1833). The work that results takes its comedy from Ainsworth and makes the Tower the location of the whole, rather than of just the final third as in Hugo. It realizes some of Cruikshank's most memorable images, but also contains an instance of pictorial allusion independent of Cruikshank. The directions for II, 1, read: "*The Audience Chamber in the Tower, a heavy sculptured arched apartment, hung with arras—antique and richly carved furniture; chair of state, stools, & c.—A few notes on the guitar are heard previous to the Act drop ascending.*—QUEEN MARY, *splendidly attired, and* DEVONSHIRE, *in the costume of the Court, are discovered. He is just relinquishing the guitar, she appears to have been listening.—See the picture of Mary, Queen of Scots, and Chatelar.*" From the other uses of Fradelle's picture (see above, p. 244), one concludes that it was the standard icon for the romance of queen and courtier. It is not called for in Hugo's *Marie Tudor*, but one scene certainly suggests it ("LA REINE *splendidement vêtue, couchée sur un lit de repos;* FABIO FABIANI, *assis sur un pliant á côté . . . une guitare à la main, chantant*"). Hugo's play, or an earlier English adaptation such as *Traitor's Gate; or, The Tower of London in 1553* by William James Lucas (1834), seems to have influenced Ainsworth directly.

[53] Cruikshank, *Artist and Author*, pp. 1-2.

[54] *Hilda; or, The Miser's Daughter*, L.C. MSS (licensed 26 Mar. 1872).

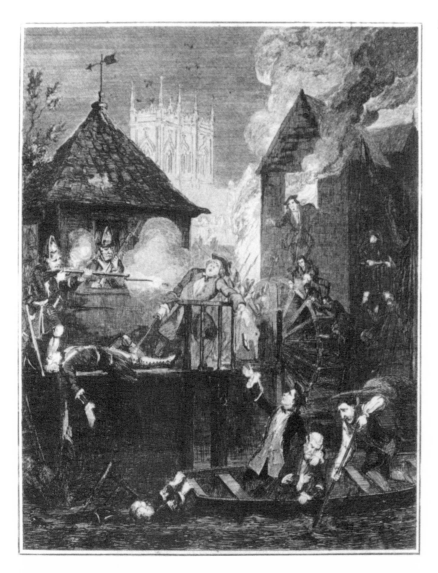

131. George Cruikshank, "Dispersion
of the Jacobite club and the death
of Cordwell Firebras," in W. H.
Ainsworth, The Miser's Daugh-
ter (London, 1842).

(24 Oct. 1842). In that version, trumpeted as "abounding in Novel
Situations and Effects," authenticity was guaranteed by the "Permis-
sion of Wm. Harrison Ainsworth, Esq. who in conjunction with Mr.
George Cruikshank, will give their personal attention to the numerous
Tableaux, & Designs for Scenery, &c."[55]

Stirling's play responds also to that fusion of historicism and urban
genre (*Life in London* one hundred years ago) that Cruikshank indi-
cates was his own original contribution, though nothing could be more
characteristic of his collaborator. The most striking of the narrative
plates are realized—such as "Abel Beechcroft discovering the body of
the Miser in the cellar" and the "Dispersion of the Jacobite club and
the death of Cordwell Firebras," which is itself conceived and drawn
as if it were the spectacular catastrophe of a sensation melodrama, and
is so used in Stirling's play. In only one of the scenes re-creating
historical locale, "Vauxhall Gardens in 1744," Stirling manages to
realize three of Cruikshank's plates as part of the spectacular effect,

[55] *The Miser's Daughter, A Drama in
Three Acts,* in Lacy, Vol. 99; and Playbill
(24 Oct. 1842), Enthoven.

and adds a fourth and a fifth (concluding) tableau with no predecessors in the novel (I, 6). The *Illustrated London News*—which chose to reproduce one of these original tableaux—comments on the transformations from novel to stage, from word to picture to performance. The comment is interesting for what it says about priorities:

> *The Miser's Daughter*, as played at the Adelphi, affords many of Cruikshank's etchings *vivified*—the creatures of the pencil transformed into flesh and blood. The characters shaped from the author's descriptions into ocular acquaintanceship by the Artist,—are again realized—all living, moving, being—upon the stage, by the actor.[56]

The road to reality leads, not back to the original inspiration, but from the word, to the picture, to the footlit stage.

Blanchard Jerrold reports a feature of Cruikshank's imaginative life and ego whose importance has been fully recognized in the case of Dickens: Cruikshank also, Jerrold tells us, believed he would have excelled as an actor, and knew a lifelong "yearning for the stage."[57] Certainly his direct involvement with the stage was considerable, merely on the evidence already noted here: his "immediate Superintendence" and direction of "the entire Arrangements" in *The Drunkard's Children* and *The Bottle* (pp. 125, 133); his contribution, with his brother, to the stage versions of Pierce Egan's *Life in London*; their frequent embellishment of the acting editions of any sort of play with a "design taken in the theatre"; his hand in the mounting of the Surrey *Jack Sheppard* and the Adelphi *Miser's Daughter*. In becoming scenic consultant, if no more, to dramatic production, Cruikshank had the example of numerous prestigious artists in the age; not only Stanfield and Roberts, who were proper scene designers by profession, but also David Wilkie, concerned above all, like Cruikshank, with the figural part of the composition, and A. W. Pugin, promoter extraordinary of the realization of the historical past in the substantial forms of the present.[58]

In the theater, the realization of a narrative through a series of epitomizing pictures was so much a matter of course that it alone could have justified Cruikshank's sense of the imaginative and functional centrality of his fictional images. The differences that appear in the dramatizations of Dickens' and Ainsworth's collaborative fictions, however, suggest that if creative priority is judged by a grasp on the audience imagination, Cruikshank had an excellent claim to be regarded as the chief creative, authorial intelligence in his collaborations with Ainsworth. In *The Bottle* and *The Drunkard's Children*, Cruikshank engrossed the whole authorial function to himself, as he did in what he conceived to be his climactic work, the huge painting of *The Worship of Bacchus*. It was "wonderful and labyrinthine," wrote Thackeray, like a vast sermon. "This sermon has the advantage over others, that you can take a chapter at a time, as it were, and return and resume the good homilist's discourse at your leisure. What is your calling in life? In some part of this vast tableau you will find it is *de te fabula*." Like *Vanity Fair*.[59]

[56] *Illustrated London News* (12 Nov. 1842), p. 428.
[57] *Cruikshank*, 2:152.
[58] On Pugin, see the DNB.
[59] "Cruikshank's Gallery," *Times*, 15 May 1863, p. 6, quoted in Jerrold's *Cruikshank*, 2:155.
A superb essay on Cruikshank's development as an illustrator of fiction, and in particular on his work in *Jack Sheppard*, is Jonathan E. Hill's "Cruikshank, Ainsworth, and Tableau Illustration," *Victorian Studies* 23 (1980):429-59. Hill's essay came to my notice after my own work was in proof; but it anticipates concretely and economically a great deal that I say about relations with nineteenth-century dramaturgy, with dioramic and panoramic form, and especially with the ethos of the tableau.

14

PRISONERS BASE

A SCENE that presents a readable and interesting narrative configuration is unlikely to be wholly original or wholly stereotyped. The recognizable component is usually in the disposition of the figures; but often the setting plays an essential role, entering the drama with the force of a character. I intend to explore one such configuration in the heart of the century: a prison scene, a local development within the larger history of prison scenes, but one specially tuned to the period sensibility. Like any such configuration, it was varied and inflected, but it was essentially a prison scene with a domestic reference.

The configuration appears in fiction and drama as well as in painting, and its course is entangled with that of a scene from earlier literature: the troubling episode from Shakespeare's *Measure for Measure* where a bond of love linking the superior innocence of a woman to the fallible weakness of a man is tested in prison surroundings. In the development of the modern configuration, the scene from *Measure for Measure* gave form to the expression of a current set of shifting intuitions and predilections, and in turn surrendered to interpretation by the altered sensibility of the age.

To discuss this particular prison configuration is useful, not because of its overriding importance in the period, but because of its limits and typicality, including the limits that come with the artist's attempt to strike a balance between stereotype and unfamiliarity. Other pictorial tropes might have served as well. One special reason for choosing this one, however, is that it extends the domestication of a Romantic motif beyond what happens to shipwreck in "The Perils of the Deep," and eventually beyond domestic genre painting with its compulsion to inform reality with moral significance, to a later, more "objective" version of the real. Another reason is that it provides a contemporary point of reference for Dickens' *Little Dorrit*, that remarkable conflation of the prison and the home as a compendious image for society, and the subject of the next chapter.

The prison house, as a scene of grim deprivation and of redemptive delivery, acquired new force and meaning with the great political rev-

132. *Joseph Wright of Derby*, The Prisoner *(1787-1789), New Haven, Yale Center for British Art, Paul Mellon Collection.*

[1] Donald Jay Grout, *A Short History of Opera*, 2nd ed. (New York, 1965), pp. 300, 312.

[2] Eitner, "Cages, Prisons, and Captives in Eighteenth-Century Art," in *Images of Romanticism*, ed. K. Kroeber and W. Walling (New Haven, 1978), pp. 30, 20-21. Eitner's main achievement here is a heterodox and convincing reinterpretation of Piranesi's *Carceri*. See also Joseph R. Roach's authoritative article, "From Baroque to Romantic: Piranesi's Contribution to Stage Design," *Theatre Survey* 19 (1978): 91-118, where Roach also summarizes the contribution of the stage to Piranesi.

olutions and the Romantic exploration of the self, and acquired also an unwonted frequency in art. *Fidelio* (1805), for example, for all its uniqueness and original power, belonged to a populous genre that flourished in the decades near the turn of the century, a genre sometimes called "rescue opera," whose structures reflected the perils and sentiments of both the jail-delivery from the Bastille and the incarcerations of the Terror.[1] Lorenz Eitner makes the point that before the last quarter of the eighteenth century, "Realistic views of prisons . . . were rare, sympathetic descriptions of prisoners rarer still" in art. "The ordinary, anonymous prisoner was scarcely an object of interest," whereas the conventional visual notion of a prison, its towering halls and stone courts, its vaulted crypts, grills, spikes, and torture machines, receding into labyrinthine shadow and space, was the invention of the stage.[2] But the last quarter of the century saw "a new type of prison picture in which the whole emphasis falls on the pathos of man-inflicted suffering witnessed at close range. . . . The figure of the solitary captive

now dominates the scene with something of the stillness and solemnity of an *Ecce Homo*," and the heavy vaults and iron bars serve to state the captive's naked misery.[3] In these images, an interest in the psychology of the prisoner comes into play. It took the nineteenth century, however, to negotiate fully the abyss between the architectural fantasies of terror and power and the familiar perspectives and emotions of private life. Despite settings still in the baroque tradition, the process is already at work in *Fidelio*, Beethoven's reworking of Jean Nicolas Boilly's *Leonore; ou, L'Amour conjugal* (1798). Here, at the turn of the century, the title tells all.

The Momentous Question

The nineteenth century's domestic version of the prison scene achieved its typifying expression and a rich set of variations well before December 1855, when the first number of *Little Dorrit* appeared. The erosion of this standard configuration, influenced by more general stylistic developments, began shortly thereafter. The essential configuration and the beginning of its dissolution are illustrated in two paintings, translated into popular engravings and embodied in popular plays, one painting and its progeny reaching back to Crabbe and perhaps Scott, and the other pointing forward to Hardy. The first, Sarah Setchel's *The Momentous Question* (1842), adheres to an idealizing treatment of private life. Despite some prosaic detail in furnishings and costume (humble but vaguely historical) and the substitution of intimacy for heroics, the figures are relatively generalized, and isolated from circumstantial domesticity. The second painting, Abraham Solomon's *Waiting for the Verdict* (1857), aims at a domestic realism. Both, however, invoke those ties and emotions that the nineteenth century often equated with the whole of private life, and are variants of one situational image, among the more highly charged in the narrative iconography of the age.

The earlier of the two paintings found dramatic expression in a play by Edward Fitzball, *The Momentous Question* (1844). Fitzball writes in his memoirs of noticing Samuel Bellin's engraving of the painting in the shops. He was struck evidently by the image in its general aspect; that is, as an affective symbol without a limiting and specific story attached. The picture shows a young woman, obviously a visitor, seated beside a dark, heavily fettered man in a prison cell. One of her hands rests delicately on the hand that covers the other in an intimate layering. She is concentrating with sober intensity, profiled and patiently expectant, on the prisoner, who hides his face in guilt or shame or remorse. "I had frequently admired that charming print, so domestically beautiful, but could not learn from whence the subject had been selected; at length I discovered, and procuring the poem, immediately set to work about the drama."[4] As a picture, the situation was readable and meaningful in its generality; but to realize it in a play, the playwright required an expanded narrative correlative, or felt that he did. The requirement is interesting, because it points to a difference between picture and play, not in affective power or symbolic value, but in narrative particularity. The play requires that its partic-

[3] Eitner, "Cages," p. 34. For fuller studies of the image of the prison and of its ethos in the nineteenth century, see Victor Brombert, *The Romantic Prison: The French Tradition* (Princeton, 1978), and Michel Foucault, *Discipline and Punish: The Birth of the Prison*, trans. Alan Sheridan (New York, 1978). Wright's powerful painting of *The Prisoner* (Fig. 132), solitary and anonymous, seems to bridge two stages of imagery.

[4] Edward Fitzball, *Thirty-Five Years of a Dramatic Author's Life* (London, 1859), 2:227.

ularity be causal, historical. *This* playwright, however, never assumes he has to invent such particularity; rather he assumes that the picture originated in a narrative of prior causes.

Sarah Setchel's painting had been originally exhibited in 1842 at the New Society of Painters in Watercolours as "A Scene from 'Smugglers and Poachers' in Crabbe's *Tales of the Hall*" (1819). Testimony to the success of its situational retitling and to its popularity as a print appears in *David Copperfield*, in a comment on David's second attempt to become Dora's accepted suitor. In Browne's illustration titled "Traddles and I in conference with the Misses Spenlow," *The Momentous Question* looks down from the wall. Browne appears to have drawn it from memory, but its attitudes are wittily echoed in the scene, where David stays for an answer.[5]

Crabbe's verse tale presents two brothers archetypally contrasted: James, a conscientious gamekeeper, and Robert, scornful of service and a poacher on principle ("Were not the gifts of Heaven for all design'd?"). The heroine, Rachel, is loved by both and devoted to the scapegrace. James, who catches Robert red-handed, offers to withhold his testimony if Rachel will have him instead of his brother. Rachel puts the question to Robert:

> I ask'd thy brother James, would'st thou command,
> Without the loving heart, the obedient hand?
> I ask thee, Robert, lover, canst thou part
> With this poor hand, when master of the heart?—
> He answer'd, Yes!—I tarry thy reply,
> Resign'd with him to live, content with thee to die.[6]

In Fitzball's melodrama, where Robert and James are childhood friends but not brothers, the question is put in nearly identical terms but less stoically. Released from the constraint of couplets, it is designed to produce a climactic effect:

> *Rachael* [*sic*] . . . James can save you. I have asked him whether this poor hand, without a heart, might purchase your release. His reply was "Yes"—and now I ask you, Robert, shall I live with him, or die with you? This is the momentous question. Consider well before you answer it. Whichever way *you* decide, so shall it be. (*Weeps*) I can say no more! (*Celebrated Picture. He covers his eyes with his hands—she observes him with fixed emotion.*)[7]

Jeffrey remarked of Crabbe's prison scene that it would "almost bear a comparison with that between Isabella and Claudio";[8] and it was perhaps an idea of measure for measure—the principle more than the play—that suggested Fitzball's further development of the narrative.

In the poem Robert consents and loses Rachel to James, but then escapes before he can be freed by the due process of his bargain. Later James leads a night raid on the outlaw band to which Robert belongs, and both brothers are shot in the first encounter. In the play, the midscene tableau of the Question leads to another tableau, a summation realizing pictorially the next situation of the drama. Robert consents to the bargain, believing he can frustrate the marriage, and Rachael unlocks his fetters and opens a door into a moonlit scene. Robert steps

[5] The illustration accompanies Chapter XLI, "Dora's Aunts." Frank Stone's aptly titled *Last Appeal* and an *Arcadia* also comment on the scene.

[6] *The Poetical Works of the Rev. George Crabbe: With His Letters and Journals, and His Life, by His Son* (London, 1834), 7:265.

[7] *The Momentous Question: an Original Domestic Drama in Two Acts*, in Duncombe, Vol. 50; I, 5, "The Prison." Fitzball uses the spelling "Rachael" throughout.

[8] Crabbe, *Poetical Works*, 7:274n. Robert's "O! sure 't is better to endure the care/ And pain of life, than go we know not where" resembles Claudio's musings in *Measure for Measure* III, 1, 116ff.

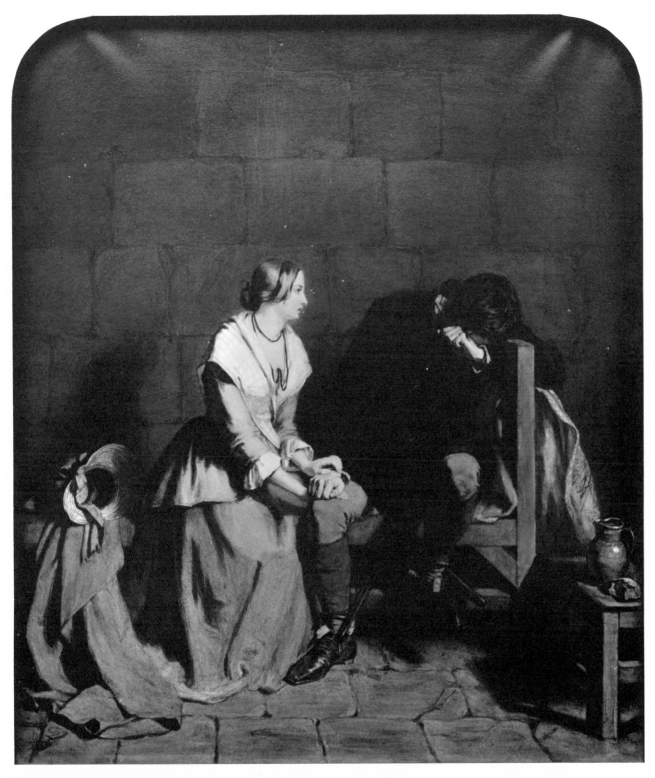

133. Sarah Setchel, The Momentous Question *(1842), Victoria & Albert Museum.*

through "exulting" in his freedom and then turns back for Rachael, whereupon she locks the door between them:

> *Rachael* . . . Go—forget me—be happy—I am another's! (James *enters through a private door*, R. H. Robert *looks through prison window*.)
> *James.* Rachael!
> *Rachael.* James! (*Falls senseless.*)
> *James.* Husband! (*Standing over her*, *joyfully exulting—Picture*.)

END OF ACT I

Such heightening of Crabbe's circumstantial and prosaic logic of events in order to achieve further situational "effects" generates a symmetrical development in Act II, where Robert turns the tables and attempts to extract measure for measure. He returns to Rachael as a captain of the smugglers, and threatens to kill James unless Rachael runs off with him. Rachael, once more on her knees to plead for a life, agrees: "Anything to avert this fearful crime—to save you—to save my *husband*." Fitzball's interest, however, in contriving this ironic reversal, is in effectiveness of situation, not in its necessitated tragic resolution. Rachael therefore is spared having to go through with her generous crime by James' early return. As he and Robert are about to fall to, Rachael, the source of their division, eloquently reminds them of their original devotion to each other, and they rush into an embrace. But all ends respectably, and less lovingly, with a picture of Robert dead and Rachael overcome in her licensed husband's arms; for at the moment of reconciliation the smugglers are attacked by "Preventives," and Robert, gallantly joining his hard-pressed band, is wounded fatally. Thus Providence forgives the unjust justicer, redeemed by domestic devotion, for his perpetrated crime against the heart; but destroys his anarchic counterpart for his unforgiveable, though only contemplated, crime against the hearth.

Sarah Setchel's painting stated a recurrent situational image in its basic form: a prison visit incorporating the loving goodness of woman, the relative unworthiness of man, and the cruel indifference of stone and iron. The basic configuration expressed itself in a cluster of details constituting an affective and narrative iconography, such as the man's turning away from the unconscious reproach that lies in superior virtue, his face-hiding gesture, the hand clasp, the leg irons, the pattern of light and dark. These appear even where the basic image is varied by a specific narrative content. For example, Cruikshank's Plate VI of *The Drunkard's Children* (1848), though set in a prison anteroom and introducing a guard with a key, is close enough to Setchel's arrangement and detail, including bonnet, handclasp, and furniture, to suggest a direct influence. (In keeping with the visitor's own fallen state, however, and her need and friendlessness, it is she who bows the head in anguish.)

The basic configuration found expression in the work of the Pre-Raphaelites, notably in Hunt's *Claudio and Isabella* (1850-1853), another version of *Measure for Measure*. As a subject for illustration, *Measure for Measure* comes into its own in the nineteenth century, especially

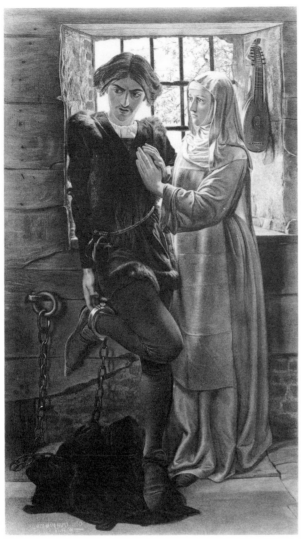

134

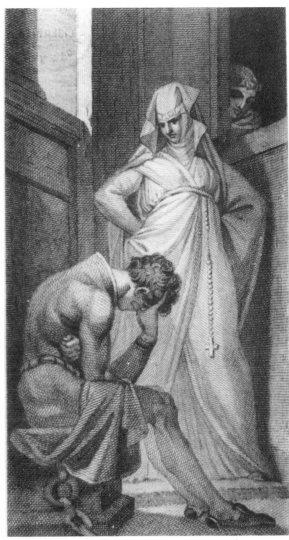

135

the scene of the interview between Isabella and Claudio in prison. Fuseli found it much to his special taste, and his design (1803) for Rivington's *Shakespeare* shows a challenging, indignant, and masterful Isabella towering over a miserable Claudio, whose nakedness appears through his clothes, and who holds himself and hides his face while the Duke of Dark Corners peeps in from above. The setting here is only an architectural screen, whose function is to frame and elevate Isabella (as if she were playing a scene in Genet's *Balcony*) rather than confine Claudio. Only the heavy chain identifies the place as a prison, and only Claudio has so far taken his proper place in the developing configuration. In other, later illustrations it is Isabella who turns away to hide her eyes, so losing militant vigor but gaining in sympathy and "womanliness." By the 1830s, as in an anonymous watercolor in the so-called "Turner *Shakespeare*," the dungeon setting is clear, and Isabella, if not patiently commiserating with her guilty brother, at least sits expostulating beside him, while Claudio sits chained to a sarcoph-

134. *W. Holman Hunt*, Claudio and Isabella *(1850-1853)*, *engraving by W. H. Simmons (1864)*, *private collection.*

135. *Heinrich Fuseli, Illustration for* Measure for Measure, *engraving by W. Bromley (1803)*, *in* William Shakespeare, Plays, *ed. Alexander Chalmers (London, 1805).*

aguslike block as he does in Fuseli's scene, and hides his face in shame or grief.[9]

In Hunt's *Claudio and Isabella*, as the successive designs show, the pictorial situation was led to serve a more complex psychological interest than in his original conception, and the configuration now reflects Isabella's dawning apprehension, rather than her earnest, loving confidence (see below, pp. 363-65). Still, both the basic configuration and the narrative and affective detail of the painting link it morphologically to *The Momentous Question*. This detail includes Isabella's searching look and touch, Claudio's turn aside, the prominent irons, and the cell wall (here in regular Pre-Raphaelite antithesis with the outdoors), and the imagery of light and dark, as provided for in Shakespeare's own costuming. The "momentous question" is addressed to the prisoner in Crabbe; but in the generalized form of the Setchel-Bellin print it is a condition embracing the whole. In Hunt's painting the question is no longer a literal verbal proposition or a way of summarizing the general situation. Both question and reply have been internalized, in the mind of Isabella.

ONE FURTHER analogue or descendant of *Measure for Measure* contributed to the configuration: Walter Scott's *Heart of Mid-Lothian* (1818), preceding Crabbe's *Tales of the Hall* by a year. Scott in his epigraphs pointedly invokes *Measure for Measure*, as he does various poems of Crabbe. The critical prison interview, framed and prepared as a "situation," between Jeanie and Effie Deans before Effie's trial for infanticide, takes for its rubric the speech beginning "Sweet sister, let me live," where Claudio argues that the sin done to save a brother's life becomes a virtue.[10]

As Catherine Gordon points out in her survey of Scott illustration, the *Heart of Mid-Lothian* was not much quarried for illustration before 1830, though it was quite popular after.[11] The change reflects a new openness in painting to the serious, noble, and pathetic in humble life, and coincides with the triumph of the domestic strain in popular melodrama. The interview between Jeanie and Effie was nevertheless illustrated as early as 1823, in a frontispiece engraving drawn by C. R. Leslie. This picture, varied and repeated in later editions and otherwise influential, already unites many of the elements in the basic configuration, though as in the novel sinner and saint are of the same sex, and there is a foreground emphasis on the presence and response of the jailor, the lawless and dissolute Ratcliffe.[12]

Scott's scene of the interview is achieved in a series of tableaux, and it is the second of these that Leslie illustrates:

The sisters walked together to the side of the pallet bed, and sate down side by side, took hold of each other's hands, and looked each other in the face, but without speaking a word. In this posture they remained for a minute, while the gleam of joy gradually faded from their features, and gave way to the most intense expression, first of melancholy, and then of agony, till, throwing themselves again into each other's arms, they, to use the language of Scripture, lifted up their voices and wept bitterly.

Even the hard-hearted turnkey, who had spent his life in scenes

[9] Thomas Turner's extra-illustrated set of Shakespeare's plays, Vol. IX, f. 74, in the Huntington Library.

[10] Four *Measure for Measure* epigraphs occur in this part of the novel. Crabbe is quoted more often than any author except Shakespeare: five epigraphs and a passage in the introductory chapter.

[11] "The Illustration of Sir Walter Scott: Nineteenth-Century Enthusiasm and Adaptation," *Jour. Warburg* 34 (1971): 311-12.

[12] Engraving by C. Rolls, *Novels and Tales of the Author of Waverley*, Vol. IX (Edinburgh and London, 1823). In the Abbotsford Edition (1843), the wood-engraving (after John Burnet) at the head of Chapter 20 and the ornamental head of Chapter 1 vary Leslie's scene, which reappears unaltered as the frontispiece of the novel in the Centenary Edition (1871).

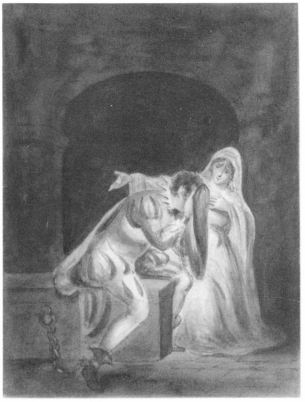

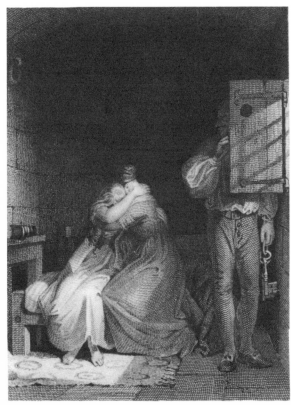

136 137

calculated to stifle both conscience and feeling, could not witness
this scene without a touch of human sympathy. It was shown in a
trifling action, but which had more delicacy in it than seemed to
belong to Ratcliffe's character and station. The unglazed window
of the miserable chamber was open, and the beams of a bright sun
fell right upon the bed where the sufferers were seated. With a
gentleness that had something of reverence in it, Ratcliffe partly
closed the shutter, and seemed thus to throw a veil over a scene
so sorrowful.[13]

136. *Scene from* Measure for Meas-
ure, *San Marino, Cal., Hun-
tington Library.*
137. *Charles R. Leslie, Frontispiece
for Walter Scott,* Heart of Mid-
Lothian, *engraving by C. Rolls
(London, 1823).*

The clasped hands and steady look belonging to the first tableau give
way to the clasped bodies of the second. Though the faces of both
sisters are hidden from the spectator in the illustration, only Effie bows
her head and hides her face behind her arm in the familiar expressive
gesture. Leslie gives great emphasis to the prison setting by means of
the grim stone enclosing the group on five of the six possible sides,
Ratcliffe's dangling keys, the ring on the wall, and the shadow of the
bars across the shutter. (John Burnet gave even greater prominence
to the ironmongery in his variant illustration for the Abbotsford Edi-
tion, where he also kept the weeping sisters face to face, and set Jeanie
in an attitude, arms extended and hands clasped around her sister's
shoulders, that reappears in Hunt's preliminary drawings for Isabella.)

But even closer than these by the sound of it to the precise config-
uration of *The Momentous Question*, which it anticipated, was one of
the ten other versions of the scene (Gordon's count) between 1836

[13] *Heart of Mid-Lothian*, Vol. I, chap.
20, *Waverley Novels* (Edinburgh, 1864)
11:369-70.

and 1849: a version by John Hayter exhibited at the British Institution in 1839:

> Mr Hayter illustrates the touching incident in "The Heart of Mid-Lothian," when "Jeanie Deans visits her sister in prison;" it is truthful, and, consequently, mournful. Jeanie, weary and foot-sore, is seated on the prison-bed of her erring sister—her patient tear-washed face and pale blue eyes express deep yet suppressed sorrow, and contrast admirably with the gasping and intense agony of Effie, whose countenance is judiciously concealed, but whose attitude and action abundantly tell her feelings. The prison looks chill and cold; the accessaries [*sic*] are carefully made out—the jailor has his back turned upon the spectator, but their sorrow is so sacred, that we wish he were not there. Still those who paint from Sir Walter Scott's descriptions, paint, it may be almost said, from history. . . . had Jeanie been made better looking, the truthfulness would have been destroyed; as it is, there is the interior of the Tolbooth, and there the erring sister, and the high-souled peasant, who will live as long as any feeling of nature stirs the heart of human kind.[14]

In the novel, the "momentous question" appears in the encounter between the sisters as a temptation addressed to the virtuous visitor—a temptation in Jeanie's case to forswear herself and so save Effie's neck. Lawyer, jailor, and in the upshot the court and the crowd hope Jeanie will do so, and Jeanie is heroic in resisting that universal desire. But as in *Measure for Measure* and "Smugglers and Poachers" and its dramatic progeny, the temptation cuts both ways, and the burden of choice, momentarily at least, is placed on the hapless prisoner. After she makes it clear that she will not be forsworn and Effie shows an understandable annoyance, Jeanie cries out: "O, Effie, look but up, and say what ye wad hae me to do, and I could find it in my heart amaist to say that I wad do't." But Effie, "after an effort," declares she is "better minded now. At my best, I was never half sae gude as ye were, and what for suld you begin to mak yoursell waur to save me, now that I am no worth saving?"[15]

Touched by grace, Effie acknowledges a moral disequilibrium between two creatures bound by ties of love and kinship, a type of relationship that would stir the Victorian imagination as almost nothing else could. Scott the historian respected the sex of the pair who inspired his fiction, and Effie remained a woman. Generally, however, in art as in life, the accused and imprisoned criminal was a man. In the standard prison-scene configuration, Victorians found, to complement their imagery of the Fallen Woman, an image of the Fallen Man. The equivalence is made in a stroke in that great historical and political novel from abroad on crime, punishment, and redemption, Victor Hugo's *Les Misérables* (1830-1861), where the hero, Jean Valjean, takes on the legacy of the dead Fantine, and in his life after prison gives himself the name "M. Madeleine."

HUNT'S PAINTING of *Claudio and Isabella* was rather eclipsed in the Academy exhibition of 1853 by Millais' *Order of Release, 1746*. The

[14] *Art-Union* 1 (Feb. 1839): 7; quoted in part by Gordon, "Illustration of Sir Walter Scott."
[15] *Heart of Mid-Lothian*, chap. 20, p. 378.

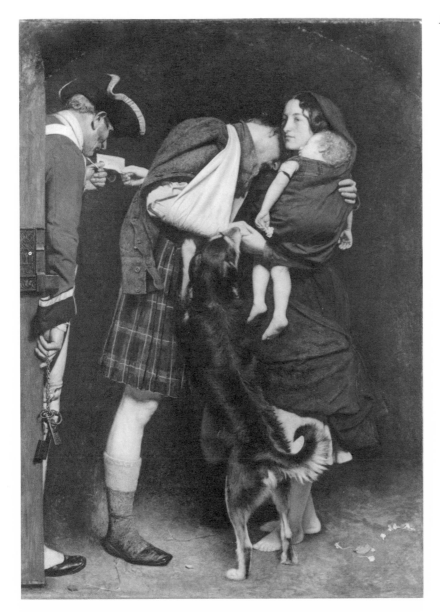

138. *John Everett Millais*, The Order
of Release, 1746 *(1853), Lon-
don, Tate Gallery.*

scene here is an ambiguous vaulted space, close and claustrophobic,
defined by the door and its heavy lock and the guard and his keys, the
latter as prominent in the narrative symbolism as in Cruikshank's
anteroom setting and in Leslie's illustration of Scott. In Millais' paint-
ing, however, the narrative situation of a judicial separation, imminent
or threatened, is reversed; and all the paraphernalia of a reuniting
domestic circle are present in the clustering centripetal group that
includes the jolly dog and sleeping infant. Nevertheless, the physically
heroic but visibly tamed and impaired rebel (one thinks of Mr. Roch-
ester and Eugene Wrayburn) once more hides his head in broken
acknowledgment of his eternal moral indebtedness to the woman who
grasps his hand. An astute commentary, combined with a notice of

Samuel Cousins' engraving of 1856, describes the "moment" of the picture as that of "the solution of bonds moral and material," and observes: "The narrative is clear, touching, and non-superfluous, as Boccacio and Defoe. The *released* prisoner is the moral *captive* of conjugal devotion. This fine tale makes us think with glistening eyes."[16]

The same commentator, who doubtless found in the guard's uniform, the Highland warrior's dress, and the date in the title a framing historical reference to the Jacobite wars, relates Millais' painting to Scott and especially to *Waverley* on the interesting grounds that Scott opened up for art the area between the "puerile primeval" and "the smooth monotony of modern citizen life," an area "near enough to have a tangible sensible interest" and yet distant enough to give "larger scope to a dramatic invention than the policed and ticketed existence of these days." This area, between the remote and the familiar, also gave scope in *Heart of Mid-Lothian* to Scott's most fully elaborated domestic drama. More than the scene of the prison interview in that novel contributed to the matrix of images and ideas from which Millais' painting drew its meaning. At the center of the novel is Jeanie Deans' heroic pilgrimage to London to secure the order of release that redeems her sister, not from prison alone but from the gallows. The well-known narrative of that difficult personal action in an eighteenth-century Scottish context surely played its part in the interpretation of the triumphant expression of Millais' barefoot woman, in making the wife not just a messenger but a heroic redeemer.

Waiting for the Verdict

A year after the review of Cousins' engraving of *The Order of Release*, Abraham Solomon shifted the scene to a wholly modern setting. *Waiting for the Verdict* (1857) achieved in reproduction something like the currency of Wilkie's pictures; and, like *The Rent Day* and *Village Politicians*, it also became the subject of at least one play.[17] Like Fitzball's *Momentous Question*, C. H. Hazlewood's *Waiting for the Verdict* (1859) illustrates the continuity of the connection between domestic melodrama and the genre and vernacular impulse in painting and fiction. The painting represents a change, however, in that the suggestion of rural or provincial circumstances does not here work to limit immediacy, or to reduce its impact as a scene of domestic crisis in a familiar present. The painting represents a change also in its altered account of the relation between impersonal social institutions and people, here the law and the threatened family that has no formal place in the court.

Ruskin thought the picture "Very full of power; but rather a subject for engraving than painting. It is too painful to be invested with the charm of colour."[18] Such a feeling helps explain why the later realistic mode in English nineteenth-century art, urban and reportorial, develops first in wood and steel engraving and book illustration, and makes its mark through the school of black-and-white realists associated with *The Graphic* (founded 1869), one of whom—from a family of engravers—was Frank Holl. The next notable prison-scene painting in the line of Setchel and Solomon would be Frank Holl's *Newgate: Committed for Trial* (1878, see below), whose power lies in the con-

[16] *Illustrated London News* 29 (25 Oct. 1856), p. 423, with a reproduction. Millais' interest in such subjects antedates his acquaintance with the Ruskins and his involvement with Effie, whom he painted as the wife. His son and biographer reproduces a drawing assigned to 1847 called "The Judge and the Prisoner's Wife," reversing the centripetal movement and domestic triumph of the later painting. That is, the family group of wife, infant, daughter, and dog are being forcibly knocked asunder, as the wife clutches the Judge's wrist and officialdom attempts to clear his path. See J. G. Millais, *The Life and Letters of Sir John Everett Millais* (London, 1899), 1:231 and 2:490.

[17] Colin Henry Hazlewood, *Waiting for the Verdict; or, Falsely Accused. A Domestic Drama, in Three Acts. Founded on and embodying the celebrated Picture of that name, by A. Solomon, Esq., in the Royal Academy*, Lacy, Vol. 99. The L.C. version is titled *Jasper Roseblade; or, The Dark Deed in the Woods* (Brit. Libr. ADD. MSS 52979).

[18] *Academy Notes* (1857), in *The Works of John Ruskin*, ed. E. T. Cook and Alexander Wedderburn (London, 1903-1912), 14:114.

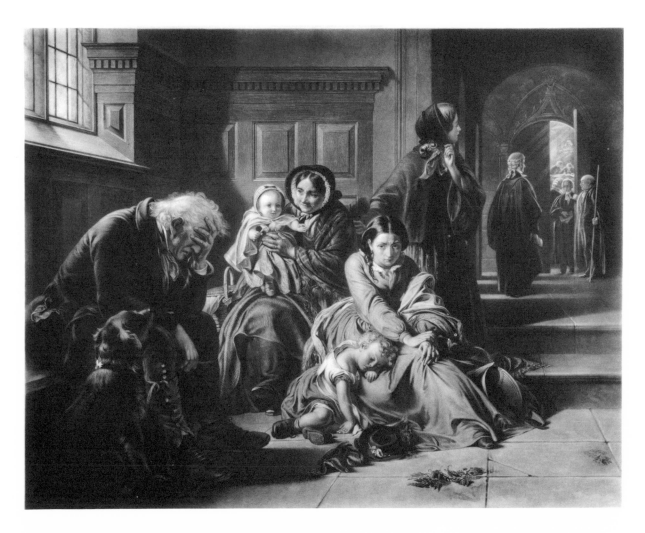

139. *Abraham Solomon*, Waiting for the Verdict *(1857), engraving by W. H. Simmons (1866), London, British Museum.*

viction that it presents an authentic atmosphere, rather than the setting for a moral drama.

Solomon's *Waiting for the Verdict* of 1857, however, was a full-fledged moral and domestic drama. It is set in an anteroom to the court, and represents the threatened family with only the prisoner—defined as husband, father, and son—absent from the incomplete circle of the group. At the center of the picture, waiting in tense anxiety for the answer to the question before the court, is the wife, who leans forward toward us but with her sight turned inward and one hand, *faut de mieux*, clasping the wrist of the other. The characteristic male attitude is transferred to the father of the accused, who sits in the left foreground, bowed down and covering his face with one hand. His dress, especially the corduroy breeches and gaiters, and the hob-nailed boots of the older child asleep on his mother's knee, mark the group as rural. (Rather too beautiful, and even romantically picturesque, the child goes near to breaking the realistic convention of the picture. By virtue of position, coloration, and feature, however, he would suggest to the studious spectator a spotless version of the missing father.) The wife's mother (linked by resemblance), looking her sympathy to the grandfather, holds a younger child (the painter is not above reinforcing his

secular domestic situation with compositional echoes of the Holy Family). The dog with its head on the grandfather's knee, a reminder of Landseer's *Old Shepherd's Chief Mourner*, suggests what a verdict of guilty is likely to mean for the old man. Like the sheepdog that steals the show in *The Order of Release*, the dog helps define the domestic circle, which the painter invites us to analyze. The recession in overt emotion through the family leads to a figure just outside the circle—an unmarried relation, perhaps, or a farm servant—whose stance directs attention to the opening door in the right rear, where lawyers, bailiff, and a glimpse of the courtroom itself suggest that the moment of truth is at hand.[19]

Unlike *The Order of Release*, which despite the formal tableau of its central group is a peephole icon, *Waiting for the Verdict* is arranged in the planes, grouping, and physical perspective of the stage. Its incorporation, as the midpoint in a series of striking effects in an exceedingly presentational play, posed no problem of translation. Moreover, though the situation in the painting required a narrative expansion and specification (some of it indicated in the play's title, *Waiting for the Verdict; or, Falsely Accused*), the realized tableau could still very handily stand as a frozen distillation of the drama as a whole.

The presentational and sensational character of the play appears, before the realization, in a first-act murder scene, where a violent struggle in a moonlit glade culminates in a sickening repeated bludgeoning. It appears also in the trial scene of the falsely accused Jasper Roseblade, complete with witnesses, speeches of counsel, and instructions to the jury, a smaller drama within the large one. Shortly thereafter (II, 4), "*The Scene opens to realize the celebrated picture of 'Waiting for the Verdict' (third and fourth grooves)*." The directions indicate that a view of the court is seen through the door "*as in picture*," and that the tableau positions are held while music plays, "*at end of which* GRAFSTON [the defending counsel] *enters Court, and the door is closed*." After some expansion of the scene in prayers and curses, gestures of anxiety and despair suggested by the picture, a clergyman brings out the verdict of "Guilty! (MARTHA *screams—Tableau, same as opening of Scene—the act drop slowly falls*)."

The endscene tableau probably repeated the picture only in the central configuration, but the repetition reinforces the image's epitomizing character for the drama as a whole. Coming after the verdict, the repetition also makes clear the irrelevance of the issue of guilt or innocence. One of the strengths of the picture as painted and engraved is that, in the absence of the Accused, we have no way of deciding the issue. Favorable prejudices are doubtless enlisted by the country virtue of his connections; but the point of the wife's anxiety and concern is devotion, regardless of guilt or innocence. The irrelevance of guilt gives focus and poignancy to the picture, and makes the present situation, even more than the coming verdict, momentous. The play, however, dilutes that focus, and in supplying a specific Accused and a specific crime and its history, shifts much of the interest to the relation of the verdict to material guilt and innocence. If the reader of the picture is teased by the question of guilt, it is just enough to make him aware of its irrelevance to the situation and its emotions.

[19] The dog reappears in Briton Riviere's *The Prisoner* (R.A. 1869), also known as *Fidelity*, a favorite among popular paintings. The dog there stands in for all the family, but most particularly takes the place of the blameless loving woman in the earlier versions of the scene. The chief prisoner, in gaitered rural dress, with bowed head, covered eyes, and arm in a sling like Millais' Scotsman, recalls figures from Setchel's poacher to Solomon's distressed father. In the Lady Lever Art Gallery, Port Sunlight.

In Hazlewood's play, the Accused is found guilty; but he has been falsely charged through a combination of malice and circumstance, and in the end he gets off through the hand of Providence. The simple sufferers remind each other from early in the play that "though the wicked may flourish for a season, yet the good man will pass through his day of trial and rise triumphant over his enemies." A clergyman reinforces the message shortly before the verdict: "if he be truly innocent, he has nothing to fear, for Providence will never permit the innocent to suffer for the guilty, so let us trust in that Providence to deliver him from danger." The secular courts having declined to trust to the justice of Providence, however, Providence speaks up directly. The convicted man's wife is led to set in train the villain's catastrophe, and to effect Jasper's redemption, by "a voice [that] seemed to whisper in my ear, Arise, Martha, away to the woods, and there thou shalt learn that which shall establish thy husband's innocence." With the gallows looming, there is a last-minute reprieve (purloined to prolong the peril), after the full elaboration of bell and procession, as if *The Beggar's Opera* and *Black Ey'd Susan* had never been.

It is hard to tell whether an audience would have been more impressed with the moral that authority and its institutions are never to be depended on, or with the moral that given the watchfulness of Providence it is blasphemous to take justice into one's own hands and abandon the patience of humility. A Providential ethos is fundamental to nineteenth-century melodrama as the condition of its dramaturgy of effect, where probability is not relevant, though causality is. That being the case, it may be said of all the melodrama of the age that while it discharged the social resentments of its audience, it encouraged that audience's passivity. On the other hand, the factor of social resentments is prominent in *Waiting for the Verdict*, a reminder of the democratic bias of domestic drama from its first efflorescence; and it is noteworthy that while many of the pious lines are directed against these resentments, most of the good lines are directed against the rich.

Solomon's painting had an advantage over the play that embodied it, in its independence of narrative antecedent and consequence. A narrative painting tied to no known story in fact or fiction, it could exclude from its charged situation the issue of antecedent guilt and the question of just punishment. Solomon, however, chose to abandon his advantage, that concentration which made the image almost "too painful" even for robust tastes, by supplying a narrative pendant. A few months after the opening of Hazlewood's play, he unveiled *Not Guilty* at the 1859 Royal Academy exhibition. Engraved like its predecessor by W. H. Simmons, it shows the joy of reunion, the domestic circle reconstituted with wife, dog, and baby all clustered on their mainstay, while the old father expresses his gratitude to heaven and the departing lawyer. The point of view on the waiting room is reversed, and now visible in the background is an open door to freedom. The domestic melodrama, which before was powerful, is now merely complete. As predicted by old Jonathan Roseblade, philosopher of the domestic scene, the good man has passed through his day of trial and risen triumphant.

The balance between the redemptive promise and the threat of dis-

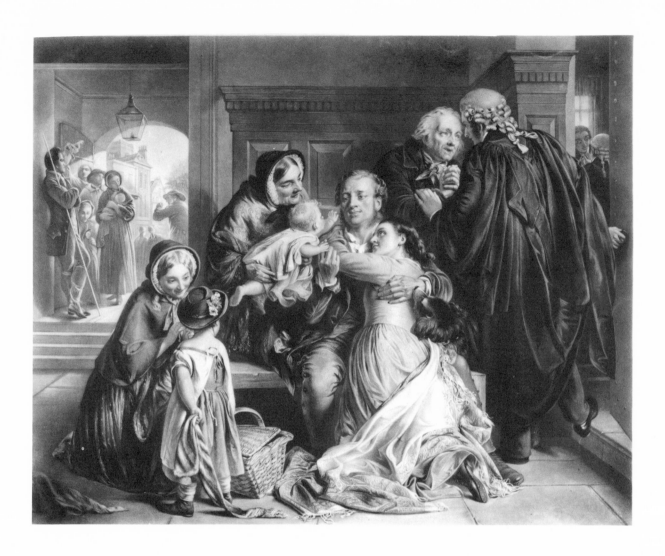

140. *Abraham Solomon,* Not Guilty *(1859), engraving by W. H. Simmons as* The Acquittal *(1866), London, British Museum.*

solution in the configuration of male and female in a prison setting shifted as the century progressed. In Solomon's *Waiting for the Verdict* the focused domestic tableau is still intact, though some of its conventional elements are displaced, notably those associated with the missing husband. But already the moral drama with its higher reassurances wavers before the social drama with its desperate anxieties. The next stage is represented by Frank Holl's notable painting in the realistic mode that flourished briefly in the seventies in association with graphic reportage, *Newgate: Committed for Trial* (1878). In Holl's painting, the intimacy and closed form of the earlier configuration has been wholly dispersed into socially and physically disconnected groups. The groups impinge on each other's privacy and visibility, but are themselves further divided by the double line of bars and wire screens that separate the prisoners from their visitors. No domestic unit is intact; and the display of hand and gesture in the two visible prisoners and the woman in the left foreground expresses the separation as a deprivation of touch. The foreign-looking group to the right, whose handsome leader seems interested in offering money to the warder, is not

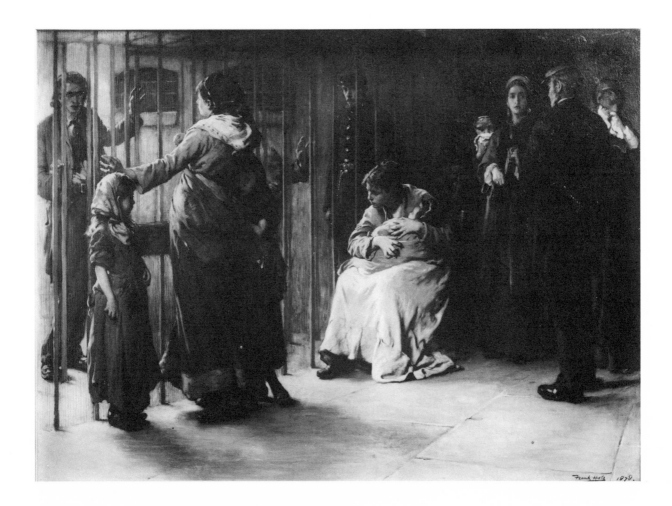

even in sight of its object of concern. The second guard, standing between the two lines of bars, has only one function: to enforce separation.[20]

At the focus, strikingly lit, of a double arc (with the men, prisoners and guards, largely on the outer circumference) is a seated woman and child. Her turned-aside face, anxious hands, and huddled attitude concentrate and summarize dull misery, vulnerable dependence, and disjuncture. The prison here is no longer the setting for a simple moral drama of remorse and innocent faith informed with domestic sentiment, just as the abstract pictorial organization is no longer congruent with a meaningful social unit. Yet the secular and to some eyes degraded maternal image at the center of the composite scene reaches behind the Rachels and Marthas of melodrama to a sacred image, and brings the domestic and gynolatrous character of the nineteenth-century prison picture to an appropriate terminus.[21]

THE REDEMPTIVE configuration of male and female amid the shades of the prison house, denied in *Newgate: Committed for Trial* but already undermined by absence and anxiety in *Waiting for the Verdict*, persisted in opera and melodrama long after the first signs of dissolution. A small

141. *Frank Holl*, Newgate: Committed for Trial *(1878)*, *Egham, Surrey, Royal Holloway College.*

[20] One reasonably appreciative reviewer (*Spectator* [8 June 1878], p. 730) attempts to see the painting in the light of the pictorial tradition, and observes the change but misses the thought in the dissolution of the familiar focused narrative and effect. He writes that " 'The committed for trial' is a despairing-looking young man, whose wife and children form the principal figures in the composition. The picture is a powerful one, with a certain grandeur of composition, and of broad masses of light and shade which are very pleasing, after a course of the ordinary pictures here, but its faults are very noticeable. The picture does not explain itself, or rather, it is two pictures, and part has a meaning, and part has not. All the left-hand divisions might be in Kamtschatka, for all they

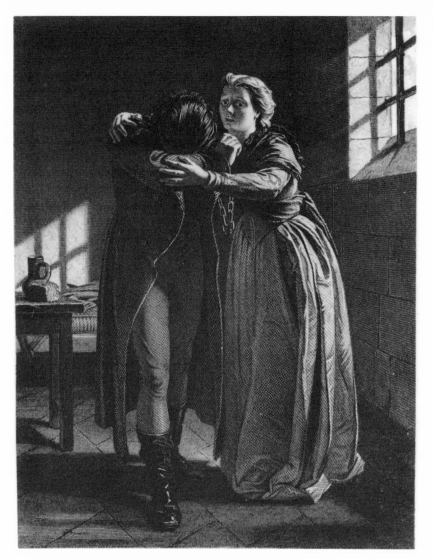

142. *Augustus Egg, Illustration for "Come, Rest in This Bosom," (1855), engraving by Francis Holl, in Thomas Moore,* Irish Melodies *(London, 1856).*

have to do with the action, and yet they occupy more than half the picture. In a work like this, which has a definitely tragic intention, it is a serious artistic error to fritter away or confuse the main effect. . . . It is a collection of studies made into a picture, without sufficient thought of the unity of the composition." (This reviewer also notes that the scene represented is "very much the same" as the one in Dickens' *Old Curiosity Shop* where Kit Nubbles' mother and entourage visit him in prison. H. K. Browne's lively illustration features only the one domestic group, separated from Kit by the guard between the gratings. Unlike Holl's painting, it is drawn from the prisoner's side, and puts Kit in the foreground, his head sunk upon his arm against the bars in the traditional attitude.)

[21] But William Rossetti, who thought Holl "entitled to ungrudging praise" for the painting, characterized the group as "a prisoner of hyaena-like savagery who browbeats his wife, an ill-used, slovenly, half-brutalised woman, seated with her baby" (*Academy* 13 [25 May 1878], p. 470). For the genesis of the painting, see Ada M. Reynolds, *The Life and Works of Frank Holl* (London, 1912), pp. 144-46.

[22] Egg had encouraged Hunt in a dark hour, and had bought his *Claudio and Isabella.* Both that prison painting and Millais' *Order of Release* appeared in the English section of the Fine Arts display at the Paris Exposition Universelle in 1855, where Dickens also had two paintings on loan (R. Hannah's *The Novel* and *The Play*). Dickens comments on English reactions to paintings at the Exposition in "Insularities" (see above, p. 81).

[23] *Exhibition of the Royal Academy of Arts* (London, 1855), #136. The painting had its share of notice, and even Ruskin allowed that "Mr. Egg has considerable power of expression, and though this subject of prison sentiment is both painful, useless, and hackneyed, he appears to have something like serious purpose in his work." But then Ruskin points out with great zest, "There is in this picture one of the most wonderful fallacies that ever painter ventured." Egg had neglected to start the strong shadows of the bars that fall on the wall behind the bed at the bars themselves, though "the sun must have come *in* at the window; it did not get through the keyhole. . . . It is dim daylight, shadowless, at the

but important testimony to its strength may be found in one of its simplest renderings, an untitled painting by Dickens' intimate friend, Augustus Egg, exhibited at The Royal Academy in May 1855, just as Dickens was winding himself up for his next major novel, *Little Dorrit*.[22] Instead of a title, the catalogue quoted one of Tom Moore's *Irish Melodies*, which begins:

> Come, rest in this bosom, my own stricken deer.
> Though the herd have fled from thee, thy home is still here,
> Here still is the smile that no cloud can o'ercast,
> And a heart and a hand all thy own to the last.[23]

The following year, an engraved version of the painting appeared in a handsomely illustrated edition of *Irish Melodies*.[24] The engraving shows a woman consoling and embracing a man who is manacled and ashamed of himself—he hides his head in his arm—in a grim prison

setting. There is nothing in Moore's poem to indicate a prison setting, or even to identify the sexes of speaker and listener, though there is perhaps a womanly and conjugal suggestion in the imagery of the first stanza, and much to suggest the disgrace and pariah status of the stricken deer. But the concreteness Egg and his school found indispensable in domestic subjects required a visual specification of locale and situation; and Egg naturally supplied the prison setting, the ready-made missing element in the configuration projected in Moore's poem. The speaker in the poem, loving, loyal, unreproaching ("I know not, I ask not, if guilt's in that heart. / I know that I love thee, whatever thou art"), is clearly unblemished herself, and is choosing to share the lot and ignominy of the pariah. She brings redemptive hopes, however, as the last lines of the last stanza (the caption of the engraving) make clear:

> Thou hast call'd me thy Angel in moments of bliss,
> And thy Angel I'll be mid the horrors of this,—
> Thro' the furnace, unshrinking, thy steps to pursue
> And shield thee, and save thee,—or perish there too!

The angelic analogue, the hand and heart, the shielding and saving action of Moore's poem were or soon became matters of convention, particularized in gesture, setting, and configuration in the visual narratives and dramatic images that succeeded it. But it is the title (as will appear), drawn from the first line, which more than anything else connects the well-worn song, Egg's illustration, and its many cognates to Dickens' *Little Dorrit*: "Come, Rest in this Bosom."

window itself. Hot sunshine, ten feet within the prison! " *Academy Notes* (1855), in *Works*, 14:14-15. Egg evidently hastened to correct this solecism, with quite good effect, for the engraving.
24 *Irish Melodies . . . Illustrated from Engravings from Drawings by Eminent Artists* (London, 1856). The poem had appeared originally in No. VI of *Irish Melodies*, whose preface was dated March 1815. It was set to the air of "Lough Sheeling."

15

✦ ⦙ ✦

DICKENS' ROMAN DAUGHTER

OASTING the Chair at the Theatrical Fund dinner of 1858, Dickens graciously asserted that "every writer of fiction, though he may not adopt the dramatic form, writes in effect for the stage."[1] The Chair's occupant—so overcome with emotion that he could barely reply—happened on this occasion to be Thackeray. Dickens could be comfortable with his declaration because he saw a firm distinction between the dramatic and the theatrical (see above, p. 81). That distinction allowed him to incorporate the dramatic as action and pathos, and exploit the theatrical as the stagey speech and behavior and the burlesqued melodramatics of so many of his grotesque and comic characters. But Thackeray generally found reason to be skeptical of such absolute and convenient dichotomies; and his qualified demurral from the general proposition of the toast is to be found in his works. Dickens was the master of "effect" among novelists, a quality Thackeray mistrusted. There is no Thackerayan fastidiousness in Dickens, no damping down or casual offhandedness in the revelation of significant events, no obvious and even perverse avoidance of climactic conjunctions. There is as much indirection in Dickens as in Thackeray, and as much coloration by complexities of tone; but these serve the preparation and enhancement of effects, rather than their dissembling and displacement. In Dickens, as in the theater, the importance of an event and its preparation and mounting are commensurate.

Dickens' familiar montage at the climaxes best represents such directed indirection. The discrete elements—synecdochic detail, homely metaphors, seemingly inconsequential phrases and images—accrete meaning with repetition and draw together into a final configuration to achieve and enhance effect. Sometimes, however, the configuration comes ready-made, a single integral image whose effect at the moment of achievement draws on assocations outside the novel. Such is the image of "Little Dorrit," Amy Dorrit, holding to her childish breast the Father of the Marshalsea in the shabby room of the debtor's prison. Its realization is a form of overt pictorial allusion, like Becky's realization of a famous *Clytemnestra* in *Vanity Fair* (discussed below). But the realization is not distanced, and its narrative consequences are not half-evaded, as in *Vanity Fair*, by theatrical labeling and a puzzling

[1] *The Speeches of Charles Dickens*, ed. K. J. Fielding (Oxford, 1960), p. 262.

relation between picture and text. In *Little Dorrit*, the image functions dramatically, and with repetition and variation it gathers weight and poignancy, marking "epochs" in the affective structure of the novel.

And yet, in none of its recurrences is the image a subject of pictorial illustration. Given Dickens' ability to exert considerable control over his illustrations, the reservation of the image to the words of the narrative bespeaks a deliberate avoidance, and even a conscious shift, in the relation between word and picture in Dickens' narrative mode. John Harvey, who locates the peak of the Dickens-Browne collaboration in *Dombey and Son*, comments on its failure in *Little Dorrit*.[2] The fault may not have been a flagging of creative response in Browne, however, but just such a change in Dickens' pictorialism. Certainly there is a notable difference between the striking series of situational tableaux through which *David Copperfield* progresses, and the style of picture-making in the narrative of *Little Dorrit*.

For all that, the picture of Little Dorrit and her father in a prison setting was clearly a generative source for the novel as a whole. The image draws, not on a single painting, like Becky's Clytemnestra, but on a pictorial and dramatic cluster, or rather two such clusters, historically linked. In the middle of the nineteenth century, prison images with a domestic interest had their own characteristic "modern" shape and furniture, whereby a tension between the prison and the familiar human affections supplied the organizing principle of the scene (see Chapter 14). But behind the dramas, pictorial and theatrical, that clothed the anxieties and fantasies of the age in the habits of a familiar world lay a pictorial antecedent from the ideal world. There heroism, piety, and a "higher" moral law licensed an image from the darker regions of dependency and desire. The first configuration, the modern prison scene, presented an image of human relations after the fall, of physical complementarity but moral and spiritual disequilibrium. The second, the classical scene, presented an image of sublime symbiosis, of paradoxical physical inversion but moral and spiritual release from the debt of time.

Unnatural Relations

In *Little Dorrit*, "Book the First: Poverty," in a chapter blandly titled "The Father of the Marshalsea in two or three Relations," Dickens comments on the now receding climax of a scene in which William Dorrit in his prison room exposes his degradation to his younger daughter, who comforts him. Dickens writes, with a glance at Dorrit's fellow prisoners, "Little recked the Collegians who were laughing in their rooms over his late address in the Lodge, what a serious picture they had in their obscure gallery of the Marshalsea that Sunday-night." He goes on to identify that picture, allusively, as a re-creation in the modern, familiar world of the much-painted scene of "Roman Charity," the story of the daughter who saved her imprisoned father from starvation with the milk in her breasts:

There was a classical daughter once—perhaps—who ministered to her father in his prison as her mother had ministered to her. Little Dorrit, though of the unheroic modern stock, and mere English,

[2] *Victorian Novelists and Their Illustrators* (London, 1970), p. 160. Q. D. Leavis, who believes that Dickens' mature art "needed no illustrator," sees evidence of a decline in the collaboration as early as *Bleak House* ("The Dickens Illustrations: Their Function," in F. R. and Q. D. Leavis, *Dickens the Novelist*, London, 1970, pp. 359-63). Michael Steig acknowledges a decline in *Little Dorrit* to the extent that "As a group, the *Little Dorrit* illustrations seem less necessary than those for *Bleak House*," but argues that the collapse occurs only in the next novel, *A Tale of Two Cities* (*Dickens and Phiz*, Bloomington, Ind., 1978, pp. 158, 311-12). All citations from *Little Dorrit* are by "Book" and chapter from the first edition (1855-1857).

did much more, in comforting her father's wasted heart upon her innocent breast, and turning to it a fountain of love and fidelity that never ran dry or waned, through all his years of famine. [*LD*, I, xix]

Shortly thereafter, when her father's tears had been dried, "and he sobbed in his weakness no longer, and was free from that touch of shame, and had recovered his usual bearing," she ministers to his literal hunger. She feeds him with her own regularly foregone dinner, concealed and smuggled home to the prison; "and, sitting by his side, rejoiced to see him eat and drink." Finally, she returns when he is in bed, to sit by him like a mother at the cradle, because "her gentle breast had been so deeply wounded by what she had seen of him, that she was unwilling to leave him alone, lest he should lament and despair again."

The collapse of Mr. Dorrit's usual air of magnanimous self-importance comes about in this episode through his introduction of the same momentous question that enlivened the prison interviews of Claudio and Isabella, Rachel and Robert, Jeanie and Effie Deans. The question is sanitized and reduced, from the heroic scale of moral choice to one of delicacy of feeling; but the issue of truth to one's essential nature, the situation in which love is asked to subvert itself, remain. Before father and daughter achieve their "serious picture," Dorrit, who "shrunk before his own knowledge of his meaning," suggests that Amy encourage young Chivery, the sentimental son of a turnkey, in his fruitless and unwelcome courtship; that she "lead him on." Dorrit has noticed some roughness in Chivery senior, and "good Heaven! If I was to lose the support and recognition of Chivery and his brother-officers, I might starve to death here." Such food his daughter cannot provide; and Little Dorrit, who has bent her head and looked another way, brings her father to an embarrassed silence in one of the series of successive juxtapositions, carefully noted, leading to the culminating configuration. Her hand has gradually crept to his lips, and "For a little while, there was a dead silence and stillness; and he remained shrunk in his chair, and she remained with her arm around his neck, and her head bowed down upon his shoulder." Food and its provision are a pedal point of the whole scene; and in the next phase he pushes from him the supper of her providing ("What does it matter whether I eat or starve? . . . A poor prisoner, fed on alms and broken victuals; a squalid, disgraced wretch!"), and "looking at her as wildly as if he had gone mad," rises into passionate speech. Little Dorrit takes to her knees; and then, trying "to take down the shaking arm that he flourished in the air," to bring him into his chair again, to put the arm around her neck, desperately works to compose the configuration compatible with her ministry. Eventually, "He burst into tears of maudlin pity for himself, and at length suffering her to embrace him, and take charge of him, let his grey head rest against her cheek, and bewailed his wretchedness." The image is not frozen. Mr. Dorrit returns the embrace, and continues (in indirect discourse) his maunderings, whereupon Dickens reflects on this "serious picture" in the "obscure gallery" of the Marshalsea and its classical analogue. His physical description of Dorrit and his daughter stops short of a full physical "realization"

of the scene of Roman Charity; the image is rather, as the language asserting Little Dorrit's transcendence of her classical predecessor makes clear, a sublimation. She holds her father's grey head to her cheek, and turns her "innocent breast," a "fountain of love and fidelity," to his "wasted heart."

The classical subject the Renaissance knew as *Caritas Romana* enjoyed a specially vigorous life in the painting of the seventeenth century, but as Robert Rosenblum has shown, it acquired a remarkable spectrum of new inflections with the onset of the Romantic movement.[3] Its most cited classical source was Valerius Maximus, where it exists in two versions, one featuring a daughter and her mother, and the other, which proved more popular though not Roman at all, a daughter and her father. Interestingly, the second account, that of Cimon and Pero, presents the scene as a picture, astonishing in its effect, which contemplation will bring to life and motion. A *word* picture, the writer claims, should be even more efficacious in giving the old story new life.[4]

Though the nineteenth century found ways of developing both the erotic and sacrificial possibilities of the image, it also found ways of evading what could be most troublesome in the scene to a heated imagination. In *Fidelio*, Leonore saves Florestan, chained to the wall of his dungeon, not only from sudden death, but also from deliberate slow starvation. Florestan "sees" Leonore in ecstatic vision as an angel in a garment of light, leading him heavenward, though she feeds him and saves him from Pizarro's knife while still disguised as Fidelio. Her reward—after the trumpet of release sounds the transforming hour— is first to embrace Florestan in this prison underworld, and then to take off his chains in the light. She is Florestan's wife, however, not his daughter; and the saving nourishment that once represented filial piety is absorbed into the redemptive action and influence of the conjugal bond. The nineteenth-century domestic prison scene, in which the chief participants may be husband and wife, brother and sister, even romantic lovers, is an adaptive modification rather than an unrelated rival of the classical image of filial piety, though a modification not without ideological significance in a progressive and revolutionary age. Dickens, however, in the course of his narrative, would create the conditions for a condensation of the two stages of the image.

Rosenblum points out that the terrible subject from Dante of Count Ugolino's incarceration in the Tower of Famine with his children, though painted by Reynolds in 1773, only became popular in later Romantic art in conjunction with the endless interest in prison and madhouse milieus.[5] The ultimate horror that Dante suggests in the incarceration was cannibalism, another subject of confused fascination for the nineteenth century. Since it was child's flesh that here volunteered itself for the meal, the Ugolino story in effect provided a dark alternative form of the theme of Roman Charity.[6] In this form, the horror of the reversal of the nurturing relation between parent and child displaces the complacent approval of sacrificial piety attached to the earlier configuration by earlier ages. That parent should batten upon child, through extremity or perversity, was appalling, *contra naturam*. And that those powerful members of society in a responsible paternal relation to the rest should claim sustenance rather than offer

[3] "Caritas Romana after 1760: Some Romantic Lactations," *Art News Annual* 38 (1972): 43-63. For several hundred earlier examples, see Andor Pigler, *Barokthemen* (Budapest, 1956), 2:284-92.

[4] Valerius Maximus, *Factorum Dictorumque Memorabilium, Libri IX*, Bk. V, chap. IV, par. 7 and ext. 1.

[5] "The Dawn of British Romantic Painting, 1760-1780," in *The Varied Pattern: Studies in the 18th Century*, ed. Peter Hughes and David Williams (Toronto, 1971), pp. 204-205.

[6] Cf. Rosenblum, "Caritas Romana," p. 49. As Ugolino bites his hands *"per dolor,"* his sons say, "Father, it will give us much less pain, if thou will eat of us: thou didst put upon us this miserable flesh, and do thou strip it off" (*Dante's Divine Comedy: The Inferno. A Literal Prose Translation*, by John A. Carlyle, London, 1849, p. 403). Carlyle (Thomas' brother) comments on Ugolino's final remark ("Then fasting had more power than grief"), "Many volumes have been written about [*Inferno* XXXIII] verse 75. Does the *più potè* ('was more powerful') indicate only that hunger killed Ugolino? Or that fasting overcame his senses, and made him die eating as his poor children had invited? The words admit of either meaning."

it, should act as wolves rather than as shepherds, should constitute a parasitic burden upon the poor and powerless, was similarly intolerable. The Revolution in France justified itself in terms of that perception; but even after the Restoration, no privileged class could afford to be perceived as wholly useless or exploitative. The echo of Ugolino in Géricault's *Raft of the Medusa* (the figure of the mourning father), and the resort to cannibalism on the historical raft, contributed to the perception of the painting as an attack on the governmental establishment.[7]

The climactic embodiment in nineteenth-century art of the deep-rooted horror of the reversal of the nurturing relation was Goya's *Saturn Devouring his Children* (ca. 1817); but the artist obsessed more than any other with that reversal in the political and institutional life of society and in the affective life of the young was Dickens.[8] The workhouse and its officials in *Oliver Twist*; the irresponsible Sir John Chester in *Barnaby Rudge*; Chancery and the voracious slow-digester, Vholes, in *Bleak House*; the great Barnacle clan, the Circumlocution Office, and the Marshalsea itself in *Little Dorrit*, all belong to the monstrous class of devouring parent. And so do the ghastly schools, and the many bosom-armored and self-engrossed, cruel *or* feeble men and women throughout Dickens who squeeze a profit out of the young and the unfortunate. Reversals, where the young are obliged to assume premature parental roles, commonly point to the larger neglect. But orphanage and bastardy play an equal part in representing this disnaturing in Dickens' world, metaphors Dickens shared with the bitter working-class writer who declared, "Trust none who is a grade above our class, and does not back us in the hour of trial. . . . Orphans we are, and bastards of society."[9] As in *Little Dorrit*, however, parentage as an imposition (Mrs. Clennam, the patriarchal Casby), and as a parasitic spiritual and economic tyranny, could be deadlier in its claims than simple abandonment. In Dickens' imagination, the underside of the transfigured image of the saving daughter that appears in *Little Dorrit* was the horror of the scene in Ugolino's tower.

Prefigurations

The image of the classical daughter "who ministered to her father in his prison as her mother had ministered to her" reached Dickens through poetry and the theater no less than through painting. Aside from a famous passage in Byron, the best known modern version of the story was Arthur Murphy's much-acted *Grecian Daughter* (1772), which remained in the repertory well into the nineteenth century.[10] The critical meeting in the play, a drama of dynastic rivalry in Sicily, is set in "the Inside of the Cavern" where Evander is held prisoner. Decorum is preserved by the father's collapse: he is borne from the stage with his daughter following, so that (in the words of the play) "the pious fraud of charity and love" may take place out of sight. The off-stage scene is reported by an enraptured jailor:

> Wonder-working virtue!
> The father foster'd at his daughter's breast!—
> Oh! filial piety!—The milk design'd

[7] See Lorenz Eitner, *Géricault's Raft of the Medusa* (London and New York, 1972), p. 46. Dickens examines the events on the raft at some length in his defense of the Franklin expedition from the imputation of cannibalism ("The Lost Arctic Voyagers," *Household Words*, 9 Dec. 1854).

[8] I do not see how to separate the "purely" psychological in this imagery from the social, political, and cultural concerns that gave it moment. For an exceedingly literal embodiment of the theme, full of horrific "effect," see Antoine Wiertz's *Hunger, Madness, Crime* (Brussels, Musée Wiertz), where a mad young mother, nurturing breast exposed, is carving and cooking her infant.

[9] James Morrison in *The Pioneer* (22 March 1834), quoted by Asa Briggs, "The Language of 'Class' in Early Nineteenth-Century England," *Essays in Labour History*, in *Memory of G.D.H. Cole*, ed. Briggs and J. Saville (London, 1967), p. 68.

[10] It was revived, for example, at Covent Garden in 1815, and Fanny Kemble had a striking success in 1830 as Euphrasia, formerly one of Mrs. Siddons' great roles. See the *Athenaeum* (23 Jan. 1830), and Leigh Hunt in the *Tatler* (26 Oct. 1830), p. 179.

For her own offspring, on the parent's lip
Allays the parching fever.
. .
 On the bare earth
Evander lies; and as his languid pow'rs
Imbibe with eager thirst the kind refreshment,
And his looks speak unutterable thanks,
Euphrasia views him with the tend'rest glance,
Ev'n as a mother doating on her child,
And, ever and anon, amidst the smiles
Of pure delight, of exquisite sensation,
A silent tear steals down; the tear of virtue,
That sweetens grief to rapture. All her laws
Inverted quite, great Nature triumphs still.[11]

The peeping guard, so moved that he effects the father's release, is in one of the versions in Valerius Maximus, and recurs frequently in the pictorial tradition. The paradox of Nature's triumph in the inversion of Nature's laws echoes another play of a father and daughter, whose impact on Dickens was more frequently renewed.

In 1838, Dickens celebrated, in a review for *The Examiner*, "The Restoration of Shakespeare's 'Lear' to the Stage" by his friend, William Charles Macready. Macready (with considerable trepidation) had restored the Fool, and the review stresses the value of the role in the production, especially the moving association of the Fool with the absent Cordelia, and the tenderness of the relation with Macready's Lear. Both the association and the tenderness were made easier by the casting; the Fool was played by an actress, Priscilla Horton. Dickens also mentions, as "touching in the last degree," Lear's recognition of Cordelia and his death scene.[12]

Irving would later make his greatest effect in the moving recognition between the newborn father and ministering daughter; but a *Lear* that played to the domestic emotions as never before was certainly Macready's achievement, despite the loss of Nahum Tate's final prison scene. Kean had boldly dropped that ending in 1823, but reverted to it before 1827, and it survived beyond his era. Tate had arranged his last scene—based on the prison scene, the "two birds in a cage," that Shakespeare's Lear only envisages—as a discovery: "SCENE, *A Prison. Lear asleep, with his Head on* Cordelia's *Lap.*"[13] That permuted and rather Christian image of piety and pathos, leading to Tate's happy ending, could not survive in the climate of an increasing reverence for Shakespeare's text and intentions; but the configuration had considerable interest in itself for the Romantic generation, as Blake's early drawing of the scene suggests.[14] An etching by the German artist Joseph Hauber (d. 1834) of Lear and Cordelia in their prison cell supports an association with Roman Charity as well. Hauber's etching might well serve as the prologue to any number of versions of the classical scene.

Dickens undoubtedly knew Murphy's *Grecian Daughter*, and he responded powerfully to the nurturing daughter and the broken father of *King Lear*. When he invokes the analogue of the classical daughter, however, it is pointedly as a picture, and a picture in an "obscure

[11] *The Grecian Daughter, A Tragedy* (London, 1772), II, [2], p. 25.

[12] *Examiner*, 4 Feb. 1838; reprinted in *Miscellaneous Papers*. Dickens' authorship is accepted by the editors of the Pilgrim Edition of *The Letters of Charles Dickens*, ed. Madeline House, Graham Storey et al. (Oxford, 1965), 1:357n.

[13] Nahum Tate, *The History of King Lear* (1681; facsim. ed., London, 1969). Cf. Kean's acting version, *Shakespeare's Tragedy of King Lear*, ed. R. W. Elliston (1820; facsim. ed., London, 1970).

[14] See Martin Butlin, *William Blake. A Complete Catalogue of the Works of William Blake in the Tate Gallery*, rev. ed. (London, 1971), pl. I.

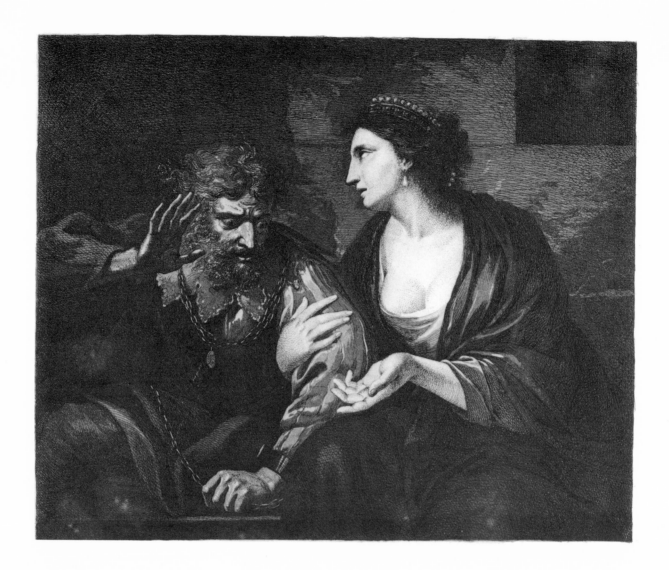

143. *Joseph Hauber*, Lear and Cordelia *(before 1834), San Marino, Cal., Huntington Library.*

gallery" at that (p. 303 below). Both his pictorial analogy and his qualifying irony have their rationale. They reflect, not only Dickens' conception of Little Dorrit's redemptive agency, but conclusions about the nature and power of his own art.

DICKENS had ample opportunity to look at distinguished pictorial versions of Roman Charity in England. Of the four paintings on the theme attributed to Rubens, one was at Blenheim, and another in the Earl of Hardwick's collection at Wimpole.[15] Further examples could be seen in royal and private collections, and the theme even appeared in English painting.[16] Like other Englishmen of his generation interested in art, however, Dickens had a large experience of European painting through engraving; and when finally well enough established to make his own Grand Tour, he found that engravings had been a more than adequate preparation, and were sometimes to be preferred to the originals.[17]

Nevertheless, his experience on this tour, in 1844-45, seems to have marked *Little Dorrit* particularly and distinctively. The editor of his

[15] Gustav Friedrich Waagen, *Treasures of Art in Great Britain*, trans. Lady Eastlake (London, 1854-1857), 3:124; Supplement (1857), p. 522.
[16] Rosenblum, "Caritas Romana," p. 46, illustrates a striking example by Zoffany.
[17] *The Letters of Charles Dickens*, Pilgrim Edition, Vol. 4 (1844-1846), ed. Kathleen Tillotson with Nina Burgis (1977), p. 276. See above, p. xvii.

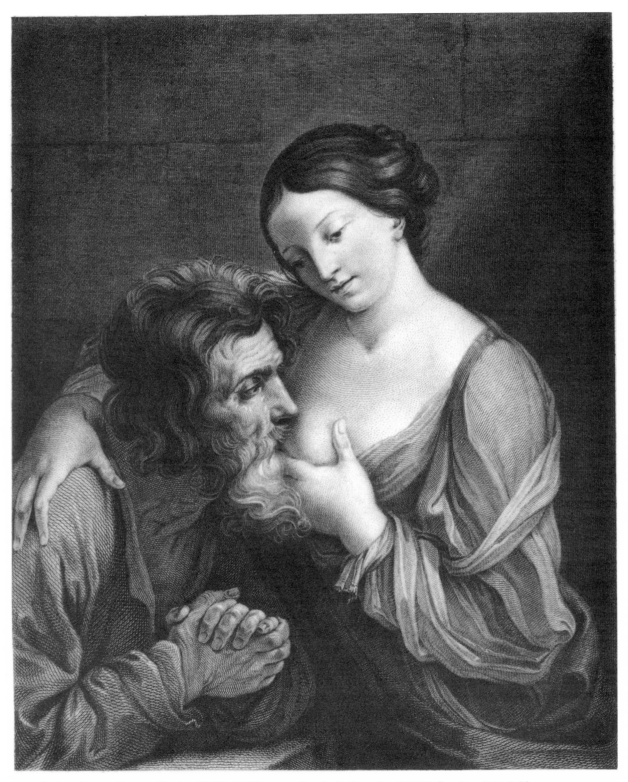

144. *Andrea Sirani*, Roman Charity *(1630-1642), engraving by J. Saunders (1799), London, British Museum.*

correspondence for the period remarks that the impressions of Italy "sank deep into his mind, to emerge a decade later as the pervasive tone of the Italian chapters of *Little Dorrit*."[18] These impressions were refreshed in 1853, when Dickens visited many of the same scenes with Augustus Egg and Wilkie Collins. Doubtless Dickens encountered the image of Roman Charity in more than one "obscure gallery"; in the private palaces of Rome, for example, where he thought "pictures are seen to the best advantage."[19] His chief headquarters in Italy, however, was Genoa, where he rented a palazzo and lived on and off between July 1844 and the following June. At Genoa too there were noteworthy versions of Roman Charity.

Dickens had small use for most of the conventional taste-shaping guidebooks, and makes savage fun of their kind in *Little Dorrit* and elsewhere.[20] He found particularly congenial, however, the independent-minded reflections of Louis Simond, who, in his account of Genoa, declines to elaborate on the notable palazzi to avoid boring the reader, but feels compelled to mention the Durazzo, for its paintings. "I particularly admired there a *Roman Charity* by Guido. The daughter fondly throws her arm about her old father whose life she is preserving. All that the human countenance can express of angelic purity, of piety, of joy, of filial reverence is there. The picture is not strongly painted; it is inferior in that respect to another Guido in the next room, a Magdalen; but much superior in the higher merit of expression."[21]

Dickens does not mention the painting in his correspondence or elsewhere. With his jaundiced view of canned raptures, he generally avoids detailed accounts of picture-viewing. But he does vividly describe, in a letter to Lady Blessington, the other painting in the Palazzo Durazzo that Simond admires at some length: a Van Dyck painting of a boy in white satin, whom Dickens thought resembled his own son.[22] It seems very unlikely that either of the two paintings Simond pays most attention to would have escaped Dickens' particular attention. One of Dickens' few pictorial rhapsodies, moreover, concerned another painting attributed to Guido Reni; in *Pictures from Italy* he exclaims over "the transcendent sweetness and beauty of the face" of the supposed *Beatrice Cenci* in the Palazzo Barberini. As in Simond's account of the *Roman Charity*, it is the expression in the human countenance that most moves and "haunts" Dickens: an expression that to his eye still echoes the terror and helpless desolation of Rome's best-known victim of a monstrous parental voracity.[23]

In Rome (where Dickens played the tourist until he had so much of churches he proscribed them, for fear he would never enter another) he would have had difficulty avoiding S. Niccolò in Carcere, a church incorporating the remains of a temple supposedly built on the site of the actual events of the *Caritas Romana*. Byron gives the church four stanzas in the most influential guidebook of the age, *Childe Harold's Pilgrimage*; and Murray's *Handbook* (too useful for Dickens to ignore), after casting some doubt on the identification of the site, quotes three of them. Murray reports:

There is a cell at the base of the columns, which is shown to strangers by torchlight as the scene of the affecting story to which

[18] Ibid., p. x. The letters home served more directly as a quarry for *Pictures from Italy* (1846).

[19] "Rome," *Pictures from Italy* (London, 1846), p. 212. At the Spada (Dickens mentions its "statue of Pompey; the statue at whose base, Caesar fell") he would have seen a *Caritas Romana* then attributed to Annibale Carracci (and more recently to Nicolò Tornioli) rather comic in its effect. It shows a weeping child clutching his hair in frustration, reaching for the breast his mother is giving the old man while favoring the infant with her loving but noncaloric look.

[20] In *Little Dorrit* the genre is summed up in "the celebrated Mr. Eustace, the classical tourist" (John Chetwode Eustace, *A Classical Tour through Italy*, 1815), identified with Mrs. General as a hierophant of "the received form." Dickens speaks of the whole body of Roman tourists as "a collection of voluntary human sacrifices, bound hand and foot, and delivered over to Mr. Eustace and his attendants, to have the entrails of their intellects arranged according to the taste of that sacred priesthood." *LD*, II, v, vii.

[21] *A Tour in Italy and Sicily* (London, 1828), p. 590. For Dickens' high regard for Simond, see *Letters*, Pilgrim Edition, 4:164 and 276: "None of the books are unaffected and true but Simond's, which charms me more and more by its boldness, and its frank exhibition of that rare and admirable quality which enables a man to form opinions for himself without a miserable and slavish reference to the pretended opinions of other people" (to John Forster, 9 March 1845). Simond is also twice mentioned in *Pictures from Italy*. The painting is now identified as by Andrea Sirani; see Piero Torriti, *La Galleria del Palazzo Durazzo Pallavicini a Genova* (Genova, 1967), pp. 173-76.

[22] *Letters*, Pilgrim Edition, 4:305; Simond, *A Tour*, p. 591. The Van Dyck is reproduced in Torriti, *Galleria*, fig. 55, as *Il Fanciullo Bianco*.

[23] *Pictures from Italy*, pp. 211-12.

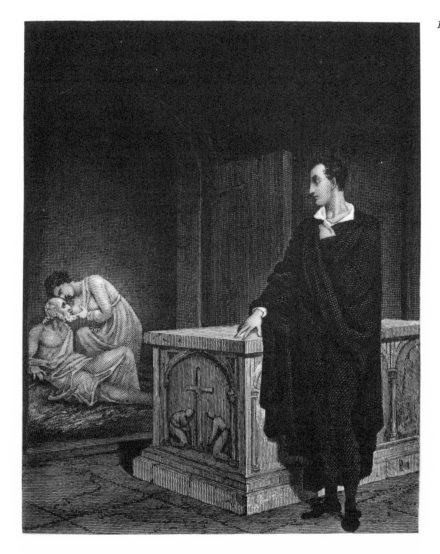

145. *Richard Westall, "Childe Harold" (1822), engraving by A. Godefroy, in* Oeuvres de Lord Byron, *trans. Amedée Pichot, 4th ed. (Paris, 1822), Vol. 2.*

we have alluded. Whatever may be the amount of the traveller's belief in the locality, he will not forget that it inspired those beautiful lines in the fourth canto of 'Childe Harold,' in which the poet pictures the scene which has given such celebrity to the Roman daughter.[24]

Byron presents the scene as a picture, materializing before the eyes in the dim, drear dungeon. His interpretation is rapturously physical as well as moral; a celebration of natural affection and the tide of life, "Great Nature's Nile," rising in "those warm and lovely veins." The moral points, not to filial piety, but to generous feelings, the replenishment of the heart by the heart; and in the end Byron rises to images of transfiguration as he muses (like Arthur Murphy) that:

> . . . sacred Nature triumphs more in this
> Reverse of her decree, than in the abyss
> Where sparkle distant worlds:—Oh, holiest Nurse!

[24] *Handbook for Travellers in Central Italy* (London: John Murray, 1843), p. 283. Dickens studied Murray's handbooks in advance of the journey to Italy (see *Letters*, Pilgrim Edition, 4: viii). *Childe Harold* was in his library.

No drop of that clear stream its way shall miss
To thy Sire's heart, replenishing its source
With life, as our freed souls rejoin the Universe.[25]

The power in Dickens' use of the motif came from his perception of a darker side to this reversal of nature; but the sublimation of the image of Roman Charity is the point at which he began.

Recalled to Life

The journey south in *Little Dorrit* coincides with the new material prosperity of Mr. Dorrit and his family, and his physical release from "the shadow of the Marshalsea." The journey is also for him, in the midst of the sensuous and material gratifications of wealth and Italy, a period of starvation of the affections. The starvation is self-imposed but externally grounded, in a servitude to fixed social ideas and to a notion of what is due to one's position. Dorrit and his prosperity create around him what Dickens presents as a physical hiatus, a literal deprivation in touch and in the flow of affective nourishment between heart and head. When in Rome, one cannot do as the Romans did; one cannot form a living picture of Roman Charity. On the road, Little Dorrit finds herself bereft, with no one to contrive for, no one's burden to assume; and strange as that was, "it was far stranger yet to find a space between herself and her father, where others occupied themselves in taking care of him, and where she was never expected to be" (*LD*, II, III). Her father admonishes her to resign her old place about him, since to fulfil the functions of a valet would derogate from her position. But she perceives that "in the midst of all the servants and attendants, he is deserted and in want of me," and writes to Clennam of the frustration of her compassionate wish "to put my arms around his neck, tell him how I love him, and cry a little on his breast" (*LD*, II, IV).

The continuation of the nourishing and healing configuration is blocked, wilfully and socially, in these new conditions, where nevertheless "the shadow of the Marshalsea" remains an inward presence. In Venice, however, with its extraordinary light, as Little Dorrit again responds to her father's complaints of her very presence with a touch that carries a reproach, there is a recapitulation of their earlier moment of atonement. Old Dorrit's angry and embarrassed justifications run down into silence, and he whimpers, "just as he had done that night in the prison when she afterwards sat at his bedside till morning" (II, V). The embrace, however, and the tears, end "much sooner than on the former occasion"; and Dickens observes that, with one final exception, "this was the only time, in his life of freedom and fortune, when he spoke to his daughter Amy of the old days."

The new shaping spirit in the Dorrit household of the Italian period is embodied in Mrs. General, a Varnisher and a Freezer in Dickens' iterated characterizing imagery, engaged "to form a surface" on the living sensibilities in her charge. In Rome, with an eye to freeing himself for a permanent union with Mrs. General, Dorrit echoes the scene in which he once advanced the prospects of John Chivery by again urging Little Dorrit to think of marriage. As justification, he

[25] *Childe Harold's Pilgrimage*, IV. cxlviii-cli; in *The Works of Lord Byron, Poetry*, ed. E. H. Coleridge (London, 1899), 2:437-39.

declares, "I cannot, my dear child, think of engrossing, and—ha—as it were, sacrificing you"—a repudiation not only of the sustaining sacrifices of the past, but of the ties of love so painfully affirmed therein. It is at this point of willed severance that Little Dorrit, cut off from all other loving connection, feels the ruin of her life complete, and finds the inner ruin echoed in the unfeeling stones of Rome. She is left to the discreetly Saturnian Mrs. General, "scratching up the dryest little bones of antiquity, and bolting them whole without any human visitings—like a Ghoule in gloves" (II, xv).

The presiding spirit of Anglo-Roman society, however, is Mrs. Merdle, who becomes in Dickens' exfoliating synecdochic fantasy the Bosom, all matter and no milk, a gorgeous marble presence and a jewel stand, the full physical antithesis to the childish and by all indications breastless figure of Little Dorrit. With such keepers and marshals as Mrs. General and Mrs. Merdle, Mr. Dorrit's chances for life-sustaining nourishment are few. But before his final relapse into the character of the Father of the Marshalsea at Mrs. Merdle's formal dinner, Dorrit sees, like Peter Pan and David Copperfield, a framed image of the scene from which he is now displaced:

> There was a draped doorway, but no door; and as he stopped here, looking in unseen, he felt a pang. Surely not like jealousy? For why like jealousy? There were only his daughter and his brother there: he, with his chair drawn to the hearth, enjoying the warmth of the evening wood fire; she, seated at a little table, busied with some embroidery-work. Allowing for the great difference in the still-life of the picture, the figures were much the same as of old; his brother being sufficiently like himself to represent himself, for a moment, in the composition. So he had sat many a night, over a coal fire far away; so had she sat, devoted to him. [II, xix]

This still, domestic scene, which once made even a prison into a home, recurs also in the imagination of Clennam, whose childhood home had been a spiritual prison. As a conventional image of domesticity, it calls for dramatis personae who are not father and daughter, old man and young woman, but husband and wife. In context, the image is a domestication of Roman Charity, not in a situation of crisis, but as a sustained condition; and it also suggests the polymorphous universality of Little Dorrit's loving, redemptive, womanly agency. Jealous now, Dorrit chases his brother to bed; and supper brought, Little Dorrit sits beside him, and "helped him to his meat and poured out his drink for him, as she had been used to do in the prison . . . for the first time since their accession to wealth." But the time of grace and nourishment is past for this Roman father, and the Bosom's indigestible dinner awaits him.

In the progress of the novel, which makes considerable use of redemptive recurrence, Mr. Dorrit's successor is not his brother William, but Arthur Clennam, a man of middle age who thinks himself old, past the possibility of a union of hearts, his feelings having been starved and frozen until it was far too late for such connection. Little Dorrit signs herself to him as "Your poor child" after he effectively erects a barrier to a more intimate union by adopting a paternal fiction. But

in the final recapitulation and fullest visual realization of the image of Roman Charity in the novel, both the ostensible paternal relationship and the visual image itself are transformed. Clennam loses his money and that of his firm in the bottomless gulf of Merdle, a man, we are told, with the digestion of an ostrich, but with an acute psychosomatic dyspepsia. Clennam's determination to exonerate his innocent partner—an atoning reversal of the original Dorrit case—makes Clennam a popular scapegoat, and he lands in the Marshalsea prison where, through the delicacy of John Chivery, he is allotted Mr. Dorrit's old room. Alone, he weeps for the absent figure in the scene, and recognizes the redemptive influence she has had on him all along. As he sits in fever and despair, unable to eat or drink or even to move, Little Dorrit appears in "her old, worn dress" to complete the picture. She kneels beside him, kisses him, and they both weep.

> As he embraced her, she said to him, "They never told me you were ill," and drawing an arm softly round his neck, laid his head upon her bosom, put a hand upon his head, and resting her cheek upon that hand, nursed him as lovingly, and GOD knows as innocently, as she had nursed her father in that room when she had been but a baby, needing all the care from others that she took of them. [II, XXIX]

The daughter in the Durrazzo Palace painting, as Simond observes, also draws an arm around her nurseling, who—black-haired and vigorous—is closer to a man of Clennam's age than to one of old Dorrit's. In re-creating the configuration, Little Dorrit and Clennam have achieved a point of fulfillment and rest, a perfect union, and in the most important sense Clennam has already been given his release. The remaining material obstacles, including the Dorrit fortune and the prison walls, cannot affect it, and obligingly evaporate in the denouement.

After the couple recover themselves, Clennam notes that "Little Dorrit looked something more womanly than when she had gone away," but was otherwise unchanged; and if that "same deep, timid earnestness that he had always seen in her" now had "a new meaning that smote him to the heart, the change was in his perception, not in her." The change is in his perception of the possibilities of love, including a generous love that pours out "its inexhaustible wealth of goodness upon him" in a domestic relation. As Little Dorrit unpacks the food and drink she has brought and begins turning the prison into a home by sewing a curtain for the window, the picture alters: "and thus, with a quiet reigning in the room, that seemed to diffuse itself through the else noisy prison, he found himself composed in his chair with Little Dorrit working at his side." Whatever reservations one may have these days about such a domestic scene as an emblem of a loving partnership, the capacity for adult union has been achieved by a redeeming recapitulation of the etiology of the heart, repairing an original starvation of the senses and affections that left the grown Arthur Clennam with the miserable sense of his own impotence, deprivation, unspecified guilt, and paralysis of the will. Little Dorrit as daughter-mother has figuratively given him her loving breast; later, as the seasons change about the changeless and barren prison, Clennam, "listening

to the voice as it read to him, heard in it all that great Nature was doing, heard in it all the soothing songs she sings to man. At no Mother's knee but her's, had he ever dwelt in his youth on hopeful promises, on playful fancies, on the harvests of tenderness and humility that lie hidden in the early-fostered seeds of the imagination; on the oaks of retreat from blighting winds, that have the germs of their strong roots in nursery acorns" (II, XXXIV). From the womb or grave of the Marshalsea he is resurrected, and his infancy and childhood are given him, by the child-woman who reverses time and Nature to redeem them.

DICKENS did not purge himself of the prison theme, or outgrow the countervailing image of Roman Charity, with the conclusion of *Little Dorrit*. He came back to them in *A Tale of Two Cities*, whose imaginative germ belongs to the period of renewed creativity immediately after his first Italian visit, and is hardly distinguishable from the germ of *Little Dorrit*.[26]

The image of Roman Charity recurs in *A Tale of Two Cities*, in a section entitled "Recalled to Life." It takes form (like a *tableau vivant*) in a prepared fictive setting, designed to accommodate the actual world to the mental world of the prisoner. Dr. Manette, recently released from the Bastille but unable to accept his condition, is brought together with his daughter, Lucie, in a garret room that has been darkened and made into a pseudo-cell. The wine-shop keeper, Defarge, ostentatiously wielding a key, stands in for the jailor. Lucie is required by her father's fragile mental state to restrain her "eagerness to lay the spectral face upon her warm young breast, and love it both to life and hope." But eventually she succeeds in taking him to her, and rocks him on her heart "like a child." The release comes, and the tableau configuration (including spectators) is completed, when she evokes Manette's tears for both the irremediable and irrecoverable past and the living present:

> He had sunk in her arms, and his face dropped on her breast: a sight so touching, yet so terrible in the tremendous wrong and suffering which had gone before it, that the two beholders covered their faces. [*TTC*, I, VI]

Much else in *A Tale of Two Cities* recalls the imagery and concerns of *Little Dorrit*, but they are shifted, as here, to a bolder, broader key, appropriate to a drama played within the heroic framework of a historical action.

Words and Pictures

There is a paradox in Little Dorrit's agency in that the achievement of a pictorial configuration is linked to the unfreezing of a fixed tableau. The paradox applies no less to Dickens' conception of his fictional vehicle than to the imaginative truth he wishes to convey. Pictures, sculpture, and all that conduces to a fixed and frozen order do not enjoy an enviable repute in *Little Dorrit*; they provide, in fact, much of the imagery antithetical to Little Dorrit's agency, and to life. The most striking domestic tableau in the novel, not without overtones of

[26] *Letters*, Pilgrim Edition, 4:590. Dickens mentioned to Forster the convoluted "idea of a man imprisoned for ten or fifteen years, emphasizing his imprisonment being the gap between the people and circumstances of the first part and the altered people and circumstances of the second, and his own changed mind." Dickens then explored the psychology of the long-term prisoner, newly released, in old Dorrit, in Arthur Clennam returning from exile, and most sensationally in Mrs. Clennam making her nightmare journey through the unaccustomed streets. He pursues the theme in Dr. Manette.

a prison picture, is the group of frozen travelers "silently assembled in a grated house" a few paces from the convent of the Great Saint Bernard:

> The mother, storm-belated many winters ago, still standing in the corner with her baby at her breast; the man who had frozen with his arm raised to his mouth in fear or hunger, still pressing it with his dry lips after years and years. An awful company, mysteriously come together!

In Dickens' reading of the tableau, the frozen configuration is finally unintelligible, though the imagery of nursing mother and child and the possibly starving man suggests a grim antithesis to Little Dorrit and her version of Roman Charity. It is not just life and time, but the narrative current that has been brought to a halt in this meaningless assemblage, whose viewers (the figures seem to say) "will never know our name, or one word of our story but the end" (II, i).

The frozen image, in stone, paint, or flesh, is associated in the novel with both the intrinsic quality and the extrinsic effects of the deadly set who are allowed to preside over the social and political life of the community. At Mrs. Gowan's dinner at Hampton Court, where the talk is all on "preserving the country," Clennam meets Lord Lancaster Stiltstalking, that "noble Refrigerator," who had "iced several European courts in his time." Elsewhere, Mr. Tite Barnacle, permanent head of the Circumlocution Office, "altogether splendid, massive, overpowering, and impracticable. . . . seemed to have been sitting for his portrait to Sir Thomas Lawrence all the days of his life." He and Merdle ruminate on an ottoman like "the two cows in the Cuyp picture over against them," soon to be joined by the great Lord Decimus, who "composed himself into the picture . . . and made a third cow in the group" (II, xii). The grinding landlord Casby sits virtually unchanged beneath his image as "the youthful Patriarch, aged ten." On her first introduction, the Bosom makes a fashionable picture as a Woman with a Parrot, arranging her dress or "the composition of her figure upon the ottoman" while alluding to her feelings "as coldly as a woman of snow." Among the women, Mrs. General's unmarked, unruffled waxen face and freezing manner complement her character and her agency. Engaged for the formation of surface, she is especially devoted to the received form in the appreciation of the arts. The shallow and heartless Henry Gowan sets himself up as a painter. That Dickens used the visual arts with malice aforethought to characterize what was deadliest in English society and government is supported circumstantially by a letter to Forster, written near the commencement of *Little Dorrit*, concerning the art at the Paris Exposition Universelle. Dickens complained of the English paintings: "There is a horrid respectability about most of the best of them—a little, finite, systematic routine in them, strangely expressive to me of the state of England itself. . . . mere form and conventionalities usurp, in English art, as in English government and social relations, the place of living force and truth."[27]

As a force inimical to life and truth, Mrs. Merdle and Mrs. General are far outclassed by Arthur's mother, whose agency is directed not to the surface but to the depths. A stony idol herself, consuming the invalid's delicacies brought to her wheelchair, she is for Arthur, and

[27] *The Letters of Dickens*, ed. Walter Dexter, Nonesuch Edition (London, 1938), 2:700 (Oct. 1855).

all those within reach of her will and subject to her power, a Medusa. "If she had been possessed of the old fabled influence, and had turned those who looked upon her into stone, she could not have rendered him more completely powerless (so it seemed to him in his distress of mind) than she did, when she turned her unyielding face to his, in her gloomy room" (II, XXIII).

Little Dorrit's agency is directly opposite: she acts to release the living from their frozen enchantment. And yet her successes are marked pictorially. Is there an inconsistency to this? The answer lies partly in a distinction between life and motion, a distinction that Fanny Dorrit fails to make when she reports her sister's virtues as "of that still character that they require a contrast—require life and movement around them, to bring them out in their right colors" (II, XXIV). Fanny herself supplies the contrast; but the stillness in her sister is also alive. Little Dorrit's pictures are islands of stillness, rather than images of arrested motion or frozen situations.

Such frozen pictorial situations occur in the novel with an ironic theatrical self-consciousness, for example, in the "grand pictorial composition" where the Dorrits (now wealthy) encounter Mrs. Merdle in wrongful possession of their rooms (II, III). Another sort of situational tableau occurs as a message from the unconscious, an effort of the imagination that falls short of intelligibility, like the frozen assemblage on the Saint Bernard. Clennam, fresh from twenty years abroad, convinced on slender grounds of his implication in a mystery that requires reparation and atonement, has encountered his mother in her decaying house, visited the portrait of his dead father in his father's unaltered room, and followed Little Dorrit to the prison, where she looks after the Father of the Marshalsea. Accidentally locked in overnight, Clennam's wakeful fancies form "but the setting of a picture in which three people kept before him. His father, with the stedfast look with which he had died, prophetically darkened forth in the portrait; his mother, with her arm up, warding off his suspicion; Little Dorrit, with her hand on the degraded arm, and her drooping head turned away" (I, VIII). These fragments he seeks to read as if they composed one picture, a single situation crystallizing the initial stage of the plot. But the unlocking of the mystery through the narrative dissolves rather than validates that scene. As a frozen emblem of mystery, rather than a living configuration, the picture represents something negative, the material resistance to the narrative flow.

The stillness in Little Dorrit informs the pictures she creates and distinguishes them from such images of arrest. Similarly the release into life that results from her agency is distinguished from mere images of movement. The elaborate program of foreign travel in the novel and the wonderful machinery of the Circumlocution Office make the point well enough, but not with such clarifying intention as the galvanizing of Mrs. Clennam into furious motion. It was during Dickens' first Italian journey that he performed his most significant experiments with therapeutic hypnosis, and these presumably contributed to his delineation of the psychomechanics of a hysterical affliction. Mrs. Clennam is precipitated into motion, after years of confinement to house and wheelchair, by a profound threat to the Deuteronomic equilibrium of her system of punishments and injuries. But released from immobility,

she is not yet presented as restored to more than a simulacrum of life. She moves through the streets and to the prison "with that new power of movement in her, which, as she had said herself, was not strength, and which was unreal to look upon, as though a picture or a statue had been animated" (II, xxxi). It is only in the immediate presence of Little Dorrit that she achieves a momentary release into real life, affective life. She blesses Little Dorrit so that "the sound of her voice, in saying those three grateful words, was at once fervent and broken. Broken by emotion as unfamiliar to her frozen eyes as action to her frozen limbs." The release is only momentary, for to justify herself she immediately reverts to the doctrines of punishing vengeance and righteous satisfaction that have governed her life, and in the end restitution and atonement are denied her. Struck dumb and motionless, "She lived and died a statue."

In the prison interview with Mrs. Clennam, Dickens becomes most explicit in identifying Little Dorrit with the exemplified charity of the New Testament, uncomplicated by dogma, dispute, ritual, or image. Heretofore Mrs. Clennam's action has not merely inverted Little Dorrit's; it has parodied and paralleled it, as the Kingdom of Darkness is supposed to parody Light. To transform vengeance and bitterness into justice and righteousness, Mrs. Clennam, we are told, "reversed the order of Creation, and breathed her own breath into a clay image of her Creator" (II, xxx). In bodying forth her own passions as God, she raises up an unnatural monster, an idol whose simulated life demands a constant living sacrifice, including her own power of motion, the blood of children, the life of the heart. Moloch like Saturn is a consumer.

When Little Dorrit breathes life into the image of Roman Charity, however, her evocation of the scene is not a galvanic animation, but rather—as I have suggested—a sublimation. Her agency at large is also sublimation, release into spiritual freedom of the life arrested in stone. She dematerializes, like the light Dickens describes in a Turnerian glimpse of Venice from a "massive stone balcony darkened by ages":

> She would watch the sunset, in its long low lines of purple and
> red, and its burning flush high up into the sky: so glowing on the
> buildings, and so lightening their structure, that it made them
> look as if their strong walls were transparent, and they shone from
> within. [II, iii]

The stones of Rome are not amenable to such transfiguration; for Dickens had a not unusual post-Reformation English response to the glories of St. Peter's and the ceremonies therein, and found the city as inhabited museum a sometimes intolerable weight on the spirit. He characterizes Rome as "a city where everything seemed to be trying to stand still for ever on the ruins of something else—except the water, which, following eternal laws, tumbled and rolled from its glorious multitude of fountains" (II, vii). The living waters, natural and human, are precisely what the English in Rome ignore. It is no accident that the portion of the novel set in the sensual, material South, with its ruins, its religion, and its literal pictorial imagery, coincides with the low point in Little Dorrit's spiritualizing influence. But—by Dickens' showing—the sensual materialism of the Catholic South pales before

the twisted idealism of the Protestant North, the stifling legalism and literalism that blight ordinary enjoyments, natural affection, and human compassion in family and social life. More remarkable yet, like Mrs. Clennam, secular English "Society" rushes to breathe life into a vast clay image of its desires, making the great Merdle—a commonplace, vulgar swindler—into the golden Mammon of the age. In a world complacent with such maimed and confined religions, Little Dorrit's influence is, on one side, that of the Word, lightening and enlightening the sensual and material Image; and, on the other, that of the Spirit, infusing the Letter with life. The first is a sublimation; the second a redemptive release. The second has implications for the matter of art; the first for the means.

"ROMAN CHARITY" was so named with reference to Christian Charity, and implied, in a Renaissance context, a secular, humanistic cognate of the supreme Christian virtue whose ultimate source and example was divine. "Roman Charity" thus became the material counterpart, within the limits of an admired "natural" ethic and "natural" feeling, of a sacred, transcendental ideal. The image itself was the secular cognate of that sacred image of loving kindness, the Virgin and Child, and a literalization of the allegorical emblems of divine Charity in post-Renaissance iconography. Charity, Ripa says, may be shown by a woman holding a child in one arm, and extending a burning heart with the other; or by a woman giving suck to one child in a figure with two others, wherein was to be read the message of Saint Paul.[28]

By the domestication of the prison scene in the nineteenth century, the secular counterpart of Divine Charity was removed still further from its spiritual analogues; it was secularized in earnest. Meanwhile altered notions of decorum affected the reading of the earlier images of Roman Charity. Dickens' sublimation of the image certainly was not intended to withdraw it from secular life; and he intensifies rather than dilutes its pertinence to the sphere of private feeling. But his sublimation was an attempt to respiritualize the image and so enlist the power of its material form. He uses it as an instrument of transfiguration and release in the narrative, and its imaginative transformation is an analogue of its use.

In the imprisoned Arthur Clennam's darkest hour, before the unimaginable visitation of Little Dorrit, he thinks another picture, putting into intelligible order the time embraced in the narrative between his first disjointed Marshalsea mind-picture and the present:

> Looking back upon his own poor story, she was its vanishing-point. Everything in its perspective led to her innocent figure. He had travelled thousands of miles towards it; previous unquiet hopes and doubts had worked themselves out before it; it was the centre of the interest of his life; it was the termination of everything that was good and pleasant in it; beyond there was nothing but mere waste, and darkened sky. [II, XXVII]

The metaphor as worked out is less the translation of a temporal narrative into a picture than a fusion of narrative and pictorial conceptions, of progressive and simultaneous orders. Like Clennam's first picture and many a theatrical tableau, the passage marks a stage of the

[28] Cesare Ripa, *Nuova Iconologia* (Padova, 1618), pp. 74-75. (Cf. Guido Reni's *La Carità*, Pal. Pitti, Florence.) In other emblems, Hope also appears as a woman giving suck (to Amor); and Nature, as a naked woman with overflowing breasts. Ripa's "Piety of Offspring towards a Father" cites the classical story, but pictures only the daughter holding out her bare breast (in company with a crow, known for filial piety).

*146. Hablot K. Browne, "The Night"
(1857), in Charles Dickens,
Little Dorrit (London, 1855-
1857).*

narrative, now about to enter its final movement. Unlike Clennam's first picture, however, it is coherent and insistently unified because it projects the course of events that produced the present situation, the present narrative position, as a narrative of internal affairs. As a mind-picture, it represents feelings and perceptions and the inner vital truth of the matter, rather than external gestures and attitudes. It also reconciles, in the concept of the vanishing point, stillness and immateriality with an atoning power. What Clennam cannot imagine as yet is that which lies beyond the vanishing point: the transfiguration of mere waste and darkened sky, or in narrative terms, the redemption of the future by delivery from the past.

Such a picture is not one that Dickens' illustrator, Browne, could have realized within the conventions of mimetic representation. Where the narrative permits, Browne does his best to create pictures that support it structurally without giving it away: as in the recapitulations toward the end of the novel, where the plate Dickens titled "In the old room" (showing Clennam's visitors in the Marshalsea), and that

entitled "Damocles" (showing Rigaud perched in the window of the Clennam house), echo the positions of Cavaletto and Rigaud in the first plate of all, "The Birds in the Cage." Dickens indicates this visual recapitulation in the narrative, and Browne with some discretion embodies it. Similarly, Browne successfully embodies (as "The Night") Dickens' pictorial cadence (the end of a chapter) presenting the two Dorrit brothers in death:

> One figure reposed upon the bed. The other, kneeling on the floor, drooped over it; the arms easily and peacefully resting on the coverlet; the face bowed down, so that the lips touched the hand over which with its last breath it had bent. The two brothers were before their Father; far beyond the twilight judgments of this world; high above its mists and obscurities. [II, XIX]

This picture is significantly a scene composed by death, both cemetery art and pure tableau, a frozen moment and the summarizing emblem of a living relationship. By importing a statue of Psyche and making much of the moonlight, Browne hints at the transcendence with which Dickens concludes the scene. But Browne can hardly do more than hint; while Dickens rejects the monumental image in permanent arrest as the last word or the deepest truth. In so doing, Dickens also rejects the fixed and material image as the equal partner of his art. For *Little Dorrit* is, along with everything else, a celebration of the triumph of the living word over the dead image, of the narrative current ("the living waters") over the arrested configuration, of poetry over paint.

16

<center>✦·✦</center>

THE PARADOX OF THE COMEDIAN: THACKERAY AND GOETHE

*T*HE CONSCIOUSNESS of an audience, for Dickens the critical difference between a "theatrical" and a "dramatic" performance, was not a matter of great concern to Thackeray. It was the self-consciousness of the performer that intrigued and worried him: the self-consciousness at the heart of the mystery in Diderot's *Paradoxe sur le comédien* (not printed till 1830), a treatise that has challenged and informed discussions on acting ever since. But if Thackeray was troubled by the self-consciousness of the performer, he was also deeply skeptical of alternative ideals of performative art, such as sincerity. The issues involved were moral and social as well as psychological, for him and for his time.

Thackeray's uneasiness and divided mind are brilliantly put to work in his fiction, where they generate a running dialogue with the aesthetics of effect, making Thackeray its chief subverter. Further, his concern with his own role and self-awareness informs the regular juxtaposition in his fiction of actors in private life with nonactors. His ambivalence enters with conscious indirection into the intimate relation between narrative and picture in his best achievements.

Most of these elements come together in *Vanity Fair*, but some matters can be further illuminated by excursions out from that novel. The practical side of Thackeray's sense of himself as a performer appears, for example, in the negotiation of the dangerous corner between *Vanity Fair* and *Pendennis*; and some of *Pendennis* speaks feelingly to the related moral and aesthetic issues. Again, the charged symbols, pictorial and dramatic, that Thackeray makes use of in developing the tensions between acting and feeling, acting and being, in the society named Vanity Fair, also appear in an earlier work of fiction that probably influenced him, a work that in any event casts light on both vehicle and tenor in *Vanity Fair*. Goethe's *Elective Affinities*, as it happens, also seems to have given the impetus to the fashion for *tableaux vivants* in the social and historical milieu Thackeray is most concerned with,

and was itself part of that milieu. But its pertinence goes deeper. Goethe enters regions and arrives at conclusions that Thackeray wants no part of; but Goethe concerns himself, like Thackeray, first with the dissonances between human nature and human society, and second, with the possible relations—based on the relations between acting and being—between the artist-performer and his art.

The ultimate reflector of Thackeray's need to find his way and keep his self-respect as a writer and performer was style, including those strategies of narrative that are aspects of style. Therefore such matters are the final concern of this exploration of Thackeray as a maker of fiction. With Thackeray, style itself was a criticism, and that criticism profoundly influenced the future of the art of effect and of the narrative-pictorial mode, in fiction, painting, and the theater, in the nineteenth century and beyond.

Hercules and Clytemnestra

Having captured a public, found his vein, and become famous in course of the part publication of *Vanity Fair*, Thackeray was understandably anxious to continue his success. Like an actor after an unexpected triumph that has raised him out of the crowd, he had to concern himself with bringing his patrons back to the same shop. Consequently the bright yellow paper of the covers that identified *Vanity Fair*, whose last number had appeared in July 1848, reappeared four months later on the first number of *The History of Pendennis*, a plain invitation to readers to renew the contract. The cover illustration which would run through all the parts was changed, like the title; but it was cleverly designed, so that, like the paper, it would serve as a vivid reminder of *Vanity Fair* as well as an epitomizing projection of *The History of Pendennis*.

Thackeray himself designed the hundreds of illustrations in *Vanity Fair* and *Pendennis*: the etched plates, the inset woodcuts, and the pictorial capitals at the beginning of every chapter; and he is the only important English novelist who illustrated his own works.[1] His design for the part covers of *Pendennis* has in consequence a peculiar authority, and beyond that a complexity of reference, of self-revelation and self-concealment, rivaling some of the most intricate moments of confidential address by Thackeray's benign narrators. Since the preface to *Pendennis*, like that to *Vanity Fair*, was written only at the end, as an introduction to the novel in volume form, the cover illustration originally had some of the uses of a preface, as a place to declare intentions, set the tone, speak of oneself, and reflect on one's art.

The reminders of *Vanity Fair* on the cover of *Pendennis* included the pair of young women, one fair, one dark; one seductive, one clinging; one worldly, one domestic; one erotic, one maternal: the paired attributes of Becky and Amelia. The worldliness of the Becky-figure's appeal is represented by the coach and crown waved by one of her supporting train, a faun that is a cross between imp and cupid. The domestic character of the Amelia-figure's appeal is represented by the children, backed by a parish church to counterbalance the faun's emblems of wealth and honor. One child, clearly a little girl, duplicates

[1] Starting with *The Newcomes* (illustrated by Richard Doyle), Thackeray shared the labor. Other novelists who illustrated their own fiction include Samuel Lover and George du Maurier.

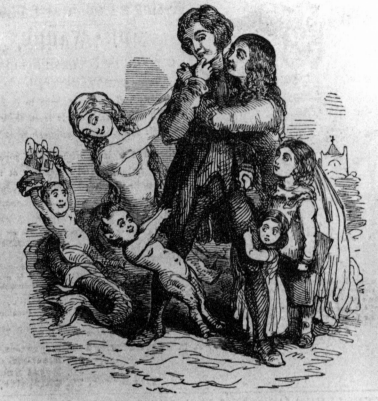

HIS FORTUNES AND MISFORTUNES,

HIS FRIENDS AND HIS GREATEST ENEMY

BY

W. M. THACKERAY,

Author of " Vanity Fair," the " Snob Papers " in Punch, &c. &c.

her mother's action and clings, balancing a second faun who, echoing his principal, leans back and tugs. The other child, old enough for lessons but still in a pinafore, stands sturdily, and looks up admiringly or trustfully at the ambivalent central figure who grasps his hand. Becky made the most of a handsome bosom, the subject of a certain amount of dubious male comment in *Vanity Fair*, and she is credited with perfecting the arts of the siren, even including music. On the *Pendennis* cover the siren's bare breast and fishy tail, with its prominent S-curve, evoke one of the more extraordinary and memorable passages in the earlier novel, the reflective opening of the last double number

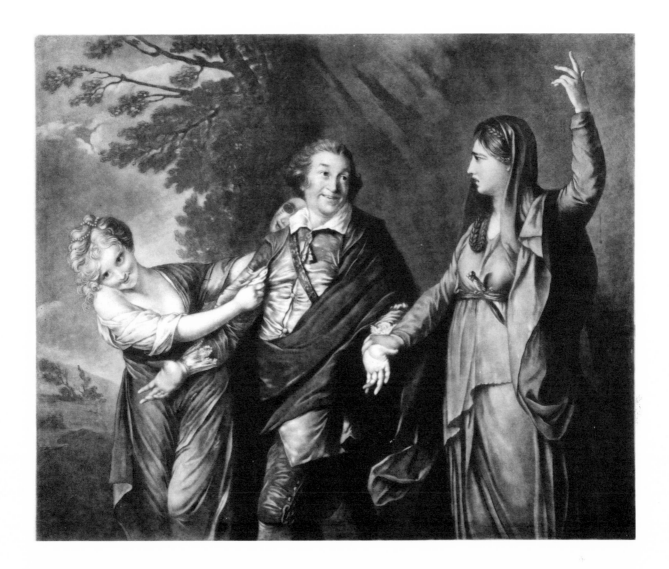

(Chapter 64), as well as a pictorial capital obviously representing Becky as a siren (Chapter 44), and a supporting network of serpentine allusion.

Thackeray uses the cover illustration to reflect on his art and speak of himself by indirection, with the help of a pictorial allusion (almost a realization, except that there is no increment in solidity). The allusion is to a painting that unites a literary-pictorial tradition with the theater: Reynolds' *Garrick between Tragedy and Comedy*.[2] The painting in turn wittily plays upon the motif of the Choice of Hercules, familiar from standard Greek and Latin school texts, and much painted since the Renaissance—by Rubens, Carracci, Poussin, West, and others.[3] Scott alludes to it familiarly in *Woodstock* (though he mistakes its source) when he dispatches the fugitive Charles II "to a solitary walk—the wilderness, where, like Hercules in the Emblem of Cebes, divided betwixt the personifications of Virtue and Pleasure, he listened alternately to the voice of Wisdom and of Passionate Folly" (Chapter 27).

148. Sir Joshua Reynolds, Garrick Between Tragedy and Comedy *(1761), engraving by Charles Corbutt, London, British Museum.*

[2] The allusion is noted by Joan Stevens in "Thackeray's Pictorial Capitals," *Costerus*, n.s. 2 (1974): 115-16.

[3] See Xenophon, *Memorabilia*, II. i. 21-34. For a perceptive discussion of Reynolds' painting, its tradition, and its place in a stylistic revolution, see Ronald Paulson's *Emblem and Expression* (Cambridge, Mass., 1975), pp. 30ff., 80. For other appearances of the *topos* in the literary and pictorial tradition, see Jean H. Hagstrum, *The Sister Arts* (Chicago, 1958), pp. 190-97.

It was, says Ronald Paulson, a common figure in English country houses in the eighteenth century, and Poussin's *Choice of Hercules* hung at Stourhead.[4]

Reynolds' compliment to Garrick, a high-comic masterpiece in its own right, admits of more than one reading. Garrick's turned-out hands, the contrapposto of legs swivelling toward comedy, head turned toward tragedy, would seem to support the reading that Garrick is unable (or unwilling) to choose, a compliment to his excellence in both kinds. Horace Walpole, however, presumably on the basis of the same gesture and Garrick's smiling sheepishness, thought that Garrick seems to be yielding to Comedy, "willingly, though endeavouring to excuse himself, and pleading that he is forced."[5] Either reading departs from the Herculean moral tradition, where the virtuous heroic choice is a foregone conclusion in the backward light of Hercules' known career, and the choice itself is an action rather than just an ambivalent situation. The visual tradition, however, was situational, with ambivalence the premise of the scene; and this portrait of Garrick, *as* a portrait of ambivalence, had meaning for Thackeray, an artist-performer himself.

The ambivalence for Thackeray extended to the theatrical mode, which Reynolds also comments on, as much through the style as through the subject of his painting.[6] Garrick is in costume, not markedly of either genre, but quite authentically theatrical in its look, details, and wrinkles. In him the theatrical is seen from the standpoint of reality, with the result that one is simultaneously aware of his existence as an actor and as a man. He might take off that costume, which doesn't quite fit. The double presence of the man and his role allows this allegory to keep its footing in the genre of portraiture. It also tilts the painting and Garrick the actor toward Comedy.

The muses are more ideally theatrical. They are in abstract generic costume with which they are entirely at one, though Tragedy, who is very classical, has a stage dagger at her waist. As for pose, despite the expressive eloquence of his stance and gesture, Garrick is in this also the most "natural" character of the lot. The characteristic theatricality of Comedy is in her direct appeal to the spectator; that of Tragedy, in her rhetorical attitude and gesture. The pictorial tradition had Virtue pointing upwards, showing the arduous path; but here the upward gesture of Tragedy is adapted to the emphatic climax of a speech in the grand style, while her other hand says, "Stay!" In company with the apologetic Garrick, and with Comedy conspiring with the spectator and indifferent to dignity or balance, the serious declamatory theatricality of Tragedy is made faintly ridiculous.

Thackeray's transformation of Reynolds' picture initiated a dialogue that furnished points in his pictorial apology. Most evident is his restoration and elaboration of the moral tenor of the scene. Hercules' classical choice, it is important to note, was not exactly between Virtue and Vice, but usually between Virtue and Pleasure, a moral choice between a life of manly heroic enterprise with all its discomforts, and unnoted inglorious gratification. Sadly, as Virtue changed her Graeco-Roman character for a Christian one, Pleasure lost her character entirely, though in the pictorial tradition she might still be represented classically, without the full stigmata of Christian Vice. Reynolds, how-

[4] Paulson, *Emblem and Expression*, pp. 30, 234.

[5] *Anecdotes of Painting in England*, quoted in Paulson, *Emblem and Expression*, p. 238.

[6] Reynolds was not the first to develop an application to the arts. Annibale Carracci's Hercules (Hagstrum, *Sister Arts*, pl. VII A.) sits between Virtue bearing the aegis of Athena with a laureled author at her side, and Pleasure with the emblems of more sensual arts at hers. These consist of a stringed instrument, a music book, and two theatrical masks. Presumably the painter, like Hercules, could choose between the moral and intellectual path of the poet and historian and the immediate sensual appeal of the player and musician.

ever, removes invidious moral distinctions of any kind, especially those that made the choice a moral lesson. Even though Reynolds' Tragedy still thinks of herself as having the higher claim, his Garrick is industrious in both genres, both redound to the actor's glory, and for either muse to claim him entirely would be a loss. Thackeray, however, restores the moral opposition between Virtue and Pleasure, now plainly labeled as Vice; in fact, by adding the fishy tail and the imps, echoing the allegories of Vice in Spenser and Milton, he gives a plainer moral cast to the emblem than ever before. And yet, thanks to the allusion to Reynolds and Garrick, Thackeray's design retains the implications of an aesthetic rivalry.

Apart from additions, the most notable changes from Reynolds in the configuration of the three principals are the clinging character of Virtue and the thoughtful, irresolute, and immobile stance of the protagonist, hand to chin, feet planted foursquare and apart. In Thackeray's version it is he who is looking at the spectator, in a wild surmise, while Pleasure peers up at him under her lids. Virtue, however, will have to be looked for within, since the figure who should embody it is no longer upright and monitory, but passive and dependent. Traditionally, as in Reynolds' picture, Virtue stands apart, energetic and dignified, while it is Pleasure who, voluptuously flaccid, is much in need of support. In Daniel Maclise's recent *Choice of Hercules* (1831), for example, it is Pleasure who clings to Hercules' left side, with bright flesh and heavy rump, while trying her arts on the spectator.

This shift from a strenuous Virtue to clinging domesticity and dependence does more than honor Becky's foil, Amelia; it alters the polarity between Comedy and Tragedy. For a Thackeray now beginning his closest approach to an autobiographical novel, who had recently found or rather established his vein, precariously balanced between satire and sentiment, the shift spoke to his own situation as a writer.[7] The pleasure and the temptation for him lay in the habit of satire, in conducting the social comedy of snobbery and pretense with a cynical worldliness that reflected his own perception and experience. But what then of virtue and goodness and innocent faith, which also have their claim to representation? And what about showing a proper feeling toward vice? Some critics asked all that about *Vanity Fair*, though there the balance was struck, and Thackeray, possibly for domestic reasons of his own, accepted the obligation of moral seriousness.[8] His serious muse, however, was not Tragedy, nor a more strenuously heroic and indignant Satire, but domestic sentiment, what Thackeray calls in *Pendennis* "that reality of love, children, and forgiveness of wrong, which will be listened to wherever it is preached, and sets all the world sympathising," despite the "balderdash" that often surrounds it (I, IV, 43). For Thackeray the artist, the happiest situation (as well as the most difficult) was to be suspended between his serious and comic muses; between Amelia and Becky, Virtue and Vice, a loving dependence and a brash vitality. Each figure is allowed her negative and positive effect on the reader; and that equilibrium, like the balance of forces on the cover of the *Pendennis* part issue, corresponds to the mixed, middling, and fairly equal conditions in which both figures find their final fictive reward.

[7] "If there is any exhibition in all Vanity Fair which Satire and Sentiment can visit arm in arm together; where you light on the strangest contrasts laughable and tearful: where you may be gentle and pathetic, or savage and cynical with perfect propriety" is how Thackeray begins the chapter on the Sedley sale. He does not mean that a public auction is an anomaly in the Fair; rather it is an epitome. (*VF*, Riverside Edition, ed. Geoffrey and Kathleen Tillotson, Boston, 1963, chap. 17, pp. 158-59. All quotations are from this edition. Those from *Pendennis* are from the Smith, Elder edition of 1869.)

[8] See Gordon N. Ray, "*Vanity Fair*: One Version of the Novelist's Responsibility," *Essays by Divers Hands*, n.s. 25 (1950): 87-101.

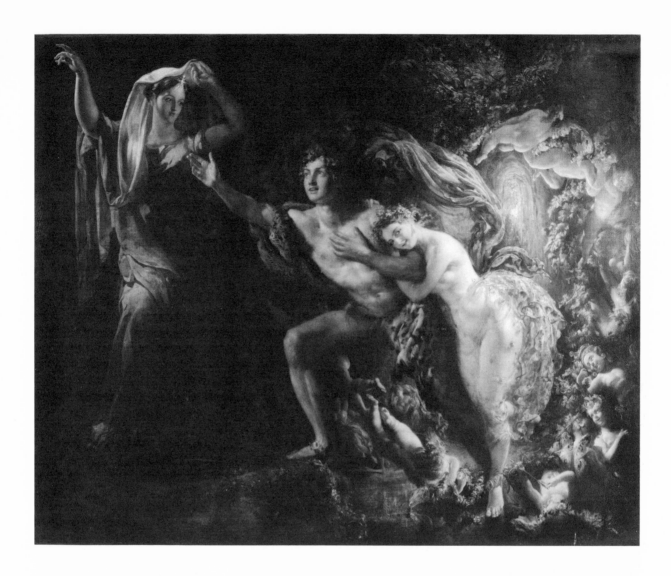

149. *Daniel Maclise,* The Choice of Hercules *(1831), collection of Hon. Christopher Lennox-Boyd, Photo: Courtauld.*

9 *Thackeray: The Critical Heritage*, ed. Geoffrey Tillotson and Donald Hawes (London, 1968), p. 90.

10 The young mother looks much like the cover-image of Pen, and echoes his pensive attitude and gesture. Joan Stevens in "Thackeray's Pictorial Capitals" identifies the bacchante as Morgiana in *The Forty Thieves.* Late in the novel (II, xxvi, "Temptation") Pen does fancy "my Morgiana will dance around me with a tambourine, and kill all my rogues and thieves with a smile" in his peculiar wooing of Blanche Amory. But the tambourine was also the standard property of the bacchante, theatrical and otherwise (as in Titian's *Bacchus and Ariadne* and

Pendennis "cannot be described as an advance on *Vanity Fair,*" wrote the *Athenaeum* reviewer. "It is rather like a pair of volumes added to that story."9 The suggestion of more of the same was certainly part of Thackeray's strategy, as reflected in the early allusions to the Marquis of Steyne, the Bareacres family, and other such personages, locating us immediately in the world of the earlier novel. But *Pendennis* is also a novel unto itself; and accordingly the cover image was a bridge, not merely a reminder, and it found new application early in *Pendennis.* The pictorial initial letters of the first two chapters show respectively a theatrical bacchante with tambourine and a young mother seated beside a cradle, versions of the two dramatic muses and representative of young Pen's own situation in the early sections, poised between the dazzling actress known as the Fotheringay and his loving, stifling, widowed mother.10 One of the two plates for the first of the published parts shows (according to its rubric) "Youth between Pleasure and Duty," in this case between a "swell" friend holding Pen's arm and taking him to the play, and the Reverend Doctor Portman, pointing

28] **PARADOX OF THE COMEDIAN**

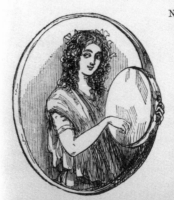
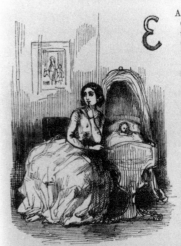

PENDENNIS.

CHAPTER I.

SHOWS HOW FIRST LOVE MAY INTERRUPT BREAKFAST.

NE fine morning in the full London season, Major Arthur Pendennis came over from his lodgings, according to his custom, to breakfast at a certain Club in Pall Mall, of which he was a chief ornament. As he was one of the finest judges of wine in England, and a man of active, dominating, and inquiring spirit, he had been very properly chosen to be a member of the Committee of this Club, and indeed was almost the manager of the institution; and the stewards and waiters bowed before him as reverentially as to a Duke or a Field-Marshal.

At a quarter past ten the Major invariably made his appearance in the best blacked boots in all London, with a checked morning cravat that never was rumpled until dinner time, a buff waistcoat which bore the crown of his sovereign on the buttons, and linen so spotless that Mr. Brummel himself asked the name of his laundress, and would probably have employed her had not misfortunes compelled that great man to fly the country. Pendennis's coat, his white gloves, his whiskers, his very cane, were perfect of their kind as specimens of the costume of a military man *en retraite*. At a distance, or seeing his back merely,

B

CHAPTER II.

A PEDIGREE AND OTHER FAMILY MATTERS.

ARLY in the Regency of George the Magnificent, there lived in a small town in the west of England, called Clavering, a gentleman whose name was Pendennis. There were those alive who remembered having seen his name painted on a board, which was surmounted by a gilt pestle and mortar over the door of a very humble little shop in the city of Bath, where Mr. Pendennis exercised the profession of apothecary and surgeon; and where he not only attended gentlemen in their sick-rooms, and ladies at the most interesting periods of their lives, but would condescend to sell a brown-paper plaster to a farmer's wife across the counter,—or to vend tooth-brushes, hair-powder, and London perfumery. For these facts a few folks at Clavering could vouch, where people's memories were more tenacious, perhaps, than they are in a great bustling metropolis.

And yet that little apothecary who sold a stray customer a pennyworth of salts, or a more fragrant cake of Windsor soap, was a gentleman of good education, and of as old a family as any in the whole county of Somerset. He had a Cornish pedigree which carried the Pendennises up to the time of the Druids,—and who knows how much farther back? They had intermarried with the Normans at a very late period of their family existence, and they were related to all the great families of Wales

the path of virtue. At the play furthermore (in the novel's second number), the Fotheringay impersonates the tragical Mrs. Haller in *The Stranger*, Benjamin Thompson's version of Kotzebue's *Menschenhass und Reue*, a role saturated with domestic sentiment and sensibility, which Pen naturally attributes to the actress's own character. The final tableau (as Thackeray reports it) re-creates the domestic-sentiment side of the title-page emblem: as the moment of reconciliation arrives, Miss Fotheringay "flung herself down on Mr. Bingley's shoulders, whilst the children clung to their knees . . . while the rest of the characters formed a group round them" (I, IV, 44).[11]

Later, Pen again finds himself between pleasure and duty, in the case of little Fanny Bolton, with his mother again acting as a restraint; and intermittently, through much of the novel, he is perplexed between Blanche Amory, a siren who comes with coach and crown (a fortune, a titled connection, and for Pen a seat in Parliament), and the deep-feeling, virtuous, and sisterly Laura. The worldly, flirtatious Blanche is an inveterate actress on the social stage, consciously performing in the manner and attitude she believes appropriate to the moment, like Becky Sharp. Despite differences in scale and character—as G. H. Lewes observed—"the two women belong to one type."[12] Thackeray endows Blanche with many of the physical characteristics of the Comic Muse—she is fair, pert, always smiling, and then exhibiting "two lovely

150. W. M. Thackeray, *Pictorial capitals for* Pendennis *(London, 1850), Chapters I and II.*

Vigée-Lebrun's *Lady Hamilton as a Bacchante*), and most likely would be interpreted generically, as unrestrained joyous pleasure, at the head of the first chapter. Thackeray's pictorial capitals almost always find their point in the chapter they head.

11 Thackeray's account stays very close in scene and dialogue to the printed text of the play, but he slightly alters the final configuration to bring it closer to the image in his cover picture. In the dramatic text, husband and wife "*gaze at each other, spread their arms, and rush into an embrace. The* CHILDREN *run, and cling round their Parents. The curtain falls.*" See Benjamin Thompson, *The Stranger*, in Mrs. Inchbald's *British Theatre* (London, 1808), 14:72.

12 Thackeray, *The Critical Heritage*, p. 107.

little pink dimples, that nestled in either cheek." But like Becky she often plays the role of the Sentimental Muse, particularly as the author of *Mes Larmes*. Thackeray indeed calls her "that inexorable little Muse" (I, XXIII, 261), and, in a passage later omitted from the chapter, once spent four paragraphs developing the trope. Pen, who likes Blanche well enough, but is far from bewitched by the time of his engagement, is rescued by the machinery of the plot and his own fastidious honor. He ends up, therefore, not with the woman of "sham emotion," who declares, "If I cannot have emotions, I must have the world" (II, xxxv, 415-16), but with her sincere rival, who furnishes loving protection against the worldly, cynical, skeptical, satirical spirit that is supposedly Pen's most dangerous temptation.

When the novel was published in volume form, having traveled a long way from its beginnings, either Thackeray or his publishers were moved to sever the tie to its predecessor by simplifying the cover illustration to suit the novel that had emerged. Pen's situation toward the end of the novel is that of a young man between two young women, with domesticity wholly prospective. Accordingly the revised vignette, placed as a half-title in Volume I, exchanges the children for an angelic cupid, balanced by a single imp on the other side; banishes crown and coach; and rather reduces the siren's fishy tail. The siren no longer tilts her head away, but pitches her appeal directly at the hero, whose eyes are on her rather than querying the audience. The man in the middle no longer wears theatrical (or antiquated) breeches and hose, but dandyish trousers. Garrick and his tempters are now remote, and the emblem has become simply a young man between two kinds of love, the erotic and the sentimental. There is no longer a perplexity about the Muses.

THE RELATION between picture and prose in *Vanity Fair* and *Pendennis* is not a tense equilibrium, but a collaboration. The theatrical and the pictorial, moreover, are nearly as inseparable in *Vanity Fair* as they are in *Garrick between Tragedy and Comedy*, though they will endure a separation for the sake of discussion. They exist in the novel both as motif and as matter of style; and the figure in whom they converge is Becky Sharp.

Though only brought home to *Vanity Fair* retrospectively, in the allusive cover of *Pendennis*, the Choice of Hercules appears in the earlier novel in several guises. George Osborne, for example, a hero only to Amelia, chooses viciously between domestic love and pleasure, Amelia and Becky, on the eve of Waterloo, where he meets his reward. Sir Pitt Crawley, who makes his first appearance as a porter (and is so illustrated), Hercules in low-comic form, soon finds himself between Ribbons and Becky, an improvement on his earlier position between Ribbons, or comic pleasure, and his lachrymose wife. Rawdon, the great Guardsman, too stupid to be a hero, appears as an ironic Hercules who follows Pleasure in his choice of Becky, but attains to something like Virtue in the domestic sequel. In her domestic character, Becky "mastered" him with "lawful matrimonial pleasures," and having fixed his love and loyalty clothes him in the shirt of Nessus.[13]

It is Becky, however, who stands in most pertinently for the hero

¹³ *VF*, chap. 30, p. 284. Thackeray moralized on Rawdon's admiration for Becky's command capability: "Is his case a rare one? and don't we see every day in the world many an honest Hercules at the apron-strings of Omphale, and great whiskered Samsons prostrate in Dalilah's lap?" (Chap. 16, p. 151).

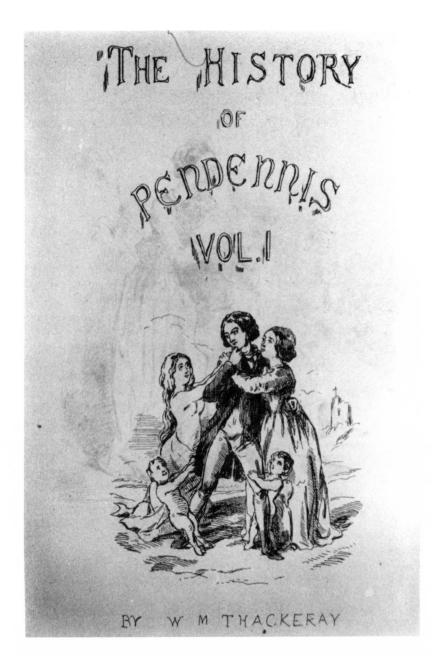

in this novel without a hero and without a central male figure like
Pendennis, the writer, to represent Thackeray. Becky is characterized
as the Napoleon of the social and sexual arena; and she is the Garrick
as well, hoping to keep her balance and evade a choice between do-
mestic respectability with Rawdon, and the world in the person of the
Marquis of Steyne. She is Garrick, moreover, in the hour of her greatest
personal triumph, when she appears in the theatricals at Gaunt House
both as Tragedy and Comedy: first as the murderous Clytemnestra,
and then "in powder and patches [as] the most *ravissante* little Mar-
quise in the world" (Chap. 51, p. 497).

Becky's gifts as an actress are a leading part of her character, asso-

152. W. M. Thackeray, Illustration
for Vanity Fair (London, 1847-
48), Chapter 51.

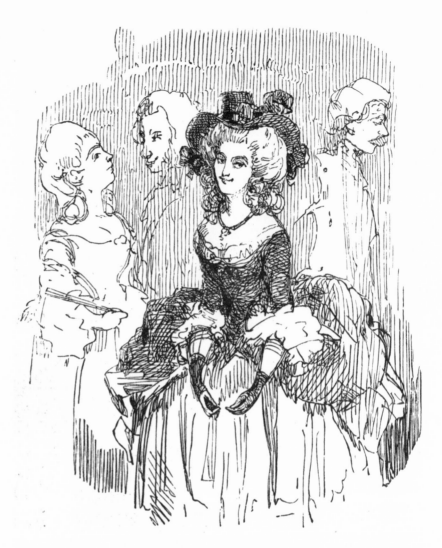

ciated with her vitality and power of fascination on the one hand, and
with her moral dubiousness on the other. She begins even at her father's
knee entertaining his friends as a mimic, that is, as an ad hominem
satirist. She develops that gift into an adaptive social mimicry that is
a basic weapon in her socially mobile campaign. Her theatrical mother
(a French "opera girl") and painter father, bohemians both, imply not
only inherited mimetic propensities, but a freedom from defined social
status, from the burden of knowing one's place. For Becky the bo-
hemian as for Napoleon, the career is open to the talents. Only, since
a career as Becky wages it is directed at achieving and maintaining
high social place, it conflicts with the anarchic condition that enables
it. Becky can be bored in the possession of the status and respectability
she campaigns for, a great point in her favor with the modern reader,
but also the self-contradiction that allows Thackeray to include her in
his spectrum of Vanity.

The moral dubiousness of Becky's acting gift is associated with her
"nostalgia for the mud," as Augier would soon call it; but the matter

goes deeper. Indeed, it affects Thackeray's conception of himself. Why should the gift of mimicry in a woman be the conventional sign of a bad disposition? To judge by literature and the stage, some of the traditional prejudice against the actress proper had weakened during the preceding two centuries. Harriet, who leads Dorimant to the brink of virtue in *The Man of Mode* (1676), is an accomplished mimic; and Kate Hardcastle, who liberates Marlowe in *She Stoops to Conquer* (1773), does so by assuming a rank, accent, and shifting persona not her own. But in the nineteenth century, the power of impersonation, of being other than oneself, appears as a significant literary symbol of moral peril, especially in a woman not already a frank professional of one kind or another. The root of the anxiety, to the extent that it peeps out, had its paradoxical aspect. On the one hand, a woman who can act feelings cannot be *known* to have them, or can dissemble those she has; on the other hand, to act feelings—those of a lover, a flirt, an adulteress, a murderer—is in some sense to have them, and to be what you act. In an age and class that made a fetish of innocence, evil and the knowledge of evil, experience and the knowledge of experience, are confounded—a position Thackeray often disparages, though his creation of Becky suggests a deeper assent.[14] The professional actress was not so dangerous, because marked with the dyer's hand, and likely herself to be a victim of her art. Both Thackeray and Dickens show such actors as harmlessly transparent because unable to separate performance from life.[15]

Becky grows as a performer in her rise to the triumph at Gaunt House. Her natural bent is toward comedy, but she must sometimes repress it and get up sentiment.[16] The acting of sentiment, an essential weapon for an unprovided woman in this society, but representing feelings foreign to Becky's nature, requires her best efforts. The reader is brought to perceive Becky as an actress because she is a bad actress of sentiment. The pretense is transparent; the language, attitudes, even the costume, are "theatrical"; that is, they are stereotyped, shrill (a favorite epithet for Becky's voice), visibly calculated for "effect," and faintly wrong in timing or tone. But Becky learns; and as her roles improve, so does her technique. The real tears that were missing from some of her earlier performances later come at will.

It is Becky's misfortune that in her world, in the only field of operations open to her, the serious muse is Domestic Sentiment, a line in which she is comparatively weak; for we are given two powerful hints that her natural bent toward comedy is complemented by an equally natural capacity for the dark passions and heroical actions of tragedy. It is only in performance that these fully appear, and we know them more by Thackeray's report of Becky's effect on an audience than by direct description. When she commits bloody murder as an actress, Steyne, whom we trust not to be impressed by minor wickedness or by anything less than the genuine article, says through his teeth amid the roaring, "By ____, she'd do it too" (Chap. 51, p. 494). Becky's complementary performance as the *ravissante* little Marquise, like much comedy acting, requires a transparent impersonation, an overt theatricality which involves playing the actress while playing the role. At the conclusion, when she presses Lord Steyne's flowers to her heart

[14] Contrast the Enlightenment assumptions of Baron Grimm in one of the earliest reports of *tableaux vivants* as a genteel social activity: "Je crois cet amusement très propre à former le goût, surtout de la jeunesse, et à lui apprendre à saisir les nuances les plus délicates de toutes sortes de caractères et de passions." Denis Diderot, *Salons*, ed. Jean Seznec and Jean Adhémar (Oxford, 1957-1963), 2:155.

[15] On the general subject, see Jonas Barish, "Antitheatrical Prejudice in the Nineteenth Century," *U. Toronto Quarterly* 40 (Summer 1971): 277-99. Apart from the novels and authors mentioned in this chapter, a basic study would include the following: Jane Austen's *Mansfield Park*, Charlotte Brontë's *Villette*, Flaubert's *Madame Bovary*, Wilkie Collins' *No Name*, Zola's *La Curée* and *Nana*, George Eliot's *Daniel Deronda*, George Moore's *A Mummer's Wife*.

[16] "It was only when her vivacity and sense of humour got the better of this sprightly creature (as they would do under most circumstances of life indeed), that she would break out with her satire, but she could soon put on a demure face. 'Dearest love,' she said, 'do you suppose I feel nothing?' and hastily dashing something from her eyes, she looked up in her husband's face with a smile" (Chap. 20, p. 285).

"with the air of a consummate comedian," Steyne is frantic with delight, and all voices agree, "with good reason, very likely," that had she been an actress "none on the stage could have surpassed her" (p. 498). But her Clytemnestra, in contrast, performed "with such ghastly truth," succeeds because the actress and the role, Becky and the assassin, seem one. The second hint of Becky's capacity for a tragic role comes near the end, more in that puzzling picture titled "Becky's second appearance in the character of Clytemnestra" than in any passage in the text.

As far as Becky is concerned, the pictorial has in fact been intimate with the theatrical all along. Attitudes—falling on one's knees, looking to heaven, clasping one's hands—are an important side of Becky's performances, and the situations she arranges and precipitates reach their high points as tableaux, when the narrator lets them. Becky's performance as Clytemnestra at Gaunt House is in its very nature both pictorial and dramatic. It is the climax of a charade on the word "Agamemnon," and incorporates a *tableau vivant*. With a mimed lead-up (borrowed from *Macbeth*), it assembles and realizes a recognizable painting, the *Clytemnestra* of Pierre-Narcisse Guérin (1817). The action is continuous, and the narrative itself does not halt to mark the realization; but two plates—in the novel the pictorial and epitomizing equivalent of tableaux in drama—make up for that. Here is Thackeray's description of the scene:

> The last act opens. It is a Grecian tent this time. A tall and stalwart man reposes on a couch there. Above him hang his helmet and shield. There is no need for them now. Ilium is down. Iphigenia is slain. Cassandra is a prisoner in his outer halls. The king of men (it is Colonel Crawley, who, indeed, has no notion about the sack of Ilium or the conquest of Cassandra), the anax andrôn is asleep in his chamber at Argos. A lamp casts the broad shadow of the sleeping warrior flickering on the wall—the sword and shield of Troy glitter in its light. The band plays the awful music of Don Juan, before the statue enters.
>
> Ægisthus steals in pale and on tiptoe. What is that ghastly face looking out balefully after him from behind the arras? He raises his dagger to strike the sleeper, who turns in his bed, and opens his broad chest as if for the blow. He cannot strike the noble slumbering chieftain. Clytemnestra glides swiftly into the room like an apparition—her arms are bare and white,—her tawny hair floats down her shoulders,—her face is deadly pale,—and her eyes are lighted up with a smile so ghastly, that people quake as they look at her.
>
> A tremor ran through the room. "Good God! " somebody said, "it's Mrs. Rawdon Crawley."
>
> Scornfully she snatches the dagger out of Ægisthus's hand, and advances to the bed. You see it shining over her head in the glimmer of the lamp, and—and the lamp goes out, with a groan, and all is dark. [Chap. 51, pp. 493-94]

Guérin, a "transitional" figure who taught the major Romantic painters, drew on aspects of theater and drama to support and to qualify a formal Davidian neo-classicism. His *Clytemnestra*, among other things,

was a striking experiment in the art of effect. The painting is soaked in a blood-red light, emanating from a lamp on Agamemnon's side of a half-open, deep-red curtain which the light irradiates, and against which the figure of Clytemnestra appears, shadowed and terrible.[17] Thackeray (confusing Guérin for the nonce with a contemporary who made similar experiments) speaks of the unnaturalness of "Girodet's green 'Deluge' for instance: or his livid 'Orestes,' or red-hot 'Clytemnestra' " at the Louvre.[18] Baudelaire, admiring "the dramatic and almost fantasmagoric qualities of the author of *Thesus and Hippolytus*" (*Phèdre et Hippolyte*, 1802), declares, "It is certain that Guérin was always much taken up with melodrama."[19]

Guérin's *Clytemnestra* has the effect of the lamp that Thackeray mentions in his account of Becky's impersonation; the shadow, the "arras," the sword and shield hanging in Damoclean fashion over the forehead of the warrior, who also "opens his broad chest as if for the blow"; the dagger, a cowardly Ægisthus, and Clytemnestra, bare-armed, hair on shoulders, and baleful.[20] But Thackeray only shows her in the attitude of Guérin's figure in the illustration, "The Triumph of Clytemnestra." Characteristically, Thackeray there chooses to illustrate, not the moment of supreme theatrical effect, but a peripheral moment which is nevertheless one of supreme social triumph in *Vanity Fair*. Guérin's Clytemnestra is "realized," but by a species of indirection, as if by accident, giving the allusion an ironic as well as figurative point. Becky's attitude, head bent, knife reversed and angled upwards, is intended as her deferential response to the presence and moronic condescension of the "great personage," His Royal Highness; but it is the attitude of the *Clytemnestra*. Tragedy and melodrama are converted to comedy and satire (her accidental tail is a further comic reminder of devilishness). The image is realized, but the "effect" is thrown away.

Only to turn up in "Becky's second appearance in the character of Clytemnestra." The dark glaring figure behind the theatrical curtain, hair down, loose-robed, with her terrible little smile, is recognizably (1) Becky, (2) the Clytemnestra of the performance, and (3) Guérin's Clytemnestra. The hand that angles upwards across her body and holds a sinister bottle recalls the dagger, while the suggestion of a cup on the supporting pillar recalls the standard paraphernalia of Tragedy (cf. the cup and dagger in Reynolds' portrait of *Mrs. Siddons as the Tragic Muse*). The image, because of its concession to "effect," completes the realization of the painting; while as Becky's "second appearance" in the character of Clytemnestra, it is offered as a narrative realization in truth and in life of the previous fictive impersonation. The performer and the role have become one—at least in the picture.

The illustration, however, notoriously fails to correspond with what we know from the narrative. Of the various kinds of illustration Thackeray incorporated in *Vanity Fair*, the full-page etched plates were most closely bound by the conventions and expectations of scenic "realization." No full-page etching departs from these literal conventions or causes problems in interpretation before the second appearance of Clytemnestra.

In the narrative, the only evidence we have against Becky as Jos Sedley's literal murderer is his nervous dread, the reluctance of the

[17] "Au travers d'un rideau de pourpre, à demi-ouvert, on voit percer la vive clarté d'une lampe placée tout près du lit, et formant une masse de lumière rougeâtre sur laquelle se dessine nettement, et avec vigueur, la figure de Clytemnestre. Celle d'Egyste ressort à peu près de la même manière.

"L'artiste a joint à l'effet des passions véhémentes celui qui naît des deux principaux moyens d'illusion, le coloris et le clair-obscur. . . . cette lumière rougeâtre, dont le tissu du rideau est en quelque sort imprégné, ne fait que mieux valoir la figure de Clytemnestre qui, vue presque toute dans l'ombre, et sous un aspect terrible, conserve néanmoins cette noblesse de caractère que donnent la grandeur et la correction des formes." C.-P. Landon, *Salon de 1817*, Annales du Musée et de l'École Moderne des Beaux-Arts (Paris, 1817), pp. 64-66.

[18] "On the French School of Painting," *The Paris Sketch Book* (London, 1869), p. 52.

[19] "The Museum of Classics," *Art in Paris 1845-1862*, trans. Jonathan Mayne (London, 1965), p. 36.

[20] Guérin may be reminding us of Jael and Sisera. Thackeray uses the Damoclean motif in a passage and a half-page illustration on the children of the house of Gaunt (*VF*, Chap. 47).

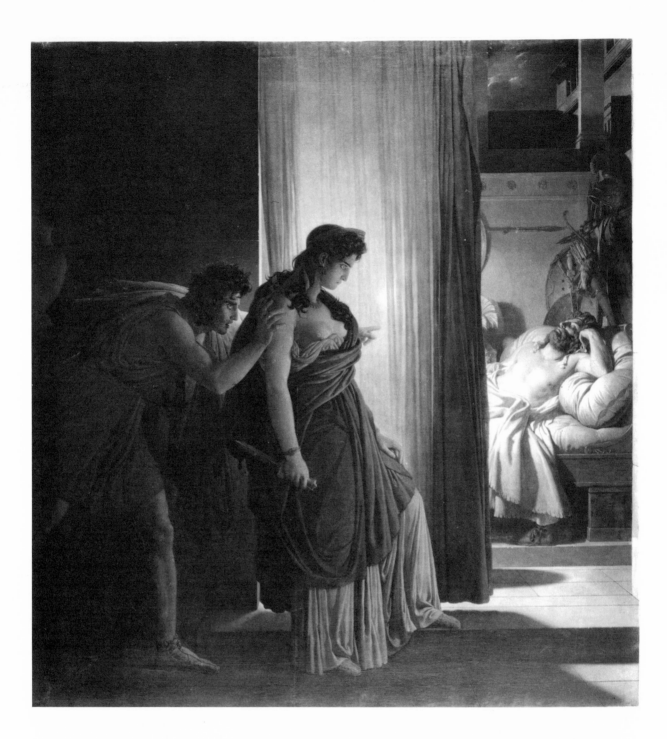

153. *Pierre-Narcisse Guérin*, Clytem-
nestra *(1817), Paris, Louvre
(cliché des Musées Nationaux).*

insurance company to pay up (a reluctance by which it stands to gain),
and the innuendo planted in the names of Becky's solicitors (Burke,
Thurtell, and Hayes, all noted murderers). No doubt Becky was the
death of Jos, just as she was surely "guilty" of betraying her husband
with the Marquis of Steyne. But the narrative offers us only moral
assurance of a moral crime, not physical assurance of a legal one. Becky
in her envisaged "second appearance" can literally represent only Jos'

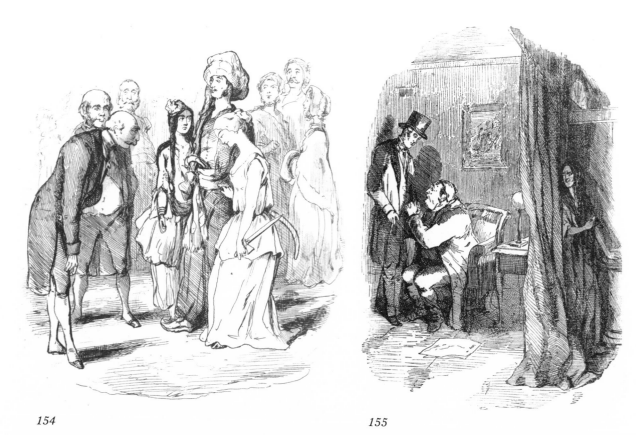

154 155

fear and a narrative possibility; and as a feeling, the embodiment of a
state of mind, she is allowed to appear with "effect."

The strong division of the pictorial space supports such an inter-
pretation, as do Becky's loose gown and hair (more tragic than the
circumstances would warrant had she just come in), and the poison
in hand (as if for immediate administration, though Jos' death is still
some way off). As the materialized projection of an overwhelming fear,
the picture succeeds; and yet the visual concreteness of the image seems
to compromise its other function: to represent only a narrative possi-
bility. The result is, historically, a partial failure in readability. It may
be that "Becky's second appearance in the character of Clytemnestra"
points to an ultimate limit on the collaboration of picture and text to
create a narrative whole.

The realism (within limits) that Thackeray the novelist claims for
himself is ultimately an epistemological realism: a true representation
of how we as social beings know things, and of the limits of what we
can know. Knowledge of others, it turns out, is not as absolute as
premised in most fictional narratives. Its real channels are often social
channels: gossip, report, declaration, document, observation, all open
to various constructions. In *Vanity Fair* "the novelist, who knows
everything" (Chap. 33, p. 318) gives place to the historian who tells
and interprets what he knows. In life, we settle for partial knowledge
and accept the fact that we are not likely to know for sure the answers
to such questions as "Was she guilty or not?" "Very likely," says
Thackeray's far-from-omniscient Worldly Wiseman when he means to

154. *W. M. Thackeray, "The
Triumph of Clytemnestra," in*
Vanity Fair, *Chapter 51.*
155. *W. M. Thackeray, "Becky's sec-
ond appearance in the character
of Clytemnestra," in* Vanity
Fair, *Chapter 67.*

express his skepticism. Narrative and reflective prose, however committed to realism, can sustain an ambiguity of fact as well as of motive and explanation; but a picture that attempts to be representational cannot. In a picture—even allowing for muffled presences and suggestive shadows—Becky either is there in the shape of a murderess or she is not. Therefore one early reviewer, who could not "sufficiently applaud the extreme discretion with which Mr. Thackeray has hinted at the possibly assistant circumstances of Joseph Sedley's dissolution," actually wrote to "advise our readers to cut out that picture of our heroine's 'Second Appearance as Clytemnestra,' which casts so uncomfortable a glare over the latter part of the volume."[21] This reviewer was someone particularly alert to what pictures do, but she nevertheless missed (or discounted) Thackeray's expressionistic intentions. The picture could not sustain the negative capability of the text, could not suspend itself between a realization in truth and life of Steyne's prediction concerning Becky, and a realization in someone's subjective experience of Steyne's perception of what lay within her, all based originally on a harmless fictive impersonation by an actress.

An Actor Prepares

The early nineteenth-century fashion for *tableaux vivants* enters *Vanity Fair* with the Gaunt House fête, not only because these forms occupy a territory between theatrical performance and pictorial and plastic art, but for reasons appropriate to a historical novelist more seriously concerned with evoking an age than Thackeray is sometimes supposed to be. As John Sutherland points out, much preparational learning went into Thackeray's historical fictions including *Vanity Fair*, though the erudition was then disguised. Sutherland very aptly compares the method to Macaulay's *and* Stanislavsky's.[22] A prior saturation primed Thackeray both as a "historian" concerned to evoke the feel of the past unobtrusively, and as an actor (or puppet master) who thought of himself as performing his narrator and animating his puppet personages.

The fashion for *tableaux vivants* was historically connected with the species of performance called "attitudes," whose leading exponent was that meteor of the age of the French Wars, Emma Lady Hamilton.[23] Abetted by the collector and classical enthusiast, Sir William Hamilton, she virtually invented the form, having profited by the prior experience of sitting for an infatuated George Romney in a vast range of personae and passions. Romney painted her as Circe, Calypso, Euphrosyne, a Sybil, a Bacchante, Saint Cecilia, Lady Macbeth, Cassandra. The last became part of Boydell's Shakespeare Gallery. Thackeray, recalling the few pictures he had to look at in childhood for amusement, cites Boydell's "black and ghastly gallery . . . there was Lady Hamilton (Romney) waving a torch, and dancing before a black background," from the painting called *Cassandra Raving*.[24]

Lady Hamilton's remarkable rise (from nephew's mistress to uncle's wife and confidante of queens); her notoriety (as Nelson's fascinator and unofficial widow); and her decline (into gambling, drink, raffish stratagems to live, confinement for debt, and exile) concluded in 1815

[21] Elizabeth Rigby (later Lady Eastlake) in the *Quarterly Review* (Dec. 1848), in Thackeray, *The Critical Heritage*, pp. 85-86.

[22] J. A. Sutherland, *Thackeray at Work* (London, 1974), pp. 128-32.

[23] See Kirsten Gram Holmström, *Monodrama, Attitudes, Tableaux Vivants* (Stockholm, 1967) and Chap. 3 above.

[24] "John Leech's Pictures of Life and Character" (1854), *Works* (London, 1869), 22:325.

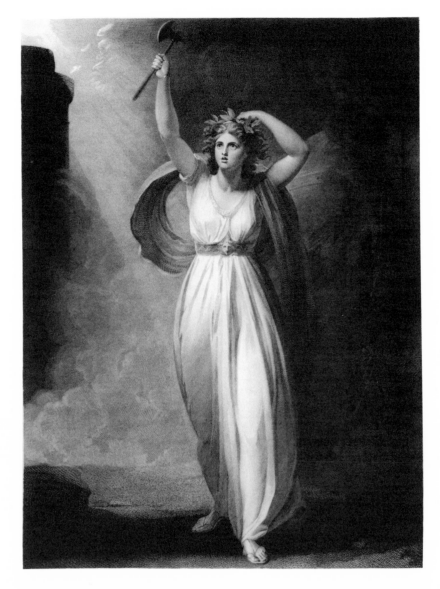

with her death and her forged and scurrilous memoirs. Her course was
too spectacular and individual to provide the model for Becky Sharp;
but in the late Georgian panorama, she added a figure with historical
magnitude and pertinent gifts to a succession of famous demireps,
courtesans, and theater bohemians like the earlier "Becky" Wells, Har-
riette Wilson, and Julia Johnstone (who played Sentiment to Har-
riette's Comedy). All produced scandalous memoirs and made their
enterprising way into the best society. The bilingual Harriette Wilson,
who was sent at fourteen to teach French and music at a girls' boarding
school in Newcastle, shortly after became the mistress of an old, ec-
centric peer, Lord Craven, the first of many distinguished patrons
including the Duke of Wellington. Her sisters, one represented as
gentle and passive, a second as sharp and malicious, were also cour-
tesans, and one of them attracted Lord Hertford, the original of Thack-

eray's Marquis of Steyne. Following the success of her memoirs, Harriette—paid to live abroad—married there, and later, much like Becky, she is supposed to have returned to England, a pious widow. She died respectably just months before the first installments of *Vanity Fair*.[25]

The most complete artist-philosopher of the age crossed the track of Lady Hamilton at least once, and that of *Vanity Fair* several times. For one thing, Johann Wolfgang von Goethe anticipated by thirty years Thackeray's use in fiction of the conjunction of the theatrical and the pictorial in *tableaux vivants*.

Goethe's early interest in "attitudes" and *tableaux vivants* appears in his travel memoir, *Italian Journey* (1816-17). In Naples in 1787, at Hamilton's residence, he saw Emma Hart (as she then was) move through an unbroken series of varying poses, in Greek costume helped by a few shawls, in a species of living sculpture. Hamilton (he wrote), the devotee of the arts and nature, here sees "what thousands of artists would have liked to express realized before him in movements and surprising transformations." Later Goethe reports seeing an odd upright box, "the interior painted black and the whole set inside a splendid gilt frame," large enough to hold a standing human figure. "Not content with seeing his image of beauty as a moving statue, this friend of art and girlhood wished also to enjoy her as an inimitable painting, and so, standing against this black background in dresses of various colours, she had sometimes imitated the antique paintings of Pompeii or even more recent masterpieces."[26] Though Goethe never witnessed such a pictorial performance, it led him to speculation on its Christmas-crèche origins, and—more than twenty years later—to the performances of Luciane and Ottilie in *Elective Affinities*.

Goethe's novel of 1809 in turn may have influenced one of the more successful and sensational events of the Congress of Vienna, whose deliberations to decide the fate of Europe after Napoleon were so shaken by the news of his return. The 1814-15 period culminating in Waterloo is crucial in Thackeray's narrative. There in the novel the seemingly momentous agitations of private life and the large-scale drama of history most conspicuously converge; and there if anywhere Thackeray sought to provide an atmospheric truth in his historical background. The Congress of Vienna, which happens offstage in *Vanity Fair*, turned out to be a Waterloo Ball on a European scale. The most agreeable and available memoirist of the occasion reports how Isabey, recently painter of Napoleon and the notables of the Empire and designer of the emperor's coronation, was allowed to take on the direction of the fêtes and *divertissements* "for which the congress was the pretext." Among them was a program of *tableaux vivants* with counts and princesses as the actors, followed by *romances en action* where courtiers in a theatrical setting mimed the action of a song. The *tableaux vivants* included *Louis XIV at the feet of Mme. de la Vallière*, "by a young Viennese artist,"[27] and "Guérin's beautiful composition, *Hippolytus Defending Himself before Theseus against Phaedra's Accusation*."[28] The memoirist thought the costumes, lighting, ensemble, the reproduction of the paintings by such distinguished persons, and above all "the immobility of the actors rendered the effect astonishing."[29]

Whatever Goethe's influence on its cultural side, the Congress of

[25] *Harriette Wilson's Memoirs of Herself and Others*, pref. James Laver (New York, 1929); Elizabeth Jenkins, *Ten Fascinating Women* (New York, 1968), pp. 131-47; *DNB*, "Harriette Wilson."

[26] *Italian Journey (1786-1788)*, trans. W. H. Auden and Elizabeth Mayer (New York, 1968), pp. 200, 311.

[27] Cf. what Thackeray describes and twice illustrates as the "image of Love on his knees before Beauty" or "the *tableau* with which the last act of our little drama [No. 4] concluded" (*VF*, Chap. 15, p. 143).

[28] Guérin's best-known painting had been realized as a *tableau vivant*, along with David's *Belisarius* and *The Oath of the Horatii*, in a court festival that Goethe contrived at Weimar in 1813, the year before the Congress. See Holmström, *Monodrama*, p. 232.

[29] A. de La Garde-Chambonas, *Fêtes et souvenirs du Congrès de Vienne* (Brussels, 1843), 1:196-87, 228-29. An English version of La Garde-Chambonas' account appeared in 1831. The writer also reports a conversation with the Princess Esterhazy "who told us she had caused similar tableaux to be executed at Eisenstadt in a temple constructed to that end in the middle of a lake, and that during the representations, Haydn, her *kappelmeister*, improvised several organ pieces in harmony with the visual effect, which added wonderfully to the illusion" (p. 226). Here was the complete *son et lumière* Happening.

Vienna was only one of numerous events on the larger stage of history that echo and reverberate on the stage of what Thackeray calls his booth (his "Becky puppet," in Paris after the war, "had a little European congress on her reception night," *VF*, Chap. 34, p. 338). But it is interesting that Thackeray also found his purposes best served by the realization of a Guérin painting of the period. Moreover, the Gaunt House entertainment is set after 1825, when "the amiable amusement of acting charades had come among us from France: and was considerably in vogue in this country" (*VF*, Chap. 51, p. 492). To incorporate the charades, "these little dramas," with *tableaux vivants*, now fraught with Germanic associations, was a stroke of cultural eclecticism, a little European congress in the drawing room.

Thackeray had a direct interest in *Elective Affinities*, however, that was more than historical, and the complex relations between that novel and *Vanity Fair* deserve a fuller exploration than they have received, or will receive here. The circumstances that promoted Thackeray's interest are amply documented. In 1830 and 1831 he took up residence in Weimar, where he read and translated Goethe and Schiller, went often to the theater, and fell variously in love with a great and apparently insipid beauty and with a young woman of wit, sensibility, and illicit origins. He met the now venerable Goethe, and formed part of his daughter-in-law Ottilie's literary and artistic circle.[30] Weimar and Thackeray's experiences appear transformed in "Fitz-Boodle's Confessions" (1842) as Kalbsbraten (the young women appear as Dorothea and Ottilia); and Weimar reappears in *Vanity Fair* as Pumpernickel when that novel reaches the chronological neighborhood of Thackeray's own sojourn. *Elective Affinities* also turns up in the course of the narrator's description of Pumpernickel's tolerance of matrimonial unsteadiness, as only to be expected "in a country where 'Werther' is still read, and the 'Wahlverwandtschaften' of Goethe is considered an edifying moral book" (*VF*, Chap. 67, p. 651).

Such disparagement belongs to the ironic moralist's public voice rather than to the voice of the imagination, which in Thackeray spoke alluringly of heated spiritual affinities and even spiritual adultery. His imagination would seem also to have responded to the contrast in *Elective Affinities* between two young women, a contrast crystallized in *tableaux vivants*. The difference between Goethe's use and Thackeray's reuse of this pictorial-theatrical device is as interesting as the similarities.

In *Elective Affinities*,[31] Luciane is the wealthy, beautiful, admired daughter, like Amelia; Ottilie the fortuneless orphan whose legitimate social possibilities go not much further than teacher and ladies' companion, like Becky. We first hear of the two at school, and read the Headmistress's reports on them, as in *Vanity Fair*. But Luciane is the Becky figure in all other respects. She is notably attractive, a coaxer, a conqueror, a sharp-tongued mocker, trailing male admirers including a complaisant fiancé, and riding over more fragile sensibilities even in her generous acts. Ottilie on the other hand, at least in her beginnings, is a low-keyed and passive sentimental heroine like Amelia, though in the end she is not a "little woman," but an awesome study in the pathology of sensibility. Luciane initiates the performances for pur-

[30] See Thackeray, "Goethe in His Old Age," *Miscellaneous Essays, Sketches, and Reviews* (London, 1886), pp. 402-405.

[31] My translations are made from *Die Wahlverwandtschaften*, in *Goethes Werke*, ed. Heinrich Kurtz (Hildburghausen, 1868), Vol. 6, abetted by R. J. Hollingdale's modern vernacular translation in the Penguin Classics series (Harmondsworth, 1971).

poses of display and conquest at a winter gathering on her parents' estate. She offers songs and recitations, but she is not very good at the latter, we are told, her declamation being "spiritless, vehement without being passionate," and overstocked with dramatic gesture. The most sophisticated member of the party suggests something more in tune with Luciane's gifts, "a new kind of performance . . . the representation of actual well-known paintings" (*Wahl.*, II, v, 321).

The party chooses from copperplate engravings Van Dyck's *Belisarius* (a painting that is now attributed to Luciano Borzone),[32] Poussin's *Esther before Ahasuerus*, and "the so-called *Paternal Admonition* of Ter Borch, and who does not know Wille's magnificent engraving of this painting?" In their representation, Luciane controls the casting and the social uses; but the creation of the picture—the stage and sets, the lighting, the posing of the persons—is the province of the resident Architect. He is the artist, and Luciane a sort of superb lay figure. It is significant that Luciane's greatest triumph is in the *Paternal Admonition*, where she keeps her splendid back to the audience, and where "the Architect had taken pains to arrange the rich folds of white satin in the most artful way, so that beyond any question this living reproduction eclipsed the original picture and aroused a universal rapture" (II, v, 323).

Ottilie has been deliberately left out of these scenes by Luciane; but on a later occasion the enamored Architect specially arranges a Christmas scene to display Ottilie's qualities, a crèche in the form of a tableau in which she represents the Madonna. The surpassing power of Ottilie's performance is described as living especially in face, eyes, and expression; but essentially her triumph lies, not in mimicry, but in the fusion of her own nature and emotion with that of her role. For Ottilie has turned out to be the "affinity" of Eduard, her Aunt Charlotte's husband and Luciane's stepfather; and her pictorial impersonation, a picture within a picture, embodies her response to the love of Eduard in the "real" life emotional center of the novel. Goethe writes of the Architect's picture, "And who could describe the countenance of the newly created Queen of Heaven? The purest humility, the most amiable emotion of modesty before an immense unmerited honor, an incomprehensible, immeasurable happiness, portrayed itself in her features, expressing as much her own feelings as her conception of the Person she was playing." As a result, "Ottilie's figure, attitude, countenance, regard, surpassed anything that a painter had ever represented. The sensitive connoisseur, seeing this vision, would stand in fear lest anything move, and in sorrow lest he never again find anything to please him so well" (II, VI, 332).

The humility, wonder, and happiness in Ottilie's performance are truths of the self, expressed through a compatible image. Her acting is not a mimetic external pretense like Luciane's. (The truth in Luciane's acting is that its limitations reveal her inner limitations, in depth of feeling, sympathy, and tact.) Implicit in Goethe's comparison is a theory of acting through affective identification, and a parable on truth and appearance in art. Becky, however, is shown as an actress in both modes, Ottilie's and Luciane's, expressive and mimetic.

In *Elective Affinities* at large (as in *Vanity Fair*), the embodied image is premonitory or emblematic of the reality that frames it.[33] So, at the

[32] See Michael Fried, *Absorption and Theatricality* (Berkeley and Los Angeles, 1980), pp. 145 and 235-36n, citing Camillo Manzitti in *Paragone* 12 (September 1971): 31-42. I here continue to refer to the image as Van Dyck's, as in Goethe's novel and on Scotin's engraving.
[33] A knowledgeable interpretation of the tableaux that differs in some respects from mine may be found in H. G. Barnes, *Goethe's 'Die Wahlwerwandtschaften'; a Literary Interpretation* (Oxford, 1967), and his earlier "Bildhafte Darstellung in den 'Wahlwerwandtschaften,'" *Deutsche Vierteljahresschrift* 30 (1956): 41-70.

simplest, the wilful Luciane is represented as much in need of that kind of paternal, masculine correction she sustains in the Ter Borch realization. And Ottilie's Christmas tableau is further realized in the miracle of the infant child of spiritual adultery, born with Ottilie's eyes though Charlotte is its mother, and with the Captain's features though Eduard is its father. The Captain is Charlotte's "affinity" and Eduard's friend. He is upright, honorable, slightly Quixotic, devoted to Charlotte and loyal to Eduard, Dobbin to Eduard's Osborne. Moreover, after inadvertently losing the child she has tended and then dying herself, Ottilie undergoes an apotheosis, performing miracle cures (it is thought) and enshrined in a glass-topped coffin in the chapel the Architect had previously decorated with holy figures bearing her face. Ottilie so seems to actualize, not only her earlier sanctified role, but its iconic immobility. At the end of a penitential phase in which she abstains from all speech, she succeeds in becoming a permanent image of herself.

The three important paintings in the original *tableaux vivants* are equally emblematic and predictive, whether considered separately or together. Together they encapsulate the moral structure of the novel, which Thackeray found so problematic.

The first, Van Dyck's *Belisarius*, showing that noble warrior reduced to blindness and receiving alms in the marketplace, functions in the novel less as an exemplum of Fortune's fickleness, man's ingratitude, or the virtue of charity (depicted), than as a tableau of sympathy. Belisarius shares the foreground with a young soldier, the only figure not engaged in an action, but *teilnehmend traurig*, with a participating sorrow. We are told that there is a real resemblance between the actor (the Architect) and the figure he impersonates, a resemblance that turns out to be internal as well as external and is linked to both character and role. The Architect remains a silent, feeling spectator of the love drama; and at the end, the tableau achieves a further degree of realization—almost like the stages of Becky's *Clytemnestra*—when he unconsciously takes up the very same "natural" attitude of sorrowing pity for Ottilie dead as for Belisarius painted, and the narrator moralizes on the parallel waste of rare human qualities (II, xviii, 401-402).

The second realization, Poussin's *Esther before Ahasuerus*, functions as a tableau of passion. It represents an overwhelming access of feeling as Esther, whom the king has raised from helotage, swoons before him when, "her heart . . . in an agony of fear," she violates the "general commandment" and comes into his presence unbidden. The king, according to the Apocrypha, "was clothed with all his robes of majesty, all glittering with gold and precious stones; and he was very dreadful."[34] Poussin's Ahasuerus is less gaudy, but bears the "countenance that shone with majesty" in the Biblical narrative; and this "Zeuslike king" on his golden throne, as Goethe describes him, is played by the handsomest, most virile-looking man in the company. Luciane plays "the fainting, sinking queen"; but in emphasizing her jealous exclusion of Ottilie, Goethe suggests the proper reference of the image. The overwhelming access of emotion, the god-and-mortal feeling toward a Cophetua, and the breaking of bounds, social, rational, and personal in response to a "higher" imperative, are Ottilie's.[35]

The third realization, Ter Borch's *Paternal Admonition*, is Luciane's prime vehicle of display and triumph, and as noted earlier it bears upon

[34] *The Rest of the Chapters of the Book of Esther*, 15:5-10. Cf. Josephus, *Antiquities*, XI.6.9.

[35] Thackeray reports on George Osborne's feelings in taking Amelia to wife: "he would be generous-minded, Sultan as he was, and raise up this kneeling Esther and make a queen of her: besides, her sadness and beauty touched him as much as her submission, and so he cheered her, and raised her up and forgave her, so to speak" (*VF*, Chap. 20, p. 187). In contrast to such Esthers, the Biblical, and especially the Apocryphal figure is presented, to her credit, as an actress. Despite her fearful heart, she enters the king's presence "ruddy with the perfection of her beauty, and her countenance was cheerful and very amiable." Moreover, she has made clear to God, in previous prayer, that she secretly abhors the glory and pleasures of her estate, including the bed of the uncircumcised, and she is obviously thought worthy of esteem for such saving duplicity. The pictorial and literary traditions, however, have tended to soft-pedal the conscious actress, and to depict Esther as in the tableau, overcome by true emotion. It is when feeling and action coincide, in the swoon, that she wins the king to kindness.

157

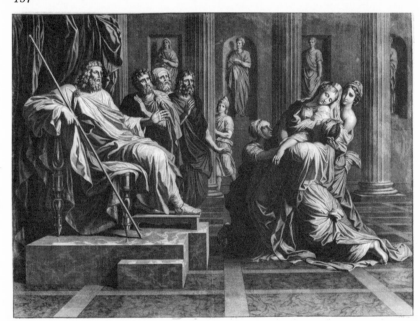

158

her character and shortcomings. But it is offered to the reader primarily
as a tableau of restraint, of passion placed under control through the
reassertion of civil, moral, and personal limits on feeling. Goethe de-
scribes the engraving as showing:

> A noble, knightly father [who] sits with one leg on the other, and
> appears to be addressing the conscience of his daughter who is
> standing before him. The daughter, a splendid figure in a richly-

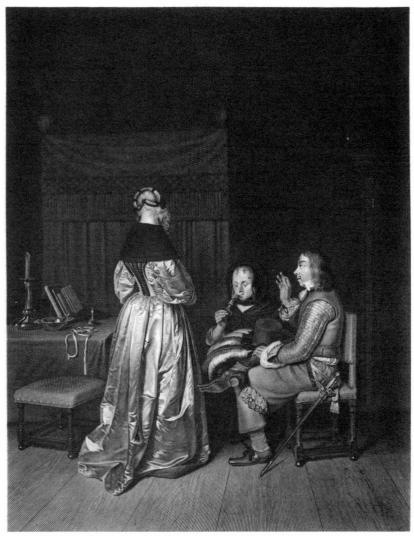

159. *Gerard Ter Borch*, Gezelschap in Interieur *(ca. 1654), engraving by J.-G. Wille as* Instruction Paternelle *(1765), London, British Museum.*

159

pleated white satin gown, is seen only from behind, but her whole presence [*Wesen*] seems to indicate self-control and attention [*das sie sich zusammennimmt*]. The expression and attitude of the father nevertheless show that the admonition is not too severe and shaming; as to the mother, she appears to be hiding some little embarrassment while looking into a glass of wine she is on the point of drinking. [II, v, 323]

Goethe removes a certain amount of ambiguity from the interpretation of the image by rendering "Paternal Instruction"—the title on the print—as "Paternal Admonition"; but he slyly restores it with his epithet of "so-called" (*sogenannte väterliche Ermahnung*). "Instruction" can embrace a variety of subjects; and there is sufficient reason, in the dress, look, and demeanor of the military gentleman, in the semidetached bibulousness of the older woman, and in the configuration of the whole, to take the young woman for what Shallow aptly called a "bona roba," present or prospective.[36] The innuendo would strike at

[36] The principal version of the painting, in Amsterdam, is now called *Gezelschap in Interieur* (Rijksmuseum #570). In some versions, the gentleman holds up a gold coin. In the Bridgewater House version, called *A Singing Lesson* (on loan, Nat'l. Gal. Scotland), the young woman holds a sheet of music.

the superficial, disorderly, exhibitionist Luciane; but the general construction Goethe placed upon the scene points elsewhere, to its role in a three-stage progress of the life of feeling: from sympathy, where the focus of experience, of action and suffering, is external; to passion, emotion rising within the self and overwhelming conscious will and self-possession; to sovereignty, where the self and its affective life achieve equilibrium in the circle of external social ties and obligations. By uniting all the stages—sympathy and consideration for the inner lives of others, passion, and restraining judgment—the sovereign self achieves its integrity. As in the humanization of the landscape, so important a motif in the novel, the self requires that "its first raw natural condition" suffer the self-imposed changes of art "so as to turn to account and enhance every existing good quality," to create the possibility of a civilized life.[37]

Beyond such balance and civility, however, Goethe seems to allow for an incandescent union of spiritual and physical life, of shadow and substance, of feeling and being; a union whose meteoric appearance in art or life smacks of miracle and is perhaps "natural" only in the saint. In the end, the distinction between imitation and authentic embodiment of the kind that illuminates Ottilie's first appearance as the Madonna is underlined in Eduard's delayed *imitatio* of Ottilie. What for her was natural and blissful is in him difficult and unlovely. He concludes that "It is a frightful task, to imitate the inimitable," and that there is genius in everything, even martyrdom (II, XVIII, 403). For such genius there is no distinction between acting and being.

Thackeray and the Art of Effect

Thackeray's concern with the art of the actress in a society both vulnerable and suspicious was a practical matter, one rooted in his sense of the novelist as performer, and encountered moment by moment in the act of writing. By picture and personation he wished to fascinate an audience and disarm it without giving it the right to condescend or to withdraw its respect. Moment by moment he had to maintain the visible sign of his superior integrity—his artist's honor, as self-defined—in the very style of his work. The style, despite its geniality, despite moments of unbuttoned confidentiality or what seems to be an access of sentiment in the narrator, is defensive, shielded with ironic baffles and set about with countervailing tone and undertone. It sustains, like the actor's ambivalence between the muses, a precarious equilibrium. The style is also overtly fastidious, calling attention to its avoidances—fastidious, that is, about how one entices the paying customers, and what one actually does in performance to send them away gratified and likely to return—as if the visible sign of the public performer's honor were knowing where to draw the line, and drawing it publicly. Without that sign the performer is defenseless against the received social opinion that "there are some very agreeable and beautiful talents, of which the possession commands a certain sort of admiration; but of which the exercise for the sake of gain is considered, whether from reason or prejudice, as a sort of public prostitution."[38]

Thackeray's concern with the performer's fastidiousness appears ear-

[37] *Wahl*. I, VI, 233. In the discussions on the reshaping of the estate into an English park, it is Ottilie who advances the idea for breaking "the pictorial circuit" (I, VII, 239-40), a clear and conscious Romantic disruption of the formal structure in art that Ronald Paulson so ably characterizes. See "The Pictorial Circuit & Related Structures in 18th-Century England," in *The Varied Pattern*, ed. Peter Hughes and David Williams (Toronto, 1971), pp. 165-187. Goethe's landscapers take their inspiration from a book on English parks (with engravings), and their own accomplishments are only brought home to Charlotte through the eyes of a wandering English gentleman who carries a portable camera obscura on his travels in order to make accurate pictures of scenes and places—the first modern tourist in literature.

[38] S.v. "Actress," *Encyclopedia Britannica*, 3rd ed. (1797-98).

lier than *Vanity Fair*, in a lesser fiction where one can see elements of the later novel in tentative form. In "The Ravenswing" (1843),[39] one of a series Thackeray called "Men's Wives," the title character comes from a theatrical and public-house background, and eventually goes on the stage as a professional actress-singer. She begins as a coquette, a self-centered, good-natured, rather vulgar beauty, and becomes in the course of the story a loving sentimental heroine, all of whose earnings go to her parasites, including a systematically unfaithful blackleg husband. While she is on the stage, where her life seems a "perpetual triumph," her only intractability toward her husband and manager is an adamant refusal to appear in the role of Captain Macheath. Since Macheath is a breeches part, involving not just disguise but impersonation of the other sex, her refusal is a sign of inner grace and womanly virtue. Thackeray directs considerable irony at public opinion and its hypocritical squeamishness toward the hard-working actress, in private a Griseldalike wife and mother. Nevertheless, the Ravenswing's redemptive transformation from a comic to a serious character is measured by her change in feeling toward the stage. She begins a little dazzled and much at home in the theatrical world; in a postscript to the story, however, she and her faithful Dobbin of a tailor, now married, are found traveling in full domestic panoply, and we learn she has "quitted the stage." She shrinks, moreover, from being reminded of it—reminded, that is, of the vulgarity, the exploitation, and the politics of popular success. The center of those politics (anatomized in the story) lies where the worlds of literary journalism, the arts, and fashion meet: Thackeray's world is a nutshell.

For Thackeray, the honor of the artist and the honor of the public performer are two faces of one situation—his own. One face, however, like Reynolds' Tragedy, speaks from the vantage of superiority. It enjoins a respect for the integrity and honesty of the work, and a qualitative standard quite apart from fashion and the market. The other face acts from the disadvantage of dependence. It requires a success that entails cajoling an audience subject to fashion and providing the market, though the performer cannot afford to seem willing to go to any lengths for popularity. The honor of the artist and that of the public performer so meet in a fastidiousness that simultaneously protects the integrity of the work and defends the performer from the stigma of his dependence. In Thackeray, this sign of integrity, of the writer's twofold honor, is a fastidiousness over the uses of "effect."

Thackeray may have been the deadliest enemy of the aesthetics of effect in England, and his influence is traceable, not only in succeeding fiction with claims to respectability and artistic seriousness—claims Thackeray did much to make possible in the climate of the nineteenth century. His influence is traceable also in painting and in the one clear revolutionary episode in English dramaturgy before the "New Drama" of the nineties, the theater of T. W. Robertson (pp. 355-58). Thackeray's impact was much more through the example of his fiction than through the urging of his criticism, but he was an art critic before he found himself as a novelist; and he found himself, moreover, by the indirect critical route of first deciding and burlesquing what a novel should *not* be like. In 1840, at a delicate moment in these processes,

[39] *Works*, 18:239-366.

he took the opportunity provided by some garish Italian landscapes in an exhibition of watercolors to declare also what a painting should *not* be like:

> On a great staring theatre such pictures may do very well—you are obliged there to seek for these startling contrasts; and by the aid of blue lights, red lights, transparencies, and plenty of drums and appropriate music, the scene thus presented to one captivates the eye, and calls down thunder from the galleries.
>
> But in little quiet rooms, on sheets of paper of a yard square, such monstrous theatrical effects are sadly painful. You don't mistake patches of brickdust for maidens' blushes, or fancy that tinfoil is diamonds, or require to be spoken to with the utmost roar of the lungs. Why, in painting, are we to have monstrous, flaring, Drury Lane tricks and claptraps put in practice, when a quieter style is, as I fancy, so infinitely more charming.[40]

The association of effect with the theater is of course stigmatizing; and the passage asserts an antipathy to effect, and a sense of scale and medium almost as appropriate to the novel of domestic manners and private sentiments, meant for domestic consumption, as to painting.

A few months before, in *Fraser's Magazine*, Thackeray had concluded *Catherine*, an assault on the novel of effect in its most successful contemporary form, the novel of lowlife criminal biography. *Jack Sheppard*, flourishing in the theaters and the popular prints, provides the target for many of Thackeray's hits, especially in his conclusion. *Catherine* had two complementary endings originally, the second a straightforward, ripely-detailed Newgate-Calendar account of the murder of Hayes (Catherine's husband), its discovery, and the executions that followed. "All this," Thackeray observes, "presents a series of delightful subjects for the artist and the theatre"; and he appends a chart in the conventional playbill form that epitomizes the play as a series of effects. It begins:



THESE FOUR MIGHT GO NICELY INTO ONE PLATE.

{
1. Hayes dancing.
 (*Comic Song. Wood, Billings, and Mrs. Cat, in chorus*).
2. Hayes in Bed. "Now's the Time!"
3. The first Stroke with the Axe!!
4. The Finisher. (*Drinking Chorus*).
}



A Grand Tableau.

MRS. CATHERINE CUTTING OFF HER HUSBAND'S HEAD.

The bill rises to another Grand Tableau, with "Blue Lights. Green Lights. The whole strength of the Band," and "CATHERINE BURNING AT THE STAKE! BILLINGS HANGED IN THE BACKGROUND!! THE THREE SCREAMS OF THE VICTIM!!!"—all terminating with the Executioner dashing out her brains with a billet.[41]

So much disdain for the art of effect in fiction had implications for Thackeray's mature novels, starting with *Vanity Fair*. "I disdain, for the most part, the tricks and surprises of the novelist's art," his narrative

[40] "A Pictorial Rhapsody," *Fraser's Mag.* 22 (July 1840): 117; in *Misc. Essays*, pp. 162-63.

[41] *Fraser's Mag.* 21 (Feb. 1840): 209. This mock playbill was eliminated from subsequent editions, along with six columns of the second ending describing the murder and execution in a realistic chronicle style; a paragraph recommending a graveyard sensation scene to the theater managers "Mr. Yates, Mr. Davidge, Mr. Crummles" (p. 205); and two penultimate paragraphs applying the message of moral danger to such works as *Oliver Twist*, *Jack Sheppard*, and their stage versions. (The same issue of *Fraser's* carried a long critical article on "William Ainsworth and Jack Sheppard.") There is an allusion in the original *Catherine* to the hit song of the version of *Jack Sheppard* at Yates's Adelphi Theatre, "Nix My Dolly Pals, Fake Away"; and the proposed four-in-one plate is an allusion to Cruikshank's innovative multiple plates in the same novel. Davidge managed the Surrey Theatre, whose version of *Jack Sheppard* had the endorsement of Ainsworth and the pictorial advice of Cruikshank himself. Thackeray, incidentally, was almost simultaneously writing his generous appreciation of Cruikshank and these same pictures (see above, p. 247).

alter ego tells us in *The Newcomes* (1853-1855), even qualifying so theatrical an emotion as disdain.[42] But since the medium for Thackeray's mature work was illustrated serial publication with its bias toward strong effects and memorable situations pictorially realized, Thackeray had to compensate in the texture of his work for his avoidances. He does so by systematic indirection, by reflection on the more general, less critical and kinetic situations of his characters, by calling attention to his avoidances, and by achieving effect through a complex of ironic baffles.

The influence of Thackeray's example probably gained most from his habit of calling attention to his avoidances. In *The Newcomes*, for example, where the failure of the Bundelcund Banking Company makes a considerable difference to the fortunes of the major characters, one looks for a dramatic equivalent in the narrative. One expects a scene that embodies the magnitude of the reversal, that encapsulates the size and importance of the event rhetorically (in suddenness and surprise perhaps), and situationally (in a critical juncture of persons and consequences). Instead, the failure is presented, not as a sudden shocking crash, but—with an appeal to the way things actually happen in life—rather as a blow followed by a slow, sickening decline. The failure is more told than shown, insofar as it is treated as an event. It is more told than shown in reaction to earlier and contemporary modes of fiction and to the aesthetics of effect, not because the novel had yet to evolve to the point of recognizing the superiority of showing to telling. Thackeray's conscious sophistication appears in the fact that such a pointed rejection of effect, of the symbolic drama of bankruptcy so momentous in the age and its fiction, has its own effect. In a small way it is as sensational as the pointed rejection of conventional reward and punishment at the end of *Vanity Fair*.

Even when Thackeray arranges such an outright piece of effect as the shocking announcement of George Osborne's death on the field of Waterloo, he hedges it by indirection; and the announcement comes at the far end of a long disclaimer, where the writer declines to provide the set-piece battle spectacular that would be expected for an event that shone in the popular imagination as the apocalyptic showdown of the age. Similarly, the momentous announcement of Clive Newcome's marriage comes climactically, at the end of a chapter that prepares us for better news; but it comes with a casual and calculated indirection, by way of a letter almost accidentally read. In the theater of effect, the importance of an event and its preparation and mounting were commensurate. In life they are often incommensurate. In Thackeray, they are regularly made to appear inversely proportional.

The middling states of the virtuous and vicious at the end of *Vanity Fair*—like their mitigating traits—are embraced in a "truth to life" defined as that which is unlike the theater, where effect, mobilized in "strong situations," governs progressive revelation. (The box of puppets with which Thackeray begins and ends *Vanity Fair* is a repudiation of the theatrical mode, rather than the reverse, for their display undercuts and hedges effect.) This "truth to life" in Thackeray includes not only how things work out, but how we know and learn things— truth to perception and cognitive experience. Pendennis, the narrator

[42] *The Newcomes* (London, 1868), II, chap. 32, p. 359.

of *The Newcomes*, gives the evidential basis of his account as he goes; tells us one section is extracted from letters, another from overheard conversation, a third from general gossip or conjecture. He is not the privileged spectator of all the events that constitute the story, but a working historian; and the spectator-reader, unlike the privileged spectator in a theater where reality is wholly objectified, also learns by indirection and inference, presumably as he would in life. In Thackeray's mature fiction, indirection, a displacement of obvious effect, and an appeal to the partialities, in all senses, of cognitive experience, become the very texture of the narrative.

Thackeray's text generates pictures, and even strong situational tableaux now and then, like the Love and Beauty tableau at the end of the fourth monthly part of *Vanity Fair* (Chap. 14); but these are generally sophisticated by complexities of tone and awareness, or by ironic literary and pictorial reference. So, in *The Newcomes*, the history of Jack Belsize and Clara Newcome, which produces several such pictorial situations, appears explicitly as a modern reenactment of Hogarth's *Marriage-à-la-Mode*. Even here, the consequences of Hogarth's drama are reduced to something less striking and more extended: a slow, gradual, and sustained catastrophe rather than a series of sudden situations. The best example of Thackeray's use of such allusion, to create and qualify effect, is the realization of Guérin's *Clytemnestra*.

Tableaux often seem to occur because certain characters within the novels are given to striking attitudes themselves, and to generating such scenes involving themselves. Becky Sharp remains in retrospect the great actress of the novels, and Thackeray exploits her talent, not only for effect, but to dissemble effect and distance it from its true perpetrator, the author. Becky is only one of a line of adventuresses, actresses all, given to calculating how they present themselves and to seducing the innocent and the simple-minded. Some are more comic than formidable, but the shortcomings of all are identified with a failure in taste and sincerity and with the habit of substituting "effect" for feeling. Yet if these performers, who have to please against the odds and make their own way in a hostile environment, are subject to their creator's irony and even his reprobation, they also tend to reveal marks of his special favor. In the case of Becky Sharp, who is something of a scourge to those who patronize her, there is more: a degree of identification. Like Becky and like Garrick, Thackeray knew himself a performer who had to please to live.

17

※ ⊹ ※

PRE-RAPHAELITE DRAMA

*I*N Edward Mayhew's 1840 treatise on stage effect, "situation" was conceived as multiple and climactic, as in the serial narrative and dramatic versions of Ainsworth's *Jack Sheppard*, with which the treatise was nearly contemporary. "Situation" does not yet have the sense of a singular underlying configuration of persons and things from which a story or an action unfolds prospectively or retrospectively. Mayhew's definition is worth repeating:

> To theatrical minds the word "situation" suggests some strong point in a play likely to command applause; where the action is wrought to a climax, where the actors strike attitudes, and form what they call "a picture," during the exhibition of which a pause takes place; after which the action is renewed, not continued; and advantage of which is frequently taken to turn the natural current of the interest.[1]

Situation so conceived is the result, not the foundation of an action. It is the chosen vessel of effect; and to effect other considerations, narrative and mimetic, are subordinated.

In the second half of the century these other considerations asserted themselves, in forms and styles that reflect a conscious separation of effect and situation, or at least a redefinition of their relationship. With Thackeray in the vanguard, the hegemony of effect is repudiated, not only in much fiction aiming at truth to the texture and experience of ordinary life, but eventually in drama and dramatic theory; and in the jargon of those arts "situation" develops something like its present meaning. In narrative painting also there are altered relations between effect and situation, and a conscious attempt at further naturalizing story in painting by redefining situation. The most important experiments along such lines in England were those of the first-phase Pre-Raphaelites, notably Holman Hunt and the early Millais. These painters embraced a realism that ostentatiously abjured painterly contrivances for effect—manipulations of light and shade, atmosphere and perspective—in favor of an analytic, even microscopic attention to the

[1] *Stage Effect: or, The Principles which Command Dramatic Success in the Theatre* (London, 1840), p. 44.

[351]

particularity of things. Such considerations operated in their restructuring of pictorial narrative, and their experiments furnish a commentary on the other narrative-pictorial forms.

The Well-Made Situation

A narrative content with the characteristics of fiction—either drawn from a literary source or using invented characters and incidents—still unsettles orthodox modern notions of realism in painting. The modern view assumes, paradoxically, that realism is better served by scenes and figures whose individuality does not reach beyond generic activity, by mowers in a hayfield rather than Ruth standing amid the alien corn. The Pre-Raphaelites, however, at the very time their enthusiasm for a faithful reportage of external nature was highest, drew upon literary sources and went even further by inventing story situations for their paintings just as if they were novelists and playwrights. The habit deserves a little consideration.

One explanatory justification is that the strictly generic is general, and insofar as the realism of the time was identified with extreme specificity, narrative particularization was all to the good. It is much to the point that the Victorian critic E. S. Dallas, speaking of the "strong tendency to REALISM" characteristic of Charles Kean's management, locates it "not merely in his mode of placing a drama upon the stage, but in his own style of acting. Look at Louis XI.—look at Cardinal Wolsey, remarkable for the specification of little traits and details that serve to realise the character as much as possible in that style which has been called pre-Raphaelite."[2] Whether set in historical circumstances or in contemporary surroundings, a particularized story of individuals was preferable on *realistic* grounds to a less differentiated presentation of the human experience.

A specificity in the circumstances was not only an antidote to generic imprecision, but also a means of incorporating greater human significance. The genesis of Millais' *Huguenot* (1852) is revealing in this connection. Millais had found a fine ivied brick wall to paint, and intended to make it the background for a pair of lovers. The whole would illustrate the line "Two lovers whispering by an orchard wall" from Tennyson's brief and schematic summary of the cycle of human life in "Circumstance." Millais' lovers, even if detailed and individuated to the same pitch as the orchard wall, would have been generic lovers, like those in the poem. Hunt objected: "your illustration of 'Two Lovers whispering by a Garden Wall' [*sic*] would have neither prelude nor sequel in the drama of life. It may be a crotchet of mine, but I have none but passing interest in pictures of lovers when they are merely this with no external interest . . . I should have liked you to be engaged on a picture with the *dramatis personae* actuated by generous thought of a larger world."[3] By offering particularizing suggestions, which Millais soon bettered, Hunt converted Millais from what was essentially a sentimental genre picture, despite its literary reference, to what was essentially a dramatic scene. In the finished painting the relationship of the lovers is made situational by a historical specificity—the time of the massacre of St. Bartholomew's Day—which also brings the painting into touch with "a larger world." The painting became, spe-

[2] "The Drama," *Blackwood's* 79 (Feb. 1856): 218. Dallas recognizes the bond between archaeological historicism and the tendency to realism (strengthened by the development of photography) that he finds in Pre-Raphaelitism and elsewhere. He writes, "if one were asked what are the most striking, the most noteworthy, or the most notorious peculiarities, at this moment, of our picture-galleries on the one hand, or of the theatres on the other, one must inevitably fix upon the pre-Raphaelitism of the one, and the Revivalism of the other, and recognize them as twins" (p. 220).

[3] Hunt, *Pre-Raphaelitism* (London, 1905), 1:285.

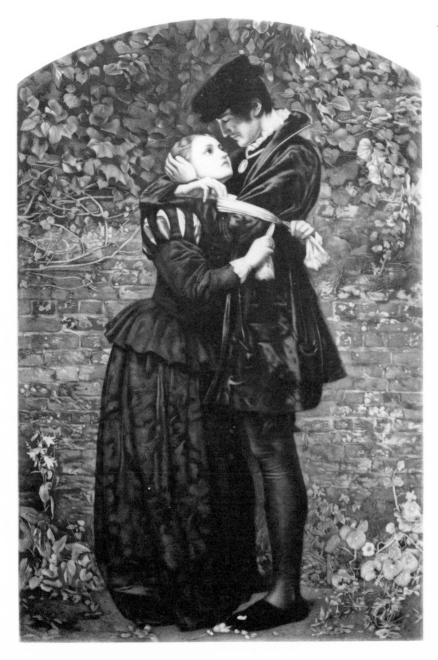

160. *John Everett Millais*, A Hu-
guenot, on St. Bartholomew's
Day, Refusing to Shield Him-
self from Danger by Wearing
the Roman Catholic Badge
*(1852), engraving by T. O.
Barlow (1857), private collec-
tion.*

cifically, *A Huguenot, on St. Bartholomew's Day, Refusing to Shield
Himself from Danger by Wearing the Roman Catholic Badge*, the badge
pressed upon him by his Roman Catholic sweetheart.

The Pre-Raphaelites thus found compatible with their version of
pictorial truth to nature that union of private history with greater
human significance characteristic of narrative and dramatic fiction. But
they found unsatisfactory the conventional ways of organizing a scene
into a significant narrative configuration. Hunt wrote of their imme-
diate predecessors, "The fault we found in this younger school was
that every scene was planned as for the stage, with second-rate actors
to play the parts, striving to look not like sober live men, but pageant

statues of waxwork."[4] Rossetti, criticizing an exhibition of paintings in 1851, complains of a St. Anne "listening like one of the Fates in a tableau vivant," and declares that while a Signol *Bride of Lammermoor* "displays much dramatic power in the principal figure . . . there is a *stationary* look, so to speak, in the figures, and a general want of characteristic accessory."[5] The stage that Hunt and Rossetti have in mind here is one dominated by the aesthetics of effect, where stereotyped elements with no inner life are arrested periodically in striking immobility, enhanced by music and broad contrasts in character and lighting.

In rejecting the chief pictorial means of what was known as effect in painting, the affective and conventionalized manipulation of light and shadow, the Pre-Raphaelites substituted a brilliant rendering of local color and an even attention to detail. Their rejection of the aesthetics of effect in the medium of representation extended to the matter represented when that was a scene which told a story. An even, scrupulous attention could not be given to all moments of a story, but the moment chosen might sufficiently embody the story without clamorous distortion if it were thoughtfully chosen and defined. Avoiding a tableau effect meant that the configuration would have to be a plausible event in itself rather than an improbable emblem, that there would be a meaningful relation between group and accessory, and that there would be meaning—qualifying and informing expressive attitude—in the fact of immobility. Such meaning Millais achieved by redefining situation. Hunt went a step further by seeking to move the action inward, and by making an inner action his subject.

Not surprisingly, both Hunt and Millais were admirers of Thackeray, Hunt finding in Thackeray's novels just the reverse of those "Pictured waxworks playing the part of human beings"[6] that inhabited the art of so many of his fellow painters. Urging Millais to get hold of *The Newcomes* immediately ("it will certainly give you more pleasure than *anything* written in the English language"), he declares that "Thackeray is to me the only man who really sees the different forms of men's minds." For Hunt, Thackeray was above all "this wondrous delineator of the hidden impulses of humanity. I had read all of his books I could lay hands on. Of all modern authors he was the one to whom I felt most reason for gratitude, in that in place of general moralising he interpreted into contemporary and personal language the passions of life."[7] Millais shared Hunt's enthusiasm, and he and Thackeray became personal friends. It is not too much to see the influence of Thackerayan strategies as well as Thackerayan proprieties in the displacement from sensational events and the determined rejection of stridency in Millais' own early account of his intentions in *A Huguenot*. His two lovers, he wrote, would be shown in the act of parting. "The girl will be endeavouring to tie the handkerchief round the man's arm, so to save him; but he, holding his faith above his greatest worldly love, will be softly preventing her. . . . It will be very quiet, and but slightly suggest the horror of a massacre."[8]

Millais was not a theorist or a dogmatist, and the group of situation paintings represented by *A Huguenot* does not bulk large in the whole of his work, except in quality and interest. They represent one happy

[4] Ibid., p. 51.

[5] Dante Gabriel Rossetti, "The Modern Pictures of All Countries at Lichfield House," *Collected Works*, ed. William Michael Rossetti (London, 1890), 1:478, 479.

[6] *Pre-Raphaelitism*, 1:48.

[7] A.L.S. [Jan.-May 1856], Huntington Library (HH 384), and *Pre-Raphaelitism*, 2nd ed. (London, 1913), 1:253.

[8] John Guille Millais, *The Life and Letters of Sir John Everett Millais* (London, 1899), 1:135 (letter, 22 Nov. 1851).

vein in Millais' most venturesome period, rather than a rigorous program. They offer a solution to problems of narrative painting, achieved quickly and fully in *A Huguenot*, and not necessarily consistent with, for example, the experiment in a modern-life heroic mode in *The Rescue* (1855). There the subject entails a simpler definition of situation which becomes—as in the theater—the scaffolding for a more direct employment of effect. *Autumn Leaves* (1856) on the other hand may be regarded as an experiment in pure effect, for situation is entirely abolished, and mood and undefined association and a condition of the light evoke an unmediated affective response. Nevertheless in *A Huguenot*, *A Proscribed Royalist, 1651* (1853), *The Order of Release, 1746* (1853), and *The Black Brunswicker* (1860), Millais put forward a species of original narrative painting (not dependent on a prior fiction) designed to contain the whole interest and significance of a story in a plausible circumstantial setting and configuration, a "situation." In all the paintings, the circumstances are defined historically. In all but one, the situation is like a diagram of countervailing forces, present together and recorded at the moment of equilibrium; an equilibrium more important than any resolution of the narrative issue. (In *The Order of Release* [Fig. 138], where the diagram of forces is more complex, the moment of dynamic equilibrium and the moment of resolution coincide.) Because the equilibrium itself becomes the focus of interest, and because the narrative is so fully contained in a situation with the characteristics of an impasse, these paintings provide a closer structural analogue than any contemporary narrative form to the ideal of the "well-made play."

The putative father of the well-made play, Eugène Scribe, also had a share in the genesis of the first of Millais' situational paintings; for Millais fixed on the character and circumstances of his divided lovers when he "suddenly remembered the opera of *The Huguenots*."[9] Scribe's libretto (1836) devotes its best energies to the crowd and spectacle scenes of the new historical drama which give so firm a foundation to Meyerbeer's choruses. The third act, however, is founded on a climactic impasse situation on the eve of the massacre, a situation prepared circumstantially from the beginning of the opera, and defined by a net of passions and obligations at cross-purposes, and by the pressure of historical events. The situation between the Huguenot hero and his Catholic beloved fearful for his life is complicated by the fact that she is the unwilling wife of a Catholic husband who has just proved himself exceptionally honorable. The Huguenot's unwillingness to deny his faith by remaining with the lady in safety is matched by her unwillingness to flee with him into adultery. The added vectors allow a more extended development of the static configuration of the lovers in the scene, but the situation and the structure of impasse are essentially that of the painting.[10]

The well-made situation would eventually come into its own among English playwrights and critics; but it was the Thackerayan aesthetic rather than the Scribean that first found characteristic expression in the English theater. The playwright who took Thackeray's example most to heart was T. W. Robertson, once canonized as a pioneer of realism on the stage, with realism understood as truth to the everyday

[9] Ibid., 1:138.
[10] *Théâtre complet de M. Eugène Scribe*, Vol. 23 (Paris, 1842). The painting in turn found echoes in subsequent drama. Watts Phillips' *Huguenot Captain* (1866) opens after the massacre, but some influence may be seen in the setting for a planned rendezvous between the lovers, divided by blood and family (II, 2): "*A garden wall, the masonry so crumbling that it seems to be almost upheld by the ivy*" (Lacy, Vol. 75). Irving used the recognizable "grouping" in his stage picture of the parting of Charles and Henrietta Maria in W. G. Wills' *Charles I* (1872). In fiction, Dinah Mulock (Mrs. Craik) made emblematic use of the painting in *John Halifax, Gentleman* (1857). See above, pp. 58, 242.

textures and tones of middle-class life. Undoubtedly Robertson and the Prince of Wales company that flourished in his plays influenced styles of acting and mounting, and conventions of language and gesture, in the direction of a quiet, richly-particularized verisimilitude, and contributed to the creation of a respectable, class-specialized theater whose descendants are "Broadway" and the "West End." But though he clearly invests situation with new responsibilities, as the sustaining condition of scene and episode, Robertson's situations are serial and multiple, as in the old dramaturgy. He may have contributed indirectly to the naturalization of the well-made play in England, but his chief contribution was a toning down of effect, or its legitimation through indirection to the extent that such Thackerayan strategies could be adapted to the dramatic medium through a lavish attention to detail and "accessory." *Caste* (1867), the most successful of Robertson's Prince of Wales comedies, was his dramatic metamorphosis of *Vanity Fair*, without a Becky Sharp, with a simplified and centralized misalliance motif, and with a George Osborne (George D'Alroy) who is a nice fellow and after twelve months comes back from the dead. He comes in carrying the milk can. "A fellow hung this on the railings," he tells his thunderstruck friends and the unprepared audience, "so I brought it in."[11]

Toning down effect—an insistent theme in Robertson's stage directions—meant an indirection whereby matters beside the point of the main interest in a scene would furnish the vehicle for sustaining and developing that interest. A conversation of lovers coming to the point, for example, would be spun out in elliptical, nearly stichomythic exchanges in an understated, antirhetorical vernacular, or stretched over simultaneous counterpointed conversations in contrasted tone. The perceived gap between flippancy and feeling, between the trivial subjects—ribbons, dogs, domestic objects—and the real matters at stake (the real situation), created a piquant dramatic tension of its own. Situation so spun out, the underlying condition of activity but not the focus of it, turns into something approaching stasis rather than something associated with climax. Nevertheless, Robertson was especially given to the pictorial tableau as punctuation, perhaps to compensate for his attenuations, and he also drew frequently on pictorial sources.

Robertson used well-known paintings for stimulus, as enrichment, and because situation as a static configuration amenable to contemplation was especially congenial to his methods. Tom Taylor, for example, thought that the best part of *M.P.* (1870), the scene of the sale in Dunscombe Hall, had been suggested by "the late R. Martineau's impressive picture of 'The Last Day in the Old House'" (*sic*).[12] In *For Love!* (1867), a drama of spectacular effect deliberately written in the popular tradition for a popular theater in the same year as *Caste*, Robertson arranged a climactic realization of H. N. O'Neil's *Eastward Ho!* (see above, Fig. 74). But the most characteristic of his pictorial exploitations was a visual allusion to Millais' *Black Brunswicker* (the painter's recapitulation—rather too close for comfort—of *A Huguenot*), where the situation of lovers on opposite sides of a conflict of nations is dramatized as an impasse over the opening of a door. The threat in their parting on the eve of battle is mortal, amenable to a rhetoric of tragedy and tears. The displacement onto a familiar, unheroic object,

[11] Thomas William Robertson, *The Principal Dramatic Works* (London, 1889), 1:131. On some of the links between *Caste* and *Vanity Fair*, see Clement Scott, *The Drama of Yesterday and To-Day* (London, 1899), 1:515, and Maynard Savin, *Thomas William Robertson: His Plays and Stagecraft* (Providence, 1950), p. 89.

[12] *Times* (25 Apr. 1870), p. 10. For the authorship, see Squire and Marie Bancroft, *Mr. and Mrs. Bancroft On and Off the Stage* (London, 1891), p. 141. Robertson characteristically appended a note to the end of his scene (*Principal Dramatic Works*, 1:365): "The actor playing Dunscombe is requested not to make too much of this situation. All that is required is a momentary memory of childhood—succeeded by the external phlegm of the man of the world. No tragedy, no tears, or pocket-handkerchief." In Martineau's picture, all three were attributes, not of the shallow man of the world or his chip-off-the-block son, but of the long-suffering wife.

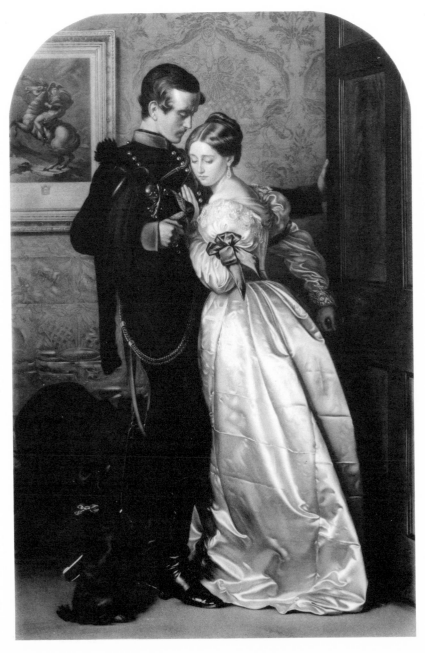

the gestural equivalent of an indirect and understated conversation or an offhand revelation, suggests what Thackeray, Robertson, and Millais share stylistically. (The white scarf in *A Huguenot*, similar in function to the door, supplies a rather more adequate correlative for the feelings and issues at stake, as an object charged with a genuine symbolic meaning in the historical circumstances.)

Thackeray is not far from the scene of Millais' painting, for the occasion it suggests is the eve of Waterloo. Just as the soldier's grim uniform identifies him as one of a corps with a special grief and a special animus against the Napoleonic French, so the woman's beribboned dress (showing, in the brilliantly rendered satin, the folds of a costume

put away for special occasions) suggests something like the Waterloo Ball. In *Vanity Fair*, where that notable event is such a high point (and where military partings are the burden of the chapter called "The Girl I Left Behind Me"), Thackeray gives considerable attention to the French sympathies of many of the Bruxellois. But whether the ball is implicated or not, the hyperbolically heroic print after David's *Napoleon* in Millais' picture not only serves as a foil for a quieter heroism, but also establishes a Francophile allegiance for the young woman, whose concern is all for her lover's safety but whose lover is her enemy.[13]

Robertson evokes Millais' picture in *Ours* (1866), his idyllic version of the Crimean War. Angus MacAlister's regiment is mustering:

> *Bugle without, at distance. Roll on side drum, four beats on big drum, then military band play "Annie Laurie"—the whole to be as if in the distance.* ANGUS *starts up, and goes to window.* BLANCHE *springs up, and stands before door,* L. ANGUS *goes to door, embracing* BLANCHE. *They form* MILLAIS' *picture of the "Black Brunswicker."*[14]

Angus and Blanche, however, are on the same side of the war, England's side, and the love across battle lines of Millais' picture survives only in an unwelcome Russian suitor. The war helps rather than hinders the cause of romance. The situation of the parting of lovers by war and duty is thus much simpler in the play. The pictorial moment provides an opportunity for contemplation and response, a release from the brightly-detailed distractions of the dialogue. As a pictorial allusion and as a silent, understated image, it provides a counterpoint to the modern situation, and a certain finesse and indirection in the release of sentiment.

In *Caste* also, where a love across *class* lines is a structural condition of the whole, a military parting provides one of the principal episodes. And in *War* (1871), where Robertson trivializes the Franco-Prussian conflict, he returns to *The Black Brunswicker* for his principal situation, reversing the sexes of Millais' French and German lovers. Robertson does not require a second realization of the painting; but he effects a transition from the drawing room to the battlefield by another pictorial allusion to the Napoleonic wars. The scene is beside a partly destroyed church at night; Oscar, the young French officer who is Lotte Hartmann's lover, has been wounded. "*Discovered,* R.H., *the* COLONEL [Oscar's father] *and* OSCAR, *forming—allowing for the difference of uniform—the picture from Horace Vernet's 'Retreat from Moscow.'* "[15]

Though Robertson appeared as a dramatic realist to an audience prepared to see realism in texture and detail, and in the negation of strong contrast, broad effect, and violent gesture and rhetoric, he remained in dramaturgy a pale scion of Romantic theater. His affinity was with the surface rather than with the deeper structure of Millais' situational painting. The "well-made play," on the other hand, is sometimes spoken of as a resurgence of classical form and classical dramaturgy in the Romantic century. Certainly its drive toward unification and concentration in a central situation supports that view. Certainly the central sustained impasse characteristic of Corneille and Racine was reborn in the new architectonics. This redefinition of situation in

[13] Cf. Millais, *Life and Letters*, 1:350, 356. Millais wrote of the picture when it was still only in his mind (18 Nov. 1859), "It is connected with the Brunswick Cavalry at Waterloo." He was annoyed on its exhibition that the *Times* "reads the story wrong," but notes that F. G. Stephens in the *Athenaeum* had it right. Stephens wrote in part: "It is well remembered even now that the Black Brunswick Corps, moved to deep hatred of the French for ravaging their country, and especially burning to revenge the death of their Duke Charles, wore a uniform of perpetual mourning—complete black, with ornaments of silver—swore neither to give nor receive quarter in battle, and paid, with the utmost interest, the insults of their enemies. At Ligny the young William Frederick, Duke of Brunswick-Oels, was slain; and Mr. Millais intends to show the effect of this renewed loss in strengthening the determination of his hussar. We surmise an intention on the part of the artist to give a French leaning to the lady's mind, deepening her purpose also; for her features seem to indicate a French origin" (*Athenaeum*, 5 May 1860, p. 620). Stephens' reliance on the features of the girl is less puzzling than J. G. Millais' comment that "the young Prussian is supposed to be saying goodbye to an English girl"—influenced perhaps by the knowledge that Dickens' daughter Kate was the model.
[14] *Principal Dramatic Works*, 2:455.
[15] Ibid., 2:766.

the drama, a concentration both narrative and pictorial, was the solution Millais found to his problem of incorporating a larger significance (a human significance) in a conscientious representation of surface and natural detail. He arranged a classical impasse set out in the costume and circumstances of Romantic historicism.

Holman Hunt and the Moment of Truth

Holman Hunt found another solution to the problem of incorporating a story with an intense human significance in a pictorial configuration that would not suggest waxworks. With Millais, the solution was synthetic: the compression of story into a counterpoised situation. With Hunt, the solution was analytic: a refinement of the pictorial moment into what was most essential and most nearly instantaneous in narrative—peripetia, the moment of change.

In the physics of motion, the moment of change is a fiction, and the rising object at its apogee only seems, briefly, at rest. But it was not the physical kinesis of narrative that Hunt wished to render through peripetia. Hunt admired Thackeray as a delineator of "the hidden impulses" of humanity, and it was these he wished to paint. He made the focus of his narrative paintings a moment of psychological change, a spirit of kinesis in a physically arrested scene. In trying to paint a changing feeling, a dawning perception, Hunt actually aimed at a realism beyond truth to the external world; at a truth to psychological experience. The terms sound modern; but the intent was wholly in keeping with Hunt's lifelong faith in the indwelling presence of spiritual significance in physical reality and external events, and his sense of the painter's vocation to make that presence legible. The moment of psychological change in its deepest significance is the moment of spiritual conversion.

Hunt's solution, the internalization of kinesis, may also be seen as an exceptionally scrupulous application to narrative painting of the doctrine of the instantaneousness of the pictorial moment and the simultaneity of all it contains. But in that case Hunt flew in the face of academic orthodoxy by being righteous overmuch. Sir Charles Eastlake for example, who became president of the Royal Academy in 1850, observes in an essay that refines on Lessing:

> A mutable expression is one of the extreme difficulties of art; the appearance of a moment is strictly within the power of representation, but the expressions of two moments, into which there is a danger of falling, would at once defeat the artist's object. An expression which constantly varies agrees with the successive and continued power of language, and may therefore be said to be more poetical than picturesque; but its changes are composed of separate moments, each of which will be much fitter for representation than for description; for the only quality attainable by the description which art could not reach, would be the abstract one of mutability, or rather of actual change.[16]

Hunt, however, thought otherwise, and he finds a special interest in pictures that seem to show mutability, "or rather . . . actual change," as the appearance of a moment. He notes, for example, in the course

[16] "Difference between Language and Art," *Contributions to the Literature of the Fine Arts*, 2nd ser. (London, 1870), pp. 310-11.

[17] *Pre-Raphaelitism* (1905), 2:480. Lamb's remarks (cited earlier, p. 22) are in "The Barrenness of the Imagination in the Productions of Modern Art," *Works*, ed. E. V. Lucas (London, 1903-1905), 2:226-27. These nineteenth-century readings of the painting are by no means off target. In classical representations (and for example in Jacob Jordaens *Bacchus and Ariadne*, Mus. Fine Arts, Boston), the god and his pack come upon the abandoned Ariadne fast asleep. In Titian's painting she has been looking out to sea after her absconded lover Theseus (perhaps in the ship near the horizon, off her left shoulder), and is now half-turned away from that past to the intensely active present. The future also comes into the scene, in the constellation that Dionysos will make of either Ariadne's wedding crown or of the bride herself (Ovid gives both versions; *Metamorphoses*, 8. 174-182, and *Fasti*, 3. 459ff.). The viewer is so asked to recognize time in its triple aspect, while metamorphosis, as the play between mutability and a divine agency, temporality and transcendence, becomes Titian's subject. Cf. Robert W. Hanning, "Ariosto, Ovid, and the Painters," in *Ariosto 1974 in America*, ed. Aldo Scaglione (Ravenna, 1976), pp. 103-104. Ovid himself associates metamorphosis with a temporal fusion in the *Fasti* poem, where Ariadne believes Bacchus has deceived her, and pacing the shore complains "*en iterum*" to the waves, dropping her tears "*en iterum*" onto the sands. She presents her situation as an image, and stresses its identity with her previous abandonment. "Only the name is changed."

[18] Hunt, *Pre-Raphaelitism* (1905), 2:274-75. Reproduced in color in Renato Barilli, *I Preraffaeliti* (Milano, 1967).

[19] See the first mention of the design (Oct. 1850) in *The P.R.B. Journal* of W. M. Rossetti, ed. William E. Fredeman (Oxford, 1975), p. 73. Early studies show a static scene, with the Lady still seated in the tapestry frame and looking in the mirror behind her, which reflects both her figure and the window (Huntington Library and Art Gallery). Hunt abandoned this first undisturbed state of affairs for the moment of transition.

[20] *Pre-Raphaelitism* (1905), 1:292.

[21] The mixed feelings aroused by *The Scapegoat* should be so understood. In the repulsive and pathetic object, "our Sin" and "our Redeemer" are simultaneously figured. The viewer's ambivalent response is not simply aesthetic, as even Ruskin would seem to suggest, but moral and personal. In the fullest response, revulsion *and* empathy would lead to identification.

of an elaborate appreciation of Titian's *Bacchus and Ariadne*, "In this meeting with the god of revelry the heaviness of soul felt by the erewhile hapless Ariadne is transformed into lightness of spirit. Looking around at the jovial care-chasing crew and their merriment, she has become somewhat transfused into responsiveness." The painting that Lamb describes as "that wonderful bringing together of two times . . . the *present* Bacchus with the *past* Ariadne" Hunt sees as unified by its focus on the kinesis itself, on the moment of psychological transformation.[17]

Hunt's experiments in the mode began in 1850, with his *Valentine Rescuing Sylvia*, and climax in *The Awakening Conscience* of 1853, just before his departure for the Bible lands. However, one of the background figures in his *Converted British Family Sheltering a Christian Priest*, begun in 1849, shows the direction of Hunt's thought, and other paintings, such as *The Shadow of Death* (1869-1873), *The Lady of Shalott* (conceived 1850, completed 1905), and *The Light of the World* (1851-1853) reflect the wider character of his conception. In *The Shadow of Death*, a bold experiment that fails, the psychological and narrative focus is intended to be the secondary figure, Mary, whose face we do not see. She kneels beside the chest containing the gifts of the Magi, seeking reassurance against time, and against the unaccountable perversity of one's offspring, from the stored-up early signs of promise. "At the moment of the revival of His mother's trust the shadow attracted her over-anxious gaze, and awoke the presentiment of the anguish she was doomed to suffer."[18] *The Lady of Shalott* represents "the breaking of the spell" which was the condition of order in the Lady's world.[19] The disruption is an inner change in the Lady, a change of heart that changes everything; but since the world of the picture is magical (and, as in Tennyson's poem, psychodramatic) inner change is represented by external event: as the shattering of the glass and the flying out of the web and the Lady's hair. *The Light of the World* is an emblem painting, the embodiment of an abstract idea. The idea, however, has to do precisely with the soul's conversion, represented in the critical moment: the knocking at the heart of a new awareness. It is a thematic distillation of Hunt's concern with the kinetics of inner transformation.

A conversation with Millais during the gestation of the painting suggests an underlying relation between Hunt's moment of change and Millais' "situations." Millais in his enthusiasm wished to paint a companion piece to *The Light of the World*, showing the door opened and the sinner at Christ's feet. Hunt objected on several grounds, among them: "One strong interest in my design depends on the uncertainty as to whether the being within will respond; your picture would destroy this."[20] The equilibrium of Millais' situations, tending toward impasse, had its equivalent in the bivalence of the moment of change, transferred in Hunt's directly symbolic pictures (*The Light of the World*, *The Scapegoat*) to the mind of the viewer.[21]

The first of Hunt's direct experiments in refining narration to the moment of inner change was *Valentine Rescuing Sylvia from Proteus*, where the psychological focus is Julia. All the other characters are given clear and even settled expressions: Sylvia now placidly trustful, Proteus schoolboy-contrite, Valentine firm and active. But Julia's

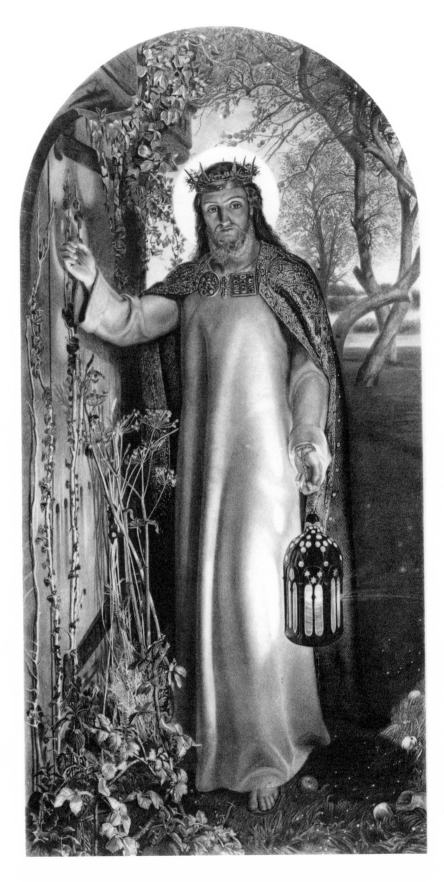

162. *W. Holman Hunt,* The Light of the World *(1851-1853), engraving by W. H. Simmons (1860), private collection.*

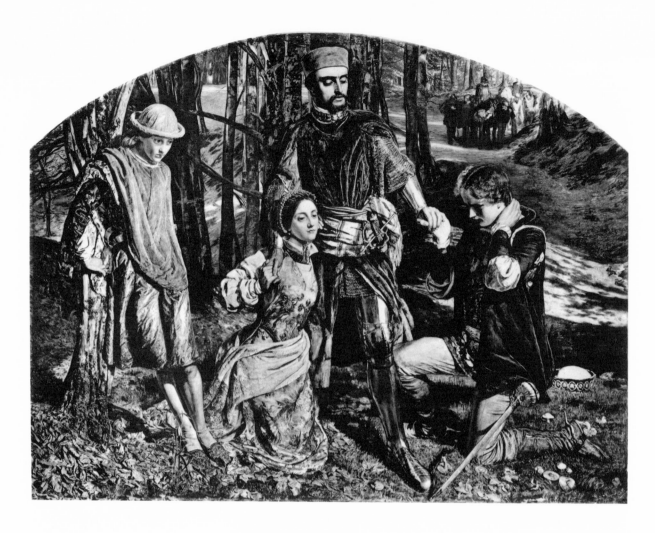

expression cannot be read so easily, for it expresses primarily Eastlake's
"mutability," a complex ambivalence and a dawning awareness. Hunt
in explanation quotes the best reader of his paintings that the age
provided. Ruskin's second letter to the *Times* in defense of the Pre-
Raphaelites praised in particular the "general conception" of the paint-
ing:

> The action of Valentine, his arm thrown round Sylvia, and his
> hand clasping hers at the same instant as she falls at his feet, is
> most faithful and beautiful, nor less so the contending of doubt
> and distress with awakening hope in the half-shadowed, half-sun-
> lit countenance of Julia.[22]

Expression, as Darwin discovered, is often given meaning by context.
In the absence of a well-defined, perfectly recognizable convention like
Le Brun's, even the simpler expressions in Hunt's paintings are in fact
defined by the narrative situation, which in turn they help define. Some
minor changes in the design of *Valentine Rescuing Sylvia* help clarify
this mutual definition, and also Hunt's direction as a narrative painter.
In the last scene of *Two Gentlemen of Verona*, Valentine rescues his

[22] *Pre-Raphaelitism* (1905), 1:255.

beloved Sylvia from a rape by his infatuated friend, Proteus. He reproves Proteus, who is overwhelmed with guilt and sorrow and asks to be forgiven. Valentine promptly forgives him, and declares (to the everlasting discomfort of Shakespeare criticism), "And, that my love may appear plain and free, / All that was mine in Sylvia I give thee." Thereupon Julia—who loves and was loved by Proteus, and has sacrificed her womanly dress and dignity to trail after him unknown—cries out and swoons. She makes some excuse, of a ring she neglected to deliver; but then manages to produce another ring that Proteus once gave her as a pledge of faith. It is the talisman, of course, that unravels all.

Hunt's first thought, as reported in William Rossetti's "P.R.B. Journal," was "a design for the last scene of the '2 Gentlemen,'—'Ruffian, forbear thy rude, uncivil touch.'[23] That line, here slightly misquoted, accompanies Valentine's sudden interruption in Shakespeare's play; and Hunt's surviving studies for the painting show Valentine, skirts flying, pushing away a kneeling Proteus and more or less supporting a kneeling Sylvia, who leans back sharply against his leg.[24] In the finished painting there is considerably less physical action, and considerably more stability in attitude and configuration. The separation of Proteus and Sylvia is accomplished by the shining steel of Valentine's left leg, worthy of St. George or St. Michael. Instead of thrusting Proteus away, however, Valentine now holds him by the hand, a bridge between Proteus and Sylvia, whom he also clasps by the hand. From that closed configuration Julia, leaning away, is excluded. Sylvia's face (altered after Ruskin complained of it) provides a center of repose, structural and expressive; but Julia's face, in diametric contrast, provides an off-center focus of inner turmoil and narrative kinesis. She holds her *own* hand, behind her back, where she fingers the ring that had once joined her to Proteus (and will soon dissolve the knot before her). She is the only figure aware of all the others. Her exclusion makes her the surrogate observer of the scene, and the locus of response. On the frame, in whose design Hunt may have had a hand, are inscribed the reproaches of Valentine on the left (not his interrupting exclamation), and Proteus' words of contrition and plea for forgiveness on the right. The moment is just before Valentine's comprehensive generosity, already indicated in the chain of hands; and in "the contending of doubt and distress with awakening hope" in Julia, the reverberator of the scene, there is the dawning of an apprehension.[25]

By moving forward in the scene to the verge of what will provoke Julia's active response, Hunt changes her from a passive choral bystander into the focus of psychological interest. He also avoids the effect of frozen action found in his original composition. He makes kinetic in the altered configuration what would otherwise be just another emblematic tableau, representing a given stage in the dramatic action as an effective situation.

An earlier design for *Claudio and Isabella* reveals a similar history.[26] The scene, from *Measure for Measure*, is Isabella's visit to her brother in prison, where she tells Claudio of Angelo's proposal to barter his life for her virtue (III, 1). The Royal Academy exhibition catalogue for 1853 quoted the beginning and end of Claudio's subsequent musing

[23] *The P.R.B. Journal*, p. 73 (Oct. 1850).

[24] See Mary Bennett's exhibition catalogue, *William Holman Hunt* (Liverpool, 1969), pls. 27 and 28.

[25] Following the Royal Academy exhibition catalogue for 1851, the *Athenaeum* refers to the painting as *Valentine receiving Sylvia from Proteus*, which the *Times* adjusts to "Valentine receiving Proteus." If one ignores the confusion of names, the substituted verb has a legitimate basis in the painting. The approaching figures in the background (the outlaws with their captives including the Duke, Sylvia's father) represent, in a perspective keyed to the time it would take to cross the ground, the final disentangling stage of the narrative.

[26] See Fig. 134 above for an engraving after the final version.

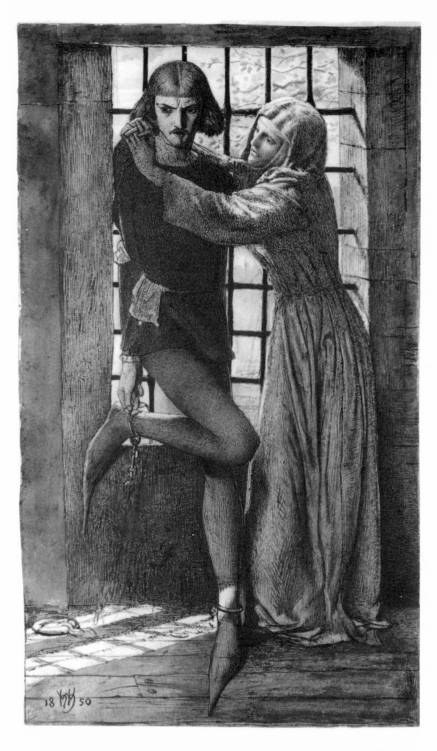

164. *W. Holman Hunt, Finished study for* Claudio and Isabella *(1850), Cambridge, Fitzwilliam Museum.*

speech on death ("Ay, but to die, and go we know not where") as he succumbs to the horror of the idea. What follows in the play is Isabella's interjection, "Alas, alas!" and Claudio's direct cry, "Sweet sister, let me live." The painting belongs to the moment before this eruption into action. As far as the moment and expressive stance are concerned, the conception of Claudio remained constant from Hunt's first design.

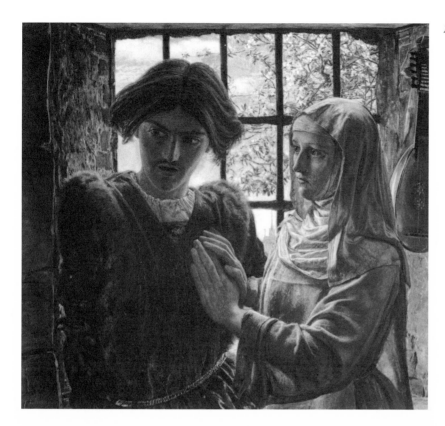

165. *W. Holman Hunt*, Claudio and
Isabella *(1850-1853)*, *detail*,
London, Tate Gallery.

Turned slightly away from Isabella and toward the thought of his own
fearful situation, Claudio feels his leg-iron in a stance at once slack and
contorted. Isabella's stance, on the other hand, was changed from the
first design. There she appeared to be reaching out, her arms encircling
her brother, her fingers interlaced on his shoulder in a strained but
sympathetic embrace, and her face down-in-the-mouth but relatively
inexpressive. In the final conception, where her physical attitude is less
kinetic, she stands with her large hands placed on her brother's heart,
as if both to test and to hide it, while her brimming face is asked to
express the dawning of an anguished apprehension, disappointment,
rejection, and despair. The change shifts attention to the psychological
action in Isabella; makes her the registering center of cognition; and
defines the pictorial moment as the moment of inner change.

Hunt hit on the subject of *The Awakening Conscience* when looking
for a "material counterpart" to *The Light of the World*. Both deal with
the awakening of conscience. The "realized idea" of grace, of the stand-
ing invitation to redemptive conversion, in the one painting is given
narrative particularity in the other. Ruskin, to shame those who claimed
to be bewildered by the secular scene, summarized the story in simplest
terms: "The poor girl has been sitting singing with her seducer; some
chance words of the song, 'Oft in the stilly night,' [Tom Moore's 'The
Light of Other Days'] have struck upon the numbed places of her
heart; she has started up in agony; he, not seeing her face, goes on
singing, striking the keys carelessly with his gloved hand."[27] The scene
is, in effect, a reversal of *Bacchus and Ariadne*, set in a tawdry island
of modern sin.

[27] Letter to the *Times* (25 May 1854),
in *The Works of John Ruskin*, ed. E. T.
Cook and Alexander Wedderburn (Lon-
don, 1903-1912), 12:333-34.

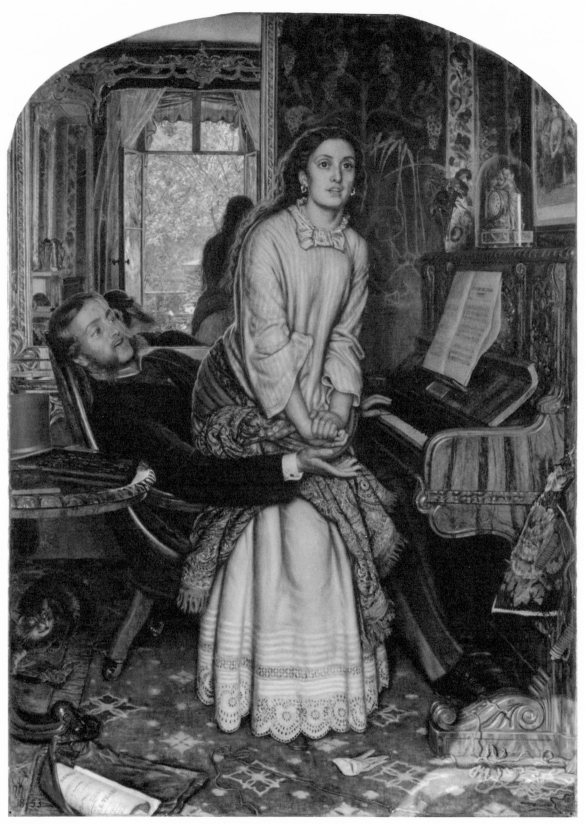

166

The "poor girl" is shown, not in the act of springing up, but already up, hands clutched, crouched and fixed on what she sees and hears within. The moment before is registered in the still uncomprehending jollity of her companion; but according to Ruskin, all other times of the narrative are included in its center, the woman's face. Hunt later repainted the face, to his regret, and Ruskin's description is the best we have: "I suppose that no one possessing the slightest knowledge of expression could remain untouched by the countenance of the lost girl, rent from its beauty into sudden horror; the lips half open, indistinct in their purple quivering; the teeth set hard; the eyes filled with the fearful light of futurity, and with tears of ancient days."[28] Like the Shakespearean paintings, this one too is an attempt to represent the moment as process, to represent not just a state of feeling and being but the emergence of new being. In this extreme instance, the phenomenon of psychological change was represented as the birth agony itself.[29]

The painter's attempt to accommodate a squeamish patron by repainting the face was not simply a betrayal of his original intention. In his history of the Pre-Raphaelite movement, Hunt consistently refers to the painting as *The Awakened Conscience*, a change which might suggest an abandonment of the self-conscious representation of psychological process. The change actually represents an attempt to paint a second, or higher stage of the process, quite in keeping with Ruskin's explanation of the symbolism of *The Light of the World*. Ruskin had written:

> Now, when Christ enters any human heart, he bears with him a twofold light: first, the light of conscience, which displays past sin, and afterwards the light of peace, the hope of salvation. The lantern, carried in Christ's left hand, is this light of conscience. Its fire is red and fierce; it falls only on the closed door, on the weeds which encumber it, and on an apple shaken from one of the trees of the orchard, thus marking that the entire awakening of the conscience is not merely to committed, but to hereditary guilt. . . . The light which proceeds from the head of the figure, on the contrary, is that of the hope of salvation; it springs from the crown of thorns, and, though itself sad, subdued, and full of softness, is yet so powerful that it entirely melts into the glow of it the forms of the leaves and boughs . . .[30]

Duration is not a calculable dimension of such subjective events; and Hunt might properly decide that he could show the second phase of the breaking in of the light of other days in the same physical circumstances. The fierce light of conscience and the soft light of peace and hope are a simultaneous presence in *The Light of the World*, and their order is more logical and hierarchical than temporal. In the "material counterpart" of that painting, the light of conscience, "which displays past sin," and the light of peace, "the hope of salvation," meet in the present moment. To the "awakening conscience," past sin is intensely present, in the immediate surroundings; to the "awakened conscience," the hope of salvation offers itself also in the present, in the visible avenue to light and to nature renewing itself. In either case conversion as a kinetic event was Hunt's subject, and as the dramatic

166. (facing page) *W. Holman Hunt, The Awakening Conscience (1853), London, Tate Gallery.*

[28] Ibid., p. 334.
[29] Cf. Ford Madox Brown's *Take Your Son Sir* (begun 1851), where the complexities of pain, triumph, and exhaustion result in a very strange expression indeed, with some affinities to Ruskin's description of Hunt's woman in travail. Like Hunt, Brown uses a mirror to present what is in his subject's immediate field of vision, echoing in Brown's case the Arnolfini portrait.
[30] Letter to the *Times* (5 May 1854), *Works*, 12:329-30.

soul of narrative it was his means for particularizing and animating a scene of modern life.

Ruskin defended *The Awakening Conscience* against the charge that the attention lavished on the immediate surroundings detracted from the principal focus and contributed to a dispersal of interest. His defense of the hallucinatory realism in the rendering of the room and its detail was that these are perceived in a moment of intense awareness and susceptibility. The defense is interesting because, although Ruskin explicitly limits it to the particular painting, such hallucinatory realism was characteristic of the group style, linked to the eschewing of broad effect and the even attention to detail. One might argue that in this painting the style has finally found and uniquely justified itself, except that a similar conception of the pictorial moment is a regular feature of first-phase Pre-Raphaelitism. Millais' *Ophelia, Ferdinand and Ariel, Lorenzo and Isabella*, and—in a paradoxical form that shows much aesthetic self-consciousness—his *Blind Girl* are paintings that embody special states of sensibility and awareness. *Christ in the House of his Parents, The Return of the Dove to the Ark*, Rossetti's *Ecce Ancilla Domini* and *its* secular counterpart, *Found*, present epiphanies. The "truer principle of the pathetic" that Ruskin finds applied in *The Awakening Conscience* was thus a common property.

This "truer principle of the pathetic," as Ruskin conceived it, is not a mood in nature echoing a mood in man, but a way of perceiving nature. It is not an effect introduced for aesthetic reasons, but a scientific report of a state of consciousness. It supposes, not a simple relation between the viewer and the painting, but the interposition of a mediating perceiver within the painting. The mirror which mediates some of the scene in *The Awakening Conscience* and the young woman are thus analogues. This is no expressionism, for we are asked to see the scene, not as the painter sees and feels it, but as the perceiving center in the painting sees it. The logic, when such a perceptual structure is justified as a form of truth to life, is dubious; but it sorts well with the location of the active element in narrative and drama in a perceiving and experiencing mind, and with the translation of peripetia, "reversal of the situation," into the phenomenon of psychological change.

The Awakening Conscience was too awkward a subject to achieve widespread familiarity, like that of *The Light of the World*, through engraving; and without general recognition value it was an unlikely candidate for realization in the theater. Its influence, however, is clearly diffused through a scene in Watts Phillips' play, *Lost in London* (Adelphi, 1867), one of the "dramas of modern life" in the popular tradition, where the dramaturgy of effect is applied to the contemporary urban and industrial scene. (The first act concludes in the depths of a working coal mine.) Phillips was an artist himself, whose visual bent comes out in the obsessive elaboration of his stage directions. The play, like *The Awakening Conscience*, owes something to the seduction plot in *David Copperfield*, and has other identifiable literary and dramatic predecessors; but it owes quite as much to pictorial sources.

In the first act, set in the Black Country, Nelly Amroyd is persuaded to abandon her husband, Job, for a "*town bred man of fashion. He is*

young and handsome, wears a blonde moustache and beard, carefully trimmed à la mode."[31] The type, "*half foppish, half blasé,*" feline rather than forthright, is that of the pianist in Hunt's painting, and the painting itself is evoked in the course of the second act. That act begins in the "*Interior of Gilbert Featherstone's Villa, Regent's Park,*" in a room whose principal feature is "*a cabinet piano, open.*" Nelly, who used to sing a great deal, has ceased to do so in Gilbert's gilded cage. At the high point of the scene she stands "*leaning against the piano; her face towards audience; her back towards him,*" while Gilbert tactlessly plays and sings a song about pledged and broken faith: "The false one now is gone / From thee, poor heart! from thee."

> NELLY. (*upon whose face has appeared the struggle of her contending emotions, during the singing, utters a stifled cry as of pain, and presses her hand tightly on her heart*) Oh, my heart is breaking! (*she makes a few faltering steps from piano, then, with another low cry, half sob, half sigh, sinks into chair.*)
> GILBERT. (*who has sprung up in alarm*). What is this? Are you ill? You are as pale as death![32]

"The struggle of her contending emotions" on Nelly's face in the situation given duration by the song is the dramatic counterpart of Hunt's psychological focus. The stifled cries and gestures that follow clarify as well as resolve what has happened: conscience has awakened and given Nelly over to remorse. Though it might seem that what is difficult and interesting in the painting has become easy and trite in the play, the location of the drama in Nelly's mobile face rather than in an abruptly formed picture marks a significant innovation in the popular dramatic mode.

The climax of this same act, another version of the breaking through of the betrayed past, provides a useful contrast. Interestingly, the culminating image evokes or at least shares the tableau character and conventions of Rossetti's cognate painting, *Found*. A reviewer wrote of the scene:

> The guests arrive—the dancing has commenced, when Job Amroyd bursts into the ball room. The strange appearance of such a visitor at such a time naturally induces the company to ask what he can possibly want. The reply, 'My wife,' is given with great effect just at the moment that Nelly enters the room and falls cowering at the feet of her injured husband. This is the finest dramatic situation in the piece, and brought down the house.[33]

"Situation" and "effect" here flourish in their ancient partnership. There is no concern for the representation of thought, for interior action or psychological processes. The external configuration is a spectacular end in itself.[34]

A CONCERN for rendering thought as process in so pictorial a medium as painting (not to mention melodrama) was bound to be symptomatic of a wider interest. Proust, Woolf, and Joyce, working in a medium much better able to evolve the stylistic and structural features that could accommodate such an interest, seem too grand to be put in this

[31] *Lost in London*, Lacy, Vol. 80, p. 5.
[32] Ibid., pp. 21, 26.
[33] *Illustrated Sporting and Dramatic News* (23 Mar. 1867), p. 181.
[34] Rossetti's incomplete painting is more conventional in its ambitions than Hunt's *Awakening Conscience*, concerned to embody the kinetics of inner experience; but it is not as externally situational as the scene in the play. Nelly (as the illustration from the play shows) turns away from her pursuer and hides her face from all the world, this time including the audience. Rossetti's fallen woman can turn away only from her discoverer, and her face gives a sensitive and powerful account of her state of feeling, especially in the separate study for her head in the City Museum and Art Gallery, Birmingham.

167. *Dante Gabriel Rossetti, Study
 for* Found *(1855), Birmingham,
 City Museum and Art Gallery.*
168. *Scene from Watts Phillips'* Lost
 in London, Illustrated Sporting
 and Dramatic News *(23 Mar.
 1867), p. 184.*

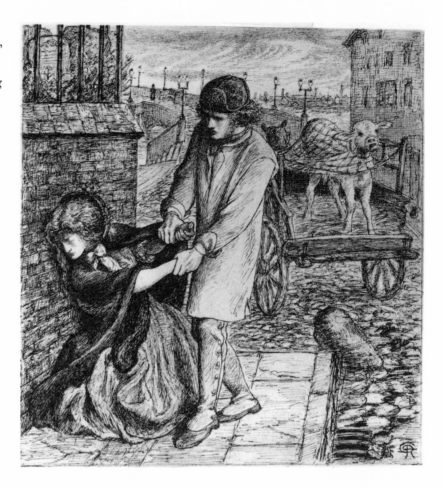

168

company; and yet in the aim of recasting existing structures of time and space, inside and outside, narrative and picture, to exhibit the dialogue of the inner world, they and their predecessors were workers in the same vineyard.

Hunt's ambitions for pictorial narrative had another fulfillment of sorts in the silent film, where a real temporal dimension is added to the height, width, and framing of the image, and mutability is the appearance of the moment. Karl Brown, who worked for D. W. Griffith, writes of the man who is supposed to have done most to establish the syntax of cinema:

> His highest objective, as nearly as I could grasp it, was to photograph thought. He could do it, too. I'd seen it. In *Judith of Bethulia* there was a scene in which Judith stands over the sleeping figure of Holofernes, sword in hand. She raises the sword, then falters. Pity and mercy have weakened her to a point of helpless irresolution. Her face softens to something that is almost love. Then she thinks, and as she thinks the screen is filled with the mangled bodies of those, her own people, slain by this same Holofernes. Then her face becomes filled with hate as she summons all her strength to bring that sword whistling down upon the neck of what is no longer a man but a blood-reeking monster.[35]

Griffith had the means to embody the succession of thought, and even to project the content of thought. The affective clues to the internal, however, are still expressed in face and gesture, and are only supplemented by representational projections of a remembered past or an imagined future. The action of the scene is still thought in motion, in a fixed encompassing situation which remains stable for as long as the focus is subjective. But the moment of conversion and mutability—so useful to Hunt as a solution to the problem of painting narrative images with a dynamic implication—loses its concentration. In compensation, the doors of possibility for the exploration of inner states and inner action through the concrete visual image are thrown wide. It is the face especially that becomes the stage of the inner action, the *real* action, and that now will enlarge until it fills the entire screen.[36]

That situational structure for narrative favored by Millais and analogous to the inner form of the well-made play also had its succession. A more or less static configuration, an impasse or a complex equilibrium which serves as the matrix of a narrative interest, had its fictional efflorescence in Henry James. Situations or configurations are created to be explored by indirection, and the psychological interest is interpersonal and contextual, social in its character. The situational mode, undramatic as it is sometimes thought to be, is James's true bond to the drama of his day.

In the drama proper the situational mode, the well-made play, gave Ibsen the form for an action that was a sustained progressive exploration of a present configuration. Ibsen in his modern life dramas and Chekhov in all his major plays were playwrights of the impasse, not as achieved effect, but as progressively revealed condition. That Shaw, the most formidable enemy of the well-made play, was also the champion of Ibsen is perfectly understandable on other grounds; but additional light

[35] Karl Brown, *Adventures with D. W. Griffith* (New York, 1973), p. 21.

[36] Hunt's use of a musical motif as the precipitating element in his *Awakening Conscience* also had an analogue in Griffith. Griffith drew, however, on an anthology of such incidents of internal mechanics, Browning's *Pippa Passes* (certainly known to Hunt, who had been endlessly exposed to Browning's poetry by Rossetti). Griffith made a film of *Pippa Passes*, then remade it (according to Karl Brown) in *Home, Sweet Home*, where the title strain takes the place of Pippa's voice in "chang[ing] the lives of a set of different characters, a sort of multiple story dominated by a single thematic idea." As such, it was also a trial run for *Intolerance*. On later films that seek to represent thought in motion, see Chaim Calev, "The Stream of Consciousness in the Films of Alain Resnais" (Ph.D. diss., Columbia, 1978); and Bruce F. Kawin, *Mindscreen: Bergman, Godard, and First-Person Film* (Princeton, 1978).

is cast by his reply to an interview question during the time he was developing his "discussion play" genre. When asked, "What is the finest dramatic situation?" he replied, "The best plays consist of a single situation, lasting several hours."[37]

Film, as the modern Proteus, is not divorced from this line of development either, the line that identifies situation with a sustained, uniformly attentive contemplation of reality, free from external manipulation for effect but with its effect implicit. André Bazin, discussing the alternative tradition to that founded by Griffith and expanded by Eisenstein writes:

> But it is most of all Stroheim who rejects photographic expressionism and the tricks of montage. In his films reality lays itself bare like a suspect confessing under the relentless examination of the commissioner of police. He has one simple rule for direction. Take a close look at the world, keep on doing so, and in the end it will lay bare for you all its cruelty and its ugliness. One could easily imagine as a matter of fact a film by Stroheim composed of a single shot as long-lasting and as close-up as you like.[38]

The serial discontinuities of the early nineteenth century, most apparent in the long-lived architectonics of popular melodrama and identified with the dramaturgy of effect, had their remote stylistic progeny in the vocabulary of montage, which however could be used to negate narrative time, to expand and sustain a situation. The situational unities of the later nineteenth century had their comparable progeny in the vocabulary of the exploratory camera and the contained and coherent scene, which however could hardly avoid the restoration of coincident narrative time to the pictorial image.

[37] *Strand Magazine* 31 (Feb. 1906), reprinted in *Shaw on Theatre*, ed. E. J. West (New York, 1958), p. 110.

[38] *What is Cinema?* trans. Hugh Gray (Berkeley, 1967), p. 27.

18

<center>✦｜✦</center>

W. P. FRITH AND THE SHAPE OF
MODERN LIFE

 N 1881, Émile Zola distilled the fruit of his four years as a drama critic into the polemic entitled *Naturalism in the Theater*. In a section on costume in which he recapitulates its evolution toward realism, he lashes out at present standards that still prevent the emergence of a drama re-creating the lives of most of the inhabitants of modern society. He argues that an appetite for spectacle and display and a limited concept of authenticity not only falsify the dramatic representation of contemporary society in its higher reaches, but rule out that vast majority of the population who do not pass their lives in dazzling and expensive clothing. But then he concedes:

> Modern clothing, it is true, makes poor spectacle. As soon as you venture beyond bourgeois tragedy, cramped within four walls, as soon as you want to use the amplitude of scenes on a large scale and fill them with crowds, you find yourself in difficulties, hampered by the monotony and uniform funereal appearance of the supernumeraries. That being the case, I think one should make use of the variety that a mixture of classes and occupations can offer. So, to make myself clear, I will imagine that an author places an act in the main square of Les Halles, the central market of Paris. The setting would be superb, swarming with life and bold in execution. Indeed, in this immense setting one could wholly achieve a truly picturesque ensemble, by showing the porters wearing their great hats, the market women in their white aprons and their vividly-colored scarves, the shoppers dressed in silk or wool or calico, ranging from ladies accompanied by their maids to female beggars foraging for garbage. All one need do is go to Les Halles and look about. What could be more variegated, more interesting? All Paris would want to see this setting if it were realized with the requisite accuracy and breadth.
>
> And how many other settings are there for the taking, for dra-

mas of the people! The interior of a factory, the interior of a mine, the gingerbread fair, a railway station, an embankment flower market, a racetrack, etc. etc. All leading contingents of modern life could appear in such scenes.[1]

An artist as well as an ideologue, Zola understands the practical problem. It is to find a way of stretching drab and limited materials (the supernumeraries) to meet the requirements of the medium for color, variety, and brilliance. But interestingly, Zola's practical solution to the problem of the drabness of costume and decor in modern life is also structural, and therefore, in a roundabout way, ideological. Zola suggests giving a panoramic, kaleidoscopic shape to contemporary reality, rather than the focused, concentrated shape so generally adopted to depict modern life in its private enclosures. His public places, inhabited by functioning representatives of all classes and occupations, suggest a sociological rather than a psychological perspective, and ultimately an alternative to bourgeois drama. The range of types and activities would be spatially rather than temporally ordered, so that juxtaposition and proximity would be functions of contemporaneity and without intrinsic narrative value. As a structure for the dramatic scene, Zola's suggestion has its problems, and his own best-known plays are more conventionally ordered. The panorama of the central market of Paris, however, and the life in and around the mine are among the "décors à prendre" that appear in Zola's fiction (*Le Ventre de Paris*, 1873; *Germinal*, 1885), where he indeed sometimes suspends traditional narrative values to provide panoramic and sociological vistas.

Panoramic structure (see above, pp. 61-62), fixed on precisely as a solution to the drabness and awkwardness of modern costume in representations of modern life, had already proven its worth in painting by the time of Zola's essay. In England, it was the formula of William Powell Frith, and the foundation of his immense success. In contrast to Zola, Frith developed his solution to the narrow problem of modern costume as the result of an admitted timidity in approaching the representation of modern life. In Frith's hands, the panoramic mode produced no works of monumental daring and imaginative grandeur like Zola's novels; but the panoramic solution had a symptomatic importance and appropriateness to the time, as a shared structure in art and as a shape transcending the presumed shapelessness of modern life.

"Theme" and Incident

Frith's autobiography presents his life's work in true perspective insofar as the highpoint of his achievement was a series of localized panoramas of modern life, notably *Life at the Sea-side* (or *Ramsgate Sands*, 1854), *The Derby Day* (1858), and *The Railway Station* (1862). Two of the paintings anticipate subjects on Zola's subsequent list. Frith presents his earlier career as marked by a restless fumbling toward modern-life subjects, ending when he had achieved an appropriate form. His later career he presents as a series of partly frustrated attempts to find equivalents, in subject and form, that would extend

[1] Nos vêtements modernes, il est vrai, sont un pauvre spectacle. Dès qu'on sort de la tragédie bourgeoise, resserrée entre quatre murs, dès qu'on veut utiliser la largeur des grandes scènes et y développer des foules, on se trouve fort embarrassé, gêné par la monotonie et le deuil uniforme de la figuration. Je crois que, dans ce cas, on devrait utiliser la variété que peut offrir le mélange des classes et des métiers. Ainsi, pour me faire entendre, j'imagine qu'un auteur place un acte dans le carré des Halles centrales, à Paris. Le décor serait superbe, d'une vie grouillante et d'une plantation hardie. Eh bien! dans ce décor immense, on pourrait parfaitement arriver à un ensemble très pittoresque, en montrant les forts de la Halle coiffés de leurs grands chapeaux, les marchandes avec leurs tabliers blancs et leurs foulards aux tons vifs, les acheteuses vêtues de soie, de laine et d'indienne, depuis les dames acompagnées de leurs bonnes, jusqu'aux mendiantes qui rôdent pour ramasser des épluchures. D'ailleurs, il suffit d'aller aux Halles et de regarder. Rien n'est plus bariolé ni plus intéressant. Tout Paris voudrait voir ce décor, s'il était réalisé avec le degré d'exactitude et de largeur nécessaire.

Et que d'autres décors à prendre, pour des drames populaires! L'intérieur d'une usine, l'intérieur d'une mine, la foire aux pains d'épices, une gare, un quai aux fleurs, un champ de courses, etc., etc. Tous les cadres de la vie moderne peuvent y passer.

[Émile Zola, *Le Naturalisme au théâtre* (Paris, 1923), pp. 122-23.]

rather than repeat his successes. His failure to do so was a direct consequence of his inhibitions, just as his previous achievement was a successful evasion of them. Subjective imperatives, current cultural demands and interests—including an ambivalent feeling toward modernity—and available technique were all elements in the problem for which Frith found a satisfying solution. The cultural, ideological, and technical biases Frith had internalized limited his further development of that solution, but also helped to give it its compelling popular appeal.

Frith writes of himself in the early 1840s, "My inclination being strongly towards the illustration of modern life, I had read the works of Dickens in the hope of finding material for the exercise of any talent I might possess; but at that time the ugliness of modern dress frightened me, and it was not till the publication of 'Barnaby Rudge,' and the delightful Dolly Varden was presented to us, that I felt my opportunity had come, with the cherry-coloured mantle and the hat and pink ribbons."[2] Dolly is an innkeeper's daughter of independent character, and her costume escapes from conventional drabness; but she flourishes in the late 1770s in *Barnaby Rudge*, one of Dickens' two novels grounded in history. In pursuing his aspirations toward the illustration of modern life, Frith could hardly have been more discreet.

Distanced genre painting, rural and provincial, had been well established since Wilkie, and "modern life" clearly meant something else to the painters who felt drawn to identify themselves, through their art, with the energy and concerns of the present age. It is worth remembering that few artists in the 1840s in England had gone further than Frith in creating a contemporary genre painting with unmitigated immediacy (Redgrave's *Poor Teacher*, 1843, is an exception). Moreover in 1851, when Frith began his designs for *Life at the Sea-side* in a much more receptive climate (the Great Exhibition gave a glamour to contemporaneity), he was still taking a chance with what turned out to be the best part of two years' work.[3] At that point the Pre-Raphaelite revolution, sometimes credited with clearing the way, had not yet produced one painting of contemporary life, and moreover was regarded as archaizing and reactionary.[4]

Frith writes that in 1848, year of revolutions, "Fear of modern-life subjects still possessed me. The hat and trousers pictures that I had seen attempted had all been dismal failures; and I felt sure, or thought I did, that unless a subject of tremendous human interest could be found—such an interest as should make the spectator forget the dresses of the actors in it—modern life was impossible." Frith's alternative, a *Coming of Age* festive scene (R.A. 1849), provoked Thackeray to ask "Why, when a man comes of age, it should be thought desirable that he should come of the age of Elizabeth?"[5] Thereafter, virtually driven by a secret, inexplicable passion (as he tells it), Frith ventured one or two modest studies from "everyday life"—a mother and a child saying its prayers, and an inadvertently risqué maid offering refreshments to the viewer—but these did not satisfy him. He had already discovered that his best chance of success lay in large compositions showing more or less characteristic public occasions, such as his *Coming of Age*, or his earlier *English Merry-Making, a Hundred Years Ago* (1847), in the direct line of the village kermis naturalized by Wilkie. Finally, on

[2] *My Autobiography and Reminiscences* (London, 1887-1888), 1:101-102.
[3] Frith quotes from his diary of 1851: "*Oct*. 3.—Finished outline of 'Sands,' an extensive business; out early to Great Exhibition." *My Autobiography*, 1:244.
[4] Millais' *Woodsman's Daughter* (1851), illustrating Patmore's poem, belongs to the world of squires and cottages despite the authenticity of the little girl's clothing. Brown's *Work*, begun in 1852, was not completed until 1863, and Rossetti's *Found* was incomplete at his death. The first painting from the Pre-Raphaelites or their sympathizers likely to be identified as an "illustration of modern life" and making an impact through its social immediacy was Holman Hunt's *Awakening Conscience*, exhibited in 1854.
[5] *My Autobiography*, 1:185, 192.

holiday in the summer of 1851, "Weary of costume-painting, I had determined to try my hand on modern life, with all its drawbacks of unpicturesque dress. The variety of character on Ramsgate Sands attracted me—all sorts and conditions of men and women were there," forming themselves, he found, "into very paintable compositions."[6]

Constable's response to Brighton a quarter of a century earlier provides an illuminating contrast, pointing not only to the difference between a landscape artist and a figure painter, but to the difference between a painter of the timeless renewals in transitory appearances and a painter of modern life:

Brighton is the receptacle of the fashion and off-scouring of London. The magnificence of the sea, and its (to use your own beautifull expression) everlasting voice, is drowned in the din & lost in the tumult of stage coaches—gigs—"flys" &c.—and the beach is only Picadilly (that part of it where we dined) by the seaside. Ladies dressed & *undressed*—gentlemen in morning gowns & slippers on, or without them altogether about *knee deep* in the breakers—footmen—children—nursery maids, dogs, boys, fishermen—*preventive service men* (with hangers & pistols), rotten fish & those hideous amphibious animals the old bathing women, whose language both in oaths & voice resembles men—all are mixed up together in endless & indecent confusion. . . . In short there is nothing here for a painter but the breakers—& sky—which have been lovely indeed and always varying.[7]

Frith sought variety to redeem modern life from the drabness in its public places and occasions, a variety not only of character but of incident. The panoramic structure entailed in such a quest tended to lengthen the horizontal dimension of the canvas and to deploy the incidents across a single plane. That tendency had to be modified by stratagems to avoid a frieze effect: overlapping pyramids, long diagonals, and in *The Derby Day* a shallow arc and a broken curl into the foreground. Variety was the prime requisite—an aesthetic virtue in itself in the age of bric-a-brac and genre chimeras—leaving rigorous formal unity to look out for itself. A prospective unity, however, was to be found in a "theme," meaning an intersection of occasion and locale. Seeking to repeat "the display of character and variety of incident that distinguished the 'Sands,' " Frith was obliged to seek out "a theme capable of affording me the opportunity of showing an appreciation of the infinite variety of everyday life."[8]

The viewer's experience of a panoramic canvas with a vast number of anecdotal particulars that have no narrative connection with each other is necessarily temporal, as eye and mind take up the implications of the fragments. There is no end to temporal fragmentation in that there is no moment of unification, as when the parts of a narrative whole fall into place. "Even at the last, the picture comes to an end, as it were, grudgingly," a reviewer writes of *The Derby Day*. "The man who closes it is cut in half by the frame, and is looking beyond the picture, so as to suggest its undefined continuousness."[9] Compositional unity—an "effect of the whole"—is rather strenuously sought in *Life at the Sea-side*. But it is a first rather than a last impression, for it must give way to an analytical reading of character and incident

[6] *My Autobiography*, 1:218-19, 243.
[7] Letter to John Fisher, *John Constable's Correspondence*, ed. R. B. Beckett, Suffolk Records Society, Vol. 12 (Ipswich, 1968), 6:171 [29 Aug. 1824].
[8] *My Autobiography*, 1:269.
[9] *Saturday Review* (15 May 1858), p. 501. See the comments on Horace Vernet's immense *Prise de la smalah d'Abd-el-Kader* (1845), p. 222n. above, and compare the structural problems of the Napoleonic battle panoramas.

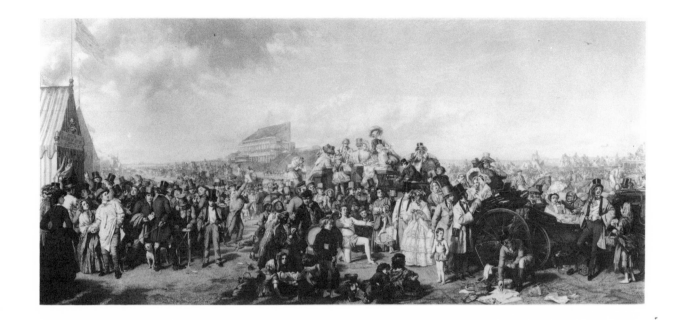

which generates no basis for a new synthesis. The "theme," however, is a unifying presence all along, a force like gravitation, more condition than agent.

169. *William Powell Frith*, The Derby Day *(1858), engraving by Auguste Blanchard (1858), London, British Museum.*

The "theme" Frith sought was not one that lay outside his window; that was for bolder or less ambitious spirits. He required of his intersection of occasion and locale that it be, not only characteristic and compendious, but special: holiday season—Ramsgate Sands; Derby Day—Epsom Downs; train time—Paddington Station. The sequence represents a trend. The last subject has the narrowest amplitude, as if to complement its highest frequency. It is the commonest occasion and the most ordinary locale of the three, and has the sharpest focus. As "theme"—it is the most aggressively modern of the three—it subjects character and incident to the unifying pressure of imminent departure. Ten thousand impediments in the path of that departure must be overcome within the constraints of clock and timetable, those transformers of variety, individuality, and the chaos of experience into mechanical regularity for social ends. The departure of the passengers in the train will be a modern miracle, a consummation in which human diversity and mechanical uniformity are reconciled.

The theme, then, provides the occasion for the vigorous embodiment of a social faith, a faith in industrial humanism. The painting is not without a sly spice of incongruity, however, to be found in the discords between the linear regularity of the impatient train and the jumble of baggage, between the overarching repetitions and exposed functional design of the modern station and the miscellaneous crowd. The painting is what Tom Taylor called it in the pamphlet that accompanied its special exhibition: the Railway looked at "from the prose side, as one of the points at which the life of our century is brought into focus."[10]

Frith once declared that it was his compositional practice to include a "main incident of dramatic force" in his panoramas of modern life.[11] Because of the increased temporal pressure, that incident is more dra-

[10] Tom Taylor, *The Railway Station, Painted by W. P. Frith, Esq., R.A.*, 2nd ed. (London, 1865), p. 4.
[11] *My Autobiography*, 2:36.

W. P. FRITH [377]

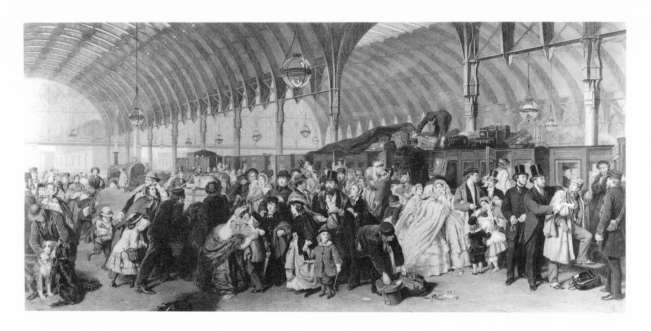

170. *William Powell Frith*, The Railway Station *(1865)*, engraving *by Francis Holl (1866),* private collection.

matic in *The Railway Station* but less central in the composition than heretofore. In fact, neither the wedding party, the foreigner and the cabman, the schoolboy and his family, nor the police incident at the extreme right edge of the canvas has the focusing power of the acrobats and their audience in *The Derby Day*. In the police incident, however, the fugitive is trapped at the apex of the angle formed by the picture plane and the plane of the line of departure; and here, uniquely, impedance is strong enough to arrest motion, where motion itself is irreconcilable with social ends. (The fugitive's stance, pointing out of the picture, is counter to the line of departure. The collaring policeman brings his head around).

In all three paintings the "weak force" inherent in occasion and locale provides a unifying tension that is not compositional in the ordinary sense, but is rather conceptual (and no less a matter of structure for that). The tension lies between the centripetal generality of the "theme" and the centrifugal individuality of the bits and pieces, of the characters, incidents, and local situations. These of course provide the possibility of ironic juxtapositions, which are on the whole broadly rather than wittily or ingeniously exploited. There is a similar tension between the idea of a crowd which all these paintings propose and the marked external individuation of all its members. Such copious individuation and iterative variety within a panoramic form, with broad contrasts and juxtapositions and a thematic unity, suggest much that is characteristic of Dickens' narrative style; and the frequent appearance of and special feeling for Dickens in Frith's autobiography confirm the contribution of that model.[12]

The Crowd as "Panoramic Epitome"

Frith and Dickens were frequently compared by contemporaries, and I shall not pursue the comparison here except as it is implicit in Frith's rendering of the crowd. The *Athenaeum* reviewer, however, in

[12] One revealing comparison implies a thorough identification with the novelist and his art. In a chapter where Frith mentions the first major engraving after his work, he writes in refutation of Carlyle (who had said Dickens' real forte was acting, not writing): "as a great actor stands to a great writer in about the same relation that a great engraver stands to a great painter, I submit that Carlyle was mistaken. . . ." *My Autobiography*, 1:267. On Dickens and the panoramic mode, see above, pp. 61-64.

his account of *The Derby Day*, carried the novelistic analogy a step farther than most. In this "panoramic epitome of English character in the year 1856," he wrote, "the scene is, as it were, in four volumes." What particularly intrigues the reviewer about this partition is the solution it offers to the problem of organizing a crowd in a picture. Frith, he shows, has chosen Veronese's way, as opposed to Raphael's or Hogarth's: a crowd "harmonized and broken into three or four special groups," around which the lesser objects move, allowing for both variety and repose, intricacy—"all that complex action and counteraction and intersection of flirting, sighing, drinking, cursing, longing, and fighting"—and rhythm. In this fashion, Frith incorporates in his "panoramic epitome" (an oxymoron) "the noisy millions of London, Whitechapel and Belgravia, smoky or scented, fashionable or unfashionable."[13]

The representation of modern life in England discovered a strong affinity for two subjects: the urban crowd (even if shown in exurban circumstances) and the sin against domesticity, in the shape of prostitution or adultery. Other subjects, namely domestic anxieties of all sorts, with partings and reunions prominent, flourished in greater number, but were not identified as the characteristic subject matter of modern life. The treatment of the sexual subject tended to be psychological, as compared with that of the crowd, where externality was expected, along with a classificatory, specimen-oriented view. Consequently only the urban crowd as modern subject implied a panoramic form. The form was all the more useful because the representation avoided qualities we think characteristic of urban life: anonymity and claustrophobia. Rather, in the three Frith canvases, in the Frith-inspired panoramas of George Hicks (e.g. *The General Post Office: One Minute to Six*, 1860), and even in Fred Barnard's later *Saturday Night in the East End* (1876) there is space, life, and always character and variety. As in Dickens, urban density and its pressures seem more productive of differentiation than similitude. The claustrophobia of the milieu and the anonymity of the urban crowd make their appearance later, in black and white, particularly in the *London* of Gustave Doré (1872), an artist much influenced by the metaphysically and historically oppressed crowds of John Martin. Urban claustrophobia, and the suppression of individuality by undermined vitality, and shared deprivations and pathologies, also begin to appear after 1869 in the black and white of the artists who worked for the *Graphic*.

The variety and vitality of the crowd in select circumstances were what made the depiction of modern life possible for Frith; and the depiction of modern life, rather than the crowd as crowd, was his object. Typically, the *Athenaeum* reviewer makes much of the variety, along with Frith's strategy for representing the occasion by plotting the circumference, "—the edge of a crowd at a race-course, with various ingenious episodes of fun, vice, passion and pathos as side-dishes."[14] But the variety Frith sought in his subject was recognizably a matter of genre and tone, as well as of class, character, and incident. So, Tom Taylor, a dramatist himself, returns constantly to dramatic genre in his account of *The Railway Station*. He writes, for example, that the prose side of things as it appears both in daily life and in Frith's picture "has its infinite varieties, its heights and depths of tragedy, comedy,

[13] *Athenaeum* (1 May 1858), p. 565.
[14] Ibid.

and farce. . . . Only the tragedy is *bourgeois*; the interest, for the most part domestic; the joy and suffering, generally, on the scale suited to the small theatre of a single household, instead of the world-wide stages peopled by great epic or dramatic creators."[15]

The small stage appropriate to each separate drama, however, is converted to the broad stage that holds all on a principle that Taylor might properly identify as that of melodrama. "The brightness and beauty of this bridal group are all the more felt, after the sickening fear and agony of the felon incident by its side. So it is that the darkest shadows and brightest lights of life come together; that joy is intensified by sorrow, and sorrow deepened by joy, as the painter uses his darks and lights to relieve each other." Beyond the bridal group are the serio-comic recruits, and in the center is the dispute with the cabman "in which the farce of life predominates," set against "sorrow, in widow's cap and grey hairs, hard by youthful Hope, in orange-blossoms."[16] This abundant variety of affective tone, the quantity and variety of incident, the contrasts and interminglings, the emblematic conception of character—youthful Hope and widowed sorrow—all belong to the ethos of melodrama.

Realizations

Panoramic and dioramic spectacle had a normal place in some forms of dramatic production after 1820, notably in Pantomime, while in fiction, the panoramic display of urban life had been the overt rationale of Pierce Egan's *Life in London* (1821) and was an important feature of the Newgate novel and the drama of the 1840s depending on it (see above, pp. 277-78). The structure of melodrama, moreover, lent itself to a series of scenes which, considered together, would metaphorically form "a panorama" of whatever life was being represented. By the 1860s, however, new standards of detailed elaboration in contemporary setting and of striking mechanical effect were carrying the sensationalism of the real further than ever before, and were carrying melodrama itself to a wealthier and more sophisticated audience. It was this audience in the late 1860s that patronized a spectacular variety of melodrama whose sensationalism was located in its reflection of modern urban life, and whose titles advertised a panoramic view. A harbinger of the fashion, Boucicault's *Poor of New York* (1857)—in which a city tenement burns and collapses on stage while an engine fights the blaze—became *The Streets of London* (1864). Theaters put up *Lost in London* (1867); *The Great City* (1867); *After Dark: A Drama of London Life in 1868* (1868); *London by Night; or, The Dark Side of Our Great City* (1868, the reworking of a play from 1845). Augustin Daly's *Under the Gaslight*, the source of the much-pirated "railway effect" (1867; London, 1868), originally bore the descriptive subtitle, "A Romantic Panorama of the Streets and Homes of New York." It was Boucicault who made the remark, quoted earlier, that the stage is a picture frame "in which is exhibited that kind of panorama where the picture being unrolled is made to move, passing before the spectator with scenic continuity."[17] This strain of melodrama continued strong in the succeeding decades, and critical objections to its modern-life sensation-

[15] Taylor, *Railway Station*, p. 4.
[16] Ibid., pp. 9-13.
[17] "My Pupils," *North American Review* 147 (1888): 438.

alism are often indistinguishable from the offended reactions to literary realism and naturalism.

"Three of my pictures," Frith recalled, "namely, 'Claude Duval' (in a piece of Burnand's), the 'Railway Station,' and the 'Derby Day,' have been represented, *en tableaux vivants*, on the stage, with a result in each case woefully disappointing to me."[18] The first was *The Derby Day*, in Dion Boucicault's racing melodrama *Flying Scud* (Holborn, 6 Oct. 1866), a drama of modern life that begins rather in the vein of a rural domestic drama, complete with wicked would-be squire, traduced country maiden, and an elaborate Wilkielike "Reading of the Will." The villains, however, are a set of London sporting men; and the high point of the drama (which soon relocates in London) is Epsom Downs as a panoramic spectacle, with the carnival crowd giving temporary place to the actual running of the Derby. The *Times* wrote that the scene—which opens with the realization of the painting—was "enlivened with all those minute realities that are combined in Mr. Frith's celebrated picture."[19] Among the most recognizable was the doubtful couple in the right foreground: the unpleasant gentleman, and the disconsolate young woman in the carriage, beset by a gypsy fortune-teller. These are important characters in the play, but less suggestive of "modern life" than in the picture; for Boucicault redeems his vacuous man-about-town from viciousness, and has his "adventuress" reject proposals of marriage until she manages to save Lord Woodbie's life by replacing him in a duel.

For the race, Boucicault clears the view by a species of dissolve: "*Bell. Cheers. A row and a fight, during which a tent is knocked down on one side and the carriages, etc., are moved off at the other so that the whole course and spectators, grandstand, etc., become visible.*"[20] The race is performed by small profile horses in perspective; and in the end the winner, Flying Scud, and his jockey appear in the flesh amid the enthusiastic forestage crowd. The *Times* further observes that "to describe the excitement of the audience during this scene would be impossible," but insists that the excitement was not "merely the result of a well-composed moving picture." In fact the *Times* finds considerable shortcomings in the *Derby Day* spectacle itself, especially "a want of artistic arrangement" in the combination of the acrobats, the thimble-riggers, and other natural appendages to a race, and a want of harmony between the painted background and the living crowd. "As a specimen of stage realism, the Derby-day, considered simply as a picture, cannot be compared for a moment with the view of Charing-cross and the Fire in the *Streets of London*, or the Telegraph-office in the *Long Strike*," pictures that originated in the theater. Frith's disappointment in the realization of *The Derby Day* had a double ground: the shortcomings of the scene as an embodiment of his painting, and its relative failure as a realistic picture of modern life.[21]

The Railway Station, the second of Frith's paintings to be given a sensational realization in the theater, presented a more powerful image of contemporary urban life, and incorporated one prominent incident already redolent of police melodrama. The realization took place at the very end of Andrew Halliday's *The Great City* (1867), and was given

[18] *My Autobiography*, 3:416.
[19] *Times* (8 Oct. 1866), p. 7.
[20] *Flying Scud*, in *Forbidden Fruit & Other Plays by Dion Boucicault*, ed. Allardyce Nicoll and F. Theodore Cloak, America's Lost Plays, vol. I (Princeton, 1940), p. 218. This version differs from the privately-printed text in the Lord Chamberlain's collection.
[21] *The Long Strike* was Boucicault's 1866 version of Mrs. Gaskell's *Mary Barton*. *The Derby Day* made at least one other theatrical appearance, overlooked by Frith but testifying to its place in popular imagery. A review of E. L. Blanchard's Drury Lane pantomime *Tom Thumb the Great* (1871) reports: "The military manoeuvres performed by moonlight on 'Little Cove Common,' belong to the series of performances by disciplined children, which has invariably been an attractive feature in Drury Lane pantomime; and the same may be said of a representation of the Derby Day, after Mr. Frith's picture, which is introduced into the harlequinade." *Times* (27 Dec. 1871), p. 3.

a structural emphasis by a return to the opening locale. The play begins with *"The Terminus at Charing Cross. Bustle incidental to the Station and hotel,"* including ringing bells, an arriving crowd (suitable for an opening), and a discussion among a morally-dubious M.P. (the villain), an Irish half-pay major, and a Jewish commercial privateer, on what a piece of work is steam.[22] In the last scene, consisting chiefly of the tableau realization of Frith's painting, the M.P., whose complex financial schemes have failed and who is sought as a forger, is arrested just as the hero and heroine are starting their bridal tour. Two prominent groups in the painting thus accommodate the ultimate fates of the major characters in the play. Despite all this, the *Athenaeum* reported, "This scene failed to be so successful as was expected; it was exceeded in interest by that of the Charing Cross Hotel and Waterloo Bridge by gaslight [I, 3], in which latter a Hansom cab and horse drove on the stage [and across the bridge], to the almost hysterical delight of the audience."[23]

Success of any one scene, however, even the narrative climax, was less important than it might have been if Halliday's play had no other affinity with Frith's picture than its physical realization. But in fact the play shared, indeed considerably widened, and perhaps ultimately dwarfed the painting's panoramic intentions. The primary design of the play was "to furnish opportunity for the introduction of some striking pictures of metropolitan localities from the pencil of Mr William Beverley."[24] Beverley's name stretched across the program in larger type than anything but the title. His function was to re-create, rather than to create in the vein of his pantomime work (see above, pp. 184-85); for as the *Daily Telegraph* observed, "each successive scene, depicting some well known locality, was hailed with hearty recognition" (23 Apr. 1867). Except that it used transitions instead of a rolling continuity, the play became a "moving panorama" of London.

Halliday's story is a pastiche, drawing noticeably upon Dickens' *Great Expectations*, Boucicault's *Streets of London*, and Cruikshank's contribution to *Jack Sheppard*. The story allows him, however, to engineer a series of strong contrasts, what the playbill cast list calls "Extremes of St James's and Giles's."[25] Waterloo Bridge (I, 3), where the hero (for a change) tries to drown himself out of despair over his drunkenness and the apparent loss of his sweetheart, gives way to Belgravia and a fashionable entertainment, with dancing, cards, city men, and titled guests. This in turn gives way to *"The Gates of the Workhouse. Casual paupers come in and crouch about the steps."* Enter Mendez and Major O'Gab smoking cigars, discussing first their recent Belgravian entertainment, then "The Theory and Practice of the Poor Law" (*"Mendez*: Look there's a sight in a Christian country"). The outside of the Workhouse gives way to "The Jolly Beggar's Club," full of sham cripples, placarded sufferers, and street cadgers, and ripe for a police raid. The thieves' kitchen, where the fraudulent beggars and street denizens relax from their dubious enterprises, is followed by "The Board-Room," where the aristocrats and businessmen set up a company swindle.

The series of contrasts creates a panorama of London that is not

[22] L.C. MSS 53058 (licensed 17 Apr. 1867).
[23] *Athenaeum* (27 Apr. 1867), p. 558.
[24] Ibid.
[25] Playbill, Drury Lane, 13 May 1867, Enthoven.

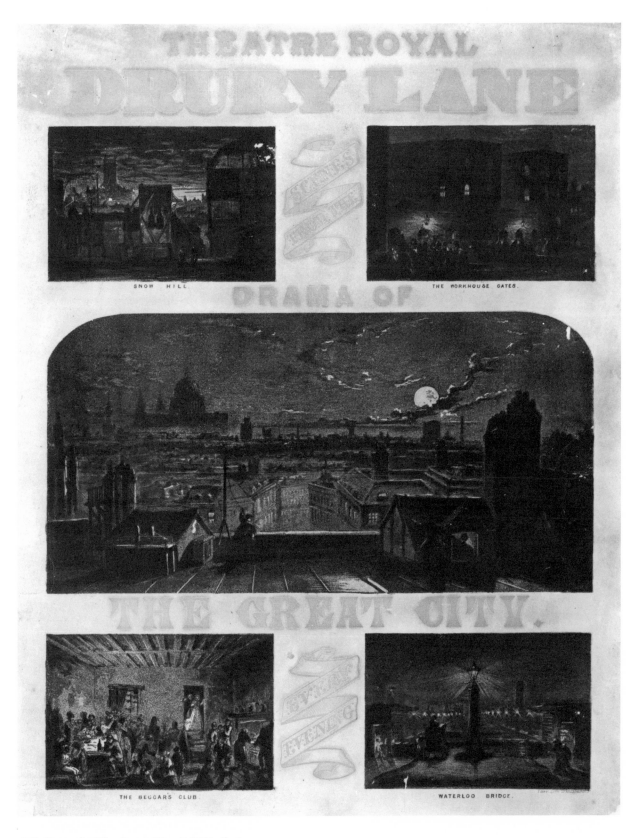

171. Poster for The Great City *(1867), Enthoven.*

merely local, tied to recognition of place and monument, but social and economic. A literal panoramic view of the Great City at the end of the third act, showing London by Night, thus becomes emblematic (see poster, Fig. 171). The scene also incorporates an escape over the rooftops (as in *Jack Sheppard* and *Oliver Twist*), where the villain sensationally cuts his dangling nemesis loose, to fall to his presumed death. After such excitements come the denouement and the "Realisation of Frith's Celebrated Picture."

The attraction of the spectacle was perhaps enhanced by the circumstance that the play was presented as an Easter piece, at a time when spectacle is looked for. But the traditional spectacle of Easter was of an ideal fantasy world; and that *The Great City* should be found so acceptable in Easter circumstances bespeaks an extraordinary appetite for the control through mimesis of the familiar, contemporary urban reality.

FRITH had painted his *Claude Duval* (1859) between *The Derby Day* and *The Railway Station*. It is an accomplished work, full of life and character, eloquent gestures and ingenious pictorial solutions. It is also a reversion to costume painting in the vein of "comedy drama," with roots in Goldsmith and Fielding. The source was doubtful history: an anecdote in Macaulay of a celebrated gallant highwayman who proposed to restore some of his takings for a coranto on the heath with one of his victims. Frith wrote, "The dramatic character of the subject attracted me. I thought if I could succeed in retaining the beauty of the lady, combined with the terror that she would feel, I should perform a feat well worthy of achievement. The dresses of the period were very picturesque; the contrast between the robbers, and the lady and her companions, would be very striking."[26] The picturesque reveals itself also in the tree and sky; but the costumed comedy of terror and incongruity, of the alfresco masked ball, destined the scene for realization, not in a simple Newgate melodrama, but in F. C. Burnand's *Claude du Val; or, The Highwayman for the Ladies, a New and Original Burlesque-Sensational-Drama* (1869), a burlesque of historical costume drama leaning on the usual sex reversal and puns and anachronisms.[27] A reviewer, noting that Claude Duval still appeared occasionally in a straightforward melodrama in the suburban theaters, compared his reputation with that of Jack Sheppard, "who enjoys a far wider fame, through the fact that he was [as] lucky in his Harrison Ainsworth, as Agamemnon in his Homer."[28] In consequence, it was the fate of Frith's picture, by a well-known process of heroic accretion, to provide a stock poster for *Jack Sheppard*.

There is nothing in Frith to suggest Dickens' haunted imagination, or the infernal side of Dickens' vision of modern life and of the Victorian city; but the shadow of the prison dogs the work of the one as much as the other. (Far off, on the horizon in Frith's *Claude Duval*, stands the gallows with its burden.) If such anxieties seem foreign to Frith, the shadow perhaps should be credited as much to the times as to the man. It is a fact, however, that the fascination with criminality and failure seems incremental and progressive in Frith's work. The criminality of pickpocket and shell game and the pains of sentimental sin in *The Derby Day* give way to the drama of arrest in *The Railway*

[26] *My Autobiography*, 1:304-305.
[27] Pub. London, 1869. Claude announces: ". . . we'll dance forthwith / The minuet immortalized by Frith. . . . (MUSIC. CLAUDE *and* MABEL *dance the Minuet, illustrating as closely as possible the subject of Frith's well-known picture* . . .)."
[28] *Times* (25 Jan. 1869), p. 9. For Ainsworth's intention to celebrate Duval as well, see above, p. 248.

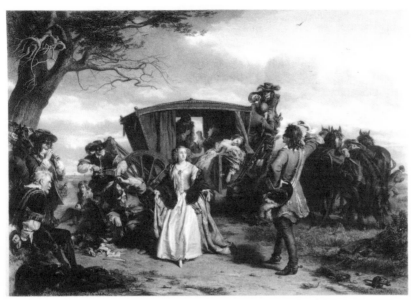

172

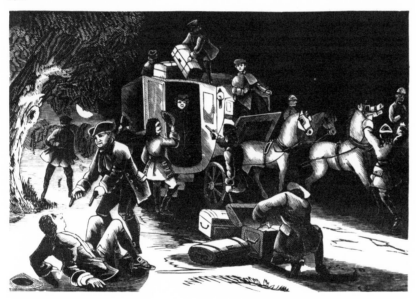

173

172. *William Powell Frith*, Claude Duval *(1859), engraving by Lumb Stocks, London, British Museum.*
173. *Stock poster for* Jack Sheppard, *from* Specimens of Show Printing *(Philadelphia: Ledger Job Printing Office, n.d.).*

Station; and that in turn leads to further exemplary depictions of modern life where the terrors of apprehension, exclusion, degradation, and failure, all implicated with money and its loss, culminate in lonely suicide behind a locked door, and in the exposed circle of the prison yard.

Frith and "The Modern Moral Drama"

With *The Railway Station*, the unmodified panoramic form ceased to serve Frith. His later *Salon d'Or, Homburg* (1871) is distinguished by a much narrower class content, a foreign locale, and a confined interior setting. His *Private View of the Royal Academy, 1881* (1883)

174-76. (facing page) *William Powell Frith, Finished studies for* The Streets of London *(1862), formerly collection of Mrs. Gerald Arbuthnot.*

presents a portrait-filled spectrum of the reigning establishment of arts and letters. In his account of "Rejected Subjects"—Frith says he even offered large rewards in his quest for themes that would carry him further in the painting of modern life—he writes that the University Boat-race had often been named as a good subject, "and in a sense it is a good one; and if I had not painted the 'Derby Day,' I might be tempted to try it." But a little reflection showed that the river-bank incidents "would be too much like those at Epsom to enable one to avoid the odious charge of repetition."[29] Interestingly, the criticism of Boucicault's play, *Formosa; or, The Railroad to Ruin* (1869), apart from its "indefensible" representation of courtesan life, was that it was "little more than a paraphrase of 'Flying Scud' " because it offered the boat race for the horse race in the climactic spectacle.[30]

Frith's most ambitious formal and thematic development of the panoramic mode occurred immediately after *The Railway Station*, but unfortunately never came to fruition. It entailed the addition of temporal serialism to extension in pictorial space. In agreement with the dealer Ernest Gambart, Frith was to paint three pictures collectively called (like Boucicault's play) *The Streets of London*. Each painting (we learn from the drawings) would seek to add the effect of deep perspective to the three-part lateral panorama, each part treating its distinct locale as an avenue into the urban distance under a progressively narrowed sky. The whole would be set in the parentheses of the curving street of the first and the boldly split and terminally limited prospect of the last. The first painting, *Morning*, was to show "a variety of incidents possible to the occasion: homeless wanderers, asleep and sleepless; burglars stopped by police red-handed; flower-girls returning from Covent Garden . . . belated young gentlemen . . . with other episodes more or less characteristic." The second, *Noon*, was to have for its *mise-en-scène* (Frith's term), "Regent Street in full tide of active life." The third, *Night*, was to show "the Haymarket by moonlight, the main incident being the exit of the audience from the theatre." A gentleman placing a cloak about a young woman's shoulders is observed "by an over-dressed and berouged woman, whose general aspect plainly proclaims her unhappy position; and by the expression of her faded though still handsome face, she feels a bitter pang at having lost forever all claim to manly care or pure affection."[31] The three times and three locales were to be painted on a scale that, together with the copyrights, was worth the astounding fee of £10,000 to Gambart. But in deference to a command to paint the wedding of the Prince of Wales, the project was postponed and ultimately put aside, much to Frith's retrospective regret.

Frith's career-long relation to Hogarth was rather like Thackeray's to Fielding, involving a self-conscious adaptation of the model to nineteenth-century canons; and Frith plainly had in mind, in conceiving his *Streets of London*, Hogarth's *Four Times of the Day*, less the satire. To compensate, Frith planned a broader range of incident and affect (from comedy to domestic tragedy), and a narrower canon of verisimilitude. Temporal serialism in the painting of modern life had already been pioneered anew, however, in Augustus Egg's tripartite *Past and Present* (1858), whose distressing last compartment, showing the unfortunate wife and her presumably illegitimate infant "under the dark

[29] *My Autobiography*, 2:46.
[30] Cf. *Athenaeum* (14 Aug. 1869), p. 217.
[31] *My Autobiography*, 1:336-37. Cf. Rossetti's watercolor of 1857, *The Gate of Memory*, Surtees, #100.

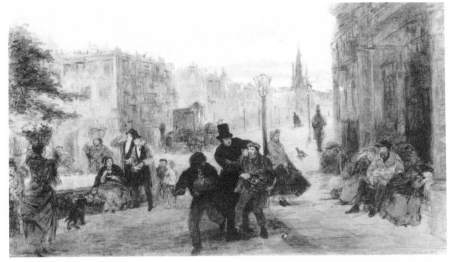

174. Morning

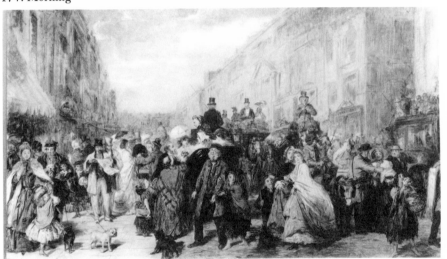

175. Noon

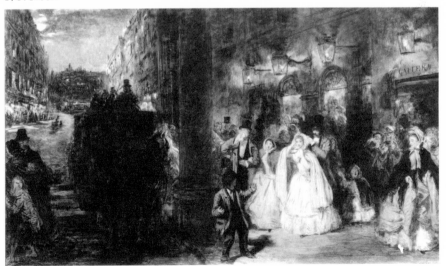

176. Night

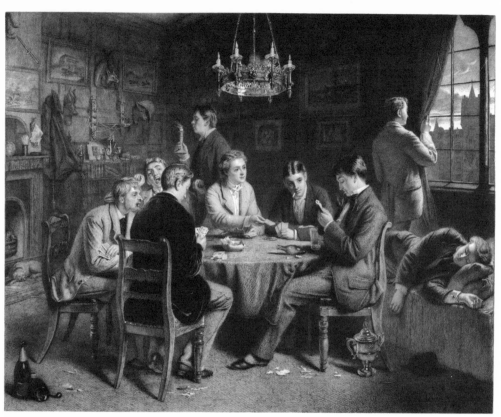

177. College

177-81. *William Powell Frith*, The
 Road to Ruin *(1877-78),* etched
 by Leopold Flameng (1878), pri-
 vate collection.

³² *Athenaeum* (1 May 1858), p. 566.
The normative combination was arch,
bridge, and moonlit river (see above, p.
138). Boucicault's *After Dark,* which
opens on the exterior of Victoria Station
with crowds, street-sellers, cabs, and
horses, spends much time under the
arched stonework of tunnels and cellars;
and when the rejected though virtuous
wife is about to drown herself, it is be-
side an "*Arch of Bridge with view of the
River Thames and St. Paul's by moon-
light. . . . Discover,* MEN, GIRLS *and*
CHILDREN *asleep in different spots on
Stage.*" De Witt's Acting Plays, #364,
"Scenery," "Properties," and pp. 9, 19.
 ³³ *My Autobiography*, 2:121.
 ³⁴ Frith only later saw Wiertz's *Suicide*
(where the subject is shown blowing his
head off) in Brussels, and he was prop-
erly horrified though much intrigued by
the artist. *My Autobiography*, 2:194.

grave-vault shadow of an Adelphi arch,—last refuge of the homeless
sin, vice and beggary of London," employed a standard iconographic
setting in the urban panorama.³²

Following the collapse of Frith's projected *summa* of modern life in
its variousness, the narrative series rather than the panorama consti-
tuted his chief instrument for the representation of modern life. He
conceived the five-part *Road to Ruin* (1877-78), he said, as "a kind of
gambler's progress,"³³ a straightforward domestic drama whose pre-
cedents lay not only in Hogarth and his graphic successors, but also in
melodrama (e.g. Ducange and Dinaux's *Trente Ans; ou, la Vie d'un
joueur* [1827] with its various English adaptations) and the fiction
that was nearly indistinguishable from it. For example, Frith's *Road
to Ruin* had a close predecessor in structure and feeling in a six-part
serial called *The Gamester's Progress.* The story ran in *Reynolds's Mis-
cellany* in 1849, each part consisting of two or three pages of text and
a half-page wood-engraving. "Stage VI.—The Last Game" shows the
gambler lying dead in a poor room, having shot himself, discovered
by a young woman who is apparently about to take poison. Such an
end is indicated in the last episode of Frith's series, though Frith
represents the moment before the gambler's suicide, and emphasizes
solitude and enclosure.³⁴

It is a mistake to look upon *The Road to Ruin* as only a neutered
Victorian evasion of the focus of Hogarth's progresses. It is a mistake
to look upon the money subject as a sublimation of the sexual subject,
and therefore feeble by definition. Insofar as there was a displacement

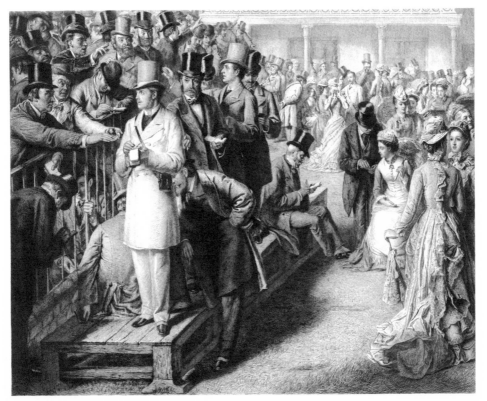

178. The Royal Enclosure at Ascot

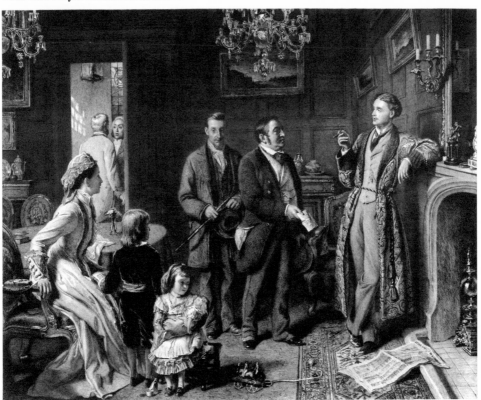

179. Arrest

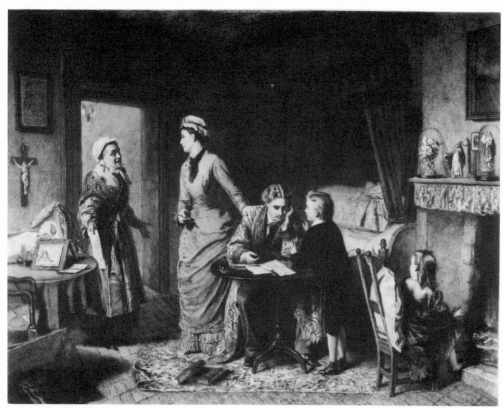

180. Struggles

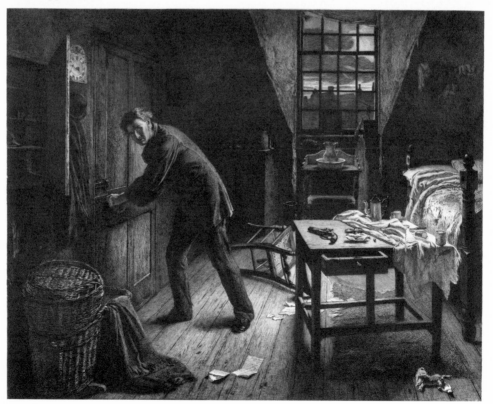

181. The End

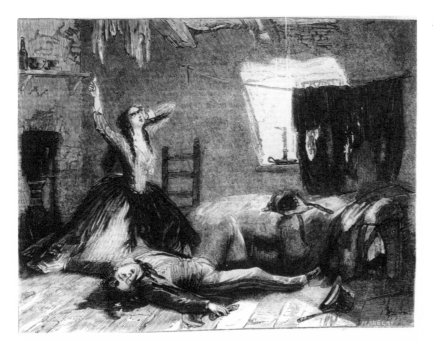

182. H. Anelay, *Illustration for Edwin F. Roberts*, The Gamester's Progress, Reynolds's Miscellany, *n.s. 2 (1849): 617.*

from sex to money (Hogarth is concerned with their *relations*) money could only gain energy by being sexualized. But gambling for the Victorians had a symbolic attraction in its own right, as a form of illicit commerce, an alternative to the iron laws of economic life and financial accountability. Like illicit sex, gambling promised gain without responsibility. Like illicit sex, it threatened a terrible visitation, or at least an addictive obsession that could destroy one's moral being and the social fabric itself. Moreover, the penalty of an easy virtue in monetary matters was also the destruction of the domestic enclave (as in *The Road to Ruin* and in Martineau's *Last Day in the Old Home* [1862]); or the corruption of sexual norms (as in Frith's *Salon d'Or* and in Elmore's *On the Brink* [1865]). The *Salon d'Or* is an infernal gambling scene that glitters with seductive splendor. Through such scenes both artist and society could indulge a prurient interest, could release and at the same time exorcize the destructive fantasy against institutional rectitude, by offering up the fantasy for the sake of the moral.

The Victorian canons of economic righteousness were Pelagian, if not actually of the Church of Eliphaz. Accordingly, free will was efficacious in economic life, and to deserve prosperity was to win it. Solvency was the reward of prudence and rectitude, and bankruptcy implied a fall from Grace rather than its mysterious withdrawal. But Victorian anxieties and the privately perceived realities remained stubbornly Calvinist. Reprobation was a mystery, unpredictable and unmanipulable; no man in his economic works could be perfect and deserving; failure, hovering from eternity, could come like a thief in the night as a sudden calamity; all might fall and be exposed to eternal derision, to notoriety and disgrace.

Four of the five paintings in *The Road to Ruin* were set in more or less private quarters (the other is on the racecourse again). Four of the five paintings in *The Race for Wealth* (1877-1880), Frith's later epic of a swindling financier, are set in more or less public places. These

183-87. (facing and following pages) *William Powell Frith*, The Race for Wealth *(1877-1880), Baroda, India, Museum and Picture Galleries.*

[35] *My Autobiography*, 2:146, 152. Compare Doré's Newgate prison circle in *London: A Pilgrimage*, by Gustave Doré and Blanchard Jerrold (1872; reprint ed. New York, 1968), p. 137, the source of Van Gogh's *La Ronde* now in The Hermitage. In Doré and Van Gogh, the vertical composition, the converging masonry floor and walls, running off on all sides, the scale of the figures relative to the architecture, and the perspective give an extraordinary sense of confinement and oppression. Frith's composition, in contrast, gives a sense of exposure. The circle is not quite closed, and its pressure forces the ex-Spider to the fore, under our notice. Even the guard, outside the circle, is looking at him, while the cell windows that line the courtyard on two sides are like rows of eyes.

[36] *My Autobiography*, 2:144-45. Frith's descriptive paraphrase of his paintings and his account of his researches are equally revealing. Large preparatory drawings are in the BM, Dept. of Prints and Drawings.

[37] *My Autobiography*, 2:144. Sullivan, whose parody also has five scenes, does in fact show the Spider in the prison yard doing time, but standing on his head. The caption (using the racing metaphor) reads: "An easy canter over the six-months' course. (The position of 'The Spider' is figurative.)" *Fun*, n.s. 31 (23 June 1880), p. 250.

are *The Spider and the Flies* (the Spider's office), *The Spider at Home* (a crowded double drawing-room), *Judgment* (the Old Bailey), and *Retribution* (the great quadrangle of Millbank prison). Only the third and pivotal painting, *Victims*, is set in a domestic enclave, that of a clergyman, earnest, anxious, and upright. He is the gambler in shares whose representative seduction and ruination counterpoint the financier's triumph and exposure. Returning (after the *Road to Ruin*) to a public and at least partly panoramic scene, the series aims at a more literal, less metaphoric representation of the driving energies of modern life. But since Frith is not content just to report the modern scene, as if that were the limit of the painter's responsibility, since he is not prepared to show the action of the marketplace without interpreting its moral and social consequences, he provides, as the moral touchstone of the series, the stereotyped domestic drama at its heart.

Nevertheless, *The Race for Wealth* has Darwinian overtones. There is no competition of vice and virtue; only the linked history of predator and prey. The moral mechanism is still retributive, but impartial. The Christian clergyman, ruined, takes the stand against the pale, fallen colossus, exposed in the dock, and brings him to the final degradation of the last scene. That nightmare compounded of exposure and confinement shows "The Spider," emblazoned with the broad arrow of his felon status, caught in the "dreadful circle" of the exercise ring, "always preserving the prescribed distance . . . not a sound but the monotonous tramp" in "the courtyard—with its surrounding cells—which forms the *mise en scène* of my picture, precisely copied from nature."[35] Frith's declared moral was—"rightly or wrongly conceived—that both those who, in their eagerness to become rich, rush into rash speculation, and the man who cheats them, should all be punished." That his own feelings were rather more complex is suggested by the language of Frith's own account of his researches for the trial scene, reminiscent of some of Dickens' imaginative exercises, and Cruikshank's assignment of his own face to Fagin in the condemned cell. "I made my way from Newgate through subterranean passages to the dock, in which I took my place as an imaginary criminal. I tried to realize the impression that the sight of the judge, with the sword of justice over him, together with a crowded court, would produce on the half-dazed eyes of the poor wretch who had come upon the scene through those dim passages."[36] Frith is sparing of sympathy toward his "foolish clergyman." He is much amused by J. F. Sullivan's parody of the series in *Fun*, where the swindler rolls along in his carriage unpunished, and "without the least display of sympathy for the poor parson, who is reduced to sweeping a crossing over which the carriage has just passed." But he identifies with the criminal, whom he treats as the tragic, representative figure, with the man who suffers the greatest fall and the greatest exposure.[37]

Beyond Frith

Trollope's *The Way We Live Now* (1874-75), Dickens' Merdle in *Little Dorrit* (1855-57), and the predatory society of *Our Mutual Friend* (1864-65) provide a sufficient literary background for *The Race for Wealth*. But the drama also made its contribution, weighted by the

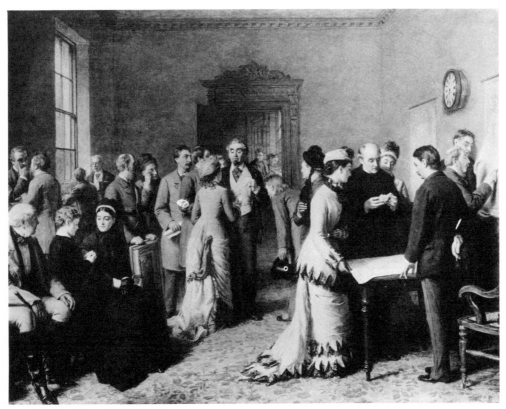

183. The Spider and the Flies

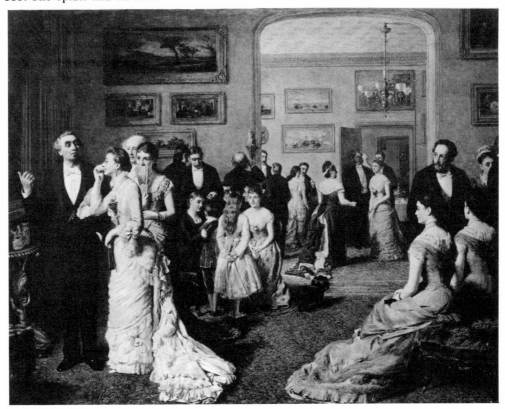

184. The Spider at Home

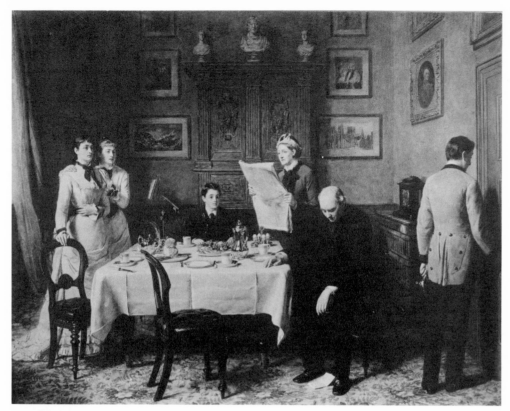

185. Victims

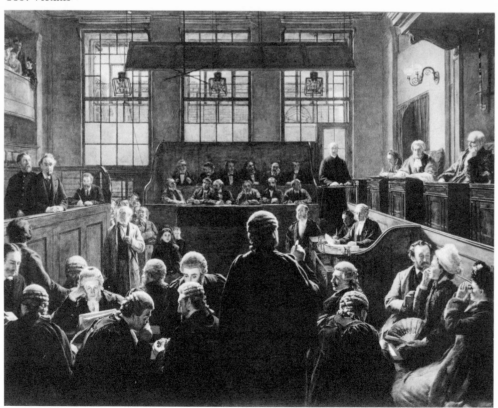

186. Judgment

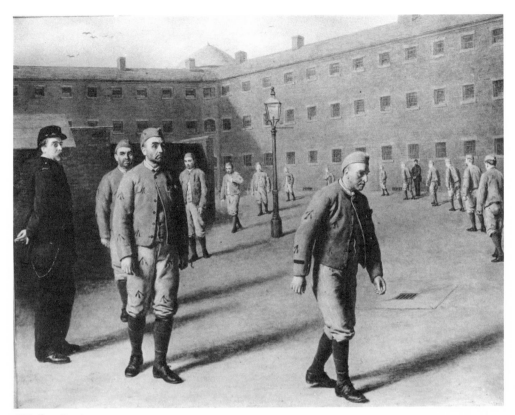

187. Retribution

affinity between the picture series and a form that aimed at striking scene and visual effect. Michael Booth points out the increasing part commercial life played in the drama of the late fifties and sixties, as in Tom Taylor's *Settling Day* (1865), with its concern to render the authentic decor and activity of the modern brokerage office.[38] Instead of the pleasure haunts, theaters, clubs, gardens, and sporting locales of Egan's *Life in London*, the newly characteristic locales were banks and brokerage houses. Periodic commercial crises, contagious speculation, and simple fraud were offered as characteristic expressions of modern life, from G. H. Lewes' often-revived *Game of Speculation* (1851, based on Balzac's *Mercadet*), to Boucicault's *Poor of New York* and Boucicault and H. J. Byron's *Lost at Sea; or a London Story* (1869).

But if commercial life could represent what was most characteristic and most essential in modern urban life, it especially exemplified middle-class life, and thereby offered only one element of the inclusive panorama. In the drama, a comprehensive and "realistic" account of modern life still implied a penetration to the bottom of things, to layers that society often found it convenient to ignore or keep concealed. In the 1880s, the formal ambitions of melodrama were comprehensive as never before. The titles alone of the Drury Lane and Surrey Theatre spectacles attest to the inclusive intentions and persistent panoramic idea in the genre: *The World; Youth; Mankind; The Sins of the City; Human Nature.* It was then that this low-life aspect of urban melodrama reasserted itself with a difference.

The year Zola published *Le Naturalisme dans le théâtre* (1881) saw

[38] Michael R. Booth, "The Metropolis on Stage," in *The Victorian City, Images and Realities*, ed. H. J. Dyos and Michael Wolff (London and Boston, 1975), 1:222-23.

a locally momentous conjunction of panoramic form in melodrama and in the pictorial representation of modern life. The actor-manager Wilson Barrett produced and starred in G. R. Sims' *Lights o' London*, wherein the presentation of London life at its least fortunate, as the background of a police hunt for the escaped (innocent) convict hero, made use of two well-known paintings from the 1870s. These illustrate the rather short-lived school of urban realist painters in England, who pushed beyond the point where Frith left off. According to Sims himself, he took it as a compliment that William Archer, the most progressive critic of the era, described the play in which these pictures appeared as "Zola diluted at Aldgate Pump."[39]

Archer wrote on Sims' play at length, and not only identified the pictorial sources, but developed a pictorial metaphor to describe the relation of dramatic narrative and dramatic image:

> "The Lights o' London" is a picture of low-class life painted with a fidelity which is almost without precedent on our stage. The melodramatic framework in which it is placed is more conventional, less truthful, and consequently less valuable. . . . Still, it is made to suit the picture with not a little skill; or rather, as in the case of Mr. Whistler's productions, the frame is artistically contrived so as to form an effective part of the picture, and not a mere arbitrary accessory. Such pictures have been common enough on canvas. Mr. Fildes' famous painting of the Casual Ward is recalled by one scene, Mr. F. Barnard's lurid "Saturday Night" by another. Many attempts, too, in the same direction have been made upon the stage, but they have generally dealt with sensational externals, and not with the real essential spirit of popular life.[40]

It is much to Sims' credit that Archer feels Sims *has* caught that essential spirit, through intimate knowledge and sympathy with the popular life he is representing. Of the two paintings Archer recognizes, Luke Fildes' *Applicants for Admission to a Casual Ward* (1874) was the earlier, having made its first appearance as a wood-engraving in 1869. This was in the first number of the *Graphic*, a new weekly journal, intended to be a competitor against both the *Illustrated London News* and the popular literary weeklies, and "to be a high-priced paper [6d], the very best we can get together by a combination of the best writers, artists, engravers and printers."[41] In periodical and other fiction, in social and industrial reports, and in the illustrated journals, pictures in black and white, on wood or steel, already provided a grimmer, more reportorial account of modern life than was thought appropriate in color. The *Graphic*, however, by joining a distinct interest in social realism to a high standard of art, consolidated a group of talented practitioners into something like a school. This "English realism" in black and white, responding in part to developments in France and Holland, was sufficiently distinctive and impressive to be collected by Van Gogh.[42] Among the significant artists were Fildes, Frank Holl, and Hubert Herkomer, with Fred Walker (who died young) an important stylistic influence.

Frederick Barnard was a little apart. He had studied in Paris, drew

[39] George R. Sims, *My Life: Sixty Years Recollections of Bohemian London* (London, 1917), p. 134. Archer actually relates Sims' command of the minutiae of the life of the people in London to Zola's documentary method, and then observes, respecting the moral and intellectual underpinnings, "His mother-milk has been watered from Aldgate Pump, and he has learnt his letters from the *Daily Telegraph*."

[40] William Archer, *English Dramatists of To-Day* (London, 1882), p. 310.

[41] William Luson Thomas, wood-engraver and founder of *The Graphic* and *The Daily Graphic*, to Fildes, 6 Sept. 1869; in L. V. Fildes, *Luke Fildes, R.A., a Victorian Painter* (London, 1968), p. 12.

[42] See Ronald Pickvance, *English Influences on Vincent Van Gogh*, 2nd ed. (Nottingham, 1974-1975).

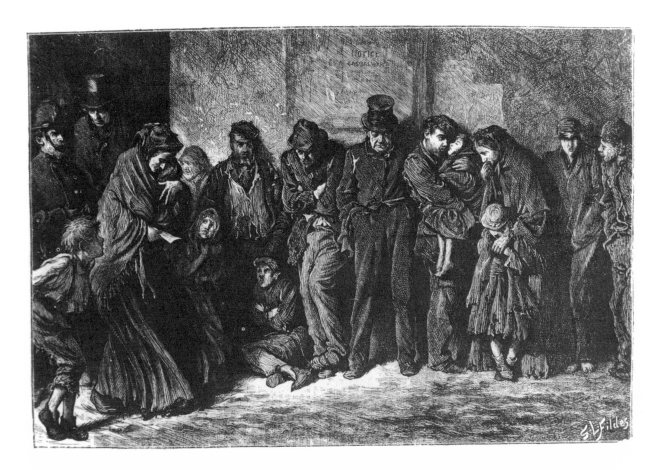

humorous designs for *Punch* and *Fun*, and developed primarily into an illustrator whose work appeared in *Good Words*, *Once a Week*, and the *Illustrated London News*. He did most of the illustrations for the "Household Edition" of Dickens (1871-1879), and in 1883, soon after the *Lights o' London*, he collaborated with Sims in a series called *How the Poor Live*, originally in the *Pictorial World*. Barnard was not himself an engraver like Herkomer (or from a family of engravers, like Holl), nor did he become so frequent and successful a painter in oils as Fildes. But for his painting, as for that of the group as a whole, the movement from a graphic medium to oils was an important stylistic determinant. In the case of some of the best-known paintings of the group, like Fildes' *Casual Ward*, the movement reversed the normal sequence whereby the engraving follows a successful painting.

Nevertheless, while something of the sobriety and reportorial immediacy of the black-and-white medium remained, the expectations, conventions, and necessities of the color medium had their effect. The difference may be seen even in the titles—as between Herkomer's *Sunday at Chelsea Hospital* (*Graphic*, 1871) and its translation in oils, *The Last Muster* (1875); or between his *Low Lodging House; St. Giles's; A Study from Life* (*Graphic*, 1872) and the related painting, *Eventide— A Scene in the Westminster Union* (1878). What is reportorial and specific in one medium becomes—relatively speaking—poetic and universal in the other. Fildes' painting is an exception in that *Applicants*

188. *Luke Fildes*, Houseless and Hungry, The Graphic *(4 Dec. 1869), p. 9.*

for Admission to a Casual Ward is a more prosaic and specific title than *Houseless and Hungry*, as the earlier print was called. But the painting also shows a greater interest than the print in oddity of character for its own sake, as well as a gentler pathos in the children, a more open composition, and a manipulation of golden light that betrays Dutch longings. F. T. Palgrave, who hailed Fildes' painting as "this work of remarkable skill and high, almost tragic impressiveness," associated it with two paintings in the Academy exhibition by the admirable but Rembrandt-ridden Josef Israels.[43]

What the melodrama of the 1860s in the urban panoramic mode provided an audience was a way of visualizing contemporary urban reality that was both locally truthful and pictorial, that gave artful form to vigorous squalor and to visually interesting reaches of everyday life that "legitimate" art found untouchable, unsalable, and uncanonical. When the young Luke Fildes became a working artist supplying drawings to the wood-engraving firms (about 1866), he also became an avid theatergoer, according to his son and biographer.[44] Consequently, the winter-night queue waiting for lodging tickets that he had observed outside the police station (and noted as a possible subject), he may also have seen as the crowd of casual paupers waiting for admission to the workhouse in Halliday's *The Great City*. Halliday's play would have had a particular attraction for an artist with modern-life interests, if only for the realization of *The Railway Station*. Such a source of inspiration would have been retrospectively appropriate; for *The Great City* owed a heavy debt to Dickens, and Dickens, looking for an artist to illustrate *Edwin Drood*, discovered him in the creator of *Houseless and Hungry* in the first number of the *Graphic*.[45]

The graphic antecedents of Frederick Barnard's *Saturday Night* (if any) are not clear, and the painting itself has not surfaced recently. But the conception and dimensions (84″ x 39″) were those of Frith's panoramas. As a sequel to those representations of modern life, Barnard's painting extends the line of development so that the scene and subject, the "panoramic epitome," is finally crowded back into the urban heart of darkness: from the seashore, to the suburban racetrack, to the western terminal of the metropolis (the very gate of escape), to the nighttime market at the end of the working week in the crowded East End slums. The openness and the innocent pleasures of light and color which redeem Frith's variegated crowds are gone here, and instead, in a "gloomy and murky atmosphere, but glowing with the light of flaring gas-jets, oil lamps, paper lanterns, and candles stuck in bottles—the faces of a motley Saturday night crowd in Whitechapel stand out with grim effect."[46] Most reviewers acknowledged the truthfulness; the *Athenaeum* thought it "a telling picture. . . . of a coarse kind, but possessing considerable merit and interest, on account of the abundance of character it displays," full of "half-brutalized figures and squalid persons buying provisions; a work which is full of motion, and gives a tolerably just notion of the scene, and it is not without pitiable illustrations of poverty and disorder."[47] Less condescending, Henry Blackburn praised the skill and knowledge in the treatment, and found the painting "valuable as a true, if slightly dramatic, study of life in the East of London."[48] As in Zola, however, the heaped-up matter and

[43] *Academy* 5 (2 May 1874), p. 500. For a fuller account of the relations between the print and the painting, see Bernard Myers, "Studies for *Houseless and Hungry* and the *Casual Ward* by Luke Fildes, R.A.," *Apollo* 116 (July 1982):36-43.

[44] Fildes, *Luke Fildes*, p. 11.

[45] Ibid., p. 13. Fildes' later painting, when exhibited at the Royal Academy, was accompanied by an epigraph from Dickens: " 'Dumb, wet, silent horrors! Sphinxes set up against that dead wall, and none likely to be at the pains of solving them until the *general* overthrow.'— *Charles Dickens. Extract from a letter in the third vol. of 'Forster's Life of Dickens.'* " *Exhibition of the Royal Academy of Arts* (London, 1874), #504.

[46] Henry Blackburn, *Academy Notes, 1876* (London, 1876), pp. 11-12. In fiction, there was in Kingsley's *Alton Locke* (1850) a brief account of a Saturday-night market in St. Giles, emphasizing its repulsiveness (chap. 8); and there would be in Gissing's *Thyrza* (1887) a vivid and more friendly description of a Saturday night in Lambeth Walk (chap. 4).

[47] *Athenaeum* (13 May 1876), p. 670.

[48] *Academy Notes*, p. 12.

characteristic light of such a locale are liable to take on an infernal cast. The most detailed description of the painting was William Rossetti's:

> *Saturday Night*, by Mr. Barnard, is one of the most remarkable illustrations of London low-life that could be cited from any period of our art. It is certainly not a sightly picture—full of grime and flare, and of human uncouthness; but this is in the nature of the subject: the redness of the lighting is pushed to an extreme, and a disagreeable extreme. The central incident is that of a sailor with a grey parrot on the top of a cab, receiving a bottle of spirits; other incidents of the drinking-plague are a sot reeling into a gin-shop, and his squalid wife clutching at him, while a girl with an unfilled beer-jug glowers at the squabble. Two street-urchins gloat over the *Police News* as they shuffle along; a butcher plies his trade; a chapman noises abroad his pottery; a harpist and a fiddler fill up with indifferent music the pauses of all the other clatter. These are but a few out of many well-varied aspects of the gaseous pandemonium of Whitechapel as pourtrayed for us only too truly by Mr. Barnard.[49]

Fildes' picture of the waiting casuals and Barnard's *Saturday Night* provided just two of the striking scenes in Sims' panorama of darkest London (the latter three acts of his play) at the Princess's Theatre. *The Lights o' London* is an ironic title, for the play opens after the hero and heroine have lost their illusions about the city, and it shows their attempt to put those lights behind them. When the hero returns to the city, it is for the darkness: as a fugitive, an escaped convict hoping to hide from his pursuers. The recognizable locales are a police station, outside and in; "Outside the Casual Ward"; the Regent's Canal (as the site of an attempted murder); and "the Borough, Saturday Night," a panoramic crowd-scene to climax the whole. The *Illustrated London News* thought "This scene of the Saturday night marketing in the Borough, with its hundreds of varied supernumeraries, men, women, and children; its grim squalor and hideous depravity, its drunkenness and its dirt, its fierce unbridled animal passion and wild-beast fighting, its street row and police-court mêlée is realism out-realized." Such scenes from actual life "make me shudder when they are reproduced with such fidelity."[50] The *Times*, raising a familiar issue in the criticism

[49] *Academy* 9 (27 May 1876), p. 518. Reviewers of the 1876 Royal Academy exhibition tended to group and discuss, as representing a distinctive and acknowledged Realist school, the paintings of Barnard, Fildes (whose *Widower* was one of the stars of the exhibition), Macbeth (a painting of agricultural laborers) and Holl. The *Spectator* was pleased to note the school was not increasing, though holding its own.
[50] *Illustrated London News* 79 (17 Sept. 1881), p. 275.

of realism, wonders "why it should please people to see reproduced on the stage painful sights with which they are only too familiar in real life," and credits Sims with "a good deal of promiscuous newspaper reading on the subject of mistaken identity, police ineptitude, the abuse of charity, London street destitution, and workhouse and gaol administration."[51]

Clement Scott thought the Saturday Night scene "a marvellous example of stage realism, complete in every possible detail," but "If anything, it is all too real, too painful, too smeared with the dirt and degradation of London life, where drunkenness, debauchery, and depravity are shown in all their naked hideousness." His account of the scene makes plain its noise and animation, with costermongers, street musicians, cadgers, and drunkards, and the "readability" of groups and incidents even before the chief action takes place: a murderous fight, ended by a police break-in, in an open upper-tenement room. The hero's escape over a roof leads to a battle through the aroused and shrieking crowd in the street, and sets off a riot, "a mêlée which distances all yet attempted in the manipulation of stage crowds."[52] Scott, like many of the reviewers, is exceedingly conscious of the visit of the Meininger Company at Drury Lane earlier in the year, and he points to the comparable achievements of native stage management: in Shakespeare and Tennyson at the Lyceum, and in melodrama at the Princess's. Reviewers made a point of crediting "the skill of Mr. Harry Jackson, who arranged the busy scenes in 'Drink' [1879, from Zola's l'Assommoir] and in all the celebrated Charles Reade revivals at this theatre."[53] Since Sims later intimated that "the famous spectacle of the Borough on Saturday Night—a realisation of a well-known picture by Fred Barnard" was developed out of his original last scene only in production,[54] the stage manager was properly a collaborator.

THOUGH Zola proposed a panoramic solution to the problem of representing modern life vividly and truthfully in the theater of 1881, the fact is that the eponymous Panorama was born with the French Revolution, and along with its numerous progeny constituted a flourishing medium of entertainment and instruction through most of the nineteenth century. In the course of that century, responding to a miscellaneous set of craft problems, technical opportunities, and cultural appetites, panoramic models influenced or legitimated the organization of an important group of novels, dramas, and easel paintings. That such organization came to be associated with the representation of modern life has a certain logic, because the literal Panorama offered so strong an illusion of immediacy and scope. While in the midst of the scene, one commanded the whole; or else (in the "moving panorama") all passed before one's eyes in a continuous present. In fiction that exploits panoramic form—in Dickens, Balzac, Zola, and Joyce—both modes collaborate: the mode in which the spectator turns through the fixed scene, shifting his concentration until the whole lies present to him, and the mode in which the scene unrolls before his fixed and riveted attention in a continuous but fugitive succession. How the collaboration worked for the Victorian reader is suggested in a contemporary review of Middlemarch, where the critic's needless appre-

[51] Times (12 Sept. 1881), p. 4. Cf. Art Journal, n.s. 15 (1876): 215, on Barnard's painting.
[52] The Theatre 4 (1 Oct. 1881): 239-40.
[53] Illustrated London News 79 (17 Sept. 1881), p. 275.
[54] Henry G. Hibbert, A Playgoer's Memories (London, 1920), p. 130.

hensions over the relation of the parts to the whole, of the narrative elements to the design, might well have been applied to the "reading" of *The Derby Day*. The reviewer writes of the experience of those to whom the novel has come as published, in parts:

> They have assisted with deep interest in the production of a vast picture, in which figure after figure has taken its place, and gone through certain transformations, more or less interesting; but it does not follow that the impression of the whole will be quite as satisfactory. The arrangement of the groups, their mutual connexion, and their relations in perspective, may provoke criticism which we who are under the immediate influence of the gradually progressive story can hardly appreciate, and may reveal defects in the very qualities that have excited our admiration.[55]

In the end, the panoramic form was useful for the representation of modern life—including the dark underside, the precariousness of social order and established position, the chaos at the heart of things—not for abstract, formal reasons, but because of the panorama's capacity for abundant life. Walter Sickert wrote of the immense and perhaps exhausting effort that Frith must have poured into *Derby Day*: "Enthusiasm sustained at such white heat begets enthusiasm, and the love that the painter most visibly lavished on his every invention and his every cunning touch has easily been returned to him a thousandfold by generations of young and old, of gentle and simple, not only of his own countrymen but of all nations. The *Derby Day* is certainly, humanly speaking, one of the great victories over death."[56]

[55] R. Monckton Milnes, *Edinburgh Review* 137 (January 1873): 246-47. Invoking Millais' *Chill October* (1870) and recent developments in landscape painting, Milnes points to the careful avoidance "of any such central effect as gives to the Sun itself in Turner's greatest works a painful monotony of treatment." Instead Milnes finds in Eliot's novel and Millais' painting "the desire to give the impression of a simple fragment of Nature, taken out of the whole scene not for any special grace or merit, or for the purpose of leaving on the mind of the spectator any stirring particular remembrance, but to stand on its own deserts as a faithful representation of an ordinary aspect of the material world about us." Milnes here (with George Eliot's help) loses sight of the novel's comprehensive, as distinct from representative ambitions.
[56] Walter Sickert, *A Free House! or, The Artist as Craftsman*, ed. Osbert Sitwell (London, 1947), pp. 203-204; from the *Burlington Mag.* (Dec. 1922).

19

✦⟋✦

IRVING AND THE ARTISTS

ETWEEN 1878, when Irving assumed control, and 1902, when he played there for the last time, Henry Irving's Lyceum Theatre flourished as a Temple of Art. No English theater had aspired to that status before, certainly not since Drury Lane, weighed down by its legitimacy, had borrowed the entertainments of the circus and the minor theaters to fill the house. In the interval other houses and managements had established reputations for splendor, for archaeology, for elegance and refinement, even for Shakespeare; but none achieved or sought the special congregational reverence and hieratic tone that marked the Lyceum. From 1890 on, aggressively named "Theatres of Art" proclaimed their high aesthetic character in France and elsewhere, but not in England. Grein's Independent Theatre of 1892 aimed at a theater of Truth. For the theater of Beauty, England had Henry Irving's Lyceum.

Irving entered into his kingdom at a time of multiple schism in middle-class culture, both in audiences and in producers of art: between a runaway vanguard and an entrenched main body; between aesthetic and mimetic principles. At the midcentury, both W. P. Frith, a mainstream Victorian, and the Pre-Raphaelite Brotherhood, a vanguard movement, could appeal programatically to a taste for the real, for the visible and recognizable truth. It was otherwise with their descendants. Frith's literary affinities were with prose fiction of an urban, modern, socially inclusive character, and with the panoramic popular drama; and his pictorial successors, more realist than he, were the *Graphic*-centered artists of modern life. The Pre-Raphaelites on the other hand found inspiration in poetry: Keats, Dante, Shakespeare, and Tennyson; and, dissolving, produced a second wave, subjective, idealist, oneiric, and stylized. This latter strain fed the self-conscious Aestheticism that set itself up as antithetical to both advanced social realism and mainstream, middle-class culture.

Irving's lively sense of the changing situation never appeared more clearly than in his initial engagement of Ellen Terry in 1878, the beginning of his reign, to play Ophelia to his Hamlet. Apparently he had no great opinion of her acting, not having seen it recently. But

she had been at the center of artistic circles and current aesthetic ferment, as model, juvenile wife, mistress, and friend; and since her return to the stage in 1874 had become a favorite, not only of an art-oriented fashionable set, but of the general public as well.[1] As a general favorite, she brought Irving a great deal more than pictorial appeal, aesthetic credentials, and a following alert to decorative elegance. But as she writes in her memoirs, she brought him particular help "in pictorial matters. Henry Irving had had little training in such matters. I had had a great deal. Judgment about colours, clothes and lighting must be *trained*. I had learned from Mr Watts [the painter], from Mr Godwin [the architect], and from other artists [notably Whistler], until a sense of decorative effect had become second nature to me."[2] She quickly goes on to scruple that "although I knew more of art and archaeology in dress than he did, he had a finer sense of what was right for the *scene*" (p. 124). Be that as it may, it is nevertheless clear that Irving, with his traditional stage wisdom and sense of scenic effect, assimilated Ellen Terry's gifts and knowledge to an idea of a theater that bridged the widening gap between aesthete and philistine.

Shaw, fighting for a playwright's theater and avant-garde interests of another cast, blames much of the failure of the theater of the nineties to rise to its opportunities on Lyceum pictorialism and the unwitting influence of Ellen Terry. Unlike many of her younger successors, Ellen Terry had had a thorough professional training.

> But if Mrs Charles Kean qualified her to be the heroine of a play, Nature presently qualified her to be the heroine of a picture by making her grow up quite unlike anybody that had ever been seen on earth before. . . . The great painters promptly pounced on her as they did on Mrs Morris and Mrs Stillman. She added what she learnt in the studio to what she had already learnt on the stage so successfully that when I first saw her in Hamlet it was exactly as if the powers of a beautiful picture of Ophelia had been extended to speaking and singing.

Though "the decorative play," Shaw insists, is really obsolete, the theater finds itself saddled with "a whole school of such pictorial leading ladies" whose "unenlightened observation of Miss Ellen Terry produced the 'aesthetic' actress, or living picture. Such a conception of stage art came very easily to a generation of young ladies whose notions of art were centred by the Slade School and the Grosvenor Gallery." In passing, he sums up Henry Irving's theater:

> And here you have the whole secret of the Lyceum: a drama worn by age into great holes, and the holes filled up with the art of the picture gallery. Sir Henry Irving as King Arthur, going solemnly through a Crummles broadsword combat with great beauty of deportment in a costume designed by Burne-Jones, is the *reductio ad absurdum* of it. Miss Ellen Terry as a beautiful living picture in the vision in the prologue is its open reduction to the art to which it really belongs.[3]

Shaw, writing toward the end of the Lyceum era for what he sees as the future, the true avenue of dramatic, intellectual, and political

[1] Irving reportedly approached Ellen Terry following the enthusiastic recommendation of Lady Pollock. Of the actress' success as Portia in 1875, Edith Craig and Christopher St. John observe, "A painter (Graham Robertson) writes that Ellen Terry was *par excellence* 'the Painter's Actress,' and appealed to the eye before the ear; her gesture and pose were eloquence itself. 'Her charm held every one but I think pre-eminently those who loved pictures.' This throws some light on the subjugation of the painters in the audience at the Prince of Wales." *Ellen Terry's Memoirs*, ed. Edith Craig and Christopher St. John (New York, 1932), pp. 118, 96.

[2] Terry, *Memoirs*, pp. 120-21.

[3] G. B. Shaw, *Our Theatres in the Nineties* (London, 1932), 3:193-95 (from the *Saturday Review*, 17 July 1897).

development, attacks the Lyceum synthesis through its weakest link, the play; and he implies the obsolescence, or at least dead-end sterility, of Irving's whole cultural and theatrical enterprise. Of course Shaw does it a considerable injustice. Irving's role in providing nineteenth-century Britain with its last-quarter theater of Art was essentially progressive. His program did not halt with the acquisition of Ellen Terry, but rather entailed the steady involvement of contemporary art and half a score of notable contemporary artists in the Lyceum productions, including Ford Madox Brown, Burne-Jones, and Lawrence Alma-Tadema. Even more telling, however, was Irving's role as the ordering and shaping artist in his own right, a role that put him in command of the final creative phase of the nineteenth-century picture stage. In that magisterial activity, nothing extrinsic to the envisaged totality of the work of art was sacred, certainly not archaeology and not the dramatic text. Irving thereby belongs in the camp of those contemporaries who proclaimed the ontological independence of art, and rested all authority in the autonomous creative consciousness.

As the final full achievement of the nineteenth-century pictorial mode, Irving's stage was also transitional. That is, it put forth processes that would take root and flourish in the revolutionary stages of the early twentieth century. Such ambivalence was characteristic of Irving's theater in other areas as well. In a sense the schismatic cultural situation gave Irving his opportunity. He managed to lay claim to powerful traditions—that of Macready and Charles Kean as *regisseur* actor-managers, and that of the illusionistic picture stage—and make them instruments of his individuality. And he managed to set up his Temple of Art, not in opposition to the philistines, but in response to their need for reassurance against the high-cultural snobbery that proclaimed their incapacity. He attracted the "respectable" classes, and brought within their range what even many of the Grosvenor Gallery set accepted as Art of the highest quality. He also brought the "respectable" classes back to the theater; and as a reward, the theater also was at last allowed a high respectability. Painting and poetry already had their peerage; the theater gained its first knighthood.

Irving's direct employment of the representatives of the fine arts in his theater was not unexampled in earlier history. Talma had turned to David for advice on costume and decor, and Garrick had made a revolution with De Loutherbourg. But no one before Irving seems to have involved so many artists and so diverse a range; and that fact in itself links Irving with the wave of the future. The theater historian Denis Bablet labels his account of the idealist and symbolist rejection of realistic decor "Les Peintres au théâtre"; and from that phenomenon deduces one of the principal directions that the evolution of theatrical decor followed in the twentieth century. "From the simple fact of the collaboration of painters, the *mise en scène* became a *mise en scène* of lines and colors, and the composition of the '*tableau scénique*' obeyed preoccupations of a pictorial, rather than of a theatrical order (tone relationships, color coordination and juxtapositions, the arrangement of lines, etc.)."[4]

Implied is a reciprocal tendency in easel painters (and other artists) to turn to the stage as a plastic medium for their shaping. In the late

[4] *Esthétique générale du décor de théâtre de 1870 à 1914*, Édit. du Centre National de la Recherche Scientifique (Paris, 1965), p. 161.

1880s Hubert Herkomer, an authoritative and authoritarian figure in English art, founded a private theater with his students to satisfy such ambitions. There, "unfettered by tradition" or a paying public, the painter "could experiment in scenic art, in grouping figures, and in story-making, only changing his canvas for the stage in order to express with real objects and real people the thoughts he placed ordinarily on canvas with brush and colour."[5] In such experiments, Herkomer, Alma-Tadema, the architect E. W. Godwin, and even the reluctant Burne-Jones reverse the pattern of earlier painters like Stanfield and Roberts, who raised themselves from the craft of scene-painting and scene design to the art of the Academy; and they anticipate Picasso, Munch, Ricketts, Bakst, Gris, Matisse, Vuillard, Braque, Derain, Arp, Miro, Ernst, and numerous other saints of the modern movement.

Irving's Palette

Irving's pictorialism drew on his experience of mid-century plays, productions, and acting skills, provincial and metropolitan, in the normative stock-company theater. He conceived himself the inheritor of a tradition, and aimed at a legitimate monarchy in the line of Macready and the two Keans, rather than at a revolution. Nevertheless, so far as he was able, Irving made his inherited illustrative pictorialism the servant of a personal conception and the agent of an individual style. His very first Hamlet throws light on his later achievement, partly by contrast. Irving first appeared in that character in Manchester, at the Theatre Royal, in 1864, on the tercentenary of Shakespeare's birth. "Thanks to his own dark hair and personal appearance, he was enabled to give a remarkable representation of John Philip Kemble as he is represented in the famous painting by Sir Thomas Lawrence."[6] Irving appeared as a picture only, in an anthology of readings and *tableaux vivants*. Part of the effect of his appearance on this occasion doubtless came from the force of his own personality and from the framing and lighting; but much of it must have come through the reference to Lawrence's *Hamlet* (1801) and the pleasure of that recognition.

This external reference to an autonomous image from an autonomous art, this fragmented impersonation leading alternatively to Hamlet or to Kemble, to Shakespeare or to Lawrence, would not be characteristic of Irving's mature stage, or of his use of painters and painting. He reverted to such pictorialism only in his first season of management, in reviving his earlier vehicle, W. G. Wills's *Charles I* (see above, pp. 240-42). In that play, Irving's impersonation of Van Dyck's universally known images and his elaborate stage-picture realization of Goodall's *Happy Days of Charles I* appealed to the pleasures of recognition and mimetic reversal (from painting to flesh, from two to three dimensions) in traditional fashion. The paintings moreover supplied an authentication, in the spirit of archaeology, for the historical subject. But even in this production, the methods of the later Irving appear in the use he seems to have made of Millais' *Huguenot* for the parting of Charles and Henrietta Maria before the execution. Here the painting is not recreated for recognition, but serves the actors, the scene, and the dramatic idea directly. It is absorbed, with a wealth of other materials

[5] Herkomer, "The Pictorial Music-Play: 'An Idyl,'" *Magazine of Art* 12 (1889): 316. The form Herkomer here describes is a compound of music, pantomime, and song that largely avoids dialogue. In *An Idyl*, based on his oil painting of a street in the Bavarian highlands (1873), he first realized the picture and then managed the plot to effect a series of visual transformations.
[6] Austin Brereton, *The Life of Henry Irving* (London, 1908), 1:54.

and agents, into the affective whole that results from the "sincere" (single-minded) enactment of one man's vision. For Irving, who exerted a total control over managerial and production problems through a small cadre of devoted lieutenants, the theater was a machine for realizing that vision.

Irving generally made sure that his recruitment of living artists was well publicized; but often the "collaboration" was not much different from those instances where he ransacked dead, absent, or anonymous artists to provide costume, scene, or feeling tone. Nor was the result any more or less pictorial. The designs in the end had no autonomous standing for the audience; whether new and "specially provided" or old, they were translated and absorbed into the new creation. Their primary function in the production was to be useful in the making; and only thereafter to evoke the sense of a familiar representational style or world, authenticating and deepening audience response to the imagery of the scene. "The first scene of the Lyceum play strikes the keynote of the Albert Düreresque and Early German feeling with which Mr. Irving has inspired his artists," Joseph Hatton wrote of Irving's *Faust* (1885). Faust's study "revives in one's memory many a half-forgotten picture, illustrating ancient books of alchemy, witchcraft, and demonology."[7]

When he could manage it, Irving behaved similarly toward sacred texts. When he wished to bring Lyceum audiences a noble and beautiful *King Arthur*, "a subject that Tennyson has made dear to every English household,"[8] Irving elicited a text from Comyns Carr that more or less ignored *The Idylls of the King*. And at bottom, he was equally cavalier with archaeology. He worked for progressive effect and an atmosphere appropriate to the whole. Gordon Craig notes that the leopard skin Irving instructed him to wear in *Cymbeline*, "in spite of Alma Tadema's presence, and Tadema was a stickler for correct costume," was "utterly incorrect," given the climate of ancient Britain. "All the correctness in the world was not worth a fig to Irving, unless it *seemed* all right."[9] When preparing his *Faust* production, he took Hawes Craven to Nuremberg to study the look of a German medieval city. Joseph Hatton reports that the artist made two drawings: "The first was a bright, realistic drawing of the subject—simple, direct, truthful. The second . . . an idealisation of the first, from the managerial point of view, under the poetic influence of the dramatic scene for which it was designed."[10]

Archaeology could generally be counted upon to support effect; and where it did not, earlier actor-managers could be counted upon to give preference to effect. In the nineties, however, an anti-archaeological animus had shown itself in the general split between aesthetic idealism and historical materialism, art and nature. When Burne-Jones was asked why he had designed such peculiar, militarily impractical armor for Irving's *King Arthur*, he quipped, "To puzzle the archaeologists!"[11]

Irving's assimilative, indirect use of established art and artists is the theme of Gordon Craig's account of the influence of Doré. Irving mounted plays—*Don Quixote, Dante, King Arthur*—involving some of the classics, old and new, that Doré had most triumphantly illustrated. But the relation between the two artists, as Craig perceives, was ultimately one of vision and style, independent of any particular parallel or borrowing.

[7] *The Lyceum "Faust,"* New Edition (London: Art Journal Office [1886]), p. 18.

[8] Clement Scott, "The Playhouses," *Illustrated London News* (19 Jan. 1895), p. 67.

[9] Edward Gordon Craig, *Henry Irving* (London, 1930), p. 115.

[10] *The Lyceum "Faust,"* p. 6.

[11] Bram Stoker, *Personal Reminiscences of Henry Irving* (London, 1906), 1:254.

190. Gustave Doré, "Ô Cruches tobosines . . . ," in Don Quixote *(Paris, 1863), Vol. II, Chapter 18.*

191. (facing page) *R. Taylor, "Faust at the Lyceum.—No. 2. The Summit of the Brocken,"* Enthoven.

Sometimes he would take a whole design of Doré's and put it on the stage—as in the illustration to the line: *"Oh, ye Tobosian wines! that awaken in my mind the thoughts of the sweet pledge of my most bitter sorrow."* . . . The wines don't count with H. I. What struck him was: "deuced good scene for *Romeo and Juliet*, where I come across the a-poth-e-cary"—and he had it carried out with a few changes.[12]

He had it carried out, not in *Don Quixote*, where it might have asked for recognition and a divided appreciation, but in *Romeo and Juliet*, as a painted drop. Ellen Terry writes on Irving's belief in "front scenes" (considered old-fashioned) to support the swift progress of Shakespeare's plots: "These cloths were sometimes so wonderfully painted and lighted that they constituted scenes of remarkable beauty. The best of all were the Apothecary scene in 'Romeo and Juliet' and the exterior of Aufidius's house in 'Coriolanus.' "[13] In singing the praises of this same Apothecary scene, carried out Craig tells us "with a few changes," Percy Fitzgerald makes clear how Irving transformed the image in assimilating it to his purposes:

> Nothing could better supply the notion of impending destiny, of gathering gloom, than the view of the dismal, heart-chilling street, the scene of the visit to the apothecary. Our actor's picturesque sense was shown in his almost perfect conception of this situation. The forlorn look of the houses, the general desolation, the stormy grandeur in keeping with the surroundings, the properly subdued grotesqueness of the seller of simples (it was the grotesqueness of *misery* that was conveyed), filled the heart with a sadness that was almost real.[14]

Craig notes other Doré illustrations that seem "all Irving," but not because Irving straightforwardly lifted them; "I mean he entered into the very essence of these two designs; absorbed every scrap that was in them; added his own power to them; and there, as he walks across the stage, say, in *Faust*, or comes on in *Louis XI*, there comes friend Doré, helping him." Similarly, Clement Scott, who can be trusted to see the obvious, writes of the sensational Brocken scene in Irving's *Faust* (a version by W. G. Wills), that its figures, groups, and lighting "suggest Gustave Doré in every corner of the picture."[15] Others, with Doré in mind, write that Irving's Mephistopheles "looks much more like a fallen Dante . . . than like a mocking Mephistopheles."[16] Mephistopheles "leaps into the centre of the throng, and the world of the Hartz is ablaze."

> Earth and air are enveloped in a burning mass. The rocks seem to melt like lava. A furnace of molten metal has broken loose. The clouds shower down fiery rain, the thunder rolls away into the distant valleys. The ghost-like crew of fiends and witches and beings of nameless shape cower beneath the fiery hail and raise their writhing arms in shivering protest. It is a scene from Dante's 'Inferno,' and there is Dante in the midst, if the actor only put into his mobile features an expression of pity instead of a sense of fiendish delight.[17]

[12] Craig, *Irving*, p. 128.

[13] Terry, *Memoirs*, p. 134.

[14] *Sir Henry Irving: A Biography* (Philadelphia, [1906]), pp. 143-44.

[15] Craig, *Irving*, p. 128; Clement Scott, *From "The Bells" to "King Arthur"* (London, 1896), p. 294. In a review in the *Illustrated London News* (26 Dec. 1885), p. 660, "C.S." wrote of the Brocken scene, "No one but an imaginative actor could have conceived such a picture, or overmastered it with such a commanding presence. All the preconceived visions of Manfred and Sardanapalus and Belshazzar pale before this extraordinary scene. In it we detect the weird fancy of Gustave Doré, the splendid daring and invention o[f] John Martin."

[16] Joseph Pennell and Elizabeth R. Pennell, "Pictorial Successes of Mr. Irving's 'Faust,' " *Century Mag.* 35 (1887-88): 309.

[17] Hatton, *The Lyceum "Faust,"* p. 26. None of these critics connects the scene with Doré's *Paradise Lost*, where Irving's debt was most particular. Cf. Figs. 191 and 192.

Irving uses Doré in each instance, not for recognition value, nor for external authentication of his *mise en scène*, but for the creation of a powerful expressive style. He draws on, not just the spectacle and melodrama, but on the sardonic tragi-comedy, the peculiar romantic energy, of the Doré illustrations. As sources of imagery, they are more directly relevant to Irving's creative needs than to unmediated audience response.

Craig, on the evidence only of his own sense of style, believes that Daumier also had an influence on Irving, and "that Daumier and Irving have things—dramatic things—very much in common." For one thing, as Craig might have noted, they have the character of Robert Macaire in common: the jolly, ragged, self-parading, pseudo-genteel villain brought to life by Frédérick Lemaître, adopted by Daumier, and resurrected by Irving. Also, the "curious romanticism—the *curious* romanticism—of every touch" that Craig found in both Doré and Irving[18] shares something with the magnified truth and vitality of Daumier's satirical scenes; and these share something with the mannered realism, irony, and energy that turn up in other artists with a direct connection to Irving, notably Ford Madox Brown, whose part in Irving's *Lear* will be discussed below. A heraldic version of some of these qualities appears also in Edwin Abbey's *Richard, Duke of Gloucester and the Lady Anne* (exhib. R.A. 1896), which caught the eye of an Irving particularly concerned to unite pageantry and movement. Bram Stoker, Irving's faithful business agent, writes of the first scene of the Lyceum *Richard III* (19 Dec. 1896), "when the funeral procession of King Henry VI. came on, Irving had tried to realise some of the effect of the great picture by Edwin A. Abbey, R. A. Here the tide of mourners seems to sweep along in resistless mass, with an extraordinary effect of the spear-poles of royal scarlet amidst the black draperies." Stoker later adds that, given the different perspectives and "the non-compressible actuality of human bodies," it was "not possible to realise on the stage Abbey's great conception." But it lay nevertheless behind Irving's, and was absorbed into it.[19]

SHAW cites the Lyceum *King Arthur* in his attack on Lyceum pictorialism, not just because the production was recent (1895), but because it was a climax to the aesthetic, Tennysonian, Pre-Raphaelite strain that entered with Ellen Terry's Ophelia, and found expression (for example) in so unlikely a vehicle as *Macbeth*.[20] But the Pre-Raphaelitism that climaxed in Burne-Jones' somnambulism (so close in that feeling to some of Maeterlinck's new drama in the nineties), and the romantic energy and irony that passed through Doré and Daumier, were not the only currents to be embodied in Lyceum pictorialism. Other strains in late Victorian aestheticism also found a place in Irving's temple, even in association with Tennyson. Irving had played a sadistically cold King Philip in Tennyson's *Queen Mary* in 1876, before he assumed the management of the Lyceum. (Whistler painted him in the role, "if not a remarkable likeness, a superb study in black and silver.")[21] And in 1881 he mounted a production of *The Cup* that brought to life, in three dimensions, what has been called the "Victorian Olympus."[22] The production united the spirit and decor of Leighton,

[18] Craig, *Irving*, p. 128-29.

[19] Stoker, *Personal Reminiscences*, 1:126 and 2:81. Abbey had a long Shakespearean phase during which he illustrated many of the plays for *Harper's Magazine*. He and Irving collaborated intensively on a planned production of *Richard II* that never came off (Stoker, 2:81-85).

[20] At the time of the *Macbeth* production (1888) Ellen Terry wrote of herself, her costumes, and her dark red hair: "the whole thing is Rossetti—rich stained-glass effects." Sargent's splendid painting of Ellen Terry in the role, much admired by Burne-Jones, contains "all that I meant to do" (*Memoirs*, pp. 233-34).

[21] Laurence Irving, *Henry Irving: The Actor and His World* (New York, 1952), p. 274.

[22] William Gaunt, *Victorian Olympus* (London, 1952).

192. (facing page) Gustave Doré, "They heard and were abashed . . . ," in John Milton, Paradise Lost *(1866),* Book I.

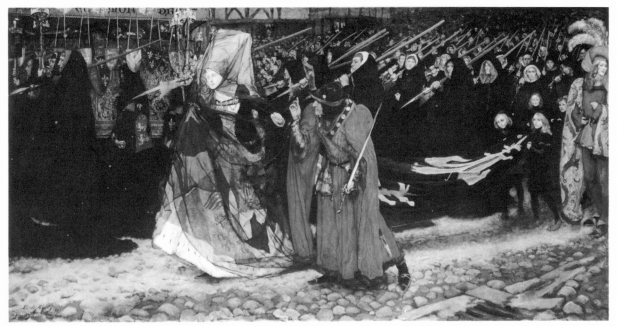

193

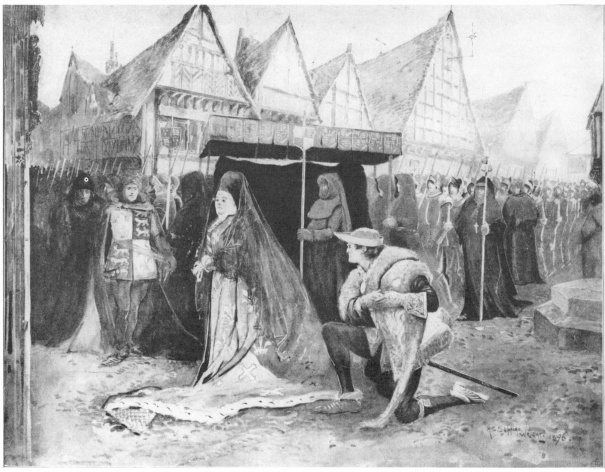

194

Alma-Tadema, and behind them the less-than-Olympian Gérôme; and it made attractive to a large audience what appeared to be a forbidding work of high aestheticism.[23] "We are inclined to doubt if the Stage has ever given to educated tastes so rare a treat," wrote the philistine Clement Scott. "In the old days such pictures might have been caviare to the general public, but the public at the Lyceum is one of culture, and a very high order of intelligence." He associates the whole with "Aesthetic tastes," often ridiculed because "everything that is affected is hateful to the ordinary English nature"; but here he finds all beautiful and elevating and the spectacle a fulfillment of the aesthetic ideal, rather than a nervous attenuation.

> We seem to see before us the concentrated essence of such fascinating art as that of Sir Frederick Leighton, and Mr. Alma Tadema, in a breathing and tangible form. Not only do the grapes grow before us, and the myrtles blossom, the snow mountains change from silver-white at daytime to roseate hues at dawn; not only are the Pagan ceremonies acted before us with a reality and a fidelity that almost baffle description, but in the midst of all this scenic allurement glide the classical draperies of Miss Ellen Terry, who is the exact representative of the period she enacts, while following her we find the eager glances of the fate-haunted Mr. Irving. The pictures that dwell on the memory [sic] are countless, and not to be effaced . . . even in an era devoted to archaeology.[24]

The play is set in an Asia Minor of the third century, when Roman policy, like Victorian, found Imperial uses for native rulers and native politics. The plot concerns the return under Roman protection of a previously exiled ruler, one Synorix, who covets his successor's wife even more than his lost realm. Synorix kills his rival in a fit of passion and lays claim to throne and consort; but in the royal wedding that follows, she poisons the cup sacred to Artemis from which they both drink, revenging her husband and preserving her purity. Irving as Synorix, Ellen Terry wrote, "was not able to look like the full-lipped, full-blooded Romans . . . so he conceived his own type of the blend of Roman intellect and sensuality with barbarian cruelty and lust."[25] Scott describes the two of them as "he with his long red hair, and haunting eyes, his weird, pale face, and swathes of leopard skins—she with her grace of movment, unmatched in our time, clad in a drapery seaweed tinted, with complexion as clear as in one of Sir Frederick Leighton's classical studies, and with every pose studied, but still natural."[26] Irving's ravaged, predatory, quasi-barbarian was *not* like one of Leighton's studies, but complemented the hybrid gorgeousness that G. A. Sala associated with the chamber of King Candaules as painted by Gérôme.

Sala nevertheless declared that "Down to the smallest detail of dresses, decorations, and stage management, everything bears trace of the consummate artistic taste of Mr. Henry Irving."[27] In fact even the pagan ritual and ceremonies, whose "fidelity" and "reality" Scott so admired, were Irving's invention.[28] Irving carefully shared responsibility, however, if not authority, with acknowledged experts outside the theater; and it is likely that at least one of the genuinely innovative elements in the production entered through their influence.

[23] For the first three and a half months of its run, *The Cup* was paired on the bill with Irving's production of *The Corsican Brothers*. Later, as a proven attraction in its own right, *The Cup* was paired with the lighter *Belle's Strategem* of Mrs. Cowley. There was no indecorum felt, however, in the original bill, yoking the sensationally spectacular melodrama and the aesthetically spectacular poetic tragedy; Lyceum audiences were clearly pleased with both.

[24] Scott, *Bells*, pp. 201-202.

[25] Terry, *Memoirs*, pp. 155-56.

[26] Scott, *Bells*, pp. 201-202.

[27] *Illustrated London News* (8 Jan. 1881), p. 31.

[28] Stoker, *Personal Reminiscences*, 1:206. Ellen Terry adds, "The thrilling effect always to be gained on the stage by the simple expedient of a great number of people doing the same thing in the same way at the same moment, was seen in 'The Cup,' when the stage was filled with a crowd of women who raised their arms about their heads with a large, rhythmic, sweeping movement and then bowed to the goddess with the regularity of a regiment saluting" (*Memoirs*, p. 155). Irving used about one hundred vestal virgins.

Irving's consultants were Alexander Murray, assistant keeper of Greek and Roman antiquities in the British Museum, for archaeological detail; E. W. Godwin (indirectly), architect and formally-estranged father of Ellen Terry's children, who designed her costumes and corrected her attitudes as Camma; and James Knowles, architect, founding editor of *The Nineteenth Century*, and an intimate of Tennyson, whose house he designed. Knowles also designed the Temple of Artemis for the second act of Tennyson's tragedy at the Lyceum, and a notice to that effect, "An announcement, which may be held tantamount to a *communiqué*," appeared in all the daily papers after the initial success.[29] The most striking innovation in the production seems to reflect this heavy presence of the architectural imagination. Sala celebrates the first-act opening tableau by comparing the scene to the grand spectacles of Clarkson Stanfield at Drury Lane fifty years earlier, and of William Beverley at Charles Kean's Princess's; "But a new departure in scenic art has been made since . . . the scenery in [*Acis and Galatea* (Drury Lane, 1842) and *A Midsummer Night's Dream* (Princess's, 1856)] took the town by storm. The plastic has now been added to the pictorial and the graphic in the pictorial embellishment of the stage; and in this opening scene—a lovely Anatolian landscape—actual bas-reliefs adorn the plinths and pedestals of the solidly built-up stairs leading to the Temple of Artemis."[30]

The temple interior, the scene of the entire second act, was the great spectacular triumph of the production, and there architectural realism, the dimensionality of "the plastic," was allowed full play. The most striking spectacles of the illusionistic picture stage—the executive creation of a line of great scene-painters represented in Irving's Lyceum by Hawes Craven, William Telbin, Joseph Harker and others—were contrived in two dimensions. Flat surfaces arranged in various planes and ordered by perspective created the third dimension with the help of illusion. Angled flats, set pieces, the box-set interior that appeared earlier in the century in domestic comedy, and even "the renowned 'oblique sets' in 'Sardanapalus' " were variations in the arrangements, but not in the art. The temple scene in *The Cup*, however, "in part suggested by the magnificent relics which remain to us of the Temple of Diana at Ephesus" and reimagined by Knowles, added volume and the organization of space to plane and perspective. Sala, seeking a spectacle of comparable magnificence, invokes the Cathedral scene in Meyerbeer's *Prophète* (1849), though he finds even that surpassed in some respects, "since at the Lyceum there are rows of real fluted columns, real moulded capitals, and real bas-reliefs on the plinths."

> The sanctuary of the goddess, with her gigantic statue, made in the likeness of the many-mammaed Diana of the Ephesians, looms awfully in the distance; and when the stage is filled with the priests and priestesses of Diana, the youths and maidens who take part in the matrimonial procession, the children bearing baskets and wreaths of flowers, and the Roman soldiers in the train of Antonius; when the aromatic fumes of the incense pervade the great expanse, and solemn litanies are chorally chanted in response to the invocations of Artemis, first by Synorix, and afterwards by

[29] *Illustrated London News* (15 Jan. 1881), p. 55.
[30] *Illustrated London News* (8 Jan. 1881), p. 31.

Camma, standing on the steps of central altar, the effect is almost appallingly grand.[31]

It is clear here that the setting as Irving used it was an integrated aspect of a spectacular whole, involving sound, movement, music, perfume, orchestrated to a climax and dazzling all the senses. The setting is a milieu, not a background, nor an independent effect like Stanfield's splendid scene for Pocock's *King Arthur* which provoked Stanfield's quarrel with Bunn (above, p. 43), nor is it even an "illustration" in the sense of ancillary enrichment. On the other hand, it is not an architectural setting for drama: permanent and conventionalized, as in the classical theater and its descendants, or abstract and adaptable, as in the modern multileveled step-and-platform tribune stage. But that Knowles' and Irving's setting carries the germ of the reinvention of the architectural stage is suggested in Sala's afterthought on what seems to him to be its striking originality: "I do not know whether solidly modelled bas-reliefs and cornices, fluted shafts of columns and moulded capitals have been used on the stage before as adjuncts to ordinary scene-painting on flat surfaces; but to me the effect at the Lyceum was as novel and as impressive as the famous permanent proscenium in low relief constructed by Palladio after the ancient Roman model in the Teatro Filarmonico at Vincenza."[32] Five years later, Godwin built his temporary Greek theater, an architectural screen, platform, and platea, in the ring of Hengler's Circus for John Todhunter's *Helena in Troas*. The production, fanatically archaeological, involving fashionable amateurs and sponsored by the promoters of aesthetic classicism, was very much of the moment; but its architectural setting influenced at least one of the prime innovators of the new theater, Godwin's son by Ellen Terry, Gordon Craig.[33]

In *The Cup*, the architectural and the pictorial, the new and the old, were not at odds. The controlling mind that believed, "It is most important that an actor should learn that he is a figure in a picture," was not likely to lose sight of the framed view from the stalls.[34] The Temple, therefore, was built, not on a scale consistent with real space, but in perspective, and in relation to the indeterminate gloom of the painted back and side walls, to create (like painting) the illusion of space, of depth and magnitude. Fitzgerald reports, "It is curious to find that the pillars and their capitals are all constructed literally in the lines of perspective such as would be drawn on a flat surface; they diminish in height as they are farther off, and their top and bottom surfaces are sloped in a converging line."[35] The effect, Ellen Terry recalled, was of "a vastness, a spaciousness of proportion . . . which I never saw again upon the stage until my son attempted something like it in the Church Scene that he designed for my production of 'Much Ado About Nothing' in 1903." Viewed from the auditorium, construction, paint, and the moving crowds and principal figures all managed to remain "in keeping." Integration was achieved through the manipulation of still another medium: "The gigantic figure of the many-breasted Artemis, placed far back in the scene-dock, loomed through a blue mist, while the foreground of the picture was in yellow light." To this management of light (and something like "atmospheric per-

[31] *Illustrated London News* (8 and 15 Jan. 1881). Laurence Irving quotes Percy Fitzgerald's interesting account of the change of scene (for which fifteen minutes were allowed) as managed backstage (*Irving*, pp. 367-68).

[32] *Illustrated London News* (15 Jan. 1881), p. 55. Sala means the Teatro Olimpico. The Teatro Filarmonico, in Verona, was built in the eighteenth century after designs by Francesco Galli Bibiena.

[33] See Dudley Harbron, *The Conscious Stone; the Life of Edward William Godwin* (London, 1949), pp. 176-81. "It was to be the most perfect of the several entertainments that had shown London the beauty of Greek Art and costume." Craig "rediscovered" Godwin in *The Mask* (1910). There are suggestions of Albert Moore in Godwin's instructions to Louise Jopling to "arrange some of the women in the same attitude as those on the Parthenon freize" (Harbron, p. 180).

[34] Henry Irving, *The Art of Acting* (London, 1893), pp. 63-64.

[35] Quoted in L. Irving, *Irving*, p. 368.

spective") Ellen Terry credits much of the effect.[36] Light here contributes, not just to the sense of vastness, but to the definition of space in this Lyceum synthesis: an illusionistic architectural stage.

By the time the century had concluded, an essayist could write on the architecture of Irving's *Coriolanus* (1901), staged from designs that Lawrence Alma-Tadema had conceived twenty years earlier: "Within the last few years . . . great changes have taken place in theatre scenes, and it has become the custom not only to limit the number of scenes, but to build them up in a more or less solid manner on the stage, trusting to the intervals between the acts to replace one by another." The writer is amazed "Accustomed as we have become of late to the solid nature of modern scenes," that with the drop scenes and side wings of old times, "Sir Lawrence should have been able . . . to convey an impression of solidity in his representations which holds its own even when matched with the single spectacle in [Beerbohm Tree's] 'Herod.' "[37] Irving had enlisted Alma-Tadema in 1879, even before the production of *The Cup*.[38] In the interval, not only had the architectural example of *The Cup* been widely followed (by Tree for one, who wished to capture precisely Irving's audience and position); but the conception of the stage as an architectural milieu had appeared antithetically in the undisguised playing space of the Elizabethan Stage Society.

The writer on *Coriolanus* credits much of "the illusion of solid architectural forms" in the painted scene to the lighting; and the relation of light to paint was a highly developed science in the Lyceum, where the chief gas man and light master (according to the scene-painter, William Telbin) was Irving himself.[39] Irving was not alone, however. A knowledgeable contemporary theater historian, discussing Hawes Craven's contribution to the system of "built-up" structures, reports: "To Mr. Craven, too, we owe the development of what is the 'medium' principle—the introduction of atmosphere, of phantasmagoric lights of different tones, which are more satisfactory than the same tones when produced by ordinary colours. The variety of the effects thus produced has been extraordinary."[40] Irving revived, besides this principle of the Eidophusicon, the use of light to define time and space. Irving's habitual use of an underlit stage, wherein light created the locale of the action, was a subject of much comment. The Brocken scene in *Faust*, a fairly solid construction and a tour de force of lighting, nevertheless used frequent "invisible" changes of drops and backings to make its progressive effects. In the Cathedral scene, on the other hand, the changes are "altogether done with lights. You would think that the scene had been transferred from the exterior to the interior then back again, but not a bit of scenery is moved. Probably that is about the best illusion we produce."[41] Not everyone agreed. The Pennells gave an account of Martha's garden, where "there is one low tree, and roses border the garden paths":

Both are seen in the warm evening light. When *Faust* and *Margaret* first come out between *Martha's* tall rose-trees the cathedral spires are dark against a glowing sky, but before they part twilight has fallen upon the place. If you watch closely, the change from the colors of sunset to the dusk of twilight may seem too

[36] Terry, *Memoirs*, pp. 154-55.
[37] R. Phené Spiers, *The Architecture of Coriolanus at the Lyceum Theatre* (London, 1901), p. 3; reprinted from *Architectural Rev.* 10 (July 1901).
[38] See Brereton, *Irving*, 1:287, 320, and Stoker, *Personal Reminiscences*, 2:65-70. The fullest modern account of the collaboration is Sybil Rosenfeld's "Alma-Tadema's Designs for Henry Irving's *Coriolanus*," in *Deutsche Shakespeare-Gesellschaft West Jahrbuch 1974* (Heidelberg, 1974), pp. 84-95.
[39] "Art in the Theatre," *Magazine of Art* 12 (1889).
[40] Fitzgerald, *Sir Henry Irving*, p. 89.
[41] "The Stage Mechanism of 'Faust.' Mr. Loveday Talks about the Settings and the Forces behind the Scenes," *New York Daily Tribune*, clipping, Theatre Museum, London. H. J. Loveday was Irving's stage manager.

violent. If you see only its effect upon the garden, it is natural enough. Gradually the flowers stand out from the green leaves with that artificial look peculiar to real roses in the hour before night, when the west is still aflame; gradually the scene is filled with the strange mystery of evening, "when the earth is all rest, and the air is all love." Of the many pictures of *Faust* and *Margaret* that have been painted, not one has equaled this of the Lyceum . . .[42]

The Cup, despite its architectural innovations, was finally a triumph of the pictorial stage, whose problem had always been the integration of its elements, particularly painting in two dimensions, using illusory perspective, and figures in three dimensions, moving within the playing area.[43] The production also gave impetus, however, to ideas that would eventually unseat the pictorial stage from its supremacy. One was an architectural rather than pictorial definition of the stage, a definition that was spatial and ultimately functional. (Implicit were an eventual redefinition of the relation between performance and audience, and the twentieth-century revolution in dramaturgy.) Another potent idea was the use of light to define space, and (later) time, as De Loutherbourg had temporalized his painted scene a century before. A third was Irving's approach to an integration of all the elements into a single embracing vision, so that the theater and the dramatic event became the projection of a single creative mind, neither author nor actor nor scene designer, but the synthesis of all these. Craig and Appia clearly gave theoretical voice to these three ideas; but the last, and certainly most important for Irving himself, had had a long underground life in the theater (ironically the most collaborative of arts) before it emerged unabashed in the program of Irving's near-contemporary, Richard Wagner.

King Lear and the Narrative Image

The most surprising and historically most interesting of Irving's enlistments from the world of "legitimate" art was Ford Madox Brown, to whom Irving turned for his 1892 production of *King Lear*.[44] Brown was then seventy-one, and less than a year away from his death. He was neither fashionable nor prosperous nor much favored by the aesthetes. Though godfather and father-in-law to the early Pre-Raphaelite Movement, he had strenuously maintained his independence of all groups. Such patronage as he had came chiefly from the northern industrial and mercantile middle class, and since 1878 he had been engaged with a series of wall decorations for the Manchester Town Hall. Nevertheless, the independence of his vision and the integrity of his work made him—for an enlightened group of painters and critics— an artist's artist. Despite his defense of painting "from love of the mere look of things,"[45] however, he often paints—with moral and philosophic intent—scenes that reflect the moral and social character of human activity. In his rendering of character and gesture—even in his softer later work—the fusion of realism and romantic energy makes for a style reminiscent of Carlyle (whom he admired) in prose, and Browning in verse: mannered in some respects and difficult, but vig-

[42] Pennell and Pennell, "Faust," p. 310.

[43] Hatton, *The Lyceum "Faust,"* p. 10, quotes an explanation Irving offered of the success of the Lyceum scenery: "One reason . . . is that in the foregrounds everything is life-size. Is it a tree, a wall, a house, or what not, it is life-size, so that the figures in front of it may retain their proper proportions to the scene, and the middle and far distance of the picture have their proper relationship to the whole."

[44] A recent account of Brown's life-long interest in *King Lear* that takes note of the Irving production is Helen O. Borowitz, " 'King Lear' in the Art of Ford Madox Brown," *Victorian Studies* 21 (1978): 309-34. The best synthetic account of Irving's production and interpretation of *King Lear* is in Alan Hughes' excellent *Henry Irving, Shakespearean* (Cambridge, 1981), pp. 122-39.

[45] *The Exhibition of WORK, and Other Paintings, by Ford Madox Brown* (London, 1865), p. 7; on *The Pretty Baa-Lambs.*

⁴⁶ *Our Theatres in the Nineties*, 3:70.

⁴⁷ W. Graham Robertson, *Life Was Worth Living* (New York, 1931), pp. 168-69. A full-page engraving after *Cordelia's Portion* by C. Carter appeared in the *Magazine of Art* 13 (1890): 293, accompanying an article on Brown by his daughter, Lucy Madox Rossetti. Mary Bennett lists several versions of the painting, in the exhibition catalogue, *Ford Madox Brown, 1821-1893* (Liverpool, 1964), #41, including "a further replica which appeared in the sale of the artist's effects in May 1894." This version is probably the one referred to in a letter of 7 July 1893, where Brown wrote Irving: "I am just finishing a 'replica' of my well known picture of 'Cordelia's Portion' which I should like you to see before you leave for America, if you can call some time next week or before you start" (Theatre Museum, London). Irving's production and Brown's well-publicized part in it made the moment propitious for executing such a replica, and Irving was certainly a likely prospect. If Irving did manage to call in the short time before his departure, however, the sale was not then consummated. Irving only returned from his extended tour in America the following March, five months after Brown's death.

⁴⁸ Signed and dated 1844. Brown's 1865 exhibition catalogue, however, states, "These outlines, made in 1843, were never intended but as rude first ideas for future more finished designs. Since then, I have always proposed completing them as a series, but as yet I have never found time to do so" (*The Exhibition of WORK*, p. 19).

⁴⁹ *Catalogue of the Collection of Ancient and Modern Pictures Water-Colour Drawings and Theatrical Portraits the Property of Sir Henry Irving*, Christie, Manson & Woods, 16 Dec. 1905, lists "Ford Madox Brown, 1884 [*sic*]. Illustrations to 'King Lear' *pen-and-ink—sixteen in two frames*." Brown originally exhibited sixteen such drawings (in 1865), and these are now all in the Whitworth Art Gallery, Manchester. However two more drawings, similarly signed and dated and apparently part of the series, are in the City Museum and Art Gallery, Birmingham. Ford Madox Hueffer owned a preliminary version of one of the drawings, which he reproduces in *Ford Madox Brown, a Record of His Life and Work* (London, 1896). He there indicates that the drawings were purchased in 1889 and 1894, but (probably following Brown's notes) lists only sixteen all told, and one other owner besides himself and Irving. When eight of the Lear designs were included in the Grafton Gallery Brown exhibition of 1897, Hueffer's catalogue note stated: "These studies were

orous, personal, and edged with irony. Shaw—while busy developing his own dramatic style of skewed and penetrative "realism"—called Brown "the most dramatic of all painters." It is likely that Shaw saw the promise of a similar style in Henry Irving before Irving turned his energies elsewhere, and therefore tried to harry Irving into his own camp of "dramatic realists." Shaw called Brown a realist "because he had vitality enough to find intense enjoyment and inexhaustible interest in the world as it really is, unbeautiful, unidealized, untitivated in any way for artistic consumption"; and because Brown in his painting had no regard for "the common market demand for prettiness, fashionableness, refinement, elegance of style, delicacy of sentiment, charm of character, sympathetic philosophy (the philosophy of the happy ending), decorative moral systems contrasting roseate and rapturous vice with lilied and languorous virtue, and making 'Love' face both ways as the universal softener and redeemer . . ."⁴⁶

A painter of the rising generation already twice removed from Brown, with the backstage freedom of Irving's Lyceum, reports that:

> Madox Brown's 'Cordelia's Portion,' a print of which hung in his dressing-room, [Irving] had always admired immensely and when he came to produce 'Lear' he founded his conception upon the Lear of Madox Brown and induced the veteran artist to advise on the mounting and to make sketches for it. The result was fine; sombre and austere throughout until the final heart-rending scene of the old king's death beside the body of Cordelia, which was enacted amongst flowery down-lands where white chalk cliffs towered out of a sea of dazzling blue under skies full of pitiless sunshine; a daring and most poetical touch which seemed to isolate the two tragic figures and to intensify the darkness of their doom.⁴⁷

The last scene was Irving's pendant (with the help of his scene-painters) to the "conception" Brown provided. The sources of that conception in Brown's work were varied and extensive, and furnish the materials for a case study in what "collaboration" between Irving and an artist might mean.

Cordelia's Portion, first painted in 1866, took its subject and design from a series of pen-and-ink drawings, representing various moments in *King Lear*, executed in Paris in 1843 or 1844.⁴⁸ These Irving not only knew, but in large part owned.⁴⁹ Brown had included them in his landmark exhibition in 1865, where William Michael Rossetti was much struck by their originality and power, despite what they revealed of foreign influence:

> To these we must add an exceedingly remarkable series of pen-and-ink designs from *King Lear*. 'Rude first ideas,' 'offensively unfinished or ill-finished,' Mr. Brown is not afraid to call them, and with some show of reason. They are nevertheless singularly full of dramatic passion and invention, heaving with energy. It is not unfair to recall for comparison with these another Shakespearean series by perhaps the greatest artist of the century, Delacroix—the lithographed set of designs from *Hamlet*: and we have no hesitation in saying that, in the qualities we have just pointed out—

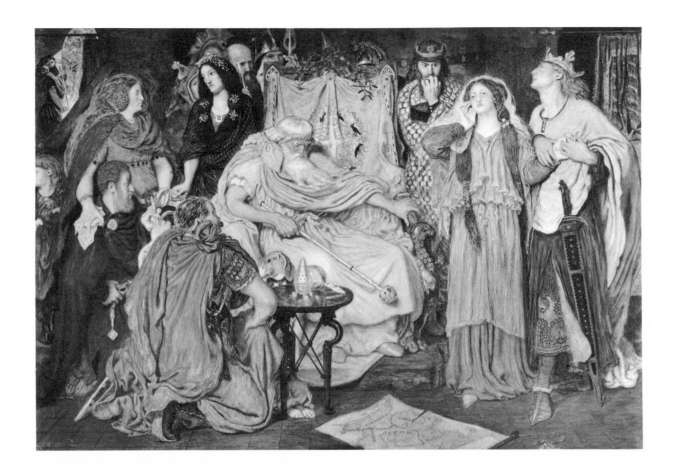

qualities, be it remarked, which form the essence of Delacroix's genius also—this Lear series by Mr. Brown is very far superior.[50]

Rossetti probably names the initial stimulus for Brown's *Lear* series. Delacroix issued a *Hamlet* series of thirteen lithographs (it only later became sixteen) in a limited edition in 1843, just before Brown, then living in Paris, made his *King Lear* sketches.[51] Brown's debt as well as his originality, however, are better understood in relation to a tradition of serial illustration, or rather of translation of drama into graphic serial form. Brown's drawings were in an outline style associated with Moritz Retzsch in particular, and German illustration in general, though its fountainhead was John Flaxman's *Illustrations to Homer*. Retzsch had published, in 1816, *Umrisse zu Goethes Faust*, twenty-six designs (later twenty-nine), followed in 1836 by eleven more on the second part of *Faust*. These had been much reproduced, reprinted, and parodied, especially in England, where they affected stage production. Between 1828 and 1845 Retzsch also produced a "Shakespeare Gallery" in outline (in collaboration with an archaeologist, a poet, and a literary historian), including a *Lear* series, and these may have influenced Brown directly.[52] Before *Hamlet*, the Faust theme had attracted Delacroix, and it became the subject of his first notable series of lithographs, issued in 1828. He later recalled their original inspiration: "I remember that about 1821 I saw Retzsch's compositions, which rather

195. *Ford Madox Brown*, Cordelia's Portion *(1866)*, *Port Sunlight, Merseyside, Lady Lever Art Gallery*.

purchased by Sir Henry Irving when the Lyceum production of Lear was in preparation [1892]. It may be remembered that Madox Brown had a considerable hand in designing the costumes and scenery of the presentation." Irving, then, eventually owned most of the designs, probably but not necessarily all those exhibited in 1865. The two drawings in the series now at Birmingham include the important reunion of Lear and Cordelia in the "tent scene" (IV, 7), the subject of Brown's painting of 1848.

[50] *Fraser's Mag.* 71 (1865), pp. 606-607.

[51] See Loÿs Delteil, *Le Peintre-Graveur illustré* (Paris, 1908), Vol. III, and Alfred Robaut and Ernest Chesneau, *L'Oeuvre complet de Eugène Delacroix* (1885; reprinted. New York, 1969). There are echoes of Delacroix's "Le Fantôme sur la terrasse" (Delteil 105) in Brown's "Lear with his Fool in the Storm" and "King Lear Mad on the

struck me; but it was especially the representation of a *drame-opéra* on *Faust*, which I saw in London in 1825, that excited me to do something of the kind." Delacroix remembered especially Daniel Terry, friend and adaptor of Scott, as Mephistopheles, and later, in Paris, as King Lear.[53]

With Retzsch influencing English stage production, and Delacroix drawing suggestion from both before providing a further impetus for Brown, the interplay between the theater and graphic serial illustration of a dramatic text was clearly complex and mutually reinforcing. The involvement in Brown's case was quite direct if, as Helen Borowitz argues, Macready's notable restoration of *King Lear*, first performed in 1838, also influenced his conception.[54] In any event, Brown's outline *Lear* illustrations, reaching one way into the early decades of the century and the other into the theater and era of Irving, seem to touch historically the entire development, dominance, and passing of the nineteenth-century serial pictorial mode.

DELACROIX had evidently hoped to issue his *Faust* lithographs without book, to tell their story with only the help of captions. He was annoyed at the "malheureuse idée" of the publisher to issue them together with Albert Stapfer's translation.[55] His *Hamlet* series corrects this error, and appeared unhampered by a text.

Once an artist wishes to do more than provide illustration (in the sense of ancillary enrichment) for a dramatic text, he must assume the burden of adequate narration. In the absence of a text, the burden is lightest where the story is most known, so that the artist can rely on evocation and recognition. In practice, the serial pictorial artist worked between two alternative methods. At one extreme he could try to refine, separate, and render the contiguous (and continuous) succession of appearances in the enacted narrative. At the other, he could select significant stages of the story and render them symbolically, as tableaux. The latter is obviously the more economical method, and the more remote from experience. The narrative ideal would be to find, in the succession of appearances, moments with symbolic extension.

Experiments in translating verbal into pictorial narrative that is conscientiously "real" rather than symbolic appear toward the end of the eighteenth century. They accompany, curiously, the rise of the tableau in narrative and dramatic forms. Among the most interesting of such experiments is J. F. Götz's *Leonardo und Blandine*, a translation of Gottfried Bürger's poem into a series of 160 drawings, put on first as a play (Munich, 1779), and then etched and issued with text and a commentary on voice, attitude, and expression in 1793.[56] According to Kirsten Holmström, Götz admits that his 160 acting moments are insufficient; that he would need over 500 to show all the variations in expression and posture inherent in the story. His experiment, however, attempts to render the nuances of change in the first fifty-one figures, and thereafter only the "more obvious changes in attitude and mime."[57] Götz's *Leonardo und Blandine*, in other words, moves from a dramatic narrative that attempts to approximate the succession of visible appearances, to one that operates through moments with greater symbolic extension.

Beach at Dover" (Whitworth D.66.1927 and D.68.1927).

[52] See Borowitz, "King Lear," pp. 316, 320-22. Brown comes closest to Retzsch's *Lear* in the scene of Lear's discovery of Kent in the stocks (Plate 5 of *Retzsch's Outlines to Shakespeare, Fourth Series, King Lear*, Leipsic and London, 1838). On Retzsch's influence in England, see William Vaughan, *German Romanticism and English Art* (Yale, 1980).

[53] *Correspondance générale de Eugène Delacroix*, ed. André Joubin (Paris, 1935-1938), 4:303-304 (1 Mar. 1862). See also *The Journal of Eugène Delacroix*, trans. Walter Pach (New York, 1972), pp. 475-76 (29 June 1855). Terry played Lear in Paris in 1828, when Delacroix saw a great deal of the English players, including Charles Kemble and Harriet Smithson in *Hamlet*.

[54] Borowitz, "King Lear," 318-22. In order to explain the choice of a subject Brown "had not designed previously," Borowitz suggests that Brown's *Lear and Cordelia* (1848-49) may have been inspired by the recognition scene in Macready's (or another) production. But such a subject had in fact been one of the original series of 1844 (see n. 49 above). The drawing was possibly not included in Brown's 1865 exhibition because the painting was there to be seen.

[55] *Correspondance*, 4:304.

[56] *Versuch einer Zahlreichen Folge leidenschaftlicher Entwürfe für empfindsame Kunst-und-Schauspiel-freunde*. Kirsten Holmström, in *Monodrama, Attitudes, Tableaux Vivants* (Stockholm, 1967), pp. 56-83, is responsible for calling attention to Götz's importance.

[57] Holmström, *Monodrama*, p. 60.

Brown's *Lear* drawings show a similar tendency. The eighteen in the series that are known, or the sixteen he exhibited in 1865, do not attempt to tell the whole story of the play, nor even of Lear and Cordelia (the subject of the two important paintings derived from them).[58] The last drawing is of Lear and Cordelia in the tent scene, with the catastrophe yet to come. But of the eighteen drawings, ten come from the first act and form two close-knit sequences. In the following account of one of these sequences (I, 3-4), the narrative is continuous and coherent, as excerpts from Brown's own captions in the 1865 catalogue make clear:

56 . . . Goneril, in the absence of her father at the chase, instigates her steward to be less respectful to him. [Lear's retinue, trumpeted by the guards, is seen approaching through the open door, preceded by a pack of unruly hounds.]

57 Lear, returned from hunting hungry, calls the steward, who passes on with a "So please you, my lord."

58 King Lear rates the steward, who answers slightingly.

59 The Duke of Kent . . . trips up the steward.

60 Goneril violently rates her father—Kent sorrowfully looks on, and the Fool rails at her.

61 King Lear incensed leaves Goneril's house, her husband in vain seeking to interpose.[59]

Between the first and the last of this sequence, in the four central images (Figs. 201-204), setting and our view of it remain constant. Moreover, the logic and continuity of each character's change of position and expression (particularly Kent's and Lear's, but also Oswald's and the dogs') are clear. In the preceding sequence of four drawings for Act I, scene 1—Cordelia's unaccommodating response to Lear's question, Cordelia chosen in marriage by the King of France, her parting from her sisters, and "Goneril and Regan compare notes"— the viewer's perspective on the scene and setting changes after the first two drawings. The throne, present throughout, serves to orient us when the point of view moves back for a wider scene in the parting (Fig. 198), and then shifts by ninety degrees for the conference of Goneril and Regan (Fig. 199). The shift serves to register (along with the emptiness of the great hall) a change of feeling and a narrative transition. There is some gestural continuity in the first two drawings, notably between the thrusting and collapsed attitudes of the king; but overall continuity is sustained in the sequence by overlapping presences, as in the *liaison des scènes* of neoclassical drama, more than by gesture and attitude. With the changes in viewer distance and angle, and the bolder leaps in the action, narrative progression is achieved through something resembling montage.

There is a similar montage in the third sequence—from Kent provoking Oswald before Regan's gates, which leads to Kent's confinement in the stocks, to Lear's angry parting from both Goneril and Regan (II, 2 and 4). Formal visual connectors then carry the narrative forward into the last three drawings, "King Lear with his Fool in the storm" (III, 2), "King Lear mad on the beach at Dover" (IV, 6), and the tent scene where Lear wakes to find Cordelia (IV, 7). Lear's arms,

196-213. (following pages) Ford Madox Brown, Designs from King Lear *(1843-44). Manchester, Whitworth Art Gallery; and Birmingham, City Museum and Art Gallery (Nos. 207 and 213).*

[58] Besides *Lear and Cordelia* and *Cordelia's Portion*, Brown worked a third episode into both an etching for the *Germ* (1850) and a later oil sketch, *The Parting of Cordelia and her Sisters* (1854); but he never carried out an intended larger version.

[59] *The Exhibition of WORK*, 1865.

196. "... Cordelia is asked to state the measure of her love.... She answers, 'Nothing my Lord.' Lear says, 'Nothing! speak again, for out of nothing nothing comes," I,1.

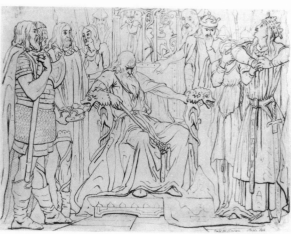

197. "Here Cordelia, disinherited, is chosen in marriage by the king of France . . . ," I,1.

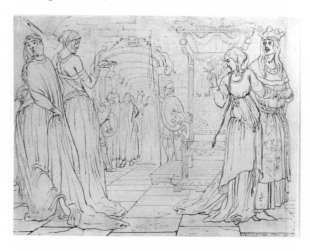

198. "The parting of Cordelia and her sisters," I,1.

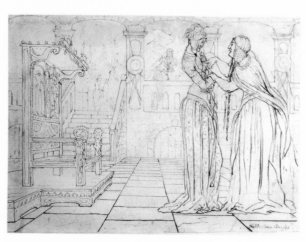

199. "Regan and Goneril compare notes," I,1.

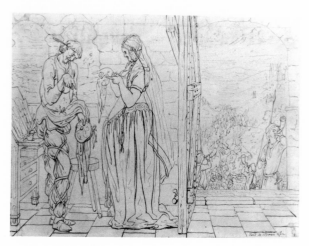

200. "... Goneril, in the absence of her father at the chase, instigates her steward to be less respectful to him," I,3.

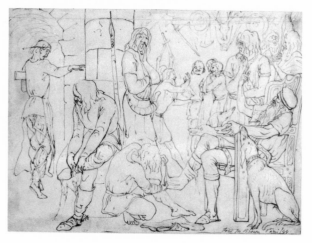

201. "Lear, returned from hunting hungry, calls the steward, who passes on with a 'So please you, my Lord,'" I,4.

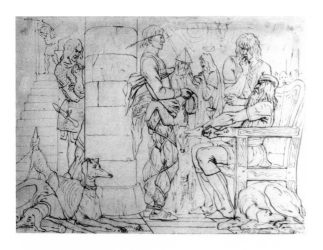

202. *"King Lear rates the steward, who answers slight-*
ingly," I,4.

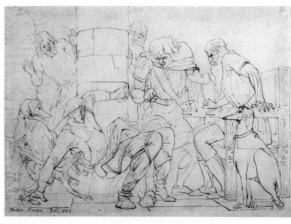

203. *"The Duke of Kent . . . trips up the steward," I,4.*

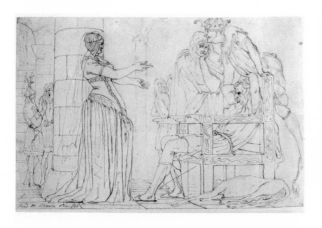

204. *"Goneril violently rates her father—Kent sorrowfully*
looks on, and the Fool rails at her," I,4.

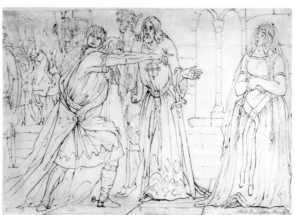

205. *"King Lear incensed leaves Goneril's house, her hus-*
band in vain seeking to interpose," I,4.

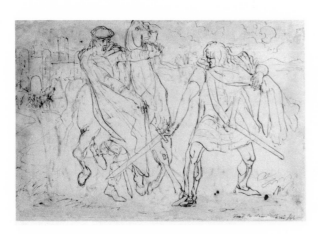

206. *"The Duke of Kent tries to pick a quarrel with*
Goneril's steward," II,2.

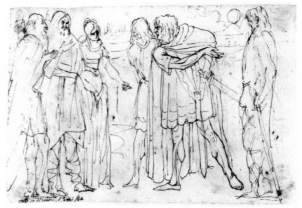

207. *[Kent, explaining his anger at the steward, before*
Cornwall, Regan, and Gloucester], II,2.

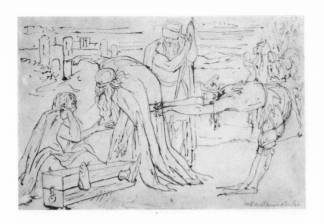

208. *"King Lear will not believe that his own daughter, Regan, would have his messenger, Kent, placed in the stocks," II,4.*

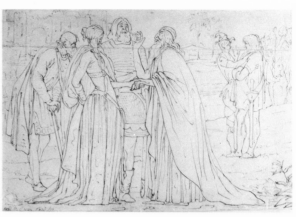

209. *"King Lear gives the history of his wrongs to Regan and her husband in the presence of the Duke of Gloucester," II,4.*

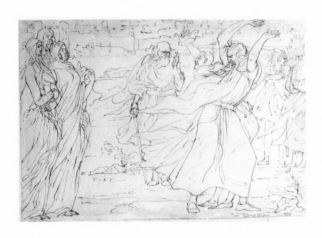

210. *"Lear . . . curses [Goneril and Regan] and goes off in the rising storm, shelterless," II,4.*

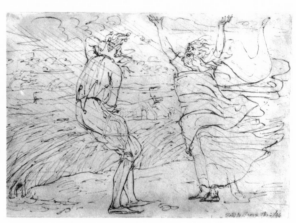

211. *"King Lear with his Fool in the storm," III,2.*

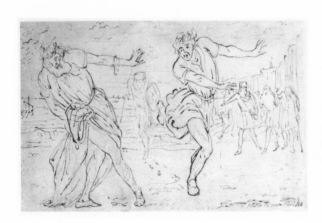

212. *"King Lear mad on the beach at Dover," IV,6.*

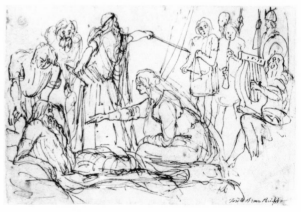

213. *[Lear wakes to music to find Cordelia], IV,7.*

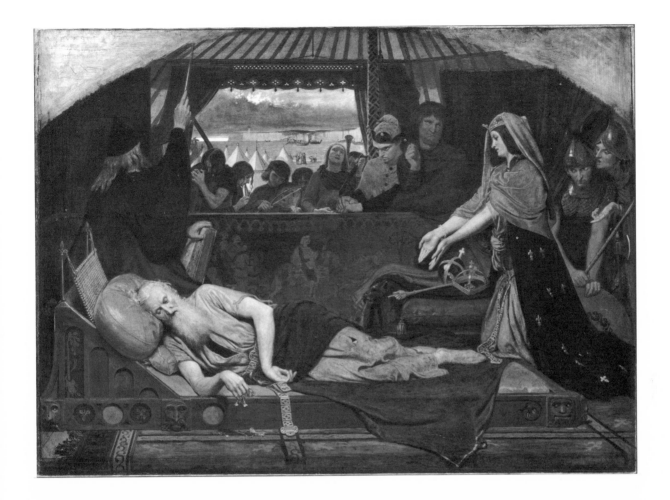

214. *Ford Madox Brown*, Lear and
Cordelia *(1848-49), London,
Tate Gallery.*

for example, raised to curse and reject in the scene of the departure
(Fig. 210), and to invoke the storm in the scene on the heath (Fig.
211), suggest sequential action. Lear's body angle, shifting progres-
sively from rightward-leaning to left, connects the last four drawings.
In the last drawing, Cordelia's open gesture to Lear recalls and reverses
his earlier accusatory gesture to Goneril (Fig. 205). Nevertheless, in
the final group of drawings Brown is chiefly seeking the single image
that summarizes, in contrast to multiple images that plot actions and
articulate their connections.

By 1865, the last image (modifed) had already become a painting
that in Brown's view epitomized the essential story, and could be called
simply *Cordelia and Lear*. Brown included it in his exhibition under
that title, declaring: "the subject is too well known to require much
description from me." He provides it anyway, making clear his am-
bitions for the symbolic extension (for narrative purposes) of the chosen
moment. The physician is about to wake Lear by means of music.

> Cordelia, at the foot of the bed, awaits anxiously the effect of her
> presence on him, and utters the touching soliloquy, beginning—
> "Had you not been their father, these white flakes
> Had challenged pity of them."

Now would she recall the moment when honesty, stiffened to pride, glued to her lips the soft words of flattery expected by the old man, and perhaps after all his due, from her who was the best beloved of his three. So virtue, too, has its shadowed side, pride—ruining itself and others.[60]

To present the unfolding scene so that it achieves such symbolic extension, so that it evokes immediate response to the moment and creates an abiding image of the action, was the essential ambition of Irving's acting, and of the mature of Lyceum style.

BROWN'S chief task for Irving was to design the Romano-British interiors of Lear's palace and Albany's hall, and an exterior view of Gloucester's seat (where Kent is stocked) with a Roman temple in the background. These were, surely not by chance, the locales of the three major sequences in the 1844 drawings.[61] These three designs, the 1844 drawings, and the two major paintings were the elements in Brown's pictorial contribution to Irving's *Lear*. The original scene-designs may not have survived; but some idea of what they became can be gleaned from sketches of the production.

The outline drawings Irving purchased would have had no recognition value for his audience as "realizations," but they fed Irving's own imagination, affected his conception of role and atmosphere, and influenced the character of the production's pictorialism. On the whole, however, the production had to assimilate their ruffianly strength to a richer, more decorative, and more finished standard, closer to the paintings. The energy of line and action in the drawings nevertheless emerged in some aspects of the production: in the movement and disposition of crowds, for example. Irving's own impersonation had the violence and passion of Brown's Lear of the drawings, but not his strength. Brown's Lear has the arms of a man still at home with a battle-axe, and a gestural repertory that leaves little room for pathos. But from the start of the play,

> . . . the paradox of "violent and weak" exactly describes the Lear of the Lyceum. From the moment when the impressive, gnarled old man strides on the stage and begins his career of "unreflecting impetuosity," and dashes his heavy sceptre up and down the lines of the map, through all the paroxysms of rage, the almost inarticulate curses, the rare moments of unnatural self-control, to the gentle, cynical imbecile who jokes Gloster on his sightlessness, and the last dying touches of the hand upon Cordelia's hair, that is the character of Mr. Irving's Lear—"violent and weak."[62]

The Lear of Brown's paintings is also a feebler man, whose glaring violence (in *Cordelia's Portion*) is coupled with a manifest impotence, registered in the unstrung arm holding his drooping sceptre.

The influence, or rather participation, of Brown's paintings, especially *Cordelia's Portion*, in Irving's production can be established through local detail. (There is an excess of corroboration in the fact that the *Souvenir of King Lear* included in the Lyceum management's scrapbooks has a reproduction of *Cordelia's Portion* pasted into its front cover.)[63] The play's master image for the public was the drawing by

[60] Ibid. "This picture," Brown writes, "I have always considered one of my chief works."

[61] In a letter to Irving dated 24 June 1892, Brown apologizes for having been out when Irving called; but "The large sketch of Lear's Castle is finished, if you would like your scene modeler to come & see it. The other designs of Albany & Cornwall's [*sic*] halls are not yet ready to show, but they will not take me long" (Theatre Museum, London; formerly at Leighton House). In his edition of *Lear* (1892), Irving credits the unorthodox choice of period to Brown's suggestion of "a time shortly after the departure of the Romans, when the Britons would naturally inhabit the houses left vacant" (*Times* review, 11 Nov. 1892, p. 10). As Alan Hughes points out in *Henry Irving, Shakespearean*, by adopting Brown's idea, Irving "was able to turn Lear's crumbling Roman palace into a powerful metaphor for his mental state" (p. 139). First one sees the magnificence; then one notices the decay. "The steps were worn, stones were chipped, creepers hung from the great arch. Like Lear, it had outlived its grandest days" (p. 123). Hughes also points out the visual progression in the production, whereby Lear moves, scene by scene, "from protected enclosure to naked exposure" (p. 139). The major part of this progression is accomplished in the first two acts through Brown's three ingenious sets, going from palace interior, to half-open atrium, to open courtyard. Next stop, the barren heath.

[62] Henry Norman, *Illustrated London News* (19 Nov. 1892), p. 637. Other critics complained that the pathos of Irving's Lear began too early, and that he was "more physically infirm than he need be in his opening scenes" (*Ill. Sporting & Dramatic News*, p. 348).

[63] Theatre Museum, London.

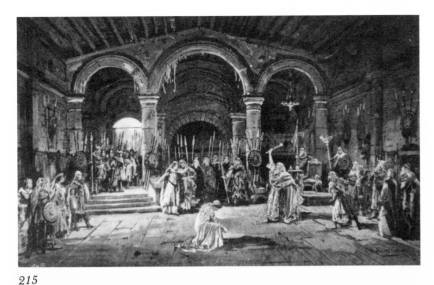

215

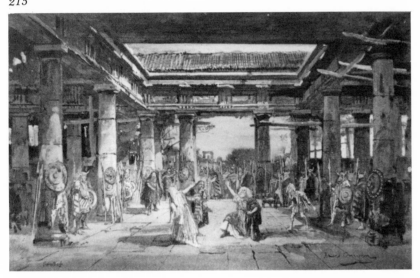

216

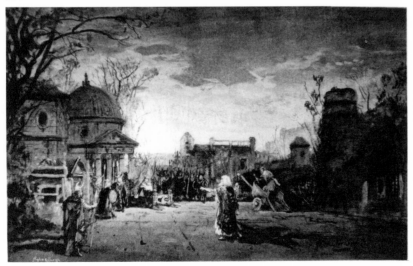

217

215. *Hawes Craven*, King Lear, *Act I, scene 1, "King Lear's Palace," scene design by Ford Madox Brown, built by Joseph Harker, in* Souvenir of Shakespeare's Tragedy King Lear, *Lyceum Theatre, London, 10 Nov. 1892.*

216. *Hawes Craven*, King Lear, *Act I, scene 3, "Duke of Albany's Castle," after F. M. Brown and Joseph Harker, in* Souvenir, *Lyceum.*

217. *Hawes Craven*, King Lear, *Act II, scene 1, "Court within Gloster's Castle," after F. M. Brown and Joseph Harker, in* Souvenir, *Lyceum.*

218. (facing page) *J. Bernard Partridge, "Mr. Henry Irving as King Lear,"* Illustrated London News *(19 Nov. 1892), cover.*

J. Bernard Partridge that appeared on the cover of the *Illustrated London News*. "Mr. Henry Irving as King Lear" here sits on his throne in the posture of Brown's Lear (reversed), glaring out under his eyebrows. His farther arm tensely grasps the map of his divided kingdom (rather than the arm of his chair, as in Brown, where the map, with "Cordelia's Portion" torn through, lies in the foreground). His nearer, bent arm loosely grasps his sceptre, angled upwards since it no longer need direct us to the map. The small Roman table and its furnishings, the carved eagle arm-post of the throne, the tree-emblem on its back-cloth, the mistletoe over the King's head, all belong to the painting that perhaps chiefly furnished Irving with the idea of an interpretation.

The legend of Irving's *Lear* is that it was recorded as a relative failure because Irving adopted a more or less incomprehensible trick of voice on the first night, and the true power of his performance only penetrated later audiences.[64] The tent scene, or the reunion with Cordelia, however, worked its magic from the beginning of the run, as the high point in an interpretation weighted toward pathos. It is significant that Irving thought in such long units of effect. The tent scene was the subject of Brown's earliest painting from *King Lear*, and more than one description of Irving's version unwittingly suggests affinities. Edward R. Russell, for example, proclaiming "Irving's 'King Lear': A New Tradition," wrote:

> Lear lies wonderfully asleep—not ordinary pretence of sleep, but a study of pose and set of the face, with all considered in it—the long weariness, the gnawing trouble, the enfeebled frame, the new ease, the comforting surroundings—insensibly, if one may say so, affecting the sensations. Miss Terry, as is her gift and grace, weeps real tears as Cordelia gazes and awaits the waking of her father.[65]

As the illustrated record makes clear, Irving arranged not one picture for the scene, emblematic of the situation and conformable to the action, but an unfolding series in close succession. Each was visually memorable, freighted with meaning, and worth lingering over, but all—like the Oswald sequence in Brown's drawings—served to plot the outline of a single episode. And in retrospect, the whole sequence condensed into a single master image. Graham Robertson recalled:

> I can still see him, weary and half dazed, sitting up on his couch and staring at the daughter he had banished as she bent tenderly over him. "You are a spirit, I know—when did you die?" he whispered, and I can almost weep now when I recall his voice.[66]

Integrity and Duplicity

A critic writing in the *Athenaeum* heaped praise upon the beauty and utility of scene and accessory in *King Lear*, and declared Irving's representation of Lear himself "enchantingly picturesque. As was said in witnessing it, to a deaf man familiar with the text it would seem not far from perfection." The same critic, however, lamented not only the enfeeblement of Lear, but that:

[64] See Robertson, *Life Was Worth Living*, pp. 167-68, and L. Irving, *Irving*, p. 551.

[65] *The Nineteenth Century* 33 (Jan. 1893): 50-51.

[66] Robertson, *Life Was Worth Living*, p. 168. Cf. Fig. 219.

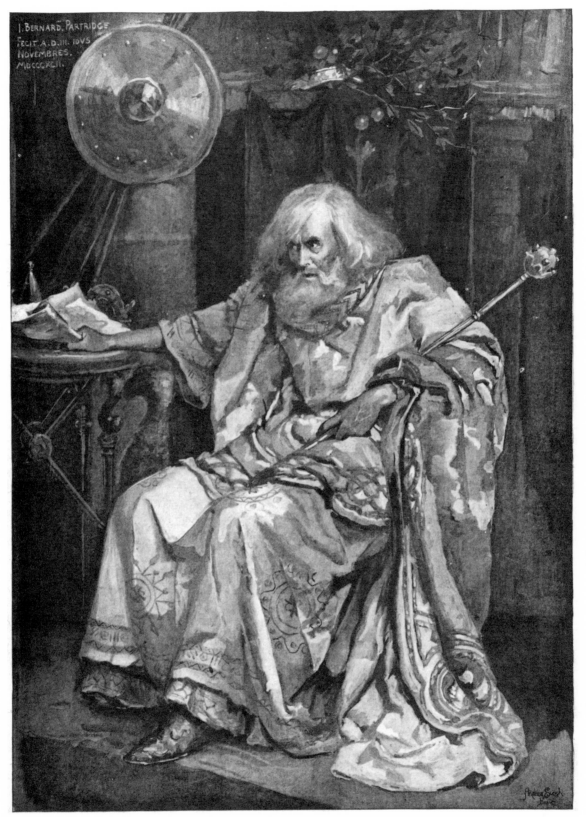

218

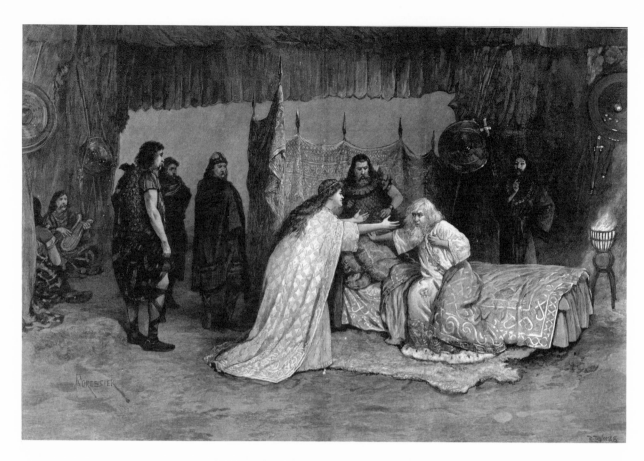

219. Forestier, "Mr. Irving and Miss Terry in 'King Lear,'" Illustrated London News (3 Dec. 1892), pp. 716-17.

. . . the whole was taken in deplorably slow time, and the most powerful scenes were prolonged until the attention was weary and the effect was lost. Yet once more Mr. Irving returned to those faults of delivery which at one time threatened to mar his career. His vowel sounds were stretched out almost "to the crack of doom," the movements were restless, the delivery jerky, and some of the sounds used had no ring either of passion or wail.[67]

Praise and blame aside, what this critic saw and heard was actually all of a piece. What he finds so irritating—Irving's prolongations, transitions, movements, even his sustained arioso vowel sounds—was part of a comprehensive dramatic-pictorial idea, in which the unfolding moment achieves symbolic resonance and extension. In pursuing this synthesis, Irving the actor and Irving the *metteur en scène* were at one. The unity of scene and persons—including the stage crowds—now so fully achieved was the unity of a single creative consciousness projecting its idea through the instrumentality of the theater. And at the physical center of this projection was that very same consciousness, like the dreamer in the heart of his dream.

The Faustian ambition of such a union of the imaginative will and its enactments, form and performer, arena and agent, appears indirectly in the Pennells' specialized account of the "Pictorial Successes of Mr. Irving's 'Faust,'" where it percolates through the language of art criticism. The Pennells write of Faust's study, perfect in its detail and moonlight, that "The dim Gothic chamber, with its uncanny shapes

[67] *Athenaeum* (19 Nov. 1892), p. 712. Bram Stoker tells of a veteran actor in the company who took over the role one night, followed Irving's staging and conception, and finished twenty minutes early (*Personal Reminiscences*, 1:122-23).

hovering in corners and from the ceiling, is but a background for the red Mephistopheles [Irving] who is ever the highest light and the center of interest, and for the somber Faust who is in such strong contrast to him. For Mr. Irving sees himself and Mr. Alexander not only as the chief characters in the tragedy, but as the principal figures in a picture rich in color, vigorous in composition." Later, the Pennells write of the scene in the town square where Faust first sees Margaret, where the medieval crowd of knights, soldiers, monks, nuns, peasants, women, children pass in and out, group, and dissolve:

> Throughout these pictures the color scheme as well as the grouping is beautifully carried out, for Mr. Irving is nothing if not a colorist. Just at the end, before the curtain falls and *Mephistopheles* is alone on the stage, the red of the sweeping roofs seems to reach its highest value in his more brilliant vermilion, as, doubled up and shrinking, he crouches against the tree near the wine-shop, his fingers in his ears to shut out the music of the cathedral chimes which it is agony for him to hear. You might, indeed, call the whole play an arrangement in red, for in all the scenes the color is toned so that it may lead up to his demon dress.[68]

The nod to Whistler points to the governing priority of a unifying aesthetic idea, and the transcendent side of Irving's theater of Art. The description itself points to the assertive, egotistical immanence at that theater's core.

WITH IRVING, the tableau, an eloquent immobility, ceases to serve as the ultimate form of pictorialism in the theater and in acting. And however powerful the unifying, projective imagination of author or *regisseur*, in the theater it is acting from which all ladders start. Always behind Irving the *metteur en scène* lay Irving the actor; and in the actor lay a notion of picture energized by personality, picture in motion. Arthur Symons, though writing as an outside observer of the theater and from a late (turn-of-the-century) perspective, nevertheless managed to set down the most convincing brief characterization of Irving's acting style. Symons compares Irving to Duse, an actress at the opposite pole from a style that could be called pictorial. Yet,

> To Duse, acting is a thing almost wholly apart from action; she thinks on the stage, scarcely moves there; when she feels emotion, it is her chief care not to express it with emphasis, but to press it down into her soul, until only the pained reflection of it glimmers out of her eyes and trembles in the hollows of her cheeks. To Irving, on the contrary, acting is all that the word literally means; it is an art of sharp, detached, yet always delicate movement; he crosses the stage with intention, as he intentionally adopts a fine, crabbed, personal, highly conventional elocution of his own. . . . It is an art wholly of rhetoric, that is to say wholly external; his emotion moves to slow music, crystallises into an attitude, dies upon a long-drawn-out word.[69]

The paradox of Irving's acting and production was that his holistic Art of the Theater was directed toward achieving a complete illusion,

[68] Pennell and Pennell, "Faust," p. 309-10. Cf. Hatton's description of the color composition, lighting, and grouping of the garden scene, *The Lyceum "Faust,"* p. 26.

[69] Arthur Symons, *Plays Acting and Music, a Book of Theory* (New York, 1909), pp. 52-54.

a seamless, ordered dramatic reality. Yet Irving remained overtly theatrical and rhetorical, a technical actor building an impersonation out of infinite detail, and informing it with his own vitality. The metaphor Symons invokes to characterize such performance, and to take account of the duplicity of the relation between the intense inner life and the visible personation (a little like that between the black-clad Bunraku-masters and their living puppets), is picture. Irving's Louis XI, Symons writes, "would be unendurable in its irreverent copy of age if it were not so obviously a picture, with no more malice than there is in the delicate lines and fine colours of a picture. The figure is at once Punch and the oldest of the Chelsea pensioners. . . . It is the picture that magnetises us, and every wrinkle seems to have been studied in movement; the hands act almost by themselves, as if every finger were a separate actor."[70] Similarly, the occasionally splendid critic A. B. Walkley, writing on one of Irving's great successes, sketched a joint impression of Shakespeare's Richard III and Irving's:

> What makes it still more amusing is that it is a perfect type of what it is now the fashion to call (especially among prigs) the "artist temperament." Richard works as enthusiastically at his own character, adding a "high light" of hypocrisy here, a warm touch of blood colour there, as a Cellini would work at a vase, or a Milton at a sonnet. He stands back from himself, so to speak, and watches with the approving eye of a connoisseur how the work progresses. When he feels he has put in a particularly neat stroke of the brush, he pauses to give himself that praise which is meat and drink to the true artist, and (being a bit of a *cabotin* into the bargain) he invites your praise too.[71]

If the nineteenth-century theater originates, philosophically at least, in Diderot's campaign for a more pictorial stage, and if by that he meant to secure a more sincere fiction—that is, a seamless dramatic illusion, a self-enclosed mimesis—then Irving was simultaneously the fulfillment, conclusion, and reduction of that powerful aesthetic ideal.

[70] Ibid., p. 55.
[71] *Illustrated London News* (26 Dec. 1896), p. 879.

THE LAST WORD

<hr>

I have spent my life in clearing out of poetry every phrase written for the eye, and bringing all back to syntax that is for ear alone.

W. B. Yeats, 1937[1]

You see, there is little difference between the action of paint and the action of people, except that paint is a nuisance because it keeps drying and setting.

Robert Rauschenberg, 1968[2]

℮VERYTHING I have had to say about the nineteenth-century narrative pictorial style bespeaks the compounding of eye and ear, not necessarily as sensory channels, but as cognitive aspects of the comprehensive experience of a work of art. Yet, in the passage where he retrospectively attributes to himself the role of Hercules cleansing the Augean stables of nineteenth-century poetics, Yeats, whose life's work began as Irving's was reaching its climax, rejects such compounding as a premise for his art. He asserts a poetic decorum based on the medium and the senses, "bringing all back to syntax . . . for ear alone"; a decorum more rigorous than that of any eighteenth-century genre purist, or any guardian of the critical tradition that sought to discriminate the temporal from the spatial arts. To find Yeats' counterpart and equal, one would have to turn to those modern theorists who locate the painter's whole excellence in the degree to which his work is "painterly."

Yeats directs his critical fire at an insipid literary pictorialism and a *fin de siècle* visual-verbal narcissism that he presents as compromising, not only the energy, but the integrity of the verse medium. But the nineteenth-century narrative pictorial style depended, not simply on the promiscuous and adulterate habit of the various arts in borrowing from each other, employing each other's means and representing each other's subject matter, but on the conjunction of story and image as a common matrix for signification and effect. Without something of the sort there is hardly any possibility of a common expressive and symbolic language in the arts. It was such a possibility, as the "Introduction" to the study now concluding tried to show, that gave scope to the nineteenth century's mainstream aesthetic of "meaningful truth," whereby

<hr>

[1] William Butler Yeats, "An Introduction for My Plays," *Essays and Introductions* (London, 1961), p. 529.

[2] Richard Kostelanetz, "A Conversation with Robert Rauschenberg," *Partisan Rev.* 35 (Winter 1968): 100; reprinted in *The Theatre of Mixed Means* (New York, 1968), p. 82.

[433]

a literal and material verisimilitude kept company with an inward signification, moral and metaphysical.

If Yeats rejects the easy assimilations, and the interchangeability of the visual and the verbal, Rauschenberg rejects the hard distinctions, and especially what I have called "the material increment" for determining what is most "real." Whereas Yeats reasserts a decorous discrimination of means, Rauschenberg confounds all bases of discrimination, not simply between art for the eye and art for the ear, but (as nearly as he can) between art and life. If Yeats—in practice the poet of dialectical complementarities—responds to the nineteenth-century's liberal synthesis with analytical rigor, and his stance is redemptive and sincere, Rauschenberg—dismissing distinctions—responds with casual chaos, and his stance is subversive and *épatant*. But Rauschenberg, for all his irreverence, is far less paradoxical than the nineteenth century when he disparages stillness, in painting or anything else, as a nuisance, and quite the reverse of an aid to the effect of a superior reality. Movement is life; narrative, the account of a transformation, is life. But rather than attempt to incorporate the action of life in a still image, Rauschenberg locates the life in the making of the image, in the painter painting, like the actor acting. Such a conception of art nicely disposes of the usual issue in prescriptive accounts of narrative painting, and of the inevitable contradictions between theory and practice they lead to; the issue encapsulated in the phrase of Matthew Arnold that supplies the title of my opening chapter, "The Moment's Story." It also casts into limbo anything that smacks of tableau. Thus, the modern Yeats discards the notion of a common ground for fiction, painting, and drama and the postmodern Rauschenberg disposes of the specialness and importance of the tableau. Between the two of them, they dismiss the principal working premises of the exploration of narrative and picture in the arts of the nineteenth century.

I hope that in the course of this exploration, I have left intact such partly independent currents as the notable stream of landscape painting, and that I have managed to give a convincing account of change and complexity. Despite the cartographic and grammatical synchrony of "Coordinates" and "Conjunctions," the titles of the two chief parts of this book, I have been concerned to show such changes over the century as the shift in the standards of representational realism, and such complexities as a transforming dialogue within the collaborative narrative-pictorial style.

The change in the standards of realism begins with the decay of the antithesis between "genre" and "history," most evident in the novels of Walter Scott and in some of the paintings of David Wilkie. The course of redefinition passes through the representational dialectic between the hero and the multitude in the Napoleonic epic. It further incorporates a concern over the place of the commonplace; the apotheosis of the domestic; and an appeal to the literal, the archaeological, and the microscopic. Well before the end of the century, the standard of the real enters into an alliance with the sociological and the psychological, as opposed to the merely historical.

The dialogue within the narrative-pictorial style begins with the dissolution of the relations between the art of effect and the uses of situation. One might argue that the art of effect belongs essentially to

the Romantic focus of the century, while the art of situation belongs essentially to the Victorian. In fact their entanglements are too complicated and persistent to carry the argument as far as one would like; but as effect and situation converge and diverge, in drama (Chapter 3), in fiction (Chapter 4), and in painting (Chapter 5), they are simultaneously exploited, rejected, and redefined by sophisticated artists in ways that condition the future. The most interesting instances are Thackeray (Chapter 16) and the Pre-Raphaelites (Chapter 17). Similarly Dickens, with different concerns, exploits and subverts the pictorial image as a dimension of narrative in the novel Shaw considered his most radically subversive, *Little Dorrit* (Chapter 15). The richness of the result in each case depends on an internal argument with a flourishing style; meanwhile, in the midst of life, they prepare its death or transfiguration.

To recapitulate: in my opening admissions, I announced a concern with the tissue of living connection between fiction, painting, and drama, and I might have added a concern with the societies they served. I anticipated that out of the tissue of connections would emerge formal similarities and shared expressive and narrative conventions. Part I, "Coordinates," in addition to reconstructing some of the issues and eliciting some of the notions transcending the divisions of the arts, tried to make plain the share these arts could claim in each other. Part II, "Conjunctions," using the theater as a meeting place for fiction, painting, and drama, tried to render the connections concretely. Starting with impulses from the eighteenth century and ending on the threshold of the twentieth, I there sought also to delineate both the flourishing variousness of a relationship which I would like to fix under the name of a style, and the elusive shape of change.

WITHOUT CHANGE, there is no such thing as style. The corollary of that truism is that what one can identify as style depends not only on what came before but on what comes after. In the nineteenth century, fiction, painting, and drama occupied certain planes of resemblance. At the end of that period fiction, painting, and drama abandoned those planes, making other kinds of resemblance possible. Fiction turned, and not only in its monumental works, to the representation of inner landscapes. Symptomatic of the change was the disappearance of pictorial collaboration. Pictures were now a nuisance, and the illustration of fiction was relegated to elegant editions of older work, magazine stories, and children's literature.

In drama proper, the nineteenth-century evolutionary succession of "effect," "situation," and "construction" finally ground to a halt. To locate the art of the drama in such practical terms was rightly perceived as reducing it to a technique. In the succeeding era, instead of a more or less generally accepted fundamental dramaturgy, there was and is a ferment of experiment to suit technique to any number of unlikely ends: the projection of inner states, or alternatively the imposition on appearances of private ways of seeing; the negation of form; the negation of sequence; the embodiment of hypothetical abstractions; the evocation of ancestral tremors; the conduct of a discursive polemic; the subversion of social and categorical fictions; the subversion of art.

Painting rejected narrative. Its subjects became the look of things;

the act of seeing itself (a rather different matter); feeling creating appearances rather than rising out of them (feeling liberated from situations rather than responding to them); the architecture of being; and above all, art itself.

The last, not uniquely the concern of the art of any age, nevertheless became the special concern of the art of this one.[3] Every major art now devotes much of its best energies to redefining its own possibilities, fetishizing its materials, and pondering its uniqueness in a self-exploration less abashed than in any previous era whose work survives. Fiction, drama, and painting also share in the breakup of the audience into mass and coterie, and its constriction, in the case of the boldest ventures, into a clutch of fellow artists poised on the edge of discovery, like a handful of particle physicists who can write only for each other, pushing into the unknown through a narrow crack of theory. The breakup of the audience became irreparable with the flight from representation, as advanced artists in all their diversity turned to the construction, not even of "ideal" versions and visions of the real, but of alternative realities.

Representation, however, is hard to escape. It cannot simply be negated—that is too dull after the first blank canvas or empty stage— and anything else tends to fill the vacuum. In the end even nonce words cannot entirely elude signification, paint evokes extrinsic pattern or the artist's own gestural presence, and other worlds all turn out to be versions of our own. Story-making, as a habit of mind, is also hard to elude; otherwise the race surely would have left off trying to make sense of its experiences some time ago. And so, to make representational pictures that are pregnant with narrative implication, and to construct eloquent tableaux in three dimensions out of modern sculptural materials, is suddenly no longer reactionary, but forward-looking. Max Ernst, always a skip ahead, provides a fitting emblem for all this in his *romans collages*, such as *Une Semaine de bonté* (1934), a surreal "narrative" constructed from nineteenth-century wood-engraved illustrations to popular novels.

It is not surprising that such work should turn up again, often with conscious reference to nineteenth-century styles, in an age whose chief forms of entertainment, perhaps its major arts, have all along entailed the most intimate union of picture and story imaginable. The age that danced on the grave of the nineteenth-century narrative pictorial style also perfected the means for implementing a more perfect union of narrative and picture. A. N. Vardac is not being fanciful when he stresses the pictorial aspects of nineteenth-century melodrama as a kind of yearning for, or "social tension" toward the motion picture that followed. And he is—as far as one can tell—perfectly correct when he demonstrates that the cinema took over the popular audience that had earlier supported the nineteenth-century pictorial stage.[4]

The habit of pictorial allusion, and of recreating literal pictorial images, continued in film (from *Christus* to *Sands of Iwo Jima* and beyond) despite the overwhelming attraction of motion as such. The *Napoleon* of Abel Gance (1927) recalls David's *Marat*; William Dieterle's *Juarez* (1939) alludes to Goya's *Third of May*; but most interesting of all, given the analogy of forms, is the opening of Teinosuke

[3] It was to reproach Constable that the *London Magazine* wrote of him in 1826, "It is evident that Mr. Constable's landscapes are like nature; it is still more evident that they are like paint. There is no attempt made to conceal art." Quoted in W. T. Whitley, *Art In England 1821-1837* (New York, 1930), p. 143.
[4] A. Nicholas Vardac, *Stage to Screen: Theatrical Method from Garrick to Griffith* (Cambridge, Mass., 1949), pp. xxv-vi.

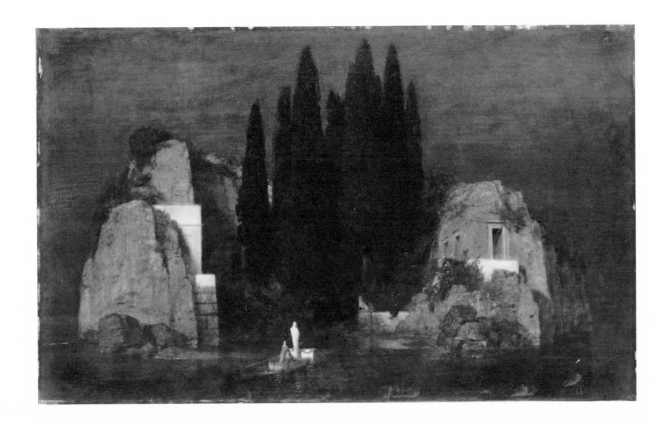

220. *Arnold Böcklin*, The Island of
the Dead *(1880), New York,
Metropolitan Museum of Art
(Reisinger Fund, 1926).*

Kinugasa's *Gate of Hell* (1953), incorporating a Japanese narrative
scroll, itself a progressive orchestration of text and images. The camera
evokes the sense of the battle rush depicted on the scroll, as it reads
from right to left; then the violent scene comes to life in flesh and
blood. From the narrative scroll to both the large and the little screen
is a very short step.

Neither was the theater entirely cut off from the older picture stage,
despite its transformations. The iconoclastic artists' theater of the twen-
tieth century would occasionally quote art as well as make it, for the
pleasure or pain of recognition.[5] The theater of impasse, from Chekhov
to Sartre and Beckett, grows out of one side of situational drama.
Among the great transforming figures, Strindberg and Shaw bring
the literal pictorial image to the stage, Strindberg in *The Ghost Sonata*
(1907): "*The room disappears. Böcklin's picture* The Island of the Dead
*is seen in the distance, and from the island comes music, soft, sweet, and
melancholy.*"[6] Wagner, interestingly, thought that Böcklin would be
the ideal designer for his *Ring* cycle; and the *Island of the Dead* in
particular, despite its affinities with the older art of the act drop and
the painted stage, has the feeling of some of Appia's great Wagnerian
conceptions.

The modern "Theater of Mixed Means," the Henze-Schnabel ora-
torio *The Raft of the Medusa* (1968), and wittier drafts upon popular
iconography like Kenneth Koch's *George Washington Crossing the Del-
aware* (1962), are reminders as well as reversals of various earlier
fashions. No modern play, however, has made such powerful and orig-

[5] E.g. in the Picabia-Satie ballet *Re-
lâche* (1924), Man (Marcel Duchamp)
and a woman appeared as Cranach's
Adam and Eve in an intermittently illu-
minated tableau. See Annabelle Henkin,
"From Dada Performance to the Surreal-
ist Sketch" (Ph.D. diss. Columbia,
1973), pl. 49.

[6] *Six Plays of Strindberg*, trans. Eliza-
beth Sprigge (New York, 1955), p. 304.
See also the discussion of Strindberg's
fragmentary play *Toten-Insel* (1906) in
Richard B. Vowles, "Strindberg's *The
Isle of the Dead*," *Modern Drama* 5
(1962): 366-78. Shaw "discovers" a re-
production of Millais' *North-West Passage*
in *Shakes vs. Shav* (1950), his late pup-
pet play, as a comment on *Heartbreak
House*. For his use of paintings else-
where, see M. Meisel, "Cleopatra and
'The Flight into Egypt,'" *Shaw Review*
7 (1964): 62-63, and Stanley Weintraub,
"Exploiting Art: the Pictures in Bernard
Shaw's Plays," *Modern Drama* 18
(1975): 215-38.

inal use of pictorial realization as Peter Weiss' *Marat-Sade* (1964). Here, in the world of the Charenton Asylum, an unresolved forensic drama of ideas accompanies a progressive reenactment of history, a reenactment interrupted unpredictably by the anarchic subjectivity of the mad actors with which the historical drama overlaps. The result is a modern conflation of the three faces of the drama: theater of the mind, theater of the world, and theater of the soul. The internal structure of each of the units devoted to the historical reenactment provides a rise to a spectacular climax, where the drama is arrested (interrupted), to resume at a lower level, so that the rhythm of the whole is like the rhythm Edward Mayhew once ascribed to the drama of effect. Yet the movement as a whole, however sporadic and discontinuous, has its culmination too, or rather, its converging culminations. The inexorably progressive historical reenactment of the official play and its anarchic subjective disruptions fuse, to culminate in the Revolution; whereupon reenactment becomes enactment, a revolution in being. But first the historical drama and the pattern of high-point interruption produce a final completing interruption; whereupon reenactment becomes realization: the assassination of Marat in the bath. David's picture is realized in the flesh; and whether the murder has taken place "in reality" in this tableau, given the supposed madness of the actors and the notorious interests of the play's "director," an audience for the moment cannot tell. The scene is a fitting postscript to a theater that had once imagined that the perfect illusion of reality was an imitation of art.

BIBLIOGRAPHY

---- ✦·✦ ----

HIS LIST of books and articles chiefly draws together citations in the notes, with the addition of some items that I have found specially pertinent but have not had occasion to mention. For the most part I have excluded the primary materials of the study. That is, I have left out plays in acting editions or archives (some hundreds), unedited novels (some dozens), and standard reviews of productions, exhibitions, works of fiction, and engravings. Reference to these may be found in the text and notes, and located through the index. Most of the plays I talk about are printed in the series listed on p. xvii, or exist in manuscript in the Lord Chamberlain's collection of plays submitted for licensing, now in the British Library. I have also made use of the Larpent Collection in the Huntington Library for the first quarter of the nineteenth century and before.

Other materials of a special nature have come from a variety of special collections. The manuscript holdings of the Huntington Library have been especially valuable for the Pre-Raphaelite painters and their circle, and I have drawn on the holdings of the Morgan Library and the Firestone Library of Princeton University for the same group. The London Library gave access to Charles Reade's notebooks. The National Library of Scotland made available a rich and varied manuscript archive pertaining to David Wilkie. The major novelists and important artists and illustrators (e.g. Cruikshank) are also abundantly represented in these collections.

For prints and drawings, I found most useful the appropriate departments in the British Museum, the Victoria & Albert Museum, and the Bibliothèque Nationale. Nineteenth-century reproductive engravings have not had much attention from public collections until recently, and no collection offers more than a sample of what was once well-known and highly esteemed, and was indeed a high achievement. For the pictorial image as such, photographic archives, notably in the Witt Collection, London, and in the Yale Center for British Art, have eased many of the difficulties.

Not the play text, but the theatrical realization of the play is at the core of this study; and an archaeology of performance is the pertinent scholarly discipline. The shards, traces, and fossil remains of performance—playbills, posters, scene-designs, prints, clippings, property lists—

are most efficiently sifted in theater collections. Those I have used most extensively are the former Enthoven Collection and other components of what is now the Theatre Museum, London; the Harvard Theatre Collection; and the Lincoln Center Theater Research Library, New York.

Adams, Eric. *Francis Danby: Varieties of Poetic Landscape*. New Haven and London, 1973.

Allen, Ralph G. "The Stage Spectacles of Philip James de Loutherbourg." Ph.D. dissertation, Yale, 1960.

Allevy, Marie-Antoinette. *La Mise en scène en France dans la première moitié du dix-neuvième siècle*. Bibliothèque de la Société des Historiens du Théâtre, vol. 10. Paris, 1938.

An Alphabetical List of Engravings Declared at the Office of the Printsellers' Association, London . . . Since Its Establishment in 1847 to the End of 1891. London, 1892.

Altick, Richard. *The Shows of London*. Cambridge, Mass., 1978.

——. *Victorian Studies in Scarlet*. New York, 1970.

Amerongen, J. B. van. *The Actor in Dickens*. London, 1926.

Antal, Frederick. *Hogarth and His Place in European Art*. London, 1962.

Antoine, André. *André Antoine's "Memories of the Théâtre-Libre."* Translated by Marvin A. Carlson. Edited by H. D. Albright. Coral Gables, Fla., 1964.

Appleton, William W. *Madame Vestris and the London Stage*. New York and London, 1974.

Archer, Frank. *How To Write a Good Play*. London, 1892.

Archer, William. *About the Theatre. Essays and Studies*. London, 1886.

——. *English Dramatists of To-Day*. London, 1882.

Arnheim, Rudolf. "Space as an Image of Time." In *Images of Romanticism: Verbal and Visual Affinities*, edited by Karl Kroeber and William Walling, pp. 1-12. New Haven, 1978.

Avery, Emmet L., A. H. Scouten, G. W. Stone, Jr., and C. B. Hogan. *The London Stage 1660-1800*, 5 parts in 11 vols. Carbondale, Ill., 1960-1968.

Axton, William F. *Circle of Fire: Dickens' Vision & Style & The Popular Victorian Theater*. Lexington, Ky., 1956.

Babinski, Hubert F. *The Mazeppa Legend in European Romanticism*. New York, 1974.

Bablet, Denis. *Esthétique générale du décor de théâtre de 1870 à 1914*. Éditions du Centre National de la Recherche Scientifique. Paris, 1965.

Balston, Thomas. *John Martin 1789-1854; His Life and Works*. London, 1947.

Bancroft, Squire and Bancroft, Marie. *Mr. & Mrs. Bancroft On and Off the Stage*. 8th ed. London, 1891.

Barish, Jonas. "Antitheatrical Prejudice in the Nineteenth Century." *U. of Toronto Quarterly* 40 (1971): 277-99.

Barnes, Donald Grove. *A History of the English Corn Laws from 1660-1846*. New York, 1930.

Barnes, Harry George. "Bildhafte Darstellung in den 'Wahlwerwandtschaften.' " *Deutsche Vierteljahresschrift* 30 (1956): 41-70.

——. *Goethe's 'Die Wahlwervandtschaften'; a Literary Interpretation*. Oxford, 1967.

Barthélemy, Auguste Marseille, and Joseph Méry. *Le Fils de l'homme; ou, souvenirs de Vienne*. Paris, 1829.

Baudelaire, Charles. *Art in Paris 1845-1862*. Translated and edited by Jonathan Mayne. London and New York, 1965.

——. *The Painter of Modern Life and Other Essays*. Translated and edited by Jonathan Mayne. London and New York, 1965.

Bazin, André. *What is Cinema?* Translated by Hugh Gray. Berkeley, 1967.

Beaumarchais, Pierre Augustin Caron de. *Théâtre complet.* Edited by G. D'Heylli and F. de Marescot. 4 vols. Paris, 1869-1871.

Beck, Hilary. *Victorian Engravings.* London, 1973.

Beckford, William. *The Travel-Diaries of William Beckford.* Edited by Guy Chapman. 2 vols. Cambridge, 1928.

Bell, Charles. *Essays on the Anatomy of Expression in Painting.* London, 1806.

Bell, Quentin. *Victorian Artists.* Cambridge, Mass., 1967.

Bennett, Mary. *Ford Madox Brown, 1821-1893.* Liverpool, 1964.

———. *William Holman Hunt.* Liverpool, 1969.

Berkeley, George. *The Works of George Berkeley.* Edited by A. C. Fraser. 4 vols. Oxford, 1901.

Blackburn, Henry. *Academy Notes, 1876.* London, 1876.

Boase, T.S.R. *English Art, 1800-1870.* Oxford, 1959.

———. "Shipwrecks in English Romantic Painting." *Journal of the Warburg & Courtauld Institute* 22 (1959): 332-46.

Boime, Albert. *The Academy and French Painting in the Nineteenth Century.* London, 1971.

Booth, Michael R. *English Melodrama.* London, 1965.

———. *English Plays of the Nineteenth Century.* 5 vols. Oxford, 1969-1976.

Born, Wolfgang. *American Landscape Painting: An Interpretation.* New Haven, 1948.

Borowitz, Helen O. "'King Lear' in the Art of Ford Madox Brown." *Victorian Studies* 21 (1978): 309-34.

Boucicault, Dion. *The Art of Acting.* Dramatic Museum of Columbia University. 5th ser., Papers on Acting, 1. New York, 1926.

———. *Forbidden Fruit & Other Plays.* Edited by Allardyce Nicoll and F. Theodore Cloak. America's Lost Plays, vol. I. Princeton, 1940.

———. "My Pupils." *North American Review* 147 (1888): 435-40.

Brereton, Austin. *The Life of Henry Irving.* 2 vols. London, 1908.

Briggs, Asa, and J. Saville, eds. *Essays in Labour History, in Memory of G.D.H. Cole.* London, 1967.

Brombert, Victor. *The Romantic Prison: The French Tradition.* Princeton, 1978. Originally *La Prison romantique: essai sur l'imaginaire.* Paris, 1975.

Brookner, Anita. *Greuze, the Rise and Fall of an Eighteenth-Century Phenomenon.* Greenwich, Conn., 1972.

Brown, Ford Madox. *The Exhibition of WORK, and Other Paintings, by Ford Madox Brown,* London, 1865.

Brown, Karl. *Adventures with D. W. Griffith.* New York, 1973.

Buckley, Jerome Hamilton. *Tennyson, the Growth of a Poet.* Boston, 1960.

Bulwer-Lytton, Edward George, Baron Lytton. *England and the English.* Edited by Standish Meacham. Chicago and London, 1970.

———. *Caxtoniana: A Series of Essays on Life, Literature, and Manners.* 2 vols. Edinburgh and London, 1863.

Bunn, Alfred. *The Stage: Both Before and Behind the Curtain.* 3 vols. London, 1840.

Burke, Edmund. *A Philosophical Enquiry into the Origin of Our Ideas of the Sublime and Beautiful.* London, 1759.

Burnet, John. *Practical Essays on Various Branches of the Fine Arts.* London, 1848.

Burnim, Kalman. *David Garrick, Director.* Pittsburgh, 1961.

Burns, Robert. *Letters of Robert Burns.* Edited by J. De Lancey Ferguson. 2 vols. Oxford, 1931.

———. *The Poems and Songs of Robert Burns.* Edited by James Kinsley. 3 vols. Oxford, 1968.

———. *The Works of Robert Burns; with an Account of his Life.* Edited by James Currie. 4 vols. 5th ed. London, 1806.

Burton, Anthony. "Cruikshank as an Illustrator of Fiction." *Princeton University Library Chronicle* 35 (1973-74): 93-128.

Butlin, Martin. *William Blake. A Complete Catalogue of the Works of William Blake in the Tate Gallery.* Rev. ed. London, 1971.

Butt, John, and Kathleen Tillotson. *Dickens at Work.* London, 1957.

Butwin, Joseph. "The French Revolution as *Theatrum Mundi.*" *Research Studies* 43 (1975): 141-52.

Byrne, Muriel St. Clare. "Charles Kean and the Meininger Myth." *Theatre Research* 3 (1964): 137-53.

Byron, George Gordon, 6th Baron. *Lord Byron, the Complete Poetical Works.* Edited by Paul Elmer More. Boston, 1933.

———. *The Works of Lord Byron, Poetry.* Edited by E. H. Coleridge. 7 vols. London, 1898-1904.

Calev, Chaim. "The Stream of Consciousness in the Films of Alain Resnais." Ph.D. dissertation, Columbia, 1978.

Campbell, Lily B. *Scenes and Machines on the English Stage during the Renaissance.* Cambridge, 1923.

Carlyle, John A. *Dante's Divine Comedy: The Inferno. A Literal Prose Translation.* London, 1849.

Carlyle, Thomas. *The French Revolution.* Everyman's Library. 2 vols. London and New York, 1955.

———. *Reminiscences.* Edited by C. E. Norton. Everyman's Library. London and New York, 1932.

Carr, Sherwyn. "Bunn, Byron and *Manfred.*" *Nineteenth-Century Theatre Research* 1 (1973): 15-27.

Chadwick, W. J. *The Magic Lantern Manual.* London [1878].

Chambers, J. D. *Population, Economy, and Society in Pre-Industrial England.* London, 1972.

———, and G. E. Mingay. *The Agricultural Revolution 1750-1880.* London, 1966.

Chateaubriand, François René, Vicomte de. *Les Quatre Stuart.* In *Oeuvres complètes.* Vol. 10. Edited by C. A. Sainte-Beuve. Paris, 1860.

Churchill, R. C. "Dickens, Drama and Tradition." *Scrutiny* 10 (1942): 358-75.

Cibber, Theophilus. *A Letter from Theophilus Cibber, Comedian, to John Highmore, Esq.* London, 1733.

Clark, Kenneth. *The Gothic Revival.* Rev. ed. London, 1950.

Coleridge, Samuel Taylor. *Specimens of the Table Talk of the Late Samuel Taylor Coleridge.* Edited by Henry Nelson Coleridge. New York, 1835.

Collins, Philip. *Dickens and Education.* London, 1963.

Conrad, Peter. *The Victorian Treasure House.* London, 1973.

Constable, John. *John Constable's Correspondence.* Edited by R. B. Beckett. Suffolk Records Society, 6 vols. Ipswich, 1962-1968.

Cook, Dutton. *Nights at the Play.* London, 1883.

Corréard, Alexandre, and H. Savigny. *Narrative of a Voyage to Senegal in 1816.* 1818. Reprint. London, 1968.

———. *Naufrage de la frégate la Méduse faisant partie de l'expédition du Sénégal en 1816 . . . ornée de huit gravures, par M. Géricault.* 3rd ed. Paris, 1821.

Cox, David. *A Treatise on Landscape Painting and Effect in Water Colours.* London, 1813. Reprinted in *The Studio,* special no., Autumn 1922.

Crabbe, George. *The Poetical Works of the Rev. George Crabbe: With His Letters and Journals, and His Life, by His Son.* 8 vols. London, 1834.

Craig, Edward Gordon. *Henry Irving.* London, 1930.

Croker, John Wilson. Review of books on the Historical Museum at Versailles. *Quarterly Review* 61 (January 1838): 1-38.

Cross, Gilbert B. *Next Week—East Lynne: Domestic Drama in Performance, 1820-1874.* Lewisburg, Pa., 1977.

Cross, James C. *Circusiana, or a Collection of the Most Favorite Ballets, Spectacles, Melo-drames, & c., Performed at the Royal Circus*. London, 1809.

Cru, Robert Loyalty. *Diderot as a Disciple of English Thought*. New York, 1913.

Cruikshank, George. *The Artist and the Author, a Statement of Facts*. London, 1872.

Culler, A. Dwight. "Monodrama and the Dramatic Monologue." *PMLA* 90 (1975): 366-85.

Cunningham, Allan. *The Life of Sir David Wilkie*. 3 vols. London, 1843.

Dacier, Émile. *La Gravure de genre et de moeurs*. In *La Gravure en France au XVIIIᵉ siècle*. Paris and Brussels, 1925.

Daguerre, Louis Jacques. *Historique et description des procédés du daguerréotype et du diorama*. Paris, 1839.

Dahl, Curtis. "Bulwer-Lytton and the School of Catastrophe." *Philological Quarterly* 32 (1953): 428-42.

————. "Recreators of Pompeii." *Archaeology* 9 (1956): 182-91.

[Dallas, Eneas Sweetland]. "The Drama." *Blackwood's Edinburgh Magazine* 79 (February 1856): 209-31.

Darwin, Charles. *The Expression of the Emotions in Man and Animals*. London, 1872.

David, J. L. Jules. *Le Peintre Louis David 1748-1825, souvenirs & documents inédits*. Paris, 1880.

Davis, Earle. *The Flint and the Flame; the Artistry of Dickens*. Columbia, Mo., 1963.

Dayot, Armand. *Journées revolutionnaires 1830-1848*. Paris, n.d.

————. *Napoléon, illustration d'après des peintures, sculptures, gravures, objets, etc., du temps*. Paris [1926].

————. *Les Vernet, Joseph, Carle, Horace*. Paris, 1898.

[Defoe, Daniel?]. *A Narrative of all the Robberies, Escapes, & c. of John Sheppard*. 8th ed. London, 1724.

Delacroix, Eugène. "Charlet." *Revue des Deux Mondes* 37 (1862): 234-42.

————. *Correspondance générale de Eugène Delacroix*. Edited by André Joubin. 5 vols. Paris, 1936-1938.

————. *The Journal of Eugène Delacroix*. Translated by Walter Pach. New York, 1972.

Delavigne, Jean François Casimir. *Oeuvres complètes de Casimir Delavigne*. Paris, 1836.

————. *Oeuvres complètes de Casimir Delavigne*. Paris, 1855.

Descartes, René. *Les Passions de l'ame*. Collection Idées. Paris, 1969.

Description of Banvard's Panorama of the Mississippi & Missouri Rivers, extensively known as the 'Three-Mile Painting.' London, 1848.

Dickens, Charles. "The American Panorama." *The Examiner* (16 December 1848), pp. 805-806.

————. *The Dickens Theatrical Reader*. Edited by Edgar and Eleanor Johnson. Boston, 1964.

————. "Insularities." *Household Words* 13 (19 January 1856): 1-3.

————. "The Late Mr. Stanfield." *All the Year Round* 17 (1 June 1867), p. 537.

————. *The Letters of Charles Dickens*. Edited by Madeline House, Graham Storey et al. Pilgrim Edition. 5 vols. to date. Oxford, 1965—.

————. *The Letters of Dickens*. Edited by Walter Dexter. Nonesuch Edition. 3 vols. London, 1938.

————. *Little Dorrit*. Edited by Harvey Peter Sucksmith. The Clarendon Dickens. Oxford, 1979.

————. *Miscellaneous Papers*. Edited by B. W. Matz. 2 vols. London, 1908.

————. *Oliver Twist*. Edited by Kathleen Tillotson. The Clarendon Dickens. Oxford, 1966.

————. *Pictures from Italy*. London, 1846.

Dickens, Charles. *The Public Readings*. Edited by Philip Collins. Oxford, 1975.
———. *The Speeches of Charles Dickens*. Edited by K. J. Fielding. Oxford, 1960.
Diderot, Denis. *Diderot's Writings on the Theatre*. Edited by F. C. Green. Cambridge, 1936.
———. *Essai sur la peinture*. Vol. 10 of *Les Oeuvres complètes de Diderot*. Edited by J. Assézat. Paris, 1876.
———. *Oeuvres de théâtre de M. Diderot*. 2 vols. Amsterdam, 1772.
———. *Salons*. Edited by Jean Seznec and Jean Adhémar. 4 vols. Oxford, 1957-1967.
Dio Cassius. *Dio's Rome*. Translated by Herbert Baldwin Forster. 6 vols. New York, 1905-1906.
Donohue, Joseph W., Jr. *Dramatic Character in the English Romantic Age*. Princeton, 1970.
Doody, Margaret Anne. *A Natural Passion: A Study of the Novels of Samuel Richardson*. Oxford, 1974.
Dorment, Richard. "Burne-Jones and the Decoration of St. Paul's American Church, Rome" Ph.D. dissertation, Columbia, 1976.
Dowd, David Lloyd. *Pageant-Master of the Republic: Jacques-Louis David and the French Revolution*. Lincoln, Neb., 1948.
Downer, Alan S. *The Eminent Tragedian, William Charles Macready*. Cambridge, Mass., 1966.
———. "Nature to Advantage Dressed: Eighteenth Century Acting." *PMLA* 58 (1943): 1002-37.
———. "Players and Painted Stage: Nineteenth Century Acting." *PMLA* 61 (1946): 522-76.
"A Dramatist." *Playwriting: A Handbook for Would-Be Dramatic Authors*. London, 1888.
Ducrocq, Jean. *Le Théâtre de Fielding 1728-1738, et ses prolongements dans l'oeuvre romanesque*. Paris. 1975.
Dumas, Alexandre. *Le Théâtre complet de Alexandre Dumas*. 25 vols. Paris, 1863-1899.
Durande, Amédée. *Joseph, Carle et Horace Vernet, correspondance et biographies*. Paris, 1863.
Eastlake, Charles Lock. *Contributions to the Literature of the Fine Arts*. 2nd ser. London, 1870.
———. *Materials for a History of Oil Painting*. 2 vols. London, 1869.
———. Preface to *A Hand-Book of the History of Painting, Part I: Italian Schools*, by Franz Kugler. London, 1842.
Edgeworth, Maria. *Letters from England, 1813-1844*. Edited by Christina Colvin. Oxford, 1971.
———. *The Life and Letters of Maria Edgeworth*. Edited by Augustus J. C. Hare. 2 vols. London, 1894.
Eisenstein, Sergei. "Dickens, Griffith, and the Film Today." *Film Form: Essays in Film Theory*. Edited and translated by Jay Leyda. New York, 1949.
Eitner, Lorenz. "Cages, Prisons, and Captives in Eighteenth-Century Art." In *Images of Romanticism*, edited by K. Kroeber and W. Walling, pp. 13-38. New Haven, 1978.
———. *Géricault's Raft of the Medusa*. London and New York, 1972.
———. "The Open Window and the Storm-Tossed Boat: An Essay in the Iconography of Romanticism." *Art Bulletin* 37 (1955): 281-90.
Ellis, S. M. *William Harrison Ainsworth and His Friends*. 2 vols. London, 1911.
Engel, Johann Jacob. *Ideen zu einer Mimik*. 2 vols. Berlin, 1785-1786.
[Errington, Lindsay]. *Sir David Wilkie's Distraining for Rent: Sources and Interpretations*. National Galleries of Scotland, Bulletin Number 2 (1976).
Fairholt, Frederick William. *A Dictionary of Terms in Art*. [London, 1854].
Farington, Joseph. *The Farington Diary 1793-1821*. Edited by James Greig. 8

vols. London, 1922-1928. (A typescript copy of the complete diary is available at the Huntington Library and Art Gallery and elsewhere.)

Farr, Dennis. *William Etty*. London, 1958.

Favart, Charles Simon. *Mémoires et correspondance littéraires, dramatiques et anecdotiques, de C. S. Favart*. 3 vols. Paris, 1808.

Fawcett, F. Dubrez. *Dickens the Dramatist, on Stage, Screen, and Radio*. London, 1952.

Feaver, William. *The Art of John Martin*. Oxford, 1975.

Fildes, L. V. *Luke Fildes, R.A., a Victorian Painter*. London, 1968.

Fitzball, Edward. *Thirty-Five Years of a Dramatic Author's Life*. 2 vols. London, 1859.

Fitzgerald, Percy. *Principles of Comedy and Dramatic Effect*. London, 1870.

———. *The World Behind the Scenes*. London, 1881.

———. *Sir Henry Irving: A Biography*. Philadelphia [1906].

Fitz-Gerald, S. J. Adair. *Dickens and the Drama*. London, 1910.

Forster, John. *The Life of Charles Dickens*. 3 vols. London, 1872.

Foucault, Michel. *Discipline and Punish: The Birth of the Prison*. Translated by Alan Sheridan. New York, 1978.

Francastel, Pierre. *Peinture et société; naissance et destruction d'un espace plastique, de la Renaissance au cubisme*. Paris, 1965.

French Painting 1774-1830: The Age of Revolution. Detroit, 1975.

Fried, Michael. *Absorption and Theatricality: Painting and Beholder in the Age of Diderot*. Berkeley and Los Angeles, 1980.

———. "Towards a Supreme Fiction: Genre and Beholder in the Art Criticism of Diderot and His Contemporaries." *New Literary History* 6 (1975): 543-85.

Frith, William Powell. *My Autobiography and Reminiscences*. 3 vols. London, 1887-1888.

Froude, James Anthony. *Thomas Carlyle, a History of the First Forty Years of His Life. 1795-1835*. 2 vols. London, 1882.

Gage, John. *Colour in Turner: Poetry and Truth*. London, 1969.

Garis, Robert. *The Dickens Theatre: A Reassessment of the Novels*. Oxford, 1965.

Gaunt, William. *Victorian Olympus*. Rev. ed. London, 1975.

Gautier, Théophile. *Histoire de l'art dramatique en France depuis vingt-cinq ans*. 6 vols. Paris, 1858-1859.

Gernsheim, Helmut and Alison Gernsheim. *L.J.M. Daguerre: The History of the Diorama and the Daguerreotype*. 1956. Reprint. New York, 1968.

Gilchrist, Alexander. *Life of William Etty, R.A.* 2 vols. London, 1855.

Goethe, Johann Wolfgang von. *Italian Journey (1786-1788)*. Translated by W. H. Auden and Elizabeth Mayer. New York, 1968.

Gombrich, E. H. "Moment and Movement in Art." *Journal of the Warburg & Courtauld Institute* 27 (1964): 293-306.

———. "Lessing." *Proceedings of the British Academy, 1957*, pp. 133-56. London, 1958.

———. "The Visual Image." *Scientific American* 227 (Sept. 1972), pp. 82-96.

Goncourt, Edmond et Jules de. *L'Art du XVIII siècle*. 3rd ser. Paris, 1895.

Gordon, Catherine. "The Illustration of Sir Walter Scott: Nineteenth-Century Enthusiasm and Adaptation." *Journal of the Warburg & Courtauld Institute* 34 (1971): 300-317.

Gowing, Lawrence. "Hogarth, Hayman, and the Vauxhall Decorations." *Burlington Magazine* 95 (1953): 4-19.

———. *Turner: Imagination and Reality*. New York, 1966.

Graves, Algernon. *The Royal Academy of Arts; a Complete Dictionary of Contributors & Their Work from . . . 1769 to 1904*. 8 vols. London, 1905-1906.

———. *The British Institution; a Complete Dictionary of Contributors & Their Work from . . . 1806 to 1867*. London, 1908.

Grout, Donald Jay. *A Short History of Opera*. 2nd ed. New York, 1965.

Grimm, Friedrich Melchior. *Correspondance littéraire, philosophique et critique par Grimm, Diderot, Reynal, Meister, etc.* Edited by Maurice Tourneaux. 16 vols. Paris, 1877-1882. Kraus Reprint, 1968.

Grundy, Joan. *Hardy and the Sister Arts*. London and New York, 1979.

Gueulette, Thomas-Simon. *Notes et souvenirs sur le Théâtre-Italien au XVIIIᵉ siècle.* Edited by J.-E. Gueulette. Bibliothèque de la Société des Historiens du Théâtre, no. 13. Paris, 1938.

Guizot, François. *History of the English Revolution of 1640, Commonly Called the Great Rebellion: From the Accession of Charles 1 to His Death.* Translated by William Hazlitt. 2 vols. New York, 1846.

Hagstrum, Jean H. *The Sister Arts: The Tradition of Literary Pictorialism and English Poetry from Dryden to Gray.* Chicago, 1958.

Hammond, Barbara and J. L. Hammond. *The Village Labourer 1760-1832.* London, 1911.

Handbook for Travellers in Central Italy, Including the Papal States, Rome, and the Cities of Etruria. London, 1843.

Hanning, Robert W. "Ariosto, Ovid and the Painters." In *Ariosto 1974 in America,* edited by Aldo Scaglione. Ravenna, 1976.

Hanson, Bernard. "D. W. Griffith: Some Sources." *Art Bulletin* 54 (1972): 493-515.

Harbron, Dudley. *The Conscious Stone; the Life of Edward William Godwin.* London, 1949.

Hardy, Barbara. "Dickens and the Passions." *Nineteenth Century Fiction* 24 (1970): 449-66.

Harker, Joseph. *Studio and Stage.* London, 1924.

Harvey, John. *Victorian Novelists and Their Illustrators.* London, 1970.

Hatton, Joseph. *The Lyceum Faust.* New Edition. Reprinted from *Art Journal.* London [1886].

Hayden, John O., ed. *Scott: The Critical Heritage.* London, 1970.

Hazlitt, William. *The Complete Works of Hazlitt.* Edited by P. P. Howe. 21 vols. London, 1930-1934.

Heine, Heinrich. "The Salon of 1831." In *Heine in Art and Letters.* Translated by Elizabeth Sharp. London, 1895.

Henkin, Annabelle. "From Dada Performance to the Surrealist Sketch." Ph.D. dissertation, Columbia, 1973.

Herkomer, Hubert. "The Pictorial Music-Play: 'An Idyl.' " *Magazine of Art* 12 (1889): 316-24.

Hibbert, Henry G. *A Playgoer's Memories.* London, 1920.

Hill, Aaron. *An Essay on the Art of Acting.* In *The Works of the Late Aaron Hill, Esq.* 4 vols. London, 1753.

Hipple, Walter John. *The Beautiful, the Sublime, & the Picturesque in Eighteenth-Century British Aesthetic Theory.* Carbondale, Ill. 1957.

Hobsbawm, Eric J. *Bandits.* 1969. Pelican ed. Harmondsworth, 1972.

—— and George Rudé. *Captain Swing.* New York, 1968.

Hofmann, Werner. *Art in the Nineteenth Century.* Translated by Brian Battershaw. London, 1961.

Hogarth, William. *The Analysis of Beauty.* Edited by Joseph Burke. Oxford, 1955.

Holcomb, Adele M. "Turner and Scott." *Journal of the Warburg & Courtauld Institute* 34 (1971): 386-97.

Hollingsworth, Keith. *The Newgate Novel, 1830-1847.* Detroit, 1963.

Holmström, Kirsten Gram. *Monodrama, Attitudes, Tableaux Vivants. Studies on Some Trends of Theatrical Fashion 1770-1815.* Stockholm, 1967.

Horne, Richard Henry (Hengist). Introduction to *Course of Lectures on Dramatic Art and Literature,* by Augustus Wilhelm Schlegel. Translated by John Black. 2nd ed. London, 1840.

Hueffer, Ford Madox. *Ford Madox Brown, a Record of His Life and Work.* London, 1896.

Hughes, Alan. *Henry Irving, Shakespearean.* Cambridge, 1981.

Hunt, John Dixon, ed. *Encounters.* New York, 1971.

Hunt, William Holman. "The Pre-Raphaelite Brotherhood; A Fight for Art." *Contemporary Review* 49 (1886): 471-88, 737-50, 820-33.

———. *Pre-Raphaelitism and the Pre-Raphaelite Brotherhood.* 2 vols. London, 1905; and 2nd ed. (rev.), 1913.

Hunter, J. Paul. *Occasional Form: Henry Fielding and the Chains of Circumstance.* Baltimore, 1975.

Hussey, Christopher. *The Picturesque: Studies in a Point of View.* 1927. Reprint. London, 1967.

Huyghe, René. *Delacroix.* London, 1963.

"Illustrated Books." *Quarterly Review,* 74 (1844): 167-99.

Irving, Henry. *The Art of Acting.* London, 1893.

Irving, Laurence. *Henry Irving: The Actor and His World.* New York, 1952.

Jack, Ian. *Keats and the Mirror of Art.* Oxford, 1967.

James, Louis. *Fiction for the Working Man, 1830-1850.* London, 1963.

Janin, Jules. *Histoire de la littérature dramatique.* 2nd ed. 6 vols. Paris, 1855-1858.

Jenkins, Elizabeth. *Ten Fascinating Women.* New York, 1968.

Jerrold, Blanchard. *The Life and Remains of Douglas Jerrold.* Boston, 1859.

———. *The Life of George Cruikshank, in Two Epochs.* 2 vols. London, 1882.

Johnson, E.D.H. "The George Cruikshank Collection at Princeton." *Princeton University Library Chronicle* 35 (1973-74): 1-33.

Johnson, Edgar. *Sir Walter Scott: The Great Unknown.* 2 vols. New York, 1970.

Johnson, Lee. "The 'Raft of the *Medusa*' in Great Britain." *Burlington Magazine* 96 (1954): 249-54.

Joppien, Rüdiger. *Die Szenenbilder Philippe Jacques de Loutherbourgs. Eine Untersuchung zu ihrer Stellung zwischen Malerei und Theater* (Cologne, 1972).

Kawin, Bruce F. *Mindscreen: Bergman, Godard, and First-Person Film.* Princeton, 1978.

Keats, John. *The Letters of John Keats.* Edited by Hyder Rollins. 2 vols. Cambridge, Mass., 1958.

Kemp, Martin. "Scott and Delacroix, with Some Assistance from Hugo and Bonington." In *Scott Bicentenary Essays,* edited by Alan Bell, pp. 213-27. Edinburgh, 1973.

Kinkead-Weekes, Mark. *Samuel Richardson; Dramatic Novelist.* Ithaca, N.Y., 1973.

Klingender, Francis Donald. *Art and the Industrial Revolution.* Edited and revised by Arthur Elton. London, 1968.

Konigsberg, Ira. *Samuel Richardson & The Dramatic Novel.* Lexington, Ky., 1968.

Kostelanetz, Richard. *The Theatre of Mixed Means.* New York, 1968.

Kotzebue, August Friedrich von. "Betrachtungen über mich Selbst." *Aus August von Kotzebues hinterlassenen Papieren.* Leipzig, 1821.

Kowzan, Tadeusz. *Littérature et spectacle.* La Haye, Paris, and Warsaw, 1975.

Kroeber, Karl. *Romantic Landscape Vision: Constable and Wordsworth.* Madison, Wis., 1975.

———. *Styles in Fictional Structure.* Princeton, 1971.

———, and William Walling, eds. *Images of Romanticism: Verbal and Visual Affinities.* New Haven, 1978.

La Garde-Chambonas, Compte A. de. *Fêtes et souvenirs du Congrès de Vienne.* 3 vols. Brussels, 1843.

Lamb, Charles. *The Letters of Charles Lamb.* Edited by E. V. Lucas. 3 vols. New Haven, 1935.

———. *The Works of Charles and Mary Lamb.* Edited by E. V. Lucas. 7 vols. London, 1903-1905.

Landon, C.-P. *Salon de 1817*. Annales du Musée et de l'École Moderne des Beaux-Arts. Paris, 1817.

Landow, George P. "Shipwrecked and Castaway on the Journey of Life: An Essay towards a Modern Iconography." *Rev. de Littérature Comparée* 46 (1972): 569-96.

———. " 'Swim or Drown': Carlyle's World of Shipwrecks, Castaways, and Stranded Voyagers." *Studies in English Literature* 15 (1975): 641-55.

———. *William Holman Hunt and Typological Symbolism*. New Haven and London, 1979.

Layard, George Somes. *Tennyson and His Pre-Raphaelite Illustrators, a Book about a Book*. London, 1894.

Leavis, F. R. and Q. D. Leavis. *Dickens the Novelist*. London, 1970.

Le Brun, Charles. *Conférence de M. Le Brun . . . sur l'expression générale et particulière*. Amsterdam and Paris, 1698.

Lecomte, Louis-Henry. *Napoléon et l'Empire racontés par le théâtre, 1797-1899*. Paris, 1900.

Lee, Rensselaer W. "*Ut Pictura Poesis*: the Humanistic Theory of Painting." *Art Bulletin* 22 (1940): 197-269.

Leslie, Charles Robert. *Autobiographical Recollections*. Edited by Tom Taylor. 2 vols. London, 1860.

———. *A Hand-Book for Young Painters*. London, 1855.

Lessing, Gotthold Ephraim. *Laocoön; or the Limits of Poetry and Painting*. Translated by William Ross. London, 1834.

Lewes, George Henry, and John Forster. *Dramatic Essays*. Third Series. Edited by W. Archer and R. W. Lowe. London, 1896.

———. *On Actors and the Art of Acting*. London, 1875.

———. "Realism in Art: Recent German Fiction." *Westminster Review* 70, n.s. 14 (1858): 488-518.

Lipking, Lawrence. *The Ordering of the Arts in Eighteenth-Century England*. Princeton, 1970.

Lockhart, John Gibson. *The Life of Sir Walter Scott, Bart*. London, 1896.

Lubbock, Percy. *The Craft of Fiction*. London, 1921.

McGann, Jerome J. *Fiery Dust: Byron's Poetic Development*. Chicago and London, 1968.

Macklin, Thomas. *Gallery of Poets . . . Catalogue of the Third Exhibition of Pictures, Painted for Mr. Macklin by the Artists of Brittain, Illustrative of the British Poets, and the Bible*. London, 1790.

———. *Illustrations of British Poets*. London, 1788-1799.

Manning, Peter J. "Byron and the Stage." Ph.D. dissertation, Yale, 1968.

Mansell, Darrell. "Ruskin and George Eliot's 'Realism.' " *Criticism* 7 (1965): 203-216.

Marrinan, Michael. "Images and Ideas of Charlotte Corday: Texts and Contexts of an Assassination." *Arts Magazine* 54 (1980): 158-76.

"John Martin, Esq." *Gentleman's Magazine* 195 (1854): 433-36.

Maurois, André. *Olympio: The Life of Victor Hugo*. Translated by Gerard Hopkins. New York, 1956.

Mayer, David, III. *Harlequin in His Element: The English Pantomime, 1806-1836*. Cambridge, Mass., 1969.

Mayhew, Edward. *Stage Effect; or, The Principles which Command Dramatic Success in the Theatre*. London, 1840.

Medwin, Thomas. *Conversations of Lord Byron*. Edited by Ernest J. Lovell, Jr., Princeton, 1966.

Meisel, Martin. "Cleopatra and 'The Flight into Egypt.' " *Shaw Review* 7 (1964): 62-63

———. " 'Half Sick of Shadows': The Aesthetic Dialogue in Pre-Raphaelite Paint-

ing." In *Nature and the Victorian Imagination*, edited by U. C. Knoepflmacher and G. B. Tennyson, pp. 309-340. Berkeley and Los Angeles, 1977.

———. "Waverly, Freud, and Topographical Metaphor." *University of Toronto Quarterly* 48 (1979): 226-44.

———. "Wilkie's Tableaux Vivants: An Amplification." *Master Drawings* 11 (1973): 55-58.

Merwe, Pieter van der. *The Spectacular Career of Clarkson Stanfield 1793-1867*. Tyne and Wear, 1979.

Meynell, Alice, and F. W. Farrar. *Holman Hunt. Art Annual*. London, 1893.

Millais, John Guille. *The Life and Letters of Sir John Everett Millais*. 2 vols. London, 1899.

Miller, J. Hillis. "The Fiction of Realism: *Sketches by Boz, Oliver Twist*, and Cruikshank's Illustrations." In *Charles Dickens and George Cruikshank; Papers Read at a Clark Library Seminar on May 9, 1970*, pp. 1-69. Los Angeles, 1971.

Mitchell, Charles. "Benjamin West's 'Death of General Wolfe' and the Popular History Piece." *Journal of the Warburg & Courtauld Institute* 7 (1944): 20-33.

Mitford, Mary Russell. *The Dramatic Works*. 2 vols. London, 1854.

Moore, Robert E. *Hogarth's Literary Relationships*. Minneapolis, 1948.

Moore, Thomas. *The Letters of Thomas Moore*. Edited by Wilfred S. Dowden. 2 vols. Oxford, 1964.

Moynet, M. J. *L'Envers du théâtre; machines et décorations*. 3rd ed. Paris, 1888.

Muret, Théodore. *L'Histoire par le théâtre, 1789-1851*. 3rd Series: *Le Gouvernement de 1830, la Seconde République*. Paris, 1865.

Musset, Alfred de. *La Confession d'un enfant du siècle*. New ed. Paris, 1864.

———. *Oeuvres complètes en prose*. Edited by M. Allem. Bibl. Pléiade. Paris, 1951.

Muther, Richard. *The History of Modern Painting*. 4 vols. Rev. ed. London, 1907.

Neville, Henry. *The Stage; Its Past and Present in Relation to Fine Art*. London, 1875.

Nicolson, Benedict. "The Raft from the Point of View of Subject-Matter." *Burlington Magazine* 96 (1954): 241-49.

Noble, Mark. *Memoirs of the Protectorate-House of Cromwell*. 2 vols. Birmingham, 1784.

Nochlin, Linda. *Realism*. Harmondsworth and Baltimore, 1971.

Odell, George C. *Shakespeare from Betterton to Irving*. 2 vols. New York, 1920.

Oppé, A. Paul. "Art." In *Early Victorian England, 1830-65*, edited by G. M. Young, 2:99-176. London, 1934.

Orgel, Stephen. "The Poetics of Spectacle." *New Literary History* 2 (1971): 367-89.

Paine, Tom. *Rights of Man; Being an Answer to Mr. Burke's Attack on the French Revolution*. Everyman Edition. London and New York, 1915.

Parsons, Coleman O. "The Wintry Duel: A Victorian Import." *Victorian Studies* 2 (1959): 317-24.

Patten, Robert L. "Boz, Phiz, and Pickwick in the Pound." *English Literary History* 36 (1969): 575-91.

———, ed. *George Cruikshank: A Revaluation*. Double number of *The Princeton University Library Chronicle* 35 (1973-74).

Paulson, Ronald. *Emblem and Expression: Meaning in English Art of the Eighteenth Century*. Cambridge, Mass., 1975.

———. *Hogarth: His Life, Art and Times*. 2 vols. New Haven and London, 1971.

———. "Life as Journey and as Theater: Two Eighteenth-Century Narrative Structures." *New Literary History* 8 (1976): 43-58.

———. "The Pictorial Circuit & Related Structures in 18th-Century England."

In *The Varied Pattern*, edited by Peter Hughes and David Williams, pp. 165-87. Toronto, 1971.

Peacock, A. J. *Bread or Blood: A Study of the Agrarian Riots in East Anglia in 1816*. London, 1965.

Pemberton, T. Edgar. *Charles Dickens and the Stage*. London, 1888.

Pennell, Joseph and Elizabeth R. Pennell. "Pictorial Successes of Mr. Irving's 'Faust.'" *Century Magazine* 35 (1887-88): 309-311.

Pérraté, André. *La Galerie des battailles, au Musée de Versailles*. Paris, 1916.

Pickvance, Ronald. *English Influences on Vincent Van Gogh*. 2nd rev. edit. Nottingham, 1974-1975.

Planché, James Robinson. *The Recollections and Reflections of J. R. Planché*. 2 vols. London, 1872.

Poe, Edgar Allan. *Literary Criticism of Edgar Allan Poe*. Edited by Robert L. Hough. Lincoln, Neb., 1965.

Pointon, Marcia R. *Milton and English Art*. Manchester, 1970.

Praz, Mario. *The Hero in Eclipse in Victorian Fiction*. Translated by Angus Davidson. London and New York, 1956.

———. *Mnemosyne: The Parallel between Literature and the Visual Arts*. Princeton, 1970.

Price, Uvedale. *A Dialogue on the Distinct Characters of the Picturesque and the Beautiful*. Hereford, 1801.

Racine, Jean. *Oeuvres complètes de J. Racine*. Edited by Louis Moland. 8 vols. Paris, 1869-1877.

Raimbach, Abraham. *Memoirs and Recollections . . . Including a Memoir of Sir David Wilkie, R.A.* London, 1843.

Ray, Gordon N. "*Vanity Fair*: One Version of the Novelist's Responsibility." *Essays by Divers Hands*, n.s. 25 (1950): 87-101.

Raymond, George. *The Life and Enterprises of Robert William Elliston, Comedian*. London, 1857.

Rede, Leman Thomas. *The Road to the Stage; or, The Performer's Preceptor*. London, 1827. Published as *The Guide to the Stage*, New York, 1868.

Redgrave, Richard and Samuel Redgrave. *A Century of Painters of the English School*. 2 vols. London, 1866.

Reed, John R. *Victorian Conventions*. Athens, Ohio, 1975.

Rémy, Tristan. "Pantomimes Napoléoniennes." *Europe* (April-May 1969): 310-325.

Reynolds, Ada M. *The Life and Works of Frank Holl*. London, 1912.

Reynolds, Joshua. *Discourses on Art*. Edited by Robert Wark. New Haven, 1975.

Ripa, Cesare. *Nuova Iconologia di Cesare Ripa Perugino*. Padova, 1618.

Roach, Joseph R. "From Baroque to Romantic: Piranesi's Contribution to Stage Design." *Theatre Survey* 19 (1978): 91-118.

Robaut, Alfred, and Ernest Chesneau. *L'Oeuvre complet de Eugène Delacroix*. 1885. Reprint. New York, 1969.

Roberts, Helene E. "Marriage, Redundancy or Sin: The Painter's View of Women in the First Twenty-Five Years of Victoria's Reign." In *Suffer and Be Still: Women in the Victorian Age*, edited by Martha Vicinus, pp. 45-76. Bloomington, Ind. 1972.

Robertson, David. *Sir Charles Eastlake and the Victorian Art World*. Princeton, 1978.

Robertson, Thomas William. *The Principal Dramatic Works of Thomas William Robertson, with a Memoir by his Son*. 2 vols. London, 1889.

———. "Theatrical Types." *Illustrated Times*, n.s. 4 (February-June 1864).

Robertson, W. Graham. *Life Was Worth Living*. New York, 1931.

Robinson, Henry Crabb. *The London Theatre, 1811-1866. Selections from the Diary of Henry Crabb Robinson*. Edited by Eluned Brown. London, 1966.

Rogerson, Brewster. "The Art of Painting the Passions." *Journal of the History of Ideas* 14 (1953): 68-94.

Rosand, David. "Theater and Structure in the Art of Paolo Veronese." *Art Bulletin* 55 (1973): 217-39.

Rosenblum, Robert. "Caritas Romana after 1760: Some Romantic Lactations." *Art News Annual* 38 (1972): 43-63.

———. "The Dawn of British Romantic Painting, 1760-1780." In *The Varied Pattern: Studies in the 18th Century*, edited by Peter Hughes and David Williams, pp. 189-210. Toronto, 1971.

———. *Transformations in Late Eighteenth Century Art.* Princeton, 1967.

Rosenfeld, Sybil. "Alma-Tadema's Designs for Henry Irving's *Coriolanus*." In *Deutsche Shakespeare-Gesellschaft West Jahrbuch 1974*, pp. 84-95. Heidelberg, 1974.

———. *A Short History of Scene Design in Great Britain.* Oxford, 1973.

———. "The Eidophusicon Illustrated." *Theatre Notebook* 18 (Winter 1963-64): 52-54.

Rossetti, Dante Gabriel. *Collected Works.* Edited by William Michael Rossetti. 2 vols. London, 1890.

Rossetti, William Michael. *The P.R.B. Journal.* Edited by William E. Fredeman. Oxford, 1975.

Royal Academy of Arts. *Exhibition of the Royal Academy.* London, 1812, 1827, 1830, 1855, 1858, 1874, 1885.

[Ruskin, John]. *Modern Painters . . . by a Graduate of Oxford.* London, 1843.

Ruskin, John. *The Works of John Ruskin.* Edited by E. T. Cook and Alexander Wedderburn. 39 vols. London, 1903-1912.

Russell, Francis. "An Album of Tableaux-Vivants Sketches by Wilkie." *Master Drawings* 10 (1972): 35-40.

Sala, George Augustus. *The Life and Adventures of G. A. Sala.* 2 vols. London, 1895.

Savin, Maynard. *Thomas William Robertson: His Plays and Stagecraft.* Providence, 1950.

Saxon, Arthur H. *Enter Foot and Horse: A History of Hippodrama in England and France.* New Haven, 1968.

Schiller, Friedrich. *Essays Aesthetical and Philosophical.* London, 1875.

Schlegel, August Wilhelm von. *Ueber Dramatische Kunst und Literatur.* 2nd ed. 2 vols. Heidelberg, 1817. Published as *Lectures on Dramatic Art and Literature.* Translated by John Black, revised by A.J.W. Morrison. London, 1904.

Schoenbaum, Samuel. *Shakespeare's Lives.* Oxford, 1970.

Scott, Clement. *The Drama of Yesterday and To-Day.* 2 vols. London, 1899.

———. *From "The Bells" to "King Arthur."* London, 1896.

Scott, Walter. *The Letters of Sir Walter Scott.* Edited by H.J.C. Grierson. 12 vols. London, 1932-1937.

Seigel, Jules, ed. *Thomas Carlyle: The Critical Heritage.* London, 1971.

Seznec, Jean. *Essais sur Diderot et l'antiquité.* Oxford, 1957.

———. *John Martin en France.* London, 1964.

Shaftesbury, Anthony Ashley Cooper, 3rd Earl of. *Characteristicks of Men, Manners, Opinions, Times.* 3 vols. London, 1732.

Shaw, George Bernard. *Music in London 1890-94.* 3 vols. London, 1932.

———. *Our Theatres in the Nineties.* 3 vols. London, 1932.

———. *Shaw on Theatre.* Edited by E. J. West. New York, 1958.

Shelley, Percy Bysshe. *The Complete Poetical Works of Percy Bysshe Shelley.* Edited by Thomas Hutchinson. Oxford Standard Authors. London, 1960.

Sheridan, Richard Brinsley. *The Dramatic Works of Richard Brinsley Sheridan.* Edited by Cecil Price. 2 vols. Oxford, 1973.

Sickert, Walter. *A Free House! or, The Artist as Craftsman.* Edited by Osbert Sitwell. London, 1947.

Siddons, Henry. *Practical Illustrations of Rhetorical Gesture and Action.* London, 1807. A version of J. J. Engel's *Ideen zu einer Mimik.*

Simond, Louis. *A Tour in Italy and Sicily.* London, 1828.

Sims, George R. *My Life: Sixty Years Recollections of Bohemian London*. London, 1917.

Souriau, Etienne. "Time in the Plastic Arts." *Journal of Aesthetics and Art Criticism* 7 (1949): 294-307.

Southern, Richard. *Changeable Scenery: Its Origin and Development in the British Theatre*. London, 1952.

———. "The Picture Frame Proscenium of 1880." *Theatre Notebook* 5 (1951): 59-61.

Speaight, George. "The Brigand in the Toy Theatre." *The Saturday Book* 29. Edited by John Hadfield, pp. 204-215. London, 1969.

Spiers, R. Phené. *The Architecture of Coriolanus at the Lyceum Theatre*. London, 1901.

Sprague, Arthur Colby. *Shakespeare and the Actors*. Cambridge, Mass., 1944.

Stedman, Jane W., ed. *Gilbert before Sullivan*. Chicago, 1967.

Steig, Michael. *Dickens and Phiz*. Bloomington, Ind., 1978.

Stevens, Joan. "Thackeray's Pictorial Capitals." *Costerus*, n.s. 2 (1974): 113-40.

Stewart, John Hall. *A Documentary Survey of the French Revolution*. New York, 1951.

Stoehr, Taylor. *Dickens: The Dreamer's Stance*. Ithaca, N.Y., 1965.

Stoker, Bram. *Personal Reminiscences of Henry Irving*. 2 vols. London, 1906.

Strong, Roy. *And When Did You Last See Your Father? The Victorian Painter and British History*. London, 1978.

Sutcliffe, Emerson Grant. "Charles Reade's Notebooks." *Studies in Philology* 27 (1930): 64-109.

———. "The Stage in Reade's Novels." *Studies in Philology* 27 (1930): 654-88.

Sutherland, J. A. *Thackeray at Work*. London, 1974.

———. *Victorian Novelists and Publishers*. Chicago, 1976.

Svendsen, Kester. "John Martin and the Expulsion Scene of Paradise Lost." *Studies in English Literature* 1 (1961): 63-73.

Symons, Arthur. *Plays Acting and Music, a Book of Theory*. New York, 1909.

Taylor, Tom. *The Railway Station, Painted by W. P. Frith, Esq., R.A.* 2nd ed. London, 1865.

Telbin, William (the Younger). "Art in the Theatre." *Magazine of Art* 12 (1889): 42-47, 92-97, 195-201.

———. "Art in the Theatre: Act Drops." *Magazine of Art* 18 (1895): 335-40.

Tennyson, Alfred, 1st Baron. *Poems*. London, 1857.

Terry, Ellen. *Ellen Terry's Memoirs*. Edited by Edith Craig and Christopher St. John. New York, 1932.

Thackeray, William Makepeace. *The Letters and Private Papers of William Makepeace Thackeray*. Edited by Gordon N. Ray. 4 vols. Cambridge, Mass., 1945-1946.

———. *Miscellaneous Essays, Sketches, and Reviews*. London, 1886.

———. *Stray Papers*. Edited by "Lewis Melville" [L. S. Benjamin]. London, 1901.

———. *Vanity Fair; A Novel Without a Hero*. Edited by Geoffrey and Kathleen Tillotson. Boston, 1963.

———. *The Works of William Makepeace Thackeray*. 22 vols. London, 1869.

"Theatrical Costume and Scenery." *Magazine of the Fine Arts* 1 (1821): 27-31.

The Thespian Preceptor; or, A Full Display of the Scenic Art. 2nd ed., improved. London, 1812.

Tillotson, Geoffrey, and Donald Hawes, eds. *Thackeray: The Critical Heritage*. London, 1968.

Torriti, Piero. *La Galleria del Palazzo Durazzo Pallavicini a Genova*. Genova, 1967.

Vardac, A. Nicholas. *Stage to Screen: Theatrical Method from Garrick to Griffith*. Cambridge, Mass., 1949.

Vaughan, William. *German Romanticism and English Art*. New Haven, 1980.

Vowles, Richard B. "Strindberg's *The Isle of the Dead*." *Modern Drama* 5 (1962): 366-78.

Waagen, Gustav Friedrich. *Treasures of Art in Great Britain*. Translated by Lady Eastlake. 4 vols. London, 1854-1857.

Wagner, Richard. *Opera and Drama*. Translated by William Ashton Ellis. London, 1893.

Weintraub, Stanley. "Exploiting Art: the Pictures in Bernard Shaw's Plays." *Modern Drama* 18 (1975): 215-38.

Weiskel, Thomas F. *The Romantic Sublime; Studies in the Structure and Psychology of Transcendence*. Baltimore, 1976.

Whitley, William Thomas. *Art in England 1821-1837*. New York, 1930.

Wilson, Harriette. *Harriette Wilson's Memoirs of Herself and Others*. Preface by James Laver. New York, 1929.

Wind, Edgar. "The Sources of David's *Horaces*." *Journal of the Warburg & Courtauld Institute* 4 (1940-41): 124-38.

———. "The Revolution of History Painting." *Journal of the Warburg & Courtauld Institute* 2 (1938-39): 116-27.

Witemeyer, Hugh. *George Eliot and the Visual Arts*. New Haven, 1979.

Woodring, Carl. "Nature and Art in the Nineteenth Century." *PMLA* 92 (1977): 193-202.

Wornum, Ralph Nicholson, ed. *Lectures on Painting by the Royal Academicians: Barry, Opie and Fuseli*. London, 1848.

Wright, Andrew. *Henry Fielding, Mask and Feast*. Berkeley, 1965.

Zeitler, Rudolf. *Die Kunst des 19. Jahrhunderts*. Propyläen Kunstgeschichte, vol. 2. Berlin, 1966.

Zola, Émile. *Le Naturalisme au théâtre*. Paris, 1923.

INDEX

(Page numbers of illustrations are italized.)

Library of Congress Cataloging in Publication Data

Meisel, Martin.
Realizations: narrative, pictorial, and
theatrical arts in nineteenth-century England.
Bibliography: p. Includes index.
1. English literature—19th century—History and criticism.
2. Narration (Rhetoric).
3. Narrative painting—England.
4. Serialized fiction—England—History and criticism.
5. Theater—England—History—19th century. I. Title.
PR468.N29M44 1983 820'.9'23 82-12292
ISBN 0-691-06553-5

Martin Meisel is Professor of English
and Comparative Literature at Columbia University.
He is the author of *Shaw and the
Nineteenth-Century Theater* (Princeton, 1963) and
many articles on literature and theater which
have appeared in anthologies and journals.